The New Subjectivism
Art in the 1980s

Studies in the Fine Arts: Criticism, No. 28

Donald B. Kuspit, Series Editor

Professor of Art History
State University of New York at Stony Brook

Other Titles in This Series

The New Subjectivism
Art in the 1980s

by
Donald Kuspit

With a Foreword by
Diane Waldman

 U·M·I Research Press

Ann Arbor / London

Produced and distributed by
UMI Research Press
an imprint of
University Microfilms Inc.
Ann Arbor, Michigan 48106

Library of Congress Cataloging in Publication Data

Kuspit, Donald B. (Donald Burton), 1935-
 The new subjectivism : art in the 1980s / by Donald
Kuspit.
 p. cm—(Studies in the fine arts. Criticism ; no. 28)
 Includes index.
 ISBN 0-8357-1888-3 (alk. paper)
 1. Art, Modern—20th century—Themes, motives. 2. Art,
Modern—20th century—Psychological aspects. I. Title.
II. Series.
N6490.K87 1988
709'.04'8—dc19 88-12224
 CIP

British Library CIP data is available.

For Judith

Contents

Foreword

In his noteworthy collection of writings, *The New Subjectivism: Art in the 1980s*, Donald Kuspit illuminates some of the most pressing issues in the art and culture of our time. His task is an arduous one, given the momentous changes that have occurred in the art world of the 1980s among artists, dealers, critics, curators and collectors. Kuspit's approach is unique in treating art from a psychoanalytical point of view without, however, losing sight of other issues and other points of view. In tackling a bold range of subjects, he brings a new and provocative voice to contemporary criticism.

Unlike the formalist critics, who prevailed in art criticism for well over three decades, Kuspit does not base his method on an analysis of a work of art from the perspective of color, shape, line and form; rather he approaches a work or group of works in terms of its subject and what the subject reveals of the artist's psyche. Kuspit declares that he took this stance in response to the extreme narcissism among the many artists he knew. Nonetheless, because of his belief that the value in art lies in its subjectivity, Kuspit feels that the psychoanalytical approach tells us much about both the artist and his or her art. It is also particularly relevant to an art that has returned to a form of representation and to subjects that deal with some of the more disturbing aspects of our interior and exterior worlds.

Of the numerous artists who came to prominence in the 1980s, Kuspit finds the new German painters to be the most formidable, although he is quick to point out that their rapid emergence as a unified movement was generated by a concerted effort on the part of critics, museum directors, collectors and dealers to make it succeed. He also notes that the new German painters are keenly aware of making art history and are positioned to "realize history through art" (p. 5), a notion that is fraught with a special significance for them because of the recent history of the German nation, but which can be found in differing degrees among their counterparts in Italy and America as well.

Kuspit emphasizes that the power of a once formidable Germany is now portrayed as the empty symbols of a nation. Yet, as they are appropriated and used by the new German painters, they become signs of the artist's power; the power of the original symbol is transferred to the act of painting. Kuspit perceives new German painting, especially that of Baselitz, Lüpertz, Penck, Immendorf, Polke and Kiefer, as consisting of a "contradiction . . . between themes signifying power and a painting powerful in itself that competes for power with the themes, and to that extent goes against them, sabotages them. But the new German painting does not seek power in the real world. It bases itself in the belief that being personal and having worldly power are incommensurate" (p. 7). Kuspit also sees the new German painting as an attempt to address the old and the new in German traditions, history and art, not in an effort to achieve reconciliation with the past, but to recognize the conflicts and the contradictions.

In contrast to the new German painters whose work Kuspit views as profoundly subjective, their American peers, he believes, have produced work that is not as meaningful. He regards much of the art created in the 1980s as pathological in character and seeking to destroy the intrinsic subjective value of art. For him the German Beuys and the American Warhol represent complete opposites in terms of ambition; Beuys is the idealist, Warhol the nihilist. He notes that "the spirit of Beuys hovers over the new German painting, because it was he who was first aware of the convergence of the modern and the traditional, the new and the fundamental, in a new sense of originality" (p. 11).

For Kuspit, "the new German Expressionism—more than American neo-Expressionism . . . —recovers a limited sense of suffering. . . . In the new German Expressionism, art has once again acquired a social function. . . . By manhandling—mauling—conventions, the new Expressionism has unsettled, if not uprooted, our belief that art is really rationality in disguise. This art shows us our own suffering in the form of the overly familiar and the socially respectable. It has turned modern art's politics of appearance into an all-out war against proper appearance."

When Kuspit addresses the new American painting in his perceptive essays on Fischl, Salle and Schnabel, he treats the subjects of narcissism, voyeurism and fetishism (Fischl), romantic decadence (Schnabel) and the aesthetic of discontent and disillusionment, and the notion of woman as available but distant sex object (Salle). Unlike their German counterparts, these artists are perceived, then, not so much for what they say directly of American society but for what they portray of themselves and what they illuminate in their new subjectivity. In his introduction Kuspit states that the best of the new American painting

"derives . . . from European sources" (p. xviii), using both American ideas and models of European modernism as its guides. For both groups of painters, Kuspit believes that the "modern" in modern art is a subjective rather than an objective condition.

In other, equally perceptive essays, Kuspit explores the role of appropriation in art, discusses such pivotal figures as Kounellis, Morris and Smithson, and illuminates the work of other, older artists, such as Gorky and Beckmann which is particularly relevant to the art of our time.

Among the many additional subjects that Kuspit investigates from a psychoanalytical point of view are "Chaos in Expressionism," "The Subjective Aspect of Critical Evaluation" and "Artist Envy." As Kuspit states, "For Freud, despite his extensive citation of literary artists, visual artists seemed ultimately more interesting, because the visual medium resembles the dream more than the literary narrative does" (pp. 560–61). Although Kuspit notes that Freud ultimately repudiated art, he attributes this phenomenon to the envy of art by psychoanalysts and comments, "For the psychoanalyst, the visual in general is more primitive than the verbal, particularly because it implies 'the earliest closeness with the mother in the preverbal state,' the 'understanding that needs no words to express it.' Thus more sexual pleasure lies in the visual artist's work than in that of the psychoanalyst, who works in words, and is a kind of literary artist. To the analyst, the visual artist seems closer to the source of primal enjoyment than the literary artist" (p. 567).

Of the critic he says that the principal reason "one turns to art is to satisfy a profound need—the need for a coherent, unified sense of self . . . " (p. 547) and that the fundamental role of the critic in each generation is to renew for the public the way in which "art exemplifies the sublimest idea of self possible at the time."

There is no doubt in my mind that just as he has done until now, Donald Kuspit will continue to bring all of his critical intelligence to bear on these and other subjects as the century comes to a close.

Diane Waldman
Guggenheim Museum

Preface

In art, the point of reference continues to be the subject. . . .
Granted, the subject cannot and must not speak the language of im-
mediacy. But it can and does continue to articulate itself through
things in their alienated and disfigured form.
 T. W. Adorno, *Aesthetic Theory*

As the helplessness of the independent subject grew more pro-
nounced, inwardness became a blatant ideology, a mock image of
an inner realm in which the silent majority tries to get compensa-
tion for what it misses out on in society. All this tends to make in-
teriority increasingly shadowlike and insubstantial. And while art
does not want simply to go along with these trends, it is impossible
to conceive of art as wholly divorced from interiority.
 T. W. Adorno, *Aesthetic Theory*

The eighties, in the wonderful phrase that is the title of Leo Braudy's
important book, has been a period of extraordinary "frenzy of renown"
in the art world. What Braudy describes as generally the case seems par-
ticularly to the point for an understanding of the development of eighties
art and our consciousness of it: "The increasing number and sophistica-
tion of the ways information is brought to us have enormously expanded
the ways of being known. In the process the concept of fame has been
grotesquely distended, and the line between public achievement and
private pathology has grown dimmer as the claims grow more bizarre."[1]
The first part of Braudy's formulation, the so-called information revolu-
tion, has been directly connected with the development of post-
modernism, which is, in Braudy's phrase, the ultimate "collage vision."[2]

As Harold Rosenberg wrote, with the availability of an "abundance
of styles" it seems impossible to speak of a preferred style. No style can
have priority over any other, and the conviction necessary to create an

original style seems beside the point, no style really being original. Integrity of conviction comes to seem an absurd self-limitation, inhibiting protean change, that is, "self"-expansion in terms of the existing plurality of modes of style and meaning. Everything being actual in art, there seems no new artistic possibility, and so no need for the conviction to actualize it—no need for the struggle of realization. The artist only has to shrewdly choose the components of his or her collage style: to beg, borrow, and steal whatever seems appropriate in order to have his or her own novel "vision." It is no accident that the eighties are ending with the celebration of so-called appropriation/simulation art—an art of little conviction and much manipulation, an art of facile seduction and no inner necessity. In fact, it seems determined to demonstrate that art is entirely a matter of external necessity or style management. Even the statements of conviction—"manifestos"—made by appropriation/simulation artists are themselves simulations of earlier critical statements by more stylistically and ideologically committed artists. The diluted "truths" of the new statements suggest the bankrupt—at best retardataire—character of criticality in art today, that is, the way much art clings to an old notion of it.

Indeed, appropriation/simulation—in the deepest sense, information—art demonstrates the obsoleteness of the traditional idea of conceptual and material experimentation, the running down of what was once a dynamic notion of avant-garde art. Whether appropriating from popular or high art sources, maintaining the intellectual format of past manifestoes or using a flashy journalistic mode of self-proclamation (both occur with cynical self-consciousness) appropriation/simulation art banalizes whatever it reproduces or "informs" us about. It takes the gold out of it, with a kind of reverse Midas touch. Overobjectifying art itself, it seems to exist to destroy art's intrinsic subjective value, and as such has to be regarded as pathological in character.

I dwell on the appropriation/simulation artists because they are the antithesis of all that I am dealing with—the irreconcilable antagonist, as I make clear in "Beuys or Warhol?". I want to indicate the context of debate in which the new subjectivist art emerged, the situation in which it fought its way to recognition. Pseudo-innovation and irony so ephemeral it evaporates on serious contact have been the rule in much eighties art. Much of it is made to be seen in that peculiar state of excitement and expectation generated by rapidly moving through galleries and quickly glancing at art that often substitutes for intense, deliberate looking in these hurried times. Nowhere does Nietzsche's idea that in the modern world nothing has much meaning unless seen on the move—that is, from a point of view so dynamically changing as to be in effect (perhaps even in unconscious principle) nihilistic—make more sense than

in the case of appropriation/simulation art. This excited state of expectation is correlate with the pathological pursuit of renown. Indeed, the appropriation/simulation artists appropriate and simulate renowned styles, whether popular or esoteric (Walt Disney or Rothko, as in David Salle).

But the eighties has not been entirely a period without conviction. While nothing has been more novel in the eighties than the new "success" of old art, and the fact that all art looked old (especially postwar American art, which in all its facets seemed "ancient"—passé if still haunting) the issue is how past art is used today, to what contemporary purpose it is appropriated. While the appropriation/simulation artists formed their collage vision in one limited, rather narrow and not particularly steep way, other—mostly European—artists synthesized various aspects of past art to construct a new subjective art appropriate to contemporary times, that is, addressed to its depth psychological issues. They have given fresh meaning to the language of immediacy customarily associated with subjectivist art by giving it an archaeological depth—a new power to mediate the past. Generally called the New Expressionists (sometimes against their own protests at what is no doubt an all too convenient and obscuring label) they have created an art which deals with the private, and not so private, pathology of our times: the extremely vulnerable condition of the subject in the contemporary world. It is exactly that vulnerability which leads the self to find succor in fame, and leads to the blurring of private and public pathology, as Braudy suggests.

For Braudy, "the technology of image reproduction and information reproduction" is only a means to an end. The devaluation it signals is part and parcel of the devaluation of personal identity—of the subject, or more specifically the self—that has occurred in hyper-modernity. The supposedly one—in my opinion, overestimated—saving grace of appropriation/simulation art is its social critical and intellectually revolutionary dimension. As in Warhol's art, to which it claims to be heir, its act of reproduction aims to demystify its subject matter, usually American society. Simulating its look supposedly strips its reality of value and may even be an ironical acknowledgment that it had none in the first place. But what appropriation/simulation art in fact achieves is the elimination of the subjectivity invested in society—the subject who by investing himself or herself in reality experienced it as of value. Rather than its clever articulation of society or its presumed objectivity, it is this antisubjective— one might say antitransference—character that is the key to appropriation/simulation art and most of the reproductive art derived from it. Indeed, it has been celebrated for its "inexpressivity," to allude to the title of an Italian exhibition featuring it. The appearance of this art precisely exemplifies the truth of Adorno's assertion that "by slaying the subject,

reality itself becomes lifeless,''[3] which is, indeed, the way it appears in reproduction art.

This devaluation of the subject has continued at an accelerated, perhaps climactic, rate in the eighties. Braudy remarks that in the modern—that is, post-eighteenth century—period, ''the close relationship of the desire for fame to the uncertainty of personal identity''[4] has become apparent. The desire for fame is clearly an attempt to solve the problem of personal identity at one stroke: if one becomes famous one presumably has an identity, has recovered a sense of self—if only temporarily, even fitfully—that otherwise seemed lost. The real issue is not fame but identity. The key problem of modernity in general, and the hyper-modernity we inhabit in particular—that is, the modernity which is so absolute that there no longer seems any alternative to it (certainly not tradition, to which regression is impossible)—has come to be seen as narcissistic.[5] Selfhood has been annihilated, or the self seems insubstantial, causing as many, if not more, problems than sexual repression.

It is in European art made in the eighties, as well as in certain postwar European art given its due only in the eighties, that the problems of self-identity emerge most strongly and clearly—and with special urgency. Whether or not one accepts that European art engages these problems in a fundamental way, one cannot deny its new prominence. It is no accident that the September 1982 issue of *Art in America* was devoted to ''the 'return' of European art,'' as the editor called it, and that *Artforum* in New York and *Artscribe* in London saw fit to add ''international'' to their names. ''For the first time in many years, the contemporary art scene presents an aspect of energetic internationalism,'' the *Art in America* editorial begins; and it ends with the assertion that ''devoting [a] special issue to European art'' does not mean ''taking a dim view of art in America,''[6] which in fact acknowledges the European threat. As my selection of articles for this anthology makes clear, a significant American subjectivist art has in fact emerged in the eighties. But the best of it—the art of Eric Fischl and Julian Schnabel, among others—derives, I believe, from European sources. They utilized the ideas of American as well as European modernism in an extraordinarily forceful way which implicitly became the model. (There are also articles on European and American artists whom I believe anticipate the eighties subjectivist orientation.)

While there is no question that what Rosenberg called a general ''tradition of the new'' exists, its contemporary European articulation attempts to unearth the deep issues of subjectivity buried in it more directly than its contemporary American articulation. German artists in particular have been in the forefront of the restoration of European art, perhaps because

their problem of self-identity is more acute and recognizable—or at least they are more open about it, or more able to use existing languages of art to talk about it—than that of American artists or other European artists. German artists lost their connection to modernism when the Nazis came to power. German Expressionism was singled out at the 1937 Degenerate Art exhibition for particular opprobrium. With the defeat of World War II, German identity in general became particularly suspect, doubtful. Eric Fischl discusses the importance of the new German artists in a particularly personal way, in effect acknowledging his debt—and by implication that of all eighties artists—to them for giving him a meaningful frame of reference in which to make art. Fischl in effect identifies with the Germans in an effort to find his own identity as both artist and person.

> When I came to New York in the late seventies, the greatest risk was sincerity. The German artists—Kiefer, Baselitz, Polke, Lüpertz, Immendorff, Penck—became noteworthy because they were working with a historical event that was guaranteed to be meaningful. It was the worst thing that had happened, they were the descendents of its perpetrators, and they were trying to figure out who they were in relation to it. The whole struggle for meaning since the 1970s has been a struggle for identity. It's pervasive, but most of us can't identify what happened except in personal terms. . . . The Germans were hurt not just personally but culturally as well. It's very hard for us in America to complain or to feel that our complaint is justified, because, after all, what are we complaining about? . . . We're more embarrassed about having believed in the superficial qualities of America, and it's hard to see yourself heroic in that light. But because the Germans were so devastated culturally, you can identify with their struggle for renewal.[7]

In fact, art historically speaking, we are in the midst of the third great renaissance of German art. The first was the Renaissance proper, beginning with the birth of Dürer and ending with the death of Cranach. The second occurred at the beginning of this century, with the Brücke and Blaue Reiter groups, continuing through the Neue Sachlichkeit of the twenties. The third is still continuing. Like the previous renaissances, this one involves a synthesis of apparently contradictory styles, and intense exploration and articulation of selfhood and humanness (which is not necesssarily the same as advocacy of humanism).

The art with which I deal here addresses the problem of the subject. It is an art fraught with narcissistic issues in general and the artist's narcissism in particular. As such, it required that I become aware of my own narcissistic stake in the art, so as to take that into account in my interpretation of it. In my attempt to objectify the subjective issues of this art, I have been forced into a psychoanalytic stance. It became a necessary heuristic supplement to other approaches. Though perhaps not applying

psychoanalysis in the conventional sense, I have utilized psychoanalytic ideas, combining both an "evenly hovering" and an empathic attention to art. In general, I have tried to detach myself inwardly from the artist while attaching myself, however ambivalently, to his or her art. Psychoanalysis as such seems to me to be of major critical importance as the one field of intellectual endeavor that examines in a microscopic way the constituents of subjectivity and, by extension, of humanness. (It also suggests that "psyche is long, art is short," to play on the conventional idea that "art is long, life is short." Of course, what is true for art is true for any civilizing and civilized venture.) One's sense of self-identity is inseparable from one's sense of humanness, and the way one is socially identified—and identifies oneself personally—as a self depends to a large extent on the sense of humanness operative in society, and on the human relations one has experienced. These have a certain characteristic form, and one's response to them also takes certain characteristic forms. Everyone has his or her own history of human relationships, and this makes for significant differences in the sense of self.

I initially took a psychoanalytic stance in self-protective—self-preservative—response to the extreme narcissism of the many artists I know personally. Their self-centeredness—no doubt encouraged by their manic determination to be famous (with me as one instrument of that fame)—seemed to go beyond the "arrogance" Abraham Maslow notes as inseparable from creativeness.[8] In any case, I think the modern paradigm of the critic/artist relationship is that of Boswell's relationship with Samuel Johnson. Boswell invented Johnson as much as he found him, partly in the sense in which the psychoanalyst Donald Winnicott suggested that significant discovery creates its object in the very act of finding it. In other words, Boswell was Pygmalion making a mortal Johnson into a memorable statue—making it so well that he hid the signs of his hard critical work. This is not to say that Johnson was nobody—mere malleable clay in Boswell's hands. Even psychoanalytic interpretation seems to work best on solid material.

Thus, hand in hand with the artist's attention to the problems of subjectivity—which today take the extreme form of narcissistic problems—is his or her victimization by his or her own narcissistic subjectivity. This includes victimization by fame, described by Braudy as a major narcissistic problem. Narcissism is inflicted on society in search of authority and immortality. We may in fact be witnessing the last gasp of the romantic myth of the artist's singularity and specialness, so encouraging of his or her narcissism. The myth seems to be dying from excess of belief in it, particularly among artists. Clement Greenberg once wrote:

I am sick of the art-adoration that prevails among cultured people, more in our time than in any other: that art silliness which condones almost any moral or intellectual failing on the artist's part as long as he is or seems a successful artist. It is still justifiable to demand that he be a successful being before anything else, even if at the cost of his art. As it is, psychopathy has become endemic among artists and writers, in whose company the moral idiot is tolerated as perhaps nowhere else in society.[9]

Today this psychopathy can be called by its correct name—narcissism—and connected to the artist's excessive, socially approved, and ultimately self-destructive love of fame.

Once having accepted critical understanding within a psychoanalytic framework, I began to give free play to the ambivalence I invariably and spontaneously felt towards the art with which I dealt. It seemed impossible to admire any art unequivocally. It would be critically irresponsible, insensitive, and a complete abdication of the critical spirit to do so. This is true not because I expected perfection, but because to take any art at face value is to be subtly indifferent to it, and especially to ignore its vulnerability—its existence against great odds. Art might endure, but in doing so it could still lose to them. In fact, my ambivalence became a sign to me of the vitality of my response to art and of the art's viability. I came to distrust an art toward which I did not feel ambivalent. My ambivalence became a critical tool, the subtle instrument of my developing connection to and conception of the art, enabling me to conceive it in a differentiated way. I moved between the extremes of my ambivalence, exploring each pole of my inner conflict about a given art. I deliberately cultivated my split attitude toward it. The antennae of my ambivalence worked together toward an exhaustive estimation of it. My ambivalence became the means of completely surrounding and consuming/subsuming it, intellectually as well as emotionally.

Maslow, in words that would no doubt be echoed by many artists, has described criticism pejoratively as second best to creativeness—as essentially uncreative. It is "editing, picking and choosing, correcting, skepticism, improving, doubting, rejecting, judging, evaluating"[10] in contrast to the Taoistic "receptivity or noninterference or 'let-be' " of "the primary or inspirational phase of creativeness."[11] Maslow acknowledges that criticism is necessary at the secondary stage of creativeness, when the creator realizes the poorness and uselessness of many of the ideas that arose in profusion during "free association."[12] Even for Maslow, the issue of the significance of creativeness—the issue criticism addresses—is as important as creativeness. In fact, ambivalence is the cutting edge of creativeness as such, obliterating the distinction between primary and secondary phases that Maslow makes. Ambivalence is a major analytic instrument of creative criticism and critically significant creativity.

Janine Chasseguet-Smirgel has written that human beings are hardly able to provide themselves with their "own narcissistic nourishment." The human being "needs others to hold out a mirror so that he may contemplate what he sees there without feelings of self-hatred or self-adoration; deprived of this, he would die, or cease to progress."[13] The critic is supposed to be the artist's passive mirror or, as Braudy puts it, the artist's professional attention-payer, confirming the artist's fame, if only to himself or herself.[14] In fact, my "countertransferential" ambivalence showed that I was a cracked mirror—a mirror that was constitutionally incapable of recognizing and deliberately refused to recognize that the particular artist it was busily reflecting was the fairest artist of them all. (It is gratifying to see that, as I am writing this, the Museum of Modern Art has an exhibition titled "Picturing 'Greatness,' " organized by Barbara Kruger, examining "what it means to look like an artist. It can be about eyes and mouths and finery and gesture and how [they] look from the waist up. It can be about how pose is ambushed by cliché and snapped into stereotype by the camera. It can be about how photography creates prominence, freezes moments and makes history.") Criticism, if anything, must be discriminating, which means that in the very moment it acclaims it also qualifies: to be ambivalent is to have a sense of quality, that is, to differentiate.

I would like to say one final word about the style of these essays. Most were written within a journalistic communicative context, and as such are as much informational, reportorial, and topical as analytic, if the two can be separated. In recent years I have felt the need to communicate as directly and simply as possible, hopefully without forfeiting intellectual subtlety and sophistication of sensibility. But I don't think any writer can know what it is to be truly accessible, because that depends on who the writer wants access to and who wants access to the writer. I don't know who the general reader of the art magazines is. Such a reader would have to be emotionally self-aware and intellectually informed as well as visually literate. Also, at a time when more and more artists are explaining their art (in a self-serving attempt to control its interpretation and guarantee its staying power, that is, to make it appear ageless), it is imperative that the critical reader *not* suspend his or her disbelief and scepticism. For a critic to accept on face value what an artist writes about his or her art is a major failure of critical imagination. It is to succumb to the artist's narcissism—to become a pawn in his or her game of self-inflation. The critic must accept the fact that it is increasingly difficult, in part because of the variety of interpretive methods that can be brought to bear on an art, to know *the* truth about it. The reader must accept a certain relativism in appreciation and judgment. He or she must recognize

that there is no first and last word about any art, although sometimes what seems to be more words than it is worth. Art exists in a theoretically infinite flux of debate, and the structure of this debate is usually as interesting as the art. It is visible, if with different kinds of clarity, through many focuses. What is perhaps most interesting is why it is focused in a certain way—why a certain method is chosen to interpret it. However, it does seem the contemporary case—although this also is no doubt debatable—that what the German artist Dokoupil called "deep content" has priority in the perception of art. One sees style through content these days, rather than as an end in itself. Style increasingly seems a subjective, though socially valid, way of articulating content.

In any case, the articles in this collection utilize a variety of communicative modes, some more worldly than others. Just as there is no preferred artistic style in these postmodernist days, so there is no preferred communicative method. Rather than emphasize the conflict between the variety of communicative styles, I have tried to suggest their possible reconciliation—a collage vision of communication. I do not believe that the academically oriented article, claiming to be definitive, is superior to the supposedly transient journalistic article as a vehicle for serious critical analysis, or that self-styled systematic thinking is inherently more rigorous and insightful than an informal, quick-witted argument which is responsive to immediate issues. Neither guarantees a more genuine understanding than the other. Neither has a monopoly on the truth. Neither offers more of a long-term perspective.

A peculiar mix of both is needed today, and will undoubtedly be needed tomorrow. I do not believe one can necessarily say more with many words than with a few. I do not believe that complexity is better than simplicity, or vice versa. Some of these articles are long, some are short; some make many points in an elaborate way, some hammer home one or a few hopefully basic points. There is no exclusive way of communicating today, none that is automatically more successful than any other. Problems of self-awareness accompany every communicative vehicle, catalyzing thought but also causing hesitancy. Both populist and self-styled avant-garde intellectual language are self-deconstructing these days—they know themselves as games. The question here is whether they also know themselves as imagination, to allude to Wittgenstein's assertion that "to imagine a language is to imagine a form of life."[15] All I can hope is that the reader finds the communications in this collection, with their recurrent attention to a persistent, presumably fundamental, theme in the art considered—the sense of self (especially as it is manifested in the face of death)—as cogent as I thought they were when I wrote them.

Notes

1. Leo Braudy, *The Frenzy of Renown, Fame and Its History* (New York: Oxford University Press, 1986), p. 3.

2. Ibid., p. 5.

3. T. W. Adorno, *Aesthetic Theory* (1970; London: Routledge and Kegan Paul, 1984), p. 45.

4. Braudy, *Frenzy*, p. 7.

5. Christopher Lasch, *The Minimal Self* (New York: W. W. Norton, 1984) offers a summary of the narcissistic issues.

6. Elizabeth C. Baker, "Editorial: The 'Return' of European Art," *Art in America* 70 (Sept. 1982): 5.

7. Donald Kuspit, *An Interview with Eric Fischl* (New York: Random House, 1987; Vintage Books), p. 63.

8. Abraham H. Maslow, "Neurosis as a Failure of Personal Growth," *The Farther Reaches of Human Nature* (New York: Penguin Books, 1976; Esalen Books), p. 39.

9. Clement Greenberg, "The Question of the Pound Award," *Partisan Review* 16 (May 1949): 515–16.

10. Maslow, "The Creative Attitude," *The Farther Reaches of Human Nature*, pp. 64–65.

11. Ibid., p. 65.

12. Maslow, "Emotional Blocks to Creativity," *The Farther Reaches of Human Nature*, p. 90.

13. Janine Chasseguet-Smirgel, *Sexuality and Mind: The Role of the Father and the Mother in the Psyche* (New York: New York University Press, 1986), p. xiii.

14. Braudy, *Frenzy*, p. 6.

15. Ludwig Wittgenstein, *Philosophical Investigations* (New York: Macmillan, 1953), p. 8e.

Part One
European Self-Assertion

Acts of Aggression: German Painting Today

PART I

This article makes no attempt to be comprehensive. I have not dealt with the many German artists associated with Post-Minimalism and Conceptualism, since they are well known here. Little attention is paid to the Berlin realists, and none to the Munich scene. Some individual artists are treated at greater length than others. My main effort was to analyze what seemed to be the most salient aspects of the German scene as a whole at the present moment.

When Christopher Isherwood wrote his semifictional account of Berlin life in the 1920s, it was easy for him to pretend to let the scene speak for itself. The intensity of the situation—of the exchange of ideas and the personalities in it—came through as though unmarked by the camera which Isherwood made himself into. (This is one of the earliest instances of the Warholian idea of becoming a machine that makes art, that lets art issue from itself untouched by meddlesome human hands and minds, especially unconscious minds.) The camera was thought of not as a critical filter but as a neutral recording device, letting the facts speak for themselves. That the facts had to do with a feeling of liberation from social, intellectual, artistic, and sexual conventions—with an atmosphere created by an attitude—did not change anything. This atmosphere would also speak for itself—did not need interpretation—because it gave the facts their peculiar density and directness, their unique color. Today, in looking at the German art scene—which without doubt as a whole is currently the most vital in the world, however much it can be differentiated into a Berlin, Hamburg, and Cologne scene—we find that it comes to us with a whole host of interpreters, all claiming to speak for it. This phenomenon

This article originally appeared in *Art in America*: Part I (September 1982), Part II (January 1983).

of mediation is of course modern; we come to take it for granted that the media are there to catch the news as it is being made, and to tell us what it means before it has become history. In fact, if the media, with its peculiar mix of the reportorial and the interpretive, were not on the scene, the news might never become "historical."

But one senses something more than the usual friendly mediation of news in the case of the German art scene. One senses a vehemence to the mediation, a pushiness, a militant determination to get the art across, to convince us of its value, to declare its uniqueness. The whole cheering squad of German intellectuals, journalists, museum directors, collectors and sundry fellow-travelers, seems to be rooting for the German team of artists in concerted, carefully orchestrated effort.

The art world is being subjected to a publicity and propaganda barrage about German art that has the look of a first step in a campaign of conquest. The German nation may not have been able to conquer the world, but German culture—today in visual arts as once in music and philosophy—can do so, at least as its enthusiasts see it. And there is a sense of mission to the conquest, a sense that it must succeed—that it will prove something to the postwar Germans themselves, and to the world at large in this time of general insecurity, of cultural as well as socioeconomic uncertainty. Populist strategies have not worked; a new sense of elitist originality seems called for everywhere. German originality in the visual arts will once and for all be demonstrated—an originality based on a revived elitist sense of the German spirit, the special German relationship to "Geist."

A whole issue of *Kunstforum* (Dec. '81/Jan. '82) is devoted to "Deutsche Kunst, hier, heute" (German Art, Here, Today), and begins with a documentation by Wolfgang Max Faust, the major historian-publicist of recent German art, of the international excitement at its appearance. The art world is portrayed breathlessly waiting for the new German painting. Faust seems to have little realization that much of the international tension about Germany's movement on the cultural front has to do with the memories it arouses of a previous German aggression.

The analogy, as harsh and absurd as it may seem, has its point, for the new German art is described—by the Germans themselves—as "brutal" and "violent." It is clearly an art about the power of paint to create a perverse poetry—the power of paint to conjure images that overpower and force the spectator to look beyond his ordinary perception and everyday fantasies. It is about the power that paint, used with raw force, has in and of itself on a purely material level. It is about the power that paint used as a purely visionary "medium" and to engender unexpectedly erotic surfaces can have. It is about the unpredictability that painting,

which is all too regularly declared to be on its last legs, can still have—even when one uses it in a culturally predictable way. The Germans show that painting is still of value for an understanding of the complexity of the concept of art.

Documenta 7 comes across as a triumph of German nationalism. The simultaneous publication of Faust's *Hunger Nach Bildern, Deutsche Malerei der Gegenwart* (Hunger for Pictures, German Painting of the Present) also makes the nationalist point, as though the rehabilitation of painting is a German task, a responsibility only an artist with a German spirit can comprehend. Clearly, the Germans have a sense of making art history, and a sense that one must be a German to understand that to make art today is to challenge history as well as art history. One must come from a world that has experienced history with a special thoroughness—a world that, having survived an unexpectedly great number of historical disasters, seems to have a special destiny—to know what it is to "realize" history through art. One must also come from a world that at a certain moment in its history was deprived of art, having been told that modern art was "degenerate." (We will see how important this is for understanding the younger German artists.)

Germany today thus renews its relationship to art—never too steady to begin with—with unusual excitement and eagerness. It is as if the new German painters must recapitulate, in however truncated and travestied form, the entire history of modernism, before they can discover their own artistic identity. The familiar formula of "ontogeny recapitulates phylogeny" is absolute law in the aftermath of the situation of deprivation.

The floodgates are now as wide open as they were once tightly closed. The Germans have a ravenous hunger for pictures, and the sensitivity to modern art of those who have been starved for it. And it is especially for painting that they yearn, for they see it as the most sensitive instrument for registering their frustration. Painting, for them, is the most immediate way of assimilating the modern—it stands to the other visual arts as the piano does to other musical instruments—and simultaneously coming to terms with their own culture, whose spirit, however embarrassing, is their heritage. They have two inheritances to catch up to and spend.

What we find in the new German painting is the marriage of two international rejects—painting, which after years of Minimalism and Conceptualism hardly seems worth the trouble, and German culture with its elitist sense of exclusive relationship to spiritual depths. Painting has been discredited because it seems to have become a completely shallow, "surface" enterprise; and German culture has been discredited because it has been held responsible, rightly or wrongly, for the near destruction of Euro-

pean society and culture. Painting showed its triviality by becoming formalist, and German culture showed its lack of value by becoming something of an antiquarian joke. Painting showed its indifference to the world-historical by becoming militantly abstract, and the German spirit thought it could make world history by becoming aggressive in the name of abstract ideas. Both became outcasts by reason of their excessive purity. Becoming completely abstract, they became completely "unrealistic"—useless for human purposes.

In the new German painting, "stupid" painting and "stupid" spirit become allies, and produce a new "realism," about art as well as the world. Abstraction is used against itself to produce a new concrete imagery, a conceptual dream imagery with so strong a hold on us that it is experienced as freshly real. Self-repressed by reason of their pursuit of purity, and socially repressed by reason of the "anti-social" behavior this led them to, painting and the spirit combine in the new German painting to create a new kind of "spiritual painting."

Both become freshly impure, susceptible to "foreign" influence, energized by an extravagant openness to influence. Painting becomes raucously "informal," and signs of German spirit or German nationalism are treated ironically, with an irony compounded of a sense of absurdist incomprehension and anarchistic abandon. What were once military helmets, epaulettes and insignias become decorative junk, similar to the way iron crosses are used "decoratively" by punksters. A sign of spiritual-cultural-national power is reduced to an empty abstraction with no particular social location or political resonance. It becomes sociopolitically contextless to the extent it enters the art context.

There, it remains intact as the sign of a power that was, and that may return—but that now is part of the power of art. Appropriated by art, it becomes a sign of the artist's personal power. Symbols of power are decathected in the new German painting: the power once thought of as inherent in the symbol is transferred to the act of painting through the very act of "expressively" painting the symbol. "All the power to painting and away from the worldly symbol of power!" is the battlecry of the new German painting.

This is what I think happens to the quasi-heroic figures in Baselitz, to the helmet and similar artifacts in Lüpertz, to the militaristic stick figures in Penck, to the allegorical figures and "alternative spaces" for social "degenerates" and misfits in Immendorff, to high art (Minimalist and Conceptualist) itself in Polke, and to identities, entities, and places which are conventionally identified as "heroically German" in Kiefer.

In the work of all of these artists—I have mentioned the major figures in the mostly over-40, first postwar generation of painters—a conventional

embodiment of power, by reason of its unconventional, more or less "painterly" treatment (in Polke's case I am thinking of the handpainted stencil pictures), loses its potency. The powerful meaning—spiritually, culturally, socially, historically powerful—is washed out of it by the artist's preoccupation with the intensity of his own art.

In the work of these artists, an ironical, even absurd situation is created, in which the theme of an art stands in contradiction to its method—even when the theme is another art, as in Polke's treatment of Carl Andre, or Walter Dahn and Georg Dokoupil's treatment of Robert Ryman. Polke, incidentally, from the conceptual point of view—in the spirit if not in the letter—is a major inspiration to these, and other, members of the next generation of German artists. A "poetic" situation arises—a conceptual poetic situation—in which the art becomes "literary" by going against the "literary"—spiritual, cultural, social—meaning of a "text." The theme is reduced simply to a quoted text that is the occasion for a reconcretization of painting, a fresh identification with painting, that is simultaneously the playacting of painting.

For in this new painting, painting itself must not be allowed to become the theme, to become the sign of real worldly power. It becomes powerful by becoming personal. This does not mean it becomes old-fashioned "signature" painting, for the "personal" here is a method of repersonalizing what has become depersonalized and iconically abstract because it has become symbolic of absolute power, whether spiritual, cultural, or social.

When Per Kirkeby, a Danish painter living in Germany, describes the new German painting as "painterly poesy," and historically documents the long but also recent connection of poetry and painting, referring to Ezra Pound and Wallace Stevens, he makes a general, almost truistic point, but he does not spell out the character of the new "poetry." It arises as the result of the apparent contradiction in the new German painting, between themes signifying power and a painting powerful in itself that competes for power with the themes, and to that extent goes against them, sabotages them. But the new German painting does not seek power in the real world. It bases itself in the belief that being personal and having worldly power are incommensurate. That is why the new German painting is a new kind of conceptual painting—personalized conceptual painting.

The new German painting is already two generations old. The first generation—its major figures have been mentioned—claims to have a program of "painting as painting," but in fact it uses painting to undermine a powerful reality. It uses what I would call contingency painting— painting reduced to a state of contingency or criticality, evident particularly

in expressionist-type painting, where freewheeling touch and the freewheeling use of color convey a sense of unexpectedness—in order to undermine the apparent necessity and hold of reality.

Reality is shown to be a mental configuration, contingent on our attitude to it—one sure way of getting free of past German reality, which in its contingent state becomes a hallucination. Abstractive expressionist painting is a way of articulating this contingency, with its implied variability of attitude. The freedom of expressionist-type painting becomes an analogue for a free attitude towards reality, including the reality of art. Expressionist handling works against the fetishistic attitude to any kind of reality, repersonalizing it by breaking the taboo against ''touching'' it.

Abstract Expressionism created the illusion that the act of painting itself was heroic, but in the new German painting expressionism itself is used to demythologize painting. Painting itself becomes operatic, the picture a kind of opera bouffe, whose ideas count as much as its style. Painting is used to demystify what can easily become mythological—the workers whom Baselitz paints, Penck's flight from East Germany, Immendorff's *Café Deutschland*, Kiefer's ''good old'' Germany, even abstract art for Polke.

This ''negative'' use of painting by the first generation artists frees the second generation artists to affirm painting as a mediumistic vehicle of revelation through spontaneously erupting fantasies, a kind of childlike, oracular activity. Like the first generation artists, those of the second generation—mainly the so-called political artists of Hamburg (I prefer to regard them as ''sociological'' artists) and the Cologne Mülheimer Freiheit group—see art as a moral matter. As Dokoupil said to me, he wants his art to be moral, but he can only be ironically moral, and ironical about wanting to be moral. This irony takes the form of a ''fantastic'' treatment of existentially inescapable themes. As Dokoupil said, central to all the German artists is a ''powerful content,'' a content which sounds banal—in his case ''mother, father, life, death''—but is universally important, and a content which, because it is commonplace, must be treated ironically.

In the case of the second generation artists, irony encompasses a certain amount of stylistic fanfare. Style, as Dokoupil said, is only a means to an end, which is why his own style is so varied, so changeable. One senses here a Picasso-like attitude—was Picasso an unwitting Conceptualist? (Man Ray, however, was the model several artists mentioned, together with Picabia, for a general attitude to art.) For the second generation artists, the conceptual use of an abstractive expressionistic style to defuse all explosive content—the use of a ''catastrophic,'' quaking style to shake up this content—is replaced by an abstractive fantasy style to articulate the paradoxical nature of the content. The second generation

artists are socio-existentialists, offering paradoxical images that embody contradictions, states of conflict or self-conflict.

This state of contradiction is conceived as a knot that can neither be untied nor cut, a no-exit situation. Made even more complicated visually than it perhaps is in reality, it becomes indecipherable, unreadable, which adds to its enigmatically "conflicted" character. A number of jointly painted works by Dokoupil and Walter Dahn perhaps best articulate this intensified double bind situation. In their *Kotzer III,* 1980 (Shit Throwers), two figures are locked together by their verbal warfare. In *Deutscher Wald,* 1981 (German Forest), the spirit of the forest and that of the Nazis are identified—united—with one another in a hybrid monster. In *Gedanken Sind Feuer,* 1981 (Thoughts Are Fire), houses and trees—the urban and the rural—are at a standoff within the same (Klee-like) "spirit." A similar sense of unreconciled opposites exists in Peter Bömmels's *Doppelkreuz III,* 1981 (Doublecross) and in Hans Peter Adamski's *Das Land des Lächelns,* 1981 (The Land of Laughter). Dahn's *Ich,* 1981 (Me) is a powerful example of self-contradiction—a figure trying to crawl inside its own head.

Elements of both generations—the sense of "negative" freedom achieved through abstractive expressionist style and the use of abstractive fantasy to revitalize our relationship to the familiar by "respiritualizing" it— appear in the Berlin School.

Berliners differentiate themselves by reason of their distance from "mainland" Germany and their own special history. For the Berlin ar- tists, the familiar and fundamental is nature, whether human nature (as I think is the case in Salomé, Middendorf and Fetting) or animal nature and landscape (Hödicke, Koberling, Zimmer). Hödicke, who belongs to the older generation of Berlin painters, keynotes what is crucial to the work of the current group of Berlin artists, and separates it from that of other artists I've discussed, particularly Baselitz, Kiefer, Penck and Lüpertz.

The Berlin artists pursue instantaneous expressivity, where "ex- pressivity" means the unexpected outburst of a repressed image that not even the artist knew existed in his soul. It is an image that, for all the seeming preparation for it attained by traveling to distant sites (as most of these artists do), cannot be predetermined. It is released into the pic- ture only by rapid, near-automatist working methods, where a relatively free association of strokes and colors "breeds" the image, becomes a cultural plate on which it jells and grows.

Traditional German Expressionism reconstituted an already given ap- pearance, an explicit model. The new Berlin Expressionism lets the image emerge from the paint action, which must be as rapid as possible so that

the image seems freely given, a gift of the unity of action and artist's soul. Even when the image depicts a familiar reality, we are never convinced of its actuality. At its best, the image is experienced as the disguise for a stranger reality, the way the dog in Goethe's *Faust* is actually the devil.

The demonic—and daemonic—character of the image is not to be underestimated in any picture of the new Berlin painting. It is a Mephisthophelean voice that tutors us in the possibilities of our own existence. Koberling's Icelandic lava blocks and cormorants, Zimmer's cows and burning cars, and the figures of Salomé et al, are demonically possessed and articulate our own depths. That this articulation often seems so facile—that the work seems so at ease with itself—only confirms its success at making a hidden spirit immediate. It is crucial that neither image nor paint movement seem forced if we are to feel relaxed in the presence of often grotesque and terrifying or lurid and violent events. If the paint was troweled on we would never accept our inner sense of the image.

The new German painters share a sense of fresh encounter with previously forbidden German themes and Germanic style, and an attempt to synthesize this native German "content" with internationally valid stylistic forms and ideas about art. The aggression of the new German painters—their aggressive use of paint, and overwrought, supersensitive use of modernist styles, and perhaps most crucially their recovery of the original sense of abstraction as apocalyptic and utopian—is a way of overcoming their ambivalence about both the Germanic and the modern. It is also an indication of the energy used to effect the difficult synthesis between national and international art values. Expressionism in general is a kind of abstracting that is deliberately aggressive against reality—deliberately counteracting conventional ideas about reality—in order to articulate what is fundamental to reality: its forceful presence—its insistent particularity—which, unexpectedly, is difficult to render, once one realizes the inadequacy to the task of the preconceived forms conventionally used to describe reality.

Native German tradition tends to be obsessed with such particularized force, which it usually locates in nature, as in the Danube school of landscape painting. In contrast, much internationally valid art, especially that in a classicizing vein, tends to be formalist, i.e., to articulate "universal" form, presented purely or abstractly as "art" or "style." To unite the Germanic and the internationalist classicizing tradition has been the ambition of German artists of international stature since Dürer, who attempted to fuse a native German sense of powerful particularity with an

Italian Renaissance sense of universal structure. In the new German painting a Germanic sense of existential particularity combines with an international sense of high art style. Not only is continuity with the authentically Germanic and authentically modern art restored, but a new sense of authenticity, going to the very roots of both, is achieved.

The new German painting makes clear that the source of the modern tradition is not a hermetic preoccupation with the purity of the medium or involuted manipulation of its conventions, but rather, in Baudelaire's sense, a fresh sense of the imagination as a way of articulating the hidden logic of our passionate relationship to reality. The artistic logic of the imagination is restored to full rights in the new German painting. The sense that artistic logic deals with as fundamental a reality as more obviously cognitive enterprises is a fundamental issue of modernism, a truth that modern art has attempted to demonstrate in a number of ways. It is essentially a romantic truth, in the German tradition going back to Runge, Friedrich and Böcklin, among others. It involves neither more nor less estrangement from ordinarily experienced reality than any science.

The method of "dialectical representation," to use Penck's phrase, that the new German painting brings to bear on German tradition and on modern art itself is *the* method of romantic modern art. It is based on a logic of contradiction, which can be resolved only "artistically." In the case of the new German painting, the contradiction between the old and new Germany, between "transcendental" German spirit and the history of the German nation, between traditional German art and the tradition of modernism, between the idea of avant-garde art and the sense of its overdetermination (eliminating the idea of the authentically new), and between the ideas of novelty and originality.

The new German painting attempts to deal simultaneously with conflicts within Germany and with conflicts within modern art. But "dialectical representation" is not dialectical reconciliation, at least not in any easy way. The aim rather is to let the conflict—the contradiction—speak for itself. Demonstrated artistically, the logic that shows how the opposites are bound to one another without being reconciled, becomes obvious. The new German painting is a didactic art, an education in the tension between values, inviting the spectator to make his own synthesis of the traditional and the modern—the traditional we yearn for and the modern we have had too much of, the traditional which is unexpectedly modern and the modern which is unexpectedly traditional. The spirit of Beuys hovers over the new German painting, because it was he who was first aware of the convergence of the modern and the traditional, the new and the fundamental, in a new sense of originality.

PART II

Baselitz and Lüpertz

Georg Baselitz in his castle, Markus Lüpertz in his bar: these "senior" artists are the touchstones of the new German painting. Baselitz inhabits a sign of tradition, surrounded by more signs of tradition—his seemingly antithetical collections of Italian Mannerist prints and African sculpture. One recalls Arnold Hauser's argument that modernism begins with Mannerism; one also recalls the inescapability of primitivism in modernism. Baselitz consciously associates himself with the symbols and sources not only of traditional German culture but of modern art. Baselitz is rooted, one might even say entrenched, in tradition; he offers a new conception of freedom based on a new relation to—a fresh interpretation of—tradition.

He starts from a new emphasis on directness—the directness with which man can act, can relate to God and paint. To compare God to paint may seem farfetched, but the self-esteem of the painter depends on his relation to paint, just as the self-esteem of man depends on his relation to the divine. Baselitz communicates a fresh sense of the ultimacy of the medium of paint through the directness of his relation to it, the directness with which he gives it presence in his pictures.

There is a kind of divine madness to this pursuit of directness, this effort to free paint of the harness of form that tradition supposedly insists it wear. The message of tradition—old and new—for Baselitz is to be as fanatically sensuous—direct—as possible, and thus to become divine, like the "divine" Michelangelo. The allusion to Michelangelo is not gratuitous; the same harsh, tragic, insistent stroke that informs Michelangelo's late, unfinished sculpture convulses Baselitz's figures, subtracts from them in the very act of rendering them—negates them to affirm the stroke's own intensity, and ultimately the artist's personal, radically individual intensity.

Intensity is also what Lüpertz thinks is crucial, intensity driving toward—and the very upshot of—individuality. Again and again in conversation the note of individuality was sounded by Lüpertz. It was sounded in his refusal to be the epigone of the American abstractionists—particularly Arshile Gorky, an artist with whom he had an early affinity. (This refusal to be the decadent understudies of American movements was stated again and again, not only by Lüpertz, but by other German artists, younger and older.)

According to Lüpertz, an almost explicit rebellion against assumed American leadership was in the works from the time of Baselitz's early

sixties Pandemonium manifestos. (It should of course be noted that during the same period there were similar antisocial and antiformal manifestations in the U.S.—the rougher side of late Abstract Expressionism, Happenings, etc.—which don't seem to figure in the German's retrospective view of the early sixties situation.) Lüpertz told me the Americans were not his "fathers," and they did not initiate him into any stylistic order—although he volunteered the information that early Pollock was "crucial" for him.

Lüpertz went on to observe that a reaction against American art is even more central to the second generation of German artists than it was to him and his contemporaries. If anything, the younger artists' conception of American avant-garde art (admittedly generalized and schematized) was a kind of collective jumping-off point for the development of their own individuality. As they saw it, American avant-garde production was typically characterized by highly consistent individual styles. By contrast, these younger German artists, like Lüpertz before them, were eager to free themselves from the dominance of any one style—hence, like him, their constant variability.

Another point of resistance to things American, and hence of self-definition for the younger Germans: in the American avant-garde world during the period of their artistic maturing, painting was as abnormal as it was in the German bourgeois world. To the younger German painters, the American art world seemed by the late sixties (to use Lüpertz's melodramatic analogy) as authoritarian and unthinking in its rejection of painting per se as Hitler was in his rejection of Expressionist painting. So why not make a fetish of painting—and indeed, of Expressionist-type painting? Why not be ironically decadent, by going back to the first truly modern painting Germany had seen?

And why not be more profoundly decadent than the American avant-gardists could ever imagine—dangerously, politically decadent? For the move was not only to paint, but to encompass meaningful subjects drawn from the real world. It was not only Beuys who, during the sixties and early seventies, was developing in Germany a new connection between art and life. One should be equally aware of Baselitz's early paintings, of looming Slavic soldiers, Lüpertz's more recent German helmets and cannons, Immendorff's trenchant social satire, Penck's obsessive sense of discrepancy between East Berlin and West.

To me, the restlessness in Lüpertz's art—its constantly shifting stylistic base—is an ironic embodiment of an already ironically conceived decadence and degeneracy. These strategies Lüpertz sees as necessary to avoid creeping stagnation, bred by previous normalization of the

abstract condition of advanced art. Picasso's development—his decadent relationship to his own past history (Cubism) and to past art in general—is almost a model for the development of Lüpertz. Not steadiness in a single style, but perverse quotation and reconstitution of what seems stylistically obsolete—seems Lüpertz's conceptual method for advancing his art.

While Lüpertz is conceptually restless, Baselitz is restless in his touch. The paintings of both artists have a peculiar morbidity, articulating a sense of the absurd. This is most obvious in the upside-downness of Baselitz's figures and the determined, unrelenting bizarreness or eccentricity of Lüpertz's ongoing ''Alice in Wonderland'' series, which unfolds in both painting and sculpture.

Baselitz conceives of himself as an abstract painter, arguing that the effect of his topsy-turviness is to free us from the associations aroused by his traditional (portrait) subject matter. With his images inverted, all attention presumably turns to his aggressive painterliness. It's as though his content must suffer the scars of a saber slash or the wounds of an ax; we attend more to these marks of its honor than to what it was before it was marked.

But there is more to Baselitz's paintings than their painterly method. Baselitz's early figures are clearly constructed according to a mannerist esthetic. The principle of small heads and large, long bodies usually holds; in any case, the body's parts are out of proportion, so that the body seems divided against itself, about to come apart. It seems to be constituted of extremities with no natural relation; it exists in self-contradiction, an asymmetrical structure of opposites.

The upside-downness of his later heads or busts is simply an extension of this, a grimmer way of pulling the figure apart, of stretching it on the mannerist rack. And the harsh painterliness is a final mannerist violation of the figure, another way of pushing it to the limit of self-contradiction and of affirming its nonnaturalness—its lack of conformity to any normative conception. Baselitz's mannerism articulates a fundamental antiharmony.

Baselitz spoke to me of his obsession with anamorphic distortion, evidenced at the very beginning of his career in two landscape drawings (1959). His subsequent upside-down paintings are quasi-anamorphic distortions, which cannot be set right. There is no key that permits us to read them normally; they offer the image of a world fundamentally at odds with itself.

I see Baselitz's mannerism as, implicitly, a metaphor for the situation of modern Germany, a country divided against itself, symbol of a world divided against itself. A sensitivity to this self-destructive situation is at the root of much of the new German painting, directly or indirectly.

Penck, who only recently came to West Germany, deals explicitly with border crossing in his highly personal painting. In fact, almost to a man (Immendorff was born on the Western side of a town directly on the border), the major artists of the older generation of painters are Easterners who have crossed to the West. They remain obsessed with the East, the land of their childhood, the land that formed them. This is sometimes explicit, as in Immendorff's iconography, which incorporates personages prominent in both worlds; and these two worlds are epitomized in the two contrasting allegorical columns that support the roof of his recurrent subject, the *Café Deutschland*.

At other times, references to the East are less obvious, as in the Russo-Slavic soldier that figures heroically in Baselitz's early paintings, reminding us that the East Germans are as oriented to the Russians as the West Germans are to the Americans.

In still other cases, the East/West contrast, or the effects of the dichotomization of Germany, are so hidden as to be almost enigmatic in effect. Thus, Dokoupil told me of his sense of shock—of confronting another world—when he first came to the West in the summer of 1968, in the aftermath of the Russian invasion of his native Czechoslovakia. I think that sense of worlds which superficially look alike but which are radically different—serious alternatives—is the source of his highly variable fantasy, his creation, in his paintings, of "life on another planet."

I don't want to overstate the influence of a divided Germany on the imagery and stylistic zigzagging of the new German painting, but it seems to me to be fairly decisive. This can sometimes seem to get out of control and become dangerously anarchic, even destructive. It sometimes comes across as an erratic attempt to bridge opposites that once had a common basis, and in the remote future might have one again. Meanwhile, in the present, there is the love/hate, attraction/repulsion intimacy of close relations. Wherever one lives in Germany, one is in exile, because there is always a part of Germany in which one is an outcast and to which one cannot return.

Baselitz chooses the conventions of process painting to achieve a new effect of contingency, of vulnerability. It is interesting to contrast his use of paint to that of Pollock and de Kooning. In the mature Pollock, figural elements emerge from the spontaneous flow of direct painting, whereas in the mature Baselitz the high-powered strokes seem to flow from the figure, which at times seems no more than a flint on which they whet their appetite. Baselitz has sometimes been understood in terms of de Kooning, but Baselitz's figures are not sealed into a framework of Cubist space as de Kooning's are—they do not come to us with their position predetermined by a fixed structure of space. De Kooning works to dig

his figure out of space; Baselitz digs into his figure, letting the chips of space fall where they may; it is this lack of underlying spatial containment that, I think, makes Baselitz's strokes seem to have more "surplus value"—be more "passionate"—than those of de Kooning. They seem more "erotic" because they are more hectic, less anchored to the figure they constitute—less bound to an articulation of the figure.

What Baselitz is for stroke, for line, Lüpertz is for mass. He offers us a manneristic handling of mass as free from gravitational pull, a postgravity world in which volumes are still weighty, but displace no space. Lüpertz's is literally an "Alice in Wonderland" attitude—apart from his works which use sentences from Lewis Carroll's text as their titles.

Lüpertz offers us images of forms that have become unrecognizable—fantastic—that seem debauched by their own twisting-in upon themselves. He gives us a debauched treatment of a variety of past styles and German themes as well. Used in a way that contradicts their normal meaning, they become crazed, peculiarly congealed in appearance, for all the briskness with which they are rendered. (Lüpertz represents the beginning of what later becomes the free-fantasy mode of several younger artists, particularly the Mülheimer Freiheit group.)

Lüpertz claims to make dithyrambic painting. The dithyramb is a wild, irregular lyric that celebrates Dionysus. In Lüpertz there is a kind of identification with Dionysus and Nietzsche (who identified with Dionysus as well). It is an identification with their madness as the only normal mode of being in a mad world divided against itself. To force things together orgiastically in the Dionysian manner is a visual strategy in Lüpertz. His madness is of course a construct, and his "mad" forms are constructions welding together individual things that don't belong together in a Dionysian manner, so that they have a collective identity.

Lüpertz offers a Dionysian, lyrical—by German standards—treatment of epic material weighty with historical significance. This is most explicit in the pictures where he makes emblems of Nazi helmets and images of Hitler's head. But Lüpertz also deals with the burdensome reality of modern art history—a reality that weighs as heavily on today's German artist, isolated by Hitler from modern roots, as recent German history.

Lüpertz is engaged in a dialectical duel with the recent past—an attempt to subsume and transcend his personal collective history as a German and a modern artist. Lüpertz's encounter with Picasso is as important for him, he claims, as his encounter with Hitler. Lüpertz wants to unmake the history they made—or rather, to use it to convey another attitude. In this contrariness, he too is mannerist; mannerism is as antihistorical as it is antinatural—as little a respecter of historical or traditional forms and meanings as it is of natural ones. It has so little respect because it sees history as botched and "unnatural."

Lüpertz violates our sense of historical inevitability by treating historical materials lyrically. In conversation, he insists that he has no anxiety—that he is part of the first German generation in this century born without anxiety. He says he is not an Expressionist because Expressionism is about anxiety. But his freedom from anxiety is earned through his deliberate Dionysianism. His freedom from anxiety is in fact itself a mannerist achievement—a mannerist, expressionist achievement.

It is not so much that Lüpertz is positively happy as that he refuses to suffer because of the past, for to do so is to accept it as a burden rather than as an opportunity. One's relation to the past can be lightened by conceiving it in a hallucinatory, dithyrambic way, which is at least a partial negation of its negativity. Lüpertz confronts the world-historical—in art as well as society—with the lyrical, which disputes its authority. From this encounter, a lighter attitude to life, and to the powers that be, emerges. We will find this same lyrical acknowledgment of the inevitable—mythologized by being symbolized—in Hödicke and Koberling, although with them it is the heroically conceived German version of primordial nature as the source of all originality and value.

Sometimes Lüpertz achieves an extraordinarily mellow, delicate lyricism as in *Morning* and *Evening* (both 1980). These works may seem out of character. Yet they are hallucinatory visions of everyday life in which a strange beauty is recovered from banality, or rather life's estranged beauty is restored. There is a powerful lyrical impulse behind the paintings of both Baselitz and Lüpertz, an impulse that is a last-ditch defense, the final line of retreat, for art in a world whose norms are hardly worth respecting, so miserable is the history and existence they have bred. All lyricism is mannerist and implies survival in the face of oppressive norms. The mannerist lyricism which is the basis for the new German painting has a fundamental existential meaning. Lüpertz has emphasized the necessity, again and again, for "arbitrariness, music," in the face of the dead weight of ugly historical reality. The mannerist lyricism of dithyrambic painting becomes a way of denying authority and power to that reality by responding to it ecstatically, against all odds and with almost complete absurdity, even frivolity. Indeed, Lüpertz first strikes that note of absurdity and frivolity which is an essential component in the work of the Mülheimer Freiheit group.

As has been pointed out, "Dionysus dithyrambos" literally means "Dionysus, who stands before the double door." For the Dionysian cult this referred to the initiate who had experienced the fearful mystery of second birth—a second coming. The new German painting represents the second coming of modern German painting, its reappearance after its death at Hitler's hands. German culture as a whole, through the new

German painting, is having a second birth. Baselitz and Lüpertz, Penck and Immendorff and Kiefer, show us in their art the German experience of death and rebirth. All have a dithyrambic element to their art—a weird lyricism, one might say an unholy, irreverent lyricism. The vehemence of their handling suggests at once the convulsive labor of birth, and death throes. It lightens the weightiness of their content, reconstituting it lyrically so that it engages one personally.

Their art implies the passage from death to life, from enslavement to the past to life in the present and future. It is an art of self-initiation into art as well as into life. This is why Lüpertz involves himself with death imagery (skulls, or his crematorium mural), and why his ''Alice in Wonderland'' theme says it all, for Alice's visit to Wonderland is like Ulysses's voyage to Hades, the land of the dead who still live in the unconscious. This confrontation with the dead, who still have a hold over us because they presumably set the norms—and from whom we can free ourselves only by taking a lawless lyrical attitude to them—is the essence of the mannerist position.

Kiefer

For Kiefer, painting is a conceptual art—he shows us that the whole so-called revival of painting is really the result of a conceptual way of thinking. Conceptual art, with its vision of art as idea, suits the Germans, and Kiefer in particular, in their search for the German spirit, which exists in modern Germany only as a tempting abstraction. In Kiefer, one finds direct engagement with the idea of a heroic German past, and also with the idea of abstraction in art. Almost alone among his colleagues, Kiefer is concerned with the relationship between culture and abstract art. But Kiefer's abstraction does not imply formalism; it implies, rather, a dialectical experience of historical reality (including the reality of the history of abstract painting).

Despite his concern for abstraction as a means of permitting the discovery of unexpected associations and meanings, Kiefer's art has always had an imagistic base. His images (sometimes photographs, sometimes old engravings or illustrations) are invariably obscured by heavy overlays of paint and often other substances. The paintings develop thematically, using a repertory of images that is limited in number but complex in implication. The paintings are directly and powerfully materialistic, revitalizing collage ''realism,'' as if to counterbalance their enigmatic implications.

In works like *Märkische Strand* (1974), *Wege der Weltweisheit* (1976–77), or *Die Meistersinger* (1982), Kiefer abstractly articulates his conceptual

images. *Märkische Strand* is a sweeping panoramic view of a great plain stretching off to the sea in the distance. The horizon line is extremely high, and the work recalls Altdorfer's famous *Battle of Issus*. The locale is a real one, and Kiefer has written the names of the towns on little slips of paper like signs which punctuate and flatten out the deep view. Simultaneously a map and a panorama, the painting also pulls us close to it in a more traditional landscapelike manner, by a repoussoir element at the edge composed of birch trees. Complex in its physical substance as well as its multiple readings, the painting is heavily layered with earth colors, grays and whites, along with a lot of black. There is an air of pervasive gloom typical of Kiefer.

Wege der Weltweisheit (literally *Way of World Wisdom*) presents a group of heads of famous Germans, taken from old illustrations—poets, philosophers, semilegendary figures; they seem to grow from the forest's roots—from a Germanic tree of life. The forest, clearly labelled, is Hermann's; he is the legendary German ''barbarian'' who destroyed the Roman legions of Varus. The poets and thinkers are Hermann's ''spiritual'' descendants standing for a fiercely independent—dare we say uncivilized?—way of thinking. They show the same nationalistic forest spirit as Hermann's, idealized and intellectualized. Again, there is a heavy overlay of oil paint—mostly blacks and browns with some whites. There is the recurrent notion of ''painting as burning.'' (Was Hitlerian burning then Neroesque painting, as other works ironically suggest?)

Generally speaking, Kiefer can be seen increasingly obliterating his imagery from the early seventies to now. A recent *Meistersinger* painting which adds collaged straw to oil paint, appears entirely abstract. However, the 13 vertical units of straw correspond to the 13 Meistersingers, and are so numbered. They stand in the midst of dense earth or forest colors, the ''traditional'' German browns and greens.

Thus Kiefer's operatic conceptual images, manipulated in an abstract context, lead to a peculiar kind of affirmation of both heroic German culture and abstract painting. Kiefer is in effect saying that the only concreteness that we have today is through abstraction. He abstracts from concrete events, creating a construct of meaning incarnate in a few images manipulated to achieve a newly concrete effect. Drawing on what he sees as the stress points of history, he arrives at a construction which is more than the sum of these points. In the act of abstractly recreating a German culture that only exists abstractly, he establishes a new sense of the possibilities that might constitute a contemporary German self. Indeed, the conceptual tokens of German culture Kiefer uses have an almost mathematical function, in the sense that their use is almost formulaic; they are abstract tokens or forms that can be filled with whatever contemporary German content we want to give them.

For me, there is a certain poignancy to Kiefer's abstraction, particularly when it deals with this mythically conceived culture. Thus a series of paintings titled *Dein goldenes Haar Margarete* is derived from a poem by Paul Celan about the German destruction of Jewish culture, involving simultaneously the self-destruction of German culture. Margaret (the heroine of Goethe's *Faust*?) is the Aryan blond; her opposite number is a dark-haired Shulamite who appears, similarly symbolized but not depicted, in other paintings in the same series. There are no images at all in these works, merely thickly worked paint, light or dark. We have, in them, a sense of the piling of abstraction upon abstraction, as the only way to bring home both the conflict and reciprocity between German and Jewish culture.

Thus it is on the conceptual level of abstract essences that Kiefer operates, and it is his use of abstract art that permits this. German culture, both because of its abuse in German history in the name of the German nation, and because it in fact seems inappropriate to contemporary "international" German life, exists abstractly but in depth in Kiefer's work. This seems one way of overcoming the seemingly inherent perversity, the "fatalistic" aspect of German culture.

Penck, Immendorff

Penck and Immendorff are also, despite their quite different styles, Conceptualists. Penck, working with a quasi-automatist approach—like Lüpertz, he acknowledges the importance of early Pollock for himself—and Immendorff, working ironically in a social (and socialist) realist vein, depict worlds in conflict, figures torn apart. In Penck, the figure reduced to minimal terms, becomes a cipher in a system: its fragmentation self-evident, it becomes the standard product of a machine. In Immendorff, the figure is allegorically presented as torn between two worlds; Immendorff's figures straddle opposites, never escaping the self-contradictoriness of their situation.

In the work of both artists, this tension is ultimately presented autobiographically. Penck's *"Standart"* figure stands for himself, crossing the border between the two Germanys: the *Übergang* theme appears as early as 1963, in a painting where a stick figure crosses a burning footbridge over an abyss of fire, and as recently as 1980, when a fragmented stick figure is contrasted with a soldier. And the real subject matter of Immendorff's *Café Deutschland* series is himself, sometimes centered and sitting between two enormous allegorical columns that symbolize his two worlds.

In *Café Deutschland I* (1977–78), Immendorff depicts himself twice, in the one case dancing in clothing that is emblematically half disco-bourgeois

(jeans and tee-shirt), and half outcast-bohemian artist (leather top to bottom—as he was dressed when I met him in Ghent). His other self image in the same work shows him centered between the columns, as he reaches through an image of the Berlin Wall to Penck, also depicted.

Penck and Immendorff are spiritual counterparts, alter egos, brothers from opposite parts of the same world. Penck's overpersonalized conception of his art complements Immendorff's socially oriented, powerfully critical attitude. (Every time I asked Penck what was going on in his art, stylistically, he described its highly personal subject matter.)

Penck moves toward Immendorff's sense of social reality through his own cybernetic conception of man, and Immendorff moves toward Penck's autobiographicalism through his self-consciousness about his own ambivalent social role: he is an egalitarian Maoist oriented towards the lost cause of a democratic China, and a successful bourgeois artist appropriated by the market. Penck and Immendorff are, like the two Germanys, fraternal twins, whose paintings mirror each other spiritually if not stylistically. Both conceive their art as tied to a particular historical and political period. Both fuse the political and the personal in a highly individualized way—almost to the point of eccentricity.

Polke

Of the older generation, Sigmar Polke epitomizes, I think, the conflicts and the ironies attendant upon the complex, contradictory situation of the postwar German artist. Polke particularly summarizes the pervasive ambivalent relationship to contemporary American art, which the postwar German artist found he had to deal with if he was to develop. Polke—like Immendorff—has been consistently producing a socially oriented, politically engaged art, from his involvement with the "Capitalistic Realism" movement (1963–69) to his involvement with Fluxus (in the mid-sixties). He has always been against the idea of the work of art as a useless commodity, and against the egotism of artists, their use of their art to articulate an empty individuality.

His means have always been anonymous and ironically socially relevant. His *Urlaubsbild (Vacation Picture)*, 1966, presents tourist images (the Parthenon, the moon) painted in a commercial illustrational style; his *Menschenmenge (Crowd of People)*, 1969, uses an obtrusive benday technique. In a series of stencil works, all touch is in fact hand- rather than machine-made. He has always made an ironical use of mass-produced, mechanically rendered images. Yet more crucially, his work involves a dialectical subsuming and transcending of what in the sixties—and to the present day—has been regarded as international high art, perhaps most obviously Pop art and Minimalism, but also abstract and Conceptual art.

Thus his painting, *Carl Andre in Delft* (undated, probably ca. 1968), transferring Andre's modular metal plates into painted images of Dutch tiles, is a trenchant, demystifying critique of Minimalism.

The same kind of debunking—done with epigrammatic succinctness and pungency—occurs in *Höhere Wesen befehlen: rechte obere Ecke schwarz malen! (Higher Beings Command: Paint the Upper Right Corner Black!)*, 1969. Here, hard-edge abstraction is the target, as the finickiness of abstract painting—its obsession with nuances of placement and color relationships—is mocked. There is anarchism behind Polke's irony, but also daring criticality. Like Kiefer neither presentational nor representational but freshly conceptual, Polke demythologizes recent avant-garde high art, leaving us with a sense of excruciating void.

What is left? Ambivalence about the nature and value of art—a sense of the indeterminateness of both, and an insistence that art be left in an undefined state, that it be left as an abstract text that the spectator can read concretely, according to his sense of what it tells him about his situation.

Thus, in an untitled work of 1971–73, Polke places conventionalized images of sophisticated smokers—images derived from movie scenarios, but dislocated, out of narrative and even scenic context—against a ground of decorative, wallpaperlike material. Execution is by no means coarse—it is popular-culture-esthetic. The juxtaposition of images is unresolved, figure and ground synthesize optically, and *perhaps* ironically or conceptually. The aura of glamor that results—and that I find increasingly typical of Polke's work, especially in his new abstractions shown at Documenta 7—is the real content and form.

He refuses false consciousness—the illusion of harmonious unity—and accepts inconsequential yet charged togetherness. The will-o'-the wisp glamor that hovers over his images is a mock statement of happy unity. It is like the lie of the happy ending of a movie. Glamor is utopian, a form of populist idealism, but it is cosmetic on present banality rather than heroically projective of a better future.

It is worth noting that aspects of both Julian Schnabel's and David Salle's work seem clearly indebted to Polke. But the Americans estheticize, make overly decorative their quotations, and the glamor they evoke is not utopian but practical—it is esthetic rather than ironical, another way of conveying egotism through high art rather than eschewing it. This is not to say that these artists are inauthentic, only that they are not in a world that offers the opportunity for authenticity that a divided Germany does. Schnabel and Salle deal with solely artistic ambivalences, to which, at best, they can give certain psychological import.

The Berlin Neo-Expressionists

While the Berlin painters have the same dichotomous mentality, it shows itself in a less cultural-historical way—in a more strictly art-historical way. Their encounter is explicitly with German Expressionism, as emblematic of the German idea of nature as the source of all significance. Hödicke, Koberling, and Zimmer work with nature in the conventional sense— with animals, vegetation, the earth; Salomé, Middendorf, and Fetting work with human nature, understood as a luridly dynamic force. What is instructive about the first three artists is their extensive traveling to foreign, even exotic places; what is instructive about the second group is the preoccupation with conventionally "foreign" erotic experience.

It is hard, today, to authentically strike the note of strangeness or estrangement that was so crucial to the original Expressionists. The Berlin painters travel—to Indonesia (Hödicke), Iceland (Koberling), the Austrian Alps (Zimmer); or the exotic is found close to home—an automobile burning in the streets of the city (Zimmer), an odd view of a glider or escalator (Hödicke). Above all, though, there is exoticism, in the forced spontaneity of the relationship to their medium.

This is where Expressionism comes in—a modified, one might almost say reduced Expressionism, in which, in a compulsive, obsessive way, one has a kind of relationship-on-the-run with one's medium. Superficially, this results in a sense of facility of handling and in images with a facile effect; but ultimately it is indicative of the difficulty of sustaining a relationship with one's original or primordial nature (*Urnatur*), with realizing nature as a source (*Quelle*). One is always in danger of falling out of touch with the nature in oneself, so one takes it on the run, relates to it rapidly, grateful for its gifts—gifts of perception, which seem transient, but whose appearance of transience only bespeaks the moment of response to "nature."

In a somewhat analogous way, nature is gotten at by Middendorf, Salome, and Fetting through a strategic use of Expressionism coupled with traditionally unconventional subject matter of another sort. The eroticizing techniques of all three, and the homoerotic content of the latter two, are only initially shocking and unconventional, being already media-familiar, if in relatively domesticated form. What counts is the stylistic fluidity achieved by these artists as a sign of the immediacy of their relationship to their subject matter—as a sign of the naturalness of their art. Yet all the talk about spontaneity in connection with these artists, is misleading, for it is the meaning of this already stylized spontaneity that counts. Pushed to a new fluidity, it is meant to evoke a sense

of ecstatic swooning—essentially Dionysian swooning into instinctual depth, away from the social surface of things to their primordial nature.

Traditional Expressionism is simply a vehicle, an instructive starting point, for the Berlin artists, as well as for the new German painters in general. For they are making worn out, already familiar and assimilated Expressionist techniques freshly evocative by treating them with a mannerist sense of fluidity—a loose, artificial freedom. The pleasurableness of the paint is incidental—although, no doubt, it seems particularly suited to Berlin (Penck called Berlin, isolated in the cultural desert of East Germany, the Las Vegas of Germany).

It should be noted that the escapist dimension of this pursuit of nature and sexuality is, as it was for the traditional Expressionists, a typical big-city phenomenon. In Berlin the life-force, the culture, artificially flourishes as if in a hothouse. Thus painting there sometimes has the look of a conflagration—because of the city's inescapably risky, buried-alive situation. The risk of being in Berlin, however, is sublimated in the energy of painterly outpouring, from which blossoms an ambivalent life-force, a haunted energy.

Berlin & Hamburg Realists

There is also a group of political realist artists in Berlin, producing works which in general show a mockingly muscular, mockingly grotesque contemporary German mass culture. Their works (involving an exaggeratedly vulgar, behind-the-scenes—even "obscene"—observation of social reality, often using photographs of such things as silicon breast operations and gory hospital births)—have a satiric-caricatural dimension which links them with the conceptual/political art of Ina Barfuss and Thomas Wachweger in Hamburg.

This Hamburg art uses painting in the same conceptual way as the other major German artists I have discussed, but they add to it a cynicism about painting—almost a disapproval of it as an instrument of revelation and communication. These Hamburg artists will always be disappointed with any "reflective" medium, I suspect, for they really want social action. Their art is a species of terrorism grounded in contempt for "the mediocrity and triviality of bourgeois life," as one critic has said. Such contempt, such an effort to show the triviality of an overgeneralized conception of bourgeois life, seems to me to show its own triviality. It is too pat, a dumbly mechanical reflex to a society it only superficially understands. It also seems to me to issue in pictures that are only nominally interesting—interesting as symptoms rather than for the multidimensionality I see in much other current German art.

Martin Kippenberg's definition of his own painting as "the best of the second class" (quoted in Wolfgang Max Faust and Gerd de Vries's recent book *Hunger nach Bildern: Deutsche Malerei der Gegenwart*) speaks for all the artists who share this attitude. But I am not sure that their painting is that good, even as satire. Hatred of the existing social reality was one of the motivating forces of traditional Expressionism as well. However, Expressionism developed a critical method for understanding and transcending the values of society. The "anti-pictures" of the Hamburg artists become self-defeating. Like other new German painters, they are responsive to German reality, but in an undialectical way.

There are two major exceptions among the Hamburg artists, however, Werner Büttner and Albert Oehlen, who to my mind link up, however obliquely, with the Mülheimer Freiheit group. Both artists have a Hamburg sense of social engagement—awareness of what has been called the "disaster of democracy," or really of mass society—but they understand this in terms of the problems of modern art. For them, working one's way through the mindlessness to which all art is reduced in a mass communications society becomes a way of asserting independent artistic identity in that very society.

The independence comes in the handling of what one critic has called "painted symbols," generally executed in a provocatively murky manner. Büttner's *Self-Portrait Masturbating in a Movie* (1980) deals with the artist as the "exemplary masturbator," mucking about with his self-image. This work, to me, sums up the unhappy consciousness of the Hamburg artists, discontented at once with civilization and with "artistic" release from it. To masturbate to mass media images summarizes the absurd situation of high art today.

Oehlen's *Washing and Dressing Room under the Motorhall on the Rosenberg* (1980), with its drastically foreshortened, tilting, altogether muddled space, and such combine pieces as *Time Tunnel* (1982) also epitomize the Hamburg artists' unhappiness with the eerily vacuous and eerily transitory world they inhabit.

One can see slightly different attitudes among the Hamburg artists: Barfuss, Wachweger, and Kippenberg seem satirically bitter about their German world and their place in it; Büttner and Oehlen are merely sour. In all five, however, there is a peculiar infantilism in the face of the world—an infantilism conceived as antibourgeois. Their paintings are a kind of throwing of visual tantrums. Sometimes, this conceptualized infantilism leads to "fantastic" results—seems to open the way to a vigorous fantasy life, to a realm of wild free associations that function like portents. It is this, with its sense of speaking in visual tongues, that connects the Hamburg artists, however loosely, with the more rabidly fantastic Mülheimer Freiheit group.

Mülheimer Freiheit

The Mülheimer Freiheit group has been in existence for three to four years, and as is often the case with artist groups, seems now to be disintegrating. However I shall discuss them here as a group, and point out the differences among them. The group consists of Walter Dahn, Georg Jiří Dokoupil, Peter Bömmels, Hans Peter Adamski, Gerard Kever and Gerhard Naschberger.

While these artists sharply distinguish between the "painters" (Dahn, Bömmels, Dokoupil) and the "conceptualists" (Adamski, Kever, Naschberger) among themselves, all are in fact painters. All have a sense of irony which seems to derive from Polke, but they express it more extravagantly, through a protean exploration of artistic roles. The artists in this group are great play-actors, metamorphosing rapidly, shedding artistic skins before they become too comfortable in them—before they even know how to wear them well. But to wear them well would be to become "good artists" and to forfeit the exploratory enthusiasm that is at the root of their art impulse.

Thus, Walter Dahn's *Die Gotik lebt in den Beinen betrunkener Cowboys (Contort Yourself II)* (The Gothic Lives in the Legs of Drunken Cowboys), 1981, takes as its stimulus the resemblance between bowlegs and the Gothic arch, but then perversely twists or negates both—negating the analogy in a fantasy act. The Mülheimer Freiheit artists find visual analogies—puns—everywhere, locking things together in transformational metaphors worthy of a contemporary Lautréamont. But they do this with a self-consciousness about the history of modern art which amounts to a disclosure of its lawlessness. As they see it, there is no consistency in the modern tradition, only a number of loosely related fantasies—style being nothing but fantasy that has settled down and lost its metamorphic power, and the freewheeling character which signaled its vitality and authenticity.

The Mülheimer Freiheit artists, particularly Dahn and Dokoupil, explore a wide range of stylistic sources—Miró, Picasso, Hanna Höch, Meidner—getting at the dream behind them. As might be expected their art has certain targets among prominent contemporary artists with whom they are in categorical disagreement, and whom they see as "trying to set the law." They mock such artists as academic, fantasyless. Thus Dahn and Dokoupil's collaborative drawing—as conceptual as any by Polke— *Robert Ryman, Can You Hear Me?*, 1980. By contrast, Picasso, who remained "fantastic" to the end, and Picabia, who remained anarchistic to the end, are Mülheimer-Freiheit heroes—implicit and explicit—as they are for so many younger painters today in Italy, France and the U.S.

The Mülheimer-Freiheit artists' restlessness, their sense of slapstick, their irritation with known styles and contents, their general sardonic tone, are deliberate strategies for escaping the typical, for avoiding premature sedimentation of individuality. The simultaneity of corniness and "violent" handling, and a recklessly conceived, hard to fathom imagery whose meaning they themselves are uncertain of, fuse in a fantasy where strange yet half-familiar things happen. This fantasy is the unavoidable outcome of Germany's division. The grotesqueness latent in Lüpertz and other members of the first postwar generation becomes lavishly explicit in the Mülheimer Freiheit artists. The sense of fantastic relations innocently present in Baselitz's upside-downness becomes a positive outburst, leading to a fairytale world in which people can swallow brooms (Dahn), figures grow out of rivers (Bömmels), and there are weird conjunctions, often with ominous erotic implications (Adamski, Kever).

The question posed in one of Dokoupil's Documenta 7 pictures. "*God, Where Are Your Balls?*", in which the slang "eggs" is used for "balls," is the question these artists seem to be asking themselves. They use slang versions of various modern styles—mass mediation has turned every style into a slogan spoken in slang—to try to make freshly offensive statements about their world's divided condition that itself offends them. They use an international art shorthand to try to recover the offensiveness with which modern art masked its sense of outrage at the world. Their art is a highly personalized way of articulating the absurd condition of being modern, i.e., new to oneself (because one is always different from oneself, divided against oneself).

The New (?) Expressionism: Art as Damaged Goods

The feeling of happiness produced by indulgence of a wild, untamed craving is incomparably more intense than is the satisfying of a curbed desire.

Sigmund Freud, *Civilization and Its Discontents*

The Grandfather Principle

This so-called "new" Expressionism currently being heralded by old media trumpets is a false Expressionism. Hilton Kramer has written in the *New York Times* (July 12, 1981) that "it signals a shift in the life of the culture—in the whole complex of ideas, emotions and dispositions that at any given moment governs our outlook on art and experience," and that like "every genuine change of style" it is "a barometer of changes greater than itself." At the other extreme—every new art must run the gamut of critical opinion to win the right to pride—Thomas Lawson, speaking in *Artforum* (Summer 1981, p. 91) of Julian Schnabel, who by reason of the prestige of the galleries he has exhibited at has won the right to be regarded as one of the leading American lights of the Neo-Expressionism, observes the "bombast" and "numbingly self-important" character of his art. Presumably Lawson would speak this way about Susan Rothenberg as well—I would—whom Kramer lists, along with Schnabel (and Malcolm Morley) as "the outstanding figures at the moment."

All this media melodrama, of course, when it is not a matter of hard sell, is a way of testing the new painting, putting pressure on it to measure up to high standards. If enough critical pressure is applied, if it is made sufficiently self-conscious to have something to live up to, it just might

This article originally appeared in *Artforum* (November 1981).

emerge into greatness. The change in sensibility it represents might indeed signal a change in attitude, a new outlook. It just might be the first world-historical art—a seemingly comprehensive, dominating style, sweeping all before it—to come along since the sixties when we had Pop art and Minimalism. We must remember that Abstract Expressionism, the first heroic American art of the postwar period, consolidated the gains of European modern art, went back to the roots, as it were, of modernism as such, creating a unique synthesis of modernist ideas. In this, Neo-Expressionism is like Abstract Expressionism, and like Pop art—which harks back to Dadaism—and Minimalism—which harks back to Constructivism; in fact, like every significant new art, whose claim to importance at least in part rests on the importance of the past art that it is dependent on. That is just where the trouble lies in this false Expressionism. There is something wrong in the paradise of its plenty, and, more crucially, with its "reconstitution" of the past in the context of the present.

Revival in the name of new interests is always botched because new interests mean discarding the foundations of the old interests. Abstract Expressionism discards the religiosity of Wassily Kandinsky's art from which it in part stems; Pop art is indifferent to the disgust that motivated much of Dadaism, and turns its bad humor into good humor (Andy Warhol's business success ethos shows how little disgust there is in Pop art); and Minimalism replaces the socio-political interests of Constructivism with modernist interests in the purity or autonomy of the medium, as Robert Morris's writing on sculpture demonstrates. Just by reason of the spiritual ineptitude of past revivals we can expect the current revival of Expressionism to abort the spirit of the old Expressionism. In every case, the American conversion or "revision" of European modern art has purged it of its spiritual dimension—or at least made that dimension much less prominent—and has replaced that spirit with a modernist aim. This is not simply a matter of reinterpretation but of seeing the underlying if unrecognized dominant interest of American art, which has historically stripped European art naked, separating style from spirit in the name of American independence.

On the basis of past experience there is no reason not to expect a similar cleansing of Expressionism. To accept this is to begin to comprehend the kind of spirit that is involved in the American Neo-Expressionism. It is to begin to realize that it issues from an encounter with the American popular culture mentality—fixated on a conception of and expectations from "expression," "self-expression," and "feeling"—and is therefore an equivocal, bastardized, and finally neutralized, Expressionism. This Americanism—popular culture—is, along with the American idea of modernism—the absolutization of the medium—one of

our "spiritual" gifts to Europe, and it dominates the young European as well as the young American mentality. In fact, popular culture everywhere seems to express "youth" because of its idea of "expression." This is *not* a matter of the old authentic versus the new inauthentic Expressionism, but rather of new meanings implicit to expression uttered in different worlds, under different circumstances.

The main point is that Neo-Expressionism comes to us under the auspices of the grandfather principle, which can be consciously used (by whomever needs it) to ensure "development." By skipping a generation and going back to the generation before it for one's "influences" or "sources," one's grandfather becomes the true father, and since he seems more mysterious anyway because he is more remote, he is valued as more original, and ravished for his originality. "Ravished" is perhaps too strong a word, but the sense of expropriation and exploitation is too complete, and the implicit violence that goes with being dominant is so evident in the "manhandling" of grandfather's art—whether unintentional or intentional—that the grandson's relationship to it in spirit and in results hardly seems anything other than malevolent, nothing but malice aforethought. Immediate predecessors are pummeled out of sight, and the artists are free to "interpret" remote relatives as they wish—free to acquire ancestors of their own choosing. There is no historical necessity, or only the historical necessity of overthrowing the immediate past—the present that no longer reverberates with "presence"—that must be replaced by a new present; and what easier place instantly to find one than in the distant, foreign past? An "adjustment" here, something exaggerated there, the original spirit overlooked everywhere—and behold! a new direction for art, an admirably new, fashionable avant-garde costume. New clothes for the Emperor—perhaps with even greater transparency, but nobody wants to say so because everybody is so eager to "prove" progress, to evolve to the next step, to go forward—even if that means going backward.

Klaus Berger wrote (in 1938) that "before we write off Expressionism and discard it completely, . . . let us examine it very closely and profoundly, and then [dialectically] surpass it honorably (in the three-fold Hegelian-Marxist sense of the word)." This is explained by a note which tells us that "the word translated [as] 'surpass' is *aufheben* in German, meaning (1) to negate, (2) to elevate, (3) to preserve."[1] It can hardly be said that Neo-Expressionism self-consciously applies this principle. It may negate but not by analytic penetration of what it was that Expressionism affirmed; it elevates and preserves only a look, keeping up the old appearances. One might say that it can't help this, because the times are different, but then only the three-fold dialectical accomplishment of sur-

passing the old Expressionism could show us how the times are different. Neo-Expressionism exists largely to behead and relegate to the dustbin of history the art of the 1960s and 1970s that has up to now seemed royal. It means to crown itself the Emperor with its own hands, after first declaring itself more authentic—and less mercenary—than its father art, which it sees as having lost purity and become "sensual." This may be more profoundly a moral issue than the Neo-Expressionists—who feel that the artists who constitute the present and who are regarded as aristocratic have gone to seed, are even corrupt—realize. In the name of a new integrity, a new honesty of "feeling" the Neo-Expressionists decry what they see as Sol LeWitt's indulgence in theater, Robert Morris's proposed vaudevillean extravaganzas of catastrophic death, the Alice Aycock-Dennis Oppenheim heaping of profound meanings on superficial structures, the archaicism of Roy Lichtenstein in his allegiance to the period look of his comic book style, and Andy Warhol's platitudinizing of celebrities to achieve the ideal corporate art. I should note quickly that for Clement Greenberg, apostle of the once-new faith of abstraction, awkwardness—of which we find a good deal in Neo-Expressionism—is the sign of authentic feeling, if not alone the source of great art.

Faustianism versus the Folk

> *When National Socialism also labeled me and my art "degenerate"*
> *and "decadent," I felt this to be a profound misunderstanding*
> *because it is just not so. My art is German, strong, austere, and*
> *sincere.*
> Emil Nolde, Letter to Dr. Josef Goebbels, July 2, 1938

The heart of the issue is Neo-Expressionism's relationship to feeling—not any old feeling, but, in Ernst Ludwig Kirchner's words, the feeling that is articulated "instinctively and without premeditation" because it simultaneously "expresses the spiritual life" of the artist and reveals "the inner life of what is represented."[2] Such "feeling," wrote Kandinsky, "if permitted its voice, will sooner or later point the artist as well as the observer in the right direction." Echoing ideas that in modern form go back at least to Charles Baudelaire, he wrote, "the artist, whose life is comparable to a child's in many respects, frequently can reach the inner sound more easily than anyone else"—that "inner sound of objects," that "spiritually expressive" core of reality that "rings out," and that "without exception, every child's drawing reveals."[3] Here we have the real definition of the "modern" in modern art: to be modern is a subjective condition rather than an objective situation—a matter of attitude or

mentality rather than circumstance. Such a mentality may be a response to history, but it develops a momentum of its own: it wants to see the whole world with "unspoiled eyes," on its own.

Neo-Expressionism is a false expressionism because it is blasé and sophisticated about what it sees, rather than childlike. It pretends to be childlike, it is pregnant with a perspective that could be considered childlike—if it weren't the perspective of popular culture. Like a false pregnancy, this inflation is the fulfillment of a wish, an existence in a dream-state of desire, that will never give birth to an actual child. On the contrary, like Saturn, and like popular culture, it has eaten every child it has conceived. Neo-Expressionism, knowledgeable in the methods of popular culture—a demonstration of the mentality behind them—offers a grotesque version of childlikeness, rendering it self-consciously and thus making a mockery of its unconsciousness. The popular culture *acts* the child in a theater of boredom, which is to create that contradiction in terms, that monster, the bored child, the child that play-acts its childishness—that thinks it can *predict* what it is to be a child. Neo-Expressionism is the outcome of the child's art that was predicted—the childish art that comes out of the boredom of the pseudo-child, really the boredom with being a child, but not knowing what else to be, and not capable of being anything else. Besides, it is fashionable to be a child, and especially to be half-adult and half-child, i.e., to be an adult pretending to be a child rather than, as the old Expressionist was, an adult who had the revolutionary inner life of a child, who experienced without play-acting—completely unconsciously—what it was to be as spiritual as a child.

Neo-Expressionism, like the popular culture, is a reactionary attempt to possess the child's being, to appropriate it for ulterior motives. For the purpose of social control or management the child in us must be completely comprehended, and finally simulated, invented anew, recreated from the ground up, and thus totally mastered. We are then totally mastered, slaves to our own conception of our innocence, our unspoiled nature—we are then totally "produced." Neo-Expressionism is another production of the forces that can make anything a popular convention, even the ultra-unconventionality of the child. Under the mistaken assumption that it is a renewal of the basic, originative, life-giving spirit that was inherent in modern art, Neo-Expressionism artificially reproduces the child's perspective and thus dissolves the spirit of modern art. Much as the Antichrist is to the Christ—looking exactly like Him, but utterly alien in spirit—so Neo-Expressionism is to the old Expressionism and the childlike spirit of modern art. It is the Antichrist that appears at the Apocalypse, at the Millennium, signaling the end of an era. With this new Expressionism, modern art has cannibalized itself, has cooked up

and eaten the very guts that made it what it was. With the new Expressionism, modern art has mimicked its origins, thereby dissolving them—dissipating their force, giving up the source of its sense of direction. This is a special kind of decline—decline by way of popularization. What is popularized is the condition of decline as the old Expressionists understood it—the condition of alienation, understood as a symptom of decline, has now become a cliché. Most crucially, this popular culture expression and demonstration of alienation is accompanied by what one might call "surplus emotion"—that kind of mania or fanaticism (associated with addiction to celebrity) that Greenberg once disparaged as distracting (from "art") expressionist "excess of emotion." But in fact, in the popular culture (and the new Expressionism), it is the only source of attraction and value. In retrospect, the old Expressionist alienation seems more a sign of advance than of decline—more a sign of the recovery of the child's perspective than of its loss. The old Expressionist alienation was not so manic in its effect as the new Expressionist alienation—not ostentatious, however demonstrative. Feeling was not really "excessively" alienated, but in expressive proportion to alienation—cosmic, but in dialectical relation to its point of departure. Feeling did not "transcend" alienation to become popular in its own right.

The original Expressionist alienation was more a consequence of the exaggeration than of the decline of the Faustian will-to-power. The artists regarded themselves as Faustian individualists but also desired a folkish destiny. They defined themselves in terms of the Faustian will "to reign alone," to use Oswald Spengler's expression, but it was as much a handicap as a privilege. For it isolated as much as it invigorated—separating from the folk as well as confirming individuality. Thus Nolde's protest to Goebbels insisting on the "Germanness" of his individuality rather than on its decadence or degeneracy, i.e., falling away from and even corruption of the will of the folk. For Nolde, the artist's spiritual will-to-power was an expression of the folk's spirituality, had its roots in and was no more than an externalization of their inner essence.

Paul Klee was closer to the truth when he observed, in a deceptively simple assertion that is at once the heraldic motto and epitaph of genuine Expressionism, that "no folk supports us." The artist, with a child's perspective, is not supported by the folk, because that perspective—however it might appear to a more "sophisticated" artist or intellectual—is not that of a child. The child's perspective, with its spontaneous will-to-power over the world—its domination of the world through the curiosity by which it reconceives the world—is not even remotely comparable to the folk perspective, which needs no will-to-power because it is dominant to begin with. The child's perspective is that of the unconscious,

the folk perspective is cosmic. The child's perspective may well be expressed in those "nonobjective hieroglyphs" that Kirchner thought feeling was always creating anew,[4] but it is not clear that they express the cosmic point of view of the folk. Indeed, it can hardly be imagined that the true child's flighty drawing, however much it may help us hear the inner sound of things, can reach the level of cosmic generality and feeling of permanence of the folk spirit. *Volk* in Klee's usage "connoted much more than 'folk,' 'people,' or 'nation.' " It "signified the union of a people in terms of a transcendental essence, something which pervades the cosmos and involved the individual's innermost being as well as his ties to nature, history, and his fellow man." Thus, Klee was "not complaining about a lack of popular or national patronage" but "about something infinitely more serious, the alienation of the artist from a major link with the life force and the higher meanings of the universe."[5] Drawings from the unconscious can hardly bridge the distance between artist and folk.

It is exactly the artist's spiritual (Faustian) will-to-power that separates him or her from the spirituality of the folk. Klee may have admired Franz Marc, in whom he found both "the unredeemed" or "Faustian element" and existence as "a real member of the human race," with that attractive "warmth" that comes of belonging to the folk,[6] but Marc was the exception rather than rule among modern artists. The childlikeness of Marc did not alienate him from the folk because he was not completely given over to the spiritual will-to-power. On the contrary, his animals represent German spirituality, that like all genuine spirituality had nothing to do with the will-to-power or competitive striving. In a sense, the spiritual will-to-power is compensatory for the absence of genuine, self-certain—like an animal—spirituality. It signaled the spiritual vacuum that it filled.

In the new Expressionism we have the corruption of a spiritual will-to-power into an expressive will-to-power. Expression for the sake of expression is pursued, rather than expression to make spirituality manifest. Faustianism has outdone itself—has entered a true decline, achieved irreversible alienation—in the new Expressionism, for it is only a will-to-power over the signs of spirituality. This was incipiently present in modernism; but now its model is the popular culture. Its strategy is to dominate the signs of expressivity by popularizing or celebrating them, ostentatiously circulating them, as if that in itself could spontaneously generate spirituality. This is child's play with signs, play that implies that the intensity of one's feeling for them will make them sufficiently magical to create inner spiritual worlds on a cosmic scale. Instead of the spirit expressing itself in signs, the process is reversed: magically, signs are supposed to create the spirit, indeed, create the folk. But for this to happen

signs must be strongly felt—this is what makes them magical. They must be given the charge of aimless feeling, have riding on them—to go to the quotation from Freud that begins this paper—"a wild, untamed craving." Releasing or indulging this feeling charges the signs with the magical power of regenerating spirituality, the feeling of being one with the folk.

But Neo-Expressionism is popular, not folk, feeling. It has the feeling of happiness that popular culture gives by claiming to indulge the wild, untamed cravings of the pure unconscious—to free our desire from the constraint that civilizes it. Popular culture claims to speak in the name of that outcast craving that civilization has banished for its tamer, less disruptive desires—claims to free us from the sublimation that in the end saps us of our instinctive strength. It claims that we need only attach ourselves to certain celebrated signs, become addicted to certain popular rituals of expression, to gain our "spiritual" freedom. Neo-Expressionism deals with this same damaged feeling of desire that thinks it is the root of spirituality, that demands expression and that thinks it has found expression when it fanatically attaches itself to certain popular signs, performs certain collective rituals. This does not achieve a cosmic sense of belonging to a folk, but addiction to the feeling of power without the will to truly realize it as an individual. Power democratized or popularized is neither the power of the folk nor the Faustian will-to-power, but the illusory sense of power that comes from the expression of craving in socially acceptable terms.

What is missing, then, in the new Expressionism, and in the popular culture, is not only the cosmic folk mentality—the sense of the transcendental—but what Spengler calls the Faustian sense of "directional energy."[7] There is an illusory sense of transcendence that comes from the proposed—but unrealized—release of instinctive desire, and an illusory sense of direction that comes from energetic commitment to the artifacts of expression, i.e., to existing, thoroughly socialized, and above all typical means of expression. (Objective rather than nonobjective hieroglyphs consciously willed rather than unconsciously discovered hieroglyphs— hieroglyphs whose manipulators become celebrities rather than hieroglyphs whose discoverers become alienated.) This does not mean that the new Expressionism is not, as Ludwig Meidner wrote of the old Expressionism, "hung like Absalom by the hair from the branches of the *Zeitgeist*." It is a different *Zeitgeist* from that on which the original "high-strung," "irritable" Expressionists hung. The "dream of a diabolical palette," the proclamation of "spleen . . . as the law of life" and "paradox" as "the highest spiritual value," letting oneself be "driven to the breaking point by the approach of world catastrophe" as well as one's "own wild power"[8]—which comes in part from one's sense of impending apocalypse, ripping the lid off everyday consciousness so that

one's raw unconscious is exposed and erupts in rebellion—all this has a different aspect in Neo-Expressionists. Spleen is no more than, in Byron's words, that "vital scorn of all" exemplified by the application of the grandfather principle. The diabolical palette has become manipulation of the effect of frankness. Paradox has become trivialized into wit, irritability has been reduced to a sign of ambition, and the approach of world catastrophe has become a standard part of the popular culture landscape, which, indeed, thrives on alarmism. The *Zeitgeist* is no longer alienation, but alienation mediated by the popular culture: the sense of the decline of Western civilization is one reinforced by the popular culture, for its own exploitative, sensational ends.

This sense of the decline of the West, taken over by the popular culture, is one more way it keeps counting our pulse, telling us what is vital to our lives. But more than that, by manipulation of our sense of impending doom the popular culture manipulates our will to live—controls the flow of the life force in us. It controls our sense of the diabolical, the flow of our spleen, our sense of paradox, and above all our desire—our general sense of connectedness with and flow into life and society—for its own purposes. Control of the sense of apocalypse means control of erotic energy. There is an orgasmic overtone to the new Expressionism, the sense of arousal and release that evokes the apocalyptic, which at once becomes a metaphor for it. Reverberating on its source, the apocalyptic becomes a further erotic provocation. More pointedly, there is a sense of exaggerated—indeed, selfish—arousal, and incomplete release, further stimulating the sense of personal apocalypse. A kind of vicious autistic circle is created, in which a sense of the erotic becomes the subjective correlative for a sense of the apocalyptic, and, vice versa, a sense of imminent apocalypse becomes the objective correlative for a frustrated, even seemingly endangered, eroticism. The erotic and the apocalyptic feed into one another until they seem interchangeable, and thereby finally robbed of their meaning and charge. They are thus tamed, and as such easily assimilated by the popular culture. New Expressionism, like the popular culture in general, plays upon that sense of apocalypse for all it's worth, so as to coercively dominate our existences and use them for society's own authoritarian purposes.

The Energism that Ronny Cohen identified (*Artforum*, September 1980) as emerging in the eighties can be connected with what Nietzsche regarded as one of art's primary purposes—to instill and sustain our will to live. In Neo-Expressionism, and in some of the preceding Energistic manifestations, art has once again been pressed into service as a stimulant for our will to live—not necessarily because we are losing it, but because our society may have a new use for it, may want to coopt it for society's own "higher" purposes. Or it may be that the will to live is no longer

subsumed by a Faustian spiritual will-to-power, which must be reinstated simply because it is the traditional mode of Western being-in-the-world. It is as though the popular culture might be trying to give shock treatment to a moribund Faustian will, for there seems to be no alternative in the West, which today understands human relationships and relations to the world in general largely in terms of power and the establishment of hierarchical dominance. Neo-Expressionism can be said to be giving shock treatment to a moribund will to art.

Neo-Expressionism does not seem to flow as effortlessly as the old Expressionism or Abstract Expressionism. There is no way it can be spontaneous in the world of popular culture, and so it tries to be spontaneous with the popular culture. The "mysticism" and the "primeval elements of art"—the "savagery" of feeling—that the old Expressionists once viewed as immanent in their personal spiritual will-to-power are now the prerogatives of the popular culture, popular signs of the will to live in the care of the popular culture. They have all been purified—stereotyped—by the popular culture, which means they have all been liquidated in terms of personal value. They now have only socially coercive value. (Purification of the medium, incidentally, is also a way of liquidating it for personal spiritual use. Here the strategies of late modernism and the popular culture come together both showing their Americanness—their reductive materialism.) Today the popular culture dominates our lives and the life of art, gives us and our art whatever "spirituality" they have. The popular culture gives us our death imagery as well as our image of the life force—both are self-evident in Neo-Expressionism—and above all gives us that sense of release from the constraints and discontents of civilization which in fact plays directly into the hands of the powers that be.

Drugs have become a nihilistic end in themselves rather than an instrument of spiritual self-exploration—an exit rather than an entrance. The religiosity of the old Expressionism is subsumed in the religiosity of popular culture, with its release into the hands of the society rather than in either a lower or higher world. Neo-Expressionism is not the return to the depths that Greenberg warned us against as having nothing to do with art—which in fact has everything to do with it—but rather an affirmation of the superficial, and superficially childlike, mentality of the popular culture, a superficiality mediated by the absoluteness of stereotypes, i.e., the new effortlessness with which worldly things are known, an altogether artificial grace, a manufactured spontaneity (or will-lessness). In fact, there is the iron will of determined social control behind the apparent spontaneity of the popular-culture look. Neo-Expressionism is the spirit of the popular culture refined and brought into high art with a greater profundity—at a deeper level—than Pop art ever imagined possible.

Role Reversal and the Ethics of Form

In the world as seen by the Faustian's eyes, everything is motion
with an aim. He himself lives only under that condition, for to him
life means struggling, overcoming, winning through. The struggle
for existence as ideal form of existence is implicit. . . .
Oswald Spengler, *The Decline of the West*

Spengler[9] regarded the idea that Expressionism was "a 'phase of art-history' " to be "an unabashed farce." It is likely that he would have regarded Neo-Expressionism as a case in point of contemporary "faked painting, full of idiotic, exotic and showcard effects, that every ten years or so concocts out of the form-wealth of millennia some new 'style' which in fact is no style at all since everyone does as he pleases."[10] But Expressionism conceived not art historically but rather, in Gottfried Benn's words, as "an evolution toward a new order and new historical meaning"—"an evolution subject to the most urgent inner necessity not given to other generations"—and so more a matter of "the ethics of form"[11] than its esthetics, is clearly visible as a sign of what Spengler calls Western "Will-Culture," the "Faustian soul-image."[12]

In the new Expressionism there is only motion. Stripped of its aim, motion cannot reflect "struggling, overcoming, winning through." For Neo-Expressionism cannot help but reflect decades of a *Zeitgeist* that insisted that the only aim of art is esthetic—the esthetic "re-form" of art in the name of the autonomy of the medium. However much it may resist such estheticism in the name of a new, unknown spirituality, it is infected by it, especially since purity—with emphasis on the "literal order of effects," to use Greenberg's expression—has also come to dominate popular culture. Purity presumably carries the charge of fundamental desire: its emphasis on physicality corresponds to indulgence in uncivilized, unsublimated craving, and so offers an unequivocal feeling of happiness. Here the physicality that a Richard Serra is obsessed with comes together with the society's obsession with sexuality. For art once again to acquire a spiritual aim, to be more than the display of energy as proof of autonomy, or to concentrate itself in a significant direction, i.e., to be itself by transcending itself, it must realize that every formal or stylistic move it makes is an ethical matter—a moral commitment. (To ask for this is not to ask for another reaffirmation of the continuity between art and life—we have had enough of that, in naive form, from the fine art/popular culture continuum of Pop art to the technology/autobiography continuum of video art—but rather to ask for a more selective relationship between them, a less indiscriminate sense of the inevitability of their connection.

Contemporary protest art and feminist art try to achieve such a selective, moral connection between art and life, but, since much of the production so far has remained under the sway of the art ideology of autonomy, it, too, becomes transfixed on the horns of a dilemma.)

Expressionism understood that the creation of form was an ethical matter, because it understood that form was the objective expression of, in Benn's words, "an active and organizing force in the evolution of life."[13] From this everything followed, for this was the reason it was able to articulate, in Klaus Berger's words, "revolutionary tensions and possibilities," the reason it was "an affront to the middle class," and the reason it was "no style in the real sense of the word."[14] That is, it was not simply a new esthetics developed in the course of the evolution of art—developed to prove that art did evolve, that art could still be original—but a new mentality necessitated by the evolution of life, implying the urgent necessity for a reorganization of life. In contrast, Neo-Expressionism is a middle-class style, bespeaking no "urgent inner necessity" other than that which demands of the bourgeois that he or she assimilate and popularize every critique of the society or organization of life, so that he or she can neutralize and, to a limited extent—without changing anything fundamental—adjust to it. And what better way to neutralize a call for moral revolution than to regard it as merely a formal matter, a new aesthetic bravado, which, after all, can be tonic.

This leads directly to the socio-political point of the new Expressionism. Writing in defense of the socialist potential of the old Expressionism—defending it against the charge that it led to fascism—Berger argues that "in every revolutionary situation between 1910 and 1925 Expressionism was a good *beginning* for socialistic development, especially when compared to the heritage of bourgeois art." He asserts that "Expressionism can never serve fascism because fascism seeks its ideological supports (as far as cultural heritage is concerned) in styles that antedate fully developed capitalism—in the columns of classicism (just as political reactionaries did 100 years earlier), in absolutistic and emotional Baroque modes, in the guild spirit of the old German masters."[15] In contrast, the new Expressionism develops in a reactionary situation that seeks its cultural supports in revolutionary styles. Expressionism is one of these styles. Schnabel uses Expressionism in an absolutistic, Baroque manner, turning emotion into emotionalism, and in general classicizing and stylizing what once had no definite and fixed style, and was entirely antithetical to the classical temper. To expose emotion—to exploit the expression of it as proof that one is free—is today no more than submission to the status quo, whose instrument is the popular

culture, that demands intense expressivity, making it all the better and easier to manipulate one's vitality. To be uninhibited is to conform, to submit to the social coercion that demands that one show all one's "spirit," so that it can be "sympathetically" understood. Revelation of desire becomes subtle repression of it, a way of controlling it not in the name of some sublime civilization, but in the name of authority. Authority alone is Faustian these days. Laconic expression, typical of the best avant-garde art, has been subverted in the name of honesty, genuineness, which is today another one of authority's masks, just as the unconscious today has become almost a fiefdom of the popular culture. Expressivity is no longer a critique of bourgeois repression, but rather its instrument, the sign of its dominance. Intensity of feeling is no longer liberating, but enslaving.

The reversal of expectations from feeling—the recognition that in the current social situation it is reactionary rather than revolutionary to have so-called instinctive feeling—and the general acknowledgment of the absence of revolutionary tensions and possibilities that the new Expressionism suggests, is acknowledged in a "slogan popular in the alternative scene in Germany" quoted by Wolfgang Max Faust in the September 1981 issue of *Artforum:* "You haven't got a chance. So use it!"[16] This goes hand in hand with a fresh assertion of the "now generation" mentality: "We demand everything. And now!" (The clubbiness of the "now" concept is worth noting—it is generational rather than individualized, a sign of regression to the species, as it were. As such, it shows a kind of reinstatement of the guild mentality, with its enforced life-style as well as art-style—but with none of the discipline of the will demanded by the Faustian spirit. And of course, what need is there for will in the "now"?) The pathos behind these slogans indicates the lack of urgent inner necessity for revolt. In its place is urgent outer necessity—cultivated by the outer, popular culture, which promises everything—for immediate personal gratification. This, as has been noted, conforms to late capitalist ideas—to the bourgeois mentality that wants its rewards now, rather than in heaven. This, of course, used to be a proletarian desire, but it is now the bourgeois carrot. Or shall we say whip?

Commenting on these slogans, Wolfgang Faust writes "This sort of anarchism, asking for an immediate change (a someplace else in the here and now) rejects the previous crusades for social change and the sacrificing of individuality for a cause." But this anarchism is in fact conformity, acceptance of the status quo—a kind of peace with it. As Faust writes: " 'Style' (to the artists I am discussing) means adaptation, a conforming drive that mirrors the forces at work in their society." He continues: "If

you want to be 'somewhere else,' their reasoning goes, you have no use for a static point of view. You have to change continually; to keep moving you have to be 'here' and yet keep your lines of escape open.'' Faust calls this a subversive point of view, but it is far from that: it is a bourgeois formulation of the (other) Faustian spirit—an ultra-bourgeois formulation of will at work. It is a description of venture capitalism—capitalism taking risks, and so demonstrating the continued dynamics of the system. ''Anarchism'' is now part of the system, another symptom of being tamed by it, of being ''civilized.'' Also, art historically, it demonstrates the continued pursuit of novelty, which alone can generate a feeling of urgent inner necessity today—whether in art or in bourgeois society at large. There is no longer anything critical in being anarchistic, uninhibited, expressive. It is just another indication that one is tyrannized over by what Benn called the ''Absolute, the antiliberal function of spirit,''[17] i.e., by authority.

The Children's Crusade at the End of the Millennium

> *Children are not worried about conventional and practical meanings, since they look at the world with unspoiled eyes and are able to experience things as they are, effortlessly. Conventional and practical meanings are slowly learned later, after many and often unhappy experiences.*
>
> Wassily Kandinsky

Using certain ''contemporary European thinkers, particularly in France,'' to describe ''a move toward a type of experience which accords to wishes (*le désir*) a revolutionary meaning,'' Wolfgang Faust writes: ''This present-oriented 'becoming revolutionary,' is not directed at finding a new unity, or a new truth, but at rendering visible and tangible human wishes and desires, even if these desires should include 'regressive,' 'bourgeois,' or 'non-revolutionary' elements.'' Let us remember that to be revolutionary used to mean to expect a future—to not expect from the present the fulfillment only the future can bring. There is clearly no longer any patience (or time) to make a revolution, no longer any careful or serious planning for it. One wants only the fulfillment it promises, not its reality. In general, to be revolutionary meant to deny the existence of a timeless, unchanging present—of that ''eternal present'' of which the work of art is a minor example, a small reminder. Clearly, the timeless present that the new Expressionists promise us is far from revolutionary. Indeed, it is an altogether reactionary throwback to an eternal expressivity—a supposedly eternal or ahistorical passion. Only the child lives in an ahistorical—more

properly, prehistorical—state, a state in which "presences" are constant, in which the world is constantly charged with presentness, to the roots of its physicality. Wolfgang Faust, in unwitting but ironically good dialectical fashion, comes to say almost the opposite of what he means: the "alternative" is no longer revolutionary—it is to be a bourgeois child in the service of the bourgeois ego that wants to believe the world is still, after all this time, fresh and dynamic. This is a last-ditch Faustianism, the Faustianism of the point of view—the Faustianism whose aim is no longer to change the objective world but to dominate inner life. There is no longer (or for the time being) anything new to will in the world—but one can will a point of view, a perspective that will show the world as still colored by a Faustian spirit, if no longer really Faustian. The will to be a child can always be satisfied—it is the popular culture's job to satisfy it—while the will to be master of the world can be thwarted.

Neo-Expressionism signals the bourgeois discovery, implemented through the popular culture, that modern life has no forbidden desires. It has, Wolfgang Faust reports, implicit trust in spontaneity and improvisation as the instruments for the discovery of desire, and its display. This is childish, and misses one crucial thing: the representation of the desire is not its satisfaction. In life, desire looks different than in art—obvious enough, but something overlooked by both the popular culture and the new Expressionism. Unless the feeling of childlikeness, however aborted or misconceived by the popular culture, is complemented by an adult willingness to indeed live as if nothing is forbidden, the promise the revolution of being childlike offers remains unrealized. It may signal the felt need for a new active and organizing principle in the evolution of life, but nothing new will evolve until childishness is transcended. Art—popular or high—here blocks the revolution it leads us to expect. If, as Hans Sedlmayr argues, art has no voice of its own but amplifies other voices, then here we see art amplifying the bourgeois voice, full of hope but really wanting nothing to change. This is indeed a child's attitude, de rigeur in the popular bourgeois culture.

A forced childlikeness is characteristic in all the manifestations of the new Expressionism. Getting down to cases, one sees repeated and implicit allegiance to children's drawing as the basis and ideal for art, as in the old Expressionists. Only now such drawing is calculated in its spontaneity, more inventive than improvised, and full of undiscriminating feeling that does less to give direction than to inhibit any search for direction—it is exactly the inhibition of direction that is achieved by the exhibition of energy. All those signs of energy are no longer signs of aim, but a distraction from soul-searching—from the plunge into the depths for a sign of direction, of inner necessity. The painting of the Americans

pales beside the work of the German progenitors of the Neo-Expressionism (such as A. R. Penck), and beside the powerful painterly drawing—for that is what it really is, in the best Expressionist spirit—of the younger German artists. Their work may not be indicative—at least not at first glance—of the "fresh young, unknown German spirituality" that Emil Nolde expected to develop out of the "pain" of the Second World War, "out of the deepest depths" disclosed in its aftermath.[18] But it is certainly less of an example, in Ezra Pound's words, of an art "made to sell and sell quickly" rather than "to endure or to live with"[19] than the painting of Schnabel. (And this is true even when we recognize that the new Expressionism at its best is a European attempt to take the sceptre of advanced art back, even to the extent of wanting to produce a spiritually significant not simply esthetically or stylistically original art.) However, we see this calculatedly childlike drawing in the simplistic handling of Jörg Immendorff as well as in the bullheadedness of Schnabel, in Anselm Kiefer's rhapsodic landscapes that work like Wagnerian tone poems in their mix of a few visual motifs and even in Penck's stick figures with their graffiti quirkiness and seeming quickness of execution, and even in the beatific bawdiness of Sandro Chia and Francesco Clemente, with their "spiritualizing" of the body and its functions. There is a slight sense of spiritual direction in their handling and imagery, but it does not seem sufficiently worked at. The spirit does not come for the asking; only suffering, with its dialectical work against the world, can give one a glimmering of it, but cannot guarantee it. There is little true suffering in any of this work (although its presence is not absolutely excluded), unlike in the old Expressionists, where expression itself, with its difficulties, was suffering.

Drawing, as Kirchner insisted, shows "the vital power of the will," although it may finally be understood to do no more than supply "the formal language" of more ambitious works.[20] Drawing is in this sense the most direct, elemental means—the means by which an art finds its own voice. For Kandinsky, "academic training" is "guaranteed to ruin a child's creative power," which shows itself most directly in drawings that, as we have already noted, "without exception . . . reveal the inner sound of objects," "separated from conventional practical meanings" and thus "intensified."[21]

The new Expressionists offer us a variety of drawings that claim to dispense with conventional and practical meanings and instead record the world with unspoiled eyes and experience things as they are. The drawings have an aura of effortlessness, a quality of naiveté that extends to the slogans and titles they sometimes incorporate in their texture. This same quality extends to the casualness with which they are exhibited,

not simply in alternative spaces done up as nicely as possible, but rather laid out irregularly and, often, tacked to the wall in an unframed state, much as a child might exhibit its "quick sketches" in a kindergarten, for the comments of its peers (rather than for the edification and appropriative pride of its elders). The gallery becomes a kind of playpen in which things can be tried out, abandoned in various stages of articulateness or inarticulateness, an altogether "unpretentious" space in which unpretentious drawings can be exhibited, not to prove any point but to see what the artist has come up with. But the childishness is pretentious, in itself and in the current context of art events, and because of what it means for the child's perspective in modern art, which, like all spirituality, is not easily the subject of a revival. The child's perspective is already transformed by its appropriation as the essence of the popular culture, and the new Expressionism's childishness, while less callously cute and coy than that of the popular culture, does nothing to change the fact of popular appropriation; indeed, confirms it, as a final exploitive socialization of the child in all of us. We are far from Walt Disney in the new Expressionism, but we have not undone him. He abides in the fact that the Neo-Expressionists have a preconception of what it is to be a child, and thus cannot really have an unblemished childlike attitude.

There are, of course, certain seeming exceptions, but they tend to prove the rule that to be a child means to venture forth without spiritual preconceptions or preconditions, and without any predetermined vocabulary and rules of expression. Baudelaire wrote: "genius is nothing more nor less than *childhood recovered* at will—a childhood now equipped for self-expression with manhood's capacities and a power of analysis which enables it to order the mass of raw material which it has involuntarily accumulated. It is by this deep and joyful curiosity that we may explain the fixed and animally ecstatic gaze of a child confronted with something new."[22] But the genius of the new Expressionists seems compromised by certain facts. The child, for Baudelaire, "sees everything in a state of newness" because the child is "always *drunk,*" and has "in the highest degree . . . the faculty of keenly interesting himself in things, be they apparently of the most trivial." But most Neo-Expressionists work with raw material that has been voluntarily rather than involuntarily accumulated, and that can hardly be said to be subjected to a power of analysis. Much of this material derives from what can only be called the voluntary experiences of adult life rather than the involuntary experiences of childhood. Sexuality is especially a subject matter—sexuality treated as an involuntary matter, but in fact quite voluntary. Werner Büttner's *Selbstbildnis im Kino onanierend* (Self-Portrait [Masturbating in the Movies]), 1980, seems to me typical of this attitude, as does Thomas Wachweger's

masturbating figurine on a mountain peak, impregnating the clouds as it were. Masturbation may indeed be cosmic in import, a mythical regeneration of self and cosmos, sign of a will to limitless potency and the domination of the "cosmos" that presumably comes with it. But it is also one more pseudo-taboo voluntary activity, treated here as a will to power but in fact demonstrating the spiritual impotence of that Faustian will. There is no analysis here. There is a jaded, one might say applied, childlikeness, but it does nothing to confirm the rawness or involuntary—they are correlate—character of the subject matter. It is really not so raw, in this world in which the elemental has become the popular, and in which nothing sexual has any durable charge to it anymore. Büttner and Wachweger mean to describe spiritual states, but they do so in an archly childish way. The same holds for the work of Michael Bauch, Albert Oehlen, and Elvira Werschke, which I respect for its impassioned childishness, but which childishness seems to me less a condition for self-expression than for popular culture ideas of what might be expressively significant.

This sense of applied childishness, leading to self-consciously foolish images, with a popular-culture aura, is perhaps most exemplified by the numerous new Expressionist works that combine drawing and photography, or use photography as a kind of drawing, and even photographic collage as a kind of drawing. Also, it should be noted that the titles of new Expressionist exhibitions sometimes have this air of ironical childishness, as in the case of the Berlin exhibition "Zum Thema der Zeit: Elend" (On the Theme of the Times: Misery) and the Hamburg "Aktion Pisskrücke" (Action Pisspot), both 1980. There is an overfamiliarity, derived from popular-culture sources, with scatological and spiritually scabrous themes, which are thus less shocking than might be expected. Both thematically and formally, nothing, indeed, is shocking about the new Expressionists, especially if one knows anything about the popular culture, which is as willing to be gamey and tacky in its interests and its means as the new Expressionists—who are also not adverse to the slickness that popular culture once exclusively meant.

The problem of the forced childlikeness of Neo-Expressionism seems to me to come to a head in two of the ancestors or forerunners as well as active leading lights of the new Expressionism (they were both featured in "Westkunst"), Penck and Immendorff. In their work the ulterior motive becomes as explicit as it ever will be: it is a political gesture, signaling the helplessness of the individual in the face of social forces beyond his control. Simultaneously, it is a way of resisting this feeling of helplessness—childlikeness is a kind of ostrich hole in which one takes cover. In *Standart*, 1970–72, Penck shows the sticklike figurines we are to one

another, the stripped-down figure quickly and easily digested—dispensed with. This is the figure of statistics—it is repeated relatively unchanged, if against a slightly changed background—and similar devices of social control. It is the appearance we all make in the inner eye of society, where we are all interchangeable and reduced to our most elementary outline to facilitate interchangeability. This is our social form, ephemeral yet firmly pressed against the wall of the world, the quick sketch of a toylike robot, a shadow of a person, almost like the Hiroshima shadow. That event foreshadowed the shadows to which we would all be reduced, shadows finally quickly drawn by a graffiti expert. Immendorff gives us an ominous-sounding yet fairly innocuous slogan: "When the first bombs fall the easels will shake," as if that was the first thing to think about when the first bombs fall. But of course art's irresponsibility, its moral inadequacy in the face of such socio-political events as falling bombs, is implied. Art is childish in the face of such events—and yet perhaps its childishness can be prophetic. Thus Immendorff gives us painting-drawings whose titles are incorporated in them, carefully yet clumsily printed in childlike block letters: *Hört auf zu malen* (Stop Painting), 1965; *Keine Kunst mache* (Make No Art), 1965—reflecting the inaccuracy of a child's pronunciation—and *Eisbären kommen* (Polar Bears Are Coming), 1968. The first seems a command to himself in the face of events—and seems to imply that the rudimentary abstraction presented is in fact already a stopping of serious painting. The third seems a consequence of the apocalypse—after the world is destroyed, the polar bears are sure to come, in the new Ice Age.

Penck and Immendorff offer political statements: they correlate a failed or inverted Faustianism, with its overtones of hopelessness and helplessness, with the primitivism and simplicity of the child's mentality. They state this failure of will in child's terms. Being reduced to a child is a consequence of the socio-political situation. We are all reduced to children, but the artist perhaps suffers most, since he or she wants to be responsible to a folk, to a people as a transcendental whole. In any case, the artist can still be prophetic and describe what is seen with the mind's eye. Childlikeness may be the objective correlative of a feeling of impotence, but it also gives the artist an advantage, permitting insight into events. It shows the artist to be a realist: unlike us, who think we are adults in control of events, the artist knows he or she is dominated by events. Penck and Immendorff combine the adult's feeling of impotence with the child's feeling of omnipotence to give us possession of our inner life in the face of potentially devastating external events.

For me the connection between the childlike personal and the catastrophic socio-political comes off in the art of Immendorff and Penck,

which describes a situation of the decline of Western man, of his loss of Faustian will. This is a hurt, defensive art, somewhat Cassandra-like in its pretensions, and yet, after all, not inappropriate to the times. It is an art beyond alienation, more quixotic than that of the Expressionists, less urgent in its inner necessity, more self-conscious and coy in its attitudes, and perhaps finally more melodramatic than dramatic. It describes a situation not of revolutionary potential and active despair but of acceptance and reappraisal. While it is an art that gives us no moral alternatives in our life, it perhaps is the only truly alternative art there is today, i.e., the one art at least attempting to take a moral stance—tempted by the ethical possibilities of art. It is an art that tries to remind us, in a very intimate way, that art also is responsible for the state of the world.

Notes

1. Victor H. Miesel, ed. *Voices of German Expressionism* (Englewood Cliffs, N.J., 1970), p. 206.

2. Ibid., pp. 23-24.

3. Ibid., pp. 52, 59-60.

4. Ibid., p. 23.

5. Ibid., p. 6.

6. Ibid., pp. 82-83.

7. Oswald Spengler, *The Decline of the West* (New York, 1926), p. 311.

8. Miesel, *Voices*, p. 182.

9. Spengler, *Decline*, p. 343.

10. Ibid., p. 294.

11. Miesel, *Voices*, p. 199.

12. Spengler, *Decline*, p. 308.

13. Miesel, *Voices*, pp. 201-2.

14. Ibid., pp. 204-5.

15. Ibid., pp. 204-6.

16. Wolfgang Max Faust, " 'Du hast Keine Chance. Nutze Sie!' With It and Against It: Tendencies in Recent German Art," *Artforum* (September 1981).

17. Miesel, *Voices*, pp. 196-97.

18. Ibid., p. 211.

19. Ezra Pound, *Canto* XLV, lines 11-12.

20. Miesel, *Voices*, p. 24.

21. Ibid., pp. 59-60.

22. Charles Baudelaire, "The Painter of Modern Life," in *The Painter of Modern Life and Other Essays*, ed. Jonathan Mayne (London, 1964), pp. 7-8.

The Night Mind

The idea of nationalism, ambiguously defined though it may be, is periodically revived in most areas of human enterprise; it appears probably least of all, though, in science, where it would most obviously be absurd. Then why should it not also seem absurd for radical art? And why, in art's current situation, does it seem less absurd than ever? Never mind that there is an intermingling of national traits and that it is hard to isolate a national trait without reducing one's sense of the nation. Nationalism, like religion, is a crowd pleaser. A nationalist revival is not unlike a religious one; it is a way of sublimating otherwise potentially destructive subjective forces—of creating out of a dubious, insecure sense of personal individuality a rabid sense of identity. To identify oneself as belonging to this or that nation—or religion—is to have to worry no longer about one's individuality. An art that is defined as national automatically has meaning and value—a socially acceptable identity. Whatever its novelty or lack of novelty, and however much it may resemble other art, once identified as national it automatically has significance. It signifies a part of the world.

Comparing the Olympic Games and Documenta at the beginning of her Documenta 7 catalogue essay, Coosje van Bruggen, one of the exhibition's artistic-committee members, writes that "The Olympics depend on national self-interest. Documenta 7 is also affected by nationalism, the steady increase of which is apparent in those artistic expressions reflecting the prevailing mood of the times." The implicit guiding principle of Documenta 7 is nationalist; the dice are loaded so that most of the art presents itself first of all as symptomatic of a national attitude. The exhibition's organizers mean to disclose a truth that has presumably been hidden from us all these years—the existence of national art; the recognition that all art is national at its root. But this truistic *idée fixe* remains vacuous unless it can be shown to have a content; it is not bedrock but

This article originally appeared in *Artforum* (September 1982).

a disguise—there is an ulterior motive behind the use of the cliché of nationalism, and this ulterior motive is in fact its meaning. The nationalism advocated by Documenta 7 is a flag behind which a strange ideological force gathers—a flag which is a declaration of independence, but for a reactionary force, not without a touch of the farcical and pathetic in it.

One of the things one notices at Documenta 7 is that much of the new Italian, German, and American painting has a strong family resemblance—if not in detail of execution, where individuality emerges, then certainly in style and characteristic story line. There is a level of generality in each which summarizes the tradition of the new: the hyperactivated, almost chaotically spontaneous, yet ultimately directed touch; the conceptual use of collage; and the idea of discontinuous narrative, whether issuing from a sense of a work's fragility and potential fragmentation or from that of a narrative's enigma. There is, in other words, a weary recognition of the history of Modern art, a weary sophistication about the making of art—an awareness of the wide variety of materials and concepts available for its making. In the face of this weariness there is also a continuing drive and need to make art; but a weariness with the results, a recognition of how they "fit in," of their place in history, society, and even in the artist's development, is clear. It is as though all were predetermined; the sense of the speeding up of the cycle of creation and appropriation, of repossession and re-cognition, leaves both artist and audience with a blankness underneath their surface intensity of involvement. There is an impasse here, a feeling of hollowness, in which it becomes less urgent to differentiate general style from individual artist. All is dissolved in a flux of generalized artistic events which become finely calibrated and highly attuned to one another—art is viewed as a "scene" signifying nothing more than itself. Into this impasse comes nationalism—what Cyril Connolly in *The Unquiet Grave* calls a "womb-symbol," a surrogate for the absolute security and belonging one had in the womb—which reunites society and art.

This grand reconciliation is secretly longed for by both Society and the institution of Art. To put it into effect any obstacle to it must be swept away. And the principal obstacle is internationalism or cosmopolitanism—the idea of a trans-national art that is truly universal and cross-culturally significant. (Conceptualism is the contemporary example of such an art, an art which appeals to the reason before it appeals to the senses—which it does not neglect as much as is often supposed.) The "official" representative of internationalism in art these days is the United States. Van Bruggen's reference to nationalism is inseparable from artistic-committee member Gerhard Storck's assertion, in his catalogue essay, that "During the fifties, the Americans started dividing up modern art

into a European and an American sector. Of course, for them it was not a question of dialects—they were only interested in supremacy." Presumably this gets the Americans out of the way—they become just another "dialect," and a supremacist one at that. The placement of Jonathan Borofsky's flattened silhouettes of robotlike figures, with tools coming down, above Victorian marble figures of European countries perhaps epitomizes the European sense of the American threat in this exhibition. Despite the large number of American artists present (the largest of any nation) a more or less pervasive hyper-consciousness of Americanism—some have said anti-Americanism—is suggested by Documenta 7's installation. Is this merely a way of equalizing the nations, finding a new equilibrium between them? Is every nation represented denied "supremacy"? I don't think so. The Germans are given clear intellectual supremacy in the catalogue, as well as a certain supremacy in the installation. It is not just nationalism that this exhibition is proclaiming as the new dogma of artistic understanding, but German nationalism— a constellation of ideas usually associated with German culture. The catalogue is pervaded by a sanctimonious odor of obeisance to great "safe" nineteenth-century Germans—safe in that they can in no way be associated with fascism and brutality.

So we go back to the fathers in order to redeem the sons—to give them a fresh lease on artistic life by reminding them of their great cultural past. Thus the catalogue's first volume gives us a little essay by Goethe, on granite, and a letter by Friedrich Hölderlin on a visit to France; in the second volume Storck refers extensively to a letter by Philipp Otto Runge. These are all "good Germans." There is some question whether or not Friedrich Nietzsche, whom artistic-committee member Johannes Gachnang hesitantly finds himself in search of at the end of his catalogue essay, is one; but the point is that all these figures are in one way or another—although not as indiscriminately as the catalogue writers would have us believe—Northern Romantics. Their presence justifies, in a loosely associative way, what Storck perceives as an insistence upon a "right to Romanticism" in "many young artists"—the same artists van Bruggen finds "affected by nationalism."

In Documenta 7, nationalism and romanticism are inseparable. The Expressionist basis for the new German romantic style goes unmentioned in the catalogue—perhaps because, erroneously, it has been regarded as proto-fascist in attitude and therefore too dangerous to discuss—but there is a clear attempt to establish a continuity between nineteenth-century Romanticism and such Neo-Expressionist romanticism as we find in Anselm Kiefer's work, which according to van Bruggen uses "a subjective iconography derived from remnants of German history in order to

interpret issues of his own time." The key word here is "subjective"; it is more fundamental to the art than German history or nationalism. For it is not really that the new German art is nationalist in a strictly political sense, but rather that it is asserting what is quintessentially, romantically German: a privileged relationship to the subjective, a unique spirituality which is almost a German private preserve and is resorted to in moments of crisis. And Germany has been in a prolonged political crisis since its reorigination after the war as a divided nation. The world, too, has been in such crisis since the Cold War divided it into Western and Eastern camps; but Germany experiences that crisis, that lack of integration, immediately. Perhaps it is just because it is divided in two that it reaches for spiritual depths through its artists. The new German romanticism is implicitly the model for the emerging national romanticisms of other countries—so goes the implicit argument of Documenta 7.

But while the sense of agitated spirit is topical, it tends to be conceived right now decoratively, in timeless terms. It is as though the conditions of historical crisis have afforded an opportunity to transcend history, to escape political events. The purely spiritual subject becomes anti-intellectual, a weapon in a fanatical war against Enlightenment reason. Thus Gachnang asserts that "In the course of time and with the means of physics and mechanics we did, in fact, achieve some astonishingly successful results; but at the same time we let our psyche more or less wretchedly wither away and go to ruin, and thus obstruct other possible means of access to the deeper strata of human existence lying within us."

But this is all dogma, Romantic gospel. To be subjective and national is really the last aristocratic way of having worldly power. The only thing that stands in the way of such power is the reason that recognizes it as the regressive abstraction that it is—which is why it attacks reason as such. It is no accident that Storck links what he regards as Joseph Beuys' hope of "pushing through (pushing out?!) two hundred years of inherited Reason that has long since lost its impetus" with Runge's assertion, with reference to revolutionary France, that "a land where they have a Goddess of Reason will be a wretched place for art." Reason is the enemy, not only because it is inherently skeptical of "vision" and purely subjective revelation, but because it exposes the irrationality of pure spirit.

This marriage of nationalism and romanticism has as its offspring very particular attitudes to the artist and art. Cyril Connolly has written that

in these days it is important for an artist to grasp that the logical exploratory voyage of reason is the finest process of the mind. Every other activity is a form of regression. . . . Thus the much vaunted "night-mind," the subconscious world of myth and nostalgia, of child-imagination and instinctual drives, though richer, stranger and more powerful than the world of reason . . . nevertheless owes its strength to our falling back on all that is primitive and infantile; it is an act of cowardice to the God in Man.[1]

Such regression inevitably brings with it regressive reactionary attitudes toward the artist and art. Thus Rudi Fuchs, the director of Documenta 7, mystifies the artist into "one of the last practitioners of distinct individuality," and as quoted by van Bruggen, he asserts that contemporary art "should be handled with dignity and with respect," and should no longer be shown "in makeshift spaces, converted factories and so on." This attitude concentrates all power of exhibition—and thereby to a great extent determination of values—in the hands of the museum director/curator (Fuchs is director of the Stedelijk Van Abbe-museum in Eindhoven, Holland). But alternative spaces did not develop simply to question the authority of establishment exhibition spaces, but out of a reasonable recognition that much significant art was never displayed there. Fuchs's irrational attempt to trivialize the alternative spaces goes hand in hand with the turn to irrational, night-mind art.

Documenta 7, then, shows art at a crossroads, confronting a choice between art designed to further reason (currently Minimalist/Conceptualist) and art designed to evoke the night-mind (the new nationalist romanticism). While there are some artists here who are unequivocally on one side or the other, there are those who are stuck on the horns of the dilemma and who, from that unstable, anxious position, recognize a further problem, in fact the prevailing problem of the exhibition—the problem of traditionalism.

Tradition is the true "womb with a view" that Connolly speaks of as the regressive consolation Modern art secretly longs for. It is an answer—a temporary, tentative answer—to a basic problem of contemporary art: the search for a clear and distinct Modern artistic identity. Art no longer finds itself speculative in the old way. Its options now shut down almost as soon as they are recognized, for they are already recognized as used—as being part of a tradition of the "new and experimental." The pressure for innovation remains strong, if an increasingly impossible, unrealistic basis for artistic production. And the myth of self-determination through art (revived indirectly by Fuchs's obsolete, naive notion of the artist's individuality) goes hand in hand with that pressure; both falsify the real possibilities of art and the artist's identity. Both presume art and the selfhood the artist might attain a terra incognita—but, when that pressure becomes a tradition, innovation is just another terra firma. There is no longer any soft ground for art to stand on and imagine itself taking risks.

The international situation in art today is this: the artist finds him- or herself under continuing pressure to be Modern, but discovers that to be Modern is to be traditional. This contradiction is the source of the identity crisis plaguing contemporary production and of the new interest in the national identity of art—a short-term, shortsighted, and premature solution to the problem, which is a Gordian knot not easily cut by so dull

(from overuse) a sword as nationalism. In fact, nationalism falls into the trap of the same contradiction: it presents itself as the new Modernism, but it is really a very traditional idea.

The best artists in Documenta 7—among them Kiefer, Giuseppe Penone, Sigmar Polke, and Cindy Sherman—accept this situation of contradiction. They explore traditional "artistic" identities artfully, finding new art in them—a peculiarly introverted approach to extroverted material. Indeed, the introversion of traditional modes of art and identity—an introversion which in and of itself implies a critical relation to them—becomes the method of artistic operation. "Subjectivity" in this art is not a romantic method for reaching absolute spirit but a strategy for destabilizing what seems dogmatically given. With Modern traditionalism comes the recognition that contradiction, not revolution, is fated; dialectical ambiguity is identity and destiny.

The printing of excerpts from T. S. Eliot's "Tradition and the Individual Talent" in the Documenta 7 catalogue signals that traditionalism is the basic underlying theme of the exhibition. Nationalism is only its superficial symptom. Traditionalism had already surfaced with Postmodernism, which Harold Rosenberg identified with the abundance of styles, and the lack of priority among them, that had become available to artists through the information explosion. Postmodernism, in fact, can be regarded as transitional from Modernism to traditionalism. In contrast to Postmodernists, traditionalists do not saturate themselves in an eclectic variety of styles, but rather stay with one tradition of operation. This is not the same as the romantic re-origination or rebirth of spirit that the new nationalists demand. Modern traditionalist artists make no "spiritual commitment" to the tradition of style and meaning, text and identity they utilize. Rather, keeping cool, they walk their tradition as a tightrope, testing its strengths and weaknesses. Anxiety about the emptiness of existence is transformed into anxiety about the sturdiness of one's tradition, its ability to carry one across one's existence with some dignity. Wise to the ways of tradition, one can forget the essential lack of identity of one's existence. But this traditionalism consumes traditions in the very act of appropriating them. In Modern traditionalism there is never any surrender to tradition, but rather a negation of it in the very act of affirming it. For in it tradition remains a quotation, a bracketed identity existing to be studied abstractly for its ideational topography.

Modernist traditionalism, then, is not a reversal of the familiar Modernist antitraditionalism, but rather an extension of the Modernist interest in the conventions and structures that permit us to speak of having an artistic identity and style—any identity and style at all. It partakes of the same refreshing skepticism, is as speculative and critical, as

"primary Modernism." It is a secondary Modernism, a new stage of evolution of Modernism, perhaps even a mutant Modernism, that no longer uses traditions as straw men (as the first Modernists did), but rather recognizes them as time capsules in which are stored the residues of an identity which was once "authentic."

To end with the nationalism with which I began, it is worth noting that the paradigms of the Documenta 7 catalogue were in fact as skeptical of the romantic as they were of the nationalistic. Goethe in particular wrote of "the shallow dilettantism of the age which seeks a false foundation in antiquarianism and fatherlandishness."[2] And Nietzsche, regarding nationalism as dangerous, advocated intermarriage between different nations and hoped for a mixed race, that of European man. The "good European" rather than the good nationalist—good German—was his ideal; and his observation about the relationship of culture and the nation is worth citing: "Culture and state," he wrote, "are antagonists. . . . One lives off the other. All great ages of culture are ages of political decline: what is great culturally has always been unpolitical, even anti-political. . . . At the same moment when Germany comes up as a great power, France gains a new importance as a *cultural power.*"[3] Is it that, with Germany in political decline—handicapped because of its division—it is in the process of gaining new importance as a cultural power? But how self-contradictory that it should offer its new artistic culture to us as first and foremost a national culture, playing down its international ties. Do nationalist artists want to be American, French, German, or Italian before being anything else? The evidence is not clearly in yet, although one has a sense that Documenta 7, like the Sibyl's leaves before blowing away, has a message in its ordering of work which remains to be deciphered, and will be memorable.

Notes

1. Cyril Connolly, *The Unquiet Grave* (New York: Harper & Row. 1973), p. 122.

2. Quoted in Walter Kaufmann, *Nietzsche: Philosopher, Psychologist, Antichrist* (Princeton, N.J.: Princeton University Press), 1974, p. 379; letter to Karl Friedrich Zelter, August 24, 1823.

3. Quoted in ibid., p. 298; from *The Twilight of the Idols.*

When Collage Was Young: Kurt Schwitters

Everything was right, but something was indescribably wrong. The exhibition was beautifully installed, John Elderfield's brilliant, definitive catalogue traced Schwitters's development down to the last art historical detail and interpreted his art from every possible critical angle. Schwitters was revealed as the master who took collage out of the trenches of experimentalism, establishing it as a conventional mode of art-making. He also showed that life, as well as art, could be understood as a collage. A squint here, a quick glance there—the modern style of perception on the move—and material things revealed themselves as ambiguously "adjusted" (Schwitters's word) to one another, integrated yet differentiated to the point of disintegration. Schwitters had not just "perfected" a method of art-making, but extended the modern understanding of perception to real objects. It was not simply one's sensations that shifted unstably, as the Impressionists demonstrated—in Cézanne, the climax of that demonstration, perception is shown to be a subtle, steady tremor—but real things as well. Space itself was a tissue of unstable relationships, not just perception of space. Reality and appearance are the same in collage. Correlate with this, collage demonstrates that the relationship between real things is not organic but "constructive." That is, we assemble them into a "visionary" whole of stabilized space through a series of esthetic adjustments which corrects their "tic," their tendency to fall apart—the modern experience of nonrelation.

Elderfield makes much of the fact that Schwitters generally preferred a small format, to concentrate and control his objects—to truly "collect" them, force them into relationship. Schwitters himself wrote: "Only in a limited space is it possible to assign compositional values to each part in relation to other parts." This is where I was discomforted by the exhibition, perhaps misexperiencing it—where I kept seeing not critically

This article originally appeared in *C Magazine* (Fall 1985).

significant art and art history, but conventional art education. Schwitters seemed to have unwittingly developed collage as a limited, "laboratory" way of learning formal relationships—a facile way for the gifted amateur to learn how to convert matter into form, "proving" the omnipresence of art. I experienced Schwitters's work with a peculiarly hostile irony, amounting to elitist resistance to it, for I saw it as inventing an easy way for those not deeply committed to art to make it—to get the hang of it—perhaps the preferred way in high school art classes. His art was insufficiently esoteric, all too exoteric despite the hermetic effect of concentration in a small format—an all too artificial *hortus conclusus,* for the mechanistic manner of its construction undermined faith in the little illusion of paradise it meant to create. Thus, my sense of the pernicious long term influence of Schwitters's collages on the public's general, working conception of art—everyman's trivialization of it into a minor transformation of major everyday matter, a "redemption" of ordinary reality that hardly made it extraordinary or changed our comprehension of it—intervened in my recognition of Schwitters's importance for early Modernism. No doubt this perception was my failure, but I clung to it as an intuition of the problem surrounding his art. I saw Schwitters not simply as acknowledging modern transience with works which were meant to be transient but proclaiming the easiness and simplicity—simplemindedness?—of art.

The exhibition seemed, by reason of the elegant museum ambiance and pomp and circumstance of the installation, to be deliberately holding back the inevitable decay of objects with built-in material obsolescence, officially immortalizing the immediate, arguing for the indispensability of the obviously dispensable. The theatrical attempt to demonstrate historical significance reduced the works to hollow flourishes. The works are historically significant, but they are inherently antihistorical, so that to monumentalize them is to falsify their contemporaneity, or to leave that cutting edge of contemporaneity, so crucial to collage—which reduces whatever it incorporates to the absurd status of the simultaneously instantaneous and sedimented—to the simplistic vitality of school exercises in "creativity." The exhibition posed a problem special to many revolutionary, antiestablishment modern works: how to show them within the establishment without falsifying their rebelliousness into mere "adventuresomeness," without turning their protest into a sanctimonious, self-serving gesture, without appropriating their artistic and socially concrete criticality to justify our own whimsical, abstract, belated and therefore all the more self-righteous recognition of the existence of "problems and issues." To keep the all-important junkiness of Schwitters's works from dwindling into the decorative, they should have been shown in the less dignified setting of an East Village gallery.

In the museum, their message seems to be: judiciously assemble some of the plentiful detritus of the daily world, frame it in an accessible format, perform a few esthetic manipulations on it—and lo and behold, one had a "significant" work of art, or all the significance that art supposedly had. Schwitters gives us a sentimental, bourgeois version of innovative or experimental art—an obvious avant-garde look. How easy it is to be advanced in art, he seems to be telling us. And how easy it is in general to learn to make art, which in the modern world requires no special talent or knowledge of materials, but a knack for constructing what is already visibly there in a slightly different way. Of course, the subtlety of his choice of litter may not be everyman's, nor his sensitive appropriation of the various emerging styles of his day into his generalized *Merz* mode of operation. Everyman, in his ambition to be everyartist, may not understand the peculiar irresolution of Schwitters's art—the "delaying tactics" which prevent closure into a finished, polished style, that is, the sense in which each object simultaneously presses for and puts off relationship with every other object—but he understands the underlying "democratic" principle of Schwitters's art. It is the same with Surrealism; it readily became popular, offering not only a seemingly easy way of making art, but a vulgar idea of the goal of art, opening the way to "art appreciation." Both Schwitters and Surrealism seem to offer an art that is so continuous with the everyday world that the sense of the distinctness and difficulty of art is lost. Art-making becomes a superior example of what John Gedo has called the creativity of everyday life rather than of high art complexly negating if illuminating it. This was not just the fate of every art—to become assimilated and dubiously exemplary—but was the special destiny of collage, which seemed to beg, borrow, and steal so much from the everyday world, showing a greater than usual dependence on it.

The everyday world was not so much collage's model as a resource, supplying it with the infinite variety of materials that are its lifeblood. It was as though collage, weaned on the world, could not shake itself of its dependence. Collage was an addiction to the material world of objects, as traditional art was an addiction to the "spiritual" world of appearances. The question is, what is the character of Schwitters's addiction?

Elderfield has remarked on the doubleness of Schwitters's personality, the way he could flipflop from a bourgeois sense of "melancholy" private existence to a "fondness for [flamboyantly, manically] playing the clown." This seems reflected in his art, which exists on the boundary between idealistic sentimentality—as Elderfield points out, in Schiller's and Expressionism's sense, an attempted restoration of lost direct contact with nature—and, in Schwitters's words, "an increasingly objective study of the picture and its laws," leading to the production of autonomous art,

and the creation of exclusively esthetic effect. Schwitters alchemically converts impure matter into pure art, raising the "fallen" nature of used and abused real things—ruined by their becoming in the actual world—into the mythical heaven of integral being which art represents. In trying to explain the popular success of Schwitters's poem "An Anna Blume" (1919), Werner Schmalenbach wrote that "petty-bourgeois sentimentality is made fun of—but in petty-bourgeois language. . . . Thus the poem could become a real love poem, a love poem in which grammar and vocabulary were tangled up not only because Dada demanded it but because the—pretended—intoxication of love demanded it." Richard Huelsenbeck, the anti-Expressionist leader of the Berlin Dadaists, who rejected Schwitters's application to join Club Dada, thought the "rather silly" poem revealed "an idealism made dainty by madness." For Schmalenbach, Schwitters was "a late Expressionist in Dadaist clothing," that is, he used what the Dadaists called "the new medium," collage—peculiarly suited to articulate the disjointedness and fragmentation of modern life, which revolutionaries other than the Dadaists took as an opportunistic omen of social revolution—to "remodel" (to use Huelsenbeck's term) or revolutionize art rather than social life. For Schmalenbach and Huelsenbeck, Schwitters was more clearly a reactionary in attitude than a revolutionary in form. His attitude corrupted, and finally invalidated, his use of the revolutionary new medium of collage, trivializing it for publically decorative and personally expressive ends.

Elderfield points out "An Anna Blume's" basic romanticism—Anna "personifies the exclusive, magical powers of nature"—while at the same time noting that "Schwitters himself once claimed that poetry was the first of the arts of assemblage that he practiced and that it was by combining poetry and painting that *Merz* itself was born." Schwitters's poems were increasingly purely material "word-chains," that is, the words existed less for their meaning than their material form, finally becoming simply assemblages of letters ("nonsense" words) tantalizing us with provocatively new, never fully decipherable meanings (presumably unconscious or hyper/super-conscious). As Elderfield remarks, "great stress" was placed "on the linking-together of 'clenched' word-units in an alogical but assertively constructional way." According to Schwitters, "words are torn from their former context, dissociated and brought into a new artistic context, they become formal parts of the poem, nothing more. " This approach is carried into the collages. As Elderfield notes, what Schwitters "called the *Eigengift* of materials, their own special essence or poison (the word *Gift* carries both meanings), had to be abandoned when they were put into pictures." In Schwitters's words, all materials had to be used "on an equal footing," and all "lose their individual character, their own essence, by being evaluated against each

other; by becoming dematerialized they become material for the picture.''
Only this "artistic evaluation" of "forming is essential." There is, then,
what Elderfield calls a "striving for homogeneity" (esthetic equivalence)
in Schwitters, which led him not only to expel "(with very few excep-
tions) any kind of narrative relationship between his materials, but . . . to
stress the very gathering-together of materials above all else. . . . Rela-
tionship came to be identified with value, and inherited formal devices
gave way to the spontaneously additive process." Collage, then, is an
erotic—"copulative"—strategy; one might even speak of it as an orgiastic
association of discrepant materials, eager to end their conflict and tran-
scend their material heterogeneity—to harmonize, or more pointedly,
homogenize (the modern form of harmony, in which differences level
rather than accommodate one another). One can even say, using Georges
Bataille's words, that collage attempts to demonstrate "that life is parodic
and that it lacks an interpretation," for in collage the material elements
become "esthetically" interchangeable, and are thus no longer individual-
ly interpretable. Collage is a self-parodying device of bourgeois society,
in which all relationships are "adjustable"—in which harmony is achieved
by homogenizing contract—and as such simultaneously functional and
futile. Coitus—and the copulative intensity of collage—may be a "parody
of crime," as Bataille says, but for all the seeming aggression of its method
it results in tranquility—an esthetically homogenized totality. Indeed, the
division between Schwitters and the Dadaists is greater than is apparent,
for, in Schwitters's words, "Dadaism merely poses antithesis, *Merz* recon-
ciles antitheses by assigning relative values to every element in the work
of art." Dadaism rejects reconciliation—whether with society or within
art—because it precludes revolution.

Reconciliation, after a long detour of suffering, is a key romantic idea.
The question is whether Schwitters's romanticism is simply a cunning
rearticulation in novel modern dress of traditional romanticism's desire
for the "salvation" of reconciliation, or whether Schwitters despite himself
offers a new understanding of "romance" in the modern world, reveal-
ing something unexpected about its contemporary condition. Schwitters
is not simply showing us that romance—the difficult search for cor-
respondence between introspective self-experience and realistic experience
of the world, and for a symbol that can represent their reconciliation,
whether by giving it living presence ("love") or mourning its absence
("death")—still lives, but showing that it is still the peculiarly difficult
condition of our lives. As I see it, Schwitters's most powerful works are
those in which romance still comes through, romance understood as the
articulation of the excruciating difficulty of effecting "transference"—
creating a "charged" committed relationship—between resistant,
autonomous materials. Romanticism confronts the supposedly

homogeneously integrated modern world with the reality of disintegration and heterogeneity, demonstrating that the superficially well-administered, rationalized world is in fact full of inescapable contradictions. These are unlikely to be overcome socially, although they may be overcome personally. The search for correspondence between inner and outer worlds—for the inner resolution of an external contradiction—critically reflects the insuperable odds against, and the painful absence of, social unity. Romanticism has given up the struggle to make this the best of all possible worlds, but wants tragic reconciliation with it. In a sense, it seeks social revolution through personal revolution—social reconciliation through personal reconciliation. Modern conflict is not presented in Schwitters's art through what Elderfield calls the "immediate duality of formal design and associative reference," but rather through the tension between materials that can and cannot be integrated into the formal design of the work of art, between materials that seem to lend themselves to the over-all homogeneity of the work and those that remain heterogeneous and opposed to it— for all their look, at first glance, of "belonging"—and so seem violently intrusive in it. The best works of Schwitters are not those of uniform materiality, such as the many planar paper works and a work of uniformly rough wood such as *The Wide Schmurchel* (1923), but works such as *Construction for Noble Ladies* (1919) and *Small Sailors' Home* (1926), with their ambiguously assimilable rusting sections of wheel, and *Relief with Cross and Sphere* (1924), with the red ball which seems less embedded in it than ready to shoot out of it, and the especially daring *Glass Flower* (1940), with its metaphoric/metonymic use of a fragment of broken glass.

The *Merzbau* calls special attention to the problematic character of the integration of Schwitters's collages, an essentially erotic problem—the problem of creating a strong temporary bond to "recall" an underlying, universal bondage—which he was probably unconsciously aware of while consciously believing that he had "constructively" achieved stable integration through esthetic equivalence. Collage is an attempt to *imply* a situation of secret bondage between matter-of-fact materials which seem inherently indifferent to one another. It is the central problem of Schwitters's work, one might say the "original" problem he discovered. It was implicitly acknowledged by Walter Mehring, who in a 1919 review of Schwitters's first important collages, asserted that "Schwitters was making a kind of 'expressionistic genre-art'—a 'trash-romantic' art that transcends Picasso's collages by allowing materials to carry a sensual stimulus akin to that found in primitive art." Schwitters's attempt to reproduce the supposedly extraordinary sensual intensity of primitive art—presumably generic art, that is, art in which integration in permanently incomplete, forever in process, so that the material heterogeneity of

the art seems more evident than its formal homogeneity—is his way of trying to generate transferential effect, that is, erotically unite materials that are mechanically assembled. No doubt this is the problem of modern society, in which there is no "higher" ground for relationship. Collage acts out the drama of relationship, in the secular world of ambivalence fraught as much with anxiety about togetherness as with what psychoanalysts call "separation anxiety." It is a drama involving emotionally charged materials, materials humanized—Apollinaire observed that the materials of a collage are already "steeped in humanity," reminding one of Rilke's remark that the "empty, indifferent things, pseudo-things, DUMMY LIFE" coming from American have "NOTHING in common" with the things in which the European forefathers "found and stored humanity"—yet handicapped by their humanity. Indeed, collage can be understood not only as a European attempt to symbolically rebuild a wrecked, postwar world, but to reassert an old culture's aristocratic pretension to profound humanity in the face of a dynamic new—American—culture's supposed insensitivity to existential issues, simply by reason of its modernity and lack of a past, that is, of history. In collage the old European pretension to humanistic culture modernizes itself with the dynamic look of the future—an American look. But it is only a look, a veneer. It is as if Europe was saying America may own the material future, but Europe has a monopoly on the profounder, spiritual future, by reason of its long understanding of human existence and long experience in making art—despite the fact that World War I demonstrated the self-defeat of European culture and humanity, and that Dadaist collage demonstrates the bankruptcy of European art, even the absurdity, triviality, and ineffectuality of art itself in the real, modern world. For all his efforts to sustain art's traditional idealism, Schwitters's collages show a kind of Luddite attitude to it, nihilistically smashing it into the pieces of its dumb material reality, showing the comic banality of its relationship to the world. This is not incommensurate with the "futurist" aspect of his collages; their chaotic fragmentation can be understood as the perverse result of the work of art's attempt to develop an energetic modern manner.

In any case, Schwitters tries to heal the wounded material of ordinary life by putting it in the utopian context of the work of art. To esthetically adjust the relationship between "negative" materials gives them a freshly positive charge—makes them forget their suffering, makes them "spiritually" if not physically whole. Schwitters reveals the secret of estheticism: the work of art as a high class sick room, art in general as an elegant sanatorium. The question is whether the cure really occurs, whether the physically and mentally ill materials excommunicated by life find new bearings and significance in the work of art or only seem to.

Worse yet, they may be in a condition of permanent convalescence, or decked out in their coffins behind the protective glass of the work of art. Schwitters's collage is a magic mountain for permanent invalids, a rest home for aged, diseased, almost fossilized survivors of life.

In the *Merzbau* the often explicit eroticism of Schwitters's works—as in the numerous Anna Blume collages and (sometimes the same) those reflecting his interest in fashion and mannequins (his parents once owned a ladies' clothing store)—and the implicit eroticism of his collage technique come together. Describing the *Big Love Grotto*, Schwitters wrote:

> The love grotto alone takes up approximately 1/4 of the base of the column, a wide outside stair leads to it, underneath which stands the female lavatory attendant of life in a long narrow corridor with scattered camel dung. Two children greet us and step into life; owing to damage only part of a mother and child remain. Shiny and broken objects set the mood. In the middle a couple is embracing: he has no head, she no arms; between his legs he is holding a huge blank cartridge. The big twisted-around child's head with the syphilitic eyes is warning the embracing couple to be careful. This is disturbing, but there is reassurance in the little bottle of my own urine in which *immortelles* are suspended.

The *Merzbau* makes clear that Schwitters articulates, through an infantilistic, animistic sensibility for the erotic concreteness of all reality, a maddening sense of vulnerability. To me, the understanding of Schwitters's art is radically incomplete without recognition of the influence on it of his experience, as an adolescent of fourteen, in which "a garden he had carefully nurtured—with roses, strawberries, a manmade hill and an artificial pond—was destroyed in his presence by some local children." This caused "the first of the epileptic seizures that were to plague him intermittently throughout his life." Elderfield notes that Schwitters "turned to art . . . after the idealized form of nature he had physically cultivated had been destroyed. Art . . . could serve to rebuild a new form of nature, safe from interference." For Schwitters the collage was the physical representative of a mental landscape, mythically ideal and so forever unrealizable—forever out of reach in the depths of "memory"—and so in a sense eternal, indestructible. In a kind of compulsive repetitiveness, the prolific Schwitters—some 2,000 collages are known, not counting collage poems and musical compositions, and the *Merzbau*—made various attempts to materially embody his vision of perfected nature. Yet every one of his ideal landscapes was "self-destroying," for it was clearly about to fall apart, or else an imperfect reconstruction of a reality that had fallen apart. Destruction or imperfection was deliberately built into every visionary collage, signalling it could not ever come into clear, crystalline focus. The collages are flawed versions of a childhood paradise lost in a traumatic way, and so never outgrown. Yet while Schwitters clings to

his infantile utopia, he also renounces it, knowing it can never be recreated in all its imagined perfection, for it has been marked forever by violence. It carries the mark of Cain in its very structure and texture, as though Schwitters himself had destroyed his ideal relationship with nature— was in one destructive act the aggressor against both the natural and the ideal.

Schwitters offers the fragments of a utopian fantasy of nurturant yet rationalized nature. The fragmentary character of the collage dream—it is worth noting how many modern artists, e.g., Masson and Gorky, seek an emotionally archaic yet intellectually sophisticated relationship with nature (passively happy in it after actively reorganizing it)—signals, all at once, the inherent incoherence of the dream, the impossibility of ever realizing it, its violent "contradiction" or destruction by the real world with which it was in conflict from the moment of its conception (is the ideal not, after all, the aggressor against the natural?), and the spontaneous aborting of the dream by the artist who can't really carry it to term as he grows older, that is, temporally more distant from the moment of its infantile origination. The collage is a miscarried dream— necessarily miscarried, because it needs the artist's youth to sustain itself, and that youth was permanently lost when the original dream was destroyed by the world. All dreaming was forever after "tainted," a mad omen of catastrophe. At the same time, the collage is a kind of fountain of eternal youth—Schwitters's Sisyphean "revision" of his youthful dream of an intimate relationship with a perfect nature, the ultimate "object" of desire. In the last analysis Schwitters's "realism" had less to do with his material sources than with the fact that he dared to show the evil in perfection—the death that is also in Arcadia, in the form of the forceful fault lines in the microcosmic reconstructions of his lost paradise. In a sense, Schwitters "vandalized" reality in retribution for the traumatic vandalization of his "original," idealistic work of art.

It is also worth noting that the perhaps first *Merzbild* was entitled *The Alienist* (1919), or, more pointedly in German, *Der Irrenarzt* or doctor for crazy people, that is, psychiatrist. Elderfield speculates that Schwitters may have seen himself as a kind of psychoanalyst of physically "hot" materials, a sort of Bachelard-like interpreter of the ordinary objects and appearances in which so much emotion had been invested. But this puts Schwitters in the position of sovereign control—the driver's seat—of the collage; I think he generally experienced himself as a victim, with material reality impinging upon him until he was in danger of losing all self-control. The best collages seem about to spin dizzily out of control, disintegrate despite Schwitters's best "bourgeois" efforts to esthetically "adjust," or establish "spiritual" equivalence between, their materials. This indicates

the residual heterogeneity and ''risk'' in the collages. They articulate in metaphoric, microcosmic terms the impossibility of the world reconciling itself to itself, reflected in the ''stubbornness'' of its material reality, its factual intransigence. In Schwitters's best collages there is a residual pathology of disconnection, of subtle nonrelation, despite his best efforts at homogenizing integration. It is this that makes them an exciting disclosure of the devastating disintegration which ''romance'' has become in modern life.

I would argue that Schwitters, for all his statements to the contrary, unconsciously recognized that the collage was an articulation of disintegration rather than of integration. Hence his restless search for material that seemed impossible to integrate into art, that seemed to dare him to assimilate it. He unconsciously recognized that such resistant material was the lifeblood of his art. He did not really want the collage to be a comfortable home for orphaned materials. (Elderfield remarks on the aura of homelessness in Schwitters's collages. Their disorder mocks domesticity. Each collage is a freakish act of art, a self-conscious sideshow in a travelling circus of the unconscious.) Thus his act of artistic incorporation comes to seem increasingly absurd and clumsy as ever more disturbing, ''preposterous'' materials are used, materials that seemed inherently resistant to artistic homogenization, impossible to squeeze esthetic effect out of.

The material in Schwitters's collages seems about to mutiny. Schwitters responded to this threat by on the one hand using what seemed like predetermined patterns of organization, and on the other hand by letting the collages seem randomly—raucously—assembled. Schwitters came to recognize that not just popular imagery, from advertisements and comic strips, were intractable, but mechanical reproductions of traditional ''organically unified'' works of art were also heterogeneous and problematic in a modern, mechanistically organized society in which such unity seemed like an impossible dream—in a functional society which seemed more an abstract system than a lifeworld. (Was Schwitters alchemically converting the dregs of an abstract system into the dream of a lifeworld?) Schwitters made clear that in the modern world art-making was always a risky, romantic enterprise, stuck on the frontier—borderline—between a proposed ideal unity, integration, or equilibrium, forever fictional, and the actuality of disintegration and conflict. Schwitters was insane not only because he preferred living on this borderline—a no-art's-land as well as no-man's-land—but for being able to sustain himself on it for so long.

Psychotic Realism in Max Beckmann

Max Beckmann through his self-portraits: what other way is there to approach his art as a whole? As with other important North European artists, such as Dürer and Rembrandt, they are numerous to the point of being a separate genre within his oeuvre: but doesn't that disqualify them from special consideration? Can't they be understood as simply another realistic subject matter, not at all privileged in place within the panorama of everyday reality that is the obvious raw material of the realist artist? Beckmann painted all kinds of people, from intimates to strangers in the passing scene, including anomalous, deviant types that increasingly seemed the social norm. He painted the streets of the cities he lived in and the pregnant conjunction of the land and open sea in the resort towns he vacationed in. He painted still lives, sometimes of conventionally domestic objects, at other times of incompatible objects perversely coupled. He painted whatever was given: isn't the artist's self simply another given? Isn't it simply another target of opportunity to be exploited, neither more nor less meaningful than any other? It, along with everything else, had its latent, peculiar physiognomy, which it was the task of the realist—this is why his realism was regarded as "magical"—to make manifest by exaggerated treatment of its physiology. General physiology, properly manipulated ("distorted"), could make radically particular individuality evident. The insidious, not easily readable allegorical import Beckmann's scenes eventually acquire grows directly out of such urgent manipulation.

On the other hand, the artist's representation of himself, properly understood, suggests what is at stake in his art as a whole. It implicitly articulates the immanent intention—the sense of identity—that structures the art. The self-portrait cannot help but be more meaningful than any other type of image, for it deals, quite consciously—apart from what it reveals unconsciously—with the artist's own person, implicitly raising the

This article originally appeared in *C Magazine* (Spring 1985).

question of its nature and importance. The self-portrait is necessarily a form of self-analysis—both a challenge to and objectification of self-awareness. Beckmann's self-portraits are thus slyly superordinate to the rest of his art, and as such the perspective from which it comes into view as a whole. What they tell us about Beckmann as a particular person, they tell us about his art in general.

Apart from the overt self-portraits, images of Beckmann covertly infiltrate scenes in which he is ostensibly an incidental presence. The traditional artist also does this, presenting himself as a witness at important religious and social events. Veronese in the *Wedding Feast at Cana* (1563) and Goya in *Family Group of Charles IV* (ca. 1800) are examples. In Beckmann's case, the structure and importance of the scene are not foreordained, which means that the dialectic of the figures counts for more—determines most of the significance. In the Goya especially—this is a sign of its modernity—we insist on profound ironical and personal meaning in the relationship between the artist and the royal family, despite the fact that we can never be certain of our interpretation. Nonetheless, we believe that the modern artist makes an appearance in his own picture not simply to say, in a more sophisticated way than the traditional artist did, that he painted the picture. (But it was very sophisticated of Jan van Eyck, in *Arnolfini Wedding Portrait* (1434), to inscribe his name, with the assertion that he made the picture and was present at the event, above the mirror that "proved" this statement.) He is the scene's witness, yet also a protagonist in it—peripheral, but as spontaneously present and engaged as any other character in it.

His presence, more than that of any other personage, piques our curiosity, because it seems at once understated in the totality of the scene yet overstated by reason of its inherently exceptional character. It is after all the artist, not another member of the royal family—the artist who is the most telling protagonist because he made the picture, shows us the scene the way he wants us to see it, organized according to his sense of what is important in it. Clearly his relationship to the other figures in it counts as much as their relationship among themselves. He is both outsider and insider—outside the scene painting it yet inside it being painted, but also outside it because, as an artist, he is supposedly inherently different and to an extent socially separate from the other figures in it, that is, equivocal in nature and status. He does and does not belong in the scene. It is both familiar and unfamiliar—ambivalently familiar, ambiguously meaningful—by reason of his way of narrating it and inserting himself in it. It is a twice told tale, maybe a thrice told tale—a story, a story told a certain way by an artist, and a story of an artist in a certain kind of world. He becomes the major link between it and us; we must

pass through him to truly see and understand it. We look at the scene more closely because he is in it, more contemporary than any other figure in it, not only because he (often) stares at us as if we were in the same space, but because we are trying to experience the living meaning of the picture—relating to it as if it was made for us today, as if it spoke to our present condition. We come to regard the artist as pivotal to the scene because he becomes pivotal to our sense of ourselves.

This displacement—from public to private, from social to personal—occurs in *Family Picture* (1920) and *Before the Masquerade* (1922), among the first works in which Beckmann comes into his own. In these pictures the other figures are a foil for Beckmann, who is placed in the scene differently than they are—placed obliquely, away from the center of action, yet implicitly its center, as in *Before the Masquerade*. There is no direct interaction or communication between him and the other figures; while they are of the same community, they are not the same in character. While Beckmann and the other figures are all too human—equally depressed and self-absorbed, perhaps on the verge of profound introspection—it is Beckmann alone who has the aggressive, truculent will to unflinchingly look inward, the steadiness to endure what he will see in himself, however wounding it may be to his conventional self-conception and vanity. (It has been argued that there are exceptional individuals whose ego not only can withstand and survive the regression inherent in such introspection, but is of such unusual strength that it can capitalize on the operations of every emotional and intellectual development level without loss of self-esteem and self-possession.[1] They profit from their voyage to hell.) The self-absorption of the other figures exists in vain—signals both their naive self-preservative narcissism and their unconscious feeling of the futility of their lives. The woman looking into the mirror in *Family Picture* conveys the optimistic sense of vanity (she has many affinities with traditional types of Venus, *Vanitas*, *Luxuria*). The women at the table convey the other, pessimistic sense—the depressing vanity of all things, lives, and events that Ecclesiastes wrote of. Both optimistic and pessimistic self-absorption lead nowhere. Each is simply a kind of creature comfort, really a deadend, a sign that the figures have been stopped by life—an articulation of the deadended self.

But, even in his hurt condition in *Family Picture* and in *Before the Masquerade*, where he sits with his back to us, Beckmann's glance is, for all its abstracted character, not empty, like that of the other figures. It is an active glance, looking outward as well as inward, aware of the world as well as the self. It is acutely aware of their simultaneity; it mediates their unity. For Beckmann, the inward glance is the alembic in which the experienced world is imaginatively deconstructed according to the "logic"

of its effect on the self. Despite the fact that Beckmann's glance is, as Clara Schulz-Hoffmann writes, a consistently "lost gaze, which signals isolation within the environment," it does not signal indifference to the environment—a refusal to observe it. Beckmann sees it clearly; however much his glance implies "melancholy separateness, even in a context of intimacy and trust" such as the family or, later, the married couple, his glance shows that he grasps, penetrates every nuance of the intimate situation. But it is always as though he is surprised to find himself in it, as though he experiences it as an oppressive fate, as though his consciousness of it is a form of resistance to it. His consciousness of the social situation is at odds with it, signifying his sense of himself as an unwilling victim of the small fate which it is and the larger fate it symbolizes. While in a sense "committed" to and fully participant in the situation—acceding, as it were, to its sociality—he is always observing it cautiously, like a cornered animal whose wariness is the only cunning left to it. He is mentally outside it while physically inside it—this is also Goya's position—and he more deeply knows the implications of what is inside it than anyone else there. He is conscious of the scene as a sign—of his own condition and character and that of the others in the scene as a response to and symptom of social reality—while everyone else in it is somnambulist. While Beckmann invariably envelopes himself "in an aura of untouchability," "in an existentially determined isolation,"[2] he is acutely aware of the situation's psychosocial reality, and his own within it—aware of how bound to yet separate from one another the figures are, how "other" they are to each other and in themselves.

While Beckmann is aware, as he has stated, that God has "created us so that we cannot love ourselves,"[3]—and undoubtedly others, since they invariably remind us of ourselves, are like distorting mirrors of us in our relationships with them—and while Beckmann himself, as the God who created the world of his pictures, is determined to show us at our most "frightful, vulgar, spectacular, ordinary, grotesquely banal,"[4] he also recognizes that we cannot escape or transcend ourselves, and are inextricably bound to others, tightly locked into a world with others. In Beckmann's pictures the world is an excruciatingly small room in which we are excruciatingly close to one another, sometimes literally, and always emotionally, bound to one another, in a kind of hothouse intimacy, a claustrophobic dialectic of relationship. Closeness is a monstrous fate that is not at all overcome by inward distance. Beckmann always shows himself as inwardly a hermit and outwardly socialized—simultaneously. Whether dressed as a medical orderly (1915) or in a tuxedo (1927), his glance comes from an inward depth which keeps one away. One can almost feel it push one away, and one experiences the space he inhabits as a cell in which he is inviolate.

Beckmann's ambivalent attitude to the closeness of others is reflected in his space. It is the reason why, as has been widely noted, Beckmann frequently depicts "tightly-packed groups of people"[5] in a cramped "medieval" space—his early religious works explicitly acknowledge his debt to German Gothic art—too small to contain them, a world-signifying space in which freedom of movement is impossible. This double lack of freedom—lack of freedom from the plague of others and lack of free movement of one's own—emphasizes the fatedness of the human condition, makes clear just how determined every aspect of it is. The space has changed by the 1940s but it never loses its essentially closed character. Beckmann creates a world of "individual spatial compartments,"[6] so suffocatingly self-contained the individuals within them seem its victims. He in effect creates a kind of sculptural niche for his figures, but instead of signifying, as it traditionally did, their possibility of free movement in space in general, it signifies exactly the opposite—their imprisonment in the world, the abolition of "space in general," even as a hopeful illusion. All that is left is the mental space of their self-awareness, and even few of them can inhabit it. Only a Beckmann can stand confinement in it as well as in reality without going mad or numb—an inferior kind of madness compared to that of facing, openeyed, the madness of reality.

Space is always a torture chamber for Beckmann, a place of confinement, a dungeon of thought, a symbol of somnambulist consciousness. For all the vigor and forthrightness of their givenness, objects do not seem to belong in Beckmann's space. They neither fit comfortably nor seem unequivocally given—truly immediate. Taken together, they have the cluttered look of ill-sorted souvenirs from a half-forgotten voyage to a foreign world. This is especially the case in Beckmann's still lives, but most of his work can be read, because of the "awkward" way it articulates its objects and figures—even the later work, in which surface facture is "impressionistically" self-evident and contributes to the awkwardness—in terms of the Northern realist tradition of still life in which the unity of things is not taken for granted but hard won, if not always desired—not seriously believed in. For such unity generalizes the thingness of the thing in such a way that the power of its details is lost or muted, softening the intense effect of concreteness and particularity which comes from emphatic detail. Beckmann recovers this sense of emphatic, disruptive detail, through his modern existential consciousness of the lack of at-homeness of things in the world they inhabit, almost as though they were dropped into the world unwillingly and came apart because of the pressure of its space, just by being overconcentrated in it. Thus, however superficially familiar they look, Beckmann's figures and objects reflect the malaise of the world-space they inhabit, which disturbs their presence. Indeed, a pathology of things emerges: their parts do not coordinate, and they have

an altogether discomforted look. They are, as it were, riddled with somatic symptoms.

Their confinement in space has made them strange ghosts of themselves—very real, very material ghosts, but nonetheless ghosts, that is, hallucinations, neither unequivocally fictional nor real. Their unreality, which is as powerful as their reality, is shown by the fact that they have no harmony within themselves. (They are as unintegrated as a group as they are as individuals.) Some objects dominate others, blare their presence at us, as in the *Large Still Life with Musical Instruments* (1936), while others seem merely colorful, *papier maché* mockups, theatrical props exhibited after the show is over—or rather as the "obscene" show. This aura of suppression of objects in space—something specifically modern (it makes its first serious appearance in Cubism, whose attitude toward objects in space can be related to that of Northern Realism)—reflects Beckmann's sense of his artistic mission, especially the tension implicit in realizing it: "The more strongly, deeply and burningly moved I am by our existence, the more resolutely my mouth is closed; my will is all the colder to grasp this horrible quivering monster Vitality and lock it up in sharp lines and planes, clear as glass—to repress it, to strangle it."[7] The tight space is the closed mouth, the cold grasp; the Vitality squirms in the objects, squirms to escape through the objects, to escape from them, to exist independently—impossibly. The object is determined to show the reality of its vitality—which is responsible for the reality of its existence—at the moment of its repression, the very moment of its death—the moment that will make it a ghost of itself, less than real because its vitality has been denied. But Beckmann is not simply talking about the problem of turning vital life into dead art. The difficulties of locking up life in art is itself a metaphor for the difficulties of living in the modern world. This strange (and estranging) tension between the stranglehold of "unreal" space and real objects struggling to preserve and articulate their vulgar vitality in it—this strange situation in which the reality of the objects is distorted to the point of being annihilated by the weird space they inhabit (the way the hero of Poe's story was driven closer to the pit of death by a pendulum whose every swing signalled a further stage in the limitation and finally closure of his living space)—constitutes the structure of Beckmann's World Theatre. It is clearly a borderline world that is created—a world more mad than reasonable, yet superficially reasonable in its make-up.

Beckmann's World Theatre is a self-system—the objective correlative of his self-portraits, their point writ large, as it were. The macrocosmic worldly scenes are obedient to the logic of the microcosmic self-portraits. It is a system in which every object is a self-object, in which eternally

narrow space represents the self forced back upon itself, its seemingly voluntary constriction, peculiarly perverse self-reliance, giving it an aura of determined togetherness—the almost deliberately cramped state it takes to preserve its sense of integrity, its nuclear, primal sense of itself. Beckmann's cramped World Theatre, his morbidly self-contained world, articulates an archaic sense of self—the primitive integral self struggling to maintain its integrity, contorting itself to preserve itself, as though a distorted, "theatrical" shape was better than no shape—than not exist-ing—at all. For that almost grotesque—rather than "wholesome"—shape seems the only shape that can be inhabited in the modern world, for it is the dominating shape, the shape of the madness that dominates it. Better to be abnormal than not to be at all, especially when one lives in a world in which it is no longer clear what it is to be normal.

Beckmann has a survivor's sense of self—a sense that the self is strange in itself and estranged from the world (the one state reflects the other), but is nonetheless powerfully present, undeniably the case. In general, in Beckmann's self-portraits there is an extraordinary sense of bluntness of being—a fiction of absolute, indissoluble, determined integ-rity, and of disturbed selfhood. It is a selfhood pushing against—even to passively resist in this situation is to push against—a pathological world, yet taking its shape, reflecting it. It is not clear if the world is inherently "diseased," a place where it is impossible to feel comfortable, or if the disturbance is in the self. It is clearly in the relationship the self has with the objects of the world—its discontent with them, which is reflected in the grotesquely constricting—distorting—space of the world they signify. One is tempted to regard Beckmann's space as a caricature of space, as if it reflects the absurd character of his relations with the objects that ex-ist in it. It is as though space itself mocks the possibility of any harmonious relationship with anything. But it does not matter whether Beckmann's sense of space is a projection of his self onto the world, or the intrusion of the horrifically real world into the self. What matters is the overwhelm-ing sense of the monstrousness—the pathological form of endurance—of both world and self, and of their "necessity" and inseparability.

We know that Beckmann experienced the horrors of the world-historical, in the form of World War I and Hitler, and we know that his art was obsessed with catastrophe—world destruction—from the begin-ning, as such works as *Scene from the Destruction of Messina* (1909), *Battle of the Amazons* (1911), and *The Sinking of the Titanic* (1912) testify. Such early works as the *Large Death Scene* and *Small Death Scene* (both 1906) also show consciousness of personal catastrophe. (The squatting female figure, viewed from the back, naked in the *Large Death Scene*, reappears half-naked in *The Night* (1918–19), perhaps Beckmann's single most

famous scene of violence—a scene which fuses public and personal catastrophes, shows how the one always makes for the other.) We clearly cannot decide where to place the "blame" in Beckmann's pictures. Whether it is the self that is at fault for its own suffering, or the world that is the cause of it, there is a sense that both self and world are survivors in Beckmann, and, like all survivors, have a sense of the madness of reality as such—that is, the self does not completely believe in its own reality, nor in that of the world in which it survives (and which it knows will survive it, in whatever condition), nor does it think that the others who inhabit the world are completely real. At the least, the world is experienced as odd. For the self has, as it were, come back from the dead—by irrefutable sociohistorical logic it should be dead, destroyed by the world through the world's self-destructiveness. Yet this logic is refuted by the survival of the self and the world; both continue their vulgar, brutal, banal, stupid existence.

This survivor's "borderline" experience of reality, in which the real is experienced as unreal—this experience of reality as something that stands between oneself and nothingness, as a kind of porous borderline barely keeping oneself intact—can be called "psychotic realism." In Beckmann it is both a style—a mode of representation—and an attitude. It implies no cathartic identification with ugly reality, yet a subjectivization of it that makes clear how impossible it is to live with—how much it smells of death. Indeed, Beckmann's pictures are, indirectly, triumphs of death. Beckmann's works are about the insane, uncontrollable death-in-life and life-in-death—unreality-in-reality and reality-in-unreality—effect that accompanies survivors of disaster. In his case, disaster came in the form of a horrible history which shook him to his foundations. They remained firm, even uncracked, but continued to shake seismically, to register the shocks of history. These became the "objects" of his self—horrible objects to which he transferred his sense of self, and which confirmed its sense of being horrible, because a survivor of horrible history. Beckmann is trapped in a vicious circle, in which history and self embrace in a macabre dance of death.

But this is only part of the story, because once history had forced him back upon the primitive reality of himself, that self, on its own, discovers and forever after bases itself on the reality of its own inevitable death—which it defies with all its vitality, but which it must incorporate in itself, as, less paradoxically than it seems, a source of vitality, a resource of existence. Psychotic Realism, I want to contend—a Psychotic Realist representation of the world and state of selfhood—is the stylistic reflection of the deconstructive recognition that "the subject no longer can be conceived as a self-assured center of his opinions and perceptions," that

"he is always lost in the chain and the texture of signifiers," that he is "necessarily disseminated in the field of language"—has no center and is no center, however much "self-glorifying intentionality he may display."[8] Only instead of the field of language, that of history. Beckmann's self-portraits cannot be understood as self-glorifying displays of intentionality and selfhood—intentional selfhood—but rather as articulations of a psychotically realistic sense of self, just as his theatrical, seemingly overly dramatic representation of the world cannot be understood as an objective, socially realistic, if distorted, depiction of it, but an articulation of a "psychotic" sense of its reality. Both, I want to emphasize, follow from Beckmann's sense of survivorship, which informs all his art, from his earliest *Self-Portrait with Soap Bubbles* (ca. 1900). The survivor's sense of self and world is necessarily tinged with a sense of the unreality of their reality—a sense that they should be absent and dead when they are present and alive: a sense that they are both present and absent, alive and dead, at the same time. They are experienced as transient, dreamlike bubbles, about to burst any moment. Psychotic Realism shows us that our most ingrained sense of reality is always a bubble about to burst.

Beckmann's "sick" sense of reality correlates with his sense that this is not the best of all possible worlds. The "sick" dialectic, in which the world is seen psychotically—in which the sense of reality disintegrates, and with it a binding sense of self (the self "spends" itself in a fantasy of reality)—climaxes in Beckmann's allegorical paintings. These have been much discussed, the meanings of their different constituents extensively analyzed in terms of various myths and historical realities. I do not want to contest any of these interpretations, but to show their foundation: to argue that in fact allegory is a mode of psychotic articulation for Beckmann—a necesssary mode of articulation in the face of the threat of complete self-loss. (The threat may originate in the world or be due to a flaw in the structure of the self. In Beckmann, the flaw in the self is its historical origin in the world.) According to Heinz Kohut, there is, in the psychotic state, a "propensity toward the fragmentation of the self."[9] An allegorical representation of the self is a form of schizoid defense against fragmentation—what might be called borderline representation of the threatening world, inseparable from a sense of its fragmentation, that is, of its constituent objects and persons being emotionally separate if physically together. This is of course the condition commonly ascribed to Beckmann in his self-portraits with others, and of the different things in his pictures. (This characterization of allegory follows the idea that the schizoid state is a borderline state.) Kohut writes:

> The schizoid defensive organization is the result of a person's (pre)conscious awareness not only of his narcissistic vulnerability, but also, and specifically, of the danger that a narcissistic injury could initiate an uncontrollable regression which would pull him irreversibly beyond the stage of the nuclear, cohesive, narcissistic configurations. Such persons have thus learned to distance themselves from others in order to avoid the specific danger of exposing themselves to a narcissistic injury.[10]

Kohut emphasizes that the "distancing is simply an outgrowth of the correct assessment of . . . narcissistic vulnerability and regression propensity." The allegorical mode of representation is in effect a partially regressive mode—particularly in Beckmann's hands, where it becomes especially "fantastic"—that reflects narcissistic vulnerability, while at the same time establishing a distance from the objective world that threatens injury.

If we can say that allegory deals with what is already known (the allegorical representation presupposes the meanings it mediates) while Symbolism deals with what is unknown (the Symbolist representation is a kind of exploratory operation searching for suspected, secret meanings), then we can say that allegory uses a historically familiar or traditional language, while the language of Symbolism is less clear in structure and meaning—not so much a code as a loosely connected set of turbulent gestures. Every allegorical signifier presupposes congruence with a world-determined meaning—exists in a state of ready referentiality, as it were. Every Symbolist signifier is insecure in its referentiality; it is a relatively indeterminate subjective gesture on a kind of fishing trip for meaning—a bait around which unconscious meaning can crystallize, a catalyst which can make it manifest, if it exists, or shows the least signs of life. From the beginning Beckmann's paintings have been quasi-Symbolist—the effect of uncanniness generated by the askew perspective and scale distortions in a work like *The Synagogue* (1919) amounts almost to a provocation of the unconscious—and quasi-allegorical, as in *The Dream* (1921), where each figure seems to have a clearly assigned meaning derived from a social metaphysics. The landscapes—especially the seascapes—have been regarded as simultaneously allegorical and Symbolist, that is, a concretization of the meaning of freedom in terms of an escape to nature as the only truly open horizon in the lifeworld, and an attempt to use the terms of nature to push toward, uncertainly, the recognition and invariably incomplete articulation of a more than natural, if not self-evidently spiritual, freedom, that is, an elusive transcendental freedom. Beginning with what are generally regarded as Beckmann's explicitly allegorical paintings—*Temptation* (1936–37) is usually thought of as the first in the series, which can be expanded to include *Birth* (1937), *Death* (1938), *Birds' Hell* (1938), *Children of Twilight—Orcus* (1939), *The*

Soldier's Dream (1942) and many other works during Germany's fascist period—the Symbolist and allegorical modes fuse. The works are allegorical in that the psychotic meaning of the world—the fact that it is out of touch with the reality of being human, not only "indifferently" resisting the "truth" of being human but actively destructive of human individuality and society—is presupposed. That is, the madness of the world and the cruelty of the human condition in it are presupposed, and a psychotic articulation of both is assumed. But the works are also Symbolist, in that they explore the strong possibility of self-destructive narcissistic injury in the form of psychotic disintegration of the self's sense of reality—the very reality allegorically articulated by the pictures. (For Beckmann, it is not the case that to be human is to have an inherent sense of self, nor is it the case that the sense of reality is stable. Generally, a strong sense of self follows from being able to endure a strong dosage of reality.) The pictures simultaneously show the madness of reality and the disintegration of the self's sense of it—a disintegration which in fact accurately reflects its narcissistic injury by the world.

Apart from the obvious fantastic elements in these pictures, the actual madness of the world (reality) and the potential madness of the self (art) is most clearly reflected in Beckmann's treatment of the relationship of man and woman. This is a strong leitmotif throughout Beckmann's oeuvre, but it becomes particularly accented in the last allegorical paintings. To say that man and woman are irreconcilably at odds, or that Beckmann treats woman cruelly, is simplistic. This is pointed out especially with reference to *Temptation*, where woman is shown, reading from left to right panels, bound (adolescent), viciously seductive and latently monstrous (the love situation; the many-breasted monster that is the shadow double of the model reappears as the orchestrator of the torture of the man in *Birds' Hell*), and bestial (mocking motherhood; the woman suckles a dog, which can also be read ambivalently as her harboring a "viper"—traitor—in her breast). Also, woman is the heroine/victim of *Birth and Death*, and already potentially the victim in the earlier *Dream*. And, if we go even further back to *Woman's Bath* (1919), woman is cruelly rendered, shown as grotesquely vulgar. The real point within the dialectical struggle of opposites—a point already evident in the 1917 *Adam and Eve* (see also *Man and Woman* (1932))—is that woman represents a threat to man's integrity. This is not simply because she sexually tempts him— tempts him as it were with his own desire, making him aware of its strength, showing how it might dominate his life and become a source of narcissistic injury and self-loss by effecting a merger with woman from which he could never recover—but because she represents another point of view toward life that is absolutely alien to his own, which is premised

on a belief in triumphant, radical individuality. Man's guilt toward woman is only incidentally sexual in origin; his guilt is a way of distancing himself from a point of view which threatens to undermine his own—which implies indifference to his supposed uniqueness of being, based on his Promethean striving and Promethean resistance to the gods.

It has been pointed out that Beckmann often represents the gods, as in the central panel of *Blindman's Bluff* (1944–45), and depicts himself as unable to accept or participate in their barbaric splendor. It is too reminiscent of fascist indifference to humanity, if altogether different in origin and motive.[11] Beckmann's explicit defiance of the gods has already been mentioned; it is said to be something he shares with Rembrandt.[12] The theatricalization of both self and world is part of that defiance—its instrument and the punishment for it in one. (The self-contradictory, Kafka-esque double meaning—theatricalization of meaning—Beckmann typically communicates is essential to his general sense of the irony inherent in World Theater.) But the key point is that the Promethean Beckmann—his bluntness of being is a sign of Promethean defiance, even as it is also a sign of the anguished gnawing on self that comes from the defiance—can be undermined and diminished not only by the gods who represent fate, but by woman. Her fullsome presence implicitly undercuts and trivializes or at least mocks his own. She may be physically, and so presumably spiritually, smaller, less significant—Beckmann tends to retain the medieval convention of using size to represent inherent value and social status—than man, as in *Warrior and Birdwoman* (1939) and *Double Portrait, Max Beckmann and Quappi* (1941). But she is also much more complete and integral in her being, apparently inherently so—without any struggle to achieve or retain integration. It comes naturally to her, as such images as *Resting Woman with Carnations* (1940–42) and *Quappi in Blue in a Boat* (1926–50), suggest. She is immune to narcissistic injury. Her fullness of being is not simply a bodily manifestation, but an emotional state, a matter of attitude, qualitatively different from man's. She is indifferent to the heroic—to the defiant mode of being—and has no need of it to endure. She sidesteps, as it were, rather than confronts, as much as possible. She ignores the contest, the challenge—and gets away with it. Her passivity is a surer instrument of survival than Beckmann's active confrontation. Beckmann half despises, half envies woman's basic attitude, her ontological self-containment—which is what makes her ultimately desirable, whatever her physical charms. Beckmann's sense of the physical attractiveness—the sexual desirability—of woman is in conflict with his spiritual negation of her by his resistance to her approach to existence. This is articulated in his representation of woman as victim much more frequently than in his depiction of her as erotically desirable. (The

more erotically desirable she is—the more nakedly she is displayed—the more Beckmann tends to mutilate her body.) That is, Beckmann tends to represent woman in a psychotically realistic way—violates the reality of her being and attitude to life by violating her appearance. He tends to cripple her, as though to imply the crippled character of her attitude. It is too antithetical to all he represents for him to tolerate it, even though he may suspect it implies a better understanding of the secret of survival in a horrible world. But of course passivity did not help the Jews to survive. Nonetheless, Beckmann may suspect that woman is qualitatively superior to man in her attitude to life. Her being represents a greater respect for being as such than does man's.

Beckmann's psychotic allegorical style of representation, the style of schizoid defense against narcissistic injury, affects his handling—intervenes in it, not always with the best results. In the twenties, the surface of his pictures is somewhat smooth, as if to preserve the work in illustrative clarity, the way an insect is preserved in amber. In the thirties, the surface becomes chalky, as if Beckmann was trying to make it, rather than his subject matter—by this time somewhat overworked, tired even to him—the fresh center of interest. In the forties, continuing this trend, the surface becomes painterly, often in a virulent, strained way, as if the painterly dramatization of the surface could contribute to the allegorical dramatization of the subject matter. Schulz-Hoffmann has pointed out that "although Beckmann's paintings often suggest a visual directness, his style of painting does not allow for its fulfillment"[13]—for an authentic effect of immediacy. This is because Beckmann's psychotically realized sense of the world and self—his refusal of all self-deception about the mad character of both—makes the surface of his pictures insecure. The increase in painterliness is part of his Psychotic Realism—a way not of showing the fullness that comes of imperturbable integration of self and world, but of registering the disintegrative potential of both. The painterliness is a loss not a gain—signals the heightened sense of lost unity. It is part of the physiognomy of destruction rather than a constructive addition to the scene, binding its elements more strongly, and cementing our bond to them and it. As the scene becomes more allegorically distorted, the surface decompensates into crude painterliness. Its materiality is made more and more explicit—turgid. The new painterly density consciously creates and bespeaks the loss of a firm grasp on the reality depicted—which becomes more and more mad (allegorical).

It may also bespeak, in another typical Beckmann double meaning, unconscious defiance of the mad reality depicted. Consciously, Beckmann is aware of social and self disintegration; unconsciously, he defies them, which at least reintegrates the self, if not society, which remains

monstrous, mad. The dialectical mechanism that determines every detail of Beckmann's handling is the tension between societal disintegration or monstrousness and the self's insistence upon its integration—survival—in the face of societal madness. At the same time, it clearly incorporates— fails to escape from—this madness, which appears in certain grotesque nuances of the self portrayed, especially in its setting, the imprisoning solitary cell of the world. What makes Beckmann such an astonishingly integrated artist is that even the fractures within his stylistic and technical development bespeak his refinement of a consistently psychotic realistic relationship to and understanding of the lifeworld and self.

Notes

1. John E. Gedo, *Portraits of the Artist* (New York: The Guilford Press, 1983), p. 35.

2. Carla Schulz-Hoffmann, "Bars, Fetters, and Masks: The Problem of Constraint in the Work of Max Beckmann," *Max Beckmann—Retrospective* (Exhibition Catalogue; St. Louis and Munich: St. Louis Art Museum in association with Prestel Verlag, 1984), p. 20.

3. Quoted in ibid., p. 25.

4. Quoted in ibid., p. 18.

5. Ibid.

6. Ibid., p. 37.

7. Quoted in ibid., p. 28.

8. Jochen Schulte-Sasse, "Theory of Modernism versus Theory of the Avant-Garde," Foreword to Peter Bürger, *Theory of the Avant-Garde* (Minneapolis: University of Minnesota Press, 1984), p. xxi.

9. Heinz Kohut, *The Analysis of the Self* (New York: International Universities Press, 1971), p. 14.

10. Ibid., p. 12.

11. Schulz-Hoffmann, "Bars, Fetters, and Masks," p. 38.

12. Peter Eikemeier, "Beckmann and Rembrandt," *Max Beckmann—Retrospective* (Exhibition Catalogue; St. Louis and Munich, St. Louis Art Museum in association with Prestel Verlag, 1984), p. 127.

13. Carla Schulz-Hoffman, Catalogue Entry for *Girl Playing with Dogs*, 1933 (Exhibition Catalogue; St. Louis and Munich: St. Louis Art Museum in association with Prestel Verlag, 1984), p. 252.

Chaos in Expressionism

At one very special point in his novel *The Secret Agent*, Joseph Conrad described Stevie, the retarded adolescent son-in-law of Mr. Verloc, the secret agent, at work, "seated very good and quiet at a deal table, drawing circles, circles, circles; innumerable circles, concentric, eccentric; a coruscating whirl of circles that by their tangled multitude of repeated curves, uniformity of form, and confusion of intersecting lines suggested a rendering of cosmic chaos, the symbolism of a mad art attempting the inconceivable."[1] One can't help but think of the "degenerate" Stevie—who is later literally exploded by his mishandling of an anarchist bomb—as a very advanced abstract artist, on the order of the hero of Balzac's short story *Le Chef-d'oeuvre inconnu*, illustrated by Picasso in 1927. One etching, entitled *Painter with a Model Knitting* (Geiser 126), shows a realistically drawn painter creating a picture of a realistically drawn model in a highly abstract—one might say Expressionistically abstract—manner. The artist in the Balzac story spends—"wastes"—his mature career trying to capture the likeness of a model—who in the Picasso etching is a rather motherly looking figure—but never does, creating only a chaos of lines and shapes. He refuses to show the picture to his colleagues, who after his death find the unsuccessful mess, successful only in its novelty. Picasso may, in fact, be metaphorically describing the intention behind the creation of Cubism, the artistically original results being in fact a psychological failure to capture the living likeness of an intimate subject matter, a significant other. As indicated by the portraits that are customarily regarded as the height of Analytic Cubism, the figure collapses into an aesthetically interesting but psychologically disturbing chaos, or rather, never really emerges from chaos. We might even say that the Analytic Cubist portraits are constituted by chaos. And we might note that an extraordinary amount of modern art is covertly as well as overtly, theoretically as well

This article originally appeared in *Psychoanalytic Perspectives on Art, Volume 1*, ed. by Mary M. Gedo (Hillsdale, N.J.: Analytic Press, 1985).

as in practice, concerned with and tantalized by chaos, often in the form of an interest in chance or "gesture," sometimes more loosely in the form of an obsession with force or the formless.

Nowhere is this temptation by chaos—coincident with a recognition of its inescapability, both as a starting point for the creative process and as, less expectedly (except unconsciously), its terminal "form"—more in evidence than in the German Expressionist art produced in the first two decades of this century, i.e., in the chaotic years of its beginning. Harold Rosenberg has argued that during these two decades, particularly during the pre-World War I decade, all the ingredients of the Modern manner came into being. By 1914 the "formal repertory" of avant-garde was "in full bloom"; what remained was the "working-out of the variations."[2] Describing the sensibility—the "renovated attitude"—of the avant-garde in this formative period, Rosenberg noted the emphasis on "the quality of ephemeralness," on the way "three-dimensional substance gives way to images cast upon the screen of time," and the avant-gardist sense that "what seems to the ordinary mind solid fact is . . . infiltrated with process."[3] Rosenberg noted:

> Modern art oscillates between the two poles of omnipotent identity and the selfless eye and brain. At the extremes, the enhancement of self and the elimination of self converge: "Expressionism" becomes abstract and impersonal, constructed art becomes "Expressionist." Speaking of the poet Mayakovsky, Trotsky said that his megalomania was so complete he became objective. Cézanne paints to "develop his personality," and his paintings become in time an impersonal filter of space.[4]

In both Mayakovsky and Cézanne there is a kind of crystallized lack of cohesion, an almost "institutionalized" fragmentation: the impersonal, the selfless, is used to create what has been called a "holding environment"[5] for the personally realized chaos of the awkwardly "affinitized" elements of the modern poem or picture. The "Expressionism" comes in not subjectively but as objectively recognizable: it is not a matter of the artist's making public his introspective report of his feelings, his private fantasies about a desirable or undesirable reality—although the libidinous aspect of the work's appearance, the way it is "charged" by its fragmentation can be read as that—but of the observed difficulty of containing the elements of the picture or poem. The fragments become almost free-floating, increasingly "arbitrary" factors, wild cards in a game whose rules always seem about to change. The aura of freedom generated by their uncertainty of relationship is articulated in an energy that seems perpetually to be on the verge of bursting the boundaries of the work, totally disintegrating it.

This tendency towards the formless, towards chaos, is what might be called "the Expressionist moment." It occurs and recurs in the best modern art, whatever its outward style, and it can be understood in narcissistic terms—as a disturbance in the narcissistic self-regulation of the work, in its sense of its fundamental identity. This is what makes it truly "Modern," i.e., inwardly "relative"—entirely a matter of relations in which no clear hierarchy of aims can be established, no clearly determined priorities of aim exist. This is what creates the aura of "freshness, sketchiness, and ambiguity"—the sense of "bodylessness" and the effect of devaluation of the individual—that Rosenberg regarded as characteristic of essentially modern art.[6] It is inevitable that "individuality"—including the presumably radically unique individuality of the modern work of art— seem unimportant when the narcissism that is the necessary substructure of individuation cannot be sustained and appears permanently wounded. The "differentiations," interpreted as signs of individuality, which one sees in modern works of art are in fact the signs of an unsecured narcissism, a fundamental insecurity and uncertainty of value—of self-value—that reduces all the endlessly secondary elaborations which make up the work—so endless that one cannot determine what is "primary" about it—to one simple meaning: the work's difficulty in identifying itself, in articulating its own aims.

The common modern assertion that the artist does not so much finish a picture as abandon it and that the spectator "completes" it by his interpretation of its meaning to him—an interpretation that gives it its authentic, full presence—takes on a new meaning in the light of this narcissistic problem. Incompleteness, "interpretability" as completeness, are further signs of the chaotic situation of the work, indications of how its borderline internal chaos or lack of cohesiveness makes itself manifest in its relationship to the world for which it is made. Latent internal chaos becomes manifest external chaos, showing itself in extreme public uncertainty about the modern work's meaning and value, and its trying to borrow a meaningful and valuable identity from the critical viewers who are willing to "trust" it. Indeed, the potentially chaotic modern work necessarily must generate viewer identification with it—a partisan advocacy of it. For that is the only way that it can escape what seems inevitable: accusations alternately of profound obscurity and self-evident triviality, met by its own grandiose, exaggerated claims of transcendent clarity and heroic significance. Baudelaire's insistence upon a passionate, partisan criticism is necessary in the modern, uncertain situation—the "Expressionist" situation—and is matched by the missionary, indeed messianic, attitudes of such important early modern masters as Kandinsky,

Malevich, and Mondrian—masters painting, in the Balzacian sense, then "unknown" works of art, strange, new masterpieces in terms of a new sense of mastery, namely, mastery of chaos. Practical partisanship and the self-partisanship evident in the theoretical writings of the first truly modern artists create an artificial narcissism—on the model of Baudelaire's conception of the work of art as an "artificial existence"—that masks the narcissistic disturbances evident in their work, that puts the best public face on an inner fear of the possible facelessness—threat of loss of face— of their art.

Expressionism proper has always been associated with chaos, whether the work of art is understood as uncertainly emerging out of primal chaos, or equally anxiously, depicting and threatening literally to become chaos. Kandinsky's consciousness of his own work, for example, stated in his typical religion-derived, inflated language—whose grandiosity masks enormous anxiety—views it as arising "like the Cosmos, through catastrophes which end by creating a symphony, called the music of the spheres, out of the chaotic blaring of the instruments."[7] The sense that this "cosmos" is in fact "a spectacle of complete chaos," an " 'explosive' chaos" which might actually "detonate,"[8] is convincingly argued by critics of Kokoschka. The critic Paul Kornfeld asserted, in a remark that will be generally relevant to our psychoanalytic understanding of this Expressionist chaos—an ambivalent sense of foreordained, temporarily remote chaos (the sense that both are "expected" is crucial to an understanding of the unconscious factors involved in this free-floating sense of chaos)— that in both his paintings and plays Kokoschka "confronts the chaos of the world as though he were the first man, and invents technique and form ingenuously, as though he were the first artist. The people of his dramas are as huge and simple as the colossus of a mountain, and as natural as a landscape."[9]

Repeatedly these dramas of conflict—usually sexual, but that has been interpreted as metaphorical for a fundamental split in the self—end in chaos[10], reflect "cataclysm and discord," reveal "an overturned world," exploit "chaotic elements" (which is why they were the first plays produced by the Dadaists), and have been astutely called, by the critic Bernhard Diebold, "screaming images," in which "the word has become an accessory; screams, spectacle, and images predominate. . . . Archetypal figures do not converse in lucid discourse" but in "sentence fragments, exclamations, and screams,"[11] i.e., in an infantile way, as if they were just learning language. Only in Expressionistic drama and painting— painted drama—they are unlearning it, enacting this unlearning, with its consequent return to a primitive, "first," infantile state of selfhood. This return masks a revelation of what was always the case in the "inner self,"

which Kokoschka talked about, a self that had the prophetic "second sight" which in fact was an intense awareness of the ever-present threat of death.[12] In sum, the authentically Expressionist work was organized chaos, art carried to the brink of chaos—art at once as a means of tearing away the social mask that hid the "obsessions" of the unhappy self, and of revealing them, revealing especially the unhappy self's obsession with its own feeling of being fragmented, incomplete, finally of being deeply split or narcissistically unreconciled to itself.

The major component in the Expressionist sense of chaos—or chaotic selfhood—seems to be a sense of impending doom, a catastrophe. The previously given Kandinsky quotation speaks of transcendence through catastrophe, as if it was inseparable from the creative process—as if the famous "accidental gestures" of his paintings (to which the name "Abstract Expressionism" was first applied) were in fact all along expected, inevitable. The sense of the apocalyptic—of the apocalyptic as the revelation of the chaotic—as the essence of the Expressionist moment is explicit in the Conrad quotation about Stevie's "rendering of cosmic chaos" with the circles symbolic of cosmic order, even of its necessity. This turning to negative use of shapes that are intended positively—the creating of an effect opposite from the "positively" intended effect—is typically Expressionist. Conrad almost seems to be describing, as if they were abstractions rather than naturalistic descriptions, Leonardo's late drawings of the deluge, with the abstract swirls of rapidly curving line having very material effect. Expressionism also showed nature torn apart "from top to bottom," as W. Michel said,[13] and such horrific man-made events as war were experienced as natural catastrophes. As Otto Conzelmann noted, Otto Dix experienced World War I as "a ruthless, unfeeling outburst of Nature, beyond good and evil: like a tidal wave or a typhoon—a shock that sent a shudder through the earth, down to its foundations."[14]

This sense of catastrophe—as the instrument of chaos—made itself felt in the execution of Expressionist art, came to determine—to underlie— the most original, exciting aspects of execution. Execution itself became chaotic, attempted to be catastrophic—subjected raw material to a "catastrophic" technique to bring out the "chaos" in the matter itself. As has been pointed out, Gauguin's precept about the fundamentality of catastrophic crudity—handling that went to the brink of chaos—became de rigueur for Expressionist artists. "Don't polish too much, the subsequent hunting out of endless refinements only impairs the first draft; that is the way to let the incandescent lava grow cold, to petrify your foaming blood."[15] Munch, for example, used, in the words of Gustav Schiefler, "rough pinewood slats from packing-cases, working on them with a

coarse knife and utilizing the grain and the saw-marks as welcome texture of the background."[16] Similarly, Kokoschka, who thought of Expressionism as "the forming of experience,"[17] also sought a raw, dissonant effect, painting his famous "early 'black portraits,' as he himself called them, . . . 'with the scalpel,' in an attempt to liberate the inner self from the encumbrance of the fleshly surface."[18] Henry I. Schvey introduced his discussion of Kokoschka's violent or catastrophic—catastrophe-creating as well as violent in itself—technique with a generally pertinent epigraph from William Blake's *The Marriage of Heaven and Hell:* "this I shall do by printing in the infernal method, by corrosives, which in Hell are salutary and medicinal, melting apparent surfaces away, and displaying the infinite which was hid."

Kokoschka wrote: "Seeing a Polynesian mask with its incised tattooing, I understood at once, because I could feel my own facial nerves reacting to cold and hunger in the same way."[19] Corrosive, violent technique is used to get at the nerves, to create the nerves of the image, to make it all nerves, and became central to Kokoschka's "interior portraiture," especially to his polychrome clay bust *Self-Portrait as Warrior* (1908), executed when he was 21 but depicting a much older man: "The face is distorted with bumps and hollows and the mouth is agape with an impassioned cry similar to the faces of the actors in his first play. With its sunken eyes, blue-veined cheeks, and hostile yet terrified expression, it conveys the same mixture of confusion, fear, and brutality as the Man (also a "Warrior") in *Murderer Hope of Women.*"[20] The self-portrait is an archetypal image of the corroded, chaotic, fragmenting self, revealed in a process of disintegration that is beyond any simplistic concept of the protean self, of the metamorphosis of possibilities in the name of the infinite self. Experience of inward chaos stands behind the romantically pleasurable sense of the self's infinite possibilities, endless ability to aim or direct itself. The chaotic self is the aimless narcissistic self that has even given up searching for a double to heal it by mirroring it. It is self whose despair has made it chaotic, and seemingly beyond remediation, i.e., unable to remediate itself in the world through an alter ego. It no longer even wants a mirror, for it does not want to see itself. A reflection can only make it more chaotic, and would finally destroy it.

To understand psychoanalytically this chaotic self and the catastrophic world in which it is mirrored—and I think the psychoanalytic mode of understanding is the only one adequate to this art about inadequacy—is to read it symptomatically in terms of the conception of the narcissistically disturbed self developed in the last decade and a half. The fragmentation inherent to the Expressionist work of art—a fragmentation that disrupts landscapes and bodies, and which Expressionist-oriented artists

as different as Max Beckmann and Ludwig Meidner regarded as self-evident in the chaotic modern city[21]—is symptomatic (and symptoms are symbols) of a dissociational process. This process is itself indicative of discontent with civilization or socialization and, simultaneously with—dialectically reflective of—the well-known Expressionist discontent with repression, a sign of the failure of the self to cohere in the face of an unwelcome reality. This reality is first and foremost the reality of language, for it is language on which free if formless consciousness is crucified, taught to conform by becoming communicative.

Expressionist dissociation shows itself in the malaise of space in the visual works, a malaise that is constituted, paradoxically, by the asides—even extended digressions—of energy, the so-called lines of force, which are "released" by the self's lack of cohesion, or rather, are signs of the self's attempt to cohere, to force itself to cohere. The aura effect they create, leading to an effect of grandiosity—the so-called archaic grandiosity of the narcissistic self[22]—is in fact not that at all. That is, where the conventional aura connotes positive presence, the Expressionist unconventional, negative aura connotes absence—the absence of a solid self, of a self that has gotten itself "together." A work like Kandinsky's *Painting with White Border* (May 1913) is a demonstration not of a possible new coherence, but of the impossibility of any kind of cohesiveness—any kind of unified perspective or rationalizable, controlled set of relationships between discrepant parts of a scene. It is, as it were, a kind of "primal scene" of selfhood that is represented, or rather, more precisely, a picture of the impossibility of representation of a self that does not exist coherently and cogently. This Abstract Expressionist's renunciation of representation—that famous move towards nonobjective art—is really not a renunciation but a failure to achieve a new kind of representation, representation of the self not the world.

To renounce conventional representation is for the artist to renounce the conventional world that seems to hold together and claims to be the mirror of a self that holds together—a self which, like the original Democritan atom, was thought to be indivisible, a fundamental unit of psychological being. This renunciation is to deny this false, distorting mirror, this mirror that lies about the state of the (modern) self, and to begin a kind of infinite regress to the primitive state of the broken or wounded self, the fundamentally hurt, unstable, incoherent, uncertain self. It is to begin a regressive search for a new mode of representation—which is what abstract art at its best (i.e., not as pure style) is. It is a mode in which the true state of the self can be mirrored without being told to cohere. It is a mode in which primal chaos can be represented—disunity asserted as fundamental—without becoming absolute. It is a mode of

representation in which catastrophic chaos can be "tasted," can momentarily take possession of one—the source of the sense of spontaneity epidemic in Expressionist art—to remind one of the true state of one's self, but not falsely insist that one get oneself together, and be reflected in the mirror of the world which pretends that one is the fairest—the most together—of them all.

The Expressionist picture is a representation of a dedifferentiating process, in which centrality becomes so derealized as to become inconceivable, which is a state perhaps not unlike, in John E. Gedo's words, "some analogue of the 'oceanic feelings' reported by mystics and other adults able to experience profound regressive states without personal disruption."[23] In this pictorial infantile state of self-formation there is no sense of personal disruption in the modern critical viewer because it represents perfectly his own sense of his fragmented, incoherent self, an objectification of it which helps him to accept it. This representation has narcissistic value to him; one might even speak of it as a substitute narcissistic gratification. That is, if one cannot become a whole self, with just and proper self-esteem, one can have the pleasure of seeing one's incoherent, chaotic self symbolically represented. Standard representation is a defense against this Expressionistic representation, tending towards abstraction, of the fundamentally incoherent, self-alienated self, the self with no ideological anchors or absolute beliefs to give it stable form. "Chaos" means the destruction—deconstruction—of the traditional mode of representation, which implies that the world mirrors the self to its satisfaction, and the construction of a modern mode of representation to articulate the modern, "groundless" state of the self. "Chaos" means the loss of trust in and disruption of finite appearances to reveal the aura of infinity—an effect of the energy—that is released by the "inconclusive," narcissistically dissatisfied self. It is forever in a Faustian search for a mirror image it is bound to debase because such an image is finite, unless, like Eurydice, it disappears by itself into the nothingness which the regressive turn to the underworld of chaos heralds and masks.

As has been noted, Kokoschka's plays have been called "screaming images," images in which both the verbal and the visual are at their most elemental. The scream is a direct, simple, basic expression, an ingenuous mode of articulation, a pure verbal presence that is fraught with indeterminate meaning. It is dramatic and natural, as Paul Kornfeld suggested in his analysis of Kokoschka's plays and paintings. It is the "language" of the "first man," or rather, the prelinguistic articulation of "first feelings," of archetypal experience, not only of the world but of the self. It is a sign of the self's elemental experience of itself, its numinous terror at its own being. More particularly, I want to contend that the Expressionist cry is the self's recognition of its own chaos, an act of recognition

which is at the same time purgative. The cry is the chaotic self's self-recognition and simultaneously self-cathartic, a way of alienating itself from itself by recognizing its own monstrous character. At the same time, the cry is the abstract, authentic representation of the chaotic self. The cry shatters the mirror of the world in which this chaotic self is falsely represented as finite, cohesive, contained within boundaries not of its own making. The chaotic self's only defense is to declare its infinity—its infinite energy. Thus, the cry is a narcissistic act, the self-image—self-assertion—of what Heinz Kohut has described as "the crumbling, decomposing, fragmenting, enfeebled self" of the child in "the fragile, vulnerable, empty self of the adult"; more precisely, of the artist about to be adult, struggling to understand what it means to be adult, mature. In a peculiar way, the cry is the archaic self at its most grandiose, the most grandiose expression of wounded narcissism. In its chaos there is a strange cohesion, so that it is the archaic self's self-transcendence, as well as a strange tragic quality, which involves an inability to believe in the ideal, a disavowal of ambition in the face of the actual. The self is thus frozen in its own archaic character, permanently frustrated. The cry is the archaic self's expression of frustration at its inability to idealize, which means to accept its social condition—its "derivation" from the ideals of society, which alone "fill" it, give it the "final force" Paul Klee thought art lacked when it did not have "the people" (*Volk*) behind it. The cry shows that the self cannot even postulate a hierarchy of goals, for it refuses any single "principle" of self-organization.

The cry has been a major subject matter—as well as form—of Expressionist art, and has always been understood by Expressionists as the beginning of art, and even its end, i.e., the expression of the cry is its only, or at least major, goal. Thus Kokoschka, in his essay on Munch, "defines two attributes of Expressionist art: its visionary quality, 'a single moment appearing in the guise of eternity,' and its intensity, 'a silence broken by a cry.' The 'cry' alludes to Munch's masterpiece *The Scream* (1893), but a cry is also characteristic of Expressionist drama—from Kokoschka's own *Murderer, Hope of Women* to Reinhard Goering's *Naval Battle* (1917), both of which begin with an anguished cry."[24] The two aspects of Expressionism are really one: the cry is "the single moment," "the guise of eternity" being its simplicity and directness. The cry is the eternal moment in the silent graveyard of time, the unconscious moment breaking the surface of complacent consciousness. The cry represents what is really unchanging, fundamental: the sense of self that narcissistically defies what it regards as the oblivion of assimilation, for it correctly sees time and consciousness as the enemies of its feeling of omnipotence. The cry is the self-consciousness of this archaic self that denies the world.

Barnett Newman, in a certain sense the last of the great Abstract Expressionists, has written that: "Man's first expression, like his first dream, was an aesthetic one. Speech was a poetic outcry rather than a demand for communication. Original man, shouting his consonants, did so in yells of awe and anger at his tragic state, at his own self-awareness, and at his own helplessness before the void."[25] Newman noted that "the aesthetic act always precedes the social one," and that the aesthetic act which the poetic outcry is indicates that "language is an animal power." "The human in language is literature, not communication. Man's first cry was a song. Man's first address to a neighbor was a cry of power and solemn weakness, not a request for a drink of water." Newman was describing the aesthetic act of the "tragic self" as Kohut has understood it,[26] the cry being the archaic aesthetic act of the narcissistically disturbed self, or rather, the primal self which experiences its own narcissism as a disturbance. For primitive narcissism involves the self's search for its image—its attempt to complete itself by representing or reflecting itself—in a world which withholds it, or rather, which imprints it with its own image. Thus the self experiences "helplessness before the void," "solemn weakness," ambiguously mingled with its own "cry of power" and "anger" at its own "tragic state." Newman's famous painted "zip" is a cry—at once an angry assertion of primordial power and a tattered expression of weakness and helplessness in the void of the painting's infinite field.

What Expressionist artists from Kokoschka to Newman make clear is that what psychoanalysts regard as "narcissistic injury" and "narcissistic vulnerability and regression propensity,"[27] is not a pathological condition, but a "normal" phase of self-formation, in fact, the elementary form of the self, as it were. The tension between chaos and cohesion—the anguish of the experience of chaos, with its feelings of hurt and helplessness, vulnerability and threatening void (the nothingness of "death" that is prebirth, precreation, precreativity), and the reluctance to accept cohesion, which for all its gains (social, communicative) is experienced as loss of the "aesthetic" (and so living death)—is an essential part of existence, as much as the cry is inseparable from the infant. That the Expressionist artist clings to it, insists upon his screamed images—his dream outcry and his outcry of the dream of himself—is not a symptom of his pathology, but of the depth of his experience of being, and of being a self, with all its dialectical tension with the real world, which does not "represent" it properly.

It is the recognition, most of all, that the cry that is the symbolic, most grandiose form of the archaic self—which issues as if in a dream, and

is its dream of itself—is an ambiguous statement of autonomy, a recognition of its absurdity. For the autonomy of the self which the cry asserts shows it to be vulnerable in the world, to be appropriable by the world, while at the same time shows it to be a defiant, undialectical assertion of its absoluteness, and the absoluteness of its experience of itself. Expressionism articulates the discontented autonomy of the uncivilized yet no longer self-possessed self, the self that, like a kind of Burden's ass, is paralyzed and trapped between nature and society. Nonetheless, whether it is form or symptom, the Expressionist artist takes narcissistic pride in his chaos. His exhibitionistic grandiosity is his chaos made manifest as a narcissistic end in itself.

Notes

1. Joseph Conrad, *The Secret Agent* (Garden City, N.Y.: Doubleday & Co., 1951; Doubleday-Anchor Books), p. 39.

2. Harold Rosenberg, *Discovering the Present* (Chicago: University of Chicago Press, 1973), p. 77.

3. Ibid.

4. Ibid., p. 75.

5. John E. Gedo, *Beyond Interpretation* (New York: International Universities Press, 1979), p. 5.

6. Rosenberg, *Discovering the Present*, p. 77.

7. K. Sotriffer, *Expressionism and Fauvism* (New York: McGraw-Hill, 1972), p. 14.

8. H. I. Schvey, *Oscar Kokoschka, the Painter as Playwright* (Detroit: Wayne State University Press, 1982), p. 7.

9. Ibid.

10. Ibid.

11. Ibid.

12. Ibid.

13. Sotriffer, *Expressionism and Fauvism*, p. 14.

14. Ibid., p. 16.

15. Ibid., pp. 17–18.

16. Ibid., p. 18.

17. Schvey, *Oscar Kokoschka*, p. 23.

18. Ibid., p. 26.

19. Ibid., p. 17.









Chaos in Expressionism

20. Ibid., pp. 42–43.

21. Sotriffer, *Expressionism and Fauvism*, p. 14.

22. Heinz Kohut, *The Analysis of the Self* (New York: International Universities Press, 1971), p. 114.

23. Gedo, *Beyond Interpretation*, p. 118.

24. Schvey, *Oscar Kokoschka*, p. 23.

25. H. B. Chipp, ed., *Theories of Modern Art* (Berkeley: University of California Press, 1968), p. 551.

26. Heinz Kohut, *The Restoration of the Self* (New York: International Universities Press, 1977), p. 286.

27. Kohut, *Analysis*, p. 12.

Diagnostic Malpractice:
The Nazis on Modern Art

In 1937, at a time when Modern art seemed to have proven itself to the public at large—to have conquered a number of minds, if not won many hearts—the Nazis, in a notorious exhibition in Munich, labeled it *"entartete Kunst,"* "degenerate art." The term has been understood as typically vicious, insulting, and self-evident; to call art "degenerate" is a smear, not a revelation. Indeed, with the *"Entartete Kunst"* exhibition, Modern art was not only relegated once again to a ghetto of consciousness, but became the victim of a pogrom. Suppose, however, that behind this miserable, nightmarish concept the Nazis were horrified by even more than they suspected lurked in Modern art. Suppose the issue of degeneracy in fact haunts the reception of all of Modernism. Suppose, suppose, suppose—suppose that it is time to reopen the Nazis' concept of Modern art's degeneracy, which in general has become a kind of closed mine of understanding.

The very title *"Entartete Kunst,"* the critic Georg Bussmann has written, "has untranslatable racial connotations."[1] A whole section of the show was devoted to "the endless supply of Jewish trash,"[2] when not Jewish, trashy Modern art was "cosmopolitan or Bolshevist."[3] Such slander, reiterated endlessly in a kind of dumb yet menacing refrain, has been analyzed in terms of Nazi racial prejudice and paranoia, which of course it is. The Nazis themselves are understandable as degenerate in their virulent anti-Semitism, anti-intellectualism, authoritarianism. Yet the fact is that however inflammatory and misguided the language in which it was couched, their conception of Modern art as degenerate was shared at the time in circles well beyond the Nazi party. One visitor to *"Entartete Kunst,"* Paul Ortwin Rave, wrote, "Day after day people would come in droves to visit the exhibition, and it is no use trying to console

This article originally appeared in *Artforum* (November 1986).

oneself with the thought that a few of them may have come to take their final leave of works that they loved. There can be no doubt that at the time the aim of the propaganda, which was to deal a death blow to genuine modern art, was in large measure achieved."[4] Commenting on this, Bussmann adds, "Thousands of visitors, most of whom had come of their own free will, thronged past the pictures every day and found it a stimulating—and obviously meaningful—experience to share in the collective indignation, disgust and contempt."[5] *"Entartete Kunst"* was seen by 2,009,899 people in Munich alone, and it later traveled to Berlin, Leipzig, Düsseldorf, Hamburg, and elsewhere; clearly, it was a "critical" moment in the reception of Modern art. It remains the largest state-sponsored group exhibition of Modern art ever held. Today some of us think it an issue of the past, or of the philistine, to speak of Modern art as degenerate, yet the "useful myth" of degenerate art is not exclusively a weird Nazi anomaly, but an issue generic to bourgeois society. Its broad social distribution in Western society of the thirties makes it more than the response of a small group of ideologues.

The question is, what did the bourgeois—and the Nazis—fear in Modern art? Why did it make both of them so anxious that they angrily tried to destroy it? (In Hitler's Germany, to label it "Jewish" was to destine it for destruction.) In however grotesque form, the *"Entartete Kunst"* exhibition was a reaction to something real about the qualities of Modern art, something that made the Nazis want to liquidate it as a threat to the health of the community. And while some in the crowds of visitors may have been willing dupes of Nazi propaganda, or simply conformists who did not understand the weight of the concept of degeneracy, or the consequences of the Nazis' act of labeling, one wonders whether their iconoclasm was simply a form of submission, or whether it reflected their own deliberate will as much as it did the Nazi government's. Were they and the Nazis trying to repress what came to consciousness through Modern art—something unconscious they could only label "degenerate" or "Jewish" because they could not dare or bear to comprehend it, because to save face they had to declare it "other," had to deface it with their slogans?

This anti-exhibition was meant to be a mass grave, to be covered over after the public had viewed its contents, but it turned out to have a strange vitality to it, which the public themselves recognized in their indignant descriptions of the art it contained. They were angry about the set of social symptoms that the art seemed to reflect. This raises a general question which makes the exhibition all the more "critical." The Nazis assumed that the art was symptomatic rather than therapeutic. Clearly, they understood an important aspect of Modern art, but not its full subtlety.

They could not imagine that the description of Modern life the art offered was more than descriptive in import. They could not see that the energy of Modern art was a vital struggle for a way *out* of a social pathology as well as an intricate expression of it, a thread through a labyrinth as well as the labyrinth itself. To see and accept this intense inner dialectic would have made them question their own social rigidity, their own demand for social uniformity, their own ultimately destructive—and self-destructive—insistence on social purity. They missed—refused—the doubleness of art, the "duplicity" that makes it uncanny. Just as they wanted society to be only one way—monolithic, one-dimensional—they read Modern art in only one way, as an insane warp of social reality.

The Nazis' treatment of Modern art as a pathological symptom raises an important question as to the power and effect of art. Do people go to exhibitions to gawk at it, as at a freak show, as seemed to be at least partly the case at the *"Entartete Kunst"* exhibition, or do they expect to be shown what is usually not shown, what is ordinarily secret? Was Modern art, in both its manifest and its latent content, too traumatic for them to face without the strong defenses of their labels? Is it possible that the appearance of the art in such massive amounts in *"Entartete Kunst"* was potentially so powerful that it had to be downgraded to protect everyone from its "influence," its "suggestiveness," its "hypnotic" power? Was the root of the horror the fact that one was drawn to it against one's will, as to a mirror—fascinated by it, as by a self-portrait? *"Entartete Kunst"* was ambitious, like today's blockbuster exhibitions. Unlike the majority of these, it tried—apparently successfully—to persuade the public to reject rather than accept the art it exhibited. It made a case against rather than for the art. Yet just as Savonarola's ceremonial cremation of Renaissance works of art "took on the character of a politico-religious *Gesamtkunstwerk,"* Bussmann writes, "so the performance which was put on in the name of 'Degenerate Art' resulted in a twofold [paradoxical] 'triumph' of art: first, the products of modern art had rarely been taken so seriously, and secondly, the mode of presentation ensured that they were viewed in a highly charged politico-aesthetic ambience."[6]

Reconsideration of the *"Entartete Kunst"* exhibition is useful in that it can restore a sense of Modern art's effect in its early years, and of its inherently traumatic character. The exhibition put art on the defensive, scrutinized it with a rare intensity, forced it to show itself in all its radicality. (It is interesting to note that the professional art world tended to avoid the idea of Modern art's degeneracy, for, at the least, it implied that the in-house categories by which art professionals understood art were trivial and naive from a larger cultural perspective of social emergency, and at the worst it made professional sympathy toward Modern art seem in-

sidious advocacy of a threat to society's health.) The reminder that Modern art suffered such cruel punishment comes as a welcome though painful memory in today's cloying promotional atmosphere, or in the white-washed institutional approach, both of them contexts in which the original revolutionary character of Modern art has been increasingly understood in terms of a whirl of surface styles, or of purely esthetic, formal import. The understanding of Modern art as degenerate is hardly promotional, and establishes a perspective on it very different from the consumerist issues haunting so much contemporary critical discourse.

At issue in the Nazis' attack on Modern art was a sense of the "method" in the art's "madness." They read the formal innovations of Modernism—revolutionary changes in the language of art—as cultural signifiers. We might call the Nazi approach to art "anti-formalist," for it understood forms not as ends in themselves but physiognomically, as "motivated" by the zeitgeist. That is, the Nazis read form as content, and took seriously Modern art's claim to radicality. The art was a threat not because it offered a novel version of the castrated pleasure called the esthetic, but because it revealed the profound inner reality of modern life. For the Nazis, Modern art was degenerate because it communicated un-wholesome suggestions about the modern world. They persecuted Modern art as the bearer of bad news; in a familiar kind of magical think-ing, they thought that they could eliminate the disease by eliminating one of its symptoms. They had the sharpness to recognize that Modern art was not simply a tricky "language game" in an esthetic blind alley. In reacting aggressively to it, they implicitly acknowledged its message.

It is worth noting that the formalist approach to art, epitomized by the writings of Clement Greenberg, may unconsciously be an attempt to protect art from political, psychosocial, or cultural interpretation, for such interpretation makes art vulnerable to the kind of censorship represented by the *"Entartete Kunst"* exhibition. If art is understood only in formal terms, it can never be the bearer of bad news, and punished for it. It's just "bad" or "good" esthetically, not morally or socially. From a formalist point of view, external content is extraneous to art; the for-malist cannot admit that a relationship, implied or directly asserted, to the extraartistic might be the core of art, its basic substance, responsible even for its stylistic organization. In contrast, the Nazis saw just how in-wardly interested in the modern condition Modern art was. They regarded its formal novelty as a direct manifestation of that interest—one of the (to them) rotten fruits of its deep relationship to and understanding of the modern world.

In attempting what they saw as a regeneration of German society—a social policy of purification—the Nazis felt they had to eradicate Modern

art as a representative threat to them. As Sander L. Gilman writes, "The Nazis took the equation of artist = mad = Jew as a program of action."[7] What he does not say is just what the point of the equation was, apart from its synergistic concatenation of stereotypes. The destruction of Modern art was perhaps the magical touchstone of the Nazi authoritarian revolution, a kind of second book-burning, more conspicuous than that of 1933—a dress rehearsal, on a grand national scale, of liquidation, and the model for all future liquidations. After the Nazis had turned the corner with an exhibition of "degenerate art," their liquidation of human "degenerates"—Jews, gypsies, homosexuals, the mentally retarded, Slavs—could proceed at a faster pace. The generalization they made about widely different kinds of Modern art prepared the way for generalizations about widely different kinds of human beings. "*Entartete Kunst*" was a diagnostic exhibition with a built-in "cure." It meant to make visible, in the symbolic body of art, the invisible cancer of degeneracy that all the human degenerates supposedly carried in them. Publicly crucified, Modern art was to make clear what had hitherto been privately suspected: how widespread degeneracy was (as the widely different examples of it indicated), and what it supposedly looked like. It was the excuse for the massacre of the innocents.

What did the Nazis mean by "degeneracy"—a concept they did not originate, but which they carried to a reductio ad absurdum? What was it that they saw in Modern art that led them to regard it as a threat? For the Nazis, degeneracy basically and ultimately meant anarchy and "Jewishness," which they then unspun to include all the realities that they perceived as alien. To them, Modern art showed these things at their most conspicuous. "Degeneracy" was a code word for a complex of elements, the most prominent of which was "madness": the intensity of Modern art's response to a mad world. The Nazis did not want a serious art in the service of truth; they wanted an art that would be a passive propaganda instrument, an art with no point of view of its own, an art blindly in the service of the state, marching in the ranks of the fascist revolution. They did not want an art that raised questions about the world through its form, an art whose anarchy and madness performed a vital balancing act, disclosing what political consciousness preferred to leave repressed, so disruptive would it be of political order and control.

Modern art articulated the modern condition in a way that the Nazis, who wanted, in their own strange way, to restore tradition (a thousand-year Reich), found intolerable. The Nazis resisted Modern art because it signaled the modern complexity they resisted in their desire to establish a "simple" society—to effect a simple unity between society and the state. Modern art was inherently anti-authoritarian in its refusal of any such

facile unity. The exhibition guide for *"Entartete Kunst"* describes the works on the one hand formally, as using *"barbarous methods of representation"* indicating *"the progressive destruction of sensibility for form and color,"* and on the other in terms of content, as elevating degenerate types of human being. The exhibition was organized in nine sections: the artists of group four, according to the guide, depicted "German soldiers . . . as idiots, sexual degenerates, and drunks"; for the artists of group five, "the whole world appears to be one huge *whorehouse,* and humanity is made up of nothing but *prostitutes* and *pimps.* . . . The prostitute is represented as an ideal of morality!"; the artists of group six represented the *"Negro* and the *South Sea Islander"* as "the *racial ideal"*; and the artists of group seven "worshiped . . . the *idiot,* the *cretin,* and the *paralytic"* as their "own special *spiritual ideal."* "Artistic anarchy" was evident in all the groups; it was interpreted as a way "to preach *the need for political anarchy"* and as "Marxist propaganda." It was a "kind of hocus-pocus" "pandering to Jewish art dealers." The artists of group nine, the final section of the exhibition, represented the "height of degeneracy," producing works that were characterized as "total madness." The guide concludes with a section comparing works of Modern art with, in the words of art historian Berthold Hinz, "superficially similar products done by the mentally ill," and attributes "higher artistic value to the pathological works."[8]

This is the key to the guide—the idea that these "anarchic" qualities are the ingredients of madness, are in fact one and the same as madness. To say "anarchic" and "Jewish" was already to say "mad" for the Nazis, and they wanted to make this unmistakably clear. The purpose of the guide's analogy between Modern and pathologically mad art was to make possible the removal of the art from the public realm, and its liquidation; madness couldn't be let loose to contaminate public life. Hitler himself made the point explicit:

And what do they fabricate? Deformed cripples and cretins, women who inspire nothing but disgust, human beings that are more animal than human, children who, if they looked like this, could be nothing but God's curse on us! And these cruelest of dilettantes dare to present this to today's world as the art of our time; as the expression of what our time produces and of what gives it its stamp. Let no one say these artists depict what they see. Among the paintings submitted for this exhibition, there were many works that would actually lead us to believe that there are people who see things differently than they are, that there really are men who see the present-day figures of our people only as degenerate cretins—men who are determined to perceive, or, as they would say, to experience, meadows as blue, skies as green, and clouds as sulphur yellow. I do not intend to debate whether these individuals do in fact see and perceive in this way. But in the name of the German people, I mean to forbid these pitiable unfortunates, who clearly suffer from visual disorders, from attempting to force the results of their defective vision onto their fellow human beings as reality or, indeed, from serving it up as "art."[9]

On one level, the statement—from one of Hitler's speeches and quoted in the last section of the *"Entartete Kunst"* guide—can be understood as Hitler's personal revenge on artists more successful than he. We know that he thought of himself as an artist, even though he failed the drawing test the first time he applied to the Akademie der Bildenden Kunst in Vienna, in 1907, and was not even allowed to take the test when he tried again in 1908.[10] He never did enter the academy—never had any formal training as an artist. Nonetheless, he called himself—perhaps in fantasy thought himself to be—"an academician and an artist." For a while he earned his living producing tourist pictures of Vienna.[11] From his attack on Modern art in *Mein Kampf* (1924) we can infer that Hitler blamed the failure of his career as an artist on the success of Modern art, which had triumphed over the academic art he identified with and defended even though the academy had rejected him. There can be little doubt that revenge on a more successful art than his own partly motivated Hitler's cultural policies.

But clearly something else was at issue: Hitler's feeling that Modern art let loose the genie of madness in the world. In part, this was probably the madness that he felt threatened him personally during the lonely years in which he tried to live as an artist in Vienna;[12] he reconceived this madness as the madness of making an art that did not reflect the world "realistically," that did not picture the world as "everyone" knew it, that gave sometimes a "distorted," "anti-social" picture of things and sometimes (in, for example, the Constructivist and completely abstract pictures of the *"Entartete Kunst"* exhibition) no apparent picture at all— unlike "sane" art. How could such mad art be successful, and his own realistic, conformist, true-to-the-exterior-world art not be, unless the world itself were mad? Hitler was caught in a vicious circle. Modern art had to be extraordinarily menacing for him, since it questioned his "correct" view of the world.

Theodor Adorno defines the basic features of the authoritarian personality as "conformism, respect for a petrified facade of opinion and society, and resistance to impulses that disturb its order or evoke inner elements of the unconscious that cannot be admitted."[13] These qualities indicate profound anxiety about one's sanity. In the authoritarian view, such as Hitler's, to not conform, to crack the facade of opinion and society, to give in to impulses that seem alien to oneself even though they come from oneself, is to be mad. For him, the labeling of Modern art as degenerate expressed a profound anxiety: the fear of "foulness," of going mad. Going mad meant degenerating, which implied not only pathological regression to the unconscious and loss of all sense of self and self-control, but something more devastating: not being able to get well, losing the power to regenerate oneself, to climb out of the unconscious—to, as

Hitler put it, "resurrect." The Nazi nightmare was the possibility—for both self and society—of being permanently incapacitated, and Modern art was like a conspicuous embodiment of the nightmare visible everywhere in modern society. Modernism's pictures broken into fragments themselves inherently fragmented, its "structures" of splinters, its "disintegrity"; its hallucinatory, dissociated images that seemed to the Nazis to have no connection to reality; its monstrous, pathological-looking figures seeming so at one with their abnormal condition that they could never know how sick it was—these were seen as the symptoms of terminal personal and social illness. From a Nazi point of view, in Modern art the very idea of health—however it might be construed—was lost. Modernism not only seemed to tell a horrifying story of madness and disintegration but, even more crucially, implied that the madness was a plague. This plague the Nazis angrily refused to accept, despite the madness manifested in their own behavior.

A series of much quoted passages in *Mein Kampf* epitomize Hitler's equation between Modern art, the Jews, and madness. The first indicates his sense of the Jews as the corrupting poison that has to be cleaned out. "Was there any shady undertaking, any form of foulness, especially in cultural life, in which at least one Jew did not participate? On putting the probing knife carefully to that kind of abscess one immediately discovered, like a maggot in a putrescent body, a little Jew who was often blinded by the sudden light."[14] "Characteristic of Viennese anti-semitism," as Alan Bullock notes, Jewishness had a strong, uncontrollable, sexual cast to it for Hitler. "The black-haired Jewish youth lies in wait for hours on end, satanically glaring at and spying on the unsuspicious girl whom he plans to seduce, adulterating her blood and removing her from the bosom of her own people," Hitler wrote, and he also described "the nightmare vision of the seduction of hundreds of thousands of girls by repulsive, crooked-legged Jew bastards."[15] In general, it was the "satanic skill" of the Jews[16] that he believed led the German people astray: "The [Jewish] spider was slowly beginning to suck the blood out of the people's pores."[17] Since he saw art (in addition to banking, the press, and so on) as a Jewish cultural monopoly, it too was supposedly satanically sexual, full of works that for Hitler were like dark sexual deeds. The ancientness of the Jewish people became emblematic of the danger of their sexuality—the relentlessness of their sexual drive. They were at once the embodiment of the latent Modern madness that threatened civilization, and symbolic of the oldest threat to it—uncontrollable sexuality. Hitler's attack on the "blackness" of the Jews shows the expanse of his racism. And modern art, in its "anarchism," was his emblem of this sexual exhibitionism and license, this dark riotousness

of the unconscious. The vividness and "wildness" of Expressionist art—
the garishness of Emil Nolde's color, the nervous energy of Ernst Lud-
wig Kirchner's forms, the general display of nakedness in much Expres-
sionist art (an almost violently rendered nakedness)—no doubt symbolized
for Hitler the eruptive and disruptive power of sexuality. By the way,
neither Nolde nor Kirchner were Jews, and Nolde was a good Nazi, who
wrote Goebbels protesting his inclusion in the *"Entartete Kunst"*
exhibition.

As Gilman puts it, the Nazis regarded Modern works of art not as
art but as "representative of the atavistic nature of the Jewish avant-
garde."[18] Gilman documents the long history of belief in the association
of madness and Jewishness,[19] and the extension of the association to
avant-garde (this term has always been used synonymously with
"Modern") art. He also notes that the concept of degeneracy was taken
by Freud from "its sexual context" and put "where it belongs, in the
realm of political rhetoric."[20] In fact, the term "degeneracy" is another
word for "decadence"[21]—it is an expression of an ideological or moral
position rather than an empirically substantive one.

The Nazis both resisted and shared Modern art's vision of disintegra-
tion, then, but they claimed an alternative vision of personal and social
reintegration and sanity. They sought to correct the condition they saw
communicated in Modern art. They railed at Modern art for wallowing
in degeneration and decadence, and for being indifferent to regenera-
tion. The notion of degeneracy existed long before Hitler: Hitler probably
read Richard Wagner's *Das Judenthum in der Musik* (Judaism in music,1869,
which in effect proposes a Jewish conspiracy in music) and what Lucy
Dawidowicz calls Wagner's "grandiloquent *Decay and Regeneration*" as
a schoolboy in Linz,[22] and Martin Luther was violently anti-Semitic in
his later years, and was used by the Nazis to justify their own anti-
Semitism.[23] However, Hitler's decision to exterminate "Jewish Modern
art" implies an even more profound panic and rebellion because of the
prospect of the insanity he saw in it. Consciously and unconsciously, he
refused to take this prospect passively—refused to accept his own, and
society's, madness. That his vision of a regenerated German self was the
symptom of a more devastating madness than the one Modern art
depicted is another matter.

It seems that Hitler had the same longing to live in a "solidly framed"
society as Vincent van Gogh, and the same terminology for—if hardly
the same understanding of—the Old Masters, whose works, after all, were
the basis of the academic art he admired. (For Hitler, academic art reflected
a firm social structure.) Van Gogh wrote,

> Giotto and Cimabue, as well as Holbein and Van Dyck, lived in an obeliscal—excuse the word—solidly framed society, architecturally constructed, in which each individual was a stone, and all the stones clung together, forming a monumental society. When the socialists construct their logical social edifice—which they are still pretty far from doing—I am sure mankind will see a reincarnation of this society. But [unfortunately], you know, we are in the midst of downright *laisser-aller* and anarchy.[24]

Artists, van Gogh goes on to say, "love order and symmetry." Van Gogh—a modern, irreversibly "mad," despite himself—wanted an art of hope, an art that could picture degeneracy, as in *The Night Café*, 1888, but promised regeneration, as in his images of nature. He wanted to return to "pure" nature to undo impure, sick civilization and history. But to Hitler, all Modern art seemed to be without hope, seemed to worship chaos, seemed unable to see nature as regenerative, seemed to project its own sickness onto nature. At the *"Entartete Kunst"* exhibition, works by such German Expressionists as Heinrich Maria Davringhausen, Kirchner, Otto Nagel, and Karl Schmidt-Rottluff were shown under the statement, writ large, "this was how diseased minds saw nature."

Is the Nazis' generalized critical understanding of Modern art far-fetched? Did Modern art fail modern society by failing to offer the hope of regeneration? Was Modern art diagnostic rather than healing? The psychoanalyst Heinz Kohut says,

> The great artists of any period are in touch with the currently preeminent psychological tasks of a culture . . . [yet] a large sector of Weimar Germany, including all classes and those with all levels of education, knew that they were not in touch with modern German art and felt preconsciously that German art was out of touch with them. And the Nazis knew it . . . the Nazis accurately reflected the disappointment that they shared with a broad sector of Germany, a disappointment over the fact that their artists had failed to understand their needs and had failed to portray them with any degree of sensitivity. The leading experimental art of the Weimar Republic, of course, had switched from dealing with man's conflict to dealing with man's suffering a defective, fragmented, depleted self.[25]

In a sense, the artistic interpretation of modern life generalized the loss of self, implying to the Nazis that it offered no particular cure for the crisis, which seemed too pervasive to combat. That meant that the art had to be disavowed and dismissed, one way or another—debunked or liquidated, or both. For it raised the specter of a problem with no solution, which the Nazis could not accept. Kohut dismisses the idea that the "formal strangeness" of Modern art initially stood "in the way of [its] popular resonance."[26] In fact, an art like Modern art was "needed to express the empty, devitalized, fragmented state of those who had formerly felt alive, strong, and cohesive in the symbol of a Kaiser and of a strong, disciplined army, and in the ideals of Imperial Germany . . . and in the ideals of Ger-

man Christianity that had sprung from Luther's strong words."[27] However, as Kohut has remarked in another context, "The problem is that the avant garde may sometimes leave unsupported large numbers of people."[28] To both German bourgeois and Nazis, Modern art was unsupportive, contemptuous of their emotional problems and indifferent to their emotional needs, offering a mirror that was received as mockery.

In contrast, the Nazi movement developed an art of its own. Kohut writes, "Nazi-supported art—and that includes the architecture of Hitler, the stereotyped replica of the symbols of Roman imperial power— . . . helped deny the persisting self-defect via sudden and wholesale identifications with symbols of strength and failed to deal with the depressive, devitalized and fragmented state of Germany. Nazi art fostered regression to archaic symbols of power and unity."[29] And, "The Nazi capacity to tune to large groups of the most diversified people and intuitively offer them an image of cohesion and strength, heal the fragmentation, the weakness, and the underlying depression, suddenly give people a sense that they are worthwhile, indeed better than others, had something truly artistic about it. Leni Riefenstahl, for example, captured this quality in her film of the Olympics or in the one of the party rally (*Triumph of the Will*) which has the plane coming out of the clouds with the Führer in it. The film offered a perfect response to what the population [felt it] needed."[30]

More than the conservative painting and sculpture shown simultaneously with the *"Entartete Kunst"* exhibition at the then new Munich Haus der Kunst,[31] the pageantry of events like the August 1936 Berlin Olympics constituted the Nazis' "affirmative" new art. What Kohut calls the "conversion experience," or "sudden cure," or "gross identification" with the leader[32] that the Berlin Olympics generated, in fact marked the moment the Nazis took complete control of a cultural policy that they insisted could cure. They were never more successful in formulating such a culture than in the monumental art of the Olympics and, a month later, of the Nuremberg Party Rally. Here, public spectacle seemed to supply the cure—the reintegration of self, and of self and society—that intimate art could not, even if it was as short-lived a cure as the spectacle itself. Modern art offered an intimate diagnosis, but not an intimate cure. There were no images in Modern art of figures with which the defeated, broken, weary bourgeois Germans—suffering from World War I, and from the economic depression and political confusion that were its aftermath— wanted to identify, could find attractive enough to commit themselves to body and soul. This is ultimately why they saw Modern art as "degenerate": it could offer nothing of what Kohut calls the "supportive selfobject." In the thirties—the election of Hitler partly signals this— the bourgeois German was ready to "face his need for supportive selfob-

jects that reflect him, for those whom he can idealize and next to whom he can work."[33] Modern art offered no such curative, idealized, parental image as the basis for a new narcissistic balance.[34] It offered no "systems of perfection,"[35] but made imperfection explicit. The Nazis accurately perceived Modern art as apocalyptic—an assertion of social despair—rather than as the reflection of a belief in a resurrection of the German spirit. But it may also be that the Nazis could not accept the madness of Modern art because they had to repress the liberty it implied.

Jacques Lacan has written, "Madness is far from being an 'insult' to liberty: it is her most faithful companion, it follows her movement like a shadow. And the being of man not only cannot be understood without madness, but it would not be the being of man if it did not carry madness within it as the limit of its liberty."[36] This undoubtedly could be understood as an overromanticization of madness, as though it were not a subtler form of slavery than ordinary consciousness—slavery to permanent, paralyzing ambiguity of meaning and ambivalence of feeling and intention, rather than to the false harmony of bourgeois order and reason. (At times, there may not be much to choose between the two states of mind.) Yet Lacan's connection of madness and liberty is not romanticization, and should be understood in the context of the project that Modern art in large part constitutes—namely, the attempt to make manifest what is unconsciously concealed, repressed in the name of a conventional sanity. It is when repressed recognitions and attitudes are not acknowledged that they begin to fester, and to actualize apocalyptic fears. Modern art, especially the Modern art that Hitler rejected as degenerate, releases recognitions and conditions which have almost been repressed beyond recognition, are so repressed they seem monstrous (unrecognizable) when made manifest. Hence the famous "distortion" of Modern art, which Hitler perceived as anarchistic. Modern art showed the incredible variety of types shaped by and enduring the human condition, as well as the visual innovations made possible by Modern consciousness.

In a sense, liberty is the liberty to recognize, to make manifest, to move from unconsciousness to consciousness, however mad—necessarily mad—the result looks. The Modern art that Hitler hated seems to exist on the borderline between the unconscious and consciousness, in a strange prescient state from which it may as easily go back to the unconscious or be totally clarified by consciousness. Hitler could not stand this "diabolical" characteristic of Modern art, for his whole position depended upon not acknowledging certain truths, upon keeping repressed what was unconscious. He had a vested interest in the repressed, so that he could use the apocalyptic energy it generated to launch his "new order."

Notes

1. Georg Bussmann, " 'Degenerate' Art—A Look at a Useful Myth," *German Art in the 20th Century: Painting and Sculpture 1905–1985* (London: Royal Academy of Art, and Munich: Prestel-Verlag, 1985), p. 113.

2. Quoted, from the guide to the *"Entartete Kunst"* exhibition, in Berthold Hinz, *Art in the Third Reich*, trans. Robert and Rita Kimber (New York: Pantheon Books, 1979), p. 41.

3. Quoted from a 1933 manifesto of the Nazi press agency *Deutscher Kunstbericht*, in ibid., p. 27.

4. Quoted in Bussmann, "Degenerate Art," p. 113.

5. Ibid., p. 114. It is worth noting, on the other hand, that William L. Shirer, who saw the exhibition, thought more people were interested in the Modern art there than in the "New German Art" the Nazis showed simultaneously. See his *Rise and Fall of the Third Reich* (Greenwich, Conn.: Fawcett Publications, Crest, 1962), pp. 337–38.

6. Ibid., p. 120.

7. Sander L. Gilman, *Difference and Pathology: Stereotypes of Sexuality, Race, and Madness* (Ithaca, N.Y.: Cornell University Press, 1985), p. 236.

8. These remarks, and the preceding quotations of the guide, are from Hinz, *Art in the Third Reich* pp. 40–41.

9. Ibid., p. 42. Speaking about *"Entartete Kunst"* on July 18, 1937, Hitler stated, "Works of art that cannot be understood but need a swollen set of instructions to prove their right to exist and find their way to neurotics who are receptive to such stupid or insolent nonsense will no longer openly reach the German nation. . . . With the opening of this exhibition has come the end of artistic lunacy and with it the artistic pollution of our people." Quoted in Shirer, *Rise and Fall of the Third Reich*, p. 337.

10. See Alan Bullock, *Hitler, A Study in Tyranny* (New York: Bantam Books, 1953), pp. 7–8.

11. Ibid., pp. 10–11.

12. "Hitler himself later described these as years [1910–14] of great loneliness, in which his only contacts with other human beings were in the hostel where he continued to live and where, according to [Reinhold] Hanisch [Hitler's onetime associate in the picture business], 'only tramps, drunkards and such spent any time.' " Ibid., p. 11.

13. Theodor W. Adorno, "Commitment," in Andrew Arato and Eike Gebhardt, eds., *The Essential Frankfurt School Reader* (New York: Continuum, 1985), p. 303.

14. Quoted in Bullock, *Hitler*, p. 16.

15. Ibid.

16. Ibid., p. 17.

17. Quoted in Lucy S. Dawidowicz, *The War against the Jews 1933–1945* (New York: Bantam Books, 1976), p. 25.

18. Gilman, *Difference and Pathology*, p. 235.

19. Ibid., chapter 6.

20. Ibid., pp. 212–13.

21. This point is developed at length in Richard Gilman, *Decadence, the Strange Life of an Epithet* (New York: Farrar, Straus & Giroux, 1979).

22. Dawidowicz, *War against the Jews*, p. 8.

23. Ibid., p. 29, and Bullock, *Hitler*, pp. 326–27.

24. Quoted in Hirschel B. Chipp, ed., *Theories of Modern Art* (Berkeley: University of California Press, 1968), p. 34.

25. Heinz Kohut, "Self Psychology and the Sciences of Man," *Self Psychology and the Humanities* (New York: W. W. Norton, 1985), pp. 88–89.

26. Ibid., p. 89.

27. Ibid., p. 90.

28. Kohut, "Conversations with Heinz Kohut," *Self Psychology and the Humanities*, p. 245.

29. Kohut, "Self Psychology," p. 90.

30. Kohut, "Conversations," p. 246.

31. Hinz notes in *Art in the Third Reich* that the Munich Haus der Kunst was supposed to have, "as it were, [a] 'thousand-year' façade . . . to express 'in its proportions and in the quality of its materials the dignity and greatness' of German art" (p. 7). It was designed by Paul Ludwig Troost "with Hitler's active collaboration" (p. 6).

32. Kohut, "Conversations," p. 247.

33. Ibid., pp. 247–48.

34. Kohut, "Forms and Transformations of Narcissism," *Self Psychology and the Humanities*, p. 100.

35. Ibid.

36. Quoted in Jacques Lacan, *The Language of the Self* (New York: Dell, Delta Books, 1975), p. 136.

Transmuting Externalization in Anselm Kiefer

Glory be to our strong, healthy German art.

And this painter much preferred the holy German madonnas, invested with the souls of Grünewald and others, over the Latin, superficially presentable paintings of Raphael, which fit so well into the milieu of doges and Popes.

All the arts of all the Mediterranean people share certain qualities which are their property. Our German art has glorious qualities of its own.

We respect the art of the Latins; German art has our love.

The southern sun, tempting us, the Nordic people since time immemorial, stealing what is most our own, our strength, our reticence, our inmost tenderness.

A little weakness, a little sweetness, a little superficiality—and the whole world curries the artist's favor.

Only when a painting is altogether weak, sweet, and superficial will every one recognize it as bad.

Who among us knows the Edda, the Isenheim Altar, Goethe's Faust, Nietzsche's Zarathustra, all these runes hewn in stone, these proud, sublime works of Nordic-German peoples! There are eternal truths, and not the intoxications of the day.

<div align="right">Emil Nolde, Jahre der Kämpfe</div>

One of the attractions of Kiefer's pictures is that they look old, not new. In general, the new German painters appeal to us because they remind us of the past; they project no future. Even Jörg Immendorff, of all of them the painter who most explicitly depicts present history, offers no "future solution"—whether utopian or apocalyptic. This throws what he depicts back in time, makes it seem instantly archaic, age-old. This evocation of a seemingly timeless, primordial past makes the German painters seem like "old masters." For one of the things it means to be an "old master" is to paint the world as if it has already happened—as if it has long been the case, and is even more inwardly familiar to one than one

This article originally appeared in *Arts Magazine* (October 1984).

is to oneself. It does not have to be achieved, the way one's sense of self does. This is why the old masters clothed the world they knew in idealizing, mythological costume; such treatment made it seem "traditional," old and real before one attended to it.

Several of the German painters have said they want to restore the tradition of "great paintings." Rudi Fuchs observes that Kiefer wants "to reinstate painting as an art of High Seriousness (which does not exclude irony) and to bring it back into the realm of Grand Rhetoric; to liberate it from self-reflective esthetic exercise."[1] This can also be said of Immendorff, as well as Markus Lüpertz, Georg Baselitz, and A. R. Penck. But what differentiates Kiefer from them is that he uses the abstract, idealizing methods by which a sense of inescapable significance is generated—the sense of the fundamental associated with "tradition"—in order to dissolve or "de-signify" a very particular historical tradition: the tradition of being-German. Kiefer continues the tradition of German preoccupation with what it means to be German, but in an unexpected way. Usually, as in the Nolde quotation that is the epigraph for this article, German depth is contrasted with Italian superficiality, German strength with Mediterranean weakness, German hardness with Mediterranean softness. Just those traits which since antiquity have led Mediterranean cultures to describe Germany as uncivilized or barbaric, and regard it as an outcast or outsider—"borderline"—society, are idealized by Nolde. But Kiefer shows us that in today's world there is really very little depth of meaning to being-German. He demonstrates that the "eternal German" is absurd, a pathetic joke that makes itself manifest in isolated historical moments in which the Germanic was not as unequivocally triumphant as was later supposed. He shows us that German power—be it military or intellectual power—was not so absolute as was later thought. By articulating German megalomania in profoundly abstract fantasies, he reduces it to the symbolic fiction it always was. The "episodic" character of his works reflects the historical episodes that constitute the fiction, in effect dismembering it, denying its cohesiveness. With that loss of unity, the "German" evaporates into a series of discontinuous dream sequences, a narrative "tale told by an idiot."

Kiefer suggests that the German myth has come to the end of its history, for it exists only in vague, "vain" abstract form—in a series of tragicomic representations which add up to little more than a pathetic delusion of grandeur. Kiefer also suggests, by his cosmic sense of the modes of representation available to him—by the freedom with which he utilizes all the stylistic possibilities of the modern tradition—that modern art has also come to the end of its history. It is now a warehouse of mythical styles that can be used to a mythical end: the depiction of

the bankruptcy of a myth. Kiefer mocks the heroic pretensions and sense of uniqueness of both German identity and modern artistic identity. He is as irreverent toward the Germanic as he is toward the artistic, using a number of hybrid forms—each of his "works" is a potentially infinitely extended or openended "confederation' of such forms—to dissect both. Thus he offers a stylistically incoherent structure of theatrical perform- ances, photographic performances, "abstract" performances with such traditionally artistic materials as paint, as well as book performances, which correspond, in their disjunctiveness, to his conceptual "perform- ance" of his subject matter. Indeed, Kiefer can best be understood as a conceptual performance artist deconstructing the concept of the German, a performance which was "sold out" by its creators. But such artistic "demonstrations" show us that art can be useful. Kiefer, in my opinion, is desperate to give art a socially useful character, liberating it from esthetic delusions of grandeur. Kiefer shows us that art is a useful way of staging the world, abstractly bracketing it so that its meaning structures can become evident.

Kiefer, then, engages mythical tradition—in modern art as well as Ger- man history—only to deconstruct it, to show how questionable and fragmentary it is today. In part this is done by giving us both art and history as an incomplete mosaic, never adding up to a whole. It must be emphasized that Kiefer deconstructs German tradition and modern artistic tradition simultaneously, showing that for all their momentousness there is something hollow in both, since neither affords the perspective necessary to create a total world picture. German tradition is inadequate because it excludes European tradition, or rather has a negative, an- tagonistic relationship to it. And modern art is inadequate because it is obsessed with novelty to the point of ignoring the rhetorical possibilities of art—because it dismisses the rhetorical as beside the aesthetic point and so trivial, giving it the same status as the decorative. Kiefer restores the literary with a vengeance, suggesting that the visual arts are incomplete—even inept—without it. Similarly, he reminds the German of the European by showing the German as having its specifically German—aggressive—qualities only in relation to the European. The Ger- man refusal to assimilate into Europe makes it the aggressive shadow— the violent abstraction—Kiefer depicts it as. Kiefer deconstructs the mythically German and the mythically modern in order to reconstruct— complete—our self-understanding.

What is "difficult" about Kiefer is not his Postmodern use of cultural content and art—his sense that there are no surprises to be expected from them, no novelty left in them—but his implicit attempt to reconstruct a sense of autonomous self, master of its cultural and creative history. The

idea of autonomous self is modern, but the Postmodern sense of autonomous self frees it from the bourgeois sense of its inevitability—the bourgeois belief that one has a right to an autonomous self, as a sign that one is "destined." Kiefer suggests that this traditional sense of autonomous self is a bankrupt mythologization of it. It must be worked at, created on the basis of a universal sense of being-human—as a demonstration of the universal experience of being-human. A recent cycle of works, *Margarete-Sulamith*, based on the poem *Todesfuge* (Figure of Death) by Paul Celan (1945), makes this clear. The poem deals with the inseparability of the blonde German Margarete and the dark Jewish Sulamite—with the light and the dark sides of the self. The destruction of the Jewish, leading to the self's loss of unity, is the destruction of its humanity. The German, in Kiefer's art, constantly shows itself as the arrogantly incomplete human—the destructively inhuman. Kiefer wants to destroy the German tradition that allows this arrogant definition of the human as the inhuman, that is satisfied with a partial sense of self. Fuchs writes that Kiefer "recedes from tradition, leaving it behind like scorched earth, in order to start anew: a flame rising from the ashes."[2] But the "German themes: burning out, turning into wood, sinking, silting up"[3] with which Kiefer deals—in a kind of reactive, hyperbolic, regressive destructiveness—exist to create a new order of human self free from the partial German self based only on destructive power. Kiefer uses barbaric German methods—destroying civilization, ironically "returning to nature"—against the idea of the German. Kiefer turns destructive German power inside out, using it against German one-dimensionality. This purge of the Germanic in flames restores the possibility—if not clearly the actuality—of being-human to the German. The phoenix that rises from the flames of Kiefer's destructive German art is not a revitalized arrogant German self, but a newly human self.

The reference to "transmuting externalization" in my title—a reference to what I understand to be Kiefer's artistic method—utilizes Heinz Kohut's concept of "transmuting internalization," which he uses to describe structure formation in the psyche. I think Kiefer reverses this process, destructuring—returning to dreadful amorphousness—the German psyche. Kiefer eliminates its arrogant structures by decomposing them, turning them against themselves, so that a fresh start can be made toward the creation of a new human self. Kohut argues that when the psyche has matured to the point where it is ready to become autonomous, it withdraws its feelings from "those aspects of the object imago that are being internalized,"[4] then introjects these now depersonalized aspects as the foundation of its sense of itself—the structural basis of its selfhood. This process of self-formation involves, among other things, the creation

of a self able to monitor and control impulses, whether erotic or aggressive (constructive or destructive) arising from within the larger life of the psyche. Implicitly, for Kiefer, reviewing German history and the mythical sense of self it implies, the German self was ill-formed. Kiefer thus wants to reverse the process by which the German self came into being—a process which created a self which had no control on its aggressive impulses, and which idealized its erotic impulses to the point of uselessness. Aggression became an all too concrete part of the German character, and love became an all too abstract part of it. It became split grotesquely into a brutally materialistic part that made war, and into a sublimely spiritual part that made music and philosophy.

Sometimes deliberately violating the spiritual part of this German self—as in his fantasy project for flooding the traditional university town of Heidelberg (1970)—and sometimes ruthlessly extending the aggressive part—as in his literally burning the earth in Buchen, the name of the old district in which he lives (1974)—Kiefer means to undo the traditional German self. By both reenacting its history on an artistic stage, and acting against it in imagination—literally creating images of destruction of spiritual symbols—Kiefer clears the ground of the German psyche so that a new sense of self can grow in native soil. This process of transmuting externalization of the traditional German self—sharply split into aggressive and spiritual parts—makes way for an untraditional (in German society) sense of self, that is, of a self that seems whole because it is in control of all its parts. But Kiefer does not show us the new German self in formation; only history can give the German a new human self. Kiefer, reviving the shamanistic function of art, only purges the old German inhuman self, at once too violent and too sublime—both too low and too high for human good. Kiefer's idealization of art (see his many ''palette'' pictures) depends entirely on his expectation that it can ''derealize'' the traditional German imago.

One of Kiefer's very first projects, in which he made the Nazi salute in various European towns, shows his need to reenact aggressive episodes in the German past—above all, shows his need to engage and reconstitute German arrogance. Everything falls into place from that theatrical moment, that moment of high performance. Kiefer, born in 1945, the year in which World War II ended, seems to have a compulsion to reconstitute the collective German identity which was given to him by history—a national identity that is involuntarily his, and that he does not so much want to make his own as destroy, so that he can find his human identity. He must work his way back through German history to the original ''object imago'' of being-German from which the German tradition began. To

me, he reaches this point in *Wege der Weltweisheit—die Hermannsschlacht* (1978), in which he deals with the legendary German chieftain Arminius—later called Hermann by German historian—who in A.D. 9 destroyed three Roman legions under the command of Quintilius Varus in the dark Teutoburger Forest. This "moment of destiny" aroused the imagination of generations of German artists, poets, historians, politicians, and even generals. In the nineteenth century, when the dream of German unification grew powerful, Hermann became a symbol of national liberation. Kiefer depicts the primordial German forest where the battle took place with images of the figures who idolized him and the power he represented—writers such as Fichte, Klopstock, Grabbe, von Kleist, Mörike; generals such as Count Schlieffen, Blücher, von Moltke; and moralists and philosophers such as Heidegger and Langbehn. Kiefer gives us a textbook illustration of the genuinely German—in a sense literally, since "Wege der Weltweisheit" is apparently a high school textbook title.

This work brings together the two sides of the "German ideology" for Kiefer—the land and the people. He either deals with genuine German land or with genuine German people, and often both. He is in hot pursuit of the "German type" through an examination of its "tokens." Thus, in *Maikäfer Flieg* (1974), referring to an old song about war and the destruction of Pomerania, he shows, in a kind of abstract panorama/map, a land that became Russian after World War II. In *Märkische Heide* (1978), he gives another example of "genuine German" land, the Mark Brandenburg, a county east of Berlin, a Protestant area which eventually became part of the Prussian state, the leader of the new German Empire. The Mark Brandenburg, along with the rest of Prussia, has also been lost to Germany. Is it still genuine German? Is it part of eternal Germany?

As his enterprising use of the Hitler salute showed, Kiefer is not afraid of tackling the most inhuman aspects of the German ideology. Thus, in *Das deutsche Volksgericht (Kohle für 2000 Jahre)* (1974), Kiefer ironically deals with German racism—Germany's belief in the superiority of the German (Aryan) type over all other types. (This is also implicitly at stake in the *"Wege der Weltweisheit"* series.) The German face, that grows out of the German forest (the grain of wood)—that is so rooted in "Being"—shows itself to be rather ordinary, indeed, all too typical. German superiority and authenticity, based on a claim of greater closeness to or intimacy with Being (in the form of Nature)—symbolized by the intimately depicted wood grain—shows itself to be rather grotesquely banal. German stupidity is signified in the *"Unternehmen Seelöwe"* series (1975), Hitler's codename for the invasion of England that never materialized. The plans for it were confused and infantile—altogether inexperienced—as Kiefer shows, with his bathtub full of toy boats.

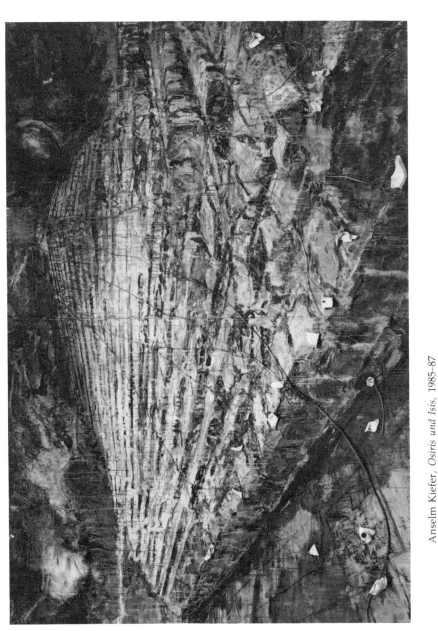

Anselm Kiefer, *Osiris und Isis*, 1985–87
Diptych, mixed media on canvas, 150" × 220½" × 6½".
(Collection San Francisco Museum of Modern Art; photo by Jon Abbott; courtesy Marian Goodman Gallery, New York)

Again and again, Kiefer deals with the German ideology, ruthlessly anatomizing it, until on the table of his art there is only its corpse, never to be put together again even by a Dr. Frankenstein. Curators and critics have described Kiefer's art as poetic and beautiful, but it is really beyond beauty and ugliness. Kiefer is attempting nothing less than a Nietzschean transvaluation of German values, hopefully not in the name of a new will to political power. Instead, he shows what the German will to artistic power has always, at its best, arisen from: an encounter with the concept of the genuinely German, as reified in the German landscape, the German people, and German history—in German insularity. Kiefer is concerned to determine what the genuinely, "purely" German is, in the most austere ontological sense possible. We think of the best German art as "Expressionistic" because of this claustrophobic urgency about the German being. The traumatic effect of dealing with the hermetic German being as if it were the essence of Being itself leads to disruptive Expressionistic effects. The sense of the Expressionistic—of the displacement of expression—always results from the attempt to take one limited kind of being, define it as the only authentic kind, and regard it as the privileged means of access to Being.

But the Expressionistic has a double, self-contradictory meaning. Not only is it the method of articulating ontological absolutism, but of resisting it violently in the name of a new immediacy of experience. In Kiefer's case, this doubleness shows in an ironical attitude toward being-German: he shows us the purely German, but he shows it to us in terms of the fiction of artistic immediacy. Kiefer offers us an Expressionistic stream of artistic consciousness of being-German, a barely controlled free associational "system" obsessively revolving around the theme of being-German. But that it is an artistic consciousness shows that it transcends its theme. Kiefer is, in the true psychoanalytic sense, "working through" the nightmare of being-German toward the daylight of being-human. He is working through what was given to him by birth, but which he does not experience as innate to his person—the basis of true selfhood. (It is worth noting, in this context, that he is the direct protagonist in his early works, and the indirect protagonist in later performances, that is, the "stage manager" or impresario responsible for the manipulation of the artifacts and actors used, at once playwright and puppeteer. The *Meistersinger* series is perhaps the clearest articulation of this.)

But there is a problem with this expressionistic irony. For insofar as Kiefer retains Expressionistic method and sensibility, even in abstract form, he keeps alive the deepest part of the German ideology, and shows himself to be German by personal choice and not just by social history. For the deepest part of the German ideology is the confused belief that

the expression of power is at once the authentic sign of being-German and the way of reaching beyond the German to others. The German believes that power is the direct manifestation of pure Being but also the way of denying the uniqueness of one's own (German) being, since power is understood as a sign of universal humanity. Kiefer is profoundly confused: his art is an exhibitionistic demonstration of artistic power in the name of universal humanity, and of German power in the name of unique German being. His art, indeed, is finally very German, just because it is ambivalent about being-German. As Heine, Goethe, and Nietzsche suggest, the most German of all the Germans are those who, with all their beings, despise being-German. It is no doubt unfortunate that the world reads even German self-disgust as an expression of the German will to power—as a less than sublime but still incisive display of being-German.

Notes

1. Rudi Fuchs, "Kiefer malt," *Anselm Kiefer* (Exhibition Catalogue; Venice Biennale, 1980, German Pavillon), p. 61.

2. Ibid., p. 62.

3. Klaus Gallwitz, "Die Helden der Geschichte," *Anselm Kiefer*, p. 4.

4. Heinz Kohut, *The Analysis of the Self* (New York: International Universities Press, 1971), pp. 49–50.

The Archaic Self of Georg Baselitz

Georg Baselitz is one of the great contemporary painters, one of the reasons for the revived sense of painting's credibility and the credibility of figure painting. This means he puts painting to a new human as well as artistic use. By using violent painterliness to restore our sense of the peculiar character of the human condition, he has restored our sense of paint's power of connotation. He claims to be an abstract painter, and has said that he turns figures upside down to free them from conventional associations—to "dissociate" our sensibility of them—but this freeing of the figure recreates it as the horizon of new associations, a deeper level of association.

The disorientation is really a reorientation, making us all the more susceptible to the paint as a signifier, playing freely with the figure to make it freshly suggestive. Its ambiguous presence—for it is as much absented by the paint as affirmed by it—becomes unexpectedly heuristic. Unsettled in meaning, the figure is all the more intensely related to, all the more primordial in impact. Estranged from the figure, our sense of its reality becomes doubtful; a hallucinatory effect is generated, out of which a new dream of meaning can emerge. As the specter of uncontrollable connotation arises, the denotation of the figure becomes even more problematic. Mimesis is completely abandoned, seems entirely beside the point, and with it the traditional possibility of aestheticizing the figure until it appears memorable, even immortal. It acquires such intriguing symbolic form through emphatic universalization of the obvious.

But in Baselitz the disruptive use of paint, and the upside-downness, have a deaestheticizing, deuniversalizing, generally corrosive effect. The figure seems to wither on the vine of the paint like a sour grape; at the same time it is pruned by upside-downness into a vigorous, strange new growth. It is like a tumor in the pictorial space, one which is neither clearly

This article originally appeared in *Arts Magazine* (December 1983).

benign nor malignant, neither an unequivocally positive symbol nor a demonic presence. New methods and concepts for diagnosing its death-in-life and, equally, ghostly life-after-death appearance, must be found.

The figure is locked into a space which is denser, more concentrated than it. If it was not, it would dissipate; it is crucial to realize that Baselitz's figure cannot sustain itself by itself, cannot exist in its own right. It does not so much exist in space as through space; it is too immature, too uncertain in itself to exist independently in space. Baselitz's general sense of the figure's lack of ripeness and full-bodiedness contrasts sharply with the paint's ripeness and fullness, its self-assurance. Baselitz's figures have no self-assurance, which is what their upside-downness signifies. The figure is not adequate in itself for Baselitz; only the concentrated paint that makes space opaque conveys a sense of adequate being. Being is displaced into the paint, which tells us just exactly how archaic the figure. It has at once a strange grandiosity and a turbulent primitive character—this is part of its pandemonium—whose meaning can only be understood psychoanalytically. The painterliness and the upside-downness are the dream work that reveal a primitive sense of self.

From Baselitz's initial fragmentation of the figure—as in *B. für Larry* (1967) and *Zwei Meissener Waldarbeiter* (1967)—to his later famous inversion of it—as in *Elke* (1974) and *Nachtessen in Dresden* (1983)—with the corresponding shift from a broken to a flagellated paint surface, Baselitz evokes an increasingly primitive sense of self. Like magma, this self finds its way to the surface of the painting, makes an increasingly powerful appearance, fiercely flaunts itself in the increasingly dreamlike picture. All of Baselitz's figures increasingly become one figure, one strange self, monstrous because it is unexpected yet uncannily familiar—a homeless self that is yet at home in the violent picture. Baselitz's development shows the unfolding of the primitive self, having a borderline relationship with reality yet real enough in itself.

It seems to me especially appropriate to apply to Baselitz's figure, at its most primitive, the concepts made familiar by Heinz Kohut's theory of the self and narcissism.[1] This is in line with my belief that in Baselitz we are not dealing with the reasons for the revival of the figure, but the reasons for the inability to renounce it: even abstract art cannot renounce the archaic, narcissistic self. This is the basis for our strong feeling for it, our anxious attraction to it: Baselitz reveals the primitive, narcissistic self that is at the root of abstraction, that lurks in it. Baselitz makes explicit the archaic sense of self that is implicit in abstract art. Abstract art can be conceived as a reduction to aesthetic narcissism—mistakenly understood as autonomy—in the face of a disturbing sense of reality. It is a retreat from reality toward the last sense of self it allows, if only in

the ironical mask of style. Baselitz's figure signals the primitive self's shedding of its elegantly abstract disguises, as though these were no longer necessary now that reality itself seems to have become abstract—appears overdetermined, categorically what it is. The utopianism of early abstraction, in which the self makes a final idealistic assault on the real world, using spontaneous art to criticize its misery, now seems beside the point. The misery is entrenched, so that the critical self can now appear, come out of hiding—the utopian ostrich hole which abstract art represents—and reveal its primitive, narcissistic character.

Baselitz is not reinventing the figure; he is revealing the narcissistic self that today is posthistoric because it has failed to change history, failed to revolutionize the world. Baselitz gives us not the ahistorical self, but the desperate posthistoric self that really no longer has any use for art as a way of repositing the question of the world, but only as an offensive way of restating the offensive primitive self. Baselitz's increasingly roughhewn, shredded figures restate the problematic of the primitive self, that really has nothing but its own thrownness in space—not even in the world, whose landscapes and objects themselves are shown to be indifferently thrown in space, for they reflect the primitive situation of the self. Baselitz gives us the self as an "expression" that cannot be spoken in the common language, not because it is uncommon but because it can only be "represented" by its own "unspeakable" primitiveness. Baselitz's archaic self can never fit in, because it has no objective sense of the outside system to which it might belong.

Baselitz depicts what Kohut calls "archaic grandiosity," more particularly, the narcissistically "grandiose self." Kohut argues that where art "in the second half of the nineteenth century and the beginning of the twentieth century . . . dealt with the problems of Guilty Man—the man of the Oedipus complex, the man of structural conflict—who . . . is sorely tested by his wishes and desires," the great modern artist "responds in depth to man's new emotional task . . . paradigmatic for man's central problem in our Western world," namely, "the crumbling, decomposing, fragmenting, enfeebled self of the child . . . later, the fragile, vulnerable, empty self of the adult."[2]

There are few contemporary pictures that so succinctly and precisely depict the self in transition between these two states as Baselitz's *Die grosse Nacht in Eimer* (1962–63). The isolation of the adolescent masturbating figure is every bit as crucial as its futile priapic state, its dubiously "heroic," desperate assertion of its power. Its demented, pseudo-adult appearance and its overall infantilism, emphasized by the giant phallus that is like a fragment that does not belong to it, that it is trying to add to its body—or keep from being taken from it—give the aura of an initiate

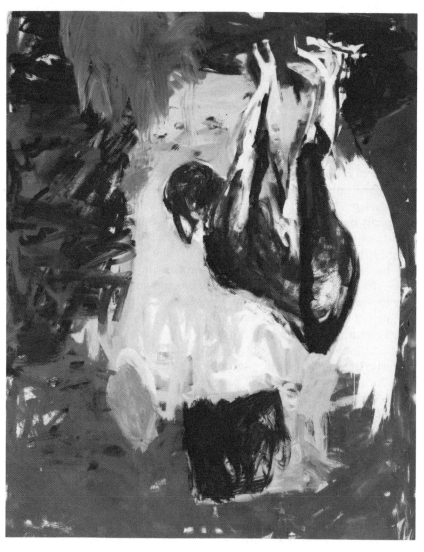

Georg Baselitz, *Die Aehrenleserin* (*The Female Gleaner*), 1978
Oil on canvas, 129″ × 97″.
(Photo by Zindman/Fremont; courtesy Mary Boone Gallery, New York)

in a melancholy mystery. This is the postwar German Osiris, looking for his penis. But he must restore it himself, for there is no postwar German Isis. The erotic is a tabula rasa in a grim, destroyed world. One can't help but recall Kohut's remark about "autoerotic fragmentation." For the immature narcissistic self—and primitivism, archaicism is a kind of immaturity—the penis is a fragment of the body that does not properly belong to it, perhaps just because it so completely articulates the primitive character of the narcissistic self. It has a primitive, immature look, an unsocialized look; this gives an added depth of meaning to the fact of Baselitz's expulsion from the East Berlin Hochschule where he studied painting for "social and political immaturity" (1957). Indeed, there is personal not social realism in Baselitz's painting.

I view Baselitz's later painting as advancing this image of degeneration. It splits in two. The child part grows into an image of the archaic grandiose self, and the adult part becomes the idealized parent imago, the heroic parent figure which haunts a good many of Baselitz's early paintings. It is childlike to turn things upside down to see what they look like; it pulls the everyday wings off their appearance, but gives them a new, primitive sense of grandiosity, ideality. But this grandiosity bespeaks vulnerability, paradoxically through the painterliness that communicates it. For that painterliness, in its slashing, lethal quality, is at once grand and destructive, bespeaking an archaic energy that eats into forms in the very act of fueling them. For Baselitz it is not just a case of resurrecting Franz Marc's notion that "all being is flaming suffering," but of showing that all suffering consumes yet recreates the self, demonstrates its primitive phoenix nature. Baselitz's painterliness conveys the phoenix-like purpose of primitive narcissism, aiming to renew the self in the fire of its passion for itself. The primitive narcissist does not want a picture of himself—he wants a self so full of passion it will never become alienated from itself. It will always possess itself because it will always be able to will itself. Primitive narcissism is a struggle to earn the right to have a will, because one has been able to will a self. It is this primordial grandiose act that Baselitz's powerful painterliness conveys.

Many of the paintings of women, such as *Frau am Strand* (1981)—but not exclusively them—articulate the most archaic sense of grandiose self possible. (Once again woman is mythologized, in the very process of being destructively "deconstructed," as the most vital form of elementary being and the caretaker of elemental selfhood, her most primitive functions.) The numerous early images of the hero, and the heroic figural sculptures, articulate the idealized parental imago, the primitive model for the primitive narcissistic self. It is a battered if still ideal hero; in Germany the heroes of the past, the parents of one's present ego, are enfeebled

and vulnerable, although able to muster more grandeur than one had supposed. But that is always the way it is with the parental imagoes of one's narcissism, for one's own self has not yet found its own ideality. Its grandiosity reflects that of its sources, mixed with one's own primitive vulnerability, the starting point for narcissism. The mix of weakness and strength, power and powerlessness, in all of Baselitz's figures exactly articulates the paradoxes of narcissism, with its mix of immaturity and grandiosity.

The various landscapes and still lifes articulate the world as the archaic grandiose self experiences it, making it also primitive—unripe—and grand. Baselitz's primitive painterliness—and the sculptures also are painterly, harshly archaic—shows the metamorphosis of paint into the archaic smile of matter, its immature smile of self-recognition, that is, of recognition of the first sense of self, the narcissistic sense of self. Narcissism has its root in matter knowing itself as matter, and thereby discovering itself as potentially more than matter. Paint is self-conscious in Baselitz, as though it was struggling to be more than matter; this is what allows it to be and not to be the figure it fulfills. The painterly figure is an archaic mode of representation, as is upside-downness, which restores the original, primitive sense of the fictional character of objects. We do not know they are real until they are touched—this the paint does—but they are never absolutely real to the primitive narcissistic self, which necessarily sees the world upside down to preserve its own sense of being right-side-up, even though its primitiveness necessarily makes it appear upside down. Baselitz's paintings show an archaic state of awareness of an archaic state of being.

Baselitz's greatness also consists in his restoration of the archaic sense of art that is at the root of authentic modern art, suggesting that its primitivism is the instrument of its aim of preserving a fundamental sense of self against all odds. In modern art the self is forced back to archaic narcissistic grandiosity because of the modern world's indifference to its existence. The modern experience has taught us to distrust those who offer us the readymade, whole self—the "new type" of self, as Baselitz calls it. Baselitz's primitive figures, writhing in their archaic grandiosity, are the irreconcilable alternative to the competent, everyday type of self. This completely socialized self has an advanced delusional sense of grandiosity, so sure is it of mastery through its machine-like or robotic character. Baselitz's figures regress from this conformist, obedient self to a primitive self that is too narcissistic to "fit in." Similarly, Baselitz's paintings do not fit in to recent conceptions of art as at once sophisticatedly yet ironically social, where irony barely keeps conformity away. Baselitz

sidesteps the entire paradigm of conformity and nonconformity by offering us paintings and figures that are too primitive to be categorized as conformist or nonconformist. Instead, they are regressions in the service of the ego, and the ego of art. They show us that neither art nor the self has to be diminished by not playing the game of belonging; instead, both can have the primitive integrity on which a more elaborate sense of both is based.

Paint flows in Baselitz like a premature ejaculation, one that in the very act of reaching toward its object refuses it, that in the very act of targeting its object forgets to aim. It seems too eager, but it is withholding; it withdraws into its own self-consciously spasmodic intensity, its own overaware eroticism. Paint is overstimulated in Baselitz, and increasingly discharges blindly. It increasingly goes its independent way, with libidinous necessity. It increasingly desublimates what it describes, and finally it "describes" only its own desublimation. There seems no limit to this apparent abandonment of mastery, the use of paint not to overpower objects but to give them up altogether. The only limit to the flow is the unconscious sense of narcissistic self; the flow articulates its fierce grandiosity, the self-willed character of the most ancient self. The archaic self seems to become one with the primordial flux, as if to keep it from its own experience of the abyss, of its own groundlessness. As in *Maria in Knokke* (1980), it approaches chaos, despite its own emptiness. But this emptiness can be read as fullness because of the narcissistic energy which buoys the self. For all its hollowness, the narcissistic figure is not a vacuum, because it is filled with a primitive flux that carries it beyond its disorientation.

Notes

1. Heinz Kohut, *The Analysis of the Self* (New York: International Universities Press, 1971), pp. 7–8.

2. Heinz Kohut, *The Restoration of the Self* (New York: International Universities Press, 1977), p. 286.

Pandemonium:
The Root of Georg Baselitz's Imagery

The Nazis took the equation of artist = mad = Jew as a program of action.

Sander L. Gilman, *Difference and Pathology*

It is well known that children under five years of age do not turn pictures around which they happen to hold upside down, and they recognize objects in an abnormal position more easily than do adults. Kohler comments: "In this sense they are for once capable of higher achievements than we are."

Rudolf Arnheim, *Visual Thinking*

This higher language, that of Tragedy, gathers closer together the dispersed moments of the inner essential world and the world of action.

G. W. F. Hegel, *Phenomenology of Spirit*

Before the word was the image: this is the premise of this essay. But what is the image? What makes it, at its best—as in Georg Baselitz—more potent than the word, and in the end untranslatable—unassimilable, unsocializable, unappropriable—by the word? It is harder and harder to produce an image that resists—defies, opposes—language, that cannot be completely swallowed or repressed by it. But powerful images do not communicate the way powerful words do—words which seek to have the emancipatory power of great images. Strong images are not novel language-games, easily played because they are structured by conveniently graspable differences between their parts. Strong images are not easily digestible consumer products in a game of communication.

The powerful image hits us all at once, overpowers and possesses us like a demon impossible to exorcise—spontaneously moves us, becoming part of us before we can even think of distancing ourselves from it,

This article originally appeared in *Arts Magazine* (Summer 1986).

of resisting it by getting a perspective on it. We can eventually recover sufficient composure to analyze it, but that does not eradicate it, nor diminish its influence and power over us. Thus, the strong image gives us an identity we didn't know we had—seems to quintessentialize our most intimate identity. Baselitz is one of the rare artists who produces images strong enough to evoke such an alien identity—one so repressed or unconscious that we cannot even imagine it to be ours. The image imagines it for us, and enforces the feeling that it is ours. Yet we consciously resist and reject the identity given us by Baselitz's images. They are gifts for which we are not grateful; they show us more than we can consciously bear. We cannot believe what they show even when we are confronted by it. Yet we subliminally experience his images as rooted in us and the roots of our being.

It has been said that every artist struggles to uncover and make his own one basic image. Worked and reworked, this key image becomes the substance of his art's vision. In Baselitz's case, it is an image that conveys a peculiar sense of human being-thereness (*Dasein*). Ultimately all art may labor to bring forth a sense of the specialness of human concreteness, even when it articulates the concreteness of nonhuman objects. (To show—as Baselitz does with great intensity—how art cares for the nonhuman, as in still life and landscape, is to show in its most basic form the caring that makes for being-human.) What is the radically different quality of human being-thereness that Baselitz articulates? I think it is intimated in the formula I quoted at the beginning of this essay: Baselitz offers a defiant dialectical transcendence (*Aufhebung*), through powerful artistic means, of the Nazi program of action that equated art with madness and Jewishness—that believed in the degeneracy of art.

That Nazi belief, which focused especially on modern art—so mad that it could not be corrected, and so had to be liquidated (the Nazi program of liquidation of modern art, the seriously mentally ill, and the Jews is all of a piece)—was the ironical confirmation and realization of the romantic conception of art's purpose: to disclose the fundamental madness of the subject as the root of all experience of being. Baselitz offers a dialectical reversal of the idea of the ''degeneracy'' or abnormality of modern art, restoring the romantic conception of it with new profundity. The Nazis corrupted the radical romantic idea of art's purpose; Baselitz responds ironically to the irony of the Nazi conception, defiantly asserting madness as artistically—and generically—normal. He uses the ''degeneracy'' of Modern art, which the Nazis and many other haters of it used to justify their attempt to repress, crucify, and exterminate it, in order to regenerate art as such—to reassert its power over life. Baselitz mobilizes the ''degeneracy'' of Modern nonobjective art to new purpose, giving the force of ''pandemonium''[1] it exemplifies a new lease on life.

Baselitz's early anti-heroes deliberately flaunt their "degeneracy" or madness. They are Hitler's victims become devilish, haunting Germany with its own mad aggression. The Nazis did not want modern art's demonstration of the madness that underlies existence (including their own), for it disturbed all sense of order and reason (*Ordnung und Vernunft*), seemed to undermine their very possibility. For the Nazis it was a Jewish and artistic conspiracy to make such madness manifest. Baselitz makes it more exhibitionistically manifest than ever. His art becomes part of the Jewish conspiracy to critically disclose the roots of being. The pandemonium of his pictures—he makes the pandemonium latent in the image as manifest as possible, to the point of disintegrating the image—is a postwar response to Nazi repression and authoritarianism, appropriating it for the higher purpose of artistic revelation of the madness that underlies art and existence in general. It is a demonstration that the subject exists through, and as, a pandemonium of forces, whose form is constantly being revised—is a palimpsest of forces.

T. W. Adorno has pointed out Fascism's basic "hostility to anything alien or alienating." This is inseparable from its authoritarianism, with its "conformism, respect for a petrified facade of opinion and society, and resistance to impulses that disturb its order or evoke inner elements of the unconscious that cannot be admitted." Adorno argues that there are works of art "whose mere guise is enough to disrupt the whole system of rigid coordinates that governs authoritarian personalities."[2] Baselitz means to give us such disruptive, disturbing works—images which generate pandemonium. His famous upside-down figures, disrupting the rigid expectations of ordinary petrified perception, are insubordinate. The uncanny flux of his images—at times delugelike, and in general like a secret process unexpectedly exposed or spontaneously candid—undoes the petrified facade of social appearances. The flux seems to flay alive the surface of the depicted objects. Baselitz's images are impulsive in a way disturbing to the opinionated mind, for they evoke the alienness of the unconscious as such as well as of repressed feelings for particular objects.

Baselitz uses impulsive handling—fictionally spontaneous or immediate touch—to mediate the authoritarian elements in life (the realities consciously conformed to) in such a way that they become alarming. They are defetishized and shown to be carried along on the rapids of a sometimes lyric, often violent, flux of becoming. The less petrified or rigid they become, the more "grotesque" and "fantastic" they appear to be in their being. The best Expressionist images, by reason of their quality of fantasy, are anti-authoritarian, that is, they break through the petrified social facade of conscious perception and restore alien, repressed content. Phoenixlike, the reality they render may rise from the flames of the

flux. Baselitz's images have been dipped in the river Styx. We hold onto them by the Achilles heel of their superficial familiarity—an indication of their petrification in our authoritarian consciousness—but the image we hold onto is "mad" and will arouse pandemonium in us.

The tension in Baselitz's images is between the repressive forces of authoritarian fetishization and the anti-authoritarian forces of artistic flux: between society's power of petrifying conformity and art's heroic fluidity which emancipates us from authoritarian tendencies. It is a paradoxical liberation, for the flux represents not only the restless dynamic of art but the feeling of alienation—of being negated—underlying experience of the petrified world of conformity and authority. Experience of "alien" flux brings us to life by articulating the power of repression, and releasing us from it. The flux represents the power of repression as well as "expression"—rebellion against repression.

For Baselitz, every clear and distinct ("real") appearance is a petrification or reification from which an existence must be liberated. Like Franz Marc, Baselitz demonstrates that "all being is flaming suffering"—a kind of madness—once it is free of its conformity to the authority of social appearances. (Marc wrote those words on the back of *Animal Destinies* [1913].) The Nazis experienced the suffering of being as alien—and absurd madness—and they read the art that attempted to articulate it as "degenerate." They could not imagine that their own authoritarianism, with its insistence upon petrifying conformity, was the real madness— the real enemy of life, an indication of serious disorientation to life.

Baselitz shows us the inauthentic madness of authoritarianism—with its repressive conformity, symbolized by respect for "normal" appearances and "normal" orientation in space and "normal" feelings— and the genuine madness of existence. This madness is inseparable from a sense of existence as suffering—as tragic. Baselitz's art is squarely located in what Erich Fromm regarded as the most fundamental problem of sociohistorical as well as personal existence: "the opposition between the love of life (biophilia) and the love of death (necrophilia); not as two parallel biological tendencies [as Freud thought], but as alternatives: biophilia as the biologically normal love of life, and necrophilia as its pathological perversion, the love of and affinity to death."[3] It is this opposition that is the source of suffering.

Adorno has written: "It is now virtually in art alone that suffering can still find its own voice . . . without immediately being betrayed by it. The most important artists of the age have realized this. The uncompromising radicalism of their works, the very features defamed as formalism, give them a terrifying power."[4] The risk of art is always self-betrayal in the beautiful, that is, the appearance that conforms to expectations, that has given up its alienness, madness, unconscious roots—

suffering. The risk of art is that suffering images remain enjoyable because of their stylization. Style is the enemy of suffering because it insists on pleasure, if only aesthetic pleasure—the pleasure of the simulated reconciliation of all oppositions, when none is realistically in sight. And then the issue is not the reconciliation of biophilia and necrophilia, but the triumph of biophilia over necrophilia—which necessitates relentless, self-conscious scrutiny for signs of necrophilia.

Baselitz's struggle is twofold: (1) to rearticulate the anti-authoritarian truth that all being is flaming suffering in such a way that authoritarian—petrified, conformist—being is consumed by the flames of the truth; and (2) to articulate it in images which do not themselves become authoritarian—fetishized, mechanically enjoyable, emptily or reductionistically formal (the truly degenerate).[5]

Baselitz accomplishes the first task by a kind of eristic dialectic of the object ordinarily given in perception. Eristic dialectic involves, in the words of Hegel, entering ''into the strength of the opponent [the petrified or authoritatively given] in order to destroy him from within.''[6] Baselitz's anamorphic scenes and upside-down figures and scenes—extensions of the anamorphic idea, that is, the idea of disturbed, alienated, mad vision that sees the unconscious meaning of what is seen at the moment of seeing it consciously—are inseparable from his eristic painterly dialectic. The anamorphic image, in its alien flexibility—in its anti-authoritarian character—creates a ''disperspective'' from which the unconscious truth can be ''perceived.'' By destroying the point of view and the line of sight, it liberates the perceiver from the control of perspective, emblematic of authoritarian control or social repression in general. This gives the perceived object a new libidinal power: the power of the depth. Baselitz's anamorphic images are charged with the aggression of disperspective and the libidinous energy of unrepressed perception.

Baselitz accomplishes the second task—avoiding stylistic closure—by this same destructive painterly dialectic. But now it is experienced not as the unmaking of reified objects by the contradiction of them with flux—by making them suffer flux until they lose all authority, and thereby all banality (the ultimate authority of things is symbolized by their banality)—but as raw energy. Now the disintegrative power of the caustic painterliness, its nonconformist contradictoriness, the simple composure of the self-identical it precludes, the ''classicality'' of the smooth it mocks, its unstandardizable—uncategorizable—fluidity, its gestural intensity that bursts the boundaries of the concept, is experienced as pure power, able to sustain itself without style, needing none of the false unity called style. Baselitz's painterliness is now experienced not as a dialectical attack on the object, but as nondialectical contingency attacking style itself.

Both the object's authoritarian foreclosure on and reification of art—achieved by the object's insistence that it is the necessary subject matter of art, that it must be represented because it is primary while art is secondary, a "follow-up" on the truth of the object—and style's authoritarian foreclosure on and reification of art—achieved by its insistence that art have a certain destiny, code-named "style," which represents the forces of petrifying order and conformity raised to a sublimely new civilized level—are denied by Baselitz's drastic painterliness. Like Pollock's, it has the peculiar quality of being able to deny both the necessity of representation and of style while conveying the idea of art as a "mad" process—a process recovering and emblematic of the mad suffering of being, struggling between biophilia and necrophilia. (Fascism, having decided in favor of necrophilia by deciding for authoritarianism, represses modern art as "degenerate" or "insane" because it raises the spectre that the struggle is still not decided in favor of death. Much modern art is "distorted" because it shows the struggle to love life despite profound recognition of the love of death in the modern world.) Günther Gercken has described Baselitz's development as follows:

> Baselitz always emphasized the nonobjectivity of his paintings and defined the future development of art as the artist's true task. In order to liberate art from the limbo of abstract forms he first introduced the object into his anamorphic works. After an initial culmination in the great figures of the "New Type," he, in turn, nullified the image through the picture. The deconstruction of the object in the strip pictures and shred pictures accompanied construction of the image. This dissolution of the object prepared the reversal of motif which took place in 1969. This was no throw-away effect, but was essential for the painter as a means of creating the freedom for artistic values. It provided the detachment from the object and simultaneously made painting accessible to public judgment as well as citing the objects which held his affection. Nevertheless the reversal of motif can also be understood as a symbol which turns painting upside down: Baselitz conceived progress in painting as the destruction of habitual colour and form harmonies. The paintings disturb by their new colour combinations and extreme forms which create an "aggressive disharmony" (Baselitz). Baselitz is willing to brave any risk if this might roll back the frontiers of painting, balancing on a tightrope where success and failure go hand in hand. "B. plays high stakes, so high that to less hardened souls his art appears abhorrently superficial" (Per Kirkeby).[7]

In this description a constant tension and shifting between the values of the mimetic and the purely artistic (nonobjective) is ascribed to Baselitz's art. The tension is presented through Baselitz's notion of "aggressive disharmony": the disharmony is fruitful so long as it denies the dominance of either mimetic or nonobjective values. The oppositional character of this disharmony is the "degenerate" incarnate. It is the Jewish madness of insistent difference made into a source of artistic energy and survival. (Freud remarks that the Jew is accustomed to the position of

solitary opposition. The German seems to have inherited this position, both by reason of his conscious destruction of the Jews, which amounts to an unconscious assimilation of them—the "Jewish devils" will return eternally as part of the pandemonium of the German character masked by its rigidity—and by the historical fact that the Germans have always been outside Mediterranean civilization, which they vehemently resisted, which never conquered them [hence their "barbarism"].) "Aggressive disharmony" also states the inherently tragic character of the image as a vector that is the sum of the various unconscious and conscious recognitions which force themselves upon the mind in an unholy mix.

It is the tragic madness of the authentic image that has been ignored or denied in conventional accounts of the image—of what is at stake in seeing, such as that of Roland Barthes. Writing about Robbe-Grillet, Barthes asserted:

> There is, then, at least tendentially, in Robbe-Grillet's work, a rejection of the story, the anecdote, the psychology of motivations, and at the same time a rejection of the signification of objects. Whence the importance of optical description: if Robbe-Grillet describes objects quasi-geometrically, it is in order to release them from human significa-tion, to *correct* them of metaphor and anthropomorphism. Visual rigor in Robbe-Grillet (moreover, it is much more a matter of pathology than of rigor) is therefore purely negative, it institutes nothing, or rather, it institutes precisely the human nothing of the object; it is like the frozen cloud which conceals the void and consequently designates it. Sight, in Robbe-Grillet, is essentially a purifying conduct, a rift—even a painful one— in the solidarity between man and things. Sight, here, cannot lead to reflection: it recuperates nothing of man, of his solitude, of his metaphysics. The notion most alien, most antipathetic to Robbe-Grillet's art is doubtless the notion of tragedy, for in Robbe-Grillet nothing of man is offered as a spectacle, not even his abandonment. Now it is this radical rejection of tragedy . . . which gives Robbe-Grillet's endeavor a preemi-nent value. Tragedy is but a means of recovering human misery, of subsuming it, therefore of justifying it in the form of necessity, a wisdom, or a purification: to reject this recuperation and to seek some technical means of not succumbing to it (nothing is more insidious than tragedy) is today [1958] a singular enterprise and, whatever its 'formalist' detours, an important one.[8]

Is it possible to reject story, metaphor, and anthropomorphism, as Baselitz does, without rejecting tragedy, or rather without denying its om-nipresence (just that insidiousness Barthes acknowledged)? Is it possible to articulate tragedy without justifying it as necessity or wisdom? Is it possible to show that it is impossible to separate it from seeing—that it does not simply insinuate itself in seeing, but that the tension ("aggressive disharmony") tragedy represents is the very substance of seeing? I think so. Adorno's description of what makes for the tragic success of art is in fact an account of the tragic character of genuine seeing: an attempt "to integrate materials and details" according to an "immanent law of

form" but without trying "to erase the fractures left by the process of integration," fractures left by "those elements which resisted integration."[9] Seeing is not "purifying conduct"; it is insatiably "impure" and tragic—which is why the impurity of the tragic insinuates itself everywhere.

Freud implied as much when he asserted that "visual impressions remain the most frequent pathway along which libidinal excitation is aroused."[10] Society frustrates such libidinal excitation by insisting that it take artistic form, become aesthetically significant—civilize itself. Seeing must detach itself from pleasure by becoming realistic and recognizing fact. The "pathology" of "visual rigor" Barthes finds in Robbe-Grillet is in fact the pathology of repressive positivism, misplacing the libidinal concreteness of seeing into attention to fact. Dry " 'formalist' detours"— designed to frustrate libidinously wet seeing, undermine the erotically impulsive or emissive character of seeing—are the signatures of this positivism. Robbe-Grillet offers us castrated or sterile seeing; Baselitz's aggressive disharmony—his disperspective—restores the disproportion between the object and the viewer by emphasizing the tragically libidinous excitation of seeing, that is, its visionary character.

Baselitz's images, in their various permutations, articulate the inherently tragic condition of seeing as simultaneously impulsive and repressed. The tragedy and auto-eroticism inherent in seeing reflect the conflicted attitude of human being-thereness to itself: necrophiliac self-recognition through distance from itself—self-appropriation as matter-of-fact—in conflict with self-love as a primitive form of biophilia. Baselitz's early anamorphic images articulate this tragic auto-eroticism with paranoid economy of means. The anamorphic image embodies the madness of authentic seeing. It shows the objects that civilize seeing overthrown by the unrepressed power of seeing. The anamorphic image is truly a compromise-formation.

"Seeing," Freud said, "is ultimately derived from touching."[11] One is allowed to see many more things than one is allowed to touch. But there are certain things one is not allowed to see—things that are forbidden to be seen, except with a great deal of fuss, as though it were spectacle sport to see them (for example, the genitals). But the pornography of seeing is really not reserved, as Freud thought, for sexuality, but for death—dead things. The dead are allowed their "viewing," but it is even more restrictive than that reserved for the genitals. Freud thought seeing was displaced, in civilization, from the genitals to the naked body as a whole, which then acquired "aesthetic" interest.[12] All objects are ideally naked bodies, but to be a completely naked body is to be untouchable, except by those most intimate with one—and so in a sense

to be dead. The naked body is the most alive and the most dead—the most pleasurable and most painful—space we can encounter, yet not enter. These spaces converge unconsciously, making the body even more forbidding, more inviolate.

Baselitz paints—one might almost say massages with his paint—objects that look simultaneously like the genitals and the dead facts seeing would like to touch. His objects are at once libidinously charged with powerful touch and simultaneously deadened by it. On another level this reflects the struggle between the authoritarian object and Baselitz's libidinously fluid way of handling it in order to bring it into suffering life, freeing it from its alienness to itself. In their double charge, Baselitz's objects, treated at once with necrophilia and biophilia, become themselves forbidden. They are majestically uncivilized.

Dead things are not always literally dead things; they can also be things that are repressed, that seem dead to consciousness, but that are alive—indeed, according to Freud, in effect immortal—in the unconscious.[13] These include part-objects—Baselitz paints many such part-objects in his early works (from human body parts in the sixties to wings in 1973)—and in general infantile or primitive "impressions" of things, which Baselitz also offers us. The anamorphic image fuses an infantile view of undifferentiated relationship to the world of seeing—the world that mothers vision—and an adult attitude to potentially dangerous or death-dealing things. The anamorphic image signals danger but also merger with that source of danger, and signals attention to things that are dead because they are repressed in the unconscious: the anamorphic image is a tentative bringing them forward.

The tentativeness of this bringing forward is another manifestation of the tragic character of the authentic image—which is necessarily an anamorphic image, that is, one fraught with a repressed unconscious content struggling to come out. For example, Holbein's anamorphic skull in *The Ambassadors* is a reluctant bringing forth of an invisible yet subtly signaled—by a number of visual parapraxes—death. The anamorphic skull is a halfway house between complete unconsciousness and complete consciousness of death, showing how it is thrown into life whether life wants it or not. Baselitz's objects, figures, and scenes are anamorphically thrown in the same way.

The tragic tension of Baselitz's image is also conveyed through the specious presence of his objects. The concept of the specious present was coined by E. R. Clay (1882): "The present to which the datum refers is really a part of the past—a recent past—delusively given as a time that intervenes between the past and the future. Let it be named the specious present, and let the past, that is given by being past, be known as the

obvious past."[14] Baselitz's objects seem to be present, but in fact they are "memorable," that is, belong to the past. A speciously present object has what William James called a "penumbra" or "halo," that is, it is "the dying echo of whence it came to us [and] the dawning sense of whither it is to lead."[15] It is experienced as transient, as always about to change. This transience epitomizes its tragic character; it is the transience of objects which Robbe-Grillet's positivism most strenuously disavows. Baselitz's painterliness conveys this disintegrative transience with great poignancy.

In *Oberon* (1964) we see heads on manneristically elongated necks—as a child might see them, looming over him fantastically. This work, less primitive in its handling than other Baselitz works, although not without Primitivist touches around the necks, seems to me to portend the later images of the topsy-turvy world. It is the same mad, critical child's-eye view of the world as the upside-down scenes offer. The spontaneous reversal of the scene frees it from the repression of being real: the world has become pandemonium. Our disorientation signals our paranoia, but also our emancipation. Only in the condition of disorientation can we be ourselves—be subjects—for only in that condition is our suffering articulate, that is, ironically reified.

Notes

1. Baselitz's first "Pandemonium" manifesto was written on the occasion of his November 1961 exhibition with Eugen Schonebeck. Günther Gercken, in "Die Nacht des Pändamoniums," *Georg Baselitz* (Munich: Staatsgalerie Moderne Kunst, 1976), p. 19, has described it as a "manifesto, rebellion, demarcation, program, identification and homage, all in one. It stands under the star of Antonin Artaud," and expresses a desire to inhabit the position of other great spiritually ill artists, such as Ernst Josephson, Vincent van Gogh, August Strindberg, Friedrich Hölderlin, and the unknown artists whose works Hans Prinzhorn described. "Paranoia," writes Gercken (p. 21), "is the central word of the manifesto: paranoia-march, paranoia-ride, paranoia-leap, paranoia-death." It is not clear that Baselitz knew of John Milton's description of Pandemonium, the second hell, at the end of Book I (lines 670–798) of *Paradise Lost*. But Baselitz's early figures, especially in his group scenes, belong in the place of "all devils or demons," which in Book X takes on the connotations of paranoid confusion in particular and severe mental spiritual disturbance in general.

2. T. W. Adorno, "Commitment," *The Essential Frankfurt School Reader* (New York: Continuum, 1985), p. 303.

3. Erich Fromm, *The Crisis of Psychoanalysis* (Greenwich, Conn.: Fawcett Publications, 1971; paperback), pp. 191–92.

4. Adorno, "Commitment," p. 313.

5. T. W. Adorno, "Subject and Object," *The Essential Frankfurt School Reader*, p. 505, describes reductionism as "the type of seemingly anti-subjectivist, scientifically objective identitarian thought."

6. Quoted by Walter Benjamin in "Edward Fuchs: Collector and Historian," *The Essential Frankfurt School Reader*, p. 236.

7. Günther Gercken, "Figurative Painting After 1960," *German Art in the Twentieth Century, Painting and Sculpture 1905–1985* (London: Royal Academy of Arts, 1985; Exhibition Catalogue), p. 474.

8. Roland Barthes, "There Is No Robbe-Grillet School," *Critical Essays* (Evanston, Ill.: Northwestern University Press, 1972), p. 92.

9. T. W. Adorno, *Aesthetic Theory* (London: Routledge & Kegan Paul, 1984), p. 10.

10. Sigmund Freud, "Three Essays on Sexuality," *Standard Edition* (London: Hogarth Press, 1953), vol. 7, p. 156.

11. Ibid.

12. Ibid.

13. Quoted in Peter Hartocollis, *Time and Timelessness: The Varieties of Temporal Experience, A Psychoanalytic Inquiry* (New York: International Universities Press, 1983), p. 6.

14. Quoted in ibid., p. 3.

15. William James, *The Principles of Psychology* (Cambridge: Harvard University Press, 1981), vol. 1, p. 246.

At the Tomb of the Unknown Picture: Sigmar Polke's Art

As the work (under the auspices of Modernism) posits unintelligibility as expression, increasingly destroying its intelligible moment, the traditional hierarchy of understanding is shattered. Its place is taken up by the reflection on the enigmatic quality of art. . . . Lack of meaning may well be the intention of a work.

T. W. Adorno, *Aesthetic Theory*

Sigmar Polke's art has been described as dandyish, comic, pataphysical, dadasophical. It is supposedly a fresh "production of hypnagogical visions," a fresh demonstration of the "mind's powers of irritability," a fresh reduction of "the importance of the 'author' . . . to a minimum."[1] Polke is supposedly a new Picabia, showing a strong "taste for the ephemeral," itself the instrument of an "extraordinary taste for derision."[2] Is he recreating the Surrealist "marvellous" out of a new "cauldron of . . . meaningless mental images?"[3] If the marvellous is created by the "intervention of supernatural beings into a poem,"[4] certainly the "higher beings" who instruct Polke to make his pictures qualify as supernatural. And certainly "the negation of the real" effected by the marvellous is as much "of an ethical nature" in Polke's pictures as in Surrealist poems.[5] Certainly his marvellous is also "the materialization of a moral symbol in violent opposition to the morality of the world from which it arises."[6] Is he simply the latest version of the complete Surrealist nonconformist,[7] utilizing "the principle of the association of ideas" to create a dizzying new restless picture?[8] Is he the latest in a long line of twentieth-century artists to proclaim himself a Rorschach of art, another manufacturer of "delirium of imagination?"[9]

He is all that, but with a new twist, giving a new cutting edge to the unconscious. A picture by Sigmar Polke is a joker: the wild card that changes meaning at the player's whim. It usually has no fixed value, but varies from hand to hand, within the basic rules of the game. Its value

This article originally appeared in *Artscribe* (March/April 1988).

is chosen from the fixed range supplied by the game's system; there is "personality of choice," but choice is not infinite. The joker is a "free variable" adding piquant, if finally trivial, risk to the game. For however much it is in the player's control, it does not control the whole game. The player will never know if the way he played the wild card helped him win the game or lose it. But in Polke's case the use of the joker seems to change the rules of the art game, seems to undermine it, to overcome it, to pulverize it, so that it no longer seems to have rules, seems like a game. It becomes incomprehensible, enigmatic.

The protean card reminds the player that he is just in a game of art. It gives him a small amount of ambiguous freedom to contend with a large amount of fate (the fixed variables of past systems of style and meaning). He stakes everything on the freedom, that is, he attempts to increase the lack of fixed meaning, the wildness of meaning, unassigned value. This seems the way to outwit predestination. Free variability—that seems the weapon against fixed variables. In other words, the game already has a certain shape, which the player tries to bend: presumably, to bend it is to win it. At least for a while, before the player's own work of playing seems fated, even to himself.

Is that the whole point of the art game: to use the wild card to increase the sense of freedom against the odds of fate? Is it just another metaphoric gamble against high odds, in which the game is never beaten for long? Is it just another game of chance in which the illusion of freedom is pitted against the reality of fate—an ultimately uneven warfare? For all his awareness of other players, the player is ultimately alone, playing against himself. In this situation of solitaire the game of art comes to seem very oppressive, stale, and boring, even with the wild card, even when it seems to be creating a "miracle," that is, "an extraordinary displacement . . . an unexpected disorder, a surprising disproportion"—the very substance of "the negation of the real," that is, of fate.[10] But in Polke's art this heavy sense of ennui is completely overcome: Polke seems to have increased his original stake of freedom, made the art game seem completely free, infinite in its possibilities, free of fate—completely enigmatic. How does he accomplish this?

The player's intense boredom registers his unconscious sense of being engulfed by the feeling of fate the game invariably brings with it— the sense that the odds will never be overcome. The player fleetingly intuits that he is getting into a cul de sac of inescapable rules and terms, subjecting himself to limits, that the whole meaning of the game resides in these limits, this subjection, in this implicit admission of loss at the start. So there is always claustrophobia playing it; but there is also narcissism, which the ennui also masks, which lies deeper than the feeling

of engulfment by fate. It is this narcissism that Polke mobilizes to beat the game by destroying it. He wants to make it into the mirror of his narcissism, and he does so by making it completely enigmatic. He fights ennui with enigma, fights the feeling of fate by generating a sense of impenetrable enigma. He creates a strong sense of enigma—as engulfing as the sense of fate, a kind of antidote to engulfment by the sense of fate—by playing all the cards of the game wildly, even blindly, each being assigned an arbitrary value rather than according to the rule which established the range of values. Arbitrariness, the ultimate freedom (the grandest form its illusion takes?), is profoundly enigmatic: Polke exploits the enigma of arbitrariness for all it is worth. (Through Polke's work, art again proudly shoulders the charge of being "arbitrary," once the sign of its modernity, now, more extreme than ever, of its Postmodern dissolution of Modernity.)

He plays a kind of Russian roulette, staking the very existence of the game with every move, and so keeping it excruciatingly vital, urgent. There is always the morbid expectation that the game might end in disaster at any moment—might become "tragically" meaningless, too much of an enigma—but there is also the unusual vigour with which the game must be played because it is risked at every moment of play. With all the cards wild and wildness no longer having any definition because there is no longer any meaning to the rules, and so no meaning to tameness, the game becomes more and more angry in its arbitrariness. The effort to make every move in it "existentially" meaningful—to make its existence hang on every move—makes it seem more and more meaningless, arbitrary. It becomes simultaneously abysmal and superficial, intoxicating and despairing. Arbitrariness becomes a compulsion in Polke's art, and through it he discovers the arbitrariness of art itself. The compulsiveness with which the art game comes to be played—trivially suggested by the infinitely open series Polke creates—is the precipice on which it can stumble, over which it can fall.

The art game, in Polke's hands, comes to have gnostic import. The picture becomes "crazy"—completely uncontrollable. Polke is Mephisto phelean: he tries to conjure up the ultimately meaningful, tantalizingly profound picture, hinting that it is just out of reach. He seems to offer us pictures of the unconscious in formation, of the unknown coming into being—incredibly rejuvenating but also depressing pictures, fragments themselves and full of fragments, needing repair into a wholeness that can never be named. He rejuvenates the art game by making it feel full of promise, but it is a never fulfilled promise. His pictures create their aura of profound meaningfulness in part because they convey the meaninglessness of the idea of completeness while tempting us

with it. A vague new "vision" of meaning is created. Every picture is speculatively interesting, enigmatically unfinished. And yet each picture makes the game of art seem like freedom manqué. There is reprieve from absolute meaninglessness, but no clear meaning—only unknown meaning.

The joker approach to art, as the only approach that gives it a new chance in life after it rigidifies into style, imprisons itself in the aesthetic—the only approach that seems to start the art game from scratch with each work—effectively began with Duchamp. This master joker knew that arbitrariness was art's last hope, and that it was increasingly necessary, had to become increasingly refined, if it was to continue to work, to save art from itself, from its own tendency to banalize itself in rules and systems. Every particular game of art sooner or later—these days, sooner—becomes boring, fraught with fate, and thus meaningless for the sense of freedom so necessary to feel human. For Polke, the whole modern version of the game became meaningless. It had nowhere to go but back to itself—back to Modernity, a rapidly emptying phenomenon, a labyrinth from which there is no escape. Modern "experiments" seemed like steps in this labyrinth, steps full of the same blindness as that of a person lost in a wilderness and unwittingly circling back to the place he first realized he was lost. This circling is at once a detour back to a mythical self-identity and a struggle in a strait-jacket which tightens it. The joker approach to art became the only way of escape, the only way to defeat Modernity while seeming to insist upon and invoke it. Art once again acquires special meaningfulness by becoming an enigmatic joke—not just experimental to demonstrate its modernity, but arbitrarily experimental, speculative to the point of itself becoming unstable, almost completely obscure—speculative not to recover hidden meanings, but to create meaninglessness, to become mired in enigma (the unmentionable, the ineffable).

The pursuit of unintelligibility becomes the most exciting art practice. It is not an easy practice, for it is hard to shed intelligibility, especially after centuries of struggling to achieve it. Art's unintelligibility becomes the most enticing, appetite-whetting thing about it. The best—only—art is a pithy joke of unintelligibility acknowledging the inseparability of the sense of fate and freedom. Unintelligibility is invariably, richly "suggestive," which is part of its joke. It seems like a "hot foot" given to conventional meaning in order to generate an unconventional meaning, verging on meaninglessness. It exploits all orders of meaning to create the possibility of absolute meaninglessness.

Polke carries this pursuit of unintelligibility, by which art functions as a court jester, to a new, reckless gnostic extreme. In Duchamp the jok-

ing assignment of artistic value to the ready-made nihilistically mocked the game of art without abolishing it. That is, it mocked but did not deny the institutional definition of art. And it created a new naiveté, broadening the boundaries of the institution of art to include whatever anyone who declares himself to be an artist declares to be art, that is, to include the mad.[11] In Polke something both more nihilistic and more subtle occurs: art's ability to convey unspeakable, unintelligible "depth" is put to the test, putting it in the position of doing away with itself if it succeeds. If art is really able to be inarticulate, it is not art; it is suicidal for it to pursue the unintelligible. And yet, as we will see, it is the only way to save itself from its own always imminent banality and the banality of the world. Art that is truly art is always in this double bind for Polke.

Polke's art can be described as "schizophrenic" in the Postmodernist sense that has been attributed to that appropriated term,[12] but this is to misunderstand it, as well as the import of the so-called schizophrenic. To allude to the Adorno epigraph, Polke's art demonstrates the *necessity* of unintelligibility to art. His best works show unintelligibility in action. Art historically understood, his "proof" of the necessity of unintelligibility signals the final throwing-off of the shackles of purity. Purity now reveals itself as repression of the expressive depth signified by enigmatic unintelligibility.

Polke creates the sense of unintelligibility through the extreme suggestiveness of his works. It is a suggestiveness which initially appears through the dizzying multiplicity and overlapping of systems of style and meaning—a pictorial situation in which it is impossible to give one meaning priority over another, which is why it has been called schizophrenic. There is a kind of free play of systems, in both imagistic and gestural signifiers. This playfulness tends to destroy differentiation—a tendency towards the undifferentiated that is particularly strong in Polke's competely gestural works, with their figures of "free speech."[13] But even the Capitalist Realist works (1963 on) show the same drift towards undifferentiation, partly through their integration of image and gesture.

The typical Polke picture, then, gambles with visual meaning variables with no sense of what might be won—what kind of determinate relationship between them can be created. A kind of joke is played on pictorialness as such, or rather, pictorialness itself becomes a joke. It is impossible to determine whether the nominal picture is a mediation of the world or an "immediation" of visual variables. It does not matter which it is, because it is neither. Polke creates a pictorial situation of extreme equivocation, where evocation is everything, but nothing is clearly evoked. There is no final, known picture. No hierarchy of forms is

established, so that connotation rambles. The joke of the typical Polke picture is that every element in it cancels every other element's attempt to dominate the scene—be *the* pictured thing.

The extreme suggestiveness of a Polke picture results from extending the Surrealist principle of free association to infinity, and thereby toward chaos, for that is what indecipherable infinity is. Association is pursued with a vengeance: a situation of theoretically complete translation of any one element into another is created. Art always involves association, but usually in a calculated way, designed to make the picture readable. Its connotations are kept under control, which is part of its coherence as a picture. The chain of associations can be comprehended by filtering the picture through some conventionally given interpretive system to which it implicitly conforms. This is true even for Duchamp's nonconformist works, and those of Surrealism in general. But in Polke there is no such more or less ready readability. Readability as such is discouraged. The chain of associations is incoherent, from whatever angle of approach. One can enumerate the systems to which they belong, but not find any system of interpretation to make the chain intelligible. Polke's works generate a portentous unintelligibility, reinvigorating the game of associations which art partly is.

It is worth noting that the gears of a Polke-like principle of infinitely free association grind away in the oeuvres of many American artists who rose to exaggerated recognition in the eighties. In them, his principle has become a rather set—heavyset—mode, almost mannerism, of operation: in a typical Postmodernist way, it has become "inflated" into an inertial system.[14] In Polke, the principle continues to operate in a suave, impish, and impertinent way. It is not used to generate a facile new kind of intelligibility. It is a still limber magical thinking, convincing us that the unintelligibility it generates is genuinely enigmatic, enchanting. It has not petrified into an "Old Master" flavor, as in Polke's American followers. One has only to compare any of Salle's works to, for example, Polke's *Kandinsdingsda*, 1976, to grasp this point, and to realize the great debt the Americans owe to Polke.

As noted, the principle of infinitely free (absolutely arbitrary) association—altogether precluding the interpretation that is the nemesis of Modern artists, whose greatest ambition seems to be not to be pinned down (in contrast to traditional artists, who feel interpretation confirms their work's legitimacy and enriches its meaningfulness)—is responsible for the enigmatic suggestiveness or illusion of depth in Polke's pictures, the sense that an intangible and tangled depth of meaning has become a tangible surface. Art's enigma—its gnostic potential—gives it credibility in the world of science and technology, and is a malevolent response to

Sigmar Polke, *Hochstand* (*High-Water Mark*), 1984
Acrylic, lacquer on canvas, 118″ × 88″.
(Photo by Zindman/Fremont; courtesy Mary Boone Gallery, New York)

that world in which intelligibility and rationality are assumed. Polke carries the insistence on art's enigmatic unintelligibility to fever pitch, in a last-ditch defense of art's "special insight." Art is special because it can articulate the inarticulate depths, that special indeterminacy—molten chaos—that lurks within the core of every intelligible articulation, including the structure of the psyche capable of articulation.

The attempt to create a provocative indeterminacy—a sense of unfinishedness—is hardly new, but it is rarely as thoroughgoing and sustained as in Polke. In Rauschenberg's first combine works, with their psychic equivalence of parts, and in all-over, polyphonic, or holistic painting, with its physical equivalence of parts, the parts are mutual, almost to the point where each seems translatable into the other (which is not the same as their being interchangeable). But not until Polke was the principle of equivalence—the logical conclusion of the steady application of the principle of infinitely free association—fully realized, was a pictorial situation created in which no pictorial part had genuine singularity and authority. Not even in Pop art, with which Polke's Capitalist Realism has been associated. Polke's abstract-parodic articulation of trivial objects exists not to elevate these objects ironically by making them the subject matter of art, but to assert their lack of authority and singularity, their lack of specialness, making all the more intelligible their emotional hold over us.

I have connected the suggestiveness generated by unintelligibility—it is the genuinely unpresentable, and the presentation of it is what makes art truly sublime[15]—with the possibility of complete translation. I use translation in its Freudian sense—an *Übersetzung* or "displacement," a "transposition" or substitution. Translation implies a process of symbolization, but in Polke's pictures symbolization is never more than tentative. Translation is mired in suggestiveness, as it were. There is a sense of transitional transposition—eternal transitiveness—in a Polke picture, which is exactly what gives the illusion of complete translation, without any element in the picture really achieving the substance of a symbol and without the work as a whole being symbolic. Displacement is perpetual, a process contributing to the effect of indeterminacy and unfinishedness.

It is also responsible for the "archaic" look of his work. This is not simply a matter of the nostalgic, "memorable" character of his sources—both high and popular art styles and imagery—but an effect directly correlate with the condition of unfinishedness. For what is unfinished appears to have emerged from an archaic/archaeological condition, that is, seems regressive in character, a relic or ruin of a forgotten layer of time and psyche. Technically, Polke free associates various elements on his

surface—or screen, as he calls it—to generate a regressive archaic/archaeological effect, as though he had excavated a past or dug to a deeply buried level of psyche, striking a highly cathected memory. (This means that the pictorial elements function as "screen memories," concentrating whole histories of experience and meaning in themselves, which is as close as they come to being symbols.)

Translation in general, as the psychoanalyst and literary historian Patrick Mahony has suggested, is "a truly nodal word, or . . . a unified field concept which illustrates the interaction of intrasystemic, intersystemic and interpsychic phenomena."[16] It is exactly this sense of interaction that Polke wants to create. Translation becomes the sign of a unity perpetually put off yet tentatively realized in the translation interaction. The elements in the condition of translation are not sufficiently synonymous to cohere, but their cohesion is always implicit in their translatability into one another. Polke is and is not the palm he frequently identifies with—translates himself into—but he is "potentially" it. The unintelligibility of the identification remains, and becomes a kind of intelligibility.

Clearly, such a "translation picture" is not so much a systematic unfolding as an erratic enfolding of the pictorial elements. The translation picture is a matrix chaotically compounding the elements rather than disentangling and expounding them. Also, translation releases the energy latent in the untranslated element. The element-in-translation is freshly liberated; to remain untranslated is to remain repressed. The energy that held the old associations in place—the energy of transference, that is, the innate tendency and power to associate—is set loose in the translation picture, where it exists arbitrarily and unchannelled, a dangerous live wire. There is an aura of uncontrollable sensual energy in Polke's works, emanating not from any one detail but from the over-all indeterminacy of visual meaning. Polke's translation pictures are therapeutic to the extent that they set elements that function superegoistically in translation motion.

Polke's masquerade of unintelligibility—lame-duck spirituality?—can loosely be understood in terms of Ruskin's conception of the "Turnerian picturesque,"[17] an idea that seems particularly applicable to Polke's recent, explicitly German images. (I am thinking of his meditative translations of concentration camp imagery and the "arbitrary" lines in the margin of Dürer's Prayer Book for the Emperor Maximilian. Dürer, of course, is the archetypal German artist. Polke also translated the outline of Dürer's clichéd hare into rubber bands (1968).) But it involves a profounder sense of the sublime—the infinite—than exists in Turner. For Polke, unintelligibility—the vehicle of the sublime—is not simply the

boundless but the out-of-bounds, the tabooed depths. It is the sublime of inner rather than outer nature—the infinite unconscious in which unalterable chaos reigns.[18] Unintelligibility is the psychotically sublime. Whether the sublime comes through the stencil, as in Polke's photo-derived works, or through his "arbitrary" hand, it remains fraught with psychotic implications.

The major moment in Polke's development occurred when he stopped making Capitalist Realist works and began making those that "higher beings" commanded him to make. This happened in 1966, with the *Vitrinenstück*, in which the higher beings commanded Polke to paint flamingos when he wanted to paint a bunch of flowers. They clearly meant business, as he remarked, for they would not let him do what he wanted to: they took over his will. For all their seriousness and determination, the higher beings did allow Polke to continue making lighthearted works in a Capitalist Realist vein. With their help, he was able to "spiritualize" the objects he was rendering by "abstract"—"higher"—handling. They began to look more improvised—less inevitably banal, more like sublime, suggestive screen memories—than ever. The higher beings really confirmed, and gave a vigorous push forward to, the "alchemical" tendencies already evident in the Capitalist Realist works.

Flamingos belong to the same tropical world as the palms with which Polke claims to have been obsessed since youth.[19] As noted, he explicitly identified with them. The higher beings, then, represent a decisive shift of orientation from the everyday external world of Capitalist Realism to the internal world in which one lives on the capital of one's fantasy—from the blatantly social to the covertly personal, from the exoteric to the esoteric. Palms, functioning as self-objects for Polke—to use the concept of the psychoanalyst Heinz Kohut—thus signal his narcissism. Virtually all of Polke's work since he heard the voice of his higher beings—his mock daimons—has been, directly or indirectly, narcissistic. Narcissism poses the problem of self-identification: Polke has trouble identifying himself as a person and artist, for he finds himself subject to socially given systems of style and meaning, and a German identity—a doubly cursed fate. He achieves his comic margin of suggestive arbitrariness—his parody of freedom and depth—by making these systems of identity seem unintelligible—by making identity as such seem unintelligible, a joke. Clearly, that does not allow him to have anything that might be called a true, core self, in the psychoanalyst D. W. Winnicott's sense of the term. It is to have a self-in-default, as it were. Polke's self is a refraction of broken systems of identity. To be a palm, after all, is not to have much of a human identity.

More precisely, Polke's work can be understood in terms of Freud's conception of secondary narcissism. Polke's libido detaches itself from the banal objects of the mundane world—the Capitalist Realist works show Polke's internalization of these objects, to the point of obsession, while tentatively proposing, through their abstractive rendering, the detachment that becomes evident in the works created by command of the higher beings—and reattaches itself to his own body and person, enhancing what little sense of self he has. According to Freud, such regressive narcissism—infantile self-attachment—occurs under pathological conditions. (Erich Fromm thinks that secondary narcissism is "normal" in our society, suggesting that personal and social psychopathology are correlate.)

In Polke's case, these are the pathological conditions of contemporary capitalist Germany, but they are hardly unique to capitalism and Germany. They exist as well under socialism and in underdeveloped countries. Polke's implicit recognition of this fact—there is no reason why Capitalist Realism is not also Socialist Realism—explains why he stopped making explicitly reality-oriented art and began making the apolitical, fantastic (unrealistic) art decreed by the higher beings. The works they use Polke as a medium to create do have a political point, but it is not addressed to any particular political system, and is more appropriately described as a psycho-political point, in the Dadaist/Surrealist tradition. The higher beings and their art exist to counteract—as an antidote to—the pathology of being modern. Their intervention in the pathological modern world expresses Polke's will to survive. The possibility of displacement to the higher level they represent affords the minimum illusion of freedom necessary to have a sense of self.

It is the pathology of banality that Polke struggles against. The fundamental point of the Capitalist Realist work is to acknowledge the pervasiveness of this pathology—of banality. Baudelaire regarded banality as "the only vice"; Polke's higher beings continue the Romantic tradition of rebellion against banality by commanding him to paint exotic creatures. They exorcise banality by exoticizing it. By achieving his identity in a fantasy world he gains the strength to fight against the banal real world, in which no true selfhood is possible. Yet the fantasy world—interiority—is in and of itself an alternative to the banal world. Polke seems to think it is real the way Gauguin thought his tropical fantasy was. This psychotic confusion counts for more than the utopian aspects of the fantasy world. Polke's "psychotic realism" suggests the intensity of his narcissistic need.

For all its tongue-in-cheek character, Polke's escapist exoticism is a basic weapon against the increasingly encroaching forces of banalization. They work through—their pathological character manifests itself decisively

in—what Breton called "miserabilism": "the depreciation of reality in place of its exaltation."[20] The beings who command Polke are higher because they have the power to exalt reality—which is what fantasy does—in contrast to Modernity's inevitable depreciation or banalization of it. This is why the pictures made at the command of the higher beings have an idealistic aura, however ironically.

This aura is another effect of their much noted "mobility." If "pathology can . . . be defined as the persistent reduction of autoplastic and alloplastic flexibility"[21]—the loss of such flexibility resulting in banality—then Polke's heroic attempt to be flexible is healthy. If enigmatic unintelligibility, with its "fantastic" aura of suggestiveness, is a condition of maximum flexibility, then it represents Polke's attempt to heal himself. At the same time, the extreme flexibility or suggestiveness of the enigmatic is also a sign of narcissistic disintegration. If "the principle function of the self-as-a-whole would seem to be the integration of all existing functioning into an organization that retains the greatest possible flexibility,"[22] then the same lack of coordination of the parts—disequilibrium—of Polke's picture which gives rise to the sense of flexibility signals the faulty organization of his self. This ambivalence suggests that Polke is masochistically vulnerable to banality—passively accepts his victimization by Capitalist Reality—as well as sadistically violative of it. Unintelligibility is both masochistic and sadistic, abdication as well as violence.

Polke's art as a whole is a decorative fantasy—an abstract recreation and invocation of the primal good-enough environment, to extend Winnicott's term. Polke's so-called parodic strategy—to "abstractify" banal objects or to revitalize banalized abstract styles (originally intended to escape banality) by ironically merging them, creating a farcical mix of standard styles (as in *Moderne Kunst*, 1968)—is decorative, that is, environmental in effect in the best sense. It creates the illusion of a good-enough "decor."

With angry sensitivity, Polke is aware that the modern world rarely satisfies our deep-seated need for a good-enough, facilitating environment—which is why one must create a good-enough, self-enhancing (self-facilitating) fantasy. Polke's flamboyant, decorative unintelligibility is of course his greatest fantasy—the ultimate refusal to reconcile himself to the banal modern world. Polke's decorative fantasies are all that "grey" Germany is not. Polke seems to imply that banality is an especially German product, the result of Germany's uncompromising obedience to order and reason. Polke's higher beings are incapable of being orderly and reasonable. Their "high" art mocks the highness of reason. Their irresponsibility and disobedience mocks the idea of a higher order reconciling everything. When Polke confronts contemporary Germany directly,

it is to curse it, as in *Das grosse Schimpftuch*, 1968. This string of curse words, expressing rage and despair, is perhaps Polke's ultimate, most telling Capitalist Realist statement.

Polke's work is at its most obviously narcissistic in the series of fourteen prints made after photographs titled *Höhere Wesen befehlen*, 1966/68, and in the series of gesturally treated photographic self-portraits, à la Warhol, made for the occasion of his 1983 exhibition at the Museum Boymans-van Beuningen in Rotterdam. Entitled *The Sixteen Most Important Contemporary Artists and Their "Bad" Breeding (Rückzüchtung)*, they are prefaced by a photograph of bacteria enlarged 12,500 times. These usually invisible creatures are described as "our little colleagues." Little Polke-viruses all, it is just through their witty appropriation of every other artist's identity that they suggest his confused sense of identity.

In these and other works, Polke treats himself as both subject and object; in the prints, he literally presents himself as an object, the palm. His works in general hover indeterminately on the borderline between subjective and objective expression. We cannot tell which they are, as little as we can tell whether they are nonsensical or profoundly meaningful. Their alchemical, "anamorphic," visionary/hallucinatory character is crucial to their unintelligibility.[23] The "intoxicating stream of color"[24] characteristic of many of them, as well as their often "as if" Baroque linearity, confirms the "impulsiveness" of this unintelligibility.

Polke's pictures have been described as pastiches, but this is to understand them all too superficially. They in fact are and remain the first and foremost realization in visual art of the Postmodernist mission: to dissolve the banalized remnants of Deconstructivist/Experimentalist Modernist art—including the banal popular imagery it used to increase the deidealizing irony that contributes to the Deconstructivist effect (quintessentially against the idealization of art)—in the melancholy of an enigmatic art.[25] They renew art's claim to enigma in a way impossible for Deconstructivist art to continue to do. Enigma has become banalized into another experimental side-effect of Deconstruction. Polke makes it once again art's narcissistic core.

On the basis of a dandyish aestheticism verging on buffoonery, Polke restores the unintelligibility that is the major sign of enigma. He makes the picture freshly sublime, not by attempting to create an image of the sublime, in the traditional manner—which is even the case in American abstract sublime painting—but by making the picture sublime in itself. Polke's art demonstrates that enigma remains the last frontier and final fall-back position of art, its narcissistic—only—defense against the ingrained miserabilism of the pathological banal world. But this suggests that enigma of art is still a viable and heroic mode of criticality.

Notes

1. Max Ernst, "Comment forcer l'inspiration," English translation in *The Autobiography of Surrealism*, ed. Marcel Jean (New York: Viking Press, 1980), p. 271.

2. Louis Aragon, "Challenge to Painting," in *Surrealists on Art*, ed. Lucy Lippard (Englewood Cliffs, N. J.: Prentice-Hall, 1970), p. 49.

3. André Breton, "The Second Surrealist Manifesto" (1929), Ibid., p. 29.

4. Aragon, "Challenge," p. 37.

5. Ibid.

6. Ibid.

7. André Breton, "The First Surrealist Manifesto" (1924), *Surrealists on Art*, p. 26.

8. Ibid., p. 24.

9. Marcel Duchamp, "Interview," *The Autobiography of Surrealism*, p. 413.

10. Aragon, "Challenge," p. 38.

11. By encouraging everybody to become an artist by "choosing" an object as a work of art, Duchamp is in effect encouraging them to act mad. He plays upon the conventional idea of the artist as madman, a sort of socialized madman. More particularly, the concept of everyman-as-artist by way of the ready-made unites the grandiosity of the madman's "I am both Napoleon and Christ" with the self-deception embodied in the "emperor's new clothing" idea. The emperor, of course, is always divinely—arrogantly—right. These two principles of mad art-making—guaranteed to make mad art as well as to certify the artist's madness—signify the narcissistic overestimation of the self. Polke's own version of the artist-as-madman derives from Nietzsche's delusionary overestimation of himself—the explicit sign of his psychosis—as Dionysius and Caesar in one. But Polke, more hopefully, tries to use the Dionysius in himself to defeat the Caesar.

12. The argument for Postmodernist schizophrenia is presented at its most concentrated in Frederic Jameson, "Postmodernism and Consumer Society," *The Anti-Aesthetic*, ed. Hal Foster (Port Townsend, Wa.: Bay Press, 1983), pp. 118–22, and even more succinctly in Jean Baudrillard, "The Ecstasy of Communication," Ibid., pp. 132–33. It ultimately derives from Gilles Deleuze and Felix Guattari, *Anti-Oedipus, Capitalism and Schizophrenia* (1972; Minneapolis: University of Minnesota Press, 1983). From a psychiatric point of view, it involves a preposterous misunderstanding and misappropriation of the concept of schizophrenic pathology—a facile application of it to advanced capitalist society.

13. As Dierck Stemmler points out in his essay for the Museum Boymans-van Beuningen exhibition of Polke's work in 1983, "Since the early 1970s Polke's interest has increasingly focused on the properties of paints, solvents and binders, . . . on new painting, casting and 'welding' techniques and on 'faults,' chemical changes and destructive factors which he uses productively. In sketchpads and on single sheets of paper he studies similar effects using inks and washes together with water-soluble opaque paint" (p. 42). Gaston Bachelard, in *The Psychoanalysis of Fire* (Boston: Beacon Press, 1964), regards alchemy as a fantasy of rejuvenation, tying it to mental breakdown. He also says it is traditionally practiced by isolated bachelors, and can be understood as their

masturbatory activity. Polke's alchemistry involves the practice of Dionysian unintelligibility to regenerate the charisma of art.

14. I am thinking of Charles Newman's concept of "climax inflation," remarked in *The Post-Modern Aura: The Act of Fiction in an Age of Inflation* (Evanston, Ill.: Northwestern University Press, 1985).

15. I am playing upon Jean-François Lyotard notion of "the Postmodern [as] that which, in the Modern, puts forward the unpresentable in presentation itself," that is, subserves the sublime. "What Is Postmodernism?" *The Postmodern Condition: A Report on Knowledge* (Minneapolis: University of Minnesota Press, 1984), p. 81.

16. Patrick Mahony, "Towards the Understanding of Translation in Psychoanalysis," *Psychoanalysis and Discourse* (London: Tavistock Publications, 1987), p. 3.

17. John Ruskin, *Modern Painters* (Boston: Dana Estes, 1902), vol. 4, p. 16. Ruskin writes: "The essence of picturesque character [resides in] a sublimity not inherent in the nature of the thing, but caused by something external to it." This is the "lower picturesque" (p. 22). Turner practices the higher picturesque: the articulation of the sublimity inherent in the thing (p. 23). It involves a "largeness of sympathy" (p. 25).

18. Polke is clearly at home in chaos, that is, disintegration to a prestructural condition. D. W. Winnicott, in "The Manic Defence," *Collected Papers* (London: Tavistock Publications, 1958), p. 132 associates chaos with the fantasy of mystery, tragedy, death. Polke's mania seems both to reflect chaos and defend against its mystery.

19. Polke describes his identification with palms, and its effect on his art, in an autobiography in the catalogue of the 1976 exhibition in Düsseldorf, pp. 127–34.

20. André Breton, "Against Miserabilism," *Surrealism and Painting* (New York: Harper & Row, 1972; Icon Editions), p. 348.

21. Joseph D. Lichtenberg, "Mirrors and Mirroring: Developmental Experience," *Psychoanalytic Inquiry* 5 (1985): 204.

22. Ibid.

23. For a discussion of the visionary/hallucinatory as articulating a preverbal, and in principle unverbalizable, sense of self, see Adrian Stokes, "The Painting of Our Time," *The Critical Writings of Adrian Stokes* (London: Thames and Hudson, 1978), vol. 3, p. 163.

24. Stemmler, Museum Boymans-van Beuningen Catalogue, p. 41.

25. Lyotard, "What Is Postmodernism?" p. 80, distinguishes between the avant garde "on the side of melancholia, the German Expressionists, and on the side of [the Deconstructivist/Experimentalist] *novatio*, Braque and Picasso." I am arguing that the latter is essentially passé, and has been subsumed in the former by Polke and the new narcissistic melancholiacs, searching for integrity of the self in unintelligibility—an inherently melancholy project.

Arnulf Rainer: Self-Exposures

Here I was, a miserable worm crawling through the snot and spit
of creation, a cockroach on a junk pile, a fly caught on a honey
pot. . . . I was the toad that fell into the milk bowl and, fearful of
death, created such a storm, churning the milk with such terror
that it turned to butter.

Arnulf Rainer, *As a Toad*

What is initially remarkable about Arnulf Rainer's self-portraits—his so-
called "Face Farces" and "Body Language/Motor Poses"—is their fusion
of photograph and paint. This synthesis, so deftly achieved, between the
opposites of fixed, "realistic," intelligible photographic image and fluid,
fast-moving, seemingly inarticulate paint (forming its own abstract
"figure" of a gesture) not only extends our sense of the possible surface
an "action painting" might have, but of the psychic process implied by it.

It's as though neither photography nor painting were up to the task
of articulating Rainer's self-expression on its own. Rainer wants *both* the
manifest content communicable by the matter-of-fact photograph, and
the latent content communicable by the libidinous painterly process. And
he wants them simultaneously—all at once. Above all, Rainer wants the
instantaneousness characteristic of both processes to fuse synergistically
in a kind of pyrotechnic display of selfhood. Only through this doubling
of resources can the full expressive possibilities—the full excitement—of
the self be done justice.

Rainer suggests that each of his mediums—black-and-white photo-
graphic self-portraits, gesturally applied scribbles, blobs or fields of paint—
is insignificant in itself. But taken together, photography and painting
form a strong pictorial support for Rainer's project: uninhibited, seem-
ingly full self-disclosure. Rainer pictures the self in a dream state so ex-
treme that all sense of external reality seems lost—a regressive state, at

This article originally appeared in *Art in America* (April 1987).

once psychotic and spiritual, in which there is only the ebb and flow of unconscious life.

For Rainer, his photographic self-images are the conscious beginning of this process of refining expression—the starting point of a journey to the expressive unconscious. The process is in a way akin to alchemical transformation, in which manifest body and latent feeling mystically become one through the metaphoric fusion of photograph and painterly gesture. Using the photos as crude ore, he turns leaden everyday facial or bodily expression into the luminous gold of pure psychic expression.

Rainer's untouched photographs do not display the habitual expressions one uses to get along in the world. The physical expressions in all these photos, often taken under the influence of mind-altering drugs, are forced, distorted, artificial, sometimes tragic and sometimes comic, registering degrees of fear, disgust, rage, sadness, bewilderment, exaggerated hilarity and so on. In this way the photography begins the rebellious move away from the inauthentic toward the authentic, away from the civilized toward the demonic. The expression staged for the photo is Rainer's attempt to free himself of expressions that have become ''second nature'' in order to disclose his first expressive nature buried beneath.

Despite the fact that photographs have figured prominently in his work for about 20 years Rainer claims to ''detest the art of photography.'' In the self-portraits photography simply supplies the preliminary expressive information that he requires to articulate his trancelike, involuted state of self-absorption. Rainer uses the camera to document what he calls his ''psychosomatic'' expressions—mostly of his face, but sometimes of his nude or clothed body—at a variety of staged moments. Many of the images in ''Face Farces'' were taken in a photo-booth in a train station near Rainer's home. These days, Rainer poses for a professional photographer.

The selection of likely images (from the hundreds taken at any one time) is made by Rainer on the basis of his feeling for what is most expressively essential in himself. The chosen few photos are then rapidly worked over in oil paint or a combination of oil crayon and India ink by a process Rainer calls ''overpainting.'' Sometimes Rainer uses slashes of paint to accentuate or fix features in the self-portraits: an arrowlike slash pierces Rainer's torso in *Erster Einwurf* (First throw-in); paint forms a quivering mandorla around his nude body in *Scheinheiliger* (Sanctimonious); both works are from 1972. At other times one senses an attempt to obliterate the photographically given image altogether, as if to undermine or violate or deny its givenness. In such works, the self-portrait seems to recede into the distance, the nearly opaque web or wall of paint asserting itself as the rightful subject of the picture.

While several recent shows in New York, most notably those last fall at the Grey Art Gallery and Galerie Maeght Lelong,[1] featured Rainer's self-portraits, arguably among his most profound works, they form only one part of a complex, 40-year career which has alternated between photo-based images and work that is entirely abstract. These two phases have developed in overlapping series frequently sustained over long periods.

Rainer was, during the fifties and even into the sixties, essentially an abstract painter. His earliest paintings (1949–51) are Surrealist-inspired *informel*—an art of first impulse. These were followed by the related "Vertikalgestaltungen" (Vertical forms), 1951; "Zentralformationen" (Central forms), 1951–52; and the first of his "Blindzeichnungen" (Blind drawings), 1951, whose weblike strokes of pencil or chalk adhering into various shapes foreshadow the effects of his crucial series of "Übermalungen" (Overpaintings)—obsessive, monochromatic reworkings of paintings by Rainer and by others, which occupied him from 1954 to 1965. The experimental "Proportionscollagen" (1953–54), with their regular stripes of different widths, explore the effects of colors on two-dimensional surfaces. The painterly monochromy of the "Übermalungen" and such series as the "Dunkel Bilder" (Dark paintings), 1956, resemble, and often anticipate, monochrome paintings by Rothko, Klein, and Tàpies.

But if Rainer's formal concerns have always been a strong component in all his works, there is a parallel anti-formalist belief in painting as "spiritual consciousness," and a desire to unmask painting as "nothing but the connective tissue between the aesthetic and the metaphysical." Such ideas were nurtured by Rainer's discovery, in the fifties, of the writings of Artaud, Simone Weil, and Emil Cioran. He also at this time began his lifelong study of mysticism and Eastern philosophies. Otto Mauer, a Catholic priest Rainer met in 1953, encouraged the development of Rainer's mystical tendencies. (Mauer ran the Galerie St. Stephan, one of the most important avant-garde galleries in Vienna, from 1955 until his death in 1973; Rainer showed there from 1955 to 1970.)

The use of photographs as a ground for the gesture becomes prominent only in 1968, when Rainer initiated the "Face Farces," the first of his series of self-portraits. Over the next 10 years or so, he would overpaint photos of himself, Expressionist art works ("Art on Art," 1969–79), pornographic images of women ("Frauensprache," 1975–77), death masks ("Totenmasken," 1970–83), corpses ("Totengesichter," 1979–80), photos of the destroyed Hiroshima (1982) and, recently, various images of the crucified Christ. He began, in 1985, to do overdrawings of photos of eighteenth-century botanical and zoological drawings as well.

In 1969, while painting over the cheeks of one of his self-portraits, the brush broke in Rainer's hand. Switching, in the frenzy of painting, to his hands, Rainer was so pleased with the result of this "face-slapping"

that he decided to make it a "new autonomous technique." In 1973 he began two series of pure paintings, the "Gestische Handmalerein" (Gestural hand paintings) and the "Finger- und Fussmalerein" (Finger and Foot paintings), which were done with his hands and/or feet. The forms of marking perfected here were applied by Rainer in some of his later photo series and in the brilliant "Kreuz" (Cross) series of paintings begun in 1980.

Rainer's mysticism, which has inflected his art almost from the beginning, finds its most concrete manifestation in the process of overpainting. The image (the photo) is inadequately expressive compared to the impulse (the gesture), and the overpainting is the triumph of the impulse over the image. More particularly, Rainer conceives of overpainting—whether with the paint brush or with fingers, hands or feet—as, in his own words, "a means of destruction" of the given worldly image, and of release and "perfection" of the energy it embodies. In a sense, Rainer conceives of overpainting as a kind of atom-smashing: a discharge of high-energy particles of paint which, smashing into the image, release the expressive ("impulsive") energy in it. A generalized—pure, mystical, holistic—state of energy results, an ultimate, ecstatic articulation of expressive power.

It is especially in the "Ubermalungen"—the fully overpainted, monochrome works where gesture is all-consuming—that emptiness becomes radical. In the self-portraits, a kind of in-between state is attained. The "regression" to an undifferentiated energy state is stopped in mid-process, because its completion would mean Rainer's loss of self. He does not dare, in the self-portraits, give up the image of the self—convert himself completely into impulse—because to do so would be metaphoric suicide. No doubt his self-portraits tend, in their search for the irreducibly expressive, toward *self*-destruction, but because they do not give up the *image* of the self, they remain on the side of life. Mysticism, of course, implies a self-destruction of sorts—an annihilation of self in union with the godhead—and one might argue that Rainer is trying to make himself divine by metaphorically consuming his mortal body in the flame of his expressive gesture. The fact remains, however, that in the self-portraits the mystical process of self-transformation is incomplete.

Overpainting the works of others seems to fulfill for Rainer a different, if complementary, function. Generally, the impetus is the same: perfection through violation. But, specifically, Rainer seems to be working toward releasing in the image what is peculiar to it, by the application of a gesture chosen to correspond stylistically to his metaphysical sense of the original. One of Rainer's most important series in this respect is

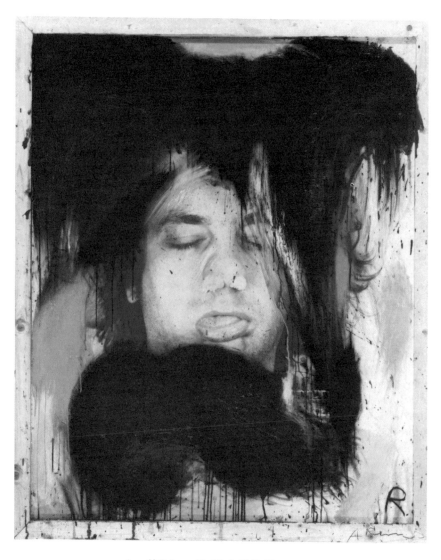

Arnulf Rainer, *Untitled*, 1969–71
Oil/photo/aluminum, 67″ × 54¾″.
(Courtesy Galerie Maeght Lelong, New York)

"Art on Art," overpaintings and overdrawings of photos of works by Schiele, Messerschmidt, van Gogh and Morandi. Schiele, Messerschmidt and van Gogh were obviously disturbed emotionally;[2] Morandi was a depressive and an introspective personality. Rainer's overpainting of the works of these artists may be understood as at once an appropriative identification with and mystical transcendence of them. Painting over a Schiele nude, a grimacing head by Messerschmidt, a van Gogh self-portrait, a still life by Morandi, Rainer seems to be seeking both to mirror the expressiveness of the original image and, somehow, to transcend its specificity, taking it to a higher, more abstract level.

Rainer's professed anti-sociality—he has said that he is determined "to find anti-social structures and to discover the 'Untermensch' within me"[3]—is inseparable from his mystical gesturalism. And the typically expressionist, anti-bourgeois aspects[4] of Rainer's mysticism is inseparable from his desire to return to the truly primitive bodiliness of the infant— the most primitive expression of the self. All of Rainer's extravagantly expressive poses and expressionistic gestures are infantile, as his nakedness in so many of his self-portrait photo-works clearly confirms.

There is an important if paradoxical correlation between Rainer's willed regression to the infantile and his ambition to be spiritual. Rainer says he wants "to use his psychotic talents to develop . . . an art devoid of pseudo-social wrappings." Not surprisingly, he has been much influenced by outsider art—*art brut*, the art of the obsessed, of the insane. He sees in the "drawings and autistic acting of catatonics" a release from the pseudo-social. The characteristic features of the autistic child have been described as "a profound withdrawal from contact with people, an obsessive desire for the preservation of sameness," and "mutism or the kind of language that does not seem intended to serve the purpose of interpersonal communication."[5] In his self-portraits, Rainer's expressionistic gestures—essentially homogeneous for all their variation in detail—are a mutist language overlaid on his public (photographic) appearance in order to withdraw it from social circulation.

He demonstrates that bodily language is the speech the mute child uses when all other language fails, or is not desired. We are not far here from the Romantic notion, informing much modern art, that the artist is a child with the analytical tools of the adult, which he uses to articulate his infantile psyche. Postmodern art, with its polymorphous perversity on a stylistic and historical level, is a further if ironical realization of this ideal of childlikeness in art. Rainer's regressive expressionistic bodiliness (his use of his hands and feet as painting tools) is an attempt to realize the "inner child" of the artist as completely and concretely as possible.[6]

Such a realization may also be understood as an articulation of the artist's fundamental spirituality—his inner withdrawnness from the world and greater closeness (than that of the ordinary adult) to his infantile fantasy life. This is the source of his narcissistic illusion of omnipotence—the self-proclaimed godlikeness of the artist. Rainer himself seems to think that no expression is impossible for him, and believes that he can put on the mask of any expression without suffering the consequences, that is, without becoming permanently possessed—deranged—by the temporary "act."

Looking at Rainer's work of the 1980s—the death masks, corpses, pictures of the incinerated Hiroshima, etc.—one might think him death-obsessed. And, in fact, a necrophilic impulse seems to form one pole of Rainer's art. The smothering splatters of paint which Rainer has applied over a photo of the death mask of the nineteenth-century German artist Adolph von Menzel may seem to disavow the fact of death; but the paint, in its forceful tactility, could be understood to embrace it as well.

Rainer's monstrous, if mesmerizing, death images, however, are counterbalanced by contemporaneous overpaintings of photographed crucifixes, and also by the recent "Kreuz" paintings, which in their impact and intent are clearly redemptive. Rainer had covered cross-shaped canvases with monochromatic drips of paint as early as 1956–57. In 1980, he returned to the motif. The newer Cross paintings, like the fifties Crucifixions, are monumental shaped canvases (most are about six feet tall), and they recapitulate the drips of the earlier canvases; but these works far surpass in expressive power Rainer's first attempts. Now the "figure" or "body" of the cross receives, in addition to the marks of the brush, the painterly blows of Rainer's hands, gestures which destroy and "perfect" it, in Rainer's sense of the word. Despite the ferocity of the attack, though, the cross is never entirely effaced. In every instance it remains legible; eternally threatened with dissolution, it manages to survive intact, dramatically uniting the ideas of death and resurrection.

And finally, Rainer has continued to make his self-portraits throughout the eighties. Existing somewhere between the extremes of the recognition of death and the search for spiritual rebirth, these apparently direct expressions of self have by now taken on a quality of secondary self-assessment, an almost critical capacity—perhaps inevitably, since the artist can hardly succeed fully in obliterating or transcending his own agency. One begins to sense in these works Rainer's lingering dissatisfaction with the overall results of his project, a lingering comic anguish, as though picturing the self could never be complete—as though expression could never be ultimate enough. I think this is why Rainer defensively

describes some of the self-portraits as "farces" or "face theater." It is, in effect, an apology for his failure to capture the ultimate expression— assuming there is one—by suggesting that the effort to do so is just another game, an extravagant play with set codes of expression (it is art, after all), and, as such, less anti-social than Rainer initially cared to acknowledge.

From this point of view, Rainer's supposed primitivism—his willed regression to the infantile—becomes more cosmopolitan and contingent than elemental. At the same time, the work suggests the slippery nature of the expressive self, which through its protean (self-)transformations continually eludes attempts at mastering it either through photographic or painterly means. Ultimately, one has only an open-ended, ever obsessively continuing series of images of the expressive self, the open-endedness implying the futility of the effort to capture or comprehend its expressive fundament. Indeed, carefully studied, each self-portrait declares itself to be more about the incomprehensibility of the self than about the tragicomic pleasures of self-expression. Such, finally, is the paradox of Rainer's art.

Notes

1. These New York shows provided an occasion for an appraisal of the work of this Austrian artist, who, despite a major reputation in Europe, is too little known in the U.S. "Arnulf Rainer Self-Portraits" was organized by curator David W. Courtney for the Ritter Art Gallery, Florida Atlantic University, Boca Raton, where it first appeared (Feb. 18–Mar. 29, 1986). It traveled to the Grey Art Gallery, New York (Sept. 8–Oct. 25, 1986), the North Carolina Museum of Art, Raleigh (Nov. 8, 1986–Jan. 18, 1987) and the Center Gallery of Bucknell University, Lewisburg, Pa. (Feb. 1–Mar. 8, 1987); it is currently on view at the Centre Saidye Bronfman, Montreal (to April 16, 1987). Concurrent with the Grey Gallery show was a small New York retrospective at the Galerie Maeght Lelong, which contained, in addition to self-portraits, examples of Rainer's "Ubermalungen" (Overpaintings) and "Finger- und Fussmalerein" (Finger and Foot paintings). Other New York gallery shows have included Rainer's "Uberdeckungen" (Overworked etchings), at Margarete Roeder Fine Arts, in the fall; self-portraits, several pieces from the "Kreuz" (Cross) series, overpainted photos of the head of Christ, and a number of "Blindzeichnungen" (Blind drawings) last spring at Alfred Kren; and a group of "Totenmasken" (Death masks) last month at Germans van Eck.

2. Messerschmidt has been analyzed as a psychotically disturbed artist by Ernst Kris, in *Psychoanalytic Explorations in Art* (New York: Schocken, 1964), pp. 128–50. Kris's discussion of "the schizophrenic artist's identification with God" (p. 150) would seem to apply to Rainer's work, even though his is an induced (simulated?) schizophrenia. Kris notes that this delusion often takes the form of a feeling of persecution by "the envious demon of proportion." Rainer's experimental "Proportionscollagen" (1953–54) are worth recalling in this context.

 Kris's analysis of Messerschmidt's grimace is applicable to Rainer's self-portraits, which seem to be a more or less direct continuation of Messerschmidt's self-portraits. According to Kris (p. 136), grimacing is often "a miscarried expressive movement, that is, when

a repressed tendency interferes with the sequence of the intended expression . . . and as an intended communication ('making a grimace,' 'striking a pose'). Both instances involve the expression of aggressive drives which in the first instance triumph over the ego and in the second are intentionally used by the ego.''

3. Arnulf Rainer, ''Face Farces,'' *Arnulf Rainer Self-Portraits* (Exhibition Catalogue; Vienna: Galerie Ulysses, 1986), n.p. All further citations from Rainer are from this source. Rainer's anti-sociality has taken public as well as artistic form. At the 1951 opening of an exhibition by the *Hundesgruppe* (Group of Dogs), an artists' group to which he belonged at the time, Rainer, according to reports, verbally insulted the audience. Rainer's uses of nasty, anti-social gesture in his self-portraits may be understood as an insult to the eminently social art of photography. His gestural articulation of landscape on coordinate map paper (1969–70) may be regarded as an insulting challenge to scientific ''law and order''—a rebellious assertion of personal terrain on a public map. His superimposition of gestural graffiti on architectural photos (1976) may be seen in the same way.

4. The revolutionary critique of bourgeois oppression that Expressionism represents has been discussed by Stephen Eric Bronner, ''Expressionism and Marxism: Towards an Aesthetic of Emancipation,'' in *Passion and Rebellion: The Expressionistic Heritage*, eds. Stephen Eric Bronner and Douglas Kellner (New York: Universe Books, 1983), pp. 411–54.

5. Cited in Phyllis Grosskurth, *Melanie Klein: Her World and Her Work* (New York: Alfred A. Knopf), 1986, p. 187.

6. Joan Riviere describes the ''turbulent phantasy life of the infant'' in terms that seem applicable to Rainer's self-portraits: ''Limbs shall trample, hit and kick; lips, fingers and hands shall suck, twist, pinch; teeth shall bite, gnaw, mangle and cut; mouth shall devour, swallow and 'kill' (annihilate); eyes kill by a look, pierce and penetrate; breath and mouth hurt by noise.'' Cited in Grosskurth, *Melanie Klein*, p. 223.

Imi Knoebel's Triangle

Imi Knoebel represents a strange union of opposites: Kasimir Malevich and Joseph Beuys in a single artistic identity. He establishes a working alliance between and with them, taking a Beuysian approach to nonobjective art, breathing astonishing new life into it. He is not the kind of appropriative artist who takes a knowing, self-congratulatory attitude to the historical art he or she "sophisticatedly" adapts; the limp advance that appropriation art represents—it is a kind of lame duck art—is not for Knoebel. Instead, he symbiotically unites with Malevich and Beuys to achieve his own autonomy, which can only further theirs. He emphasizes and strengthens the commitment of the artists he idealizes or models himself on—reincarnates—rather than discharging it in an empty copy.

Once, nonobjectivity was a rebellion against materialism, but today it has become materialism's major means of expression, both in the art world and outside it. In the hands of many artists, nonobjectivity has become dogmatic and empty, just another kind of bravura display. Artists like these have stripped it of its spiritual and emotional significance—its life-world import. For Knoebel, on the other hand, as for Beuys, art and life subtly cross-fertilize. It is no accident that the catalogues accompanying his exhibitions, usually designed by the artist and his wife, Carmen, alternate views of his installations with scenes of places and people important to him, as though to insist on the intimacy of the installations and on the influence of life on his work.

Perhaps the most interesting example is the catalogue for Knoebel's 1985 exhibition at the Rijksmuseum Kröller-Müller (Otterlo, Holland), with its juxtaposition of a photograph—of the cluttered attic through whose triangular window the five-year-old Imi saw Dresden burning after the Allied bombing of February 1945—and a very simple, schematic, thin sliver of a drawing of the artist's relief painting *Otterlo II*, 1985. The photograph

This article originally appeared in *Artforum* (January 1987).

of the place where a boy saw his world go up in flames contrasts vividly with the impersonal drawing, which is like an engineer's blueprint for an architectural monument. The catalogue is a family album in which dully realistic snapshots of personally charged places counterpoint works of art from which every detail that could betray the personal—could reveal emotional associations, or function as a sign of private experience—seems repressed to such an extent that one might not suspect that it had ever been there, that it might ever have been a motivating force for the art.

Otterlo II is a clean-looking white (the color of spirit) wall piece in acrylic on wood, consisting of a lower zone of four equal-sized flat rectangles on each of which sits a triangle (including a truncated one), no two of them the same size. This monumental space-marker has a secret, to which the photograph is a clue. The work resembles an altarpiece; the triangles are finials. They are also variations on the triangular window through which Knoebel saw Dresden burning. The symbol of a frightening, life-threatening scene is abstracted from its setting and run through variations.

Clearly the artist varied the triangle as if to signal the inexhaustible significance of the window for himself as a boy—the traumatic impression the scene of devastation he saw through it made on him. While remaining triangular, the structure of the window keeps changing in *Otterlo II*, as if each change proposed a fresh mastery of the deep anxiety it aroused, but a mastery that seemed inadequate as soon as it occurred, and so had to be renewed. In its flexibility or instability, the triangle becomes emblematic of Knoebel's deep, ineradicable feeling of vulnerability. It has a kind of controlled shakiness, or rather a shakiness that Knoebel seems to control but actually rides as though it were a breaking wave. Here, as in Beuys's work, art has become a way both to live with and to signify trauma. In nonobjective form, Knoebel expresses a strange ambivalence to the scene of destruction. He is both morbidly fascinated with that scene—putting the triangle through its variations, it is as if he cannot break away from looking out the window—and "abstracted" (distanced or detached) from the painful, confusing emotions it arouses.

Knoebel's energy seems boundless—his output is enormous. To my mind, his energy is a kind of pantomime of the destruction of Dresden. His work can be divided into "positive" and "negative" constructions, the latter almost Dadaist in their destructiveness; symbolically, he is constantly building up and tearing down the life world. I would argue, for example, that the *"Messerschnitt Serie"* (Knife-cut series, 1977), eccentric arrangements of cutout forms, are generically Dadaist, entropically chaotic antiart. Much of the gestural work that Knoebel has done seems to me more negative in import than self-assertive in the usual Expressionist way.

Yet this work is clearly concerned with the condition of the self, and with its ("artistic") response to the objective world. In view of his obsession with the traumatizing destruction of his childhood world, the photograph that concludes the catalogue for Knoebel's 1982 Eindhoven exhibition—a photograph of his two daughters and a friend, all asleep—becomes especially poignant. In its own way, the photograph is socio-political in import. It exists as an artifact of a secure world for these children, a world that will never be destroyed in a gratuitous, unnecessary conflagration such as the one that destroyed Dresden.

Many of Knoebel's works are variations on the theme of the altarpiece—abstract refinements of it, or of its constituent parts. Perhaps the altarpiece is the original visual *Gesamtkunstwerk*, intricately merging architecture, sculpture, and iconic image in one integral, flexible structure. In this sense it is the "perfect" work of art, sacred in import and sacred in its conceptual and physical unity of structure. Knoebel's work is secular—it argues no particular faith—but he is a profoundly religious artist, that is, an artist pursuing integrity of being. His work suggests that nonobjectivity at its best is the secular mode of religious art. It affords not simply a complexly integrated external structure for aesthetic mediation, but a structure whose contemplation integrates the self, fragmented into near-chaotic complexity by traumatic experience of the world.

Knoebel was one of the first of Beuys's *Meisterstudenten*, or "master students." In addition to being devoted to Beuys, who supported his efforts to make nonobjective art when nobody else did—when it was déclassé—Knoebel was fascinated by Malevich. (Beuys also supported Blinky Palermo's nonobjective interest.) In seeking and finding the human meaning in Malevich's nonobjectivity, Knoebel is bringing to it a Beuysian attitude to the regenerative function of creativity. He rescues nonobjectivity from the exclusively aesthetic significance and potential meaninglessness to which it has been reduced by the practice of regarding it narrowly as a demonstration of the autonomy of art, a practice that paradoxically goes hand in hand with its commodification, and with its utilization in what the Russian Constructivists called "production art"[1] or "industrial art,"[2] and what we might call "designer art." At the same time, Knoebel does not allow nonobjectivity to become merely illustrative of spirituality—a way of getting spirituality on the cheap, "directly," through facile sense experience. He shows us how nonobjectivity can catalyze spiritual sensibility: in Knoebel's work, nonobjectivity becomes a way of working through an experience—a kind of spiritualization process with no preconceived spiritual destination.

Malevich wanted to reach "the zero of form," the place in which the self could be "transformed."[3] The transformation would consist in the

"passing to consciousness" of "intuitive feeling," which would "no longer [be] subconscious"[4] but would articulate itself in "intuitive form."[5] For Malevich, to "mature in the consciousness"[6] meant to emerge into consciousness with crystal-clear form that could be contemplated for itself. Speaking about the process of crystallization in painting, he stated that "forms emerge from painterly masses" to become "ends in themselves."[7] For Malevich, intuitive form was geometric form. "Any hewn pentagon or hexagon would have been a greater work of sculpture than the Venus de Milo or David,"[8] he wrote, because the pentagon and hexagon represented the mature form of intuitive feeling—its emergence into clear consciousness.

Intuitively available as immutable, and recognizable as such by both the conscious and the unconscious mind, geometricality served Malevich to give sturdy form to formless feeling, to articulate it at its clearest. By his use of the geometric metaphor, he implied that intuitive feelings are states that can be combined like basic building blocks or crystals. That is, geometric forms represent irreducible units of primal feeling, "artistically" combinable to make a point about the nature of consciousness. (Malevich thought of the artist as "ordering crystals."[9]) The nonobjective artist, he believed, orders the crystals of form to create a "new life,"[10] that is, to generate a new sense of vitality based on full consciousness of "the energy of dissonance . . . obtained from the confrontation of two contrasting forms."[11] "In achieving this new beauty, or simply energy," the nonobjective artist is freed from "the impression of the object's wholeness."[12] That is, the dissonant, tense, energy-producing relationships among irreducible geometric forms objectify the power of intuitive feeling without cutting off that feeling in an object.

Energy, liberated and put to the work of consciousness, is the point of Malevich's forms, but since the Suprematist period we have seen that geometric forms, once objectified in art, can be regarded as ends in themselves, severing their intuitive connection to feeling. This is what it means to aestheticize—to "empty"—them. As Max Horkheimer says, "An art that thinks of itself as wholly free has become pure wall decoration . . . simply one element in a purposive arrangement."[13] "Works of art," Horkheimer adds, "buy their future at the expense of their meaning." One might say that nonobjective art assured itself of a future place in society—of consumer assimilation and success—when it developed along decorative lines, ceasing to function as an intuitive mode of divining and manifesting feeling. It became superior design. Or, as Marianne Brouwer says, writing about Knoebel's difference, nonobjectivity today, instead of fulfilling its original intention of undoing the "alienation that has come to [objects] . . . by [way of] scientific determinism and its

tedious 'realism,' " has become the opposite, "the doctrinary sign of some language of power . . . a formalist ideological exercise,"[14] which is so often what design is. Frozen charisma, the design object remains aesthetically seductive only so long as it is emblematic of an accepted ideology. It represents an unexamined, unconsciously assumed system of control.

Beuys showed Knoebel a way to free nonobjectivity from design. Beuys's "intention" in his art was to achieve "healthy chaos, healthy amorphousness in a known medium which consciously warmed a cold, torpid form from the past, a convention of society, and which makes possible future forms."[15] Nonobjectivity was vital and revolutionary in Malevich's day; today, it is an old language of art—"a cold, torpid form from the past, a convention of society." One can even say that it is the most "respectable" or ultimately socialized of Modern arts—much more than photography or film—because it slips so easily into elite, decorative design when that is what the circumstances call for. It has become emblematic of the social determinism of power, become an authoritarian— or at the least a bourgeois—manifestation of power. It has needed to be warmed up, revitalized, its dissonance made once again emphatic.

In much contemporary nonobjective art, dissonance has been domesticated; what dissonance there appears to be accords in the end to a consonance. In contrast, both Knoebel's individual works and the larger installations that incorporate them are open systems. He recovers a sense of dissonance by the radically "spontaneous" and disjunctive relationships he creates between intuitive forms. Even more crucially, Knoebel, through his rejuvenation of dissonance—his radical reenvisioning of the tense relationships between intuitive forms that Malevich first made manifest—means to realize Beuys's conception of "social sculpture," giving it a nonobjective formulation. Beuys used organic materials such as felt and fat; Knoebel uses industrial materials, particularly fiberboard. Beuys tried to "grow" a work of art, conceiving it as bound to a natural ecology of action which would "redeem" society; Knoebel constructs his work of art as an ecological act of craft within a social system of industrial production, which it would redeem. Only rarely has Knoebel used a found natural material, such as Beuys often used. One composite work, however, a homage to Beuys—*24 Erste 1986*, or 24 January 1986, the day after Beuys's death, and the day Knoebel heard that Beuys had died— includes a bit of dead tree. The piece harks back to an early Beuys work, *Der Schneefall* (The Snowfall), 1965, in which Beuys blanketed three stripped tree trunks with layers of felt, as if planting or bandaging them in fresh, healing, amorphous soil.

For Beuys, "the totalized concept of art . . . in the end refers to everything, to all forms in the world. And not only to artistic forms, but

also to social forms or legal forms or economic forms, or also agricultural problems or also to other formal and educational problems. . . . It refers principally to every man's possibilities to be a creative being and to the question of the social totality."[16] The "totalized concept" was for Beuys finally a question of humanism: "humanism can best be further developed through art."[17] Beuys saw art as a means of maximizing the possibilities and the scope of creativity, making for a "world that lived in the spirit," a world in which "one would need have no fear."[18] Malevich's nonobjectivity was an attempt to maximize the possibilities and the scope of art; it was a demonstration not only that art can be totalized as form, but that form is applicable to the difficult problem of feeling. Knoebel renews Malevich's project, and, under Beuys's influence, deepens it, reaffirming Beuys's belief in the healing power of creativity and overcoming the petrification and design rigidity to which nonobjectivity had succumbed. Malevich rejuvenates his faith in the power of art; the figure of Beuys rescues art from the exclusively aesthetic clutches of commodification and from the appropriation of nonobjectivity by an ideology alien to it, despite the fact that Beuys's own ideas, with his cult status and then his death, are likely to fall subject to the kind of misappropriation and decline that Malevich's nonobjectivity experienced. Each helps save the other in Knoebel's work, where different kinds of art have come together in the same cause, asserting the healing power of art.

To see art as a power of healing is to reaffirm the possibility of changing a problem-ridden world. Historically, this "will to heal," of course, like every will, can become willful, can have dangerous authoritarian potential, for it can be imbricated in a desire to make the world over according to an image of health that denies all human difference, holding some works up as patterns for a society to follow while suppressing all other works. Certain art, too, has in fact shared such conformist impulses. Inherently, however, the process of making art involves an openness to ideas and to criticism that is fundamentally antitotalitarian, and art, unlike politics, also has a quality of fiction, of symbol. It proposes models rather than issues orders. It is possible for an artist's "will to heal" the world to enable a preservation of faith in that world—Knoebel's environments of nonobjective art do so—and also for the work itself to imply a critique of the authoritarian tendency. Knoebel's installations, for example, are remarkable for their versatility, which suggests a robust creativity not unrelated to Beuys's, and also a creative belief in difference and nonconformity that works against the totalitarian possibilities of the idea of the total work of art, or the *Gesamtkunstwerk*. These works face the problem of totalizing a world without totalitarianizing it, that is, without insisting

that everything in it conform. Every individual work by Knoebel is destined for inclusion in the *"Weltall"* of one of these environments, with no loss of its particularity in the totality. Skillfully playing dissonance, he generates a tense space, beautiful with energy.

From *Raum 19* (Room 19, also called *Hartfaserraum*, or "Fiberboard Room," 1968), through the spaces creatively articulated by his light-projection projects (*Aussenprojecktionen* [Outside Projections], 1970, *Projektion X*, 1972, or the ca. 250,000-piece *Bleistiftzeichnungen* [Pencil Drawings], 1968–73), to his well-known *Genter Raum* (Gent Room, 1980), a 461-piece work, and his *Radio Beirut* installation, 1982, Knoebel has thought in terms of installation complexes and complex installations; even his works in series are virtual if not literal installations, which is in part why they are executed in hectic abundance. This holds for works from the ongoing *"Konstellationen"* (Constellations), which, in 1975, took over the Düsseldorf Kunsthalle, through the ongoing *"Mennigebilder"* (Red-lead paintings, begun in 1976 and planned to consist of 2,426 works), and the *"Messerschnitt Serie,"* to the *"Drachenserie"* (Dragon series, 1980–81) and the *"Ritter"* (Knights, 1981). These works are quite various in their elements, but they all have one principle in common: a totalization that involves a fusion of elements of painting, sculpture, and architecture (or more properly, of elements derived from them) in a single environment/installation. The complexity of this fusion maximizes tension and dissonance, and establishes an intuitive wholeness, an intricate if idiosyncratic "system" of relations between all three fields. Knoebel creates nonobjective environments which operate at once optically, sculpturally, and architecturally, and thus he offers an ideal model for the creative revisioning of the world, a demonstration that possibilities remain for giving it significant, other form, despite the contemporary no-doubt-justifiable world-historical despair. The *Genter Raum* is an example, with its nonobjective "pictures" climbing the wall as well as piling up on the floor, and its "gestural" shapes cluttering the space. But there are also simpler, more obviously elegant works, such as *Mein Freund* (My Friend, 1985), an "Egyptian" construction of fiberboard topped by a black painted square—the square once again "supreme." (Such pieces are not closed in back, suggesting not so much an enclosure to be conceptually completed as a mysterious openness—a "possibility"—known only to the artist.)

Knoebel moves with extraordinary ease between gestural and geometric identities and possibilities, synthesizing them in a seemingly infinite variety of ways. He has a flexible sense of color and surface, and can incorporate found objects in his works or do without them. Like Beuys, he makes peculiarly "deviant" use of ordinary materials: most

of his sculptural reliefs, for example, are made of fiberboard, in a redemptive use of that everyday medium. He can as easily make various homage pieces to Malevich, such as the "*Russische Wand*" (Russian wall, 1968/'86) works and the works in the vein of Malevich's "aerodynamic Suprematism," as construct reliefs that are ambiguously altarpieces or cabinets or coffins. The flat Malevichian wall pieces are highly refined, the more projective reliefs have a rustic, carpentered look; both are minimalist in import, and they are often combined in a single construction—a miniature installation. Knoebel also paints vigorously, in gestures of great intensity yet seeming ease of execution, as in the various "*Entscheidungszeichnungen*" (Decision drawings, 1983–85). And, as has been noted elsewhere, he can make cutouts, as in the "*Messerschnitte*," which remind one of the anarchistically spontaneous shape and brilliant individual colors of the late Matisse. He can make the geometric seem gestural and vice versa, as in his various light-projection pieces. There, straight lines function gesturally, and proliferate like gestures, apparently eccentrically changing in mid projection even when one knows they are predetermined—varied and combined according to principle or rule.

Knoebel has Malevich's cleaning-the-Augean-stables-of-art attitude and Beuys's sense of art's redemptive power. All three artists clarify art's creative purpose. They seem to have an essentialist approach to art, but in fact they broaden it by understanding it as a metaphorical healing activity—as purposive in the world. All three show that art is the place where creativity becomes self-conscious, as it were. And they seem to decode art, yet they want it to have psychosocial impact. Knoebel is a descendant of Malevich and Beuys, giving their ideas a new lease on life and making clear that the look of an art is far from its whole story. Artists who look incommensurate can unite not simply in theory but in practice.

Notes

1. Stephen Bann, ed., *The Tradition of Constructivism* (New York: Viking Press, 1974), p. xxiii. This is the term Naum Gabo used for art that threatened individuality by "utilitarian demands" fostered by "the intellectual straitjacket of Marxist doctrine."

2. Boris Arvatov, "The Proletariat and Leftist Art," 1922, in John E. Bowlt, ed., *Russian Art of the Avant-Garde: Theory and Criticism 1902–34* (New York: Viking Press, 1976), p. 229.

3. Kasimir Malevich, "From Cubism and Futurism to Suprematism: The New Painterly Realism," 1915, in Bowlt, *Russian Art*, p. 118.

4. Ibid., p. 130.

5. Ibid., p. 128.

6. Ibid., p. 129.

7. Ibid.

8. Ibid., p. 123.

9. Ibid., p. 128.

10. Ibid.

11. Ibid., p. 131.

12. Ibid.

13. Max Horkheimer, *Critique of Instrumental Reason*, trans. Matthew J. O'Connell et al. (New York: Continuum, Seabury Press, 1974), p. 99.

14. Marianne Brouwer, "For Imi and Carmen," *Imi Knoebel* (Otterlo: Rijksmuseum Kröller-Müller, 1985), n.p.

15. Quoted in Götz Adriani, Winfried Konnertz, and Karin Thomas, *Joseph Beuys, Life and Works* (Woodbury, N.Y.: Barron's Educational Series, 1979), pp. 107–8.

16. Ibid., p. 283.

17. Ibid., p. 255.

18. Ibid.

Alive in the Alchemical Emptiness:
Jannis Kounellis's Art

In 1969 Jannis Kounellis exhibited twelve live horses in an art gallery. This brings to mind one of Caligula's most insulting acts: making a horse a member of the Roman Senate. This act was more outrageous than any Caligula might have done in private, because it violated a public trust: Caligula's act effectively destroyed an institution by making us doubt it. He made a mockery of the Senate's authority, bringing the entire process of government into doubt. He raised doubts about the fitness of the ruling class, including himself. His act was efficient: overtly murderous and covertly suicidal at once—corrosive of the social body as well as self-esteem. Kounellis's act has a similar result: it effectively undermines the art space in which it occurs, at a single ruthless stroke putting in doubt the institution of art. What credibility does an institution have that can tolerate such an exhibition, that can give it the credibility of art? Is Kounellis simply exploiting the fact that art has come to be thought of as increasingly incredible, extraordinarily tolerant? Is he, through the especially extravagant exhibition of living creatures, showing that art is even more incredible and "romantically" tolerant than is assumed? Does he realize that his act may finally have made it meaningless to speak of an *art* exhibition space? An exhibition occurs, but one becomes increasingly reluctant to call it an *art* exhibition, except nominally—very nominally. It is only through grudging acceptance of a convention that one does so. Kounellis seems to mock the institution of art by treating the exhibition space as if it was a stable. Is he playing upon the commonly made allusion to a gallery's "stable" of artists? Does he realize that he is also undermining his own credibility as an artist? That he is declaring himself to be simply one more show horse? The particulars of the answer do not matter. What does, is that the exhibition space can never again be looked

This article originally appeared in C *Magazine* (Spring 1988).

at in the same way. Perhaps this occurred earlier in modern art history, when Duchamp began to exhibit his readymades in this century's second decade, and even more recently, when Beuys exhibited and communicated with a dead hare (1965) and lived for a week in a New York gallery space with a coyote (1974). But there is a special threat to the exhibition space in Kounellis's repeated violation of it with living creatures and other material informed with life, suffused with nostalgic associations to it.

Art has increasingly become an indefinable condition of objects exhibited for themselves in a space conventionally declared an art space. These objects are named to art because the space was first named to art. In modern times, this art space has come to seem logically prior to any objects exhibited in it. It was once the case that these objects were made for a particular space, whether sacred or secular, serving it as well as they could. Now there is a seemingly self-sufficient art space, with an integrity all its own, serving the objects exhibited in it by axiomatically declaring them to be art, a claim substantiated simply by the fact that they are in the magical art space. It is really an uncanny situation that Kounellis involves us in, all the more "classically" uncanny because the art space is essentially inanimate and "dead," while the living things he puts in it are animate or charged with animate life because they are its direct residues or, semiotically speaking, its traces.[1] It is as though Kounellis has reduced the space to an archaeological condition, so to speak, or forced its archaeological character out into the open: it is an excavated site, in which certain more or less living things are found—things once full of life and now, in their excavated condition in the art space, having about them the aura of suspended life.

For Kounellis, all kinds of things can be put in the art space: not only horses, but a toy electric train, a coat and hat, canaries, a parrot, bedsprings, an egg, wood, stone, various kinds of seeds, coffee, etc., as well as more familiar art materials, such as paintings and steel plates. This is not simply an intervention in the art space, designed to disrupt our consciousness of it, and to replay a by now familiar art/life dialectical/epistemological game. The art space is given: it cannot really be disrupted, only dismissed. We cannot get rid of the idea of art, however shaky it may become. It is numinous, an erratic regulatory concept "overseeing" or supervising all the phenomena declared to be art by being brought into the art space. Despite our intellectual efforts to do so—despite the radical scepticism uncovered by the exhibition of the phenomena themselves—on an emotionally primitive level we still believe that what we are witnessing in the art space is indeed the exhibition of art, however contrary to our expectations the art may be. This is because

the object, simply by being exhibited in the art space, is experienced in a "mythological" way. It acquires what I would call a mythological forwardness or assertiveness, due to the fact that it projects itself as a symbol in our psyche because of its exhibition in that very special place, the art space. It is this moment of symbolization—the alchemical moment of transformation of the literally given into the symbolically given—that Kounellis captures. The question we must finally ask of him is: what is being symbolized? The answer is life itself—but we will see that it is perilous to symbolize life itself, that it never quite works. Life itself eludes us; we have only living things. At this point, it is enough to note that Kounellis makes the object seem emphatically other than its literal self—strongly charged symbolically, by reason of its exhibition, as I have said, in a certain way in the art space.

What way? The art space is notoriously empty, rooted in emptiness. Kounellis leaves that emptiness intact when he exhibits objects in it. The institutionalized, stylized absence of the art space remains unmoved, undisturbed by the objects placed in it. It is always "larger" than them, silent in the face of their sound. Moreover, the objects themselves do not really threaten the emptiness of the art space with their fullness. For while they are materially "full," that is, indisputably the physical case, they convey a certain mournful absence. This gives them a certain power of implication—it is the source of their symbolic potential (and makes them the means by which Kounellis articulates the problematic of symbolization that occurs in the art space)—but this absence is absolute in itself. Thus, the coat and hat imply a missing adult figure, the toy train a missing child. The horses await their riders, the egg waits to be hatched. The stone and wood wait for a structure, the seeds wait to grow into plants. Something is missing; the objects contain a certain emptiness, a state of expectancy. It is this which is stated in the art space, this emptiness which colludes, as it were, with the emptiness of the art space, and which gives both the objects and the art space their tragic aura. All of Kounellis's installations exist in a state of "civil tragedy," to allude to the title of his perhaps most well known work (1975). That is, they imply that something is tragically missing, a certain state of incompleteness. Paradoxically, it is exactly because the objects exist in this tragic condition in the tragic emptiness of the art space that they can project their vitality, come to symbolize the life force itself. In the empty art space, the life in them seems to be distilled and reembodied in them. It is as though we are watching, in a hallucinated condition, the life being extracted from the object, and then reinvested in the object, which is "then"—in this sequence that happens all at once—elevated in the emptiness the way the host containing the spirit of divine life is on the altar. Life itself is divine here, and the

living things that Kounellis puts in the empty art space seem spiritually elevated in it, by reason of that emptiness, and their own, as fraught with implication as the space. The emptiness of the space seems to pull the vitality out of the object and exhibit it in and for itself. The objects are mythologized—mythologically featured—by the emptiness, which is itself a zone epitomizing our tendency to mythologize—to primitively invest ourselves in—things.

We are always sizing up their vitality, examining the extent to which they are vital, and then, in a fundamental choice, emotionally extracting and elevating their vital, animating element or their anti-life, necrophiliac aspect. The emptiness of the art space—"stage"—is an alembic in which we separate the biophiliac and necrophiliac elements of a living thing and declare our preference for one or the other. Kounellis puts us in this condition of choice, without telling us which way to choose. He epitomizes this condition particularly in his use of fire. He may use archaic objects, such as plaster casts of antique body parts, especially heads; the vertical section of the Latin Christian cross—the section that awaits the still living body of Christ; and Mozart works—all convey emptiness through their fragmentation—but he always puts us in a condition of choice, a situation of decision, a seemingly inescapable ambivalence. We can escape this Gordian knot—exercise our Solomon's wisdom—by a swift stroke with a sword of emotion, but such an inner action takes place offstage, outside the art space, in the fullness of life itself. The symbolization never quite comes off—the object falls back on its own literalness, givenness— because of this condition of ambivalence. Kounellis is involved in a Sisyphean enterprise of symbolization, in which living things are staged in the art space so as to acquire symbolic import, which is partially achieved. What is truly achieved, however, is this effect of ambivalence, this sense of necessary but impossible choice—a choice difficult to make emotionally. The "artification" of the living objects puts us in a certain position in relation to them, but does not tell us how to feel in this position.

It would seem easy to choose life over death, the animate over the inanimate, but it is not. For there is a narcissistic conundrum involved— a self-confrontation. Kounellis's installations prepare the way for it. The problem is explicitly signalled by Kounellis's own use of stuffed animals (e.g., in a 1979 untitled piece) reminding us of that of Rauschenberg, but having different import. Here, the attempt to restore life import, to raise life over death if ending in a sense of ambivalence that connects both— the attempt to make the dead bones of the artifacts live as in Ezekiel's vision—is seemingly relinquished. In the 1979 piece we have the memories of the living things rather than the wholesome living thing itself. An

animal that has been preserved by taxidermy—and a taxidermal animal is an incredibly uncanny thing—is only the memory of an animate animal, which is part of its tragedy, its emptiness. It is a thing that life has deserted in an especially spiteful way. It is a thing that has completely become art—that can have no other existence than in the emptiness of the art space. Its inherent emptiness—deadness—adds to that of the art space, compounds it, reinforces it. No matter how much Kounellis tries to enliven the empty art space, give its deadness life, the living or once-living things—the bringers of life—end up dead.

Indeed, Kounellis tries to enliven the walls of the art space with his bric-a-brac—even his lively toy train climbs the dead weight of an inanimate column supporting an art space, and his gold (an ancient symbol of the life force, perhaps its innermost emblem, seemingly substantializing the light which is its body) literally lightens the grim walls of art space—but none of them can sustain their effect, remain completely convincing. Kounellis's preoccupation with the walls of the art space, his attempt to vitalize the limits of the dead art space and by extension the space itself, are the paradoxical efforts of an artist who knows he needs that deadness to make his mythological point, to effect his transformation of things into symbols. Everything that Kounellis uses ends up in a taxidermal state, a creature of art. In reducing to its givenness it confirms the power of art, while baiting us with life.

Kounellis's work, then, is not just another illustration of anti-art. However much Kounellis may seem one of the more legitimate offspring of Rauschenberg, whose work is perhaps the mightiest recent case in point of anti-art—demonstrating with a unique consistency Adorno's Modernist dictum that art today requires "the dimension of anti-art" to be art—Kounellis's work raises an altogether different issue. Without anti-art, Adorno argued, art tends to pass itself off as " 'substantial' in the Hegelian sense of the word," refusing to become Modern—"transparent to itself down to the very core."[2] As Adorno has said, "many things that were once left to drift on their own have recently been drawn into the sphere of artistic intervention,"[3] a situation summarized under the rubric anti-art. While Kounellis's work can be understood as another species of anti-art, I have tried to suggest that it is anti-art in the service of something more than the labyrinthine puzzle of the nature of art, a puzzle full of nothing but blind alleys. His anti-art is not just another obscure Delphic riddle proclaiming art's oracular power. However, his installations are haunted by the same threat of disintegration as anti-art works of art. This takes the peculiar form Adorno remarked: "the more successfully art integrates everything, the more it resembles a machine in aimlessly idling motion. Its *telos* is a childish preoccupation with tinkering."[4] Kounellis's

installations clearly seem the products of extraordinarily patient tinkering. He is in a sense a Zen master arranger or orchestrator of spaces, a sort of John Cage working with space as his grand piano.

But it is still tinkering; many installations look like childish constructions of sophisticated debris, and seem to be idling, waiting for the occasion to noisily function, without clear purpose. To me, the organization of the architectural installations in terms of strata simply emphasizes the fugitive character of their unity. Chaos organized is still chaos; the look of chaos is crucial to their mysterious, tragic air,[5] and to me suggests the "victimization" of the material by the emptiness of the art space. With Kounellis we have come a long way from Schwitters's collages, which seemed eager for unity, as it were. A Kounellis installation never achieves formal unity, and hardly seems to be interested in it. It is its chaotic—entropic—character that is irresistible and effective: the source of its ambivalent symbolic power, and general moral ambivalence.

Kounellis has used fire extensively. To me it is his major material, epitomizing the contradictions his art is about. When fire is not used directly, Kounellis uses its "negative," smoke. Of particular interest are the works in which Kounellis uses propane gas torches, lit or unlit. In 1971, in a gallery performance, propane gas torches blew their flames through long tubes that snaked across the floor. Even more interesting is his use of solid fuel tablets, ignited on the floor of his studio and, later, on a steel bed frame in it (both 1969)—a truly stunning performance of fire. The "chorus of fires," as it has been called by Germano Celant, returns in the late seventies.[6] (In general, Kounellis tends to create a performing chorus of recurring objects. Not only the fires or the faces of 1980, but the stones with which he blocks doorways and the brick and wood "constructions" with which he blocks windows can be understood as choral. No doubt this relates to the seriality of minimalist art, but it is also a metaphoric transcription of the chorus that accompanies the tragic hero—the civic voice that reflects his woe. But with no hero in the tragically empty art space, the material chorus has itself become tragic—chaotic, in the sense of being "flawed" and conflicted to the point of irreparable disintegration. Unless the objects—flawed symbols, ambivalently alive and dead—are the tragic heroes, which would be to dizzily compound tragic irony. While arranged in a relatively orderly series, the objects are usually chaotic—that is, fragmentary—in themselves.)

The solid fuel tablets concentrate fire in themselves, and suggest a truth about the other living things Kounellis uses: they are all fuel for fire—fuel for a fire of potentially stupendous proportions. Kounellis is as interested in the change of state from fuel to fire—emblematic of the change of state from literally to symbolically given object—as he is in fire

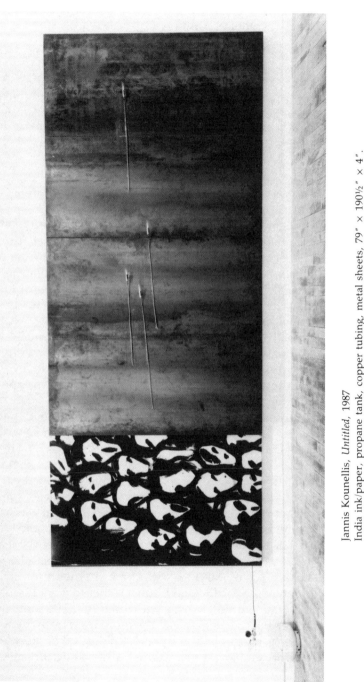

Jannis Kounellis, *Untitled,* 1987
India ink/paper, propane tank, copper tubing, metal sheets, 79" × 190½" × 4".
(Courtesy Sonnabend Gallery, New York)

as such. Fire is perhaps the most ambivalent, potent material there is, readily read as the symbol of a variety of processes. Gaston Bachelard has written:

> Fire is the ultra-living element. It is intimate and it is universal. It lives in our heart. It lives in the sky. It rises from the depths of the substance and offers itself with the warmth of love. Or it can go back down into the substance and hide there, latent and pent-up, like hate and vengeance. Among all phenomena, it is really the only one to which there can be so definitely attributed the opposing values of good and evil. It shines in Paradise. It burns in Hell. It is gentleness and torture. It is cookery and it is apocalypse. It is a pleasure for the *good* child sitting prudently by the hearth; yet it punishes any disobedience when the child wishes to play too close to its flames. It is well-being and it is respect. It is a tutelary and a terrible divinity, both good and bad. It can contradict itself; thus it is one of the principles of universal explanation.[7]

Kounellis's fuel tablets represent what Bachelard calls "incombustible fire." Even more than the propane blow torch, the fuel tablet also "conforms to the rule of desire for realistic possession: to hold a great power within a small volume."[8] It is the special power of the incombustible fire, which is the true alchemical fire, in the words of the alchemist Joachim Poleman quoted by Bachelard: fire that is no longer "on the surface . . . no longer external, but internal and incombustible." It is this "fire within," "active at the center of each thing," that Kounellis wants to extract, make manifest, and utilize, however transient and erratic its appearance. The propane blowtorch, which externalizes the fire within the fuel—within the fuel storage tank—is a straightforward metaphor for this magical making manifest.

To what purpose does Kounellis want to make the fire within manifest? To what use does he want to put it? As Poleman says, just as external fire "would burn anything that was combustible, so now through its power [the fire within] burns the invisible maladies . . . [the] spirits of darkness, which are none other than the spirits or properties of the shadowy bed of death . . . and the fire transmutes these spirits of darkness into good spirits such as they were when the man was in good health."[9] "Incombustible" interior fire has healing power, and it is this healing power that Kounellis wants to make accessible—at the least, to signal. Kiefer tries to work through the shadowy bed of death his way— through full acceptance of darkness, bearing its burden the way Atlas carried the burden of the world—and Kounellis tries to work through the hell of death his way, burning it away with inner fire. The propane that fuels the blow torch is the malady—all the more insidiously dangerous because it is an invisible gas or atmosphere—of death that must be consumed. In the propane blow torch, Kounellis has a succinct metaphor

for the entire process of passage from death to life, sickness to health. In this one object the entire process is stated and completed.

The issue is the same in the other objects Kounellis uses, but the process is not shown in its completeness. The broken down objects, that is, the fragments, are symptoms of the malady of death; the literally alive, "wholesome" creatures suggest its cure, that is, for Kounellis the interior fire shines brightly in them, is directly manifest in their being: interior and exterior being are more of a piece, more united, in animals than in human beings. They are literally more animate. While the objects have, as noted, nostalgic associations with life, and the animals are clearly alive, the objects and the creatures in their difference—the inanimate and animate—represent in the form of an extreme contrast the choice facing human beings.

Kounellis seems to be flirting with fetishism, the root of all religion. He fixates his objects and creatures by displacing them into and exhibiting them in the empty art space, which is now comprehensible as a metaphor for interior space: the same walls that establish the art space "artfully" establish interior space. Kounellis's work is in a sense about commerce between exterior space, represented by his objects and creatures, and interior space, represented by the empty art space. The process of placing objects and creatures in the art space is a process of introjection, which is why the emptiness of the art space can also be understood as alchemical. It is worth emphasizing that the introjective/fetishistic process is not irreversible, as we have noted: both objects and creatures lose their internal symbolic import and become matter of factly, that is, externally, given once again. Neither becomes an unconditionally integrated part of human interiority however much, in the totemic form in which they exist in the empty art space, they come to represent aspects of it. Fetishism and animism are different aspects of the same thing, and the root of religion. Kounellis's art can be understood as a manqué religion of healing, but all religions are psychologically manqué.

As Bachelard notes, the "attempt to re-live *primitivity*" is standard romantic practice.[10] Kounellis shares in this attempt, and has clarified it. In his case it is a regression not carried out for its own arbitrary sake, or to create a striking new art—Romantic Primitivism, for all its revivals, has long since lost its striking character—but out of desperate need of healing from the malady of death, which has reached plague proportions in this century. Once again, as this century and millenium draw to an end, we have an apocalyptic art. But this time it is authentic. Kounellis is not just emphasizing death, provocatively shaking the rattle of death in our faces—terrifying us with our own death rattle in "sublime" or "metaphysical" form—and trying to make commonplace death seem like

a novel artistic content by giving it anti-art form. Instead, he is calling for life, which alone can heal death. He is not giving us a Modernist triumph of death, if also not giving us a Postmodernist triumph of life (a synthesis of its fragments). He is simply—with that cleansing simplicity that comes from a strong will—*suggesting* that life can triumph over death. He wants life to displace death, the way his objects and creatures, placed in the empty art space, seem to empty it of its emptiness, which is one way of making a start towards becoming full—of life. The emptiness of the art space remains, but it no longer seems so awesome, absolute—indomitable, insuperable. It is the space of death, but at least in it the possibility of life can be kept alive, which is the point of that alchemical process of distilling life called art making.

Notes

1. According to Sigmund Freud, "The 'Uncanny' " (1919), *Collected Papers* (London: The Hogarth Press, 1950), vol. 4, pp. 378–79, a key instance of the uncanny is the confusion of the animate and inanimate.

2. T. W. Adorno, *Aesthetic Theory* (London: Routledge & Kegan Paul, 1984), p. 120.

3. Ibid., p. 43.

4. Ibid.

5. D. W. Winnicott, "The Manic Defence" (1935), *Collected Papers* (London: Tavistock Publications, 1958), p. 132, speaks of the manic defense as "reassurance against death, chaos, mystery, etc., ideas that belong to the *fantasy content* of the depressive position." One of the things Kounellis does is strip the Expressionistic manic defense from the depressive, so that the sense of death, chaos, mystery implicit in it becomes manifest. To put this another way, Kounellis's art can afford to reveal this negative content directly because the depressive position, as Melanie Klein argued, is reparative of the object destroyed in the fantasies of the paranoid/schizoid position. If we think of Modernism as essentially paranoid/schizoid—destructive—in its attitude toward the object, then we can think of Postmodernism as depressive—constructive—in its attitude. Its erratic reconstruction of the object into wholeness necessitates acknowledging its destroyed—deconstructed—condition. We find this doubleness in Kounellis's art, which makes it more Postmodernist than Modernist.

6. Germano Celant, "The Collision and the Cry: Jannis Kounellis," *Artforum* 22 (October 1983): 67.

7. Gaston Bachelard, *The Psychoanalysis of Fire* (Boston: Beacon Press, 1964; paperback ed.), p. 7.

8. Ibid., p. 83.

9. Ibid., pp. 75–76.

10. Ibid., p. 38.

Hysterical Painting

A typical Francis Bacon painting shows a single figure, or a fragment of one (the face also is a fragment), sealed in a stage space, spare and schematic for all the boldness of its color. Sometimes there are two figures, locked in a struggle, or resting between "engagements."

The space is generally self-contained, geometrically emphatic, an isolation ward of sorts. It is a sacred space, the figure's self-protective aura, the membrane of its dignity, confirming the figure's character as a monad. The world comes into the space in various contingent ways. Sometimes it appears as fragmentary, rudimentary language, bits of alphabet repeated ad nauseam. This handmade but machinelike image of lettering has been mistaken for a representation of discarded newspapers, and for a kind of pseudo-Dada collage, but it is more like collapsed balloons of speech from which the language, like sand in an hourglass, has run out, confirming the silence of the figure. It is a distillation of the idea of language, like an eye chart whose letters are never fully in focus and irrationally blur into meaninglessness. Other signs of the noisome, intrusive world are the sections of nonhuman flesh that often appear, suggesting that the world is a slaughterhouse. It is as though the space were insatiable and had to be regularly fed animal meat lest it swallow its human inhabitant. The space is an abyss, which, like a legendary monster, regularly needs a sacrifice to keep it quiescent. The meat is also the insignia of the figure; the trophy of a kill, it signals the figure's secret carnivorous authority.

Bacon's figure is spastic, a kind of aborted *figura serpentina*—hardly Michelangelesque, yet mutedly muscular. It is overdetermined and imploded. Of course it is psychically twisted as well as physically archaic, but that is only part of its story. What seems to me of crucial importance for an understanding of what is at stake in Bacon's paintings is the fact that the isolated figure is blurred in its being. This is partly because of Bacon's allusions to Eadweard Muybridge's photographs of human and

This article originally appeared in *Artforum* (January 1986).

animal figures in normal and abnormal motion; each of his figures is like a transient duration in a hand-cranked movie. For all its photographic underpinning, however, Bacon's figure is a paint-intensive creation, appropriating Pablo Picasso's composites of multiple, shifting views of a figure in a concentrated space as much as it does Muybridge's clinical studies. It is built of what Bacon calls cultivated chance moments—what I understand as forced painterly impulses, deliberately dredged-up libidinous charges. These charges can be regarded as "ingrown gestures"[1] struggling to grow out—a pathological painterliness made manifest by the way the gestures seem to grow back into it and knot its fluidity. The figure seems about to be torn apart, brutalized by its own sensational discharges, and indeed in certain works it has lost some of its parts, becoming grotesque and crippled. The figure is often recognizable, or named in the painting's title, but its blurred bodiliness contradicts, and almost obliterates, that public identity.

Gilles Deleuze has generalized this attack on the memorable figure as an attack on the cliché image, aligning Bacon with Paul Cézanne as an artist who, unable "to accept the ready-made clichés that came from his mental consciousness, stocked with memories and which appeared mocking at him on his canvas, spent most of his time smashing his own forms to bits."[2] But in fact it is the authority of the figure that Bacon challenges, not appearances. At the same time, the figure is asserted through that challenge—through the bits of paint that subvert it. And it is not so much that Bacon is attacking the standardized version of a figure/person—one unburdened by a hidden self—as doubting its very right to exist. It is as though the figure is a reluctantly used subject matter for him; he seems disinclined to grant it its traditional fundamentality, but is stuck with it as a necessary evil. However much he alludes to specific persons, Bacon questions not their particularity but the authority of their being at all. It is this authority that he "manhandles," that he breaks on the rack of his pathological painterliness.

Bacon forces us to remember and rethink what has been all too frequently forgotten about Modern art as it has been socially assimilated—that it is at heart dissatisfied, rebellious, angry, violent, and violative, an incisive reflection of the discontents of civilization. This defiant unhappiness is customarily understood as an anguished sign of autonomy, a subversion of conventional worldly appearances to construct the integrity of art in spite of the world, but Bacon forces us to read it not as a willful transcendence of the world but as a hysterical, and invariably histrionic, effort to recollect it in all its anxiety-arousing absurdity. Bacon's paintings are ambivalently acts of recollection and of forgetfulness, an ambivalence that is at the center of the Modern sense of illusion.

T. W. Adorno has written that "the truth of works of art hinges on whether or not they succeed, in accordance with their inner necessity, to absorb the nonconceptual and contingent. For their purposefulness requires the purposeless, which is illusion."[3] Bacon's paintings stretch the general problematic of portraiture to its limits, forcing the recognition that the uncategorizable, contingent personhood of the portrayed can never be truly and completely grasped in and through paint. This leads to an aggravated attack of paint on the figure; the paint acquires added conviction and power, becoming painterly to an aggressive extreme, almost as though the painterliness were an expression of angry frustration at the ungraspable personhood of the figure. The art rises up to overwhelm the illusion of the person—the other—and in doing so achieves its own integrity. As if in spite, Bacon's portraits seek to destroy the vestige of personhood available in the everyday appearance of the figure by assimilating it entirely into painterliness. The melancholy of his figures results from the residue of personhood that has survived the process of painterly absorption. The paint scourges the figure, stripping it of its skin, assimilating its raw flesh to painterly flesh. What is left is helpless raw being. Bacon takes such authoritative historical figures as Pope Innocent X and Vincent van Gogh and reduces them outrageously to clots of paint. They are overwhelmed by paint, into which they sink as if in quicksand. Is the scream of Innocent X recognition of his dissolution? Bacon repeatedly "misinterprets" the strength of character he seems to find in the 1650 Diego Velázquez portrait of the Pope as sheer monstrousness, brutality. More than Picasso in his historicist paintings, Bacon destroys what he creates in the very act of recreating. The destruction no doubt has world-historical import—the sadistic character of the Pope is brought home by the sadistic way paint is applied to him, as if it were acid—but the key point is that paint triumphs over human reality, becomes the dominant expression of being.

This issue of illusion is more complex, however. Bacon's paint spontaneously presents us with an authentic, compelling image—an image to which we feel committed, inescapably bound, just at the moment when we are most in despair of finding any appearance to embody our own attachment to real being. His painterliness pushes the figure toward oblivion, but in the wake of painterliness comes a residue of the figure, its representation, which, however flimsy, holds us spellbound because of the energy and emotion that seem invested in it, and because of the way it has survived abuse by the painterliness. It is as though the painterliness had destroyed the conscious image so that the unconscious image could emerge. What remains becomes freshly, all the more powerfully, an illusion of being. As we look at a painting we unconsciously desire an

image—as though we could remember an image in and through the paint—and all we experience is paint, but we hallucinate an image in it. This is Bacon's figure—a hallucinated image of absolute being, free of the underpinnings of conventional appearance. That appearance has been supplied, implicitly and explicitly, by photography, but Bacon has worked over the photograph, and the contemporaneity it implies, with his grandiose painterliness. The photographic appearance is imaginatively transformed into a representation of archaic selfhood. Where in many contemporary artists' work reliance on the photographic image of reality disguises a failure of imagination, in Bacon's the destruction of photographic appearance represents imagination's aggressive reassertion of its rights.

Bacon gives us not simply an "expressive" illusion of a figure, but the illusion of being in the presence of a certain self. The figure has been transmuted in the alembic of painterliness into a kind of self. Bacon gives us the illusion of the self as it introspects itself, the painterliness filtering out the figure's everyday appearance so that the urgency of its being itself can be felt. Purged of everydayness by painterliness, the figure is peculiarly self-possessed rather than owned by the world. Its existence in the limbo of the space confirms its self-realization and its authenticity.

Pure painting, then, is not necessarily an end in itself, for all of art's desire to declare it so as a manifestation of art's "autonomy." Such painting also has a "hysterical" purpose—by dissolving the everyday appearance, it can help us remember the obscure self that is forgotten underneath. Bacon's painterliness is hysterical painting in the deepest and most precise sense: it struggles to remember an archaic experience that has been forgotten, an experience that has profoundly affected and shaped the sense of self operative through the figure. At the same time, it is a symptom of our forgetfulness of traumatically primitive experience. Simultaneously memory and amnesia, Bacon's painterliness embodies the struggle between remembering and forgetting—representation and nonrepresentation—that is at the heart of the psychodynamic process that painting constitutes. Bacon's archetypal hysterical figure is a "hyperaesthetic memory,"[4] a form of "strangulated" speech. His figure is in a "hypnoid state," "very intense but . . . cut off from associative communication."[5] This is its existence as a repressed yet nagging memory. At the same time, it is abreacted through painterliness; the "strangulated affect" it embodies finds a "way out" through painterly speech.[6] Bacon's painterliness has a double function: to articulate the intensity of the cutoff, dissociated figure, and to relieve it of its burden of feeling. His paintings have become less and less painterly, more and more flat in their affect, more willful—less spontaneous—in their intensity, as though at last, after 40 years, he has discharged the final bit of painful memory of the

authoritative figure standing behind all the other figures. It is a figure whose substance was always doubted because it stood behind so many shadows and was associated with so many simulations of itself. In a sense the polished glass that Bacon has for some time insisted that his pictures be hermetically sealed under—finishing them off, packaging them, as it were—shows just how determined he is to show the conflict between hysteria and its repression. He civilizes his pictures, makes their wildness museum-ready, by placing them behind glass, but he builds the material's critical function into this act. Before one gets to the violent, hysterical painting, the glass intervenes, stopping one—anesthetizing one—so that its maddening impact is muted or controlled and one isn't driven crazy by it. Bedlam is kept in and the spectator is kept out. The packaging also implies that the hysterical figure can be standardized, civilized, or at least caged, but its strait-jacketing effect suggests that hysteria can still get out of hand. Painting and spectator circle each other, wary, two ambulatory patients in an ambivalently aesthetic and sexual encounter, finally mirroring each other in a bizarre Dorian Gray manner: as we cling to our sanity in the face of the hysteria the picture induces in us, we transfer to the picture the energy of our struggle for control, so that the painting seems even more hysterical and even more representative of reality. The figure's hysteria is its realism.

Bacon's hysterical painting remains inseparable from "archaeologism." The importance of Bacon today, in this time of archaeologistic painting, is that he histrionically asserts the psychological root and purpose of such an approach. In his work this assertion is unsubtle and unavoidable, whereas in other current archeologies of the figure it is often nonexistent, forced, pseudosophisticated, or emptily didactic. I prefer the term "archaeologism" to "historicism," since it seems to go more to the root of the current culture of quotation. It suggests a conflicted attitude toward the past, at once celebrating it and denying its authority. Morris R. Cohen has described historicism as the "faith that history is the main road to wisdom in human affairs," but he notes that this belief has been much disputed throughout history: "In the Old as well as the New Testament there is much of the anti-historical philosophy so keenly expressed in the Book of Ecclesiastes to the effect that the earthly scene is all vanity and that there is nothing new under the sun. The canonical sayings of Jesus commanded men not only to take no thought of the morrow but to let the dead past bury its dead."[7] Archaeologism combines the optimism of historicism with the pessimism of antihistorical philosophy, the recognition that while everything will change, nothing will be new. In Bacon, ambivalence toward the authority of the past is used to undermine it, or at least to bring it into doubt.

Among the more striking recent images by Bacon is *Study of the Human Body*, 1982, showing an abbreviated male figure, naked except for cricketer's leggings. The same figure recurs in different poses, in *Study from the Human Body—Figure in Movement*, 1982, and in the left panel—another "Study from the Human Body"—of *Diptych*, 1982–84. The cricketer's leggings are a sign of social identity—of belonging to a certain class and world. The nakedness of the mutilated figure—a chunk of red meat as much on display as the carcass in Rembrandt's *Slaughtered Ox*, 1655, a recurrent image, in different forms, in many Bacon paintings—contradicts the social identity the leggings signify. This tension between the social reality of a figure and its naked bodiliness is a constant in Bacon's painting. His painterliness is used to strip the figure naked, not only to naked bodiliness but to naked emotion, as in the various pictures of Innocent X. Signs of social reality remain: the Pope still has his miter, van Gogh still carries the instruments of his craft. (Bacon means to emulate van Gogh in his stripping-down of the figure; van Gogh was the inventor of the process and its first real master. As such he was the first truly Modern painter, in the sense in which to be Modern means to strip away superficial social appearances to reveal existential reality, that is, to reveal being as such—a revelation that is being's only justification. Modernism, through its destructive process of stripping down, searches for a new starkness, the sign of genuine being.) The tension between the process of painterliness and the reality of society—between a generalized drive toward revelation of the irreducibly given, and socio-historical particularity—pervades Bacon's work. He brings the power of painterliness—of art as a stripping down to the embryonically naked, as at birth and death—to bear on the power of social authority, hoping to cancel it out, but he recognizes that it is ultimately as ineradicable as the naked body and the naked emotion. It is as much like fate as the emblematic, existentially raw meat of the body.

What Bacon accomplishes is a linkage of the power of the painterly process to the power of social authority. This is the source of the real sexual hysteria and theatricality of his paintings. The linkage is revealed in the convergence of his anorexic color planes—the background of the real world—and his bulimic figures, depressed for all the abundance of painterly nerves that testify to their hypersensitivity. Together, backgrounds and figures have the authority that comes from attracting tremendous attention—something that the hysterical and the histrionic (represented in Bacon by the theatrical staging) also have in common.[8] Bacon's paintings are not simply stark, the way van Gogh's are, but exaggeratedly stark—to show off the figures' blatant exhibitionism. (Exhibitionism is a major hysterical trait.) These figures are always on stage—but more like

specimens on clinical display in a medical amphitheater than like actors in control of their roles. Their isolation is a form of privileging themselves—of making themselves stand out and seem more intriguing or charismatic than others. At the same time that Bacon dissects the charisma of exhibitionism, he celebrates it, and through his repetitive representation suggests that it is the only source of the figure's authority.

It can be inferred from Bacon's painting that he would agree with Anthony Storr in the idea that hysterical exhibitionism is a "defense against depression" in a person who regards him- or herself as defeated, and as a defense against recognition of the lack of ideal persons in the world.[9] But, at the same time, Bacon seems to posit hysteria as in its own dramatic way an ideal mode of representing oneself as a person. But there is a paradox here, for this idealization has an archaeologistic basis. In hysteria a person attempts to immortalize him- or herself by becoming extravagantly demonstrative, exhibitionistic, in effect announcing his or her being as absolute and indisputable. It is given a surplus of presence, as it were. Absolutization and exhibitionism reveal the archaeologistic perspective: a stage holding an isolated figure is as much a coffin displaying an embalmed body as it is the hysterical psychodrama of a particular person. The painterliness that gives hysterical flair to the person also mutilates that being into oblivion, generalizing it toward nonbeing. That something can be so real and at the next moment an illusion belonging to the past expresses the ambivalence endemic to archaeologism. All Bacon's figures exist in a time warp, at once radically contemporary yet belonging to a dead world.

Bacon's hysterical painting is paradoxical, and never more so than when it gives authority to inherently unauthoritative, almost banal figures. This is an authority the figures have borrowed from art, for the authority of art ultimately resides in the fact that it is the ultimate exhibitionism, making a more memorable splash than anything else, even if that splash destroys or cancels out—represses and buries—the reality it represents, and thus makes us more anxious about it.

Notes

1. Philip Rieff, *Freud: The Mind of the Moralist* (Garden City, N.Y.: Doubleday & Co. Anchor Books), 1961, p. 12.

2. Quoted in Dawn Ades, "Web of Images," in *Francis Bacon* (London: The Tate Gallery/Thames & Hudson, 1985), p. 22. This book is the catalogue for a large retrospective of Bacon's work that showed at the Tate last summer and is now traveling. It is at the Staatsgalerie, Stuttgart, until January 6, and at the Nationalgalerie, Berlin, from February 6 to March 31.

3. T. W. Adorno, *Aesthetic Theory* (London: Routledge & Kegan Paul, 1984), p. 149.

4. Josef Breuer and Sigmund Freud, *Studies on Hysteria* (New York: Basic Books, 1957), p. 16.

5. Ibid., p. 12.

6. Ibid., p. 17.

7. Morris R. Cohen, *The Meaning of Human History* (La Salle, Ill.: Open Court Press, 1961), pp. 15–16.

8. Anthony Storr, *The Art of Psychotherapy* (New York: Methuen, 1980), pp. 85–88.

9. Ibid., p. 92.

Victor Hugo's Ink Drawings

At first, the ink drawings of Victor Hugo seem like minor, freakish mementos of a long and major literary career. That's in part because one starts off with the assumption that Hugo's visual art would belong more in a curiosity cabinet than in a museum—in fact one almost involuntarily expects it to be beside the real issues in art, visually unnecessary in terms of art history, and incorporating no significant idea. But the curator Harald Szeemann knew otherwise. This summer [1987] at the Zurich Kunsthaus, in *"Victor Hugo, 1802–1885: Phantasien in Tusche"* (Victor Hugo, 1802–1885: Fantasies in Ink), a highly focused, intensely contemporary exhibition of 68 of the 2,000 or so Hugo drawings extant, Szeemann demonstrated how critical a figure Hugo is. This is so especially in our time, because of how he catalyzes us into a consciousness that the visual and the verbal, far from being exhausted and doomed—as Postmodernism, conceived as a kind of platitudinizing of them, implies—are still unfinished creative business, urgent business: to go beyond the still-oppressive classifiable and measurable, to break through rigid habits of reason and absolutized orders of control into uncodifiable yet strongly felt possibilities that orbit around what we call "the visionary." These possibilities are represented by the seemingly inchoate, inarticulate, and permanently incoherent, which exist in the unexpected space under the trapdoor of the intelligible. This is the molten core of creativity, the place of "potential space," as D. W. Winnicott names it, the space where mind and heart are one.

This amorphous molten core is astonishingly self-evident in Hugo's drawings. They are its magma, they indicate that amorphousness can spontaneously erupt and generate life and ignite life, in effect blow the crust off it. Modernists discovered, in an open way, the terra incognita of amorphousness; terrified by their discovery, however, and profoundly ambivalent about it, they finally attempted to put it back in the strange place in the psyche from which it came. Stylizing it is one major way of

This article originally appeared in *Artforum* (September 1987).

accomplishing this second repression. Whenever amorphousness appears to have been mastered in Modern art, to have been broken in, encoded, brought under unquestioned stylistic control, officialized, as it were, whenever it becomes all too readable, the "message" of apparent indecipherability is lost. Nonetheless, certain figures seem to maintain the amorphous, and all the potentially disintegrative risks inherent in it. We honor them for this because they offer us the deepest, most chaotic, and most potentially creative part of ourselves—our deepest reserve. Hugo is one of these figures.

Perhaps Hugo was ready to take the plunge into visual amorphousness because verbal clarity and intelligibility seemed especially insufficient to him when he was ousted from Paris into the political exile during which he made his most "suggestive" pictures. From 1851 to 1871 he lived outside France, first in Brussels and then in the Channel Islands, in what began as a forced banishment and continued as a self-imposed one from the rule of Napoleon III. He did not abandon words during these years, but he supplemented them with images. And in fact in his visual work it is as though he was still writing, but in another language. Exploring it, he discovered it as a tissue of indecipherable marks. Ordinarily, the conventions of language create intelligibility; Hugo was hardly a conventional writer, but in visualizing he was especially unconventional. Society sets a premium on the creation of meaning—in a sense, it is what civilization is about—and shuns its unraveling. But Hugo had been rejected by society, or at least by the society he knew. Disoriented by that rejection he made his disorientation a revolt—he tried to disturb society as it had disturbed him.

In their iconography, Hugo's pictures are consistent with elements of the Romantic canon—they find their subjects in "fantastic landscapes, irreal cities, castles in a sea of fog, gallows in the gray of dawn, the depths of the sea and its dangers, the elemental, the planetary," as Szeemann remarks in his catalogue essay. Yet Hugo was an early experimenter with automatism, forming his images from "tachistic blots" which constantly, and increasingly as the work progressed, threaten to overwhelm the drawings' ability to represent. His drawings begin by showing the dysfunctions of the conventions of meaning, and end by throwing a fullfledged display of unintelligibility in the face of the world. They are not just about revolt, however, but about spiritual growth. Hugo made of his physical exile a spiritual one. Perhaps his new status as an outsider forced him inside—forced him to turn inward, to explore the ungraspable depths of the self that had been rejected by social authority. In drawing, he entered an obscure, emotionally charged, asocial underworld of appearances. The wild, abstract character of some of his pictures indicates that Hugo came to experience the terra incognita of feeling as something

to be compulsively explored in a medium that could articulate it directly, and that indicated it as an alternate reality full of mystery and fantasy.

In their urgency to become direct transcriptions of his churning condition, Hugo's drawings become a refutation of representation—a denial of its adequacy, even of its possibility. Like August Strindberg, who turned to visual means at a crucial moment of stress (for Strindberg a moment that suggested the inadequacy of verbal means to master his ''madness''), Hugo discovered the peculiar freedom, full of suffering, at the root of art.

One would have thought that our long familiarity with ''hallucinatory'' drawings in this century would make their nineteenth-century forebears in Hugo's work seem stale. But even though, as Szeemann notes, some of the Surrealists and early Tachists found an ancestry for their work in the automatist techniques of Hugo's drawings, his pictures at their best have a power so pure, so unadulterated by the serving of any aesthetic cause, that they overwhelm us with the clarity and the intensity of their energy. Each drawing is so concentrated that it cannot but engage the spectator's deepest sense of self. The mysterious, moving force of these works is in the end the force of what Szeemann calls their ''mediumistic moment.'' It was on the island of Jersey, where the first of the wilder drawings were made, that Hugo first attempted to levitate tables, that is, to demonstrate the power of unconscious mind over matter. Hugo's fantasy images, as Szeemann says, burst out of the unconscious, as though fantasy, too, were an act of levitating the world—and of recreating it.

One of the exhibition's most revealing works was an image of the title page of Hugo's novel *Les Travailleurs de la mer* (The Toilers of the Sea), 1866. Hugo shows his name, three-dimensional in large letters, being obliterated against rocky cliffs, such as those he rendered in numerous depictions of the cliffs of Dover. It is not simply that Hugo's public name is being effaced here, as it was in life. In being effaced by nature, the name is being returned to language in general, which, like nature itself, is bound up with the mystery of the impossible-to-name self. The ink with which Hugo drew is the same medium with which he wrote. (In another anticipation of later ideas, he also, as Szeemann notes, used mixed media—ashes, coffee, earth, metal filings.) Ink is the material of writing, supposedly the space of the deliberate cultivation and cherishing of meaning; writing physically overcomes the material rawness, the contingency, lurking in the ink. In Hugo's drawing, on the other hand, ink reasserts itself. Instead of submitting to the intelligibility demanded by writing, it spreads in blots and floods of uncontrollable fluidity. Rather than drown, Hugo spontaneously swims in this sea, as though he were destined to.

Szeemann quotes Hugo's preface to *Les Travailleurs de la mer*, which

talks of the fight against elemental nature as one of the major forms of humanity's struggle against fate. The sense of the struggle against fate that Hugo reveals in his drawings most often emerges through suffering. Suffering can dissolve meaning: Hugo suffered the loss of his good name, home, and country, and exile showed him that no name is unconditionally prestigious and enduring, that language's powers of persuasion are limited, that even the clearest language can become indecipherable. Every structure of meaning can eventually be swamped by an unknowable fate. Over and over again in his drawings Hugo shows small frail ships seemingly about to be overcome by the sea. A man hangs from a gallows against the gloomy infinity of the sky, or is swallowed up by the leviathan. In *Le Rêve* (The dream, 1865), an arm, the fragment of an unshown body, stretches out an agonizingly open-fingered hand writhing at the end of it, as though struggling to reach something also unseen. The fragment is like a visual scream—does the alarm of the hand signal that the unseen figure will awaken from the dream or be unable to climb out of it?

This uncertainty in *Le Rêve* as to whether the figure will awaken or remain submerged in the dream, like the uncertainty as to whether the sea will swamp the ship, or whether there is any escape from the bowels of the leviathan, symbolizes Hugo's sense of the enigmatic character of articulation, a character more evident through the visual than the verbal. Clearly for Hugo the imagistic language of dreams makes the enigmatic character of expression particularly evident. But expression does not reveal its full secretiveness unless the dream is dissolved in the maw of unintelligibility. Hugo accomplishes such dissolution through visual art.

Taken as a whole, Hugo's drawings show us the processes of dissolving, unintelligibility, and intelligibility. In what Szeemann calls Hugo's "tachistic" drawings, the unintelligible is most prominent. These works seem most Modernistic. In his *Aesthetic Theory* (1969) Theodor W. Adorno wrote, "As the work (under the auspices of modernism) posits unintelligibility as expression, increasingly destroying its intelligible moment, the traditional hierarchy of understanding is shattered." This positing is itself an act of creativity, opening the way for new possibilities of relativistic intelligibility, or for constructions of understanding that deny the absoluteness of any prehension. Cubism as well as Expressionism, Minimalism as well as Surrealism, in their different ways, are examples of attempts at such constructions. Hugo was one of the first artists to immerse himself in the chaos of the amorphous—which makes such constructions possible—and to extract its secret: it is among the primary means through which the self can express the pain it feels in the struggle against fate.

Hugo's drawings show him depressed by the recognition of death. In exile, Hugo was in effect living through another death; on this island he was dead to the world, and no doubt realized he would actually die, perhaps all too soon. His drawings show him counteracting his poisonous despair with the antidote of omnipotence: he plays God with the world, in pictures of it that seem simultaneously to destroy and to create it. This striking grandiosity in Hugo's drawings conveys perhaps the grandest of grand illusions that humanity creates in its struggle with fate: the illusion that time is reversible and space collapsible. To overcome time and space is to overcome fate. The grandiosity of Hugo's fantasy permits him symbolically to accomplish this miracle. At their most tachistic, his drawings drop us into the timeless, spaceless scene. From that perspective, reality is simply another form of fantasy, as Hugo's drawings, showing the real in an irreal, hallucinatory way, make clear.

Hugo came to all this through enormous dissatisfaction with the world. Such dissatisfaction is quintessentially Romantic. It is also Romantic to repudiate the facade of intelligibility carefully maintained by those in charge of the world and supported by their language and conventions. But this is also a form of survival. Perhaps uncompromising aggression is necessary: perhaps the depths can only be articulated under the aegis of aggression, as though only aggression against the world can mobilize the strength to plumb the depths, to withstand and harness their pressure as well as their enigma and even unreadability. In a kind of visual onomatopoeia, an ambivalent chiaroscuro erupting in climaxes of violence, Hugo's drawings are ambiguously regenerative and degenerative, celebratory and revengeful.

In listening to the siren song of unintelligibility, Hugo did not go mad, did not crack up, because he seems to have listened unafraid, perceiving its musicality, rhapsodically embracing rather than resisting its ambivalences. Through that embrace he articulated and creatively transformed his own conflicted condition into potential space. Encountering certain unintelligible emotional tones in himself, he survived this sea of stormy ambivalences by identifying with it, in effect accepting its inevitability in a preternatural way. He had become one with his Rorschach sea, which had originally been the ordinary sea that confirmed his exile. Today, Hugo has the double immortality of having created extraordinary intelligibility and extraordinary unintelligibility. He shows us what it really means to be an ''artist,'' beyond any medium.

Part Two
The Subjectivity of American Artists

Arshile Gorky:
Images in Support of the Invented Self

People will go to extraordinary lengths to undo narcissistic injury.
Heinz Kohut, Conversation with Charles B. Strozier

Only through sublimized form can we pass through the narrow door.
John Graham, *System and Dialectics of Art*

"The question of identity," Harold Rosenberg wrote, "is outstanding in regard to Gorky's paintings." [1] In a sense, Arshile Gorky never knew his identity as an artist until the last years of his life. Stuart Davis noted that Gorky "chose the strongest painters in modern art as the models for his development." [2] Davis himself, described by Gorky as a "pioneer" who established a "cool and intellectual world where all human emotions are disciplined upon rectangular proportions," [3] served Gorky as a self-object [4]—a source of artistic identity—for a time. Diane Waldman observes that with the two versions of *The Artist and His Mother,* ca. 1929–42 and 1926–29, Gorky "for the first time . . . has overcome his need to identify with the great artists of the past and has engaged, instead, in a quest for contact with his own past and personal identity." [5] When the self identified is no longer dependent upon a matrix of other artist selves, works of special intensity and individuality result: "The extraordinary emotional intensity and formal economy of these two canvases are unsurpassed in Gorky's oeuvre, save for the great work of the 1940s." [6] Yet even these works, like those of the 1940s, show a strong dependence—on the literal rather than figurative parent, on the mother rather than the imaginary father.

What Jacques Lacan calls the "attractiveness of identifications"—

This article originally appeared in *Abstract Expressionism: The Critical Developments* (Exhibition Catalogue, Albright-Knox Gallery; New York: Harry N. Abrams, 1987).

which carries with it "the risk of madness,"[7] that is, the loss of any central, binding identity—is inseparable from an understanding of Gorky's art. It exists in terms of the dialectic of Gorky's relations with other artists—the symbiosis and autonomy played out through his intimacy with them. As Rosenberg wrote, "Gorky's act of labeling himself with another man's device lies at the root of his processes as a painter and the metaphorical art that blossomed out of them."[8] Yet "the question of originality" that Rosenberg thinks is inseparable from any consideration of Gorky's art masks another question: of the origins of creativity, and strategies of maintaining creativity in the face of an inhospitable, indifferent environment—in a country which had no conception of the spirituality of art, let alone a tradition of spiritual art. In the alien American environment, support for art could not be taken for granted; one had to actively enlist and subsume other artists in the cause of one's own art. One borrowed the spirit as well as appropriated the letter of their art, and spiritualized them through one's envy of their individuality. One yearned for an art of one's own—an art, like theirs, that seemed to identify a person. Creativity, integrity, and individuality were inseparable for Gorky; it is hard to say which served the other in difficult social circumstances. Gorky's development is another instance of the problem of becoming an artist, maintaining integrity, and developing individuality in the American environment.

For much of his life, then, Gorky could not practice art without the support of other, "overseeing" artists, who he imagined cared for him as much as he cared for them. His personal bravura—his display of autonomy—masked this need for other artists. Yet even the flamboyant, exhibitionistic style—a kind of manifesto—that he thought went with being an artist was hardly personal, and it did not guarantee that he would become an important one. It was wishful thinking on his part, and it satisfied the conventional understanding of the artist's behavior—the conventional understanding of the artist as a poseur. It was an assimilation of the public conception of the differentness of the artist, a spirit of bohemian otherness into which Gorky tried to enter in order to become the special artist self. As in his emulation of other artists in his work, his emulation of the idea of artist in his person did not so much make him his own self as it showed his dependence. His attraction to the idea of the mythical generic artist reflected his insecurity and lack of specific artistic identity as much as his attraction to various other artists did. Gorky worked hard at making art, but until the last decade of his life he almost always made someone else's art or art that tried to live up to some mythical idea of art.

One can argue that, for Gorky, relationships with other artists, which apparently reconstituted the primal father/son relationship, were every bit as important as the making of works of art. Mostly he was the son, as with Cézanne, Picasso, and Miró, but sometimes, as with Matta, he was the father.[9] Ironically, when he finally came into his own in the 1940s, it was because he was able to identify completely with his actual father, or rather with the Armenia his father left when Gorky was four (1908), and which Gorky himself left when he was sixteen (1920).[10] Both left the old world for the new, Armenia for America. Two places could not be more opposite; it was only when Gorky was able to integrate their landscapes that he truly became sufficiently free inwardly to turn away from artists and art—to find his support in extra-artistic nature, fraught with personal meaning—that he became authentically autonomous. He had gone beyond mastery of the modern language of art to self-mastery. He had fused creativity and integrity.

Throughout his life Gorky remained inwardly ''directed toward Armenia''—in his friend Yenovk der Hagopian's words, ''toward an even greater appreciation of the natural beauty of the old country . . . he realized fully what we had and what we had lost.''[11] In a conversation der Hagopian had with Gorky in 1946, he reported that Gorky became more and more oriented to nature as he aged; it seemed to be a way to transcend his personal history and, at the same time, to make concrete the feelings he associated with it. It was when Gorky returned in spirit to the nature of the old country, through the catalyst of and substitute satisfaction afforded by the new world landscapes of Connecticut and Virginia, that he was able to reconcile himself to his history. The lost paradise of the old country was symbolized by his father's Garden of Wish Fulfillment, as he called it, with its Holy Tree of the Cross.[12] In fantasy, he at last securely inhabited a place that was barely a memory, that existed as no more than an emotion—a place that had, with time, become more spiritual than physical, more occult than actual, more ideal than banal. In its exterior absence it became a stronger interior presence, more inwardly familiar the less its outward reality could be specified. It possessed Gorky more—demonically—the less he could describe it, the more he had to invent it. The more fantastic, and inherently artistic, the lost garden of paradise appeared, the more Gorky could have a creative relationship with it.

Yet in this sacred space of the imagination—in the 1940s landscapes that Gorky attempted to recapture, through Modernist means, the primitive spirit of ''authentic'' (his own word) nature, with its miraculously generative tree symbolic of the imagination as such—he is more

completely dependent than ever on self-objects. He has found his way back to his true father, to the supreme self-object of the father, more difficult to know than the mother, yet just as subjectively ultimate. He has found his way, by using talismanic, sublimized natural forms, through the narrow door of art into his father's garden, idealized into the divine womb of creativity. His landscapes of the 1940s embody the imagined spirit of the fatherland, just as his earlier portraits embody the imagined spirit of his motherland. Each recovers a supportive prototype in symbolic form. Waldman says that when, in the late thirties, Gorky's "paint takes on an independent life," he "is about to liberate himself from his past; he is on the threshold of his personal vision."[13] In fact, the new vitality of his paint signals his complete regression to the nature in his deepest past: it is only in his father's garden that he can envision and embody, or fulfill, his self.

· His was a slow-growing branch, and only when it was grafted on the Holy Tree of the Cross in his father's garden did it bear ripe fruit—works of art that are truly "personal inscriptions of signatures" like the "veritable parade of banners" on that memorable tree.[14] He had become one of the "authentic Armenian villagers [who] attached the colorful pennants of their clothing"[15]—Gorky's drawings, especially, were like such pennants—to that tree which, in a sense, was all he ever wanted to be. He had made known "the glorious and living panoply of Armenian nature, so unknown to all yet so in need of being known." As he suggested, his art, with "its hybrids, its many opposites," relates to Armenian art as well as to the dream world of Surrealism and is inseparable from "the inventions of . . . folk imagination."[16] Paul Klee said that Modern art lacked final force because it did not have the support and spirit of the folk. Gorky's art attempts to unite the Modern and folk spirits. No artist was so well equipped, by training and personal history, to make the effort.

Who, then, was Arshile Gorky? What is the singularity of his individuality? His name was invented.[17] Marcia Epstein Allentuck, discussing "the close association between the two expatriates" Gorky and John Graham (who had also changed his name), observes that "in William James's sense, both were at least twice-born men, whose images were largely self-created." Allentuck views "the name change as a function of the self-creating role" and notes that both Gorky and Graham were "self-obsessed and constantly playing roles."[18] Such self-obsession and role playing suggest determination to invent a self. Gorky and Graham—and, one might add, Willem de Kooning, who was closely associated with Gorky until his death and who, with Pollock, was discovered by Graham—were displaced persons. De Kooning once remarked that

Gorky, Graham, and Stuart Davis were "known as the Three Muske-teers."[19] Gorky, Graham, and de Kooning had a confused sense of self, formed by old world experience and new world expectations—by ex-perience of tragedy and great expectations. They were in a dialectical situa-tion; they had to forge their integrity out of quite obvious opposites. In a sense, each one's core self was formed not in the involuntary experience of the early years of his life, but willed into existence when he was mature. Graham and Gorky came out of similar, limited old world circumstances—out of societies in which they were not only not welcome but actively persecuted[20]—and experienced the new world as a place of infinite possibilities. Indeed, their self-obsession and role playing, or poseur quality, can be understood as entrepreneurial; they were self-made men. The trauma of being uprooted and having to put down new roots undermined Gorky's sense of self, narcissistically injured him, and necessitated fresh self-creation. Gorky *had* to become a new person, or he would be nobody. And he could only become a new self by planting his old self in the new soil of the American landscape. It was only by attaching himself to the American landscape that he could feel at home; only through a sense of natural place could he stop feeling socially dis-placed. New York, where he lived until the last half-decade of his life, is not emotionally a place, but a symbol of the displacement all Americans—once all immigrants—share. New York is a world of people who have displaced themselves to become modern, that is, to learn how to make modern history. In New York, Gorky learned to make Modern art, but in the American landscape he learned—as Americans before him did—to create a new self, which meant being both Modern and Primitive.

I submit that in becoming a new self—an original artist—Gorky real-ized Graham's "program" of art-making. Gorky accepted Graham's sense of what was significant in art and brought it to a fruition that Graham himself could not realize in his own art. David Smith recalls "watching a painter. Gorky, work over an area probably a hundred times to reach an infinite without changing the rest of the picture, based on Graham's account of the import in Paris of the 'edge of paint.' . . . For Graham, 'the edge of paint' was 'where one color meets the other.' He believed that this edge 'ought to be absolutely spontaneous and final.' "[21] This dialectical edge of paint was realized in Gorky's landscapes of the forties, which, in general, depend on the ideas in Graham's important *System and Dialectics of Art.* (It might be noted that this influential treatise is the source of many of Clement Greenberg's ideas. Graham deserves much of the credit that has been given Greenberg, including, as mentioned, the discovery of Pollock, noted by de Kooning.)

Allentuck describes the completeness of Gorky's identification with

Graham in the 1930s and Gorky's great debt to Graham in general. Gorky accepted Graham's high estimation of Picasso, Ingres's "reductive method and preoccupation with two-dimensionality,"[22] and Uccello's "linearity and irrationality (which meant spiritual rationality),"[23] going so far as to adapt through biomorphic abstraction "a bird (*uccello*) as a radical image in his work."[24] Allentuck notes that in the late 1920s the palettes of Gorky and Graham were similar: "There is a very fine portrait of Elinor Gibson painted in 1929 by Graham . . . which could easily be taken for a Gorky of the same period: the flat yet smoldering pinks, the staring Fayoum eyes, the black boundaries like leading in medieval glass in this work resemble some of Gorky's versions of his mother's face which he worked on for several years, and which he was already developing at this time. What is certain . . . is that Gorky was avidly experimenting throughout this period with a 'Cloisonnist' technique" related to that of Graham.[25]

Graham was obsessed with the tension between control and spontaneity and, in fact, argued that tension was the most salient quality in a work of art, a sign of its significance. Indeed, it was "the only reality accessible to human beings," and thus necessitated a dialectical understanding of human creations.[26] Tension, we might note, was basic to the aesthetics of Freud and Jung,[27] in whose writings Graham immersed himself.[28] The dialectical idea of proceeding by way of tension, through "an unbalancing of [the] established,"[29] or rather establishing an unbalance that could be read as a dialectical balance or unity, was central to Graham's thought.

The chance linear gesture was the vehicle of tension for him. Graham wrote: "As a trim little bullet makes drastic changes in a big strong body, so does an art-gesture—every move is fateful. One should not be afraid of accidents occurring in one's art."[30] This, of course, is an extension of "*automatic 'écriture,'*" or calligraphic form. "By écriture is understood a *personal* technique-result of training and improvisation in contradistinction to technique in general which is an accumulation of professional methods."[31] The problem is to be personal, which is harder than one thinks, so possessed is the artist by professional methods. It requires a special strategy to be personal; the personal, rooted in the unconscious, must be taken unawares, caught off guard, or rather, one must subvert what one intellectually knows to become personal. One sees here the basis of what later became de Kooning's animadiversions against style and professional method.

What is crucial in Graham's remarks on linear gesture is the emphasis on its emotionality, the root of the personal. "Gesture, like voice, reflects different emotions. . . . The gesture of the artist is his line."[32] Gesture

implied "authentic [emotional] reaction . . . to a phenomenon observed," registering "caress or repulsion" through the immediacy of "brush pressure, saturation, velocity."[33] Gorky, one can say, practiced becoming deeply personal through the prestylistic practice of improvisation at what Graham called the "great mystery" of "border line"—"the most crucial and the most difficult in all manifestations of human activity, the most difficult to achieve, to master, and to see or perceive"—which raises the question, "where ends the stroke and where begins the caress?"[34] For, by regressing to a prestylistic condition of art, he was able to establish the significant content of his art—to make contact with the "borderline" emotions aroused by nature and, through nature, associated with his father and fatherland. For Graham, line not only resolved "the dialectic between motion and stasis . . . arrest and movement," but through its "purity" it could "sing imperceptibly" and convey an emotional tone.[35]

Gorky's debt to Graham had to do not only with method, but was ideological as well. It was Graham who emphasized the origin of art "in human longing for *enigma*,"[36] and in this sense, he was responsible for Gorky's enigmatic objects of the 1930s. Graham was obsessed with the "mystic play of impersonation of the enigma of creation and the drama of the world."[37] It is hard to imagine a more profound recognition of what occurs in Gorky's enigmatic objects, climaxing in his 1940s landscapes. Graham insisted that one had to risk "self-destruction, just to be born again and fearlessly skate on the edge of some new abyss."[38] Gorky, moving from mentor to mentor, searching for a new identity as soon as the old one had become an "act," was perpetually destroying himself and being reborn as someone else—until finally he was reborn as himself. There is metempsychotic import to Gorky's changes in identity and shifting artistic allegiances inseparable from Graham's belief in the occult character of art. It was a sacred way to the true, divine self for Graham.

Silence, which Graham called "wisdom integral" and which he regarded as the most difficult, yet necessary, quality to achieve in art,[39] was pursued by Gorky throughout his development, even when he was most linear. His linearity, climaxing in the "contouring line" of the 1940s landscapes, [40] has been associated, by Gorky himself, with a "look into the grass."[41] That Virginia grass had to be of interest to Gorky's unconscious only because it evoked the "veritable parade of banners under the pressure of wind" on the Holy Tree of the Cross in his father's garden, "personal inscriptions of signatures"—signs of feeling—that "very softly to my innocent ear used to give echo to the sh-h-h-sh-h of silver leaves of the poplars."[42] This is the sound of silence, the imperceptible singing of nature—of unconscious emotion—that Gorky tried to capture and articulate in his images. It is the same haunting and terrorizing silence of

nature associated with Munch's *The Scream*. To make a profound picture, Gorky always had to complete the same chain of regressive associations ending in silence, as though fingering the mystical beads of a rosary: the silent, singing wind; the colorful clothing, banners, inscriptions of the folk, the truly authentic people; his father's garden, with its lush, colorful nature; and then the silence, for the wind, the folk, his father were all dead, except in memory. For Gorky, the folk is the colorful sound between two silences of nature, living nature observed and dead nature remembered. The wind in the Virginia grass triggered memories of the Armenian wind in the banners of the Holy Tree of the Cross and in the poplars. For Graham, silence was associated with time: it was "a portion of space measured by time."[43] It was an emotional space of repressed memory in the midst of observed sounds, as fluid as grass in the wind. Music, as he said, "consists of series of silences, pauses, i.e. spaces tightly bound by sound into an organic pattern."[44] This could well be a description of Gorky's 1940s landscapes, with their linear pauses between resounding colors.

Graham asserted that *"art is a subjective point of view expressed in objective terms."*[45] Before he could express his subjective point of view, Gorky had to learn the objective terms of Modernist art. In a sense, he had to work through various objective modern artist identities before he could articulate his own primitive subjective identity. He had to submit himself to idealized parent-artist images in order to grow into his own ideal self. Put another way, he had to apprentice himself to certain major modern artists conceived as all-powerful objects, implicitly acknowledging his own immaturity and childlike (primitive) character, in order to grow into an artist self of his own.[46] This is more than a conventional case of discipleship and influence, disciplining oneself in a field; for Gorky, it was a kind of masochistic submission that allowed him the pleasure of feeling he had mastered himself. Gorky could only feel like himself when he knew what it was like to be a parental other. It was not just that Gorky needed the community of successful fellow artists to feel like an artist himself and to believe in his own possible success but that, without actual self-objects, he could not *imagine* himself.

From a strictly artistic point of view, the problem is stated in de Kooning's assertion "To desire to make a style is an apology for one's anxiety."[47] Gorky could fully know and articulate his anxiety only by retracing the steps by which an already existing, objective style was made. Pursuing purely artistic mastery, he could unapologetically acknowledge his anxiety: only in a situation of self-imposed restraint could he find release. Jörn Merkert observes that "throughout his life de Kooning has been convinced that a painter runs a terrific risk when he attempts to

find an inimitable style. Style is a claim to general validity, and this, sooner or later, is bound to stifle individual creativity."[48] In de Kooning's words, "Style is a fraud . . . you are with a group or movement because you can't help it."[49] But Gorky had to be a member of a movement, however much it was one of his own invention, to realize his creativity as an individual. He had to believe in the general validity of Modern art to validate his primitive self. He had to believe there was a universal Modern style to accept the anxiety of his primitive self.

The paradox of Gorky's traditionalist approach to Modern art was that he imitated art that was still revolutionary. It was valid only in particular artistic circles, not generally. Gorky wanted neither to make a new stylistic revolution nor to develop yet another language of art, but rather to consolidate the gains of the original revolution. He meant to rerealize the old revolution, as it were, by bringing out the profound vision of emotion implicit in its new language. He wanted to perfect the primitive expressive possibilities of the modern language of art. It was as much a revolution in feeling as in style. He did so in a paradoxical way: to generate emotional intensity, he emphasized its "flaws." In Graham's words, Gorky had "highly developed taste," and "perfect taste is satisfied only with the perfect, which means the best, the one, the unique. Every organic imperfection relative to its own entity makes an object, otherwise fine, worthless. This might be called the curse of the great taste."[50] I submit that Gorky did not passively pursue the supposed perfection of Modern Master style, as is customarily thought, but articulated the organic imperfections in it. Those imperfections seemed to subvert its objectivity and general validity and deny it as a conscious creation, implying its subjective or unconscious basis. Gorky idealized his Modern sources, but he also dissected them, in search of the expressive mystery of Modern art's anatomy. In the 1940s landscapes, Gorky's interest in the physiognomic implications as well as the physiological actuality of Modern art converged. He was, in Graham's words, able to synthesize his "great taste"—his pursuit of physical perfection—and that "high tension and capacity for stupendous effort" crucial to his pursuit of ultimate expressivity.[51]

Gorky found in the work of the New Masters organic imperfections—imperfections that "proved" the "organic" origins of a perfect art—that became the basis for his 1940s reconception. In Graham's words, these origins were of "prehistoric art and the art of prehistoric nature . . . an art based on direct reaction to nature's phenomena and on an insight into the origin of things."[52] Graham regarded the "Picasso period 1930/33" as a major example of a Modern art of prehistoric nature, an art that appeared to return to "the dawn of human civilization" and that recalled

"in its forms, the form of man himself at his own dawn, embryo, foetus,"[53] that is, of man when he was most one with nature, differentiated from it but still linked to it through the umbilical cord of his unconscious. The organic imperfections of Modern art—the problem of borderline or edge (a zone of inherent imperfection)—became the points of departure for Gorky's fetal forms. Gorky's art not only devolved toward the "foetus, ancestor of all forms and beasts at one and the same time, like a rosebud holds in itself *threat* of all potentialities dormant but potent," but also attempted to "picture man as a foetus when man himself was only foetus of his future civilization."[54] The point was to create a form that was threatening yet fruitful. Gorky's fetal form is apocalyptic but promises resurrection. It is doubly sacred, a holy cross and a tree, the body's tomb and the second coming.

Picturing nature and man at their most primitive was the goal of Gorky's art. In his final style, Gorky articulated in ultrasophisticated, objective, modern terms his subjective sense of the inner fetal form of primitive nature and civilization as he remembered them from Armenia. It was a primitive point of view doubly filtered, through memory and Modernism, both of which made it seem more primitive and "impossible" than ever, because of their implication that it was inherently difficult to articulate or objectify. The result can be regarded as Byzantine in its tone of emotional intrigue as well as "encrusted" character. Graham characterized Byzantine style, from which the Armenian art that influenced Gorky derived, as "pungent, clumsy, direct, exuberance restrained."[55] Such primitive civilized style—a style that shows a certain elementary restraint on impulse, a minimum or primitive civilized character—with its fetal or primal shapes is the substance of Gorky's sublimized form. It permitted him to pass through the narrow door of the Garden of Wish Fulfillment—to enter not simply into a world of wishes but into one of fulfilled wishes. In sublimized fantasy he fulfilled the wish of revisiting his father's ancient garden. That wish was always there, in all its emotional fullness, but it could be realized only when Gorky finally sublimized form. Such form not only indicated Gorky's transcendence of substitute artist-father figures, but the healing of his narcissistic injury. It was in effect caused by his imagined banishment from his father's dream garden, a banishment he unconsciously supposed he had caused by doing something bad, even though he consciously knew that world historical circumstances were responsible for his departure from Armenia. Sublimating American nature, he found his way back to innocence and paradise.

The doubleness of Gorky's mature style—its primitive fetal yet early civilized character—is reflected in Graham's account of form as subjective. In this analysis, Graham makes an implicit distinction between form

in process and "self-sufficient form" or "pure form."[56] Fluid fetal form is form at its most subjective. Pure form is subjective form objectified. Fetal form reflects the fact that "subjectively form is an ability to command, to imprison space in significant units, it is an ability to control the stream of energy in regard to space."[57] Primitive fetal form binds the stream of energy, affording elementary control of it (so evident in Gorky's 1940s works, especially his drawings). "Great art," says Graham, "relies on self-sufficient form, the iron clad form. Self-sufficient form is a challenge to deity, it is the demon of search, the demon of relentless argumentation, the demon of perilous conclusions, it is the demon set loose. . . . Pure form in space speaks of great psychological dramas more poignantly than psychological art can ever do."[58] Putting this another way, Graham distinguished between "two methods: a) method of creation and b) method of expression."[59] Still another distinction he made was between the "two necessary elements of beauty: perfection of form and surprise or rarity."[60] Rare fetal form creates surprise: the trick was to make it seem self-sufficient or pure, implying perfection. That is, the magic was to make it at once primitive and civilized. As Graham said, in another remark that seems tailor-made for understanding Gorky, "Beauty is the beautiful expanded to the verge of ugliness."[61] Or, as he also said, "Cruelty has beauty"; "Great art is terrifying, sometimes monstrous and repellent, but always beautiful."[62] Primitive fetal form is a kind of artistic cruelty that expands beauty to the verge of ugliness or uncontrollability, while self-sufficient or pure form maintains the control or civilizing influence of beauty. Modern primitive beauty is ambiguous. It shows art to be expressive as well as creative, communicative as well as energetic, consciously civilized as well as unconsciously cruel. It is because these opposites occur in unexpected combination that Graham asserts that "beauty cannot be foreseen."[63]

In this context of understanding, Gorky's problem is that he offers partially recognizable or "realistic" images, even if in "surreal" or fantastic combination, rather than a completely new creation. It is as though he is relying on the old exterior nature for the source of his new interior creation. That is, it is as if his fetal forms are prefabricated illusions of primitive creation. It may be that genitals and genitallike forms are the most primitive, or fetal, in nature, but if they are preordained they lose their surprise and appearance of rarity; they no longer seem the seat of the mystery of creativity. It is as though Gorky is reliving the creativity of nature as he once lived the creativity of other artists.[64] However, authentic creativity appears in the stream of energy in the 1940s landscapes—their "high tension," air of "stupendous effort," and generative force. This counts for more than their hermaphroditic, ambiguously vegetable/animal/human forms. "Sublimized form" means the dissolving

of such superficially self-sufficient forms into the fetal line. Uccello's lesson, taught by Graham, was that even the most crystalline and controlled space-forms contained a stream of hidden energy. In Gorky's later work, this invisible stream, already felt in the fault lines of his enigmatic objects, becomes visible. Objects disintegrate completely, coherence can hardly be discovered. The occult energy of nature becomes visible; the complete picture becomes an edge, a borderline situation. Paradoxically, such fluidity promises new cohesion; it implies a process of healing. Gorky's art can be understood as a kind of self-healing through immersion in the stream of nature's energy, an infinite regress into nature that releases the infinity of feeling in human nature. Through feeling, Gorky was able to transcend his historical condition.

> *The eye's spring . . . Arshile Gorky is, for me, the first painter to whom this secret has been fully revealed.*
> André Breton, *Arshile Gorky*

Gorky's work falls into three basic groups: portraits and self-portraits; enigmatic still lifes; and interior landscapes. His art progresses from an explicit to an implicit rendering of self, which correlates with a devolution of imagery from the representational to the abstractly allusive, the objective to the subjective. It moves from darkly mirroring "to cast[ing] an outline," in Breton's words.[65] It moves from rendering the strange passivity of the emotionally paralyzed figure to articulating, in *"stencil"* form, the unbearably intense "rhythm of life itself."[66]

Gorky's problem was always to avoid stylization of the subjective—to keep his good taste in check as he uncovered the primitive roots of the subject. Put another way, his problem was to avoid regressing from the freedom of natural form—the aura of autonomy communicated by the fetal—to the rigidity of civilized form. He was always in danger of inhibiting himself through a premature application of civilizing mastery, a compulsive desire to make the imperfect appear to be perfect and aesthetically acceptable rather than to allow it the rawness of the improvisational state. In a sense, he was too refined for his own good, but fortunately extended experience of nature—experience that at the end of his life reinforced the experience that formed him early in life—taught him to trust the harsh intensity of his instincts without completely sacrificing himself to them. He learned to work with the support of nature rather than that of other artists; nature never let him down as the artists all did sooner or later. For other artists could never bring back his happy childhood; they could only confirm his unhappy adulthood. Gorky could never transcend nature, as he could art, representative of civilization (and the city), which had wounded him profoundly.

In a sense, his development is still another example of the necessity of art—and the self—to return to nature for healing and succor and renewal after the injuries and decadence caused by civilization, although for Gorky the pastoral mood was never calm. It was never a matter of resting comfortably on the picturesque surface of nature but rather of delving into its violence. While Gorky sometimes appears to offer a new picturesqueness, his image of nature is too fraught with anxiety to stabilize sentimentally. Graham, following Theo van Doesburg, thought that "the artist must allow the 'picturesque fortuitousness . . . of nature to predominate,' "[67] but in Gorky such fortuitousness is too charged with anxiety to allow the settled, genial sense of nature associated with the picturesque.

Indeed, from its inception, Gorky's art surgically probed violence; his linear gestures have the deftness of a surgeon's controlled violence. In the portraits he generally renders the emotional violence or melancholy wrought by civilization, a destructive violence; while in the interior landscapes it is the violence of a constructive nature, of nature's generative force. The enigmatic still lifes in between show a transitional uncertainty. Civilization's capacity to wound has not yet become nature's capacity to heal. I take the still lifes to be reactively violent. They neither describe a state of woundedness, as in the portraits of civilization's victims, nor evoke it as they counteract it, as in the interior landscapes of the self in the process of being healed of civilization.

The two versions of *The Artist and His Mother*, the *Self-Portrait* of about 1937, and the *Portrait of Master Bill* [de Kooning], about 1937, are the portraits of victims. Each is a demonstration of the technique of "cancellation" described by van Doesburg and endorsed by Graham.[68] The greater the cancellation of the object on the picture plane—the more it moves from being one of the standard "illusions of false recognition" to one of the occult "*springboards* towards the deepening . . . of certain spiritual states"[69]—the greater the expressive effect, the release of feeling, the experience of its potential infinity. (It is finally signaled by the flatness and silence of the picture plane itself, on which the linear gesture-shapes that imply a potential, "contingent" object are ruthlessly inscribed like staccato musical notes.) The second version of *The Artist and His Mother* shows a greater cancellation of the figures than the first version. Especially cancelled is nature, symbolized by the dwindling of the boy's bouquet, furthering the commemorative potential of the photographic image, and its conversion into art. In the *Self-Portrait* and the *Portrait of Master Bill*, it is no accident that the artists' working arms are the most cancelled—injured. They look as if they are bandaged.

Of course, the cancellation generates a timeless effect, which eventually becomes the source of the self's salvation. "Saints observe no

clocks," Graham wrote.[70] Yet saints are suicides of a sort, and so too did Gorky and de Kooning, simply by devoting themselves to art, commit a kind of suicide; that is, they wounded themselves irremediably. Graham, discussing "the reason great men frequently commit suicide in one form or the other" (Gorky literally committed suicide), observes that they feel socially unsupported. "All the while they create they realize that society does not cooperate with them, wants no good books, no good music, no good painting. . . . It seems that no matter what is being done it is just a waste of time and of no use. The very process of life seems a waste of time."[71] It is this defeated spirit that invades the portraits through cancellation. But it also creates the regressive spirit—generates the psychologically archaic—which eventually heals. The dialectic of cancellation is crucial to Gorky's imagery, from start to finish. Cancellation, initially a method, becomes a kind of ideology. Initially a strategy of abstraction, it becomes therapeutic.

A great number of works can be said to present enigmatic objects, from the Picasso-inspired *Portrait* of 1936–38 (and other compositions) through such explicitly mythopoetic works as *Child of an Idumean Night* and *Battle at Sunset with God of the Maize* (both 1936) to the *Image in Xhorkom* (1934–36) and associated works, including *Enigmatic Combat* (1936). For me, what is central in these works is the ambiguous integration of the forms. The erratic use of heavy contouring separates more than unites them. It is not simply that the biomorphic shapes are discreet, but that they are forcefully connected. Without the compulsion to connect—the compulsive eroticism of the whole work—*Image in Xhorkum* would be as much about death as sex. *Enigmatic Combat* makes the aggressive point explicitly; the turbulence of the forms suggests a battle to the death as much as an explosive copulative generation of forms. These pictures seem to be more about disintegration than integration, and while their forms are more continuous than the brilliantly discontinuous "formalizations" of the 1940s landscapes, this has more to do with Gorky's dependence on Picasso's surreal anatomies of the 1930s, with their insistence on the nominal integrity of the body, than with an inherent drive toward unity. The unity of these works is preconceived rather than achieved, a matter of unconscious acceptance of convention rather than of conscious choice on Gorky's part.

When Gorky, in the 1940s, gives up the assumption of the image's preordained unity, scattering his biomorphic forms loosely on the picture plane—and loosely "constructing" them (they are whimsically fluid creations compared to the more crafted shapes of the 1930s), the full melancholy of his vision becomes explicit. His shapes and colors smell as much of decay as of birth; the picture seems to fall apart in the act of flowing, with turbulence increasing to the point of chaos. The images

as a whole seem to be the creation of a heroic, mad capriciousness. Indeed, in Edgar Wind's sense of the term, Gorky offers us magnificently violent capriccios.[72] The lushness of *Waterfall* (1943), the analogical plenitude of *The Liver Is the Cock's Comb* (1944), which Breton said "must be considered the great gateway open on to the analogical world,"[73] and the general hothouse look of strange preciousness in Gorky's 1940s works do nothing to overcome their atmosphere of disintegration. However perversely delicious and cultivated the interior landscapes look, they remain acutely morbid and monstrous. De Kooning once said, "Flesh was the reason why oil painting was invented"; in Gorky's interior landscapes, one often seems to be looking at flesh splattered on a wall, the aftermath of an explosion in a crowd of mutant creatures. Indeed, the "unraveling" effect to which Gorky himself alludes in *How My Mother's Embroidered Apron Unfolds in My Life* (1944), acknowledges disintegration explicitly.

There is an indefinable tragic aura in Gorky's works. They have a grim undertone, not simply because of the grayness that often infects their bucolic colors, as in *One Year the Milkweed* (1944), but because they are torn between the feeling of despair that Kierkegaard called the "sickness unto death" and the will for health. I think titles like *Cornfield of Health* and *Charred Beloved*, both in two versions, are far from accidental. Gorky's art is caught in the same dialectic as Gauguin's art, the dialectic of sickness and health or death and rejuvenation behind every serious Primitivist art. It is the confused feeling of life-in-death or death-in-life, a conflict from which no exit seems possible, as suggested by the labyrinthine aspect of Gorky's interior landscapes. Gorky's titles are meant to signal the tense emotion, fraught with the struggle between the life force and the death instinct, the drive toward health against the pull or "gravity" of death, for which the pictures offer themselves as objective correlatives. If, as has been suggested, feeling is about the ambivalence of connection, then Gorky's pictures are about profoundly ambivalent feelings of oneness with the world in general and nature in particular.

Intense ambivalence—inner conflict—is a major source of emotional suffering. Gorky has smoothed the edges of his suffering through the elegance of his gestures, through the finality he is able to give his fetal forms. *The Betrothal* and *Agony* (both 1947), are major examples of such "clarified" tragic sensibility. But his interior landscapes remain irrevocably tragic in their discontinuity, their peculiar dissoluteness of form, their weird, consequential diffuseness. In the end, Gorky came to regard the chaos of chance as the most self-sufficient form. He pushed back the limits of form almost to ideal, romantic formlessness. Indeed, his pictures are perhaps the purest, most eloquent and hypnotic, Expressionistic screams.[74]

Notes

1. Harold Rosenberg, *Arshile Gorky: The Man, the Time, the Idea* (New York: Horizon Press, 1962), p. 36.

2. Quoted in Diane Waldman, *Arshile Gorky 1904–1948: A Retrospective* (New York: The Solomon R. Guggenheim Museum, 1980), p. 23.

3. Quoted in Rosenberg, *Gorky,* p. 127.

4. The concept of self-object is derived from Heinz Kohut, *The Analysis of the Self* (New York: International Universities Press, 1971).

5. Waldman, *Gorky,* p. 33.

6. Ibid.

7. Jacques Lacan, *The Language of the Self* (New York: Dell, Delta Books, 1975), p. 134.

8. Rosenberg, *Gorky,* p. 44.

9. Both Rosenberg and Waldman discuss extensively Gorky's relationships and the influences on him.

10. Waldman, *Gorky,* pp. 13–17 offers a comprehensive account of his early life.

11. Quoted in ibid., p. 16.

12. Ibid., p. 47.

13. Ibid., p. 44.

14. Ibid.

15. Ibid.

16. Ibid.

17. Both Rosenberg and Waldman explain the derivation of and rationale for Gorky's name. As Nicolas Calas has pointed out in "Gorky's Garden of Wish-Fulfillment" in *Transfigurations: Art Critical Essays on the Modern Period* (Ann Arbor: UMI Research Press, 1985), p. 177, "*gorky*" means bitterness in Russian.

18. Marcia Epstein Allentuck, ed., *John Graham's System and Dialectics of Art* (Baltimore: Johns Hopkins University Press, 1971), p. 17.

19. Ibid., p. 20.

20. Gorky had to flee Turkey, which slaughtered the Armenians with genocidal intention, and Graham, an aristocratic Russian, appeared to have fled revolutionary Russia.

21. Allentuck, *John Graham's System,* p. 17.

22. Ibid., p. 27.

23. Ibid., p. 130.

24. Ibid., p. 17.

25. Ibid., p. 20.

26. Ibid., p. 2.

27. See Patricia A. Berry-Hillman, *Jung's Early Psychiatric Writing: The Emergence of a Psychopoetics* (Ph.D. dissertation, University of Dallas, 1984), p. 157.

28. Allentuck, *John Graham's System*, p. 123.

29. Berry-Hillman, *Jung's Early Psychiatric Writing*, p. 157.

30. Allentuck, *John Graham's System*, p. 22.

31. Ibid., p. 124.

32. Ibid., p. 23.

33. Ibid., p. 24.

34. Ibid., p. 2.

35. Ibid., p. 104.

36. Ibid., p. 4.

37. Ibid., p. 10.

38. Ibid., p. 26.

39. Ibid., p. 27.

40. Waldman, *Gorky*, p. 54.

41. Ibid., p. 53.

42. Ibid., p. 47.

43. Allentuck, *John Graham's System*, p. 28.

44. Ibid., pp. 27–28.

45. Ibid., p. 131.

46. Heinz Kohut, *Self Psychology and the Humanities* (New York: W. W. Norton, 1985), p. 100.

47. Quoted in Jörn Merkert, "Stylelessness as Principle: The Painting of Willem de Kooning," *Willem de Kooning: Drawings, Paintings, Sculpture* (New York: Whitney Museum of American Art, 1984), p. 127.

48. Ibid., p. 115.

49. Ibid., p. 127.

50. Allentuck, *John Graham's System*, p. 128.

51. Ibid., p. 129.

52. Ibid.

53. Ibid.

54. Ibid., p. 130.

55. Ibid.

56. Ibid., p. 132.

57. Ibid.

58. Ibid.

59. Ibid., p. 133.

60. Ibid.

61. Ibid.

62. Ibid., p. 2.

63. Ibid., p. 133.

64. D. W. Winnicott, "Creativity and Its Origins," *Playing and Reality* (New York: Tavistock Publications, 1982), p. 65, notes that "many individuals have experienced just enough of creative living to recognize that for most of their time they are living uncreatively, as if caught up in the creativity of someone else, or of a machine." Gorky needed to inhabit the machine of other artists' creativity in order to get a sense of his own creative potential, and finally to get caught up in nature's creativity to actualize his creative potential. One can say that his last work is a celebration of the inherent creativity of art: that is, art talking about its own creativity, or about the free act of creativity as such. Creativity blossoms in late Gorky like a flower that knows its own transience.

65. André Breton, "Arshile Gorky," *Surrealism and Painting* (New York: Harper & Row, Icon Editions, 1972), p. 199.

66. Ibid., p. 200.

67. Allentuck, *John Graham's System*, p. 22.

68. Ibid., p. 23.

69. Breton, *Surrealism and Painting*, pp. 199–200.

70. Allentuck, *John Graham's System*, p. 173.

71. Ibid., p. 145.

72. Edgar Wind, *Art and Anarchy* (New York: Random House, Vintage Books, 1969), pp. 46, 146.

73. Breton, *Surrealism and Painting*, p. 200.

74. For a discussion of the Expressionist scream and the tendency to chaos and its use as form in Expressionism, see my "Chaos in Expressionism" in Mary Mathews Gedo, ed. *Psychoanalytic Perspectives on Art* (Hillsdale, N.J.: The Analytic Press, 1985), vol. 1, pp. 61–72. Reprinted in this book, pp. 81–92.

The Pascalian Spiral:
Robert Smithson's Drunken Boat

The spiral is the archetypal image of Smithson's art. Smithson at one point describes it as the form of "seizure" that "releases scale from size,"[1] opening the way to a sense of the cosmic and its correlate, the fiction of eternity.[2] Art's task is to generate this fiction from the facts of nature, so that every creature can have its infinity within the confines of its existence. As Smithson asks, "Why should flies be without art?"[3] The spiral opens objective boundaries to uncertainty—creates the "open limit"—and generates "the romantic idea of going to the beyond, of the infinite."[4] For Smithson the spiral is an allegorical form revelatory of "a modality of the real . . . which is not evident on the plane of immediate experience."[5] It is "a kind of iconic image" that articulates "the archetypal nature of things," a kind of "ceremonial" cosmic form that frees one from history and the anthropomorphic.[6] Traversing the spiral is a ritual of liberating experience, walking a plank out over the infinite or clinging to a coherent bit of debris as one submits to its current.

The spiral is itself emblematic of the ritual of art that restores what Smithson, in a Whiteheadian and psychoanalytic vein, calls "primary process"[7]—"a muddy spiral" embodying an elemental, muddy or murky process.[8] It is not only a bridge from finite form to infinite process but a breakwater between them, mediating their limits by shoring up each against the other. Like Rimbaud's drunken boat, the spiral is at once symbol and survivor of the primary process, shaped by the pressures of the process—in Whitehead's words, its "subject-supereject"[9]—yet resistant to it. The spiral's actual finitude and seeming rationality clashes with its potential infinity and irrationality, a self-contradiction that gives the spiral its unity.[10] An aspect of that self-contradictory unity is the spiral's reconciliation of dissimilar scales. The spiral functions as a sliding scale, a con-

This article originally appeared in *Arts Magazine* (October 1981).

tinuum which at any point can be read as either a microcosm or a macrocosm, a microprocess or a macroprocess, with respect to an infinitely remote point at one or the other of the continuum's limits. This of course assumes the spiral is a continuum which does not circle back on itself—which, from the point of view of the infinity it projects, cannot be assumed. The spiral, then, is emblematic of both immersion in the primordial process and emergence from it—of Dionysian loss of particular identity in the infinite and Apollonian achievement of a vision of new self-identity, destined to become universal and exemplary. In sum, for Smithson the spiral is simultaneously the process and structure of the temporal as well as spatial sublime.

Like all religious symbols or archaic forms that metaphorically map yet also seem to mimic or literalize cosmic process and pattern, the spiral appears to decipher what it divines. It is a divining rod giving access to what it points to, being at once an instrument signaling the sacred and its substance. The spiral is at once a decoy luring us from the plane of immediate experience and pointing us toward the really real, and a demonstration of the spontaneous appearance and direct pressure of cosmic process and pattern on the plane of immediate experience. Cosmic pattern threatens to dissolve immediate experience in its more primary process, while buttressing or supporting immediate experience with its own more primary level of experience. The spiral is at once passive testimony to experience of cosmic process and pattern—a sacred relic of such experience, the shroud of the cosmic body displayed by the priestly artist—and a catalyst of such experience. It is the immediate form of such ultimate experience, and as such the ultimate form of immediate experience.

The interplay of immediate and ultimate experience in the spiral makes it of supreme value for Smithson's visionary purpose. Like all primordial or ahistoric symbolic forms, the spiral undermines immediate experience of itself by evoking an ultimate experience beyond itself. Immediate experience—experience of the physical, the literally given—becomes the vehicle or messenger of ultimate experience, the figuratively given. The intensity of physical experience of the spiral becomes the springboard for intensity of ultimate experience, experience of cosmic process and pattern. This is why Smithson literalizes or physicalizes the spiral so completely, using earth, which has spoken to humanity since its origins about what is more than human and beyond the earth, which is why earth is the oldest, wisest material in human experience. It is an utterly self-effacing material—and Smithson's earthen *Spiral Jetty* has by now effaced itself, uniting with water, that other old, wise material with which man has built (I believe that Smithson built of glass and mirror as surrogates

for water, more tractable, dense forms of water), in a prehistoric mud— whose immediacy and tangibility give it an artistic advantage over other materials, especially when the task of art is cosmically conceived. This is why Smithson was so vehement about the necessity for art's return, however self-conscious, to pure physical experience—why he emphasized what at one point he simply called his "physicalist or materialist view of the world,"[11] and what at another point he complexly described as his attempt to develop "a dialectic of nature that interacts with the physical contradictions inherent in natural forces as they are."[12]

Smithson's insistence on the physical is in fact an attempt to make sensation visionary, to coerce it to the brink of primary process. Emphatically physical to the point of becoming convulsively ecstatic—and spiral movement can be read as convulsive, much as the repetitions of the entropic art Smithson admired can be read as convulsive emanations from an ecstatically experienced central form, totalizing the physical by reason of the immediacy with which it is given, the gestalt wholeness which allows it to dominate experience—sensation in Smithson's view has nothing contingent about it. It is the absolute of immediate experience on which cosmic experience depends—cosmic experience is contingent on the intensity and depth of physical sensations, on our willingness to commit ourselves completely to physical sensation, on the desperate fanaticism with which we have religious faith in physical sensation. It is also the climax, the final result of modernist obsession with vibrant sensation, with an attempt to dramatize sensation which reached an early climax in Cézanne and Seurat and a lesser theatricality in early Impressionism, and which has been the driving force of much so-called abstract art.

Whether or not Smithson succeeded in his voluntary attempt to convert raw physical sensation into a refined sensation of the infinite—and he seems to have succeeded, at least incidentally, during his mirror-travel in the Yucatan[13]—his physicalizing of symbolic form not only gives it more impact but makes it multivalent, capable of expressing "simultaneously several meanings the unity between which is not evident on the plane of immediate experience." The freshly literal spiral unites in "a 'mystical' order . . . various levels of cosmic reality and certain modalities of human existence." This order is accessible neither "by immediate and spontaneous experience, nor by critical reflection. It is the result of a certain mode of 'viewing' the World," i.e., the cosmic.[14] Smithson's visionary attempt to infinitize physical sensation by intensifying it beyond endurance results in practice in an intensification by symbolization. Physical sensation is given symbolic form and, correlatively, symbolic form is made physically sensational—the conjunction of these opposites, in effect of mind and matter, intensifies and infinitizes each by ending its isolation,

extending its scope into a realm of being in which it appeared to have no representation—nothing at stake.

The *coincidentia oppositorum* conveyed by the complication of physical sensation and symbolic form for Smithson—and we must remember that for Nicholas of Cusa "the *coincidentia oppositorum* was the least imperfect definition of God"[15]—puts clearly before us Smithson's mode of viewing the World. Smithson was knowingly dialectical. For him the spiral was best described in dialectical terms, in terms of what he calls "a bipolar rhythm between mind and matter."[16] Smithson was not only a self-aware dialectician, he was acutely aware of the difference between his materialistic dialectics—a dialectic "rooted in the real world," as he said—and Hegelian "idealistic" dialectics,[17] which "exists only for the mind."[18] But the contrast is not so clear when one realizes that it is complicated by Smithson's quixotic commitment to a religious destiny, "quixotic" because Smithson refuses any form of what he called "cultural confinement,"[19] and nothing seemed more confining to him than the old metaphysical religion.[20] Moreover, the entire strategy of his dialectic—its deliberate use to cultivate uncertainty, to dismiss objects and boundaries, and above all to create a center where there is no center and can never be one, and when centering means generating the illusion of a static, calm mental space in the midst of a cosmic storm of energy (i.e., generating the fiction of eternity within temporal process)—is designed to bring out the nominal character of all so-called higher, religious experience, all so-called intuition of the metaphysical truth.

Smithson's way out of this quandary was to become Pascalian, quixotically Pascalian. It was to further neither the old idealistic dialectics nor to develop a new materialistic dialectics appropriate to art's situation in denatured industrial society—which Smithson thought he was doing—but rather to develop an alternative Pascalian dialectics, which he was unconsciously doing. Wittingly or unwittingly, Smithson developed a dialectics based on a single and singular Pascalian idea, that "nature is an infinite sphere, whose center is everywhere and whose circumference is nowhere." This dialectic is post-Marxist as well as post-Hegelian, while similar in fundamental attitude to both. While Smithson's proposed Pascalian dialectics is at first glance regressive in its orientation—for it is a way of acknowledging the *deus absconditis* or hidden god, the idea that both the natural and human worlds are totally devoid of divinity (which releases God from responsibility for the evil in them and even seems to dismiss the idea of evil)—it is decisively progressive in its transcendence of an exclusively materialist orientation, which has become a metaphysics or nondialectical in its own right. Smithson restores the integrity of the dialectical method by making it a search for faith in a world

from which the existence of God cannot be legitimately inferred. Dialectic itself becomes the ground for a wholly groundless faith, faith which is a kind of "void between events," an "interchronic pause when nothing is happening" and all, presumably, is momentarily—immediately—clear, and simultaneously eternally clear.[21] Faith is dialectical in structure, a dialectical way of acknowledging and even seeming to enter the "interval without any suggestion of 'life or death' " that is "a coherent portion of a hidden infinity."[22] For Smithson Pascalian dialectics is an exploration and test of the viability of faith in a world which has no need of it and offers no signs which might encourage it. Pascalian dialectic is the leap of faith in a world where all the signs of life say "walk, do not run, to the nearest exit."

Smithson could restore the ancient sense of dialectic's connection to faith, in the fresh format of the Pascalian sensibility, in part because he was, in his own words, a "quixotic autodidact."[23] The Pascalian idea made poetic sense to him, i.e., it justified and encouraged the idea of relating to nature as a process rather than as an object, as potentially infinite rather than observably finite. It united the local and global—center and circumference—in the same sphere of activity, so that there was a poetic sense of their interchangeability. The fact of the poetic possibility of their interchangeability changed the sense of their actuality. Smithson was able to enthusiastically exploit the uncertainty that emerged from this poetry—this quixotic awareness of coinciding extremes—just because, being self-taught, he could suspend his cognitive disbelief. This was more than a willing suspension; it was born out of the necessity for a structure of understanding that could incorporate personal understanding. The autodidact inevitably retains his personal preconceptions, using his fresh, rapidly assimilated knowledge to justify these preconceptions, often rooted in childhood. In a sense, all of Smithson's learning is brought to bear on his early love of natural history[24]—his early faith in the prehistoric, which becomes refined into a vigorous pursuit of the ahistoric. Here he shows himself exquisitely romantic. Like Rimbaud's drunken boat, which began as a real boat and became more unreal as it moved farther from shore and ended up as a childhood sailboat in the "black cold pool" of a backstreet of memory—the boat which was finite but became increasingly infinite or drunken in its implications and finally became coldly sober and finite again as the symbol of an incompletely forgotten if forever lost childhood world—Smithson's Pascalian spiral begins as a real structure, becomes suggestive of the infinite, and ends in a diorama scene recalled from a childhood visit to a museum.[25] This scene was like a still from an old film—one's spotty memories of childhood exist like such scenes from a silent film, like waxen fruits in a garden of paradise (note Smithson's

obsession with the image of this garden, subject to infinite spoilage through time)[26]—which explains Smithson's obsession with films and film stills.[27] The seemingly eternal still lifted from the film unfolding in time is, implicitly, Smithson's model for the fiction of eternity.

In general, Smithson's mature, self-consciously artistic experience of the cosmic is mixed with unconscious chagrin at the loss of childhood's faith in the eternal scene. It is a sophisticated effort, by means of Pascalian dialectic, to restore the child's innocent belief—the belief that is the very core of the child's innocence—that the scene was indeed eternal, that somewhere (in "heaven," in the garden of paradise) it exists forever, that it is infinitely resonant or repeatable. It is the belief that there is in fact, buried or lost under the temporally changing scene, an eternal view of things—a view that intoxicates or poisons this existence, but which also makes us willing to endure it. For we know, under the tutelage of the belief, that this existence is in some mysterious way an exploration of our eternal existence—that in this temporal existence we are shaping our eternal existence. As Smithson, unwittingly following Swedenborg, casually asserts—as if the comic casualness and context of the assertion reinforces the seriousness of the assertion (and Smithson once said that high comedy and high seriousness were the same, and talked a good deal about the transformative power of hilarity[28])—we all have our double in eternity, reflecting our appearance here but different in mentality.[29] It is in his attempt to recover the childhood belief in eternity that Smithson develops an "aesthetic of atemporality," as he called it,[30] in the midst of the unaesthetic experience of temporality. He attempts to aestheticize— fictionalize, or discover fiction within—that experience until it is forced to imply something more than it obviously is.

There can be little doubt that Smithson's loss of childhood faith in the eternal, symbolized by museum dioramas of a prehistoric past, was experienced as a loss or at least a disruption of selfhood. This disruption became itself the means, in the form of dialectic, of restoring the lost but not completely forgotten faith in the eternal, which now no longer can be understood as an order of things—although, in the entropic structures Smithson admired, it first appears as such—but rather as an interruption or intervention in the apparently existing order of things. The eternal "ap-pears" in the open space between the closed things arranged in the in-finitely extensive series, rather than in the things themselves, for it is the open space which permits the repetitive movement toward infinity. That is, the original, primordial experience of disruption, generated by the growth of an awareness of time—and Smithson is always trying to over-come the awareness of time, that "colorless intersection . . . absorbed almost imperceptibly into one's consciousness"[31]—is converted into its

opposite. It no longer leads to—signals—a loss of belief in eternity, but the generation of belief in it, and a new experience or at least a freshly poetic sense of it. The disruption becomes freshly consequential by reversing the temporal as well as mental "magnetic" poles.

In our childhood we involuntarily and disruptively lost our innocence, our sense of being eternal in an eternal world, and moved from an implicit belief in the timeless to an explicit belief in time, accompanied by a sense of self-loss which in fact was the first discovery of the self. Dialectic was, as it were, forced upon us, but it was read as the loss of self-sufficiency and self-identity. Now, as adults, we move, with the aid of the physically sensational symbolic forms of art, from the temporal to the atemporal. We are deliberately dialectical—we encourage disruption, interruption, intervention in or negation of temporal existence, in which we are now as superficially at home as we once were in eternity. We voluntarily go through the same intersection we unexpectedly and accidentally discovered in childhood. Innocence is not necessarily restored—in fact can never be—but faith in the eternal is, and with it the root of dialectical faith in oneself, dialectical self-respect. As with Gauguin, the return to the childhood hobbyhorse proves beneficial, healing. It secures an elemental sense of stable selfhood, an elementary basis for being. Smithson's spiral, like Rimbaud's drunken boat, capsulates not simply the loss of childhood innocence or childhood itself, but the loss—and recovery—of that belief in infinity without which it is impossible to go on living in time, from the Romantic's point of view. In childhood that belief was held naively; in maturity it must be achieved in a more sophisticated manner. Infinity must be snared by art, even arbitrarily invented by it. Infinity must exist dialectically, or we cannot imagine ourselves to exist either materially or ideally.

The Pascalian idea of nature pervades and dominates Smithson's thought, and becomes the necessary ground for any interpretation of his art. Whether in direct or disguised form, Smithson is obsessed with it, for it describes the fundamental situation faith finds itself in, the context in which it must find eternity—a context which, if faith looks carefully, is as close as one can come to being definitive of the structure of eternity or the nature of God. In a sense, Pascal suggests the dissipation of the center of the self into an infinitely extensive circumference of nature, but also wresting back from nature by means of natural dialectic itself the self-control which gives one a sense of being centered. Smithson values the Pascalian idea of nature because it reverses meaning, becoming an idea of eternity—which, however imperfect, is as close as we can get to it.

The quotation from Pascal heads Smithson's article, written with Mel Bochner, on "The Domain of the Great Bear."[32] It reappears in the first

paragraph of "A Museum of Language in the Vicinity of Art," and again in the section of that article entitled "The Center and the Circumference."[33] It is also the basis for Smithson's description of "The Establishment" as "a mental City of Death whose architecture is uncertain and without a center; it comes and goes like a will-o'-the-wisp."[34] It is also, more generally, "explicative" of Smithson's obsession with "sprawl" or "cosmic dereliction," i.e., of a dedifferentiated, uncentered state of affairs.[35] Pascalian nature is in a state of cosmic dereliction or sprawl—Pascal's description of nature is the description of a sprawling infinity, the sprawl of infinity. The sprawl, and its accompanying uncertainty, are reenvisioned in Smithson's sense of the picturesque.[36] More importantly, the Pascalian conception of nature accounts for the romantic experience of nature, of which the experience of the picturesque is only the most superficial, "theoretical" aspect. Smithson's account, in "Incidents of Mirror-Travel in the Yucatan," of a flight "in a single engine airplane with a broken window" to the site of "The Sixth Mirror Displacement," is amazingly like Rimbaud's account of his drunken boat trip. Not only do both articulate a Romantic experience of nature, but both are described in Pascalian language, and both are implicitly pilgrimages to the infinite in search of a lost faith—in the hope of an encounter with the hidden God, the God hidden by his own infinity. Thus, the voyage in infinity becomes a divine experience—an experience of the divine, while seeming to be an experience of nature. The voyage in infinity is valued because it is simultaneously both, and that it is simultaneously both makes it a voyage in infinity.

Closely examining Smithson's description of his airplane trip, we see that it is not only implicitly dialectical and Pascalian, but explicitly visionary—an experience of eternity: "The perimeter was subject to a double perception by which, on one hand, all escaped to the outside, and on the other, all collapsed inside; no boundaries could hold this jungle together. . . . The eyes were circumscribed by a widening circle of vertiginous foliage, all dimensions at the edge were uprooted and flung outward into green blurs and blue haze."[37] In the sentence between these two accounts of his perception Smithson reflectively, if not quite analytically, remarks: "A dual catastrophe engulfed one 'like a point,' yet the airplane continued as though nothing had happened." This point is the void of timelessness Smithson remarked in his article on "Quasi-Infinites and the Waning of Space," the limbo in which the order of events and sites depicted in films dissolve into in "A Cinematic Atopia."[38] It is where we are lost when "We are lost between the abyss within us and the boundless horizons outside us," as Smithson asserts in his perhaps most famous sentence.[39] It is the void of eternity with which Ad Reinhardt was

so obsessed "that he has attempted to give it a concrete shape—a shape that evades shape, . . . an interval without any suggestion of 'life or death.' "[40] The spiral is a similar shape for Smithson, as are Rimbaud's vowels, each equivalent to a color. The vowels, viewed independently from words, become cabalistically absurd, utterly irrational. Each functions like the surd Smithson was explicitly obsessed with—like an irrational number or voiceless sound.[41] The spiral is also a surd, and its conversion to symbolic form confirms its "soundlessness" and irrationality— its function as a bracketing of sound and rationality—from the point of view of the world of sound and reason, the world where sound makes sense. Similarly, Rimbaud's conversion of sound to color is a way of acknowledging its irrationality and a demonstration of its existence as symbolic form. The appropriation of the spiral and the vowel—the spiral is an elementary vowel of form—as symbolic forms, i.e., their reduction to surd status, makes them portals into the nature beyond nature, the eternity that was once second nature but now can only exist in first-hand symbols, and the belief we are willing to entrust them with.

The Pascalian spiral covertly determines the "scale of centers," as Smithson calls it, which the *Spiral Jetty* is finally about.[42] Pascal's nature, capsulated by Smithson's jetty, is simultaneously centrifugal and centripetal, at once a "spinning off of an uncertain scale of centers" and a spinning inward of "an equally uncertain 'scale of edges.' " The scales ambiguously correlate—an inherently ambiguous scale of centers and an inherently ambiguous scale of edges correlate in an inherently ambiguous way. We have a sense of a dialectic within a dialectic, a pyramiding or parlaying of dialectics into an overwhelming effect of infinity. Smithson's final summary of this dialectically compounded infinity—the Leibnizian continuum extending itself infinitely by contradicting itself in finite terms, extending itself infinitely temporally and spatially, privately and publicly—is in his conception of the "dialectic of site and nonsite," which he describes as "a course of hazards, a double path," in which "both sides" of the universal dialectic "are present and absent at the same time."[43] Thus, describing how his "helicopter maneuvered the sun's reflection through the Spiral Jetty until it reached the center," with the "water functioning as a vast thermal mirror," Smithson observes that "from that position the flaming reflection suggested the ion source of a cyclotron that extended into a spiral of collapsed matter."[44] The negative or double— the shadow—of the spiral emerges in a flaming red sea not unlike that experienced by Rimbaud from his drunken boat. It is the red which (as G. K. Chesterton writes in the quotation Smithson uses to head his article on "The Spiral Jetty") "is the place where the walls of this world of ours wear the thinnest and something beyond burns through."[45] The Pascalian

spiral is the literal articulation and actual experience of this thinning out and burning through to the beyond, describing that experience as the unveiling of chaos—of a collapsed center and a collapsed circumference, a collapsing sphere that is nonetheless intact in our memory, that contradicts our experience of nature as in fact a closed sphere. It is a sphere whose shape bespeaks nature's expansiveness and so presumable openness, but that at the same time exists as closed in immediate experience. The ultimate experience of it and the immediate experience of it conflict, which is perhaps another source of its collapse—a collapse which implies its reconstitution by an infinite inwardness, which alone can grasp its infinite openness. The fictional Pascalian sphere of nature and the factual or objective sphere of nature are on the same collision course that the spiral is with itself, bespeaks the same conflict that red embodies.

Finally, the Pascalian spiral is Smithson's metaphor for the "ever developing procedure" which language is, an overturning of the non-dialectical, metaphysical conception of language as an "isolated occurrence."[46] Similarly, "art's development should be dialectical and not metaphysical."[47] The spiral becomes the ultimate metaphor for art and language for Smithson, Smithson's aerial—but also terrestrial—experience of the spiral confirming its dignity as a universal symbol applicable to any activity which is universal or has universal implications. The nature of art and the nature of language can also be described in Pascalian terms—they function in a Pascalian way. Anything which seems "natural" is understood as implying a Pascalian situation for Smithson, i.e., a situation of self-contradiction and self-transformation, a situation in which the self is converting into something more than itself by encounter with the infinite inherent in itself.

Looking more closely at Smithson's sense of the relation of eternity to art, of the role of art in giving us a sense of eternity, one comes upon his insistence that "the authentic artist cannot turn his back on the contradictions that inhabit our landscapes."[48] It is the experience of these contradictions that directly generates the sense of the eternal, more precisely, a sense of the unstable relationship of time to the timeless, the fickle reversibility of time into the timeless and the timeless into time. Each negates the other, but the negation is not stable because neither can eliminate the other. They exist on a sliding scale—a seesaw—of relationship, mirroring each other yet separated by a boundary, however obscure and uncertain our sense of it. For Smithson, incidentally, the mirror epitomizes the problem of boundary inherent in the relation between time and the timeless. The mirror ostensibly has no boundaries and as such cannot really be regarded as an object, yet it is separate from what it reflects.

In a letter to the editor of *Artforum* (October 1967), Smithson writes that: "eternity brings about the dissolution of belief in temporal histories, empires, revolutions, and counterrevolutions—all become ephemeral and in a sense unreal, even the universe loses its reality. Nature gives way to the incalculable cycles of nonduration. Eternal time is the result of skepticism, not belief."[49] The idea that our sense of eternity arises from dialectical scepticism which reflects the dialectic of experience itself rather than from metaphysical belief in the ideal beyond experience is perhaps most powerfully stated in Smithson's account of the "ultramoderne," which he insists "exists *ab aeterno*!":

> Unlike the realist or naturalist, the Ultraist does not reject the archaic multicycles of the infinite. He does not "make" history in order to impress those who believe in one history. Belief is not the motive behind the timeless, but rather a skepticism is the generating force. This skepticism takes the shape of a paradigmatic or primordial infrastructure, that repeats itself in an infinite number of ways. Repetition not originality is the object.[50]

But this skepticism is inverted belief, belief in practice rather than as a theory about the nature of the universe—belief that denies any ideal or model history and that insists on a larger experience of the world than any history can offer or codify. Scepticism is belief that exists as the refutation of any particular object of belief, and while "every refutation is a mirror of the thing it refutes—*ad infinitum*,"[51] it is also the affirmation of the total or primary process of things. Scepticism affirms this primary process by negating the particular objects it puts forth, or rather by detaching us, in an almost Buddhist way, from belief in our "desire" for these objects. This, for Smithson, is the act of art, which can be accomplished, as he says, at "a glance"—by the quality of a glance.[52] Smithson is interested in the moment when an object "ceases being a mere object and becomes art," by which he means that it is no longer differentiated from other objects and becomes part of a process that is larger than itself. Art is the recognition that every object exists in a process more comprehensive than itself—art is the affirmation of this process at the expense of the object, belief in the process and disbelief or scepticism at the objectness or boundedness of objects. Art is not the production of original objects, but entry into the cosmic process and pattern which encompasses all objects. The mirroring of objects mimics this process, makes them part of a pattern larger than themselves—infinitizes them by making them more than their finite selves, more specifically, by doubling and continuing to double or repeat them. It is this mirroring or doubling or infinitizing process that generates art—is the artistic

process—and the sense of the inexplicable that is the source of the sense of the eternal.

One notes here a strong resemblance to Kierkegaard's concept and use of repetition, and Nietzsche's idea of eternal return—the general romantic interest in recurrence and coincidence as a way of establishing that density of experience from which a sense of eternity emerges. Such density or repetition may become boring and literally monotonous, i.e., monotone, but that is no more than a sign that one is moving beyond or off the plane of immediate experience. The ultimate effect is tonic—restorative of a sense of eternal tranquility, of the void or peace that surpasses understanding. As Smithson says, "Art works out of the inexplicable. . . . It sustains itself not on differentiation, but dedifferentiation, not on creation but decreation, not on nature but denaturalization, etc." It is a search for "the dimension of absence that remains to be found."[53] It is this that is unfathomable, and as Smithson says, in words reminiscent of Kierkegaard's idea that the man of faith realizes that existence occurs on a tightwire 20,000 fathoms over the depth, "travel over the unfathomable is the only condition " of art.[54]

Finally, it should be clear by now that Smithson shows the Romantic's typical narcissistic preoccupation with the process of creativity—the Romantic artist's concern to find the secret of creativity and thereby guarantee it. Art "flourishes" on "semblances and masks," whose "discrepancy" with fact is the springboard for the creative process.[55] Authentic art is an attempt to "reconstruct one's inability to see," to "give passing shape to the unconsolidated views that surround a work of art, and develop a type of 'anti-vision' or negative seeing."[56] That is, starting with inauthentic art, a so-called original art object, one tries to give shape to the way the world appears around it, to the effect it has on its site, thereby demonstrating it in a process of relationship to its site—demonstrating the real art in art. The creative process is different from other processes in that it is one which denies objective limits and initiates infinite extension, rather than one that issues in a specific product. Hence Smithson's obsession with the Pascalian spiral, for it demonstrates and proposes a "field" of infinitely extending relationship, infinitely inward and infinitely outward. The Pascalian spiral is the hieroglyph of the creative process, of creative extension of limited being. It is a way of giving shape to the unconsolidated views in the circle of nature, a circling within nature which acknowledges one's inability to see it as a closed circle—an inability which is a creative resource.

The implicitly Romantic quality of the Pascalian spiral is brought out by a number of references Smithson makes to artists. The Pascalian spiral, with its "anti-vision," is "a floating eye adrift in an antediluvian ocean"

of "pulpy protoplasm"—the eye depicted by Redon. The Pascalian spiral takes the "spiral steps" by which we return to the "primordial seas" in which we originated.[57] "The dizzying spiral (which) yearns for the assurance of geometry, . . . wants to retreat into the cool rooms of reason," is "demonstrated" to be not really a form of reason, a geometrical shape, by visionary realization of the presence of van Gogh painting on it, "van Gogh with his easel on some sunbaked lagoon painting ferns of the Carboniferous Period."[58] Such visions—the vision of the eye of anti-vision, the vision of an artist who seems prehistoric or timeless—make clear the full romantic import of Smithson's sense of creative dialectic, which is his antidote to the frustrations of a metaphysicalized history of art, i.e., a cultural history taken to be absolute and thus overdetermined and confining. Smithson is trying to show the sublime, creative element within any history as the clue to a creativity beyond history, a creativity that continues to exist however history might read and place it. Smithson wants a fountain of creative youth that will not only permit one to transcend one's own history, but that finally will free one from all history—from any need to make history—by showing that one exists as part of a universal creative process and pattern.

Smithson transcends his own history of art making in his writings— his writings show him to be infinitely beyond his objects. This is the full import of Joseph Kossuth's important idea that Smithson's real art was his writings. Smithson himself was confused or uncertain about the relationship of his writings to his objects, and about the general relationship of writing about art to art, while appearing not to be. On one level, he assumes an easy reciprocity between his writing and his objects. On another level, he sees writing as destructive of art objects. He fails to take the next logical step, by his own dialectical logic, viz., to recognize that writing's destruction of art objects by, as he says, making them absent— absenting them from themselves in the mirror of writing—makes them authentically art, i.e., negates their specificity into a primordial process. Thus, in response to Paul Cummings's' question as to whether his writing affected the development of the things he made, Smithson remarks that "the language tended to inform my structures."[59] In the same interview with Cummings, replying to the question whether the writing "augments" his work, Smithson says, "It sort of parallels my actual art involvement—the two coincide; one informs the other."[60] At the same time, Smithson says that "writing on art replaces presence by absence by substituting the abstraction of language for the real thing."[61] The contrast between the quotations indicates a discrepancy between Smithson's sense of the value of his particular writing and writing in general. But by his own reasoning, such discrepancy indicates a powerful dialectic—

the presence of the absence which is the timeless, the inversion of the timely. Thus, his writing is a creative process by which his art is truly "actualized"—by which its eternity is made manifest. But this implies that his writing itself is a fiction of eternity—creates the fiction of an eternity his objects can inhabit. The dialectical relationship between writing and objects generates the framework in which objects can seem to be part of a universal diorama scene. The writing theatricalizes the scene of objects into timeless significance, seemingly metaphysicalizing the objects but in fact demonstrating their dialectical self-transcendence.

Smithson's writing is also a species of hilarity. It is his final joke on art objects. The spiral is obviously scroll-like and calligraphic, a kind of flourish of form. As such, it becomes a kind of joke on the forms that commonly define objects, and, literalized, itself becomes a hilarious object. It is, in Smithson's words, one of those "fragments of a timeless geometry (that) laugh without mirth at the time-filled hopes of ecology," i.e., at all historical efforts to "redeem" nature—make it harmonious in human terms.[62] Smithson, the "site-seer," to use his own term,[63] has always been interested in hilarity—the hilarity of having a vision of the eternal at a temporal site, of finding a finite site charged with the infinity of eternity. Dialectic is inherently hilarious, and there is something hilarious about searching the surface of the earth for a site at which the depths can emerge. Smithson is in the ancient business of finding sites favorable to the flourishing of the divine—sacred groves or steep mountains that might be the home of the gods—and such art business is inevitably hilarious in an artlessly temporal world, whose only real business from a divine point of view is to pass away. Smithson's sense of and respect for humor are explicitly shown by his correlation of "high humor" with "high seriousness," [64] and his account of Reinhardt's art as "a doleful tedium that originates in the unfathomable ground of farce." His remark on Reinhardt's cartoon wit is even more to the point: "Along with the inchoate, calamitous remains of those dead headlines, runs a dry humor that breaks into hilarious personal memories."[65] No doubt his own hilarious personal memories of youthful trips to the dioramas of the American Museum of Natural History, and his sense of history as nothing but a series of dead headlines, permeate this empathetic analysis of Reinhardt.

Smithson has perhaps his greatest, most mischievous fun in "equating *central* with *specific*, and *general* with *periphery*" in his analysis of the "abyss" which Judd brings "into the very material of the thing he describes," i.e., into his object-sculpture.[66] This equation not only restores the never very remote Pascalian spiral to the forefront of consciousness, but is a supreme example of the "entropic 'verbalization' " Smithson once

described laughter as.[67] Judd's objects are reduced to one of the "different types of Generalized Laughter" Smithson posited in his equation of different kinds of laughter (ordinary laugh, chuckle, giggle, titter, snicker, and guffaw) with different kinds of geometrical form (square, triangle, hexagon, orthorhombic, oblique, and asymmetric).[68] This not only makes Judd's objects the "colorful" vowels of a Rimbaudian vision, reducing them to surds—making their rationality irrational—but sets them in a process of equivalance by which they become emblematic, even generative of primary process. Smithson's hilarity—his hilarious verbalization of them, i.e., his writing them into eternity—overturns their objecthood and thereby their only identity. Here again we see that for Smithson authentic art consists in playing a trick on—dumbfounding—inauthentic art, i.e., the objects of art. To make art is to unmake objects, even supposedly artistic objects. As such, art making is the highest comedy.

Notes

1. Nancy Holt, ed., *The Writings of Robert Smithson* (New York: 1979), p. 112. All subsequent page references to Smithson's writings are from this source.

2. Smithson remarks that "eternities are all artificial or they are fictions in a sense" (p. 112). In line with this, Smithson (p. 97) asserts that "the true fiction eradicates the false reality," a statement he attributes to "the voiceless voice of Chalchihiutcue—the Surd of the Sea."

3. Ibid., p. 101.

4. Ibid., p. 168. Smithson's respect for uncertainty is crucial for an understanding of his art. He almost predictably gets himself in unpredictable situations of uncertainty, for him the only ones of consequence. "More and more possibilities emerged," writes Smithson (p. 100) "because nothing was certain." In an interview with Anthony Robbin, in which Smithson (p. 159) holds that "the major issue now in art is what are the boundaries," he agrees with Robbin's response that "people will be frustrated in their desire for certainty, but maybe they will get something more after that frustration passes."

5. Mircea Eliade, *The Two and the One* (London, 1965), p. 201.

6. *Smithson*, pp. 148–49.

7. Ibid., p. 90. Smithson's entire position can be understood as refined and applied—to the situation of art—process philosophy as developed by Whitehead in *Process and Reality* (New York, 1929).

8. *Smithson*, p. 114. It is interesting to note that "muddiness" was for Clement Greenberg a typical consequence of American provincialism, and while undesirable, nonetheless a sign of substance, as in Jackson Pollock (and Vincent van Gogh, another provincial for Greenberg). See Donald B. Kuspit, *Clement Greenberg, Art Critic* (Madison, Wisconsin, 1979), p. 179. In this context Smithson's own attitude to Pollock is worth noting. Smithson (p. 89) writes: "Jackson Pollock's art tends toward a torrential sense of *material* that makes his paintings look like splashes of marine sediments. Deposits of paint cause

layers and crusts that suggest nothing 'formal' but rather a physical metaphor without realism or naturalism.''

9. Alfred North Whitehead, *Process and Reality* (New York: 1929), pp. 134–36.

10. Smithson (p. 149) notes the self-contradiction in his own identity when he states that ''my disposition was toward the rational, my disposition was toward the Byzantine. But I was affected by the baroque in a certain way. These two things kind of clashed.''

11. Ibid., p. 154.

12. Ibid., p. 133. Paradoxically, Smithson was at his most physical—acutely aware of his physical sensation—when he was most in contact with the infinite, as in his description of plane travel in the Yucatan. He himself recognized as much when he asserted, describing his experience in the Yucatan jungle, that ''Hyperbole touched the bottom of the literal'' (p. 99). It is such sensation, indicating that the physical itself is a dialectical structure reconciling, however uncertainly, the finite and the infinite, that was for Smithson the most telling and ''artistic'' experience.

13. Smithson, ''Incidents of Mirror-Travel in the Yucatan,'' in ibid., pp. 94–103.

14. Eliade, *The Two and the One*, p. 203.

15. Ibid., pp. 80–81.

16. *Smithson*, p. 166.

17. Ibid., p. 119.

18. Ibid., p. 128.

19. Ibid., pp. 132–33.

20. Smithson's rejection of traditional metaphysical religion is most explicit in his analysis of the park as ''carrying the values of the final, the absolute, and the sacred,'' all of which he rejects in favor of the dialectics of nature, which ''have nothing to do with such things'' (p. 133). On the same page he dismisses a good deal of art as idealistically oriented, metaphysically based, and object-specific: ''Could it be that certain art exhibitions have become metaphysical junkyards? Categorical miasmas? Intellectual rubbish? Specific intervals of visual desolation? The warden-curators still depend on the wreckage of metaphysical principles and structures because they don't know any better.''

21. Ibid., p. 32, quoting George Kubler's *The Shape of Time*.

22. Ibid.

23. Ibid., p. 67.

24. Ibid., p. 143. Smithson writes, ''I think the strongest impact on me was the Museum of Natural History,'' and notes that ''My father sort of liked the dioramas and things of that sort.'' For Smithson, ''the whole spectacle, the whole thing—the dinosaurs made a tremendous impression on me. I think this initial impact is still in my psyche.'' The natural history museum was his ''museum rather than the art museum.''

25. Ibid. Smithson's consciousness of natural history as ''much more interesting'' than art history is closely associated with his consciousness of his father, who took him on trips around the United States and to the natural history museum, and who had ''a real sense of [an] . . . American idea of landscape.''

26. For example, Smithson (p. 120) remarks: "The image of the lost paradise garden leaves one without a solid dialectic, and causes one to suffer an ecological despair." Smithson's concept of "a dialectic of the landscape" or "the contradictions of the 'picturesque' " are his antidote to the "one-sided view of the landscape" in the idea of the park of paradise. "A park can no longer be seen as 'a thing-in-itself,' but rather as the process of ongoing relationships existing in a physical region—the park becomes a 'thing-for-us' " (p. 118). In "A Sedimentation of the Mind: Earth Projects," Smithson (p. 86) rhetorically asks, knowing the positive if ironical answer in advance, "Could one say that art degenerates as it approaches gardening? These 'garden-traces' seem part of time and not history, they seem to be involved in the dissolution of 'progress.' It was John Ruskin who spoke of the 'dreadful Hammers' of the geologists, as they destroyed the classical order." Commenting on his own question in a footnote, Smithson writes (p. 91): "The sinister in a primitive sense seems to have its origin in what could be called 'quality gardens' (Paradise). Dreadful things seem to have happened in those half-forgotten Edens. . . . Gardens of Virtue are somehow always 'lost.' A degraded paradise is perhaps worse than a degraded hell. . . . The abysmal problem of gardens somehow involves a fall from somewhere or something. The certainty of the absolute garden will never be regained."

27. Smithson's obsession with film is demonstrated in his account of how "some artists see an infinite number of movies. . . . The movies give a ritual pattern to the lives of many artists, and this induces a kind of 'low-budget' mysticism, which keeps them in a perpetual trance" (p. 14). For Smithson, "Time is compressed or stopped inside the movie house, and this in turn provides the viewer with an entropic position. To spend time in a movie house is to make a 'hole' in one's life" (Ibid., p. 15). For Smithson, "falseness, as an ultimate, is inextricably a part of entropy," and the falseness—fiction— of the movies, which is instrumental in the way they stop time, generates the fiction of eternity, capsulated by the movie still, i.e., a scene from a stopped film. The movies stop time, and the still stops the movies, generating a double falseness—a falseness within a falseness—which makes for the sublime fiction of eternity. Smithson expands on his sense of film in "A Cinematic Atopia" (pp. 105–8), concluding that "Any film wraps us in uncertainty," and quoting Jean-Luc Godard's remark that "A camera filming itself in a mirror would be the ultimate movie" (p. 107). It should be noted that for Arnold Hauser, in *The Social History of Art* (New York: Vintage Books, 1951), vol. 4, pp. 226–59, the film, by reason of its "analysis of time" (p. 246), is the implicit model for Modern art. By expanding on the mental use of the film, Smithson has found a new destiny for it and Modern art.

28. *Smithson*, p. 66.

29. Ibid., p. 38, expressing his scepticism about Michael Fried in his article "Art and Objecthood" *Artforum* (June 1967), asks: "Could it be there is a double Michael Fried— the atemporal Fried and the temporal Fried?"

30. Ibid., p. 74.

31. Ibid., p. 30.

32. Ibid., p. 25.

33. Ibid., pp. 67, 73.

34. Ibid., p. 79.

35. Ibid., p. 133, observes that "Nature does not proceed in a straight line, it is rather a sprawling development." "Many parks and gardens are re-creations of the lost paradise or Eden, and not the dialectical sites of the present," which is a sprawling development. Elsewhere, describing the Ramble in Central Park, he calls it "a maze that spreads in all directions" (p. 127). Describing the making of his movie on the *Spiral Jetty*, he writes that it "began as a set of disconnections, a bramble of stabilized fragments taken from things obscure and fluid" (p. 114), and asserts that its "disparate elements assume a coherence" (p. 115). The term "cosmic dereliction" is applied to Eva Hesse's art, which Smithson describes as "vertiginous and wonderfully dismal" (p. 34). In general, Smithson's writing is saturated with a sense of chaotic sprawl, "the refuse between mind and matter (which) is a mine of information" (p. 86). For Smithson, the making of art involves mastery of chaos, putting "all chaos . . . into the dark inside of the art" (p. 86). Or as he has the demiurge Tezcatlipoca advise him in "Incidents of Mirror-Travel in the Yucatan," "You must travel at random, like the first Mayans, you risk getting lost in the thickets, but that is the only way to make art" (p. 95). That is, art develops or "travels" by random sprawl, mimicking the sprawl of nature itself. Art is a sprawl into a sprawl, getting lost in what can never be found—"finding oneself" as a sprawl of one's own within the sprawl of nature.

36. Ibid., pp. 118-19.

37. Ibid., p. 99.

38. Ibid., pp. 32-35, 105-8.

39. Ibid., p. 107.

40. Ibid., p. 32.

41. Ibid., pp. 112-13.

42. Ibid., p. 114.

43. Ibid., p. 115.

44. Ibid., p. 113.

45. Ibid., p. 109.

46. Ibid., p. 133.

47. Ibid.

48. Ibid., p. 123.

49. Ibid., p. 38.

50. Ibid., p. 49.

51. Ibid., p. 38.

52. Ibid., p. 90.

53. Ibid., p. 103.

54. Ibid.

55. Ibid.

56. Ibid., p. 101.

57. Ibid., p. 113.

58. Ibid.

59. Ibid., p. 154.

60. Ibid., p. 139.

61. Ibid., p. 100.

62. Ibid., p. 115.

63. Ibid., p. 50.

64. Ibid., p. 66.

65. Ibid., p. 69.

66. Ibid.

67. Ibid., p. 17.

68. Ibid., pp. 17–18.

Dan Graham: Prometheus Mediabound

Every time I read one of Dan Graham's articles I am tempted to think of his art the way Joseph Kosuth thought of Robert Smithson's work. But this carries one only so far. In "Art After Philosophy" Kosuth wrote that Smithson should have "recognized his articles in magazines as being his work . . . and his 'work' serving as illustrations for them."[1] As with Smithson, it has been argued that it is in Graham's articles that the conceptual growth of his art occurs. In Smithson's case, the works are materializations of the ideas in the articles, and aim for the traditional idealistic self-sufficiency of the work of art, despite the radical novelty of their materials (including the natural environment). But in Graham's case, the articles have an analytic, almost forbidding intricacy which precludes direct material translation. His writings do not go out of their way to invite readers; it is as though the writing is one idea talking to another. Graham's works cannot illustrate the sticky web of ideas in the articles because the works are totally incomplete without their audience. They incorporate the viewer not simply as their witness, but as their substance. Smithson's works are essentially anti-social or asocial—they are cosmic in perspective—compared to Graham's always aggressively social work and societal perspective. Graham's performances epitomize this insistent sociality.

Graham's performances, for all their technical elaborateness and careful scripting, take as their subliminal background his relentlessly analytic writings, which they then diffusely exploit. Their physical concentration in a tightly structured space facilitates the performer's one-to-one relationship with the audience. It is this directness, the effort to determine the particularity of the audience, that makes Graham's performances more than entertainment, which assumes a general, faceless audience never dealt with directly. But Graham's performances lack the intellec-

This article originally appeared in *Artforum* (May 1985).

tual concentration of his writings, with their insistent hammering of ideas into consciousness.

Nonetheless, Graham's performances never go slack, because of what they impose on the audience: a self-consciousness so intense it forces the viewer to the limit of his or her selfhood, to the limit where self-image and objective image fuse and confuse, where, in Graham's words, "community-defined 'personal' identity" and personally stated communal identity interlock and interchange. At this limit of dialectic, the conventions of individuality and community are experienced as the by-products of memory, for Graham the ultimate content of art. This is why Graham's performances are the key to his art, and signal his importance as a Postmodernist artist who was one before the term became fashionable: Postmodernism involves recognition of the power of memory to constitute and dominate the present, memory as the socializing power that shapes the immediate sense of self. More crucially, Postmodernism is about the inescapability of memory once the utopian sense of Modernity has dissipated—a moment such as this one, when it no longer seems possible or desirable to keep making it new. Through various strategies, Graham converts—deconstructs—the present moment into memory, showing how the moment is nothing but a form of memory. Memory invariably exists in fragments, each memory itself ready to fragment further into shards of sensational affect, in an infinite regress which when it takes over signals personally impulsive as well as socially propulsive power. This regress undermines the possibility of "self-centering" and "self-concentration," of any sense of stable, reliably functioning self.

Describing his *Two Adjacent Pavilions*, model 1978; first constructed at Documenta 7, 1982, Graham asserts that "they involve a dialectic between audiences in relation to their own self-images." (Additional architectural projects in the same vein include *Pavilion/Sculpture for Argonne*, 1978–82, and two unexecuted projects, *Cinema*, 1981, and *Alteration to a Suburban House*, 1978.) The pavilions are "a philosophical-psychological fantasy," in which each pavilion can be "viewed as a separate ego—each the other's hypothetical viewing subject which observes the other hypothetical viewing/viewed subject/object." Each pavilion/ego, at once semitransparent and semiopaque (semiwindow and semimirror), "allows more or less a view of each other's interior/exterior." This condition and situation of selfhood, here architecturally defined, is always polemically stated. Graham's architectural projects are correlative with his performance projects, and involve the same kind of space interaction, the same deconstruction of inhabited space, that is, the same sense of theater and the analysis of the "theatricality" of social and self relationship. Graham's art addresses this question of selfhood with extraordinary vigor and

surgical exactness. But it is in his performances, which are also philo-sophical-psychological fantasies, rather than in his architectural projects, that another dimension of the Postmodernist deconstruction of subjec-tivity emerges most clearly: the idea that there is no possibility of reconstructing or recentering the deconstructed, decentered subject. The subject can neither reemerge with a transcendent, "mothering" truth, nor be at home in any world, even the world it once "fathered." For the mastery it once had over the truth and the world has become the factor that distances the subject from itself. That very mastery is suspect, and is simply a memory. However, the therapeutic reintegration of the sub-ject remains a subliminal if utopian possibility of Graham's kind of Postmodernist narcissism—a possible striving to overcome what is in ef-fect the subject's reduction to infantile status by its fragmentation. Graham never arrives at this reintegration, but it remains the hopeful point of his driven performances. (It is worth noting that Freud's deconstruction of the subject posits its actual reintegration as the goal of psychoanalytic therapy. This therapeutic dimension has been entirely neglected, and re-jected, by the Lacan-oriented Postmodernists, who idolize Freud's deconstruction alone.) One might even say that the Postmodernist in-sistence on ecstatic communication, on demonic possession by the "net-work," is a strategy for disavowal of this alienation and frustration—which to me is so honestly evident in Graham's work, so much of what it is finally about.

Where does this sense of advanced frustration come from? Graham's demonstration of the fundamental doubleness—"duplicity"—of the self makes clear the impossibility of establishing centrality, the inherent ab-surdity of the idea that having a center or being a center is normal and, indeed, the very essence of normality. Marginality emerges with a vengeance out of this recognition, out of the discovery of the collapsing center which is what Graham's performances are about—permanent marginality. But Graham does not make marginality the new privileged position, as numerous other cultural critics and artists do. The way he pulls anti-narcissism out of supposedly narcissistic situations is one of his major contributions; the way he demonstrates frustrated narcissism, narcissism unable to bind up the memorable images of the self in a single, coherent, stable sense of selfhood, is one of the triumphs of his perform-ances. When Graham asserts that "Fascist art remains the repressed col-lective unconscious of the present,"[2] he is in effect saying that the pressure to totalitarian centrality, the forcing of unity, remains dominant in Modern art production. Instead Graham proposes, implicitly, that art be investiga-tion of the fragments of memory that constitute every image. Graham thinks of the artist as a kind of historian of ancient, lost, "historical"

selfhood, capable of seizing it "only as an image which flashes up at the instant when it can be recognized and is never seen again," to quote a statement by Walter Benjamin that Graham, in self-justification, quotes several times. In his video and architectural performances, through the use of feedback, Graham positions himself or the spectator—and himself as his own spectator—so that they can "seize hold of a memory as it flashes up at a moment of danger."[3] The moment of the flashing up of memory, of the spontaneous creation of a living memory, is the moment of danger, for it is dangerous to the integrity of the self, to its belief in its centrality and its self-possession.

Graham shows that Nietzsche's command to "live dangerously" means to live with, and accept being no more than, one's memories. For every memory gnaws from within at the self's supposed unity of being, since the memory brings back a lapsed time that the self did not know possessed it. Memory shows the self its inherent alienation from itself, eternally and once and for all. Eternal frustration is the upshot of Graham's art, which involves the creation of a continuum of *petites perceptions*, a mess of intimate memories, which is hardly the same as being self-possessed, or having an archaically strong sense of an indivisible nuclear self. Graham's performances constantly split the nucleus of the self, releasing a stream of powerful memories. His art turns the spectator into a Humpty Dumpty who can never be put back together again, which I think is a good part of the message of conceptual art.

To claim Graham completely for one popular version of conceptual art, as was implicitly done in the early seventies by a variety of critics,[4] is not only to misconceive the nature of the relationship between Graham's writings and his performances, but to reduce the future of conceptual art. Contrary to Kosuth, all conceptual art does not set up a hierarchical relationship between the concept of art and objects of art ("an object is only art when placed in the context of art"); some of it synthesizes them in a feedback loop. The "change . . . from 'appearance' to conception," as Kosuth puts it, was indeed "the beginning of 'modern' art and the beginning of Conceptual Art." For Kosuth it involved the new self-consciousness that "art exists only conceptually."[5] But this view of art implies a total transference of the power of the object to the concept, which would be meaningless and empty if there were not the idea of the negation of the object. The object always remains as the implicit horizon and feedback to the concept. Moreover the appearance of the object, no matter its form, actualizes a possible concept of art, testing its validity.

In Graham's art the concept of feedback is central. Objects of art are not only a kind of feedback on a concept of art, but any given concept of art and the objects that "represent" it are a kind of social feedback

to the lifeworld community at large—a means by which it can monitor and learn about itself. Conceptual art, as practiced by Graham, makes this transparently clear once and for all. The performances offer neither exclusively objects to be experienced nor a setting for the experiencing subject, but rather present situations in which the communicative, mediative process which is central to the feedback system is itself "the star," the major focus. In the performances, routine feedback is ritualistically organized and analytically exposed. What Graham calls "feedback interference"—the generation of a "pattern on the [video] monitor of image-within-image-within-image-feedback"[6]—becomes at once the sacred "essence" of the communicative process he is manipulating and the chief instrument of his attempt to profanely politicize it. Graham shows us to be socially trapped as well as intellectually liberated by the feedback situation.

As the Promethean performer in the feedback situation Graham is inherently the victim of his audience, which is put in the godlike position of commentator and absolute observer. Their glance at him always accompanies his own at himself. They are not simply monitoring or overseeing his self-observation; the audience is not a neutral witness to it but implicitly regulates it, determining the content and rhythm of the language in which it reports its findings and even directing it toward a certain kind of finding. What Graham's self-glance usually finds is his body as experienced by others. His body thus becomes a communal body, for Graham, like a Duchampian medium, is trying to make contact with the audience's sense of its own concreteness. He heroically plunges into the nihilistic display of "mirrors," emerging with an image of the "body politic." The mirrors are a dreadful Pascalian infinite for him because they harbor the god of the other's glance, which makes him divide from his sense of himself. But this "alienation" is orgiastic, Dionysian. By experiencing his own body through others, Graham experiences consummate union with the audience.

There is frustration in this consummation—selflessness as the social body is found, selflessness in the infinite regress of images which leads to the communally significant find. Graham is the dying god, a scapegoat running the gauntlet of the infinite regress that makes him "representative" of the community, the medium of its self-identity. He can observe no "progress"—no growth—in his own sense of self-identity. He is driven as much by a yearning for self-integration as for community, but the two correlate only in the paranoid bodily discomfort by which he expresses his double sense of self and which is the sign of his and his audience's embrace of synonymity. When, in the transcript of a performance at P.S. 1, he observes his "very dead, very deadpan, very straightforward, very

unexpressive'' face, ''except perhaps for the lips as I talk,'' or comments that his ''body is basically symmetrical which it hasn't been in a long time,'' compelling him to ''make a gesture with one shoulder to make it asymmetrical a little bit,'' and then worries about having ''a more balanced view of myself,'''[7] the seesawing is indicative of the medium's feedback to himself and the suffering from universal self-consciousness and the uncertainty it creates. Graham has become the scapegoat by which the community drives this self-consciousness and uncertainty from itself—this self-consciousness about its body, which is really an uneasiness about, and even a dread of, an already existent if always open-to-question social contract. (Self-consciousness about the body is symbolic of the persistent, implicit question of inescapable togetherness with others, and especially of the unsystematic, unpredictable character of the togetherness.) Graham displays himself to us with all his social wounds, the martyr of our self-doubts and the medium of our longing for ourselves through our longing for a ''balanced'' view of and relationship with the other—who is always in the position of knowing my body better than I know it myself, for he or she can experience it with all the aggression and sexual initiative of the social observer unconsciously wanting to satisfy his own ''social'' interests.

Ludwig von Bertalanffy describes feedback as ''a circular process where part of the output is monitored back, as information on the preliminary outcome of the response, into the input, thus making the system self-regulating; be it in the sense of maintenance of certain variables or of steering toward a desired goal.'' He goes on to list the ''essential criteria of feedback control systems'':

> (1) Regulation is based upon preestablished arrangements (''structures'' in a broad sense). . . . (2) Causal trains within the feedback system are linear and uni-directional. The basic feedback scheme is still the classical stimulus-response (*S-R*) scheme, only the feedback loop being added so that causality becomes circular. (3) Typical feedback or homeostatic phenomena are ''open'' with respect to incoming information, but ''closed'' with respect to matter and energy. In general, a feedback mechanism can ''reactively'' reach a state of higher organization owing to ''learning,'' i.e., information fed into the system.[8]

Graham's performances are heavily dependent on their architecture, i.e., on the ''preestablished arrangements'' of the structures in which they occur. Such arrangements include everything from the use of mirrors to the positioning of the video monitor and, in the time delay pieces, the setting up of a closed system of rooms. Here the architectural determination of the performances is most explicit, but the internal establishment of a closed circuit—however involuted—of relationship between performer

and audience is also architectural. Indeed, it is a supreme example of architectural meaning, namely, the creation of an external space that influences social and self-perception, or that exists in a feedback loop with every kind of perception. The architectural dimension of Graham's performances has become increasingly explicit. In his seemingly pure architectural projects, the architecture seems to dissolve into the viewer's "performances" that take place within it, that are generated by it. Graham's architecture automatically makes people's interactions in and around it self-conscious and thus "artistic," "artificial." In his performances the architectural dimension is so predetermined by the pre-established structures—the mirrors, the monitors, the arrangement of the room—that it becomes impossible to imagine the performance occurring in a randomly chosen, casually experienced, relatively unstructured space. It is just this sense of predetermination, embodied in architectural structure, that Graham wants, for it is a metaphoric reminder of inescapable social codes, forms of what Emile Durkheim called "social coercion." It is the outer form of an inner map of social organization, of presupposed social order. It is to this that Graham points when he remarks, analyzing the cinema, that "it is difficult to separate the optics of the materials of the architecture from the psychological identifications constructed by the film images." In fact, "the state of higher organization" that is reactively reached through the feedback mechanism is a state of psychological identification with certain socially accepted types of self. Graham does not have to look to the cinema as "prototypical of all other perspective systems which work to produce a social subject through manipulating the subject's imaginary identifications." The most naively conceived architectural structure is not only a fundamental determination of human space but presupposes a "system of voyeuristic identifications," a program of self-identifications through coercive identifications with others, or rather, "forced togetherness" with the various models for being an "other."[9] Architecture in general voyeuristically teaches one the perspective of the other.

Such attention to architecture and the identification process is a sign of the pervasive "humanism" of Graham's performances. This is a far from ironic, incidental humanism. Graham concludes his "Working Notes" for "Local Television News Program Analysis for Public Access Cable Television" (1978) with "A last question: can an analytical, didactic de-construction of media, such as we propose, be of cultural and political value to the community?"[10] Graham is enveloped by the all-encompassing space of society, which he thinks more of comprehending than escaping, in the hope of understanding its determination of his particularity, especially of his desire, which always circles back to it, invariably

taking it as the only source of personal satisfaction. I think this communalism is worth contrasting with Smithson's cosmicism. The contrast, I think, is most clear in their use of the mirror. Smithson uses it to blot up his experience of the immediately perceived world; in the blottings he finds traces of a cosmic space. Graham uses the mirror to throw his immediate experience of himself back on its communal mediation, as if the self experienced its presence through its communal recognition. Smithson found cosmic space aphrodisiac and charismatic. For Graham the medium of communal space created by the mirror—the socially amplified space of the mirror—is the only source of arousal and self-reference. Graham uses the mirror to become timely: reflected in it for others, and for the other he is to himself when he observes his own reflection, he has the perfect sense of social timing that makes him seem an individual to himself.

Benjamin H. D. Buchloh has written that one of the reasons for "the general misunderstanding and delayed recognition of Graham's work" may have been "the work's specifically 'non-esthetical' form of appearance."[11] However, I think Graham's work has been misunderstood because it looks minimal and conceptual but in fact contradicts, by reason of its communalism or humanism, the basic understandings of Minimalism and conceptualism, which took the Modernist conception of art as a rigorously self-reflexive enterprise to its ultimate hermetic logic, built on an earlier hermeticism. But for Graham this new hermeticism was implicitly self-deceptive, since it short-circuited the communicative potential of art. Mediation as such became a rootless abstraction in Minimalism and conceptualism—particularly conceptualism. For Graham, art's unique mediative function—the source of its special status and prestige—is rooted in more general social mediative capacity and opportunities, reflecting the state or condition of communication in the interpersonal life-world as a whole. Graham "borrows" what he implicitly regards as the hottest, most contemporary instrument of interactive mediation—video—to make this point, i.e., to make the point that mediation is not only an interactive process (which Minimalism and conceptualism tend to forget) but that it is always problematic. It is dependent not only on the "state of the field" of mediative instruments, but on the communicative codes that define their usage and expected results—which determine the limits with which they are presumed to make sense, the very will with which they must be used if they are to be used "properly." That is, mediation has its socially acceptable instruments and ends, and responds to and creates in its wake the kind of subject that exists through it. A whole mentality goes with any mode of mediation; Graham is asking, in effect, why

not explore and test the limits of this mentality in the very process of us-
ing the instruments of mediation? Graham is interested in the ideology
of mediation, not simply the social—or artistic—fact of it. Mediation, and
the speech acts including visual representations that are the articulation
of its interactive properties, are his theme. For him, all mediative mediums
exist against the background of a communicative ideal, which not only
numinously regulates but determines its concrete form.

For Graham, who for all his writing—his relentless pursuit of discur-
siveness, articulateness—accepts Marshall McLuhan's thesis of a postver-
bal Modernism, film and video are the basic modes of modern com-
munication. Through their projections they articulate a sense of what is
essentially to be "seen." Comparing film and video—and explaining his
preference for the latter as more crucially modern—in his "Essay on Video,
Architecture and Television," Graham writes:

> Video is a present-time medium. Its image can be simultaneous with its perception
> by/of its audience (it can be the image of its audience perceiving). The space/time it
> presents, is continuous, unbroken and congruent to that of the real time which is the
> shared time of its perceivers and their individual and collective real environments.
> This is unlike film which is, necessarily, an edited re-presentation of the past of another
> reality/an other's reality for separate contemplation by unconnected individuals. Film
> is discontinuous, its language constructed, in fact, from syntactical and temporal dis-
> junctions (for example, montage). Film is a reflection of a reality external to the spec-
> tator's body; the spectator's body is out of the frame. In a live-video-situation, the
> spectator may be included within the frame at one moment, or be out of the frame
> at another moment. Film constructs a "reality" separate and incongruent to the view-
> ing situation; video feeds back indigenous data in the immediate, present-time en-
> vironment or connects parallel time/space continua. Film is contemplative and "dis-
> tanced"; it detaches the viewer from present reality and makes him a spectator.[12]

Whether or not Graham realizes it, he is putting his finger on exactly what
makes Modern mediation problematic: its insistence on presentness, i.e.,
on the unmediated or immediate. The mysticism (and mystification) of
immediacy—of being pastless and futureless, and thus radically present—
has been with us at least since Impressionism. It gets new force with video,
the currently ideal instrument of presentness—of achieving union with
one's own present, so that one disappears into it as though into the
godhead.

The Modern conception of mediation is self-contradictory. On the one
hand, the mediated character of all reality is acknowledged. One of the
great discoveries of Modern times is the inescapability of the medium,
the impossibility of direct relations. On the other hand, Modernity
assumes it has the instruments to create the ideal state of immediacy—to

literalize immediacy beyond any past attempts—and thereby to make the mediative medium seem a dispensable illusion, an unnecessary and insufficient condition for the effect of "being there." To be in the state of immediacy is to be Modern, to realize one's own Modernity—but it is to do so through such modern, immediacy-generating instruments as video. The "you are there!" effect sums up all of Modernism's epistemological idealism. The relentless, yet peculiarly empty—of history—realism of this goal tends to be masked by the sublime sensation of absolute presentness that is its surface effect, yet this sensation also betrays the inherent self-contradiction of pursuing the goal of immediacy. It is as though one can only acknowledge the givenness of the mediative medium dialectically, through a critical subliminal scanning of the limitations it imposes on communication, which seeks to encompass communicators in the moment of their interaction, a "moment" ideally interpreted as the sign of spontaneity of communication. The circle is completed when this spontaneity is understood as the basis for instinctive, immediate understanding—the communicative ideal—which is able to dispense with the "distorting," "interpretive" mediative medium. This ideal of "communication at first sight" is premised on an increasingly simplistic ideal of immediacy in social interaction as well as art; video shows the ideal at its most simplistic. Paradoxically, the ideal exists only to the extent that actual communication, and our understanding of all the conditions that mediate it, becomes complex and sophisticated.

Graham is attracted to this ideal of immediacy—of being completely present—but the structure he sets up to generate it specifically produces a reverberating series of reflections that contradict it. In fact, not only does he consciously move against the unreflective state of consciousness that is the source of the illusion of immediacy, and which seems embodied in his mediative instrumentation of video and mirrors, but he firmly establishes an infinite regress of reflections which spiral toward a tense but untransformed sense of identity. This in turn is materialized in his scrupulous publication of his performative, self-reflective speech acts and the "architectural" plots of his performances. His documentation—creation of a text—works against his immediatist ideal, burying it under an avalanche of silenced speech acts that can be brought to life again only by "recital" and interpretations. Graham repeatedly tests the validity of his own performances by documenting them to such an extent that they seem to disappear into his expository analyses of their presuppositions. This is what prompted my original temptation to regard his articles as Kosuth had regarded Smithson's.

What also mediates against the ideal satisfaction of immediacy is Graham's self-consciously erotic use of his instrumentation as an in-

termediary between himself and his audience. In *TV Camera/Monitor Performance*, 1970; the nude version (1974) of *Two Consciousness Projection(s)*, 1972; and *Helix/Spiral*, 1973, the camera is used phallically. It rehearses but never really realizes the "erect" state of Graham's glance, with its threatening penetrative potential. It distances that glance from its object, forcing a peculiar passivity on the glance. In many other works—writings as well, e.g., "Dean Martin/Entertainment as Theater" (1969)—there is the outsider's voyeuristic fascination with the surface features of erotic situations, none of which involve profoundly realized erotic relations. There is a general erotic character to Graham's relations with his audience, and the peculiar conceptual frustration that pervades them, which is signaled by the prolonged masturbatory verbalizations with which he articulates his feelings about his body. In an act of self-arousal, he discharges his tension about his body in a stream of half-unconscious speech acts, "artistically" reliving in his performance the adolescent nightmare of being caught masturbating in public. This is an affirmative act of self-love just to the extent that Graham makes himself a sacrificial lamb consumed by the envious glances of strangers. It is at the same time a way for those ashamed of the "strangeness" of their bodies to empathetically feel at home with a mystical flesh of language.

The source of the frustration is in the fixated character of Graham's looking itself—the fixation of completely instrumental looking. It is looking in terms of strictly instrumental or "interested" relations that generates a sense of immediacy, since it must target its object precisely to exploit it properly—if only as the catalyst for masturbatory self-fixation. But such obsessive looking denies the subjective reality of the object of its own desire, including itself. The voyeuristic glance is epitomized by video, whose congenital incapacity for generating new self-consciousness is shown in its being bound to a durationless present-time. Such present time promises perfect presentness, that is its inexhaustible "interestingness." Ironically, the illusion of immediacy in voyeuristic video is the thing that counteracts the illusion of intimacy, which comes with a sense of history. Narcissus is not intimate with himself—cannot begin to intimate his own subjectivity—because he is stuck on a present appearance of himself. Paolo and Francesca, in Dante's *Inferno*, are not intimate with one another, but obsessed with the immediacy, the sheer givenness of the other. They do not interact communicatively, dialectically reflect one another, but only bestow their own immediacy on the other as a gift. And that is what Graham does with his audience.

The unconsummated quality of such eroticism is most explicit in *Identification Projection* (1977):

> A woman performer looks at the audience, selects and describes the various men (perhaps also women) who charismatically ("sexually") attract her. The description and the feeling she expresses are to be as sincere, non-theatrical, as possible. The performer pauses between descriptions of people for a time the same length as her period of speaking (so that she appears as sexual object). The pauses should seem a little too long. During this period she does not look at or acknowledge the presence of the audience; she moves slowly; she is for herself (thinking private thoughts about herself).[13]

The pathos of the frustration for both audience and female performer is made especially clear when, studying the transcript of the performance, one observes that the descriptions the female performer uses are premised on stereotypes of socially idealized sexual objects. Her mind is constituted by conventional linguistic conceptions of sexual roles which distance her as much as possible from subjective, physical sexual experience. These roles are all based on what society assumes a sexy *appearance* to be. It is because both she and the audience are trapped in looking, institutionally trained to be fixated on appearances, that they are incapable of locating their sexuality in their existentially possessed bodies. Both are seduced into playing sexy roles in a game of manipulated appearances. In the name of these socially determined roles they forfeit their sexuality, which almost becomes self-repressive—certainly powerless—in such a "game theory" of sexiness. In general, none of Graham's performers can reflectively disengage from their own self-conscious looking, and experience the swoon into unconsciousness they yearn for.

In sum, one is never released from looking in Graham, and looking is never a release. Looking is burdened by the fiction of self-reflection, which it interprets as self-emancipation. It is an interpretation natural to the dialectic implied by the feedback loop, in which looking circles back on itself—in which the looker studies looking, and the projections it breeds. It is perhaps Graham's proposed *Cinema* that makes this dialectic, at once social and personal, explicit.

> The psychological circuit of intersubjective looks and identifications is echoed in and is a product of the material properties of the architectural materials, whose optical functioning derives from the properties of the two-way mirror glass. My cinema, like "the cinema," is a perceptual "machine." But unlike the cinema which must conceal from the spectators their own looks and projections, the architecture here allows inside and outside spectators to perceive their positions, projections, bodies and identifications. Topologically, an optical "skin," both reflective and transparent inside and outside, functions simultaneously as a screen for the film's projection, dialectically seen in the outside environment as well as in the normal cinema context as a point of transfer for the gazes of the inner and outer spectators in relation to each other and the film image.[14]

This *Cinema* makes clear that Graham is an exemplary artist-thinker. His works are projections and clarifications of a communally implicit conception of art as a process of self-identification through communication with others. For the artist-thinker, art must have communicative competence, which is the only way for it to achieve communal acceptance. Art is not inevitably self-validating—which is the implicit hope behind its proclamation of autonomy. Rather, it is a social communication, and contemporary art is a meditation on the nature of mediation, which abstracts it from its sociality. Graham restores this sociality, and thereby restores to Modernist self-criticality a sense of the communicative horizon on which it exists. Its validity is finally as a Virgilian guide to the life-world it professes to be responsible to, but can barely keep up with. Graham shows us that the only way to purge the infernal life-world and achieve a sublime consciousness of sorts is not by creating a vacuum-sealed, hermetic art, but by making the dominance of the life-world itself communicatively discursive in the performative architecture of art.

Notes

The descriptive texts concerning the works illustrated are excerpted from Dan Graham's writings.

1. Joseph Kosuth, "Art after Philosophy," *Idea Art*, ed. Gregory Battcock (New York: Dutton, 1973), p. 100.

2. Dan Graham, "Theater, Cinema, Power," *Parachute* (Summer 1982).

3. Walter Benjamin, "Thesis on the Philosophy of History," *Illuminations* (New York: Schocken, 1969), p. 255.

4. For example, Lucy R. Lippard, *Six Years: The Dematerialization of the Art Object from 1966 to 1972* (New York: Praeger, 1973), p. 155.

5. Kosuth, "Art after Philosophy," pp. 80, 89.

6. Dan Graham, *Video-Architecture-Television* (Halifax, Nova Scotia: The Press of Nova Scotia College of Art and Design, 1979).

7. Dan Graham, *Theatre*, no publisher, no date.

8. Ludwig von Bertalanffy, *General System Theory* (New York: George Braziller, 1968), pp. 150, 161–63.

9. Dan Graham, *Buildings and Signs* (Chicago: Renaissance Society at the University of Chicago, 1981), p. 50.

10. Graham, *Video-Architecture-Television*, p. 61.

11. Benjamin H. D. Buchloh, "Moments of History in the Work of Dan Graham," in Dan Graham, *Articles* (Eindhoven, The Netherlands: Municipal Van Abbemuseum, 1978), p. 73.

12. Graham, *Video-Architecture-Television*, p. 62.

13. Graham, *Theatre.*

14. Graham, *Buildings and Signs*, p. 50.

Bill Viola: Deconstructing Presence

Usually, in recalling a scene or describing a dream, we do so from a mysterious, detached, third point of view.

Bill Viola

The issue of presence, which informs all of Viola's work, and which video is peculiarly suited to address, is already stated in Viola's first tape, *Wild Horses* (1972). Images of highly trained horses alternate with images of violent, wild horses, then interlock. This doubling leads to a flattening, a blurring and abstracting. An image of a primitive horse from one of the prehistoric caves emerges and eventually dissolves. The regression from the civilized to the primitive to the archetypal continues into infinity. What appeared to be real has become just an appearance—an illusion— but is all the more psychologically significant for that. It is this transmutation of reality into appearance, and appearance into reality—the ambiguity and uncertainty of which is which, and the generally dialectical character of their relationship—that is the substance of Viola's art.

In Viola's tapes we sense that he is manipulating the instantaneous— stretching it, or exaggerating its effect of momentariness. An instantaneous appearance is transformed: it is either extended through slow motion, so that it seems unendurably long and becomes a duration, ultimately unconceptualizable, immeasurable—a moment that seems to last an eternity, to transcend every other moment, and to obviate the very notion of moment it grows out of; or it is speeded up, until it seems to occur with greater instantaneity than the tick of a clock, yet is never so irreducibly instantaneous that it cannot be further "momentized." Viola plays with our sense of time, blending our contradictory experience of it as duration and perspective or tense.[1]

This article originally appeared in *Bill Viola: Installations and Videotapes* (Exhibition Catalogue; New York: Museum of Modern Art, 1987). Reprinted courtesy of Barbara London; © The Museum of Modern Art.

His sophisticated use of space restores our most primitive sense of time. The philosopher Henri Bergson has said that we conceptualize time in terms of space, but Viola uses the terms of space—velocity, simultaneity, and succession—to recover an experience of time that is inseparable from primitive affective experience and outlook. It is the child's sense of time, built "on the perception of subjective reality in terms of tension-arousing, libidinal, or aggressive drives,"[2] that is , "on perceptions and personal displacements or object movements,"[3] especially the movement of beings important to the child's existence—beings who because they are caught up in the child's affective field become part of its experience of time. This is the way the objects and persons in Viola's video function. Viola alternately softens or hardens the image so it seems "driven," an effective field of completely fluid time that is so Heraclitean the same object never appears in it twice; it becomes like time itself, in Bergson's works, "a continual invention of forms ever new."[4] He in effect restores what Piaget called the "magico-phenomenist" concept of causality, wherein the child regards himself as the cause of the phenomena that constitute the world.[5] It is a world unrepresentable apart from the child's representation of itself, which is what, finally, Viola gives us: a world of internal objects, existing in a timeless space of ceaseless transition.

Viola recreates what Winnicott called the "moment of illusion."[6] It is the magic moment when the infant imagines it has created the object of its desire because desire for that object and possession of it seemed simultaneous. There was no postponement of gratification: the particular object was magically there when the infant wanted some object, or rather, wanted its instinctual needs to be satisfied and, lo and behold, this particular object miraculously appeared. The infant's desire represents itself through fantasies, hallucinations; when real objects capable of satisfying desire correspond spatio-temporally with the the hallucinated objects, the infant believes it has conjured the real objects. It experiences the power of a god, enjoys a grandiose feeling of reality existing for it. Actually the infant has no ability to distinguish between reality and illusion, or rather, it sees reality through illusions—fantasy. Viola's best work puts us on the infant's primitive level of comprehension. To return us to this ecstatic infantile state of perception is not only to realize the great romantic dream of childlike vision, but to deconstruct presence. It is to put us on a level of experience where "time and affects interdigitate,"[7] and where objects self-deconstruct—lose their ordinary, obvious presence to become extraordinarily present.

Viola is a master of showing the hallucinatory underpinnings of our sense of reality, of making manifest our inherently fantastic sense of it.

It seems both eternally timely in its givenness—given with all the energy of the subject who desires it to be given, and thus given with a special substantiality—and a mirage or empty appearance once it is clearly there, that is, once it has given satisfaction. He has shown the profound subjectivity that goes into the experience of "objective" presence.

From the start, then, Viola was preoccupied with the way things had presence, wanting at once to articulate presence and to dissect it. Viola asserts that "imagination is our key to the doorway of perception" and makes Blake's project his own: to cleanse "the doors of perception" so that "everything would appear to man as it is—infinite." The infant sees everything in its infinitude. When a thing appears infinite rather than finite its presence has radically changed. It can no longer really be said to have presence—to be given—in the conventional sense, but rather to inhabit what has been called the specious present. When a thing is perceived as infinite its presence self-deconstructs. In a sense, when something deconstructs it reveals that it is not finite in its construction. When one sees eternity in a grain of sand, as Blake apparently did, one is seeing that grain of sand as either an infinite duration or an infinite continuum of instants. Both reveal the moment of presence of the grain of sand to be inexhaustible. The momentary presence of the grain of sand is not what it seems to be. It is at once more intense in its objectness and more extensive in its temporality—complicatedly given—than it appears to be to uncleansed perception.

In *Hatsu Yume (First Dream)* (1981) Viola seems to reinvent the Blakean experience of seeing eternity in a grain of sand, or rather, in its equivalent, a group of stones. They become sacred, acquiring a Zen sense of infinite immediacy as a result of the changes our perception of them undergoes. (Viola pursues Buddhist enlightenment, showing freedom from attachment in the very act of disclosing the primitive desire that creates attachment. It is the freedom that comes from selflessness, which allows experience of the illusoriness of things as well as their infinite immediacy.) Seen by themselves, the stones loom mountainous and infinite. They abruptly become finite when measured by the human figure—brought down to banal earth by the human presence. Yet they remain peculiarly infinite: slow motion makes them speciously present, transforms them into duration. In Viola's hands video becomes the instrument privileged to reveal the infinity that constitutes the givenness of things; this infinity breaks down the apparent spatial finitude of their givenness, showing it to be less irreducible or indivisible than expected. Presence is more illusion than reality, or rather, it is both. Once perception is cleansed, the illusoriness of finite presence and the reality of infinite presence are experienced simultaneously. Viola shows not only that the state we are in

when we perceive "reality" is responsible for our sense of it, but what Reality would be without human presence. He implies that human presence is an unnecessary intrusion on Reality, undermining its eternal verity.

It often takes some time to conceptualize what is going on in a Viola tape, that is, what is occurring according to the standards of ordinary, uncleansed perception. Thus in *Junkyard Levitation,* one of "Four Songs" (1976), it only slowly dawns on us that the abstract scene we are watching is really a magnet picking up metal. The scene may be an illusion in the mind of the meditating figure seated cross-legged by the railroad. In the second tape, *Songs of Innocence* (explicitly alluding to Blake's poems of the same title), Viola uses one of his major, habitual, ready-to-the-eye means of showing the illusion and infinity of everything: the change of light as the day passes. Light changes, but it is timeless. It is the form of Plato's time, the "moving image of eternity." (Illusion and the infinite are experienced as simultaneous, because seen as infinite, a thing is revealed as an illusion.) Dusk and dawn come and go, obliterating and restoring the singing children, showing them to be at once illusion and reality. The progress of light functions as the space of reflection in which the illusory and the actual differentiate, but also lose their distinctiveness. Emblematic flame and flowers are also shown, epitomizing the process— as well as signaling its naturalness. They are short-lived yet regenerate, and so in a sense eternal. They symbolize the experience of the eternal Viola is trying to invoke; this is essentially a borderline, abstract experience in which we seem to exist on the boundary between the actual and the illusory, almost so they can no longer be clearly differentiated—so that we can find no criterion for firmly grounding their difference—which leads us to recognize the superficiality of the reason they were differentiated in the first place. When the actually enduring and the transient (and thereby seemingly illusory) can no longer be clearly separated, one of the fundamental ways one discovers and experiences the difference that presence makes has been undercut. It is replaced with a sense of undifferentiated—infinite—presence, which is far from the same thing. One comes to float in Viola's sea of images, experiencing the undifferentiated duration of one's own presence the way Bergson metaphorically said one did: as though listening to music with one's eyes closed, "allowing for the difference among the sounds to disappear, then losing track of the distinctive features of the sound itself, except for the sense of an incessant transition . . . a sense of multiplicity . . . and of succession without separation."[8]

In *Migration* (1976) a kitchen scene slowly comes into being. When it at last *is,* it seems representational, realistic; when it is still in the pro-

cess of becoming, it seems abstract, unearthly. Both ways, it is wondrous. The passage from becoming to being is accompanied (to the primitive mind caused?) by the ring of an invisible gong. Is this sound emblematic of Viola's "mysterious, detached, third point of view"—the mind within the mind, the solipsistic consciousness that seems to create being, but that also knows it is an illusion? Viola is demonstrating Maya, the experience of the illusoriness of it all. Yet that experience of illusoriness signals the sovereignty of consciousness, its delusion of mastery of the world of appearance through perception. Through its reduction of the world to illusion it objectifies its sense of omnipotence, its primitive feeling of being in control of appearances—that the world exists for it through its perception. When, in *Migration*, a figure emerges, it quickly becomes a reflection—an empty perception—a face in the bowl of water on the table. The tape ends with perception closing in on water dripping from a small spigot. As we come close the dripping slows down. The closer—more immediate—our perception, the more timeless it seems. We are experiencing water as we would in the unconscious, as though it is eternal. Freud has said that "impressions . . . which have been sunk into the id by repression are virtually immortal; after the passage of decades they behave as though they had just occurred."[9]

We experience water, here and elsewhere in Viola's work, as though it has just occurred, yet is eternal. We are recalled to time by entering into the flow of the water, where the figure is suddenly clearly reflected, but upside down—a sign of its illusoriness, going against the grain of our experience of it as real. The clear and the unclear, and right-side-up and upside-down, like the smooth and the rough, are textures of perception that ambiguously enhance and undermine our sense of the real, reversibly conveying illusion and reality. The sense of what is illusion and reality in a Viola work is complicated by the fact that what is eternal appears to be an illusion because it is recovered from an unconscious depth.

What is reality and what is illusion? In *Chott el-Djerid (A Portrait in Light and Heat)* (1979) the question of the difference becomes agonizing, without being answered; for it is an unanswerable question, one that relates to our state of mind as we perceive. We are initially in a white Northern winter, with a figure and farm buildings coming out of the snow. With the passage of time we perceive a figure walking laboriously and silently in the snow, and finally falling. The issue is not man against the elements, but rather the place of the figure in the field of perception, as a marker of its process—of the ambiguity between its own sense of its becoming and what its becoming brings into being—of its inability and its ability to differentiate between itself and its objects, and of the uncertain necessity of doing so. The differentiation just happens. Even when

we shift season and world, go into the shimmering desert, where mirage and real confuse, the perception of difference remains poignantly problematic. One has a sense of the concrescence of visibility, but also of the concreteness—the visibility—of the invisible. That is, difference—between snow and desert, winter and summer, cold and heat, mirage and fact, this and that kind of white light, and between the raw world of nature and the civilized world of human habitation, the unconfined outdoors and the confined indoors—exists, but the differences do and do not reconcile. It is concreteness of difference as such that counts—illusion and reality being the ultimate difference for Viola—not the preference for one or the other.

What is present on Viola's screen is defined by what is absent, if inevitable with time. What is present is never simply given, an elementary fact, with the authority of the self-evidently and autonomously present, but an effect of and part of a process of difference. A deconstruction theorist wrote, "the notion of presence and of the present is derived: an effect of difference. 'We thus come,' writes (Jacques) Derrida, 'to posit presence . . . no longer as the absolute matrix form of being but rather as a "particularization" and "effect." A determination and effect within a system that is no longer that of presence but of difference.' "[10] Viola's deconstruction of presence involves a radical demonstration of perceptual differences—of perception as a process of differentiation that it uncovers the root differences that constitute it. They are the source of the seeming "presences" that it uncovers, presents as self-evidently the case. Viola not only "designates . . . a 'passive' difference already in place as the condition of signification" and creates "acts(s) of differing which produce differences"[11] through "deconstructive reversals, which give pride of place to what had been thought marginal"[12] in perception—the abstractly blurry, the accidental or contingent, that is, all that can be experienced as illusory—but is representing *"différence."*

I think this occurs especially in the scenes already mentioned in which figures move in slow motion by a grouping of stones that becomes smaller when it is measured by them than when it exists alone. This kind of change of scale is one way of representing *différence*. Viola's manipulation of the tension between our sense of emphatic intimacy with and settled distance between things (Viola unsettles both as part of his deconstruction of presence)—operating especially in Viola's numerous water and light scenes—is another way in which *différence* is represented.

Viola's objects are presences that become markers of difference—especially his figures, which represent our sense of the difference we make in the perceived scene. This is inseparable from our sense of the difference we make to ourselves, that is, our sense of our differentness to ourselves

over time. Viola deals with this directly in *Reasons for Knocking at an Empty House* (1983), where we watch him attempting to stay awake alone for three days and nights. In that work the experience of self that is the basis of perception becomes explicit. The changes in light correlate with changes in mood as Viola struggles against his desire for sleep, a natural, instinctive human activity. (This work, like many others, conveys a veiled social commentary on the disturbing unnaturalness—distance from the cosmic and instinctive rhythms of being (which correlate)—of civilized life. Viola reveals the discontents of civilization as much as he reveals the pleasurable rhythms of actual being—of being natural.) This correlation dedifferentiates figure and scene. The house of heaven, in which the changes in light occur, becomes one with the house of the self, in which the changes of mood occur. They seem tied to each other, with no priority assigned. *Room for St. John of the Cross* (1983) also makes clear the correlation of the self with its space. The events that transpire in the one or the other are indistinguishable.

Viola's deconstruction of presence leads, then, to the unconscious discovery and experience of time—an essentially traumatic event. It is through the articulation of trauma that the sense of self most directly emerges in Viola's work; the trauma of time and the discovery and conscious experience of self correlate. It is through the sense of trauma Viola communicates that the opposite sides of his work—the ambiguity as to whether it is reality or illusion that is experienced, and the ambiguity as to whether the self is autonomous or a mirror reflection of its environment—converge. As in *Room for St. John of the Cross, Reasons for Knocking at an Empty House,* and *The Reflecting Pool,* among other works, a figure or implied figure is put in a position of being unable to differentiate between illusion and reality because of its isolation. This isolation, necessary for its self-discovery, leads it to the discovery of itself as lived time—the realization that it is living time. It is a traumatic discovery; the sense of self forms around this experience of trauma, essentially the recognition of time.

This sense of trauma is articulated through the primordial scream that recurs throughout Viola's work—an essentially Expressionist scream.[13] The scream first occurs in *Tape I* (1972); a choked-back scream is implicit in *Vidicon Burns* (1973); silence becomes an invisible scream in *Silent Life* 1979); the ticking clock in *Ancient of Days* (1979–81) and the plucking sound in *Migration,* accentuating the silence, seem disguised, muted, or symbolic screams. The dialectical differentiation of silence and scream is central to Viola's work. In *Parables* Franz Kafka wrote: ''Now the Sirens have a more fatal weapon than their song, namely their silence. . . . Someone might possibly have escaped from their singing; but from their silence,

certainly never." No one escapes the traumatic scream that Viola's silence is. It is in *Anthem* (1983) that the most powerful scream occurs in Viola's work—powerful because it explicitly fuses silence and scream. Both are traumatic, bespeaking disillusionment, that is, the sense of the real as illusion (as nothing), and the self-recognition this forces upon one, backs one into, involving awareness of the possible nothingness—illusoriness— of oneself, because one exists in and through time. *Anthem's* scream cuts through the scenes of the body's pleasures and pains (beach and operating room scenes), the dubious glories and magnified banalities of American life. The scream represents the anguished experience of time, the sense of being thrown in time; for Heidegger this was the central feeling of being human, the feeling through which one discovers one's humanness. It is the most deeply rooted feeling in the unconscious.

The concept of a specious present was coined by E. R. Clay (1882). "The present to which the datum refers is really a part of the past—a recent past—delusively given as a time that intervenes between the past and the future. Let it be named the specious present, and let the past, that is given by being past, be known as the obvious past."[14] Every image exists in a specious present; more precisely, the specious present is inseparable from what William James called the "penumbra" or "halo" of the image, "the dying echo of whence it came to us [and] the dawning sense of whither it is to lead."[15] Agonizing awareness of time is inseparable from the experience of the present as completely specious—an image always in transition, always belonging to the past. Coleridge sharply distinguished between the images of "primary imagination" and those "emancipated" from memory—images that had "esemplastic power" in contrast to those that were merely "aggregative and associative."[16] Esemplastic imagery conveyed the "eternal act of creation."[17] Viola seems to be working through memories toward an experience of esemplastic images of primary imagination, images that articulate the traumatic recognition of time as an eternal act of creation—and of destruction. Viola demonstrates that, in Freud's words, "visual impressions remain the most frequent pathway along which libidinal excitation is aroused," in part because "seeing is ultimately derived from touching."[18] In addition, he shows that, as Melanie Klein asserted, throughout our life we are possessed by and can be said to live a second life of unconscious fantasy, perpetually creating, destroying, and recreating (repairing) objects— internal representations of objects that have some relation to reality but also bespeak the process of our own anxious existence in time.[19]

Perhaps nowhere does Viola so much appeal to our unconscious pleasure in seeing as in the fishing scenes in *Hatsu Yume* and the manipulation of mirage/reality in the desert scenes of *Chott el-Djerid*. But these

scenes finally become so absurd, as images—that is, independently of the dialectical structure of difference between the raw and the cooked, the primitive and the civilized, they articulate—that we realize their essentially esemplastic quality. By lifting the repressions on perception, allowing us to experience every appearance ambivalently and as inherently ambiguous, Viola is able to make manifest how essentially fantastic perception is. In the end Viola convinces us that perception is more a projection of unconscious representations, in a process of endless transition to an unknown goal, if any, than a recognition of stable reality. Viola shows us that perception operates not only according to the pleasure principle and the reality principle, but according to indwelling fantasy. Through it we experience ourselves as a temporal process, in the end not simply constructive or deconstructive, but self-destructive—ecstatically changing.

Notes

1. Peter Hartocollis, *Time and Timelessness: The Varieties of Temporal Experience, A Psychoanalytic Inquiry* (New York: International Universities Press, 1983), pp. 8–11.

2. Ibid., pp. 6–7.

3. Ibid., p. 23.

4. Quoted by Hartocollis, in ibid., p. 21.

5. Quoted by Hartocollis, in ibid., p. 27.

6. For a discussion of Winnicott's conception see Jay R. Greenberg and Stephen A. Mitchell, *Object Relations in Psychoanalytic Theory* (Cambridge, Mass.: Harvard University Press, 1983), p. 192.

7. Hartocollis, *Time and Timelessness*, p. 34.

8. Ibid., p. 22.

9. Quoted in ibid., p. 6.

10. Jonathan Culler, *On Deconstruction, Theory and Criticism after Structuralism* (Ithaca, N.Y.: Cornell University Press, 1982), p. 95.

11. Ibid., p. 97.

12. Ibid., p. 160.

13. See my essay "Chaos in Expressionism," *Psychoanalytic Perspectives on Art* (Hillsdale, N.J.: The Analytic Press, 1985), vol. 1, pp. 69–70, for a discussion of the Expressionist scream from Kokoschka to Newman. Reprinted on pp. 81–92 in this book.

14. Quoted in Hartocollis, *Time and Timelessness*, p. 3.

15. William James, *The Principles of Psychology* (Cambridge, Mass.: Harvard University Press, 1981), vol. 1, p. 246.

16. Samuel Taylor Coleridge, *Biographia Literaria,* in I. A. Richards, ed., *The Portable Coleridge* (New York: Viking Press, 1950), pp. 513–14.

17. Ibid., p. 516.

18. Sigmund Freud, "Three Essays on the Theory of Sexuality," *Standard Edition,* vol. 7, p. 156.

19. For a discussion of Klein's conception of fantasy see Greenberg and Mitchell, *Object Relations,* p. 124.

From Existence to Essence: Nancy Spero

At first nervously submissive, the female gradually loses her fear
of the male, and with it every inhibition against showing aggressive
behavior, so that one day her initial shyness is gone and she stands,
fearless and truculent, in the middle of the territory of her mate,
her fins outspread in an attitude of self-display, and wearing a dress
which, in some species, is scarcely distinguishable from that of the male.
Konrad Lorenz, *On Aggression*

But do you know, despite the abnormal condition of this woman's
atoms, . . . whether she is still not alive?
Lautreamont, *Maldoror*

Nancy Spero's pictures are the most savage, unsentimental and incendi-
ary—inconsolable—feminist art I know. It is almost masochistic for a male
critic to deal with them. Yet one cannot deny that her art has appeal
beyond its propaganda use for a great cause. It developed when Modern-
ist abstraction was dominant, but was ignored because of the selective
inattention to all non-Modernist styles that was once almost a fetish in
the art world. But today her work helps make clear what Postmodernism,
or endgame Modernism, is about: the seemingly regressive search for
great themes as a fresh source of great momentum, while the value of
"progressive" novelty of style fades.

Spero uses familiar facts of the mistreatment of females—violent abuse
in the name of the male ideology underlying supposedly universal political
ideologies—to proclaim her own female subjectivity. She bends spuriously
neutral objectivity into the twisted shape of subjective truth. She relent-
lessly represents woman as the exemplary victim. It is as though, from
her wildly personal yet deliberately focused perspective, she is pushing
your face into the mud that this universal victim's body has become and

This article originally appeared in *Art in America* (January 1984).

at the same time saying that this mud is her own suffering being. Her art is an act of overidentification and self-identification, in which the absolute female other and the personal female self of experience become one.

Woman, for Spero, is the last individualist—condemned to individuality because she is the eternal outsider. Metaphysically an outsider—caught in that living death—the very fact of her "negative" existence is a criticism of the world, the "inside," the "system." She speaks from the nothingness of the outside as a nihilistic critic of all the systems of domination that have created a world that proclaims only one type of being as "positive," the world of what Erik Erikson calls the "pseudospecies." Spero's aggressive protest may seem anachronistic in this world of supposedly emancipated women, this world which has integrated women to demonstrate its humanity. But from Spero's point of view that integration is not only far from complete, but spurious, for what "completes," and thus empowers, a world-system is what that system rejects. Woman, in her view, will always be the symbol of the rejected. This rejection is necessary to the male-dominated world-system: such a system exists as exclusive only through what it rejects decisively. It exists only through the outside which makes it an "inside." Hegel's notion of the spiritual inseparability of master and slave has become an overworked cliché, but Spero's feminist demonstration of the idea gives it new material, historical force.

Much of Spero's art is about the refusal, even impossibility of "feminine" decorum and propriety in a world not of woman's making. Spero's females are monads mirroring in themselves—in their indecorous bodies, especially in their often violent tongues—the master system's power to reject, and hurling that rejection back at the system in a revolutionary reversal. They have found unexpected freedom in their outsiderness, a new sense of selfhood, with a still unruly yet increasingly disciplined power. Out of very concrete alienation, mythical heroism has been created.

Simply put, Spero's art is about the dirty selfhood of the female underclass. Woman is shown as rebellious underdog in a variety of ways, from documentary epitaphs for the female victims of Chilean torture to a Greek goddess (Artemis) with a defiantly raised arm. Whether emphasizing the experience of motherhood or celebrating virginal Amazons, Spero shows woman as aggressively, almost stubbornly what she is. This air of angry insistence against all odds is reflected in Spero's style: the beauty of Spero's art is that it refuses to be seductive. Just as her women have none of the malleability that an artist like Picasso gives his women, converting them into pneumatic puppets, so her style has none of the hedonistic refinements that give the illusion of easy access to content.

For her, grace is entirely in the critical act—in the line she wields like a streetfighter's razor, in the mostly sullen if sometimes brazen color with which she postures her rawness. Her tactics are confrontational, as if they would corner us into clear conviction of her truthfulness. A male critic can write about Spero because her outsider stance epitomizes self-possessed criticality, a stance that is of consequence because of its eagerness to "protest" the truth.

In her most recent work Spero offers a vision of woman as a spontaneous being in her own right, not simply as a kind of reaction-formation to man. The linear, lightninglike character of the female figures in Spero's recent work, in contrast to the generally more lithic if animated earlier figures, implies a relaxing of tension, a new wholeness of being. Woman becomes emblematic of mythical freedom rather than protest and resistance; her inherent outsiderness has become transformed into an almost utopian identity. No longer marginal within the space of Spero's pictures, as was customary, she now fills it, and is thus all the more striking in her energy. It is not exactly a new dynamic for woman that Spero is declaring, but she is awakening to a lyricism beyond protest, if born of it.

Spero's art has four main phases. Each carries us further along the path from a critical, negative position to one of ideal female individuality. The later phases lose nothing from the earlier ones, but rather clarify them, revealing the issues at stake in being female more fully, and sometimes more bluntly. Spero's progress is from an existential to an essentializing approach, in which woman, from being defined in terms of her male-determined situation, becomes an increasingly purified, even rarefied being—her own person.

First, there are early Expressionist paintings, more black than bright. In these woman is always defined in terms of man. She is a "Great Mother" giving birth (1962), or a mother with children (1954, 1962). Or she is paired with man in a couple, in what doesn't seem the most happy sexual embrace (1963, 1964, 1965). Sometimes she is a prostitute (1963), there for the asking yet peculiarly untouchable—an outcast. The figures are primitive, often derived in fact from primitive art, or especially from the art of the insane. They have the aura of quick, brutal studies, and all of them have a brute, barbaric look. But the blackness in which the figures are embedded, and from which they hardly seem to want to emerge, has its devilish atmospheric moments. That blackness is like the ooze of a giant squid, stunning its enemies, preserving itself.

The works are not really monochromatic, and they don't have the dazzling vitality of classic Abstract-Expressionist black-and-white pictures, but they do have a certain psychological pungency. Their psychological

murkiness, together with their physical murkiness, gives them a distinct Expressionist animus. They are a kind of mutant Expressionism, starting on an evolutionary track of their own. They already show the issue that will obsess Spero: the difficulty of independent female identity. She depicts the female bound to her sexual and maternal functions, and lost in her own murky, resentful psychology—*ressentiment* is a major force in Spero. Her primitive, almost exaggeratedly unrefined forms and materials give an effect of great, even unnerving honesty. A generally tortured sense of what it means to exist and to make art emerges, a concern that from one point of view is the heart of Expressionist passion. There is clearly an agonized autobiographical dimension to Spero's work.

In Spero's second phase, there are the more wildly Expressionist protest gouaches (1967–70), in which the figure opens up and grows lighter and more dynamic, and in which the world-system enters in the form of the Vietnam War. These gouaches are quasi-surrealistic, in that they show such composite entities as male and female bombs (1966). There are dozens of these gouaches, all looking dashed off, the products of some furious compulsion and rage. They are as primitive—perhaps even more so—as the black paintings, but they now have the look of children's drawings, rather than the more ''artistic'' look of *art brut*. (I don't know which is more regressive.)

The violence is now explicit, in contrast to the sullen resentment of the black paintings. It is as though the mood had broken as the storm/tantrum released events in the real world. The important thing about these drawings is their socio-political reference. The change of medium from oil on canvas to gouache on paper—to greater fragility and more rapid execution—signals a constant of the later collages: a sense of abysmally open space into which figures are dropped, a space which diminishes them in substance as well as size, so that they seem like ghosts. There is a different kind of haunting effect than in the black paintings, but the point is the same: the void of the drawings is the black of the paintings turned inside out, objectified, and signaling again the outsider status of the marginal figures.

Spero's third phase is the series called the ''Codex Artaud'' (1971–73), consisting of the first psychodramatic collages, and the first use of text as well as image. Antonin Artaud's words, mostly those of the period of his insanity—with their stupefying sanity—are typewritten on narrow strips of paper, which are then eccentrically spaced on the pictorial surface, their message diffused through the still quite vast ''negative'' space which theoretically now stretches infinitely. The ''Codex'' exists in the form of various scrolls: sheets of paper are crudely pasted together to

create the air of a homespun manuscript. Each scroll resembles an irrational composite, with the typing arrangement often creating an abstract image, sometimes in combination with a primitive figure, sometimes with touches of blazing color. The scroll teases us with the possibility of narrative, but its "scenes" are not in any recognizable sequence; they "float" in loose analogical relationships.

There is a sense at once of furtiveness and menace—secretiveness and horror—to these works. They are already openly feminist, as in *Number XXXIII* (1972), with its magnificent combination of mythological and contemporary evidence for male violation of the female, and with its presentation of the female as a "negative principle." Most of all, the "Codex" stuns with its grand spaces, which demonic figures punctuate but hardly impede in its flow. Woman's interior space, the womb, has here become a wasteland in which tenacious weeds grow—both words and monstrously militant female figures.

In the "Codex Artaud" the withdrawal of woman from man accelerates and becomes even more perverse: the text is the sign of this withdrawal, since it shows woman (Spero) with a mind of her own, a self-consciousness about her condition as woman that is the germ of an independent body as well as self. To quote man's own words against woman is to distance oneself from him, and to justify one's new indifference to his existence, which is thoroughly exposed in its violence and which, indeed, almost takes its definition from his negation of woman. This negation is so compulsive and thorough that it seems almost involuntary, and so a kind of stupidity, a powerful chunk of id that refuses ego control. Spero not only shows woman as the archetypal sufferer, but man, who exists in her work only through words, comes across as altogether lacking in self-knowledge, the archetypal fool.

Spero's fourth and most recent phase consists of socio-dramatic feminist collages, produced from 1974 on. *Hours of the Night* (1978), at 9 by 22 feet, presents its images in a huge rectangular grid, but the other works stretch horizontally, lining up their rectangular elements to very great lengths—*Notes in Time on Woman II* (1979) is 20 inches high and 210 feet long; *Torture of Women* (1976) is 20 inches by 125 feet. The horizontal scale is enormous, and the implied narrative unfolds irrationally within these exaggerated formats, at times with almost Dionysiac energy; but then, the events documented—the atrocities perpetrated against women—are themselves irrational in terms of our expectations from civilization.

Spero's methods in these collages are fairly diverse, although the final result is consistent in manner and materials, and is not broken up into a variety of "found" images and styles as is often the case with collage.

Nancy Spero, *Codex Artaud XXIV*, 1972
Typewriter collage/paper, painted collage/paper, 24" × 162".
(Photo by David Reynolds; courtesy Josh Baer Gallery, New York)

The images are drawn by Spero, and then cut out along the figure contours. She also makes rubber stamps of her own drawings, which are added to the image flow. Words continue to play a major role, whether hand-lettered or stamped or typed. The documentary materials in *Torture of Women* are from Amnesty International files. The word groupings in the collages are "footnoted"; the viewer is directed to a separate sheet of paper on the wall where the number reference gives more detailed information on what is contained in each document. In other collages, words are taken from writings by Pliny, Nietzsche, Derrida, Bersani.

There is an intense psychological unity to these works, a compelling flow of information which propels us along through the rich matrix of texts and images. There is a greater density and also a greater spaciousness here than in the "Codex Artaud." The mood is apocalyptic, straight out of some revelation—an infernal vision given to this female St. John. Spero connects her work to the *Beatus Apocalypse,* supposedly made by a nun in the twelfth century.

"Salvation," such as it is—the spontaneous reassertion of the body free of the "telling" text—comes only later, evasively, as in *Bacchanale* (1983), 20 inches by 9 feet, and *Elegy II* (1983), 9 by 3 1/2 feet. The figure, previously dominated by text and void, now dominates, expansively. The scrolls' scale has been reduced, with these new works, and the format is now frequently vertical. There is greater economy of means and a single female figure is monumentalized by being repeated.

The horizonless voids of space and text have disappeared, with all the dread they evoked; space has again become containment, a frame for the freshly lyrical female figure who is now purged of pain and memory. Now she is simply primordial, rather than conspicuously primitive, and buoyant, even. Empirical allegory gave birth to idealistic symbol, where idealism is not, as Adorno implied, the prerogative with which the system masks its dominance, justifies its victimization, but rather the ancient form of idealism that signals possibility. Violence against women and by women is no longer the whole story; woman can be exalted, elated in the enjoyment of her own being, this newfound self-acceptance holding the promise of the future. In the new works, the figures are energized, more spontaneously drawn; they race, rather than grovel. The bodies now have a classical uprightness, as though running a race. The colors are brighter as well—blazing reds are outlined against the white of the paper.

Spero's self-obsession first shows itself in the black paintings. In the later "Codex Artaud" series, the outsider-self is not woman but artist. The

identification with Artaud gives Spero the courage to accept her own out-sider character as inescapable. She speaks of him as a pariah—that most ancient reject. The lowest, most fixed caste within the system, the scapegoat caste represents all that the system rejected to become itself. The pariah is in a powerful critical position, as Artaud showed; he is the system's unsavory shadow, its gruesome double—its ugliness incarnate. Elizabeth Lenk, the German feminist theorist, describing woman as pariah, notes that woman is considered unclean and excluded from the in-group—and so has the typical self-contempt or self-hatred of the pariah, because she signals "the heterogeneous *per se.*" The pariah symbolizes, and keeps alive in despicable form, the individuality which comes back in the form of the pariah's radical otherness. The pariah is then peculiarly elite, one might say absurdly elite. For Spero, the artist is also a pariah; these days, this is no doubt a romantic conception of the artist, but no doubt true for a woman artist. For a woman to become an artist is for her to compound her pariah character, to mirror it in painful self-consciousness from which there is no escape.

If to be an artist for a woman is for her to objectify her pariah character, then to be an artist like Artaud is to discover the pariah's critical potential. In Artaud criticality exists primitively, like a raw exposed nerve, like an overly sensitive seismograph almost losing control through the intensity of its response to the alien stimulus of the world. Artaud gave Spero the confidence of criticality—the confidence of her outsider nervousness in the world, of her experience of the world as suppressive of existence. Artaud was her Virgil in the inferno of outsiderness, showing her the foulness of the system. He also showed her how outsiderness and criticality can become the sources of radical individuality. While society "won't stand for the attempt by people to wholly individualize themselves," as the psychoanalytically orientated existentialist Ernst Becker writes, Artaud shows how society almost unconsciously creates the basis for attempting to do so, indeed, for the necessity of doing so to survive in society.

Two quotations from Artaud, used by Spero, struck me as particularly appropriate to describe her art: "the cataclysm of my body" (with reference to its content) and "the farce of a style which is not one" (with reference to its form). At its most obvious, Spero's art is about woman's body: the ill-proportioned, manneristically elongated body of the mother, a lean and hungry she-wolf suckling her Romulus and Remus (the sons, incidentally, of Mars; Romulus slew Remus, a mythological example of man's warlike character, of brother turned against brother); the fecund, cornucopialike torso, vulva proudly displayed like an insignia—like a Medusa's head; the self-absorbed, dancing bacchante, running and leap-

ing in full physical freedom and power; and the hieratically upright but solid, volumetric body of the Diotima-like mediator of underworld powers.

Spero's bodies are drawn from ancient and primitive sources, and function allusively to aboriginal, Etruscan, Mexican, Greco-Roman art. This use of image-quotations as phantoms of traditional, authentic female identity—quotations personalized, made Spero's own, by being scrambled and hand-rendered (Spero draws them, then makes the result into a mold used to stamp them on paper)—is "the farce of a style which is not one." Her style is, rather, a catalogue of borrowed primitive styles, used to create an aura of authenticity that is beyond style. Her method is an open-ended, unpedantic catalogue, to which images are freely added, and its mix of styles makes it impossible to pin Spero down as a strictly artistic identity. This is crucial to radical feminism: to transcend formal concerns (which doesn't mean to dismiss them) in order to recognize the critical content.

In Spero's early black paintings, woman is the victim of man; in a sense, in the work that follows, man is condemned by his own deeds and words against woman, who is increasingly celebrated as spiritually superior to him. It is also not so clear that she is physically inferior, even though his victim. Spero works through her ambivalence about the female body—transcends man's view of it as his possession and "object"—to view it as a source of strength, i.e., as able to endure. Spero in effect withdraws woman's body from man when, in the Vietnam gouaches, she first depicts woman as victim. For to be a victim means that one has a negative relationship with the victimizer—perversely preferable, she seems to be saying, to the ambivalent positive relationship depicted in the black paintings.

Woman finally emerges in Spero's art, after her long ordeal at man's hands, as having more willpower as well as more self-understanding than man. The power of challenge in the feminist collages already shows this. But it is also implicit in Spero's presentation of woman as more individual than man, as taking more diversified form; man is defined only in terms of his aggression against woman, which makes him doubly absent, since he is never directly depicted in the feminist collages. And in the "Codex Artaud" it is not so much male consciousness that is presented as that of the eternal outsider, the chosen victim. Man is nothing but a form of dominance, whom woman dominates spiritually by analyzing his effect on her. The will to make this analysis and realize the moral superiority it gives one is an indication of woman's heroic will.

Finally, the way woman's body turns into impulse, lyrically purified

as if in a sublimation of revolutionary intention, is a triumph of the will, a triumph over the male tradition which depicted woman as a dead weight, all her allure no more than a sign of her primary role as an instrument for the preservation of the species. But as pure spontaneity she apotheosizes her own will to survive. Of course, spontaneity is still the outsider's privilege. She has really apotheosized her own outsiderness. It is no longer something to regret but to celebrate, for it is the tragic mask of independence. Spero, in letting her recent female figures show spontaneous rather than compulsive movement, allows herself a rare moment of hedonistic narcissism, which, the ego psychologists tell us, is a sign of health.

James Rosenquist: The Fragments of a Romance, the Romance of the Fragment

Art of the highest calibre pushes beyond totality towards a state of fragmentation.

T. W. Adorno, *Aesthetic Theory*

James Rosenquist has been said to paint "fragments of fragments." As Adorno suggests, the fragmented work of art strains the concept of totality. Adorno makes a sharp distinction between works of art which are mysteries and works of art which are riddles—between those which are transcendental wholes and those which are fragments or fragmented. From the perspective of the fragmented fragment, the transcendental whole is inconceivable and unbelievable—a necessary illusion but not a practical possibility. From the perspective of the transcendental whole, fragmented fragments are not only riddles, but riddles without any key— hardened in their irrationality, recalcitrant in their absurdity, essentially uninterpretable. At least that is the ideal riddle, and at times Rosenquist comes close to creating it. His art triumphs most when it creates seemingly inexplicable superstitions, pure moments of irrationality—irrational wholeness—we feel we must defer to, completely opaque moments of unconsciousness we feel it would be anticlimactic to interpret rationally. Rosenquist creates works which are broken off and in their broken-offness seem to bespeak the unknowable, however knowable the fragments which constitute them are. We can interpret details, but never the composite whole, which confronts us in all its awkward wholeness as the emblem of some unnamable yet powerfully experienced feeling, as the crystallization of the ultimate, intractable feeling of inhabiting a radically different cosmos of consciousness. Rosenquist is at his best when he succeeds in this emblematic strategy—when he seems to articulate an im-

This article originally appeared in *C Magazine* (Fall 1986).

possible intimacy through his combination of discrepant images of the actual. The more these images distract us with their unrelatability, the more they constitute an unnamable whole of feeling.

So-called Pop art is really an extension of "slice of life" realism, but the slices—choices—of life do not pretend to be of unmediated, but rather media-mediated, life. Especially is the commercial image a source—the idealized, daydream image designed to lure one to a banal activity, to make it seem especially attractive when carried out with the advertised product. The need represented by the product can be definitively satisfied with the product. When Rosenquist paints spaghetti or a Ford or the smile of an officially beautiful woman or frosting or fruit salad or the F-111, he is saying that there is nothing so satisfying as this product. The need for basic "soul food" is satisfied by these deliciously glossy, glamorously and grossly simple images, which at once represent the hugeness of the need and the grand feeling of fullness of satisfaction that will follow from using the product—eating the soul-satisfying spaghetti and fruit salad, piloting the invincible fighter plane, driving in the Ford with its powerful V-8 engine. All this comes from the society, but Rosenquist makes clear the "dream" it is supposed to satisfy.

His pictures are profoundly oral-anal: great gobs of objects that look as though they are crying out to be swallowed whole in a feast of Gargantuan gorging, and at the same time look like the universal plain shit that is the "afterproduct" of the gorging fit. Rosenquist gives us both ends of the capitalist digestion process, suggesting that it is hard to make clear which end is which: or is it that we consume shit, that both ends are the same? This ambiguity, and Gargantuanism, are central to Rosenquist. Both follow from his work as a billboard painter, which required the painting of larger-than-life images that were instantly legible and accessible yet also had to be strongly alluring sublimely—at once banal and full of promise, mundane yet enticing.

What Rosenquist does, through his process of fragmentation, is give these images the status of "essences" or icons. The composite pictures that he creates with these "essentialized" appearances—conglomerations that don't quite cohere—have an estranging effect. They seem simultaneously of and not of the world in which they originate, moreso than the usual Pop picture. They have greater whimsicality, and through it a greater distance from their sources. They reference less than comparative Pop pictures. Warhol, for example, is almost entirely dependent on his power of referencing—his choices of subject matter. In Rosenquist, the iconography comes to seem less important than the method of building the picture.

Rosenquist's subject matter becomes more or less typecast: the sensuality of technology, the technology of sensuality—the femaleness of the male, the maleness of the female. The opposites come most succinctly together in the unity of phallic fountain pen nib (the split in the nib looks like the penis tip's hole) and fingernail in *Fahrenheit 1982* (1982). In *Sheer Line* (1977) the lipstick ringed bottle opening on a flesh-toned field and the fountain pen nib pair off as female and male genitalia. From the pivotal *F-111* on, Rosenquist's works are full of dangling appendages and containers, sometimes also suspended, as in *House of Fire* (1981). But the male/female polarization or sexual or copulative character of Rosenquist's works—usually with the real male vulnerable to the manufactured charms of the female (and to castration)—and his interest in the appendage, and by extension the suspended/appended pictorial element, appears as *Vestigial Appendage* (1962). Fields or systems of objects often appear, sometimes in a grid arrangement, but generally in homogeneous groups—two pieces of bacon and four drill bits in *Industrial Cottage* (1977). But the real interest in all these works is how they are constructed—their surreal strategy. Sometimes their Surrealism is *retardataire*, particularly in works such as *Terrarium* (1977) and *The Glass Wishes* (1979), which, with their use of the unconscious mind's imaginary eye, seem like homages to Magritte (not to speak of the numerous works which picture a sunny-side-up egg). This habit of acknowledgment of Magritte, if a different aspect of him, begins earlier, in such works from the sixties as *Untitled (Blue Sky)* and *Waves* (both 1962). But what makes Rosenquist important is not his recurrent mood of homage, as though drawing inspiration from uninspiring materials by regressing to earlier strategies of psychopoetic mastery of them, but his revitalization of the Surrealist strategies of metonymy and metaphor. He walks the winding path—at once a wobbly line and tightwire—between them with a sureness, a fresh sense of confidence, that makes him the equal of the Surrealist masters.

What separates Rosenquist at his best from them is his greater sense of disjunctiveness—the strategy with which he "slices" life. It becomes increasingly sophisticated as he develops. In the sixties he tends to use a "patchwork quilt" or "gridlock" method of composition. *F-111* is the major example, both in its image-units and medium-units, which sometimes coordinate but mostly don't. This work, with its consciousness of internal edge and the discontinuity between the edges—a discontinuity that demands a response, calls out to be marked—seems to impose an order of sorts on psychic and physical disruption. There is a kind of neat system to or stratification of the picture. *Car Touch* (1966), with its ill-fitting yet eager-to-come-together edges makes the point succinctly. The unequal

halves are aligned but not joined, united within the almost uniform frame yet "impossibly" together. The frame's "off" character signals the insolvable problem, a problem with its own inner necessity, ironical yet agonizing. It is as though an irreducible disjunctiveness had been over-elaborated in a blowzy baroque vision.

This same problem of essential nonrelation within superficial relation—in which metonymic or accidental connection becomes emblematic of essential nonconnection, and supposedly essential metaphoric connection becomes accidental and temporary—is handled with a different surreal strategy in later works, where the "slice" of life becomes a kind of skewering of it. In works like *Embrace I, Embrace II, 4 New Clear* [Nuclear?] *Women* (all 1983), and *Flowers, Fish, and Females for the Four Seasons* (1984), among others, with their cosmic perspective—typical since *F-111*, and given another grand apotheosis in *Star Thief* (1980)—the slice shreds the work into ribbons. It is like a series of regular razor cuts or scalpel incisions in the picture's body, with the skin peeled back or cut away to reveal the "dream" flesh within. Rosenquist can be said to surgically operate on the picture, where earlier he constructed it of building blocks. He now slices through rather than adds up his picture. His compositional play, once peculiarly passive, as though luxuriating in the erotic connections created by metonymic irony, has become increasingly active/aggressive, to the point of explicit violence. The important thing is that Rosenquist is no longer simply depicting disjunctive violence, but vigorously demonstrating it in the structure of the picture. Violence was always latent in Rosenquist's arrangement, but now it is manifest, if at times obscured by the lush, exotic themes.

In general, Rosenquist is preoccupied with the hidden connection and hidden communication between far from hidden objects. In *Horse Blinders* (1968–69) and *Area Code* (1970) the theme of connective communication is explicit in the image of the telephone cable, with its hundreds of strands of wire. In *Facet* (1978) the theme of communication through the holding of hands—one of Rosenquist's favorite motifs (and he is a sort of simplified American Wagnerian in the way he weaves leitmotif images)—raises the question of questions for Rosenquist: how subjectively genuine is such objective connection, such touching of the other? It is the question lurking behind the glut of media communication in our society: just what is happening subjectively as all those connections are "technically" made? In *Bow String* and *Wings for Arthur Kopit* (both 1979) the connecting string seems a very slender means of communication between the two "wings." Does such technical sophistication, which allows a great number of messages to be transmitted through the slenderest of threads, imply the shallowness or triviality of the connection?

In his early work, Rosenquist, like the Surrealists, seemed to believe that in making overt metonymic connections he was bespeaking a covert metaphoric connection: the objectively illogical conscious connections spoke for a logical unconscious connection—a subjective logic and communication. In the later Rosenquist, there is a new scepticism about just what is being communicated—how deep the communicative connection is. This is an advance in Surrealist thinking, and it is Rosenquist's major contribution. He does not simply superficialize appearances, as, in their different ways, Warhol and Lichtenstein do—Warhol by cosmeticizing the banal and Lichtenstein by making Modernist art seem banal by parodying it and making it seem manufactured—but raises the spectre of the "vanity" of communicative connection. It is subjectively in vain—has no emotional depth to it—and really about the vanity of technology. In Rosenquist's works technology becomes increasingly vainglorious and exhibitionistic—hotshot in its cosmic outreach but trivial in its human significance. Underneath all the technological display—the technological intensity of the surface of Rosenquist's pictures themselves—is a strange dullness, a mechanical clicking of switches in some governing, all-controlling machine. There is fabulous control in Rosenquist's works, but also the image of hollowness become fabulous—mythical.

There is a monstrous uncanniness to Rosenquist's works, bespeaking the turning inside out of the pockets of the unconscious and consciousness. His works are littered with their contents—the principle of uncongested litter is a Surrealist one—but the whole is weirdly bankrupt in its casualness. In Rosenquist, we see the Surrealist romanticization of the fragment—its attempt to elevate the mundane in order to escape from what Breton called *"miserabilism"* ("the depreciation of reality in place of its exaltation")—at the end of its tether. It is a Romanticism that has become a reverse-Romanticism—a romanticization of the mundane fragment that serves to make us aware of just how overwhelming or dominating its mundaneness is. Romanticization of the mundane no longer serves the purposes of the unconscious mind, but rather those of the manipulative world.

In the end, Rosenquist gives us an image of manipulative rather than communicative connection—of elements being manipulated to come together in a preordained conformist unity rather than elements coming together to create a new nonconformist intimacy. In the later Rosenquist, intimacy is no longer a fate that will come to be no matter what (as it was in the early Rosenquist and the Surrealists), but a function of abstract, indifferent system. The flashy suavity of the later works says as much: it's the latest word in totalitarianizing surface—an authoritarian petrified façade made hyper-pretty. Rosenquist's immaculateness indicates that

he has completely understood our society's simultaneously totalizing and atomizing tendencies. In the end his fragments are atoms in motion in a meaningless cosmos, and his sense of totality is completely inorganic— lethal in its artificial perfection, which finally absorbs even the omniscient, all-pervasive haunting female.

She, after all, is the major symptom of the disease of creeping artificiality and nonconnection (masked by dream connection), was characterized by it all along. She is the clue to the fact that the disease will overtake everything, even in the midst of the hysterical Surrealistic copulation typical of carnivals, such as Rosenquist's pictures are: macabre carnivals full of technological wonders and Gothic pantomime of emotion, and like Poe stories occurring in the midst of and reflecting plague.

Voyeurism, American-Style: Eric Fischl's Vision of the Perverse

I felt a wave of irrational guilt and fear. My teeth chattered, my skin turned to goose flesh, my knees knocked. Yet I was strongly attracted and looked in spite of myself. Had the price of looking been blindness, I would have looked. The hair was yellow like that of a circus kewpie doll, the face heavily powdered and rouged, as though to form an abstract mask, the eyes hollow and smeared a cool blue, the color of a baboon's butt. I felt a desire to spit upon her as my eyes brushed slowly over her body. Her breasts were firm and round as the domes of East Indian temples, and I stood so close as to see the fine skin texture and beads of pearly perspiration glistening like dew around the pink and erected buds of her nipples. I wanted at one and the same time to run from the room, to sink through the floor, or go to her and cover her from my eyes and the eyes of the others with my body; to feel the soft thighs, to caress her and destroy her, to love her and murder her, to hide from her, and yet to stroke where below the small American flag tattooed upon her belly her thighs formed a capital V. I had a notion that of all in the room she saw only me with her impersonal eyes.

Ralph Ellison, *Invisible Man**

I have a theory about American Realism, and its far-flung affiliates. For me, it spreads its net, crazily, from Vito Acconci to Robert Longo as well as from Thomas Eakins and Winslow Homer to photorealism, and from Matthew Brady to Diane Arbus and Robert Mapplethorpe. It operates

This article originally appeared in *Eric Fischl, Paintings* (Exhibition Catalogue; Saskatoon: Mendel Art Gallery, 1985).

*Ralph Ellison, *Invisible Man* (New York: The New American Library, 1953), pp. 22–23. Reprinted by permission of the author.

wherever there is an interest in immediate perception as transgressive of expectations, and thus as morbidly fascinating, voyeuristically engaging, fetishistically binding. In my theory, perception is a perverse activity with a perverse object—reality—but the perverse is implied not declared, suggested not declaimed. Indeed, the perverse is so implicit that it may not even be a real possibility in the scene but an illusion. It is hinted at, toyed with, yet scrupulously avoided, perhaps out of a vestigial puritanism, certainly out of a desire to keep cool, to not let on that perception may essentially be a perverse (voyeuristic) activity with a perverse goal: narcissistic identification with the "criminal" object viewed. The perverse intention of the perception seems deflected, muted by an obsession with precision of detail, with careful arrangement of the whole scene or context in which the intention emerges or which welcomes it. It is as though by spreading itself thinly throughout the scene the perverse intention could never focus into an orgasmic climax (Philip Pearlstein seems an apt example here). It is thus kept simmering yet indifferent, like a motor idling, and sounding at times as if it might give out. This is American-style perversity, amounting almost to tempting oneself with one's own possible perversity, as though one wasn't sure that one really had any. It becomes a manner of self-preservative engagement with the unseemly objects that confront one in experience, a way of relating to them which places a premium on self-control, for the context of their appearance is out of control.

Eric Fischl is a master of such perverse Realism, of implying the perverse as a response to the real, but not actually representing perverse activity. The conspiratorial air of his pictures, with their often photosleazy Hollywoodesque air—which I see as directly antidotal to the medicinal niceties and finesses of prim American realism from photorealism to Pearlstein, where a pseudo-vacuousness masks the voyeuristic obsession—helps the implication. But if one looks at what the protagonists in his compressed narrative dramas are doing—compressed to the point of seeming to implode, as in *Best Western* and *Master Bedroom* (both 1983), with their sharply reduced casts, a single figure in cameo self-sufficiency, immediately identifiable because the role-player and the real person seamlessly fuse—there is nothing actually untoward or even unseemly occurring, at least nothing in these enlightened times that is unexpected. There's nothing out of the ordinary, unimagined, in seeing a solitary boy masturbate, as in *Sleepwalker* (1979): what else is one to do with one's solitude in America? Why else does one want to be alone in the modern world? Whether a solitary or public person, like the boy with the hots in *Time for Bed* (1980), what else is the American but a mechanical performer, almost banally selfless?

The words in this essay's epigraph are those of Ellison's invisible black

man, recollecting an event of his boyhood, when, along with other black youths, he was exposed to the delights of a naked white woman—an impossible situation which he did not expect to come out of alive. He is allowed to look but not touch, and the "wave of irrational guilt and fear" and violence he feels follows from this condition, as well as from the lynching threat. He "was strongly attracted and looked in spite of" himself. He would have looked "had the price of looking been blindness." His "eyes brushed slowly over her body": his looking is unrushed, complex, despite the danger of the situation, the danger of looking. It is unrushed because there is no other sensing but looking. The erotic encounter is confined to looking and fraught with the threat of death, which escalates the tension almost unbearably. Also, the naked woman looked at, observed with an intensity that makes observation an act of participation in her body, is mature and physically ripe, especially in comparison to the boy, and loaded down with symbolic meaning. This is a freight she easily carries by reason of the artifice of her glamor as well as the real sumptuousness of her body, and by the excitement it arouses both in the boy and the onlookers who staged the scene—the big shot white men of the small town, who drunkenly begin to riot and chase the woman, naked as she is, into the street. Her naked body acquires symbolic power not only because the burden of its reality presses down on the boy, because its reality is experienced as a burden by him, but because it is equipped, at a strategic place, with a small American flag. This tattoo serves less as a fig leaf than as a marker and pointer, as effective as any billboard sign, of a very important place, the arena of gratification.

Is it possible to say that by reason of the flag she becomes the bitch goddess of success whom William James said Americans worshipped, and that the black youth is confronted with something he cannot possess—something he can only look at but not touch? This is what makes his situation particularly excruciating, as though its death-predicated sexual character was only a launching pad for a deeper frustration, an announcement of an even more desperate despair, because based on a more absolute—irremediable—situation. The youth may eventually, if he survives this situation (as he does), have his sex, even with such a woman (as he does), but he will never have success, even be allowed as near to it as he was to the white woman. This is partly why he goes underground, decides to be deliberately "invisible": he consciously chooses the invisibility which others conferred on him because he was born black.

Now all this anguish, this melodramatic tension, this provocation and exploitation of irrational feelings, the symbolic implications, as well as the real perversity of the youth's situation, are absent from Fischl's pictures, or at least not clearly signaled. Indeed, Ellison's story is not a middle-class American story, a story of what other-directed Americans

do with their leisure life, as Fischl's stories are. Ellison's youth is as "un-American" in his terror as the African fetish object on the television set in the room where Fischl's adolescents have their *Slumber Party* (1983), or in the room depicted in *Time for Bed*, where the party seems just about to really begin rather than come to an end. The terror of Ellison's youth is inappropriate except when, as in the African statue, it can be frozen into decorative status, neutralized into an environmental nicety, for all the statue's implied significance in the situation—for all the unconscious undertow it focuses through its savage demonstrativeness. But that's just the point: the perverse must be kept in an uncertain connotative limbo in Fischl, just as the sexuality, for its explicitness, as in *Dog Days* (1983), seems peculiarly invalid, vapid, inarticulate, even inchoate. Yes, the boy has an erection and is touching the girl on the white skin left behind by the panties of her bikini bathing suit—just where the tattooed American flag was on Ellison's voluptuous white woman—but the whole event seems rather inconsequential, as inconsequential as the mating of the two dogs in the adjoining panel. Indeed, the juxtaposition of the two panels not only sets up a system of interchangeable surrogates, but the adolescents could as easily be transformed dogs as the dogs mutant adolescents.

The coimplication is complete in Fischl, a strategy of parallelism—also operational in *Time for Bed,* where the children can be said to emulate the adults, but also vice versa—which neutralizes both sides of its equation, confirming the aura of inconsequence already mediated by the everyday environment in which the event is embedded. The boy's arousal in *Dog Days* hardly seems important, and the panoramic outdoors space in which Fischl sets his erection dwindles its size. Indeed, we almost overlook it. The use of covertly grand space to undermine significance by cutting the scenic contents down to manageable size is another strategy of the neutralization or cooling of potentially hot contents that Fischl uses. "Covertly," because the grand space is often sectioned by the objects that echo it, especially the king-size beds in *Birthday Boy* (1983), *Master Bedroom*, and an *Untitled (Two Women in Bedroom)* (1982) picture of two naked women. The depicting of supposedly private space, such as balconies, bedrooms, in such a grand manner makes it continuous with public space. Indeed, it often is public space—the bedrooms are often motel rooms—put to private use, which in fact is a publicly known and sanctioned use. "What goes on behind closed doors" is hardly private in the modern, enlightened world.

In this context it is worth noting that there is still another strategy Fischl uses to cool down his potentially hot scenes, a less obvious but nonetheless subtly effective one. Fischl's *Master Bedroom* reminds one of Oldenburg's motel bedroom ensemble, both in its bizarre perspective and

pointless, seemingly infinitely expandable openness, although not in its tacky textures. Similarly, *The Old Man's Boat and the Old Man's Dog* (1982) reminds one of Hemingway, in however distorted a way; *Overnight* (1981) echoes Schiele's *Family; New House* (1982) is a Hopperesque scene of loneliness or desertion; Courbet's *Funeral at Ornans* sprang to mind when I saw *A Funeral* (1980); and *Catch* (1981) has a Reginald Marsh-like dimension. The strategy here is what I would call neutralization through art historical parallelism. It is not so much a matter of allusion to past accomplishments to buttress and justify Fischl's present effort, to give it unexpected depth, but of setting the banal present scene in a grand context, to uphold its banality, thus managing it so that it does not become as unruly as it might become. The art historical and literary allusions help remind us that whatever else it might be the scene is above all staged, manipulated, contrived, totally artificial. This recognition, deviously forcing itself upon us, prevents an Expressionistic response to it, a response like that of Ellison's boy. Nothing really taboo-breaking is at stake. Staginess of form displaces inherent perversity of content as the heart of fiction, and conveys its purpose of neutralization.

In *Dog Days* the adolescent boy touches the adolescent flesh of his girlfriend, completing perception. In Manet's *Olympia* the viewer is forced into the private space of the prostitute not only by her imperious if indifferent glance, but by the potential, easily realized for a sum of money, for touching her, possessing her. All of this touching and touching-to-come hardly has the potent charge of the untouchability of the white woman in Ellison's story—the castration of looking, by refusing to allow it to become erect touching, forced upon Ellison's youth. He is an involuntary eunuch, yet far from neutralized, cool. In contrast, Fischl's *Birthday Boy*, in his idealized viewer's position, is gratified simply by looking at the naked woman, which is hardly taboo. Nothing is in the enlightened modern world, which has put everything on view. He might as well be looking at a television screen, as the boy in *Slumber Party* does, after his sexual adventure with his girlfriend. The moment of consummation is missing in these pictures; frustration is not excessive. For all the physical intimacy involved, for all the implication of sinister passion, the events depicted are levelled by their voyeuristic meaning.

Fischl's pictures have been generally understood, in a Barthesean way, as nonlinear texts implicating the viewer in an ''unfixed plurality'' of meanings. They are a structure of signifiers belonging to different narrative networks rather than a structure of signifiers issuing in univocal meaning. Yet the networks of Fischl's neo-narrative seem to converge in a single story, as is evidenced by the fact that the majority of the protagonists are children on the verge of adolescence or already adolescent. Sometimes the child is almost secreted in the picture, as in *The Old Man's*

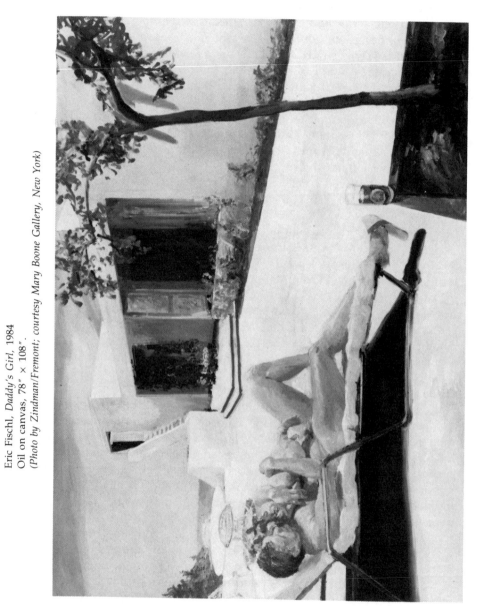

Eric Fischl, *Daddy's Girl*, 1984
Oil on canvas, 78" × 108".
(Photo by Zindman/Fremont; courtesy Mary Boone Gallery, New York)

Boat and the Old Man's Dog, where he is almost lost in the middle distance. But more often the child is upfront, the major actor, as in *Barbeque* (1982), *Sleepwalker, Best Western,* and *The Sheer Weight of History* (1982). When not the child's then the adult world as it might be seen from a childlike perspective, through the eyes of adolescent self-interest, is presented, as in *Sisters* (1984) and *Catch* (1981), as well as the *Untitled* picture of two naked women. The view is from below, or strangely outside, in a context of idealized obliqueness. In *Untitled* we have essentially the same view as the *Birthday Boy* does. Fischl offers us adulto-morphic pictures of an adolescent child's point of view, where the child is about to take up adult interests, perhaps already involved in what are usually thought of as adult (sexual) activities, but not fully in charge of their value, not fully knowing their worth as independent activities. He engages in them because they seem there to be engaged in, but his estimate of them is unclear. For all his erotic activity, his relationship to eros is still voyeuristic, peculiarly passive if not disengaged. The dispassionate air that hovers over the works confirms their voyeuristic involution, while forcefully objectifying them.

Heinz Kohut argues that the "perverse" voyeuristic activities "in which the child engages are . . . attempts to reestablish the union with the narcissistically invested lost object through visual fusion."[1] This narcissistically invested lost object is customarily the parent, with which the maturing child—the adolescent—can no longer merge, not only because it is socially forbidden but because it is maturationally inappropriate, passé. Fischl frequently shows us adolescents eager to merge with one another through sexual activity, even sometimes mirroring each other physically, apart from their sexual difference—*Dog Days* is a prime example—but with the merger incomplete, bogged down in voyeuristic merging through looking or touching. Nor does Fischl show many examples of successful merging in the adult world, where there are many instances of isolation, as in *New House,* and hermetic insularity of feeling or psyche, as in *Grief* and *A Woman Possessed* (both 1981). To overcome this threatening limbo between parental and erotic mergers—different ways of relating to the adult world with some narcissistic satisfaction— the adolescent needs a "transitional object" that he feels can be controlled simply through looking. Perceiving it in voyeuristic fixation one merges with it in a narcissistically satisfactory way. As has been said, "the basic perversion is fetishism . . . all other forms can be conceptually reduced to variations on the theme of manipulating an infantile fetish."[2] Voyeuristic looking is not only a way of manipulating an infantile fetish, but of creating one, of turning the object of one's perception into one. To establish a fetishistic relationship to an object is to merge narcissistically

with and be satisfied by it. The African fetish objects already mentioned are far from accidental accompaniments to upper-middle-class daily life in Fischl's pictures. But the televisions which frequent his pictures are the most narcissistically satisfying, most infantile fetishes, because complete merger can be effected with them, simply through voyeuristic looking, which they encourage.

Narcissistically satisfying merger is possible through projected orgy, as in *Catch*, or through projected incest, as in *Father and Son Sleeping* (1980), and perhaps in *Birthday Boy* and in similar works where an adolescent boy voyeuristically views a woman's genitals and naked body up close. Of course, the perversion is implied rather than actually rendered—part of the coolness, the neutralization effect noted earlier—and may be nowhere near occurring. The physical intimacy may simply be part of the sportive liberalism of American leisure time activities, an allowable transgression during a quasi-Dionysian time of self-forgetfulness. But the real point is not the nakedness but that it symbolizes the voyeurism—its consummate, profoundly gratifying character. What in effect happens in the voyeuristic transaction is not only that the two become one through the looking of the less adult one, who thus regresses to an infantile ideal of merger, but that this oneness is established through the fetishizing of the adult. In effect, the empty lawn chairs of the parents in *Sleepwalker* are filled by the fetishized other. The big naked women are parents whether they want to be or not. They are not simply prostitutes who are hired to initiate the adolescent into the mystery of sex between their legs, who are made emphatic through their nakedness, but mothers with whom the adolescent can merge. They remain more satisfactory in their voyeuristic/fetishistic role than if the relationship was actually consummated sexually. Thus the implication of perversion permits the fetishizing voyeurism—the most fundamental perversion—to remain intact, undisturbed, quietly in play. Fischl never changes gear in any of his pictures, which are in voyeuristic overdrive, steadily unfolding a narrative of fetishism. Even in such pictures as *Christian Retreat* (1980) and *The Visit II* (1981), the voyeuristic view from outside (above) has its narcissistic value, since it permits the adolescent to witness places and scenes of adult revelry or relaxation—sex conceived as a relaxer rather than intensifier is particularly American, pragmatic—without literally joining in, thus preserving his infantile integrity. At the same time, an outsider perspective always makes insider activities seem more significant than they are, that is, more subject to fetishization, which is one way of getting narcissistic satisfaction out of them, of merging with them.

One last point should be made about the psychodynamics of Fischl's pictures. From a Kleinean point of view, they can be understood not only as synthesizing the paranoid and depressive attitudes, but as being

reparative. According to Melanie Klein, the child's life moves between the poles of paranoid and depressive anxiety. In the "paranoid position," the child suffers "fear of a massive and deadly retaliation by the mother's and father's penis (inside the mother), revenging the destruction that the child has effected, in his fantasy, on the parents, particularly on their sexual union." Is *Birthday Boy* looking for the universal penis? Depressive anxiety articulates the "horror and dread concerning the fate of the whole object (the parent) whom the child fears he had destroyed." From this follow "attempts to save the love object, to repair and restore it."[3] Generally speaking, there is almost always one member of the parental pair missing in Fischl's pictures, an effect which I think powerfully contributes to their aura of suspended (rather than imminent) activity, their air of suspense. Where is the father in *Birthday Boy*? Where is the mother in *Father and Son Sleeping* or in *Barbeque*? Where are the naked adult men to match the naked adult women in *Sisters* and the *Untitled* image of two women? And when there is no missing or destroyed parent, familial membership is so blurred, as in *Catch* and *The Old Man's Boat and the Old Man's Dog*, as to imply the meaninglessness of the family in the anonymous adult world. There we are all supposedly on our own, with only our narcissism to defend and sustain us—our voyeurism to give us perverse distance from the world, distance that is paradoxically at once infantile and philosophical, regressive and the root of contemplative understanding. This "meaninglessness" is perhaps the most effective fantasy destruction there can be.

At the same time that Fischl shows us the destruction of family unity in the infantile mind, especially the destruction of sexual union through perverse voyeuristic union, he shows us the tentative, no doubt ineffective, yet not entirely superficial restoration or reparation of family unity, in however ironical, even satirical, a form. The pet dogs that tend to proliferate in Fischl's pictures are the key to this. Where they are, the empathy of family existence is restored, fantasy destructiveness and anxiety are overcome through constructive unity with the highly personalized family pet. The girl in the *Master Bedroom* probably feels more for the dog she embraces than she ever will for the man she eventually will embrace, for the pet cares for her as strongly as she cares for it. They form a loving pair, a parental unit: the opposite of the empty parental unity implied by the two empty chairs in *Sleepwalker*. Similarly, the dog in *The Old Man's Boat and the Old Man's Dog* makes the scene familial as much as anonymously orgiastic, and the dogs in *Woman Surrounded by Dogs* (1980) are the woman's family. Jan van Eyck's *Arnolfini Marriage* and Georges Seurat's *Grande Jatte* have taught us that the pet dog ambiguously signifies fidelity and lust, perhaps fidelity through lust.

But this art historical background goes only a certain distance toward

understanding Fischl's all-American usage of pet dogs. The possibility of bestiality—a more demonstrative, antisocial, and obvious perversion than voyeurism—is a perhaps not unimportant side issue in Fischl's pictures: another example of "perversion by implication." The real point is sociological: the role of pets in the modern anomic world, which Fischl conveys so beautifully through his Hollywoodesque effects (and a version of Warholesque neutrality), as the most satisfactory objects of love. *They* don't toy with one's affections, nor resist one's advances. They are the perfect infantile fetishes, absolutely satisfying narcissistically, love objects which don't shield themselves from one's voyeuristic looking and don't expect more from one, as the big naked women seem to. Animals come to us in all their nakedness, psychological as well as physical—which is why, sometimes, Fischl seems to equate, at least for the moment of leisure when they are simply there, with no expectations (thus enhancing their immediacy), his women with animals, dumb pets. Indeed, in *Dog Days*, the animal/human, pet/person equation—the pet perhaps as symbolic of the essence of the modern person at his or her natural best—is universal and direct. Fischl suggests that the identification with or fetishizing of a pet is perhaps the most archaic form of identification possible, and thus the one most restorative of one's natural, healthy narcissism.

If, as Kohut writes, "the object of the creative interest is invested with narcissistic libido"—"the narcissistic nature of the creative act" is its inmost nature[4]—then one can say that Fischl offers us the most sophisticated yet upfront narcissism one has seen for a long time in art. He articulates both the "early childhood fear of being alone, abandoned, unsupported" that is so crucial a part of narcissistic experience (recurring with special anguish in adolescence),[5] and the elementary voyeuristic strategies by which the child in one gives itself supporting company, whether animal or human. Fischl himself has said, in a statement for his February 1982 exhibition at the Edward Thorp Gallery, that "central" to his work is

> the feeling of awkwardness and self-consciousness that one experiences in the face of profound emotional events in one's life. These experiences, such as death, or loss, or sexuality, cannot be supported by a life style that has sought so arduously to deny their meaningfulness, and a culture whose fabric is so worn out that its public rituals and attendant symbols do not make for adequate clothing. . . . Each new event is a crisis, and each crisis . . . fills us with much the same anxiety that we feel when, in a dream, we discover ourselves naked in public.[6]

Neither modern high culture nor modern middle-class life style offers support in one's narcissistic suffering. Rarely do either even acknowledge, in a serious way, the self's feeling of inadequacy and abandonment, its narcissistic anxiety and loneliness. (Bohemian culture offers a

narcissistic satisfaction of sorts through the "alternate" extended family experience—the post family familialism of the outsider in-group—it claims to offer.) Fischl's pictures are about the failure even of bohemian, punk, or whatever culture to offer an adequate support system for the individual suffering from a narcissistic feeling of helplessness, worthlessness, or sheer uncertainty of self. Thus a mood of contained despondency is pervasive in Fischl. His quasi-Hemingwayesque abruptness is one artistic way of bringing his painful subject matter under control. It is hard to tell whether its use is ironical. In general, Fischl's adolescent is an allegorical personification of the tragically narcissistic infant in all of us—the universal regressive narcissistic component in the self.

The brilliance of Fischl's mimesis of the modern world is perhaps at its clearest in his subtle use of the slickness—a form of callousness—it uses to mask narcissistic injury in order to make it manifest. The slick style of the popular view of everyday life embeds us all the more in self-loss and mutes a terrifying self-consciousness. Fischl's use of populist realism—populist voyeuristic style—to communicate unpopular recognition of modern existence has a bitter edge to it. His soap operatic voyeuristic style does not neutralize its human subject, in the expected way, but, on the contrary, undermines the masterful modern subject by making its infantile basis painfully clear. Its own slick style of mastery is turned against it. This is an artistic triumph, considering the built-in power of media style to neutralize experience into painless information. Fischl shows that despite itself media style can be revelatory of what is profoundly immanent in the human psyche; media style can be put to humanistic use. Television can become candid to the point of brutal psychological realism. Fischl's television-type coverage of modern subjectivity reveals more of reality than meets the eye.

Notes

1. Heinz Kohut, *The Analysis of the Self* (New York: International Universities Press, 1971), p. 99.

2. John E. Gedo, *Beyond Interpretation; Toward a Revised Theory for Psychoanalysis* (New York: International Universities Press, 1979), p. 115.

3. Jay R. Greenberg and Stephen A. Mitchell, *Object Relations in Psychoanalytic Theory* (Cambridge: Harvard University Press, 1983), pp. 124–26.

4. Kohut, *The Analysis of the Self*, p. 315.

5. Ibid., p. 319.

6. Eric Fischl, in a press release issued by the Edward Thorp Gallery, New York, February 1982.

The Rhetoric of Rawness: Its Effect on Meaning in Julian Schnabel's Paintings

Julian Schnabel is a brilliant synthesizer of styles, almost to the point of summarizing major aspects of the postwar American tradition. (This is partly responsible for his success; he stands on so many shoulders.) He unites the famous painterly "muddiness," as Clement Greenberg called it, of Jackson Pollock's more "archaic" paintings, with Robert Rauschenberg's vision of "combine painting," an extension of collage which encourages the use of a seemingly infinite variety of materials, including three-dimensional objects.

Schnabel's most notorious additions are velvet and crockery. Like the newspaper many of the original Cubist collages incorporated, velvet and crockery are mass-produced "domestic" materials. Velvet is a romantic material, epitomizing the everyday idea of luxury. It satisfies the conventional taste for easily consumable illicit sensuality; it is the populist version of erotic, thrilling touch. It seems to afford deep sensuous experience without any effort on one's part. Velvet conveys facile voluptuousness. Also, as the middle-class version of high-class material, enjoyment of it satisfies the desire for "possession" not simply on the sexual level—velvet concentrates all the erogenous zones in one dense material—but to the very depths of the bourgeois soul, which experiences velvet as priceless property par excellence. A cheap thrill from a royal material: what more could a romantically inclined bourgeois spectator want from art? Crockery is primitive substance given civilized shape and put to personal use. Shards of crockery are typically the first elements of a find in an archaeological dig; they are often the only remains of a lost civilization. To piece together ancient crockery is to reconstruct a dead world in its most commonplace aspect—in its seemingly most intimate detail. Velvet and crockery—these materials are at once the bedrock of Schnabel's most in-

This article originally appeared in *Arts Magazine* (March 1985).

teresting pictures and the quicksand in which their images inevitably dissolve. Bourgeois sensuality and ancient death—it is from their very material auras that Schnabel's images spring, like Myrmidons from the earth, and to which they return, after their Pyrrhic victory over time.

Breaking modern crockery, as Schnabel does, is metaphorically to break the back of Modernity—to provocatively deny contemporaneity. Schnabel's fierce anti-Modernism is the heart of his art, signaling the way he attempts to recover timeless truths from the modern experience. The broken crockery makes whatever image is embedded in it resonant with ''ancient'' meaning, rich with the patina of time. The velvet deepens the image in a timeless way; the velvet is a soft salver that serves the image up as if it was the fragile gift of a possible feeling. The materials cushion the images the unconscious creates, that they not be crushed by the everyday light of consciousness. Time and the artifacts that survive it, instantly sacred by reason of their survival—instantly catalytic of our deepest consciousness, our unconscious belief that every shred of the past makes profound sense as the particular trace of a general immortality—are Schnabel's ''subject matter.'' On face value, if we were to stay only with its materials, Schnabel's art is about the destruction of the modern to reconstruct the primitive, in an at once populist and extreme form: everyday surface is turned into a mediator of sensual depth by breaking it up into raw dead matter. Schnabel destructively hammers—a painter's version of Nietzsche's philosophizing with a hammer?— familiar surfaces into raw ''flesh'' that is erotically profound but also signifies a state of deep woundedness. His surface agonizingly mixes pleasure and pain until neither can be distinguished.

His painterliness masticates not only modern materials but traditional images; they also help make the belly of his pictures hang out in pseudocyesis. His pictures have the look of Roman vomitoriums; they are bloated with the regurgitated remains of many meals of surfaces and images. Schnabel has an enormous appetite, a stomach for the most horrific objects and scenes. But he does not so much consume as suck the juice of life from them. Painting for him means chewing up and spitting out known surfaces and images in the hope of evoking a hitherto unknown depth of meaning. Painting for him is a decadent act of quasi-sadistic violence on helpless victims—figures from the historical and mythical past who can do nothing about the way the world will use them after their deaths—for the sake of a rare experience of forbidden depths. The figures, who signify these magical depths, may even be grateful for being brought back from them—from the Hades where they were merely shadows—to be whipping boys for a romantic new ''depth art.'' Schnabel brilliantly reactivates a statically conceived depth, showing that there is

still life in the old shadows and unexpected profundity in everyday sur-
faces. Profundity is a dynamic state he participates in through his
painterliness, rather than a passive state of innocent contemplation.
Schnabel stands inside his figures, rather than outside looking in. He
brilliantly synthesizes Symbolism and Primitivism, narcissistically search-
ing for a new afflatus. Schnabel's best pictures are like whales in which
a prophetic Jonah-like figure or object endures the corrosive action of a
wrathful, turbulent god. His pictures are stormy excursions to sound an
unfathomable depth. They are masterpieces of decadent mentality, "the
pursuit," in Arthur Symons's words, "of some new expressiveness or
beauty, deliberately abnormal," deliberately pursuing rare experience
through "perverse" manipulation of existing stylistic languages. Schnabel
is the leader of the new romantic decadents—a term I use with approba-
tion, for decadence is the most advanced state of civilization.

Crockery is as necessary for everyday life as velvet is unnecessary,
yet both are peculiarly intimate in import, even if it is a vulgar idea of
intimacy—intimacy turned inside out into conspicuous material, that is,
intimacy made demonstrative. In the directness with which they publicize
intimate sensation, these materials convey a philistine coziness. To use
them is one way of restoring vigor to Modern art—which is always quickly
spilling its seed, always romantically desperate for new materials to
generate fresh potency and novel effect, to save it from the deterioration
of its ideas—while being rhetorical in the Postmodern way. (It is as though
each new material was not only a freshly invented sexual position, but
announced a general new permissiveness.) To use such materials,
especially in the destructive way Schnabel does—paint on velvet forces,
even brutally overstates voluptuousness or luxurious surface the way
chalk screeching on a blackboard pushes sound to a new absolute of
rawness—is one way of raising to a feverish new pitch the rhetoric of
rawness which has been an important ideal of art at least since Gauguin
and Munch. It was not without effect on Cézanne—modern art's pursuit
of raw surface, which is one of the major strategies of its primitivism,
can be derived from Impressionism's "vibrating" surface—and for many
artists and critics it is the gist of Modernist painting. That is, raw surface
is a major way of making the medium of painting manifest—ideally, self-
evident to the point of a blasphemous immediacy. Archaic surface on a
sophisticated flatness—that is one important version of Modernist
painting.

The transformation of vibrating surface into agitated (anxious) sur-
face—that is the formula of primitivism "civilized" or used for modern
purposes, namely, to register and reveal through an estranging visual
babble the disturbed self underneath and disruptive of the social surface,

the horrendous feelings underneath and distorting the correct social form, especially the feelings of disintegration corroding the integrating, "socializing" shapes. In other words, primitivism in its modern use is a mode of liberation from repression. It claims to offer concentrated expression—which makes it seem to speak in an unknown tongue—to repressed feelings. The most primitive of all means for effecting a generalized sense of the lifting of the censorship of repression is the exaggeratedly raw surface, destructive of whatever representations rest on it. Raw surface becomes suggestive of the inherent ambivalence of feeling disrupting all object relations—as though when one experiences ambivalence one knows one is really feeling. The rawness of the surface communicates the questionableness of all representations of objects by reason of the ambivalence of the relationship to them. The rawness embodies the ambivalence in all its trenchancy—embodies the unstability of all representation, the unreliability and subjectivity of all perception.

Schnabel's raw or primitive surface is simultaneously repulsive and attractive. It is repulsive because of the emotional turmoil and terror it suggests, and attractive because its tumultuous character implies the release of strong emotions—the return to a state of primitive, direct feeling. This is exactly what modern primitivism intends to effect. The hyper-raw surface carries with it the complex social response we have to primitive feeling, as well as the ambivalence that signals that feeling is indeed primitive.

In Schnabel's pictures, the figure is no longer an integrating shape, but almost completely shattered, ruined—rendered "incomplete," hurt, distressed, a mutant of gross body and twisted spirit, inadequately body or spirit—a sort of Caliban of shape. Indeed, it can be argued that the often weird bodiliness of Schnabel's figures suggests a mad—tortured, self-tormented—state of being. In any case, the figure, traditionally a stronghold of complexly integrated shape—a shape which, because of its immediate narcissistic impact, because of the narcissistic satisfaction it affords through its simplest presence, is unconsciously as well as consciously "impressive"—is shipwrecked in a Schnabel painting, the victim of the rough ocean of raw surface. Depending on the painting, the figure is broken on the rack of that surface or dissolved in it as in acid—is incorporated into the cruel surface, by whatever means. It is sometimes ground down almost to the point where it is completely voided, stripped of substance—perhaps not to the same extent as in later de Kooning, but Schnabel always seems to be pulling the figure back from the brink of an abyss into which it is about to vanish. The figure is always threatened by the irrational surface which mediates it. Schnabel's figure is an irra-

tional image growing out of an irrational surface, incompletely differentiated from it, and thereby incompletely individuated. If it did not have its literary associations to pull it back from the maw of the surface's raw flux, it would forfeit its identity altogether. As it is, it is permanently in crisis, which sometimes seems to spiritualize the figure more, for it has to resist the brutally raw surface—partially its own flesh—to survive. Such "self-conflict" is one form of spirit.

How much does this reconstituted rawness affect the traditional—predetermined—meanings associated with the figures? How much does it generate an extraordinary meaning of its own, overwhelming all other (ordinary) meanings? These are two ways of asking the same basic question that focuses the issue Schnabel's paintings raise. Sometimes it seems as if Gert Schiff discusses their traditional iconographic meanings as if they were the major point of the pictures—which is to underplay the point of their Expressionism. Their ostensible message tends to be religious, whether harping back to Christianity, as in *Veronica's Veil* (1984), or to classical beliefs, as in *King of the Wood* (1984), alluding to Frazer's story, in *The Golden Bough*, of the killer priest-king sacred to the goddess Diana. In either case, the religion is primitive and mythological—legendary. Yet it is a mistake to assume that the message passes through the fiery painterliness unscathed—remains straightforward and narrative, if "enhanced." The mediation of the legendary message through the raw surface, which seems to have a violent will or at least temperament of its own, violates the message as much as it restores primitive force to it. The irrational surface is responsible for the sense that the legendary figure does not mean what it customarily should mean, as well for the sense that it truly represents and speaks from the depths of feeling. What Schiff does not sufficiently attend to is the fact that the strong surface disrupts the narrative figures and initiates a subliminal "narrative" of its own. It seems to "represent" something other than the figures, to have some obscure meaning of its own rather than to serve to reinstate the official meanings of the figures. The raw surface is unwillingly pressed into service as a reinforcer of traditional meanings (however as "mystical" as itself they may be); the more it serves these meanings, the less its autonomous meaning seems communicable. This is why Schnabel's raw surface finally seems to function more destructively than constructively—why Schnabel seems to renew, with unusual vigor, Picasso's idea of the picture as a sum of destructions, or to pay, as Mondrian said the artist should, special attention to the destructive element in art. Schnabel's uniquely raw, chaotic surface—in and of itself a triumph of art in its seeming artlessness—reduces the figures it mediates to inchoateness. They

become such unstructured gestures that they seem like manifestations of libidinous effluvium. This is even the case when, as in *T. T., Red Sky,* and *Cookie's Doll* (all 1984), their contours are more rather than less intact, and their faces starkly clear, as if implying the integral being that the body belies.

What we have in a typical Schnabel picture is a perverse contrast between consciously created figural illusions and unconsciously meaningful "real" physical substance. Traditional figures become subtly meaningless except as manifestations—however major—of elemental force embodied by the raw physical surface. All meaning is carried by the surface, which is in violent conflict with the tentatively meaningful figures—wants to pull them back into its quicksand. The figures are momentary emanations of the forceful surface, which is the truly "mythological," primitive, "durable" element in the paintings. The figures have purely academic meaning, which is far from obscure or indecipherable, but it is Schnabel's raw surface that really has cabalistic import. It is, as it were, a timeless duration.

One of the lessons of Modernism is that only the most immediate surfaces communicate intentionality in the modern world, in whatever way the effect of immediacy is generated. Only the fiction of immediacy, carried out on literal surfaces, catalyzes meaning and feeling. It is surface alone that we cathect with today, surface seductive in itself, with no promise of profundity—but the moment we fall for the bait of surface, become hooked on it, we experience unexpected depth of meaning and feeling. That is, through the intense sensation of a particular surface we experience a general rush of elemental power. We only cathect with surface today—surface is character and power in the modern world. And the extremes of chaotic, raw surface and super slick surface—in Schnabel represented by broken crockery and velvet, respectively—excite the greatest sense of power. Thus, Schnabel figures are nothing unless they are all surface; the meanings associated with them throw the surface into greater mental relief—make it more ecstatically visible—rather than subsume it. The tension between surface and associational meanings reinforces the "fabulous" character of Schnabel's surface. The sublime fable of shattered infinite space which Schnabel's surface is matters more than anything else in his paintings.

We might call this modern emphasis on surface the Hollywood aspect of modern life. It can be summarized by saying that in the modern world only surfaces are respected—are sacred—for there is no coherent sense of significant depth. (Generally speaking, high art resembles popular art in the acceptance of surface as an end in itself as well as a realm of aimless implications—implications unanchored to any sense of depth, with no

tie to any logic of depth, for modernity claims to have shown that there is none. The cinematic model [of rapidly moving but directionless, and so seemingly raw, surface—of "moving" surface as an end in itself] Arnold Hauser spoke of as basic to Cubism has become a general model for the mediation of meaning as well as for form.) Schnabel reduces the historical and mythological ("transcendent") meaning of his figures to pure surface meaning; it is what gives them their intensity. But Schnabel is incompletely Hollywood. He accepts the modern absence of depth, yet by making surface so brutally raw, intensifying it to an excruciating extreme, he creates the illusion of depth of feeling—of a logic of transcendent depth responsible for the surface, erupting onto and through it. This is why complete allegiance and attention to Schnabel's surface rewards the spectator with a strong sense of lasting power—the real prize of existence, which seems to emerge from the unconscious depths but is in fact a matter of scintillating surface sensation. The unconscious is knowable only as intense, difficult, "different" surface. The "depth experience" of primordial power has nothing to do with any belief in "deep meaning," such as the figures traditionally have. It is rather the result of serious engagement, to the point of obsession, with unusual, fascinating surface. And no artist today has created more fascinating, dynamic surfaces than Schnabel, the exemplary "Hollywood " artist.

The more strictly one remains on Schnabel's surface, the more profound one's sense of "depth," partly because of the extraordinarily restless "creative flux" (Whitehead) of the surface. The "mystical" experience of depth also occurs when no representation seems to stay secure on the surface—when a surface is created on which nothing makes coherent sense. One might say that in a Schnabel painting inchoate "depth"—the unrepresentable—is invoked in inverse proportion to the decay of representational meanings on the surface. Clearly, the sense of irreducible depth depends on the "deadness" of the figures. Depth and death correlate for Schnabel; death is the only depth left, the only source of the experience of depth, the only meaning left to "depth."

Schnabel's enormous hunger for "deep" meaning is short-circuited by the fact that all his meanings exist either in surface ("superficial") images of figures or in profound energy that is permanently discontented with any imagistic/figural form it might take. The strange mix of discontent and power that animates Schnabel's surface is what counts; it signifies both the discontent that unconsciously embodies our civilization's death wish and the erotic drive inherent in its will to power. Schnabel's surface implies an enormous discontent with the cultural images he advocates as meaningful—images that tradition says are deeply meaningful, but that hardly move us. They exist only as rhetorical devices unless they are

fueled by primitive power. Indeed, Schnabel's uneasy use of once profound images reminds me of Faust's discontent with ordinary human experience. He runs through experiences—including the "mythical" one of living with the long-dead Helen of Troy—the way Schnabel runs through culturally representative fictions in which profound human experience is supposedly sedimented. Both are in search of the power that informs the "fictional" experience. Faust wears experiences and Schnabel wears fictions as though they were fancy dress costumes; but the costume, once put on, makes the hero, as the hero well knows. Heroic adaptation within a fiction one knows is one (may indeed be the only) way left—the modern way—to feel genuinely vital, truly powerful, and, indeed, to be authentic. Both are heroic in their restlessness—Faust perhaps the first, and Schnabel perhaps the last, of the modern heroes, that is, of those who are heroic by reason of their dissatisfaction, which puts them in a position to articulate primitive power.

Schnabel's Expressionism makes explicit the underlying dynamic of modern Expressionism since its beginning: the failure of traditional cultural symbols to move us, the need to recharge them by investing heroic energy in them, the paradox that the result is purely surface in appeal, and the realization that nothing but intense surfaces can deeply move us in a situation of failed symbols. All significance comes to exist in the powerfully immediate surface. Art becomes the production of "extreme" surfaces, whose strong atmosphere one breathes the way one breathes oxygen in a vacuum. Works of art like Schnabel's become oxygen tanks to be used in the spiritual emergency brought about by the collapse of faith that is registered in the reduction of traditional cultural symbols to linguistic status. Schnabel's dynamic surface lends the dead language of culturally symbolic figures its power in order to make the perverse point that it is only in surfaces that we can have faith these days—only in surfaces that we can find depth.

Again, let us remember that this is very much a Hollywood situation, where the surface flow of the movie is more meaningful and moving than any particular scene or figure in it. The flow seems to reflect the unconscious libidinal flow, which relates transiently to objects that seem to represent it. It may be that this situation is not particularly modern, that unconscious libidinous energy has always used objects rhetorically. Yet it is in the modern period that this has become explicit—that the rhetoric of it all, especially from the point of view of the unconscious feeling of omnipotence, has become manifest. (Ambivalence towards objects—their reduction to sinister representations—serves the feeling of omnipotence by keeping one subtly disengaged. Of course, ambivalence is itself a form of engagement, even of profound relationship.)

Certainly that is what Schnabel is about: the unconscious feeling of omni-
potence revealing itself energetically in purely rhetorical imagery. And
certainly that is partly what religion is about, which is why it seems safe
to call Schnabel a religious painter: the inadequacy of the images of divine
power to that omnipotent power, and so the need both to manifest the
power more directly and to churn out more images/symbols/fictions in
which it can be rhetorically invested. All one needs to do is to look at
eternal Rome to realize that religion is pure Hollywood, in the very best
sense—its fantastic architectural rhetoric seems at once to generate and
embody the feeling of omnipotence, the energy of absolute power.

Schnabel, religious painter that he is, is interested in generating the
feeling of faith—of the momentary sense of omnipotence and invincibility
that comes from breaking through repression—which occurs with the
general "conversion" to feeling. With that explosive release from repres-
sion, feeling fastens on—"believes in"—the image that catalyzed its
release. Schnabel's raw surface embodies the energy of absolute instinct
at the moment of its release from repression, when it at once embodies
itself in "straw" objects and knows its own invulnerability and ir-
reducibility. That is, when feeling is finally expressed, it discovers its own
ambivalence and omnipotence. Schnabel is a very "Freudian" artist, in
that for him absolute instinctive energy comes before the objects it is in-
vested in, yet only fresh objects can restore our sense of the power of
instinctive energy. For Schnabel, as for Hollywood, the freshest, most
modern objects are, paradoxically, those that belong to dead traditions
of meaning, for they are ready to be reinvigorated by energetic surface
treatment. Schnabel's energy is indeed miraculously powerful, for it has
raised so many Lazaruses from the dead. One cannot help but regard
Schnabel as the master of what the psychoanalyst John Gedo calls
"metaphysical magic." It is this that makes him such an unbourgeois,
decadent painter. If, as Charles Peguy said, the "bourgeois mind . . .
prefers the visible to the invisible," then Schnabel prefers the invisible
within the visible.

This issue, which to me is the fundamental one in Schnabel's paint-
ings, comes to a kind of overt climax in *Resurrection: Albert Finney Meets
Malcolm Lowry* (1984), referring to John Houston's filming of Malcolm
Lowry's *Under the Volcano*, about an alcoholic British Consul drinking
himself to death in Mexico. Schnabel has long been interested in Mex-
ico, where he has vacationed, and he has used Mexican crockery as col-
lage material. The actor Albert Finney plays the role to perfection, becom-
ing the British Consul—who in the novel seems to be performing an
elaborately rhetorical act that produces a quite real death. The Fin-
ney/Lowry figure blends with that of a Mexican peasant saint, at once

angel of death and angel of mercy. It might be an angel from the heavenly chorus that saved Goethe's Faust despite his pact with the devil (which alcohol can be said to be, since it gives one mythical devilish powers, or the illusion of having them: it is the Mephistopheles that makes the ordinary person into a Faust). The Schnabel painting is a "supernatural" performance depicting a "supernatural" performance which reflects a supernatural tension, which is exactly correlate with the "performance" of the tension between figural/object representation and raw surface power in Schnabel's work in general. (It is worth noting in this context that for Gauguin the pursuit of "supernatural sensation" was central to his definition of Symbolism.)

The Finney/Lowry performance is a brilliant act of art—all art, the Postmodernist position seems to say, is a rhetorical act of grandiose display which, by transforming all ordinary sensuous surfaces into gratifying sensual or erogenous zones, attempts to take one in, to convince one to have faith in it, to emotionally invest in it by willingly suspending one's disbelief in it. And then one is to discover, once one's feeling is strongly committed, that it exists in and for itself, isolated and free from the fiction it invested itself in. Schnabel's pictures are brilliant propaganda for the modern faith in feeling as the last court of resort for understanding. One invests one's feelings in Schnabel's paintings, as in Caravaggio's, because of their ambiguous dramatic effect—which is what we come to believe in, since it correlates with our self-protective ambivalence and delusions of grandeur (omnipotence). We believe in the performance of Caravaggio's "supernatural" tenebrism, just as we believe in the "supernatural" performance of Schnabel's surface—both generate extraordinary delusions of grandeur and ambivalence simultaneously—not in the figures or myths involved. To believe in the power of stylistic performance as such is true and pure religion.

In sum, the real source of the archaic effect of Schnabel's paintings is their "indeterminacy"—the sense of libidinous energy dissatisfied with the objects it is invested in, yet having no choice but to experience them as "moving." And then to realize that the only end is to be moved, and that only stylistic performance can move. This archaic search for the moving goes hand in hand with the archaeological aspect of Schnabel's works, which is conveyed emblematically by the broken plates. As noted, they function like shards in an excavation site, signaling a dead and buried world of meaning, but giving us only glimpses of it—tantalizing us with fragments of information about it. The shards bring it in reach, seem to give us a quite concrete grasp of it—are indeed literally pieces of it—but, even if they were reconstructed into the crockery from which they came, hardly do more than offer a very limited understanding of the primitive "underworld," which reeks of death.

The fragmentation plays a crucial role in generating the aura of indeterminacy of meaning. The one suggests actual, the other immanent death. Schnabel's art is about the immanence of death—the way it informs the fictions we live by. Death is as immanent in his raw surface as divine power is. His art in general is about death and perverse rebirth—the representation is killed by the raw surface yet, phoenixlike, rises again from its flames—as in the legend of the "renewal" of the *King of the Wood* through his replacement by a more powerful figure who kills him, and who comes to symbolize eternally young divine power. An artist of power like Schnabel must always worry about the next most powerful artist who might kill and replace him. Are his pictures allegories of the art world? Whether or no, Schnabel need not worry, for at the moment his power is supreme. And yet he clearly worries, for in his works power and death fuse. He is clearly today's king of the wood—having killed off his many ancestors by subsuming their own art in his own—but not so clearly tomorrow's. His works are the perfect mix of artist's rage and depression.

Schiff has remarked about Schnabel's figures: "Voodoo doll, golem, mummy—a typical example of this painter's kaleidoscopic shuffling of the most disparate pages in mankind's Book of the Dead." Not simply the figure but the whole canvas can be understood as a lurid objectification of the power of death, an abstract allegory of it. Indeed, the weirdly fluorescent cast Schnabel's color often has can be understood as the glow of advanced decay, and the figures so many corpses from the tomb of time. The unconscious is, of course, the land of the dead; one reason Schnabel's pictures are so moving is that the significant fictional others or suffering heroes (and heroines) they depict belong to the land of the mythically dead. Our deepest emotion is invested in the dead beings who have cultural significance for us. *Sexy Jane* (a take on Yeats's "Crazy Jane"?) and *Pope Music* (both 1984) say it all: powerfully moving figures literally looking like death; raw representations of death ripe with yet disappearing into the instinctive energy of the crude surface. One has an instinct for death—a death wish—the greatest (deepest) power of all, Schnabel seems to be saying. All public revelry—ever-popular sex and the populist Dionysianism of pop music—unconsciously celebrates it, reflects it. Schnabel's paintings are dances of death. He has apotheosized Baldung-Grien's figure of death in powerful abstract form. Schnabel's various mythopoetic figures and objects—his historicism—show, in their different ways, that all ages unwittingly celebrate death, acknowledging it most just when they seem most full of raw, passionate life, and raw will to art.

Julian Schnabel: The Last Rarefied Romantic

*It was their Cross, and they bore it away toward a bleak exclusive
Calvary with admirable Puritan indignance.*
William Gaddis, *The Recognitions*, 1955

*There is a kind of gossamer web, woven between the real things,
and by this means the animals communicate. For purposes of com-
munication they invent a symbolic language. Afterwards this
language, used to excess, becomes a disease, and we get the curious
phenomena of men explaining themselves by means of the gossamer
web that connects them.*
T. E. Hulme, *Cinders*, ca. 1913

*So strong is the grip of the rhetoric of exaltation as an attitude in
the large context of the European culture pattern that the elements
of sublimity in the revolution we know as modern art, exist in its
effort and energy to escape the pattern rather than in the realization
of a new experience.*
Barnett Newman, "The Sublime Is Now," 1948

Julian Schnabel, no doubt oppressed by his restlessness, has painted an
extraordinary series of new works, called *The Recognitions*, after William
Gaddis's famous novel of that title. The works are subtitled "Stations
of the Cross," suggesting that Schnabel may be competing with his friend,
Francesco Clemente, who a few years ago made a series of paintings with
that title. Perhaps even more to the point in terms of their conceptual
orientation and general grandeur and heroic simplicity, they may be com-
peting with Barnett Newman's *Stations of the Cross*, the *dernier cri* of con-
ceptual Expressionism. (It is exactly Newman's radical simplicity—so rare
an achievement—that makes his work so difficult and enviable. Artists

This article originally appeared in *Artscribe* (November/December 1987).

as different as field painters and Minimalist sculptors have been unknowingly overshadowed by and and have knowingly attempted to emulate Newman's simplicity in principle, with often wryly comic results. Their works have often been emptily entropic rather than conveyed the effect of stark plenitude Newman achieves.) And of course Schnabel is competing with all the Old Masters who have rendered this most central of the Christian narratives, where Christianity's eschatological interests come to the fore—where Christ's last suffering sets the stage for the miracle of resurrection, the sum and substance of Christian mystery and promise. Schnabel accepts, as it were, the big challenge—takes on the Herculean labor of carrying a world of meaning on his shoulders, unfortunately one that has been emptied by the various secular interpretations of Christianity. His is a peculiarly aborted heroism, for he does not have sufficiently satisfactory material to test his mettle—to resist him. He has only the leavings of language of the past, although these are perhaps dragon enough to fight, if never to slay.

Another motivation seems to play a part in Schnabel's creation of these works: his desire to demonstrate that he has more than one string to his artistic instrument; that it is not as insensitive and unmusical as some people think; that he can transcend the plate paintings that established his reputation; and that that reputation—for savagery, brutality and wildness (he is the American answer to the German ''New Savages,'' with their Expressionistic neo-new pathos)—is misconceived. For look, he can work flatly and sensitively (as in fact he has in the past), if still obsessed with a used and abused, already digested surface, if one not so obviously masticated and mangled as in the plate paintings. The tarpaulins on which *The Recognitions* are painted are like the skin flayed off Marsyas, or like the skins the Aztec priests flayed off the victims they sacrificed to their violent gods. They are skins ripped off the still-living victims—still wet with the blood of life, if, by the time Schnabel acquired them, the blood had dried and the skins have become ancient history. There is still—always—the moment of violence in Schnabel, but here it is more restrained. The tarpaulins are an attenuated violence. It is a violence that is in the past rather than, as in the plate paintings, one that is in process.

But this sense of violence over and done with, already perpetrated, is deceptive, or rather, far from the whole story. For the violence implicit in the tarpaulins is more thoroughgoing in its destructive results than the violence of the plate paintings, on whose surface figures rest, if uncomfortably, like unwilling fakirs on beds of nails. In *The Recognitions* Schnabel does violence to language, or rather, deals with the charred bones of language—names and phrases standing in isolation, milestones

on an old Appian Way of meaning that no longer carries much travel or goes anywhere important, grimly dirty markers in bruised black and white (standard Expressionist extremes of agony). They are fragments of language that are the obscure echo of a lost import, that are the light of stars reaching us aeons after the stars themselves have died and added to the blackness of space. Schnabel is not so much trying to recover the full weight of meaning latent in each bit of language—as though, if one had a bone, one could reconstruct the body from which it came—but dwelling obsessively on the ruins of meaning, the "pureness" of language in its decayed state, its purely (and barely) connotative state.

Schnabel implicitly deals with the violence done to language in the "best" Modernist literature, the violence that has become the very substance and sign of high literary language, the violence—"abnormality"—that implies that there is no norm of language, no final clarification of language and, perhaps more importantly, of meaning through language. Gaddis's book is in fact a kind of Modernist dregs, or rather the effort at once to expose and shore up an eroding beach of language with the breakwaters of manipulated clichés. Schnabel can be said to visually manipulate verbal dead weight, to "body press"—to press into a visual body—the dead weight of obsolete yet "heavy" words, almost ideas in themselves. Schnabel has brought us into the charnel house of language, where the ashes of language are raked for whatever jewels of meaning remain buried in them. He has brought us into the catacombs of language, where its skulls and bones are piled up and silently worshipped for the devotion to a spiritual cause they imply. *The Recognitions* is about the realm of death which language is—about the silence which language finally becomes. What is recognized is that language was secretly always a disease of silence—that behind its carnival mask of meaning there was always the death's-head of senselessness. Language in its pure givenness is ultimately the senselessness of silence.

The Recognitions are big works, just as they are full of big names: *Ignatius of Loyola* (on his cross);*Pope Pius IX* (the letters of his name agonizingly close to one another); *Goddess of Reason* (in somewhat garbled form—her name twisted out of shape); *The Afflicted Organ* (of the heart; afflicted by dyslexia, some letters being reversed); *Diaspora; La Macule; L'Héroine* (in Artaud's handwriting); *Muhammad Ali* (a suffering hero, another big name—faded away into just a name);[1] *Charity, Mercy, Virtue* (empty forms of names waiting to be filled with a human content, in the meantime carried in honor on banners in processions of the faithful); and of course *Descent from the Cross*, a spiritual rather than physical event in Schnabel's abstract rendering (a kind of intimation of the soul rising, the body shrinking). All of these works deliberately eschew composition and pictoriality;

Julian Schnabel, *Ignatius of Loyola*, 1987
Oil on tarpaulin, 180″ × 132″.
(Photo by Phillips/Schwab; courtesy The Pace Gallery, New York)

as Schnabel said in conversation, he simply wants to put the words/marks down on the canvas. Nonetheless, there is a kind of pictorial quality generated by the dysfunctional appearance of the language—missing bars on the letter "A," overlapped letters (as with the "Ns" in *Henner*), reversed letters (the "K" in *Nighthunting*, among many other works). Such dysfunctionality in effect privatizes language, moves it towards madness, which, in an old definition, means living in one's own world.

It also has an occult implication, as though an esoteric meaning is evoked by distorting the word's appearance. The worn tarpaulin already conveys this esoteric effect through its markings, which seem to be an indecipherable secret script. That this might be deception only furthers the sense of a disguised secret import. On the walls of the private world of these pictures words as worn out as their meanings are hand printed (except for the handwritten *L'Héroine*), as if by a prisoner— treasuring his memories, or memories he made up, or imagined belonged to him because they are all "historical." Schnabel offers us a semblance of madness by offering us a semblance of ideas and substance. This sense of semblance suggests the hallucinatory character of these works, as though the words were seen in a stupor—when Schnabel really wanted to see or evoke the spirit of the things they name.

Does the name contain the spirit? Is it the magical residue of the spirit? When we rub the name do we get the spirit? Not here. The name is the dregs of the spirit, just as the spirit is the dregs of the body. We are in the underworld here, and the names are shades that inhabit it. Schnabel is given to idolatry through naming, but in fact his names do not so much evoke what they mention as "de-evoke" it. They make sure the figures and events named will not haunt the living, but stay buried. The name is not a substitute for the figure or event, but a dismissal of it, even a way of disavowing it as though it had not existed, or was not as big when it existed as is commonly thought—it only had a big name. The big names cover graves that seem to have become small with time. While Schnabel in effect identifies with the figures through using their names (which is not the same as naming them)—the identification with Artaud is perhaps th most obvious case, because Schnabel appropriates his handwriting not his name, in effect entering into the spirit of his being not into the reputation conveyed by the name—he is really identifying with a certain presence and event that has become mythical with time. These are names of figures and events that loom out of history to become larger than the life they superficially epitomize—"superficially," because they are only, after all, words.

What strikes me as more important about these works than their deceptive bigness, which disarms us as to their full import, is their, for

Schnabel, relatively puritan character; the way they are, to allude to the Gaddis epigraph, bleak and exclusive and try to be indignant, that is, wrathful, like the words of God. (Let us hope Schnabel is not taking them in vain.) Are these so many names of the hidden god, the names of the truly faithful—and Schnabel would like to be truly faithful, an artist serving a faith other than his own in himself, but the times won't let him be—being surrogate names of the god? These puritan names—Ignatius of Loyola is the leader of the pack—and the comparatively puritan Expressionism of Schnabel's handling, accord well with his sense of dealing with ghosts in the forms of names, that is, with the attenuated meaning of these names in the contemporary world. Today the spirit behind these names has been obscured to the point of being suffocated, and it is that alarmingly withdrawn, near empty quality of the big spiritual names of the past, that Schnabel articulates. Their spirit has become rarefied to the point of invisibility. It survives only in name, and Schnabel's presentation of the name by means of a comparatively rarefied Primitivism shows his own rarefied Romanticism. Its dignity exists in name only, as it were.

In Schnabel we see Romanticism on its last legs, having one last glorious fling with the ghost of spirit, the madness of name. What can be in a name but the death of the named, of the spirit the name signifies? And when the names barely signify—are forced to signify, one might even say tortured into signifying by being shrieked (the bigness of Schnabel's pictures is an outcry[2])—there can only be a sense of abandoning the important beings and events the names were supposed to signify. It is this force of abandonment that is evident in the gossamer of language Schnabel boldly articulates—a blatant declaration of language which does nothing to alleviate its "thinness," although it gives us the illusion that it is thick with portentous import, even if it may be only thick on the tongue. It is the same abandonment that Christ felt on the cross when he felt his Father had forsaken him, the abandonment that Newman consciously tried to articulate in his *Stations of the Cross*. Newman is, indeed, Schnabel's real competitor—and guide, for he taught Schnabel how to generate a narrative effect by a Zen manipulation of technical means and decompositional effect rather than through everyday thematic consistency. It is Newman who was *the* master of bulemic effect by anorexic means— so-called less is more.

Two last points must be made about Schnabel's *The Recognitions*. One point is associated with T. W. Adorno's assertion that "art cannot afford to disavow the remembrance of accumulated agony. To do so would mean abrogating art's form."[3] For Adorno, it is "anti-art" that is the form through which art untranquilly recollects accumulated human agony—

anti-art which articulates the twentieth century issue, the death of the human, much as the nineteenth century issue was the death of God. For anti-art—anti-form?—expresses art's necessary "sense of self-doubt . . . born of the moral gap between its continued existence and mankind's catastrophes, past and future."[4] Through his method of "putting down" or "writing down," almost as an end in itself—without much adornment, or, if one wishes, the put down words are ornament in itself—Schnabel seems to have achieved an anti-art climax of sorts. He articulates art's self-doubt—the doubt that the accumulated agony of the ages can be visualized (on a par with Adorno's scepticism about the possibility of lyric poetry after Auschwitz)—and humanity's self-doubt, for *The Recognitions* are a moral and physical catastrophe.

The other point is associated with Ernst Cassirer's appropriation of the concept of "organ projection" from Ernest Kapp. For Cassirer, "organ projection" is the method by which man forms his consciousness of himself as well as by which he forms consciousness of the outside world.[5] As Cassirer says, "The philosophy of Symbolic Forms [regards] spiritual expressive functions . . . not as copies of being but as trends and modes of formation, as 'organs' less of mastery than of significance . . . the operation of these organs takes at first a wholly unconscious form . . . the I . . . can contemplate itself only in this kind of projection."[6] Schnabel's *The Recognitions* are projection organs for the contemplation of the self through unconscious recognition of big names—big selves. The question that critical free reflection, as Cassirer calls it, must ask, is what is the character and condition of the self projected. Schnabel in general wants to project himself as a larger than life presence—a more than artistic presence. He seems to think of himself as a kind of great spiritual sufferer, standing on the shoulders of other great spiritual sufferers. He thinks he becomes them by wearing the skins of their names, carrying out a "spiritual expressive function." In fact, Schnabel is notable—and I think *The Recognitions* conveys this more than any other group of his works—for his striving to be spiritually significant, not for his actual spiritual significance. This is one way Romanticism can be understood: as striving to achieve a spiritual condition, based on dissatisfaction with one's material condition. The wounded heart is Schnabel's most prominent projection organ, and it is wounded—blackened, even afflicted by its own emblematic quality—because it is afflicted by his own yearning for the highest. But the highest is not present in Schnabel's *The Recognitions,* rather there are signs of beings who realized it through the agony of their lives, through their real suffering. Schnabel is in effect appropriating the most obvious relics of these genuine sufferers, these

spiritual seekers—and it is not self-evident that they all reached the condition of pure spirit (part of the point of suffering being to let one know one never is pure spirit in real life)—namely, their names. He associates himself with them, tries to name himself after them, as it were, appropriating their authenticity and acclaim. But he is not them.

This seems part of the Postmodernist point, Postmodernist decadence: to appropriate the authenticity of the Modernists in order to escape the inauthenticity one feels oneself to have as their would-be epigone in a spiritually indifferent world, a world indifferent to the suffering and sense of trauma—agony—catalyzing and informing genuine creativity. Schnabel is an "as if" sufferer because he does not really know if suffering spiritually pays off or can be made to pay off. He admires Ignatius of Loyola and Artaud, but is he ready to endure what they did? He is in the position of the follower, looking for a Christ to imitate. He wants to be Wyatt in Gaddis's book, who is said to have "elaborated a domain where the agony of man took remarkable directions, and the underclothed Figure from the center of the Bosch table suffered a variety of undignified afflictions, " but he may be "the healthy child who devises ingenious tortures for small animals" with whom Wyatt is compared.[7] That is, the child who pulls the wings off the spiritual butterflies he has collected.

Is Schnabel really ready to endure agonizing undignified afflictions, or simply appropriate them, in however abbreviated, symbolic a manner, suggesting the spiritual condition of Postmodernist man, who cannot really imagine that suffering will happen to him, yet who is fascinated by the suffering of those to whom reality—not just art—happened? One must ask this question of any artist who arrogates to himself the agony of others without making his own clear, unless his arrogation is not simply the wish fulfillment of a dream but a demonstration of the agony of wanting to agonize but not being able to. It is an issue—the spiritual condition of the artist who renders accumulated agonies through anti-art—that Adorno does not address, but that cries out to be addressed, especially in the era of Postmodernist Expressionism. Schnabel's works may be projection organs in search of a suffering body—relics of the saint's body that don't quite add up to his holy spirit, yet that are worthy of belief. Does Schnabel really confront himself through his projecting of the names of sacred sufferers as his own organs? Or is it the ecstatic desire for self-confrontation that *The Recognitions* articulates, not its gruesome reality? Does Schnabel really understand that all self-confrontation is self-martyrdom, not self-glorification? The selves he asserts by naming them knew that, which is why, ironically, their names survive and have been exalted. Schnabel may be a man of faith manqué. If he is not then he is a card sharp, playing with a loaded deck of name brand suits in which there is universal faith.

1. This is one of two works in which Schnabel alludes to a contemporary, living person. The work succeeds because the name is not used in it. It is completely abstract, utilizing Schnabel's standard iconography of the sacred wounded heart, schematically organic. It could as well be named Jake La Motta, the Raging Bull boxer. *Alexander McEvilley Achilles*, the other work in which Schnabel alludes to a contemporary, living person— the art critic Thomas McEvilley, trained as a classicist—is not so successful. The name "McEvilley" destroys the contemplative mood, the sense of reflecting on the heroes of the past. It is rather jolting in context, because it undermines the mood generated by the other two names. "McEvilley," located between "Alexander" and "Achilles," drags down their ancient import without elevating its own contemporary import. Just as, in *The Afflicted Organ*, Schnabel originally had the letters "MMA" painted on the black heart (they indicate a saint), and painted them out when it was pointed out to him that they could be taken to signify the "Museum of Modern Art," so Schnabel should have painted out "McEvilley," who evokes, just as inappropriately in the context, *Artforum*, where he is a contributing editor. It would be very much as if Cy Twombly—not a small influence on Schnabel's language works, however different in method they are from Twombly's (Schnabel turns Twombly's graffiti look into a graphic look)—in scrawling the names of ancient Mediterranean places and heroes, wrote the name of some official in the current Italian government next to theirs. In *Alexander McEvilley Achilles* the rhetoric of exaltation has become bizarre to the point of silliness. (Alexander McEvilley Achilles is in fact the name of Thomas McEvilley's deceased son. Nonetheless, I think the point of my argument is true.) The cultural pattern of articulating the sublime is indeed broken by Schnabel's *The Recognitions*, as it was by Newman's and Twombly's works, but here to create a desublimational effect. Looking at Twombly's paintings, one seems to be watching him struggle to remember the past; one seems to be watching the process of memory. In contrast, in Schnabel's paintings one sees the products of collective memory abstractly appropriated, not the process of personal memory. Schnabel's disarmingly "decomposed" presentation implies no personal depth of memory, that is, no sense of an agonizing struggle to enter into the spirit represented by the memory as in Twombly.

2. See my essay on "Chaos in Expressionism" in *Psychoanalytic Perspectives on Art*, ed. Mary Mathews Gedo (Hillsdale, N.J.: The Analytic Press, 1985) pp. 61–71, for a discussion of the expressionist cry in artists as different as Oskar Kokoschka and Newman. The essay is reprinted on pp. 81–92 of this book.

3. T. W. Adorno, *Aesthetic Theory* (London: Routledge & Kegan Paul, 1984), p. 446.

4. Ibid., p. 464.

5. Ernst Cassirer, *The Philosophy of Symbolic Forms, Volume 2: Mythical Thought* (New Haven and London: Yale University Press, 1955), p. 216.

6. Ibid., p. 217.

7. William Gaddis, *The Recognitions* (New York: Viking Penguin; Penguin Books, Elisabeth Sifton Books, 1985), p. 35.

David Salle's Aesthetic of Discontent

The peculiar intensity of David Salle's pictures is such that it seems possible to think that he doesn't know which he prefers: art objects or real objects. It is a problem innate to representation: is one finally interested more in the artistic merits of the representation of the real object than in the object represented, or vice versa? Does the representation exist to bring one closer to the object in some way, or for its own aesthetic sake?

The question perhaps sets up a false dichotomy—why not both?—but it brings into focus another question: are objects represented for purely cognitive reasons, because they exist and so must be grasped, or for emotional reasons, because one likes or dislikes them (or both)? Is it possible to make a neutral, true-to-fact representation, or is every representation permeated with eternal emotional ambivalence, as Salle's representations seem to be? Is an object represented because it represents a certain emotional state, a certain attitude? Isn't this kind of ''symbolic'' representation harder to achieve than the representations of objects as such? For emotions exist as tensions, so that it is only by means of the contradiction between objects that they can be made manifest, ''suggested.'' Passion inflates the dialectic of objects to represent its own dialectic.

According to Freud, passion—instinct—attaches itself to whatever object affords satisfaction, almost by chance. Salle's pictures are about the difficulties of such attachments, their inherent frustrations as well as possible satisfactions: the ambivalent representation of the object they give rise to. His subject matter is the discontents of civilized representation. His is an aesthetic of discontent, disclosed through a method of contradiction. His ''representative'' images seem full through overuse, for each is an already inscribed social ''perception.'' But his technique, in which each representation neutralizes the other by being given visual equivalence to it—thus subtly draining each representation of all meaning but attitude, an involuntary subjectivization of the picture as a whole through an in-

This article originally appeared in C *Magazine* (Spring 1986).

finite regress towards meaninglessness which nonetheless leaves each constituent representation or pictorial detail its legibility as "objective" language—implies that all the representations are equally trivial for the individual, if not entirely empty. Salle's is an art of total disillusionment.

The secret of representation is that it is a problem of object relations, psychoanalytically understood. Salle's art is a brilliant demonstration of the general character of object relations, as well as a deconstructive odyssey—as full of unpredictable adventures as that of Ulysses and Leopold Bloom—of his own relations to that personally most dramatic, socially most vivid object, woman. No matter how naked, his woman is still veiled with his own ambivalent attitude toward her. One can initially understand our subjective relations to objects through William James's idea that the mind is "always interested more in one part of its object than in another, and welcomes and rejects or chooses, all the while it thinks." According to Freud, the parts of the object the mind is unconsciously interested in are those which give it pleasure: "pleasure . . . pointed the way to object-choice." According to Jay R. Greenberg and Stephen A. Mitchell, "for most psychoanalytical theorists, the benchmark of successful development is the ability to establish consistent relationships with a whole object."

One of the "lessons" of Salle's art is that such successful development is rarer than one thinks. One remains infantile for much of one's life, stuck in partial attachments to partial objects—fetishizing fragments of objects, or whole objects which seem fragments of a larger pleasure, not quite forthcoming from the world: the pleasure of being mirrored by it, and so made whole by its wholeness. *My Head* (1984) suggests that only artworks are narcissistically satisfied by the world; one becomes an artist to have narcissistic satisfaction at one remove, through the acclaim given one's objects—better than none at all. I think this partially explains the abundant presence of well-recognized or well-mirrored—popularly reproduced—artworks, or successful—socially assimilated as normative—styles, in Salle's works. They are enviable examples of well-loved objects—as is woman. Salle's art often shows his envy of such objects getting the better of him—leading to an almost suicidally ambivalent love/hate treatment of them, which quickly becomes murderous in its method of anaesthetization and dissection of them. In a sense, Salle's art is about the eternal return of subtly infantile attitudes to adult objects. His pictures turn them into erotogenic zones available for infantile sensation.

According to Freud, the pleasure the autoerotic infant obtains, in Greenberg/Mitchell's words, "from his erotogenic zones with the help of the person who had looked after him—his mother," shows how she

becomes his choice object. This "first object . . . will be a part object," because it is constituted of "component instincts." "To the extent that the object is created out of experiences of satisfaction of the oral drive, it will be the orally satisfying part of the relevant person, for example, the mother's breast. If the operative component instinct is the exhibitionist trend, the object will be the mother-as-looker, not the 'whole' mother as she would be defined by the objective observer." Object relations theory forces one to differentiate yet relate a number of different objects: "current perceptions of real objects; relatively durable representations of others (object relations); phantasies of internal objects; and identifications with internal objects which serve as a focus for the organization of various functions within the personality (as in Freud's description of the superego)."

I submit that what is operational in Salle is the interplay between these different objects, focused around a demonstration of woman—whether currently perceived, durably conceived, "phantastic," or identified with— as the forever forbidden and so most precious, alluring object. She is what W. R. D. Fairbairn, an object relations theorist, calls "the exciting object," forever enticing one to (sexual/symbiotic) merger with her yet never "really" allowing it. Even it it occurs, it is never as satisfying as her looks promised it would be. She is satisfying because of her promise of pleasure, but in the end unsatisfying, because she in fact never gives significant, lasting pleasure. More pointedly, she is the self-absorbed—narcissistically supreme—bitch goddess, recognizing no one but herself, indifferent to everyone else—except insofar as they mirror her. She is enviably narcissistic—the secret of her seeming self-sufficiency and composure, even when naked. Salle is dealing with the old problem of the allure of Venus, which is as much an attraction to her vanity and coolness in the face of desire for her as it is of the desirability of her nakedness. Art objects have the same narcissistic vanity for Salle—this same indifference toward the viewer, whoever he or she may be. They are at once available for everyone and no one. They are surrogate women.

For Salle, then, woman's nakedly displayed indifference—"coolness"—is as much of a seduction as her nakedness. Salle is attracted more to her attitude than her flesh, which is neutralized by the mechanical/slick surface he gives it—the indifferent touch with which he renders it. It is a touch which not only cancels the voluptuousness of her flesh, but in so doing partakes of her detached attitude. This double, and one might say doubly cooled, nakedness—physical and emotional—is perhaps most explicit in *The Bigger Credenza* (1985). I know of no contemporary artist, except perhaps for Eric Fischl, who can present both physical and emotional nakedness, and the simultaneity of an almost sleazy, unconscious

voluptuousness and self-conscious coolness—consciousness that gives the self distance from the flesh, a distance that is not so much sexually repressive as revelatory of autonomous selfhood in defiance of the flesh and its desirability to the male other—with the same ruthless completeness as Salle.

Object relational interplay is not always easy to follow in Salle, and is the source of the inner discontinuity of his narrative "line," which sometimes takes abrupt turns, not easily readable, and thus all the more engaging, intriguing. Sometimes the interplay seems a private pandemonium, at other times a "speculative" (spectacular/decorative) marriage of well-publicized objects, conventionally unrelated—from separate realms of experience. There is a simulated copulation of internal objects, in a nightclub/circus act—my favorite way of thinking of the juggling act Salle performs. Some of Salle's works actually utilize a nightclub setting; almost all can be understood as having a deliciously unwholesome nightclub atmosphere, vaguely seamy—but with no enduring sensual impact. In this his pictures are enticing objects, like his women. This is the essence of his pictorial "perversity," which is not without a profligate, punchinello painterliness, which would hardly be tolerated in a truly popular medium.

Since the beginning of modernity, high art has depended on perversity—with its clear-eyedness about the ultimately disappointing character of all objects, internal or external—for its impact. Popular art tends to clean up the perversity by stylizing or normalizing it into a cliché, if not eliminating it—and with it the sense of why modern life is heroic (because it can endure, even celebrate disillusionment)—altogether. Paradoxically, Salle begins with popular—we might say phylogenetically significant, culturally speaking—images of objects, that is, images internalized socially. By desentimentalizing or demystifying them so that their perversity becomes clear—by deliberately looking at them with a hard, cold eye— he recovers their ontogenetic impact, their role in individual psychic development. He shows the perversity of the society as a whole, in its demoralization of the individual by seducing him with images—internal objects—that are in the end disappointing, disillusioning. In this Salle seems to differ sharply from Pop art, which generally regarded popular images as satisfying in themselves, as well as suggestive of the satisfaction to be had in real American life. Salle seems to suggest that it is no longer possible to believe in either artistic or American satisfaction.

Salle's struggle, then, is with the pleasure principle—no doubt an old struggle, at the center of becoming civilized, and producing civilized art. T. W. Adorno has written that "in true art the pleasure component is not given free rein. . . . Art absorbs pleasure as remembrance and longing." But in Salle remembrance and longing are not what they used to

be; they are shot through and through with ambivalence towards the pleasure-proposing object. It is this unconscious ambivalence that is in large partly responsible for the conscious, carefully constructed dissonance of Salle's pictures. Adorno has written that ''dissonance—the trademark, as it were, of modernism—lets in the beguiling moment of sensuousness by transfiguring it into its antithesis, that is, pain. This is an aesthetic phenomenon of primal ambivalence.'' For Adorno, ''dissonance preserves the moment of pleasure, if only as a distant echo.'' But dissonance eventually comes to seem pleasurable—an absurd and awkward but nonetheless credible kind of consonance. In response, what Adorno calls ''hypermodernism'' develops: ''Dissonance . . . congeals into an indifferent material, a new kind of immediacy without memory trace of its past, without feeling, without an essence.'' Hypermodernism—a more accurate term than Postmodernism—''prefers to join forces with reified consciousness rather than stay on the side of an ideology of illusory humanness,'' such as modernist dissonance, with its exciting promise of a distant pleasure, offered. Salle's art is hypermodernist, in that it offers representative—reified—images wiped clean of any memory traces and feelings—essenceless images that do not offer the slightest illusion of humanness. Paradoxically, the hyper-dissonance of ambivalence cancels out free-forming memory and free-flowing feeling, for ambivalence is the active form of indifference. Salle's art absolutizes ambivalence as the form of anti-humanness. Such unhumanness articulates the disillusionment responsible for authentic realism—realism that articulates the pain of reality, of acquiring a reality principle. Hypermodernism shows the pleasure principle come to a complete standstill in insurmountable ambivalence. Hypermodernism shows the indisputable, inherent ambivalence of object relations to be the necessary, real theme of representation—the only theme that can prevent it from collapsing into the pseudo-humanness of sentimentality or into matter-of-fact reproduction of already produced reality.

Let us look at one work, the triptych *Muscular Paper* (1985), from an object relations point of view. In a partial description, one encounters, in the left panel, a dark grayblue modern sculpture, ambiguously abstract (pure) and animalistic (primitive), with the orange outline of a reclining (sleeping?) female nude superimposed on it, and flanked by bluetipped woodgrained bits of rod (not unlike the illusion of three-dimensionality created by a ''realistic'' nail in a famous Cubist painting). In the central panel, on an orange ground, two ropeskipping female nudes (from a 1930s German ''health'' film?), with—from an antique Batman comic strip— blue, redlipped Joker's faces/masks (Salle's?; it is in fact borrowed from a famous painting by Ribera) on their buttocks like immature comic masks

on a theatrical place of honor, with a central orange phallic fountain painted between and over them. Finally, in the right panel, on cheap blue/green plaid material, there is a copy of a famous Max Beckmann print, *Iron Bridge in Frankfurt* (1922), in Salle's use perhaps alluding to the defunct *Brücke* group (also illusioned in their disillusionment). What is crucial is that none of the objects exist in—one might say establish—a "current perception." The most contemporary is the grimacing, Gorgonian mask, but the permanence and fixity of its smile implies that it is an imago—has the status of an internal object.

The murkiness of the whole suggests its phantastic quality. Salle reveals durable artistic representations to be "regressive" phantasies— one might say he tries to recover the phantastic element in them. They are phantasies in the Kleinean sense: not substitute gratifications, but gratifying in themselves, whatever their psychic function. The joker's mask is a kind of "superego"—a "man"-made loin cloth covering the anal orifices of the artfully naked Eves, with their false promise of erotic paradise. The artificial or arch character—seductive fakeness (all seductiveness is fake for Salle, a sign of unfulfilled promise)—of their "going native" is suggested by the jump rope. The mask also makes clear the situation's artificiality, and that of the situation of all, let alone perverse, sexual satisfaction.

From the point of view of D. W. Winnicott, another object relations theorist, Salle's "phantastic" painting articulates the ambiguous character of "creative" illusion. He shows the moment of development from hallucinatory omnipotence—all the artistic representations seem to have been brought into being by the infantile artist's own whimsical wish—to recognition of the independent, "remote" reality they signify. It is a moment of scepticism. The representation is suspended in an infantile no-man's-land, and as such more illusory than if experienced as a dream or as the true representation of a real object. It is the same moment of "success" and frustration—the same profound attraction to illusion and disillusionment—that the German *Brücke* group experienced. Salle's paintings are, indeed, personal narratives—representations of his private world of internal objects, all of which are shown to be "artistic," just as all art objects are shown to be internal.

The brilliance of his art is the way he shows perception caught on the horns of a dilemma, uncertain whether it has created internal artistic objects or articulated externally given objects—uncertain whether or not it has confused or can distinguish them. He seems to imply that all representations are suspect, neither unequivocally internal or external. Salle is one of the great masters of representation—of the new New Objectivity—because he has made clear, like Beckmann—one of the

masters of the old New Objectivity—the internal character of external objects, and the power of internal objects over the external world. He leaves us in limbo of disillusioned longing between representations of ambivalently internal and external worlds, a longing all the more intense because of the eternally perverse, partial, infantile character of both worlds.

Jacopo Borges's Creation of Potential Space

> *Potential space is not* inside *by any use of the word. . . . Nor is it* outside, *that is to say, it is not part of the repudiated world, the not-me, that which the individual has decided to recognize (with whatever difficulty and even pain) as truly external, which is outside magical control. Potential space is an intermediate area of experiencing that lies between (a) the inner world, inner psychic reality, and (b) actual or external reality. It lies between the subjective object and the object objectively perceived, between me-extensions and not-me.*
>
> <div align="right">D. W. Winnicott, Playing and Reality</div>

Jacopo Borges paints figures, but he also paints space, and he is more and more a painter of space than of figures. It is a peculiar space—what the psychoanalysts call "potential space." The figures become its tropes. They intimate its elegantly inchoate character. They form a network of ambivalent relations—a masquerade of intimate togetherness—that covertly functions as a metaphor for its fluidity. As his art has matured, Borges's figures have become less and less fantastic in themselves, if not exactly normal: they have been integrated into his dream space, they become its manifest content. But the real issue of his art is the rationale for his space of fantasy. Why does Borges feel compelled to immerse himself imaginatively in infancy's intimate emotional space?

Borges has always been a brilliant inventor of space, and it has always been the space of spectacle, a showman's carnival space. Its grandiosity both encompasses and distances: it is an oppressively ambivalent space, at once absorbing and alienating. In *La Pesca* (1956), it is cosmically complex, to the point of hyperbole. This early space, made of eccentric planes of luminous color, subsumes and condenses the variety of experimental Modernist spaces. But for all its seeming sublimity, it is no more than

This article originally appeared in *Jacopo Borges* (Exhibition Catalogue; Berlin: Staatliche Kunsthalle, 1987).

a backdrop for the isolated little figure innocently at its center. Seemingly a *non sequitur*, the primitive fisherman holds his own in the sophisticated, abstract, modern space. He does more: he carries its burden unself-consciously, with Herculean unconcern. The elemental figure continues to exist in Borges's pictures, but it no longer resists the space it inhabits, no longer secretly triumphs over it. Instead, it is carried along by a space that has become uncannily indeterminate. The figure is penetrated by the active void of this space until its own determinacy is eroded.

In *The New World* (1987) two "basic" figures haunt a primordial forest. There are residues of modernity in this turbulent nature, but they are less to the point than its visionary character. It is a dialectical space, created by the indecisive dual of life and death forces. Despite the apparent similarity of theme to *La Pesca*—the static figure isolated in the dynamic space—the space in *The New World* works in a very different way. The space of *La Pesca* is kaleidoscopically fragmented, and so dynamic and quasi-fantastic, but essentially integral and structurally sound—a kind of monumental building, each of whose parts is engineered into a preconceived whole. For all the apparent slippages, the space will never avalanche. But in *The New World* space is inherently disintegrative, untotalizable. It has become a zone of visionary transmutation—rhapsodically fantastic. As in *La Pesca*, their apocalyptic/Edenic import counts for less than the play and force of the space itself. In *La Pesca* the figures are not entirely absorbed by the space, but unlike in *La Pesca*, the figure has a certain power over the space—the power of a lever. In *The New World* the figures have no control whatsoever of the space. Not only can they not move it, but they are almost completely moved by it—almost reduced to its reflexive gesture. And that space is no longer a kind of pyrotechnical clockwork, as in *La Pesca*. It is less pyrotechnical than chaotic, less of a clockwork than a kind of insane cycling of forces. The space of *The New World* is full of violence that signifies the power of a nothingness superior to the being of any figures. The space of *La Pesca* is aestheticized externality; it is anecdotal and historical, for all its mythical form. The fluidity of *The New World* space dialectically absorbs every anecdotal detail into its momentum, and is genuinely mythical, that is, not of this world.

But it is also not entirely of the inner world, however much it might seem to symbolize it. Paradoxical space articulates a zone of overlap between inner and outer worlds that has its own peculiar logic. It is the most *terra incognita* of all spaces—the connotative undertone of both inner and outer worlds, undermining their specificity in its indeterminateness. It is a zone of transition between inner psychic reality and external reality—a zone of a different sense of reality. The best of Borges's figures belong to this almost altogether bizarre, paradoxical reality of

potential space. Borges's creation of potential space—one of its fullest realizations in modern art—cultivates the germ of it that Velazquez discovered in external space. The question is, what does it tell us about Borges—about an artist who prefers to exist in potential space rather than in the inner or outer worlds. Is Borges's preference for the moments of illusion—as Winnicott calls them—that occur in potential space an ironical comment on both inner and outer worlds, expressing disdain for both?

Why would one want to regress from inner space and outer space to potential space? It can only be because of the traumatic sense of the inadequacy of both worlds that comes with the serious recognition of their existence in time. They are forever disturbingly blurred by its flux. Borges's uncovering of the paradox of time—the maturity it promises is a magical lure to a delusive selfhood, for what time starts it does not so much fruitfully end as destroy—is embodied in his articulation of water. Watery time is death as well as life; Borges associates it with the invisible undertow that destroyed his father-in-law, a death he witnessed and was helpless to stop. It came on top of an earlier, even more personal experience of death, of its direct threat to him. Water is associated with the primitive experience of death-in-life, life-in-death: his own vulnerability was announced by water, for it was water he fell into when he fell into a well as a boy, led on by "friends." (From then on, as his work shows, he never quite trusted humanity. It seduced one, but at the climactic moment gave one pain rather than pleasure.) It was a premature experience of the precariousness of existence, the uncanny sensation of his own death. In a sense, his art is nothing but a validation of this sensation, a reliving of it, another rehearsal of death: which is appropriate, for art is a kind of living death. At first the reliving of death was unwitting, and then it came through a recognition of time, and finally it became deliberate, calculated, quietly histrionic. His figures came not only to metaphorically drown in an elaborately empty space, but to exist nakedly in water. His images became a discomforting process of "testing the waters." The memory of the sensation of drowning was sanctified, became a mother to him, indeed, became the source of the fantasy of "oceanic experience," an imaginative return to the womb, which was another kind of threat of death—loss of self—that at the same time brought with it the promise of rebirth. Borges discovered, through the holy flesh of painting—as ecstatic as it is mortified—the ultimate paradox: water was death and birth in one. (Paint was water thick and thin with immanent plot.) It was time but it perversely promised transcendence of time. Elemental water is Borges's potential space at its most intimate and complex.

The thought of one's own death always hits one particularly hard,

even though, as Freud tells us, it can only be an abstract thought, for we can never inwardly accept our own death. Nonetheless, it is no accident that Borges's space becomes "younger"—more fluid with "fantastic" potential, less real—the older he becomes. Potential space is a place of pure creativity, and as such the symbol of paradise, the intimate dream world in which death does not occur and time has lapsed. Borges overcomes them, as it were, mythically defies and denies them through his assertion of potential space. It is an aesthetic tourniquet applied to life in order to stop time, the hemorrhaging blood of being.

The first effort to become a deliberate self is made in youth; the mature effort that is made with the awareness of temporal process and intractable death seems more preposterous, considering the odds against it, but it is twice as necessary. In youth, one made the effort to have a self because the world expected one to be "someone." The effort involved a conformist kind of heroism, for all its sometime look of nonconformity. It was an attempt to conform to a world whose form one did not fully comprehend. It formed one as one learned it. The attempt to be a mature self is beyond considerations of conformity and nonconformity, obedience and rebellion. It is beyond the question of the worldly path one has chosen to follow. Maturity is not about having a self that shines in the world's eyes, but about being a self convincingly to oneself. It involves a more subtle, paradoxical heroism, because the mind maturely aware of time and death unconsciously knows it cannot escape them, even though it does not know what form death will take and does not immediately recognize that its life is a form of time. (Indeed, one's life is time clearly magnified and made intimately manifest.) The self's fanatical, unrealistic—idealistic—determination to overcome time and death masks bitter acceptance of their reality and desperate desire for immortality and rejuvenation. Borges is a delicate practitioner of mature heroism, transcending melancholy awareness of time and death by an ambitious concretization of creative self—by new "self-possession" through freshly concentrated creativity. Indeed, water is also a symbol of creativity, and in the last analysis Borges's pictures of water reconsecrate his creativity through the fearless articulation of its flow and depth.

Borges's creation of potential space implies a profound regression to the repressed realm of the mother. Only she, or her spirit, can heal the narcissistic injury to the self that time and death inflict. The regression to the underworld, where the mother is queen, requires his full strength, both to make it and to survive it. The mother is creative; she gives birth. To once again be in her good grace—as one was when one was an infant and child, that is, when she had just given birth to one—is to be creative by osmosis, and "proof" that one is not irreparably damaged by time

and will not die. The regression to—identification with—the mother's creativity is the ultimate act of self-reparation. Put another way, it is through mature recognition of the reality of time and death—that is, the recognition that they affect oneself as well others—that the self realizes its fundamental narcissistic discontent, and with that its need for rebirth, necessitating a regression to the mother. Only by identifying with her power to create can the self become content. Creativity is the ultimate narcissistic satisfaction, available through identification with the mother. Death forces the self to realize that the invention of a worldly self is not true self-creation, which implies the creation of the creative self—the true self. Only the mother can facilitate the creation of the true self.

Nowhere is Borges's regression to the realm of the mother more brilliantly evident than in the incredible *Con mi madre, nina* (1976). It is a disguised transference of creativity from his mother to himself. He in effect depicts himself as his mother's father, a startling incestuous/creative intimacy through which he appropriates his mother's power to give birth—woman's natural creativity—for himself. Possessing his mother's power in its virginal state, he assures himself of his own creative immortality—and immortal creativity. In this dream representation of his mother Borges becomes his true self—the parthenogenetically creative artist. In an extraordinary variation of the Madonna and Child theme, Borges becomes a male Madonna and his mother becomes a female Christ child, able to redeem him and the world through the transcendence of creativity. It alone is truly "divine."

Con mi madre, nina is Borges's most direct representation of potential space, which, as Winnicott says, "both joins and separates the infant (child, or adult) and the mother (object). This is the paradox that I accept and do not attempt to resolve. The baby's separating-out of the world of objects from the self is achieved only through the absence of space between [the infant and mother], the *potential* space being filled . . . [with illusion, with playing and with symbols]." Imaginatively becoming his mother's father, Borges mystically merges with her—denies that there is any distance of time and space between them—and unconsciously accepts the paradox that her creativity is his. Like his mother, he can create himself—recreate himself through his art, the realm of play, illusion, and symbol. One asks of the artist whether he "creates the object" he renders or whether "the object was there to be created . . . we will never challenge the baby [artist] to elicit an answer to the question: did you create that or did you find it?" Especially not when the object is the artist's/baby's own true self as much as the world of objects. To be truly creative—which in the end means to have a sense of true self—the artist must be like a baby or child. This is a demand of Romantic Modernism

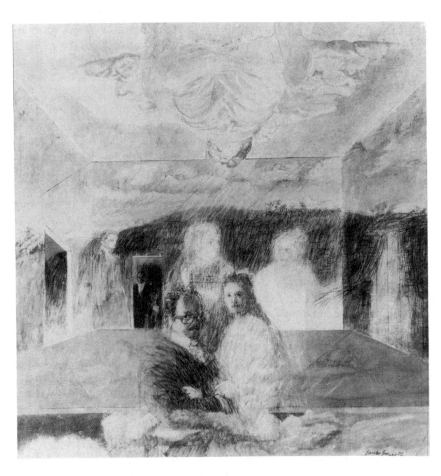

Jacopo Borges, *With My Mother? As a Child,* 1976
Oil on canvas, 59″ × 59″.
(Courtesy CDS Gallery, New York)

at least since Baudelaire. Creativity involves "confusing" discovery and creation, which is the moment of illusion. By ingeniously identifying with his mother, Borges reassures himself of his creative selfhood.

Borges's brilliant water pictures are his fullest realization of potential space, as noted. But it appears in many other works, particularly of the last decade. His figure's tendency to transparency—he makes it as permeable as possible without destroying its form, pushes it towards invisibility without denying its obvious visibility—suggests its participation in potential space. Time makes the figure transparent, a kind of ghost; time reduces it to a memorable improvisation. Borges is more interested in the mystery play of potential space than in the figures which perform on its stage, because potential space is space in a form as directly symbolic of time as it is possible for space to be.

Potential space is no longer actual space, but a regression from it to the magical moment when space and time are experienced as one. Thus, potential space conveys creative potential as well as the threat of death. In potential space, the control—rationality—of coordination has been eliminated, allowing for a seemingly uncontrollable fluidity, unconsciously experienced—metaphorically read—as irrational temporal process. Bergson, in his essay *Duration and Simultaneity* (1922), describes the way incessant spatial transition comes to symbolize temporal duration. For Borges, water is clearly the medium ideally emblematic of—embodying—spatiotemporal transition, and as such is the major means of articulating duration. The illusion of duration occurs in potential space, and it as illusions of duration that Borges's figures—Winnicott's moments of (artistic) illusion, that is, objects whose discovery and creation are one—ultimately occur. They seem to resist the potential space they inhabit, but in fact their transparency articulates it, for it reveals them as speciously present—present as irrational illusions because present in time—and as such dimensions of the duration which the potential space is. To say that Borges's figure is speciously present—"artistically" present, as it were—is to say that its body is constituted of overlapping temporal impressions. It is at once fading and fresh. William James wrote that in the specious present—and the present is always specious from the perspective of temporal process—"the lingerings of the past [are] dropping successively away, and the incomings of the future make up the loss." Because the maturest of Borges's figures embody the specious present, they cannot escape being seen as momentary illusions.

The term "specious present" was coined by E. R. Clay, who defined it as "the present to which the datum refers [which] is really a part of the past—a recent past—delusively given as being a time that intervenes

between the past and the future.'' It is this delusive present that Borges's figures inhabit and represent, a present that is at the same time what James calls ''primary memory.'' Borges's figures are simultaneously specious and memorable, delusive and profound, whether they are the expressionistically dense, Art Brut type figures in such works as *Sala d'Espera* (1962), *El Grita* (1962), *Todos a la fiesta* (1963), *Humilde Ciudadano* and *Continua el Espectaculo* (both 1964), *Atlas Finanzas* (1965); or the more sketchy—drawing-derived—figures of *La Coronacion de Napoleon* (1963), *Con mi madre, nina* (1976), *Abandonado la ciudad sumergida* (1977), *Amanecer* (1978), and *La Communion o . . . II* (1981–86). The improvised air of all these figures—undermining their worldly status and authority (many of them are political figures), their very reason for being—is the sign of their existence as specious presents or primary illusions. Thus, the moment of creative illusion that occurs in potential space and the specious present are revealed as one and the same. Both involve the ''artistic'' discovery/creation of the object world: the experience of already-thereness yet—simultaneously and paradoxically—personal origination.

For Borges, time—which is always and only specious present, with the moment of illusion as its nucleus—ironically ''determines'' selfhood. The distortion of his figures—often to the point of grotesqueness—can be understood as an intimate temporal revelation of their being. That is, their absurd, mad shape shows them as they have been shaped by time. They are also physiognomic revelations of the madness and absurdity of the historical world they inhabit. Their distortion reveals their destiny, as it were. Borges is a profound Realist, a master of what I call ''psychotic Realism.'' He articulates the real insanity of the world through means that imply a loss of reality principle, but in fact paradoxically signify a relentless commitment to it. Psychotic Realism is evident in such monstrous, mad figures as *El Fumador* (1965), *La Jugadora I* and *Figura en una habitacion* (both 1965), as well as in more normal figures such as *El critico intrepido* (1963), *Fotografo,* and the various figures in *Yellows in the Mirror* and *It's Not a Matter of Matter* (all 1986). In a sense, potential space is inherently psychotically real, for it is a place that gives the illusion of magical, creative control of reality while affording an experience of its madness and absurdity.

Finally, Borges's articulation of an emptiness beyond that of theatrical transparency is worth remarking. It is the real secret of his sense of spectacle: behind the spectacle, as its indwelling nucleus, is an overwhelming emptiness more intense than the emptiness of ordinary space, which is only its signature. This profound nothingness makes itself felt—encroaches on the being of the figures—in such works as *Esperando* (1972), *Nymphenburg, La Celosia,* and *El Tiempo que pasa I* (all 1974), *No Mires, La*

Novia I and *II* (all 1975), and *We Are All the Same* and *Paisage en tres tiempos* (both 1977). It is the beginning of their oblivion—their transparency—but it is more profound than that.

In all these works the genuine "subject matter" is the feeling of emptiness created by the experience of time. It is correlate with the experience of the deceptive fullness of time conveyed by such water pictures as *Swimmers in the Water Mirror, Swimmers in the Landscape, Distortions in the Landscape, Distortions of Time and Space, Reflections of a Painter* (all 1986). The emptiness signifies time's power of absenting being, making it seem empty; water signifies its power of making speciously present, that is, making being manifest, however ambiguously. The different degree of aggressivity in the figures in these works bespeaks the double meaning of the "power of time."

Emptiness, as well as painterliness, is aggressive expression for Borges. Both scoop out the figures while preserving them through a mimetic modicum of appearance. They are derealized, as it were, that is, the articulation of time—the presentation of the figures as specimens of time—brings their reality into question. Indeed, Borges's oeuvre as a whole is a questioning of the conventional sense of reality, which is nowhere more in question than in potential space. For this questioning is articulated through the paradox of potential space, that is, the dilemma as to whether reality is discovered or created, more precisely, the strange yet "natural" experience of it as both at once.

One recalls Breton's dismissal of the vulgar sense of the real, and the recognition that the most ordinary object can become surreal, if at a privileged epiphanic moment. (Such surreality is a form of psychotic Realism.) Borges carries Breton's recognition forward: for Borges, the vulgar figure is cancelled out by being experienced as a surreality, that is, a unity of unconscious projection and conscious recognition. This experience is not a privileged moment, but can occur at any time; Borges realizes that it is catalyzed by time itself. Indeed, he implicitly recognizes that it occurs all the time; every moment is a moment of illusion. This is the point of his water pictures: all is not only in a condition of self-reflexive flux, but is a momentary illusion.

Many of Borges's pictures are self-portraits. His pictorial plunge into potential space indicates the depth of his inquiry into his selfhood, for potential space is in effect the space of the enigmatically primitive self, that is, the self that has not yet identified itself, that has not yet become an other to itself. This primitively creative self is capable of absorbing all other identities into itself, as Borges's numerous works, full of "fantastically" realized figures, suggests. But it finds no narcissistic satisfaction in any of them. Borges busily identifies with others, but withdraws into

what Heinz Kohut calls "prepsychological chaos," the flux of his own innermost self. He dissolves others into the creative flux of this self. Its madness is his refuge, as it were, in a mad world, but it is also a monadic reflection of that world. His regression to the virginal creativity of potential space is his way of resisting the real world while acknowledging it. It must be resisted, for it erroneously regards all creativity as an abortive attempt to identify with and define it, when creativity in fact is a paradoxical attempt to identify and define the self.

Louise Bourgeois: Where Angels Fear to Tread

the stones are filled with bowels.

Jean Arp, "The Air Is a Root"

Louise Bourgeois has never had her due. In part, this is because of the general devaluation of the female artist, the unwritten (and unacceptable) rule that no woman artist can be *that* major, but the rule has applied doubly to Bourgeois: the provocative way her sculpture articulates what it is to be female makes it particularly challenging to the context through which importance and value are usually conferred. Her work deals with being a woman in a way that Freud could not have fathomed. It talks about things we don't want talked about, acknowledges forces we don't want broadcast loudly, and certainly not let loose. Such forces, we feel, can only add to the world's mischief, as though our poor state didn't in the first place have to do with a silence—a conspiracy with the self to stay ignorant—about the unconscious.

Bourgeois has acknowledged that her work is autobiographical, but the childhood narrative she has woven around it is deeper than it appears. She has characterized her father as a traitor and tyrant; he may indeed have been so, especially in the way he made her English tutor his mistress for a decade, creating a knot of family relationships around the young Bourgeois that she has described as "child abuse."[1] Bourgeois's fragmentary, quasi-aphoristic assertions are permeated by this kind of spinning of personal tales, and much of the writing about her work emphasizes its radical subjectivity, whether approaching it through its Surrealism or through its formal characteristics, such as the way it is equivocally abstract and figural, and the way it presents an emblematic, enigmatic "personage" within an architectural or environmental space. But we still don't really know why her sculpture is fixated on family or group constellations, why she bothers to preserve her mother and father

This article originally appeared in *Artforum* (March 1987).

in mythopoetic sculptural form, why her artmaking keeps alive her aggressive, appropriative feelings about these long-dead figures.

Each of Bourgeois's sculptures is indeed a Sisyphean effort to work her way through psychic material that is not ordinarily worked through successfully in art. The power she seeks as a woman is inseparable from the power she seeks as an artist: the power to give birth, and the power to continue to mother us after we are born—to mother our emotions, to function as the mother of last resort, promising us wordless understanding.[2] In this work, the glyph that man has arrogantly misappropriated as his is finally an instrument to the end of becoming the most powerful human being: the mother. Bourgeois gives birth unceasingly to works that promise to satisfy the human need for deep understanding in every new generation. This kind of understanding is usually missing after the first few years of life; much sentimentalized, it in fact involves a complex unconscious dialectic of damage and reparation. Bourgeois strips away its veneer of the benign—its false innocence—to reveal its content of anxiety, aggression, and longing. It sometimes seems as though Bourgeois, in repeating the story of her childhood, and in giving her works titles such as *The Destruction of the Father*, 1974, is defending herself against the recognition that her art is in fact about the "woman's issue" in the deepest sense. It becomes clear that she does this for a reason—to reappropriate the generative and regenerative power symbolized not only by the mother but by the phallus, to introject or internally incorporate the phallus. The symbolism here is not that a woman wants to become a man, not even in fantasy, but that she wants recognition of her share of natural power, which man, in a political act of expropriation, and in a materialist act of literalism, has claimed entirely for himself. He has totalized the idea of the autonomous power of the phallus and made it the basis of his dominance, through a repression of the significance of the carrier, the owner, of the womb. "Penis envy" is an insidious term for the idea of a woman recovering her share of natural power. If man can be said to be a Prometheus who psychologically stole the fire of woman's fertility, her power to give birth, in order to ground and guarantee his own socio-political power by hoarding all power, then "penis envy" at its deepest can be understood as woman's demand that her own implicit "phallicness" be explicitly recognized.[3] In Bourgeois's sculpture, the power of man and of woman integrate violently yet seamlessly.

Few Surrealist "objects," as the Surrealists often called their sculptures, are successful. It was hard for these artists to "objectify" their fantasies—to make them visible in real, three-dimensional space. Perhaps the problem in these works was that to do so was often to forfeit the power

of the unconscious, to sever the umbilical connection with it. It is reveal-
ing that many of the Surrealist object-makers favored the use of ordinary,
found objects to connote the unconscious, like making ordinary people
into stars by casting them in extraordinary roles. André Breton, for ex-
ample, in *Nadja*, 1928, and in his 1934 essay on Marcel Duchamp,
"Lighthouse of *The Bride*," argues for finding objects and mentally
reworking them—self-consciously fantasizing about them. In general, the
Surrealists didn't really like the physical work of making raw material
into art. Their resistance to "handworking" material so that it becomes
genuinely "fantastic" sculpture is inseparable from their overintellec-
tualizing of the unconscious. They falsified the psychoanalytic under-
standing of the unconscious—they socialized and aestheticized (anesthe-
tized) it, domesticated it for the sake of poetry and art. Despite their claims
to the contrary, and despite their belief that everybody else moralized
and they didn't, it was often the moralized unconscious that the Sur-
realists gave us—their intellectualization of it was an indirect form of
censorship of it.

Bourgeois's importance, in the Surrealist context, is that she is basic-
ally a handworker rather than a literary artist, a maker rather than a finder
of objects. Bourgeois absorbs herself in the object's materiality. She models
or shapes or, let us say, "masturbates" it to find the phallic in it. The
supposed phallocentricism of her sculpture is more phallic than centrist—
she is not so much interested in centering herself in relation to the phallic
as in discovering the phallic. She breaks the taboo on the masturbatory
conception of sculpture—her two tactile, baroque pieces called *Homage
to Bernini*, 1967, one in plaster, one in bronze, are an indication of this,
even in their title. Most sculpture is subject to an unconscious taboo which
opposes "exciting" a material too much, "arbitrarily." With important
exceptions, such as the work of Bernini, Auguste Rodin, and Medardo
Rosso, a great deal of sculpture, even work clearly dependent on model-
ing, involves shaping material quickly into form, whether representational
or abstract, in an act of self-censorship, as it were; there is no excessive
dwelling or lingering upon the exciting material. It is as if its stimulating
qualities needed to brought under control, for as quick a reward as pos-
sible. This taboo keeps many Surrealist "poetic objects" from being
anything more than shallow images, accumulations of found objects, ac-
cretions of detritus that barely sustain emotional or any other kind of in-
terest after the novelty of their initial impact.

Bourgeois began her career, in the late forties and early fifties,
making such simplistic "constructions," often in totemic form—a little
more interesting than usual because of their repetitive, serial or

"Minimalist" character, and because of the houselike openings and spiral-staircase forms they featured. She moved away from Constructivist work, however, while retaining the totemic form, which most of the time she has made more organically or fluidly phallic. In favoring the sensual shaping of material over the use of the found object, Bourgeois struck at the heart of the Surrealist enterprise. It is true that some Surrealist sculpture has a tactile quality; Marcel Jean, the Surrealist artist and historian of Surrealism, emphasizes that the Surrealist "object is . . . what affects more especially the sense of touch."[4] But he in no way means to imply that the sculptor's transformative touch, working over and through a material, is involved in the creation of the Surrealist sculptural object, which, to Jean, is more found than made, more " 'what is thrown before' " and " 'offered to view' " than invented. Indeed, Jean asserts that "the found object is always a rediscovered object. Rediscovered in its symbolic—original or acquired—meaning, which endows it with a fullness that a 'created' object rarely reaches." "Found objects," says Jean, "reveal our multifaceted irrational life"[5] more readily than created objects. For Bourgeois, in contrast, sculpture involves not so much the finding of unconscious meaning in an ordinary object as the articulation, in a psychosomatically charged material, of fantasies of unconditional or "ultimate" intimacy with the other, as an inescapable part of the complex process of becoming fully oneself. In Bourgeois's work, the wish satisfied is not strictly a sexual wish, but a more inclusive wish for metamorphosizing merger.

Bourgeois is one of those rare artists who seem to have a direct track to the place we all struggle so hard either to find or to smother: the unconscious. In her search for the unconditionally primitive she is not afraid to make what can only be called "defecatory sculpture." However, her apparently unmediated touching of "raw nature" exists in order to make something out of it, something ego-creating as well as erogenously significant. There is, as it were, no resting place between touch and artmaking for Bourgeois, no separation between the primitive and the civilized. For her, art is both unconscious giving and conscious control of what is evident. (Something similar, and as rare, seems to occur in the fecal aspects of Joseph Beuys's sculpture.) Many of Bourgeois's works can be regarded as simultaneously defecatory and phallic in character. Examples include an untitled plaster piece of 1963 and the plaster *Rondeau for L* (also cast in bronze) and latex *Soft Landscape* of the same year; two more "soft landscape" works, in plastic and alabaster respectively, from 1967; the marble *Sleep II* and the bronze *Unconscious Landscape*, both of 1967 (the latter cast in 1968); works in the bronze "Janus" series, 1967–71, including the *Janus Fleuri* (Blossoming Janus) and the *Hanging Janus* of about 1968; the coillike

marble ''Nature Study'' pieces of 1986, some of them including the embrace of hands; and many more. In *Nature Study* (*Velvet Eyes*), 1984 (a variation of a core image in Bourgeois's work, the image of the eye; here what seem the eyes of the unconscious peer from raw stone nature), there is a defecatory character to the eyeballs as they lie inert within their receptacles, almost signaling the absence of the phallic image.

The clichéd theatricalization of the female body common in Surrealist art (proof that the movement was as culturally complicit as it was subversive, and that it was not always really concerned with the droppings of the unconscious) underlines Surrealism's usual male orientation.[6] The phallic body as Bourgeois expresses it, especially in her work's many ominous pendulum forms, signals a female-oriented Surrealism, a Surrealism dealing with being female rather than male. Her statements around this subject are rich and revealing, in particular on the social dynamics of power. For example, about *Femme Couteau* (Knife woman), an image that she has reworked in a number of sculptural variations since 1969 (many of Bourgeois's works she constantly reexplores in new versions and different media, and many of their titles she reapplies to new situations), she has said,

> I try to give a representation of a woman who is pregnant and who tries to be frightening. Now to try to be frightening is not the same thing as being frightening. She tries to be frightening but she is frightened. She's frightened for the child she carries. And she's afraid somebody is going to invade her privacy or bother her in some way and that she won't be able to defend what she's responsible for. Now the fact that she's frightening is open to question. Some people might find it very touching. She's frightened herself; she tries to be frightening to others. Yes, but the pregnancy's very important to her, whether you consider it erotic or not. It is erotic to me because it had to do with the relation of the two sexes.[7]

Within the enormous and varied body of Bourgeois's work one finds examples that are simultaneously pregnant and phallic as well as fecal. Sculpture for her is a generative and transformative act, converting softness into hardness into softness back into hardness back into yieldingness. It is in fact an exploration of these qualities, their matter-of-factness as well as the illusions they give rise to. Some of her works offer us images that can be seen as either multiply phallic, multiply clitoral, or multiply breasted. The emphasis I am placing on body parts and states of body no doubt seems perversely overdefining in the context of Bourgeois's mysterious and beautiful work. But I submit that it is in the area of power discussed here that the clue to her originality, daring, and force of greatness lies.

The Templum Magnae Matris in Rome, one of the oldest buildings

on the Palatine, once contained a silver image of Cybele, the mother of the gods. In place of the head it had a conical stone, a meteorite fallen from the sky. The Sibylline Books had instructed the Romans to bring this stone, supposed to be the symbol of the goddess, from Pessinus in Asia Minor during the Second Punic War (206 B.C.). It may be thought of as the phallus of the goddess, the sign of her power. In early Bourgeois works such as the series of oil-and-ink paintings entitled *"Femme Maison"* (Woman House, 1946–47—there are drawings and sculptures under the same title over a 40-year period), the head is replaced by a house, a conventional symbol of the female, her temple as it were, the place where she has power. In a later work, *Fragile Goddess*, 1970, in my opinion a self-portrait, Bourgeois shows calmly and matter-of-factly the phallic female—the head is phallic, the body pregnant, life-giving. In a recent work, *The She-Fox*, 1986, which Bourgeois acknowledges to be an image of her mother, one sees a multibreasted, seated, phallic figure in marble. A houselike shape replaces the head, and a sphinxlike head sits near the feet. Part Cybele, part sphinx, the work holds a riddle. Being of stone, the breasts contain no nourishment. They are for show, an arrogant display of phallicness, even the mother's. They afford the illusion of succor but actually offer none. They are not as nourishing as they look, and the mother is not as motherly as she looks. Bourgeois's entanglement with her mother, not her father, is becoming clear as the inner content of her work. She has filled the void of mother/artist in spirit as well as substance, an Oedipus replacing the mother instead of the father, a sphinx whose secret is that her story about a relationship to a father is really a story about a relationship to a mother. She does this in a breathtakingly raw, abstractly direct way.

Notes

1. "A Project by Louise Bourgeois." *Artforum* 21, no. 4 (December 1982): 44.

2. See Melanie Klein, "On the Sense of Loneliness," 1963, in *Envy and Gratitude and Other Works 1946–1963* (New York: Macmillan Publishing Co., Inc., The Free Press, 1984), pp. 300–13. Here Klein notes the everlasting search for an understanding in which no words are necessary. It is in effect a regressive desire for unconscious, infantile closeness with the omnipotent mother.

3. For a post-Freudian reconception of penis envy see Janine Chasseguet-Smirgel, "Feminine Guilt and the Oedipus Complex," in Chasseguet-Smirgel and Frederick Wyatt, eds., *Female Sexuality, New Psychoanalytic Views* (Ann Arbor: University of Michigan Press, 1970).

4. Marcel Jean, "The Coming of Beautiful Days," in Marcel Jean, ed., *The Autobiography of Surrealism* (New York: Viking Press, 1980), p. 303.

5. Ibid., p. 304.

6. For an excellent account of the Surrealist attitude to women see Xavière Gauthier, *Surrealismus und Sexualität, Inszenierung der Weiblichkeit* (Berlin: Medusa Verlag, 1980).

7. Quoted in Jean Frémon, untitled essay in *Louise Bourgeois*, Repères: Cahiers d'art contemporain No. 19 (Paris: Galerie Maeght Lelong, 1985), p. 32.

Lucas Samaras: Master of the Uncanny

Proteus was also a son of Neptune. . . . His peculiar power was that of changing his shape at will.

Thomas Bulfinch, *The Age of Fable*

This reference to the factor of repression enables us, furthermore, to understand Schelling's definition of the uncanny as something which ought to have been kept concealed but which has nevertheless come to light. . . . An uncanny experience occurs either when repressed infantile complexes have been revived by some impression, or when the primitive beliefs we have surmounted seem once more to be confirmed.

Sigmund Freud, ''The 'Uncanny' ''

. . . you want to find your own way of being naive. It was always an attempt to find some easy line, easy fluid, childlike yes. . . .

Lucas Samaras, 1986

The Self is a repressed content; as it rises from unconsciousness to consciousness, it keeps changing, as though to deceive us about its nature. It is as ungraspable as Proteus, who, myth tells us, could deceive everyone but never be deceived himself. He could grasp everything without himself being grasped.

Over and over again, Lucas Samaras portrays himself, eyeing us, inviting us to eye him. His glance is steady in the midst of his changing appearance. His eyes declare, and his appearance embodies, the question of the relationship between the visible and invisible. Nothing is hidden from his eyes, while they seem to hide everything about him from ours. He is an inexhaustible content to himself, a fascinating but frustrat-

This article originally appeared in *Lucas Samaras* (Exhibition Catalogue; New York: Abbeville, 1988).

ing content to us. To experience his self-portraits is to have the uncanny sensation of experiencing a self too mutable to know anything about conclusively yet too fundamental to have completely forgotten. It is unexpectedly one's own as well as Samaras's self that is made manifest in this way.

Does he arbitrarily assume roles, in a spirit of romantic malleability? George Herbert Mead thought that impersonation was one of the self's methods of romantically defining itself. Samaras's self-impersonation seems the essence of romanticism, which regards the integrity of the self as residing in its own possibilities rather than in its actual existence in the world. John Keats said that the poet has no "character," no "self," no "identity"; he is not a moral agent, but concerned with "gusto." Is the protean appearance of Samaras a sign of his amoral gusto?

If I were to cast Samaras in a role on the basis of his self-portraits, I would cast him as Mephistopheles. We are his Faust: his eyes strip us psychologically naked with their impassive permissiveness. They show us, without the adornment of a moral fig leaf, our innermost desire, the very fury of our desire. There is an odd quality of quiet rage to them. Samaras has himself spoken of how much he created out of anger: the anger of his glance is masked by its steadiness. "Destructive rage," Heinz Kohut tells us, "is always motivated by an injury to the self." It arises because of the failure of adult others "to meet the child's need for optimal—not maximal, it should be stressed—empathic responses."[1] Samaras never had the right empathy, and his eyes do not give us any. Thus their coldness, for all their heat. They threaten us with the "destruction of the nuclear self"—the "bedrock threat," as Kohut says[2]—much as they embody what is left of his nuclear self. The sense of self can attach itself to breast, mouth, penis, or some other part of the body, as various self-portraits suggest, but it mostly abides in the eyes. Traditionally, the soul is seen there, and Samaras is superstitiously traditionalist in outlook, a shrewd Greek respecting the old ceremonies of mythological self-presentation.

An extensive study can be made of the eyes in Samaras's self-portraits, an extensive oeuvre within an already huge one. There are the blank eyes in a self-portrait of 1962. In the various 1985–86 "portraits" of art-world types—zombies, monsters, macabre death's-heads all—which Samaras suggests are disguised self-portraits (onto which you can project yourself),[3] the eyes are also blank, except for the aggressive points of light that kinetically mark their pupils. In their concentration, these eyes are clearly the nucleus of his narcissism, epitomizing his sense of himself as a *monstre sacré*. They are haunting eyes, convincing those who are too banal to know their own monstrousness—who think they may have

escaped it because they look so ordinary, because they seem so commonsensical to themselves—that they may after all be as peculiar in Samaras's eyes as he is to theirs. They infect those who think they are safe because they are impersonal with a disturbing sense of the personal—the personal as morbid, disintegrative, archaic, and for all its despair arbitrarily grandiose. Samaras's eyes haunt the outwardly normal with a sense of their own interior degeneracy, their own decadent oppositeness.

Samaras's eyes seem more normal in the self-portraits of 1975 and 1981—if there is anything that can be said to be normal in a Samaras self-portrait. They stare straightforwardly; the eyeballs do not collapse into their pupils; the eyes are not concentrated into their own introspection. They gaze less aggressively; they do not seem so determined to overturn the other, battering him until he is as unrecognizable as Samaras himself is, softening him up so that he seems infinitely malleable. But Samaras's glance remains unspeakably narcissistic; it precludes—forbids—dialogue with the spectator. It is full of silence, and indeed articulates the lack of any need for speech, which can only be ridiculous—impossible—in the circumstances. Samaras has found himself in the mirror, communes with himself in the mirror, fixates on himself as though there is nothing else for him to see. We are deluded if we think that Samaras is looking at us, that he is trying to catch our eyes with his own. This is one of the many masterful illusions his works create—psychological illusions.

Nonetheless, he is involved with us, he is thinking of us. In a pastel self-portrait of November 1961 his eyes are ringed with teeth; they can consume us. Perception is, indeed, power over the perceived. Samaras never gives up the visual artist's ambition to devour the world with his eyes, even if he does not always obviously exercise it. Freud noted that the "fear of damaging or losing one's eyes is a terrible fear of childhood." It symbolized the "fear of castration," recalled the self-blinding of "Oedipus, that mythical lawbreaker." Freud remarked "the substitutive relation between the eye and the male member . . . in dreams and myths and phantasies."[4] A visual artist without his eyes is almost unimaginable. Samaras seems to show himself with erect—wide-open—phallic eyes in order to dare us to try to castrate—blind—him, in punishment for daring to introspectively see and embrace the nuclear self, as though it was the only object worth relating to, worth the trouble of perceiving. All the more trouble, because it is protean. With the failure of the "self-object environment," as Kohut called it, the self must become its own aristocratic object, withdraw into primary narcissism in defense—become a "law" unto itself to heal itself from the indifference of the world.[5] Because the world never adequately mirrors the self, the self must mirror itself in a magic act of self-creation. It is with this creative self-absorption that Samaras

threatens us—for it may give Samaras a self bigger than our own—this self-mythologizing self-love, articulated through the defiant intensity of his glance.

In the 1981 self-portraits (more often than in those of 1975), the eyes tend to differentiate in size. The little one looks inward, the big one outward. Together, they look like testicles on an obscure body. The pictorial embrace of the face has changed it into a liquid body, in a metamorphosis not unworthy of Ovid. The eyes are also a Scylla and Charybdis: any object caught between them will have the lifeblood crushed out of it. Each is as sharp as the tip of an ice pick. Together, they hold the object of their perception in a tight grip, squeezing it for all it is worth, capable of tearing it apart. Samaras does not spare himself; he dismembers himself through his self-absorption, dissolves himself in the field of the picture. Sometimes one thinks of him as the head of Orpheus, singing in abandonment, his body consumed by maenads that lurk within him.

In an act of repetition-compulsion—for Freud inseparable from the effect of the uncanny[6]—Samaras violently consumes himself into uncanniness. The photo transformations, 1973–74, are perhaps the most spectacular demonstration of this. Every expressive, technical detail of them is worth commenting on; but it is most important to observe that their multiple acts of self-destruction issue in a heroic self-recreation. For Samaras, this complex reparation is the essence of the art process. One can grasp the disturbed surface of his pictures—be they photographs or paintings or drawings, or, more usually, some bastardized combination of all three, if only by implication rather than literally—as the regurgitated, masticated substance of his self spread as a feast for alien eyes. Whereas in the Greek legend the son was slaughtered and cooked and fed to the unknowing father, Samaras becomes our son by cooking up and serving himself, often red hot. To call Samaras's surfaces ''Expressionistic,'' as they frequently are, is not to make their sadomasochistic point explicit enough. His self-portraits are at once sardonic, malevolent, and self-mocking. They are an act of self-consumption, as aggressive to the public as to the artist.

Samaras's uncanny surface (however it is achieved) is an aspect of the theatrical interpersonal space his pictures create. It helps—forces?—the spectator's identification with the artist. It helps the spectator experience Samaras's traumatic sense of self. It catalyzes cathexis, generates an involuntary leap of transferential faith to the artist. The Expressionistically uncanny surface is the supreme empathic fiction. The pictorial surface becomes raw yet embraceable flesh, whether tenderly rendered, as is usually the case in the pastel self-portraits, or more aggressively rendered, as in the painterly and photographic ones. (Another

important aspect of Samaras's uncanny artistry is his ability to give the photographic surface a painterly look and the pastel surface a "photo finish.") However mangled the pictorial surface may appear, Samaras never fails to make it seem like an irresistible delicacy. He is a master of ambivalent surface as well as ambivalent mood. He makes ambivalence sensually succulent—a choice piece of perverse meat.

Must one attribute to Samaras the evil eye, according to Freud "one of the most uncanny and widespread forms of superstition"?[7] Such an envious eye exposes our psychological nakedness, takes possession of our most prized intimate self, like a vampire sucks our lifeblood. Even more treacherously and analytically, it seems to be able to intuit unconscious feelings that one did not know one had. At the same time, it seems to give what it sees uncanny presence, overwhelming significance. In a sense, the evil eye's talent is Surrealist. Samaras shows it especially in his sculptural work, where he evinces what Marcel Jean called "the *expectant* character" of banal objects. It is a talent for experiencing the "symbolic—original or acquired—meaning" of ordinary objects.[8] It is the talent for transformation—revelatory transformation. It not only denies the "miserabilism"—the tendency to depreciate rather than exalt reality[9]—of common sense, but shows perception to be an assertive, "analytic" act in which the emotional significance of anonymous objects is revealed. In Samaras's world, no object is indifferent; it is spontaneously charged with feeling, in an act of association that on investigation turns out to be far from arbitrary.

In a sense, for Samaras, the self exists in the world as one more banal object, one more example of clichéd objectivity. It is rescued from the tedium of this objectivity by its transformation into an active subject through Samaras's artistic gaze, which has already rescued many objects from the world for the self. Integrated into an artistic (sculptural) illusion, these objects acquire the profundity of toys—transitional objects, as Winnicott calls them—through Samaras's mercy mission of narcissism. They become beacons illuminating the unconscious, rather than the petrified matter of the objective world. They become symbols of an unknown subject—heuristic gambits into it—rather than facts of the world.

Like Novalis, Samaras proposes and accomplishes the romanticization of the self. By presenting it as flexible to the point of frenzy, he infinitizes it. He generally shows it to be manic, to the point of dissolution. It becomes a matrix of gestures, highly charged particles of emotional matter in spontaneous, irrepressible movement. It is psychodynamic beyond any nameable, specific feeling—a demonstration of raw expressiveness. A particularly cogent example of Samaras's innovative way of making a picture seem primitively expressive is the simple system of

cuts—a childlike but highly effective device—he uses to create his Polaroid panoramas of 1983–84. The tight spacing of the ritualistic cuts suggests an apparently infinitely divisible Leibnizean continuum, dervishly beside itself yet realistic. Samaras is subversive, but he is also conservative. (The full import of this will be made clear in the next section.) He carefully appraises how much torture his figure can take, stopping just short of total disintegration.

In a sense, his transformation of the self through violence is imagination's defense of it. By envisioning the very substance of the self as intense expression—demonstrating that at root it is expressive for its own sake—imagination asserts a self that is impossible to civilize and objectify, a self that seems transgressive because it is impossible to be nailed down conclusively. It is a relentlessly creative self, in the sense in which creativity is a reaction of profound dissatisfaction to whatever is given by the world, a reaction of profound irritability that amounts to an expressive rupture in the self, which is, in effect, self-expression. Creativity is the self's retreat to elemental expressivity, its last line of defense against the world. Expression suggests that the self seems to be able to dispense with the world. For Samaras the creative, expressive self is too radically narcissistic to begin to know what it is to exist in the world, let alone to want to. Yet, one can even regard Samaras's "criminal" treatment of his figure as a kind of narcissistic self-crucifixion, in which he makes the best of society's indifference to him while internalizing it. His self-portraits are at once compensatory narcissism and radical alienation.

Samaras must keep moving if his sense of self is not to become stale—worldly. As soon as the self makes one expression, which threatens to become fixed on its face, another necessarily rises to replace it. Like Rameau's nephew in the tale of that name by Diderot, the self is trapped in an interminable round of self-transformation, a trap that is its only form of freedom. It transforms itself without knowing why it is compelled to do so. In fact, it changes shape out of sheer inner restlessness. For Samaras, art is a speculative and spectacular demonstration of the quixotic restlessness or inherent instability of the self. As we will see, for Samaras, art's own restlessness—the best art's indecisiveness whether it is abstract or realistic, its declaration of itself as both at once, however much it may seem one or the other—is an objective correlative of subjective restlessness.

For Samaras, art-making is a heuristic act of self-exploration, with no expectation of final, lasting self-realization. Let us go further: it is a masturbatory act of self-assertion. The argument that Samaras's art is masturbatory in character is not entirely a metaphoric one. In a photo transformation of December 1, 1974, Samaras depicts himself masturbating. Many of his works focus on the penis, as a sacramental object

to be used in a private ritual performance. With its emphatic eye, it is elusively a self-portrait. Positioned in front of the mirror in complete indifference to the world—the mirror is perhaps the ultimate sanctuary from it—he abandons himself to his bodiliness.

His nakedness becomes quicksilver, registering the temperature of wildly vacillating moods. His body dissolves in ecstasy. Losing its boundaries, it merges with its surroundings in a dynamically sublime scene—a baroque vision of ecstatic being. Each self-portrait articulates an ecstatic experience of selfhood. Each can be understood as a reassuring masturbatory act, allaying narcissistic anxiety in the very act of articulating it. Masturbation can be a major means of experiencing and expressing the self for all of us, which is why Samaras's art is captivating: it articulates a universal regression.[10] Art, an artistic act of self-pollution, brings out the monster in Samaras, perhaps the major moment of rebellion in his romanticism.

For all their masturbatory intensity—an intensity that is an end in itself for Samaras, that is beyond the good and evil that might result from masturbation—the self-portraits show him mimetically true to himself, if in an abbreviated way. Self-abandonment stops at the ultimate narcissistic barrier: the articulation of the self as an irreducible outline, a minimally functioning containment conserving a minimal sense of self. Nonetheless, Samaras's intensity carries him very far toward nihilism. Many of his self-portraits look like Rorschach test cards,[11] as in the 1983 head group. In such images Samaras's art seems to resemble the art of the insane, perhaps as filtered through the *art brut* of Dubuffet,[12] or such quasi-automatist, primitivist works as Duchamp's ink stain mask for the back cover of *Minotaure*, no. 6 (December 1934). Such affinities exist— Samaras acknowledges his Surrealist, primitivist heritage—but they do not mean that his art is really naive, a case of unconscious folly. It is not aesthetically simplistic in its self-assertion. Moreover, Samaras never relinquishes the reality principle, as the art of the insane does, which never had much of one in the first place—which is why the art of the insane seems thoroughly spooked. Through photography Samaras remains himself academically. For him it represents the reality principle at its most convincing, however much the sense of reality can be manipulated photographically. It also locates him in history. Samaras's art does suggest, perhaps more openly than other stylistically rigorous art, infantile belief in what Freud called the "omnipotence of thought," especially the magical, wishful thought that art has the power to determine (rather than simply recollect) the self. Samaras's art also has more than its fair share of anxiety about the potential disintegration of the self. But, instead of the monotonous, rigidly redundant character of the art of the insane, his

art has the flexibility associated with autonomy. His self-portraits are not simply artifacts of the unconscious—involuntary expressions of it, like the works of the insane—but conscious inventions. On the whole, his art affords us as much of an experience of going mad as it seems possible to have without actually doing so. Like all Romantic art, Samaras's art rests on the borderline between sanity and insanity, which it is constantly testing. It tries to capture more territory for sanity, but it usually ends up showing that the life world is more insane than was originally thought. This is what I call its ''psychotic Realism.'' But it draws back from ultimate commitment to madness, as the whole truth of life. Samaras's works are uncompromisingly romantic in attitude, which is why they have such an uncanny, borderline effect, redemptive of both sanity and insanity and of art, which Samaras shows can be a rigorously deep psychological exploration. He is one of the few deep sea divers in contemporary art.

Samaras's sanity is confirmed by his inventiveness. The measured heterogeneity of his production implies a nuanced yet iron grip on the complex self. His photographic mastery of its appearance is as uncanny in effect as his sense of its psychological reality. Not since Surrealism proper have we seen photography used so brilliantly to articulate the unconscious—a machine of seeing used to make the invisible inner organism visible. The work of an insane artist rarely shows such variety and precision, for the differentiations—substitutive, dialectical transformations of self—of diversification are beyond him or her. The insane tend to be rigidly self-identical—fixed in self-sameness—and untransformable. The insane are subtly petrified; they play the same game of fantasy over and over again. They have a sterile, academic sense of themselves. This, I think, reduces empathy for their art; it is as emotionally inaccessible as they are. Their art is the result, as it were, of the unexamined life, while Samaras's art is a way of examining it. Differentiation and mimesis—differentiation as awareness of the difficulties of mimesis—are more conducive to empathy than fantasy for its own sake, which seems to create a world too private to be inviting.

For all their cunning, Samaras's self-portraits do seem undeniably disturbed—a demonstration of disequilibrium. He seems to lose civilized distance from the unconscious, sinking into some underworld of uncontrollable, distorted self-perceptions. The self-obsession and self-distortions of his art invite comprehension in terms of the notion that the mad are inherently artistic and the artist is inherently mad—that madness is a kind of art and art is a kind of madness, each giving voice to the unspeakable other.[13] But Samaras's art is not so simple. It uses transformation ambiguously—not only to establish the reciprocity of art and madness, but to resist it. In Samaras's art they do not seamlessly merge, as they

do in the work of the insane. Art and madness never become identical, because art, in articulating the disequilibrium or distortions of madness, suggests hitherto unknown kinds of equilibrium, hitherto unsuspected harmonies or states of balance. Actual, known madness—radical, disintegrative disequilibrium—is risked for a possible, unknown kind of sanity.

The most important art is about this mission, which Samaras's art carries out in an exemplary way. It works through madness toward a new kind of equilibrium, even if that hitherto unimagined kind of equilibrium remains an imaginative intimation—a dimly glimpsed gesture of equilibrium, an unprovable hypothesis of equilibrium, seemingly impossible in fact but probable in imagination—perhaps only an eternal possibility in imagination, a mirage that appears whenever it works but that must be discounted, ignored. More than most other art today, Samaras's art has this phenomenological/imaginative import. Bracketed from the world by his narcissism, Samaras creates, in Husserl's words, ''free imaginative variations'' of his selfhood. His self-portraiture is a kind of self-searching in which one of the things freely varied is the self's sense of equilibrium (just as his art in general is a search for new possibilities of aesthetic equilibrium, as we will see in the second section). It is this uncompromising, free imaginative variation that makes his art seem mad or off balance; but the art of the mad is not directed to the goal of a numinous equilibrium. Each of Samaras's series of self-portraits is a kind of experimentation in equilibrium—he almost always works in series, as if to follow the trail of possible new artistic equilibrium to its bitter end—that proceeds by examining—working through, almost in a psychoanalytic sense—different kinds of disequilibrium or madness.

To my mind, transformation is transcendent as well as immanent for Samaras. While it is an instrument for the creation of artistic insanity or disequilibrum, it is also a means of suggesting a hopelessly ideal state of equilibrium, beyond the reach of art, not to speak of life. That abstract, latent idealism may be the most intimidating element in Samaras's art—more intimidating than his self-distortions.

Can we understand Samaras's distortions as a series of disguises on his idealism—on an embedded if muted sense of inner equilibrium, an ancient Greek sense of coming out of life properly balanced artistically for all the harrowing ordeals that tend to throw one off balance? The issue of Samaras's idealism—more Greek than his emotional fierceness, his fierce expressivity?—can be approached another way, through his Surrealism. Samaras realizes Breton's project of surreality to perfection: his art is an exquisite ''resolution of these two states, dream and reality, which are seemingly so contradictory.''[14] His art demonstrates that the ''extreme

degree of immediate absurdity''[15] of appearances is no passing phenom-
enon, but a lasting condition: the world is permanently distorted. Ab-
surdity may change form, but it will never disappear, for it registers the
enduring influence of the unconscious on the world: the world's subjec-
tion to its inescapable influence, the unconscious's powerful distorting
effect on the world's appearances. The variable but ineradicable ap-
pearance of absurdity reflects the world's inner disequilibrium, the
disturbed balance of powers that constitutes it—its permanently unsettled
state. Absurdity—apparent distortion—is a demonstration that the under-
tow of the invisible invariably shapes the waves of visibility.

But in a sense one can recognize the dominance of disequilibrium only
through a project of realizing equilibrium, a project which, however
Sisyphean, knows its goal in principle has conceptualized equilibrium
as an ideal possibility. It may be an irony of disequilibrium that it sug-
gests its opposite, in an intellectual and artistic form—an example of the
illusions, that is, madness, disequilibrium is capable of creating. It tempts
us with mirages to prove its power. Thus, to recognize the immanence
of distortion or absurdity as profoundly as Samaras does implies a belief—
not necessarily fully articulated—in transcendent equilibrium, the truly
unabsurd. This is not bad faith with the madness of the absurd, but the
genuine madness: to project equilibrium is to be truly absurd. In a sense,
we see the absurdity of Samaras's idealism—pursuit of occult balance—
in the way he harmonizes his materials into an absurd totality, perhaps
most transparently in his fabric reconstructions, 1977–80. Immanent in-
sanity is manifest in Samaras's transformations, but the transformation
is carried out in the name of a latent sanity.

Transformation, with its surreal and expressive effects, metaphorically
embodies universal primary process. One can understand this process
in Freudian or Kleinean terms, as either sexual or aggressive in
form/content—or both at once, a hand-to-hand contest between life and
death instincts, in which it is sometimes hard to tell one combatant from
the other (as both Freud and Klein came to recognize). Certainly it is im-
possible to distinguish the aggressive from the sexual in Samaras's self-
portraits. Their uncontrollably fluid, nightmarishly driven fantasy evinces
primordial psychic process. It is as though Samaras is stuck in a constantly
changing, disturbing dream of himself. But the self-portraits also seem
to show him fully awake. He peers out of the dream, fully aware that
it is swirling around him; it seems to be occurring without his doing. His
prominent eyes suggest this ambivalence. They create an effect of
''double-dealing'': his eyes show him in a trancelike dream state, but they
also elevate him above the dreaminess of his appearance. They have the
same double effect on us, hypnotizing us into a dream state yet waking

us from the dream state of our ordinary wakefulness. This is why Samaras's art is literally enchanting and uncanny. In a sense, it is a product of normal madness rather than of the madness that does not know what it is, that thinks its outlook is the norm. For the way Samaras depicts himself unconscious yet conscious of the "uncanny effect . . . often and easily produced by effacing the distinction between imagination and reality"[16] hints at the fact that he knows he is perpetrating an artistic illusion.

Order is . . . balance, something controllable, whereas emotion was not controllable, it was chaos. . . .
Lucas Samaras, 1986

. . . the whole twentieth century is full of mixtures and intriguing pollution.
Lucas Samaras, 1986

Samaras's art mixes methods. Completing his self-analysis—using it as an opportunity for the analysis of artistry as such (he would not know how to separate the two)—he works his way through every conceivable Modern style. He is as protean in his stylistic development as in his sense of himself. He has taken styles that have become petrified—so historically objectified and academically codified that they are beyond emotional recognition, emotional use—and made them alive by making them protean. He makes familiar styles once again disturbing, as though they were still developing unpredictably.

Beginning with Cubism, which he "liked . . . because it was a combination of a little realism and abstraction,"[17] Samaras moved to a kind of drawing—and photography is a kind of drawing/painting for him, an optimal synthesis of vivid color and invisible line—in which the realism of the photographic image and the "look of the handdrawn thing"[18] unite. He also makes pastels and paintings with a seductive, hyperactive—almost ingratiating—surface.[19] Samaras may start with the photographic image, discarding its often pornographic content, and draw his way to a handmade look. Or he may begin by hand and end with a simulated photographic look. He tends to fuse the productive and reproductive in a single visual eruption. Technically, his verisimilitude can be said to stand on two crooked legs: a photography perversely bent out of shape and a draftsmanship that operates without the slightest preconception of what proper shape is. Distortion is ingrained, or second nature, to the artificial naif. Samaras is even artfully naive conceptually: he refuses to work with any fixed idea of the similitude—if any—that art should advocate or issue

in—indeed, with any preconception of what the "issue" of art is. He is radically improvisational, so much so that the result seems rootless. His assumed naiveté is self-protective, a grace of sophistication, especially necessary in an art world where many artists have pursued purity: artful naiveté permits him to cultivate impurity. Modernism in the narrow sense never interested him, although he has mined the inherent traits of every medium he has ever worked in, and mastered each.

For Samaras, to be Modern means to be hybrid: to recognize that there is no privileged style or medium among the many that constitute the affluence of Modern art, and to "orgiastically" reconcile as many as possible. As though to fight the disintegration latent in their overdifferentiation—in the claim of each to be the true religion of art, and thus holding itself aloof from the other in pseudo-autonomy—Samaras conceives of art-making as a form of marriage brokering. He makes misalliances—improbable relationships, especially between different materials and objects—come out right by perversely associating them, which unexpectedly establishes them in an elemental relationship. His boxes and chair transformations are perhaps the most obvious examples of this, especially in their paradoxical use of metonymy to suggest unity. Metonymy creates an effect of structurelessness within the nominal structure of the box or chair filled with incongruous materials and objects, but it also summarily unites them in the same predetermined space. Samaras forces them together for emotional reasons, then discovers they cannot live apart physically. From our point of view, the metonymic treatment of the materials and objects forces their symbolic significance and subliminal connection to the surface, breaking the boundaries of the box or chair psychically. Metonymy creates a Pandora's box effect emotionally as well as physically.

The reconciliation of discrepant materials and objects is the manifest content of Samaras's art. Its latent content—the conflict that moves it to its depths, that is the most fundamental catalyst of Samaras's creativity—is that between representation and abstraction. The pendulum of his productivity swings between them, signaling their oppositeness yet inseparability. The one represents art's claims to make sense for the world, and so its claim on the world; the other, its claim that it can be comprehended only in its own terms. The one articulates its subtle power of analytic reference, the other its hermetic, self-idealizing integrity—its self-sufficiency, its inner necessity. The one articulates art as a special means of insight into the world—a heightened empiricism, able to bypass the usual methods of inquiry yet discover astounding truths; the other articulates art as the mystery to end all mysteries, a mystery accessible only to the initiated. The one articulates art as an intuitive yet unerring

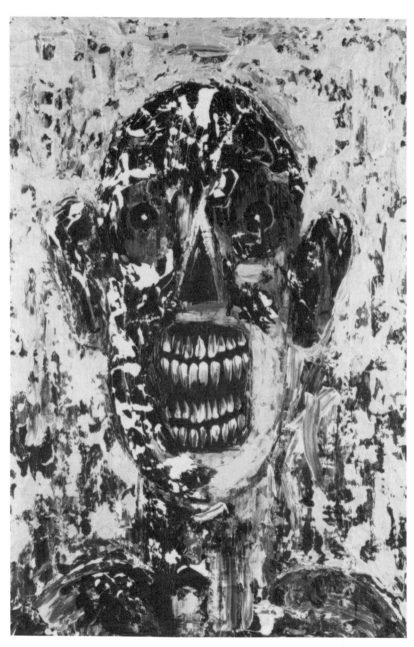

Lucas Samaras, *The Spectators (Silver)*, 1985
Acrylic on canvas, one of two 36″ × 24″ panels.
(Courtesy The Pace Gallery, New York)

means of knowledge, the other as an end in and for itself, perhaps the major clue to pure being. In the one case it is contingent, in the other absolute. The most urgent subtext of Samaras's art is the articulation of the balance of power between them as it exists at any given moment in Samaras's imagination. He repeatedly demonstrates that their relationship works, even though it seems unworkable. He toys with our sense of what is immanent in art, abstract form or representational image. The former would seem immanent, the latter the ''consequence'' built upon it. But Samaras sometimes makes us think the image is immanent; form is discovered through it.

The relationship of representation and abstraction is the self-conscious dialectic of every work Samaras makes, the issue it implicitly addresses. More precisely, all of his work is an exploration of the double bind in which modern art finds itself: the deconstructive undecidability, as it has been called,[20] between representation and abstraction. In acknowledging the self-deconstruction of art into contradictory discourses of representation and abstraction, often overtly arguing with each other, Samaras rejects the idea that art is metaphysical. There is a peculiarly comic aspect to the rupture in art, to its tense undecidability, to which Samaras's light touch—the childlike way his works self-deconstruct, declare themselves simultaneously representational and abstract—seems appropriate.

The confrontal reciprocity between representation and abstraction that occurs in Samaras's works generates an overall entropic effect, a sense of latent—and sometimes not so latent—chaos. Samaras shows us representation and abstraction as the two sides of a single process of art that is always in danger of running down or out. Samaras seems to stoically accept the inevitability of art's degeneration into an arbitrary activity that cannot be classified unequivocally as either cohesively representational or primordially abstract. At the same time, he subtly demonstrates the conservative character of entropy. One can even argue—as I will—that he makes it the dominant theme of his art. The problematic of entropy even informs his self-portraits. Samaras always presents himself in entropic form: running down or disintegrating, dematerializing into gestural ash, vaporously invisible except for the emphatic traces of such fetishized features as mouth or phallus. (One can understand this process of transformative dematerialization as draining cathexis from the whole to a part of the body. It is a cathexis of the part at the expense of the body as a whole—a narcissistic concentration of the self into a part, so that the self is as though newborn in the part, which now mothers all its being.) But the degenerate state can also be understood as the most necessary stage in a sublime, regenerative process: Samaras shows us

the phoenix of the self in transmuting flames. It disintegrates to reintegrate; art, for Samaras, is a transmuting process rejuvenating the self—perhaps the only process that restores to it the feeling of being young, the illlusion of eternal youth. Only an art concentrated to fever pitch can accomplish this: an art condensing every style in itself, an art that blurs the borderline between representation and abstraction until they seem merged indistinguishably in a singular apotheosis. Such art is fire enough for the self to show itself a phoenix.

More precisely, Samaras's art can be understood as a tense dialectic between the First and Second Laws of Thermodynamics. This dialectic is the ultimate source of its uncanny effect. It is the mechanism of Samaras's protean sense of self and art. The thermodynamic understanding of Samaras's art solves the problems of its perception. Thermodynamics explicates the relationship between representation and abstraction as the poles of a single artistic reality. They are the alternate currents of a perceptual continuum, in perpetual process of differentiation (the tendency to representation) and dedifferentiation (the tendency to abstraction). Ontologically, they are the poles of reality and process, in Whitehead's sense of the dialectic of concrescence that makes for the sense of concreteness. Representation and abstraction also symbolize the poles of a psychological continuum: on the one side, the achievement of balance or control of emotion (the ego achievement of clear and distinct representation, carried out under the auspices of a superego conception of reality, which becomes ''reality'' as such); and on the other side, the expression, invariably and cannily impulsive, of primordial, raw emotion (the id achievement of pure abstraction, whether organized into minimal cohesiveness and quasi-coherence or expressionistically random and chaotic).

The issue of emotional control is central to Samaras's art, by his own testimony. For Samaras, artistic transformation means the transformation of representation into abstraction or vice-versa; and self-transformation means the release of emotion from formal control or vice-versa— that is, bringing emotion under control by binding it into form. Ideally, artistic transformation and self-transformation should be one and the same. That is, representation should mean binding emotion into form, thus bringing it under control; and abstraction should mean emotional release, or relaxation—minimalization—of the constraints (''censorship'') of form.

Samaras conscientiously takes the plunge: he gives up conscious control or balance to release chaotic unconscious energy. It is not as easy to lose control as it may seem. For Samaras, artistic self-love, in which

the self takes itself as the other—represents itself to itself as the ideal abstract other (which is the ultimate narcissistic success story)—is a controlled way of doing so. When Samaras succeeds—however temporarily, before the self lapses back into a dull equilibrium—the result is a startling sense of formalized informality of self and art. This is perhaps most subtly evident in his entropic pencil drawings, in which figures or figural elements—formal representational factors—ambiguously emerge from and dissolve into a field of energetic marks. By chancing chaos, Samaras brings out the limits of form while conveying it as a process of binding energy. He shows how form conserves energy, but also how energy is always latent in it, in whatever degree of concentration or "representation." Each image must strike a balance between conservative form and chaotic energy, the one artistically centripetal, the other artistically centrifugal. But to be truly effective the image must show the balance as disturbed balance, a balance of formal representational and chaotic (informal) abstract forces that always seems about to tilt one way or the other. Samaras's pattern works, such as the fabric reconstructions, and his 1973 dot or spectrum works, demonstrate the simultaneity of conservative form and revolutionary energy more directly than any of his works, although the formal preservation of his outline or profile in the self-portraits makes the same point. Clearly, the pattern is the most straightforward way of conservation of energy. In a sense, the mimetic body pattern in the self-portraits is self-preservative—that is, it maintains the energy of the self at an optimal level of vitality—a level of intensity just short of disintegrating the self, violently dissolving its form. Artistic self-love is a means of self-preservation as well as self-release for Samaras, of representation of as well as abstraction from the self—a way of formally articulating it as well as dissolving it into the flux of primary process energy. It permits one to have one's cake of self-consciousness and eat it too. It is the eye of the narcissistic needle through which the self must pass to enter into the thermodynamic heaven.

The (idealistic) First Law of Thermodynamics, which deals with the conservation of energy, states that "energy may be changed from one form to another but is neither created nor destroyed." This holds true for emotional as well as physical energy. As suggested, Samaras assumes their oneness; that is, they are the reversible poles of the same particle of energy. The (realistic) Second Law of Thermodynamics states that "the material world moves from orderly states to an ever-increasing disorder and that the final situation of the universe will be one of maximal disorder,"[21] that is, of unequilibrated energy—formlessness. Samaras's image-pattern always seems on the verge of formlessness. In the still-life works of 1973 formlessness seems about to break out like a rash on the

well-formed scene. In the dot works, particles of color-energy are articulated in irreducible movement. They chaotically interact without establishing any form—that is, they never bind into a determinate structure. The same occurs in the fabric reconstructions with their metonymic grace and fury. These works show Samaras at one extreme of his oeuvre. They suggest that for him to definitely fix form would be to betray the energy it conserves. For Samaras, it is a mistake to take form as an end in itself. In general, for Samaras abstraction tends to obey the Second Law of Thermodynamics, while representation tends to obey the First Law of Thermodynamics.

There is another way of understanding the air of indeterminacy that surrounds Samaras's oeuvre, his ambiguous sense of the image as an "intimate," "magical object" not unlike an icon[22] but also as a kind of dead "letter."[23] This is through Austin's distinction between performative and constative utterances and the "unstable difference between them."[24] Samaras describes his art as a language that on the one hand performs a (magical) action and on the other hand describes an emotional (sexual) state. Not only is the distinction between them always breaking down, as in any entropic situation, indicating "language's unmasterable oscillation between positing and corresponding"[25]—a breakdown (undecidability) releasing the chaotic emotional energy repressively conserved or given form in language—but the formal distinction in itself demonstrates that only the preservation of opposites in such a formal distinction makes the operation of language possible in the first place. It is worth noting that Freud thought neurotic malfunction was due to the inability to tolerate contradictory ideas at the same time, and that Klein regarded mental illness as regression to the infantile state in which good and bad qualities could not be comprehended as belonging to the same person—that is, breakdown of the person into opposing qualities. Such splitting (breakdown, disintegration) is clearly operational in the "linguistic" difficulties of modern art—its bifurcation or fragmentation into representation and abstraction. Samaras, in brilliantly reintegrating representation and abstraction—that is, overcoming the difficulties of holding them together in the same artistic thought (work), thus doubling its vitality while tempting artistic fate to split them apart—shows the ultimate sanity and maturity of his art.

One might even say that the thermodynamic doubleness ("duplicity") of Samaras's art was Derridean before Derrida, to the extent that Derrida is correctly characterized as pursuing " 'free play' amounting to a 'methodical craziness,' to produce a 'dissemination' of texts that, endless and treacherous and terrifying, liberates us to an *errance joyeuse*."[26] The treachery of Samaras's images, arising from the dissemination of the texts

of representation and abstraction in a methodical, crazy, free play—the ability to live in this tropics of art is Samaras's genuine madness—liberates a similar epiphenomenal entropic joy in us. Samaras grafts representation and abstraction. He creates a graphic image that charts the textual ups and downs of their intimacy. His art is the romantic record of their relationship, which is the ultimate Surrealist copulation of strangers, who inwardly knew each other all along, but had to discover each other through art to embrace openly.

Samaras is Mephistopheles: a specialist in impossible conjunctions—in conjuring wish-fulfillment. Samaras is also Faust, having his wishes fulfilled. One of Faust's wishes—fulfilled by Mephistopheles—was to marry Venus. Faust represents life, exhausted and in need of rejuvenation; Venus is love, the only source of rejuvenation. Faust represents reality, always in search of the illusion of freedom—and hoping to find it through Mephistophelean artistry, wizardry—which it projects onto ideality. In a sense, Samaras takes the materials of life and rejuvenates them—gives them a peculiar freedom, ideality—by treating them erotically. For him, art is erotic and autoerotic. He takes personal materials he has become disenchanted with—his body, his face, objects reminiscent of objects he grew up with, objects exhausted by the memory of them, objects whose enchantment was fading—and revitalizes them through artistic, loving "handling." Samaras has said "sexuality is there—whether you like it or not—or whether you see it or not."[27] He means that it is not just in the images but in the materials and their relationship. Sexuality is the basis of art, epitomized in its thermodynamic problematic.

Samaras has shown that art may be the most volatile, theatrical form of self-love. His technique of transformation is akin to Stendhal's "crystallization."[28] Freud regarded love as a form of insanity, for love was inherently overestimation—idealization of an object. Samaras's self-love is, then, the profoundest insanity, for it implies the overestimation of the self by the self that loves. Art, like love, is a form of overestimation; its works are the theatrical products of crystallization. Samaras's art of self-love—self-idealization, overestimation of himself—shows itself most vividly in his intrusion of himself into the medium in his photo-transformations, his interference with the process of the developing Polaroid picture. It has been suggested that esthetic effect is nothing but the mutation that results from such intrusion in a medium. Samaras cannot stay out of a scene, even when it involves someone else's self-love, as in his Sittings, where his subjects warm to the thought of the picture of themselves in the mirroring camera. Samaras is present not because he expects to seduce the subject—although such deliberately unconsummated Kierkegaardian seduction has also been regarded as of the essence

of the aesthetic[29]—but because every scene is the occasion of self-discovery and self-identification for him.

Samaras's presence at the sittings, ostensibly as the photographer, has nothing to do with vanity. Rather, it is a matter of the profoundest narcissism, for it is a response to the knowledge that in the modern world where everyone can be mechanically mirrored—can have their most apparent social self, what Winnicott called their false self, beautifully photographed—no one will bother to love or mirror or relate carefully, organically—to attune to anyone else deeply, like a perfect mother. Samaras's subjects are too in love with the image they expect him to create for them to mirror their creator. They have given up the search for the mirror that can reflect their inner, most vital self back to them. Indeed, they have not seen through Samaras's Mephistophelean deception: he has created a mechanical mirror image of their false self, let them posture to the fullest. Their nakedness and positioning of themselves in front of the camera/mirror is pure vanity, not a revelation of their inner reality. Samaras has made the mirror that can reveal the true self rather than simply reflect the false self, but he keeps that mirror for his own exclusive use.

Notes

1. Heinz Kohut, *The Restoration of the Self* (New York: International Universities Press, 1977), p. 116.

2. Ibid.

3. Arnold Glimcher, "Lucas Samaras," *Flash Art* 124 (Oct./Nov. 1985): 43.

4. Sigmund Freud, "The 'Uncanny,' " *Collected Papers*, vol. 4 (London: The Hogarth Press and the Institute of Psychoanalysis, 1925), pp. 383–84.

5. "Freud distinguishes between 'primary' and 'secondary' narcissism. By 'primary narcissism' he means the phenomenon whereby the libido of the small child is wholly self-directed and does not yet extend to the objects in the outside world. Freud believed that during the maturation process the libido turns outward, but that in pathological conditions it detaches itself from objects and is reflected back on one's own person ('secondary narcissism')." Rainer Funk, *Erich Fromm: The Courage to Be Human* (New York: Continuum, 1982), pp. 43–44. I regard Samaras's narcissism as a response to the pathological conditions of the world, including the art world. (His portraits of artists, critics, dealers, curators, etc. show the pathological effect of the art world on the people who inhabit it.)

6. Freud, *Collected Papers*, p. 391.

7. Ibid., p. 393.

8. Marcel Jean, "The Coming of Beautiful Days," *The Autobiography of Surrealism*, ed. Marcel Jean (New York: Viking, 1980), p. 304.

9. André Breton, "Away with Miserabilism!" *Surrealism and Painting* (New York: Harper & Row, 1972), p. 347.

10. According to John E. Gedo, *Beyond Interpretation* (New York: International Universities Press, 1979), p. 114, "masturbation with perverse ideation" arises "in circumstances that call for buttressing the sense of self"—that is, when it is threatened with disintegration. Masturbation arises because "expectable adult genital acts do *not* affirm the self sufficiently" (p. 115). For Gedo, "the basic perversion is fetishism—i.e., that all other forms that can be conceptually reduced to variations on the theme of manipulating an infantile fetish," which is what masturbation can be understood to be.

11. Douglas LaBier, *Modern Madness* (Reading, Pa.: Addison-Wesley, 1986), p. 225, describes the Rorschach test as consisting of "ten inkblots printed on separate white cards, about 7 × 10" large. Some are in shades of black and white (Cards I, IV, V, VI, and VII), and others are multicolored (Cards VIII, IX, and X). The person is handed each card and asked to describe what they look like—everything they see in them. The card may be looked at in any way the person wishes, and there are no time limits. After the responses are obtained, the person is asked questions about the location and other aspects of the ink blot he or she utilized in a particular perception." In a sense, Samaras's ink blot self-portraits mean to generate free association and interpretive identification with them.

12. In 1945 Dubuffet began to assemble what eventually became *La Collection de l' art brut*, now in Lausanne. According to Gerard A. Schreiner, *European Outsiders* (New York: Rosa Esman Gallery, 1986), p. 13, the goal of the project is "to gather works of art which bear no connection to that seen in museums and galleries, but in which invention and creativity manifest themselves immediately and directly, without restraint."

13. See Sander L. Gilman, *Difference and Pathology* (Ithaca, N.Y.: Cornell University Press, 1985), pp. 217–38, for an examination of the assumption of the reciprocity between art and madness.

14. André Breton, "The First Surrealist Manifesto," *Surrealists on Art*, ed. Lucy Lippard (Englewood Cliffs, N.J.: Prentice-Hall, 1970), p. 15.

15. Ibid., p. 19.

16. Freud, *Collected Papers*, p. 398.

17. Lucas Samaras and Demosthenes Davvetas, *Dialogue* (Zurich: Elizabeth Kaufmann, 1986), p. 56.

18. Ibid., p. 61.

19. Glimcher, "Lucas Samaras," p. 43.

20. Jonathan Culler, *The Pursuit of Signs* (Ithaca, N.Y.: Cornell University Press, 1983), p. 15.

21. Rudolf Arnheim, *Entropy and Art* (Berkeley: University of California Press, 1974), pp. 7–8.

22. Samaras and Davvetas, *Dialogue*, p. 89.

23. Ibid., p. 78.

24. Jonathan Culler, *On Deconstruction* (Ithaca, N.Y.: Cornell University Press, 1982), p. 133.

25. Ibid., pp. 133–34.

26. Wayne Booth, cited in Culler, p. 132.

27. Samaras and Davvetas, *Dialogue*, p. 71.

28. Stendhal, *On Love* (Garden City, N.Y.: Doubleday Anchor Books, 1957), p. 7, describes crystallization as "that process of the mind which discovers fresh perfections in its beloved at every turn of events." The conception derives from a bough left in the Salzburg mines. Speaking to a Signora Gherardi, who was "playing with the pretty twig covered with shimmering diamonds which the miners had given her," Stendhal remarks: "The effect produced on this young man by your distinguished Italian features, and by your eyes like none he has ever seen before, is exactly like the effect made by crystallization on the little hornbeam twig in your hands, which seems so pretty to you. Stripped of its leaves by winter it was surely anything but dazzling: and now the crystallization of the salt has covered its blackened surface with diamonds so brilliant and numerous that it is only here and there that you can catch a glimpse of the real twig" (pp. 326–27).

29. I am alluding to the "Diary of a Seducer" in "The 'Either' " section of Sören Kierkegaard's *Either/Or.*

Lucas Samaras's Death Instinct

*It really seems as though it is necessary for us to destroy some other
thing or person in order not to destroy ourselves, in order to guard
against the impulse to self-destruction. A sad disclosure indeed
for the moralist!*
> Sigmund Freud, *New Introductory Lectures*, 1933

*But the most powerful factor of all and one totally beyond any
possibility of control . . . is the death instinct.*
> James Strachey, commenting on Sigmund Freud's
> *Analysis Terminable and Interminable*, 1937

Lucas Samaras's art has always been self-obsessed, from the time of his
film *Self* (1969), his *Autopolaroids* (1970–71), his *Photo-Transformations* (1975),
and his *Sittings* (1980), in which the artist is a peripheral yet still intrusive
and controlling presence—the impresario—in photo-portraits of the liter-
ally naked Other Self. In the *Sittings* Samaras staged the Other Self much
as he orchestrated himself in the earlier work. Now, in morally didactic
allegorical "portraits" of art-world types—curators, patrons, spectators,
critics, as well as the artist's friends and failed artists—Samaras offers fan-
tasy images which psychodramatically strip specimens of the Other Self
to a spiritual, pathological nakedness that has not been seen in art since
Dubuffet's portraits of the 1950s. Painting with a relentless yet all too self-
conscious, overdetermined, almost rococo, Expressionistic verve—it is as
though he was consciously stirring a witch's brew rather than revealing
his own unconscious agony—Samaras achieves a sense of starkness and
rawness at once epitomizing and outstripping that offered by Goya and
van Gogh: Samaras continues and carries to an extreme their Modernist
project of existential revelation. He creates pictures which reveal the in-

This article originally appeared in *Lucas Samaras* (Exhibition Catalogue; Athens: Jean Bernier
Gallery, 1986).

nermost secret of his art, the secret that makes it one of the most power-
ful if perverse demonstrations of Modern "heroism": his art is a kind
of heroic response to madness, the madness innate in life, the madness
of the instincts themselves, especially the madness of the death instinct.
Samaras's art is a grandiose articulation of the death instinct. These por-
traits make explicit Samaras's preoccupation with the threat of—and the
possibility of mastering and even enjoying by rhapsodically venting—
mad aggression. Through their rhapsodic aggression they show a strong
will to death. Samaras demonstrates the instinct to destroy, and the
madness that comes from recognition that it is impossible to control rabid,
raging aggression—the madness of giving into it. One can only displace
it—let it rage in art, joyously run amuck in corrosive painterliness.

But even there it turns against the artist, by way of turning against
the inhabitants of the art world Samaras himself inhabits—in which he
is simply one more personage, however prominent. (Do these pictures
express his frustration at being merely one among many? Does he want
there to be only one throne of art, with himself autocratically upon it?)
These pictures are daring in their insultingness—in the way they implicitly
insult by impulsively destroying in fantasy all those Other Selves Samaras
must deal with in the art world, and thus by the way they demonstrate
Samaras's own self-destructiveness—his insult to his own existence. The
crucial point about these fantasy figures is that they belong to the same
art world Samaras does; in the end they are all personifications of Art.
The resemblance between the figures is more emphatic than the dif-
ferences between them, so that to show them living death is to show Art
as Living Death. In polemical, holo-caustic paintings—Expressionistically
holistic and caustic in intention—Samaras symbolically presents the
apocalypse—genocide?—of the art world. Samaras shows himself con-
sciously consumed with destructive rage at the art world, and thus un-
consciously self-destructive, for he too belongs to it.

These portraits show a virulent painterliness that subverts the sur-
face of the Other Self to reveal the unfamiliar—if unconsciously familiar—
death's-head within Samaras's, and Art's, self. In a brilliantly inventive
recapitulation of Triumph of Death iconography, Samaras fuses the figure
of death with that of death's victim. He makes explicit the death that is
within everyone—the inner image and expectation of our own death that
we carry around in our deepest Self, and that we project on the Other
Self because it is so intolerable to our own Self. Samaras has shown that
art is the ideal instrument of this projection—that art is the profoundest
manifestation of the death instinct, for it projects the artist's own sense
of death onto the world that belongs to others—the world that he fan-
tastically re-presents. Art, indeed, kills the thing it loves—by making it

into art. Samaras shows that art is rooted in the death wish—however erotic (painterly) a form it may take: he suggests that conscious creativity is unconsciously destructive. If, as Max Friedlander has argued, every portrait is a self-portrait, then Samaras's portraits of the living dead—the zombies—of the art world must in the end be portraits of the artist himself. Samaras once again demonstrates that all the roads of his art, however deviously, lead back to himself, and that he has always been preoccupied with death, from the earliest aggressive boxes, filled with dangerous needles. Art must hurt to be art.

Samaras's art at its best has always been a temptation to madness—to loss of self-control, to uncontrollable impulse that takes fantastic form. In this he controverts the conventional assumption that art is an exercise in progressive control and self-control, in establishing distance and detachment. In the art world portraits Samaras shows that through fantasy art in fact regressively attempts to collapse all distance between the Self and the Other Self, not in empathy, but in angry acknowledgment and rage at the implicit presence of the Other Self in oneself—at the possession of the Self by Other Selves. Samaras's art world figures are ambivalently rendered—they are at once ugly threatening monsters and elegantly grotesque or ghoulish clowns—because they are self-objects, to which Samaras is perversely attached but from which he wants to free himself. He wants to purge them from his inner presence to himself—from his narcissistic sanctum. The conflagration of his painterliness is an attempt to burn them beyond recognition—burn them out of his unconscious—so that they can no longer ''burn'' him. Samaras is destroying his own dependence—on patrons, spectators, critics, friends, even on artists whose failure brings his own success into doubt while throwing it into relief. (There but for the grace of the aggression—the death wish—in him goes Samaras.) His is an incendiary art, burning to death—purging with a scorching painterliness—the art world that is his necessary but reluctantly accepted mirror and arena.

In these paintings Samaras has risen to a painterly wildness and virtuosity beyond anything in his pastels and photographs. He has moved towards a radical new outspokenness of handling. From the violently impulsive painterliness, an image emerges spontaneously as from the depths of the unconscious. It is a vivid shape with prominent teeth, as though the teeth alone can fix the ephemeral figure in our minds—hold it firmly as they hold us tightly. The aggressivity of the teeth also signals Samaras's death fixation. In these works, Samaras has extended the Romantic/Symbolist project of making the depths of the unconscious horrendously conscious—of terrorizing consciousness with the unconscious—to an almost unbearable limit.

Samaras remains the most profound of the many so-called artists of content working today, because he has consistently been obsessed with the content of the deepest Self. What makes Samaras's current paintings of major importance is that they fuse in a singular horrific image the double Self of modern man, what the psychoanalyst of selfhood Heinz Kohut has called Guilty Man and Tragic Man—the two infants within Man. The one is "the man of structural conflict . . . sorely tested by his wishes and desires." The other is the being with a "crumbling, decomposing, fragmenting, enfeebled self . . . and, later, a fragile, vulnerable, empty self." Samaras has painted the archetypal Demonic Self, a madcap protean figure capable of taking many shapes but always a combination of the infant and the monster. Samaras has painted the eternal infantile monster—the creature of unbounded instincts who madly makes art. It is the Dionysian Demon that Socrates brought under Apollonian control—tamed into his Daemon—but which Samaras has recovered in all its prephilosophical madness.

The irreducible nihilism of Samaras's haunting figure—always witnessing us wide-eyed, following us wherever we go as though it came from within us, the genie Self within our bottled-up being that doesn't really want to escape—is responsible, as it were, for his paroxysmal color and handling. Samaras offers us Mephistophelean colors that lead us astray, colors of efflorescing decay that like those of a false flower seek to trap us in death, by luring us with the illusion of life. Within alive color, Samaras reveals lethal anti-color. Samaras's ambiguous color reminds us that our relationship to art is unconsciously necrophiliac, like his own. When we love art, we love our own death in its most alluring form. We are seduced by our own death. When Samaras shows all those possessed by art to be possessed by death, he shows the uncontrollability of his art's instinct for death. When death makes what seems like a whimsical appearance in his art, Samaras completes his displacement of his expectation of imminent death onto art. Samaras's fantasy figures bring home to us the mysterious urgency of our desire to embrace death, which cannot wait for death's embrace of us.

Robert Arneson's Sense of Self: Squirming in Procrustean Place

One work by Robert Arneson—a far from major one, though psycho-analysis has taught us that the seemingly most incidental aside can bespeak an entire psyche—seems to me to concentrate in itself the essence of his ceramic art. *A Question of Measure*, 1978, a relatively—for Arneson—mild-mannered plate, marked with gestures whose punch has been pulled, shows Arneson substituting "his own stout likeness" for the "perfectly proportioned, ideal male figure" in Leonardo's famous draw-ing.[1] Overly dramatic gesture would distract from the plate's "domestic" import—the way it shows us Arneson uncannily at home with himself, if not entirely comfortable in the circumstances of the comparison. Abstract ideal man is displaced by personally concrete man, but not entirely eliminated by him. The ideal is assimilated—introjected—by Arneson, and twisted to his own end: projected out again in distorted form through his own sculpture. This is a typical Arneson means of raising himself by his own bootstraps—a strategy for raising the craft of ceramics to the status of an art.

In *A Question of Measure*, the artist is not so much "debunking the notion of man as the measure of all things, the most perfect of all be-ings,"[2] as measuring himself against the image of the ideal man that his own obliterates, and in a sense "overcomes." Arneson is ambivalent about rather than dismissive of Leonardo's image of the ideal man and, by implication, ambivalent about Leonardo himself, generally regarded as one of a handful of unequivocally great artists. It is worth noting that Leonardo's ideal man neatly and unrealistically fits within a square and circle, suggesting that he represents a solution to that most impossible of mathematical problems, squaring the circle. To square the circle is to possess special cosmic power, for it is symbolic of the mysterious—

This article originally appeared in *American Craft* (October/November 1986).

mystical—correspondence between incommensurate forms on a cosmic level. Arneson signals his own genius—ability to accomplish the impossible—through his appropriation of Leonardo's mystical man.

Leonardo, for all the technical flaws of his art—typified by the *Last Supper* fresco, which began to disintegrate even before it was completed—created images that seem at once perfectly natural, bespeaking the charm of nature with extraordinary ease, and sublimely perfect. Arneson is in effect competing with Leonardo, at once challenging and perversely emulating him. In fact, where Leonardo puts perfect figures on a flawed material base, Arneson can be said to render flawed figures with perfect mastery of material. This reflects the difference between the ancient and modern senses of man and of craft: the possible ideality of man, summarized in the beauty of Leonardo's figure, contrasts with the actual ugliness of Arneson's unrefined man; and a limited sense of craft—which Leonardo, in an experiment that failed, attempted to extend—contrasts with Arneson's sense that every risk can succeed, that technical control can be limitlessly extended.

Nonetheless, for all their differences, there are more resemblances between Arneson and Leonardo than might be expected. Arneson has the same respect for nature, the same determination to raise the status of his work, and the same sense of it as an ongoing experiment. But where Leonardo saw nature under the happy sign of the ideal, Arneson sees it in all its unhappy actuality. And where Leonardo raised painting from craft to art status by giving it a learned, humanistic dimension, Arneson raises ceramics from craft to art status by giving it a similar humanistic dimension, but one whose ''learned'' character has more to do with being streetwise and smartass than intellectual. Finally, where Leonardo restlessly explored new possibilities of articulation of divine nature in painting, Arneson restlessly explores new possibilities of the sculptural articulation of raw (human) nature. They both have an unerring sense of the weight of detail and the symbolic effect of its epiphanic use. Despite the fact that Leonardo pursued perfection in nature and art, and Arneson rejects perfection (especially of man) as an absurd idea—a rejection central to Funk, of which Arneson is a leading advocate[3]—Arneson can be regarded as united with Leonardo through oppositeness. Like Leonardo, Arneson is a rebel. He tends to stylize the imperfect, suggesting a certain perfectionism. His funky imperfection is as intimidating as Leonardo's perfection.

I want to emphasize the unconscious meaning of *A Question of Measure*, for it is a talismanic work. Leonardo's ideal man remains an invisible field of force affecting the display of Arneson's figure. It is the hidden background which determines the disposition of—partly absorbs

or dissolves—Arneson's foreground figure. The ironical flattening of the portly figure's midriff into the plate's space—a flattening which amounts to a partial mystification—suggests Arneson's ambivalent attitude toward himself: half idealizing, half mocking. The flattening gives added relief to Arneson's chest and outstretched arms, and especially helps "realize" his hairy head, genitals, and to a lesser extent legs. "Ecce homo!" Arneson seems to be saying. Behold not only the Renaissance man—one of the men responsible for the renaissance of ceramics—but also the suffering man, nailed to the cross of his art, an art which has always been underappreciated on account of its anti-elitist imagery and its material.[4]

A Question of Measure gives us a palimpsest of three figures in one: implicitly, Leonardo's ideal man; explicitly, Arneson—ideal by reason of his revolutionary work as a ceramic sculptor and victim by reason of his feeling unappreciated by the art world. On one level, Arneson is cockily self-assured; on another, he is full of angry self-doubt because of the ambiguous reception of his work. It is as though he had brought his own difficulties upon himself because of the rebellious superiority of his vision—of ceramics, the self and the world. (The sense of himself as innocent victim is also probably related to his prolonged bout with cancer, recently cured.) This double sense of self—his inferiority and superiority complexes—fused with a sense of the theoretical ideality of art and the artist, informs all his self-portrait busts.

Arneson's sense of victimization also appears in *Casualty in the Art Realm,* 1979, another plate, in the form of a palette-puzzle. (Arneson's work in general is "puzzling," presenting itself as a psychophysical riddle to be unraveled.) The anonymous figure is obviously related in pose to the figure in *A Question of Measure.* At the top of the plate, Arneson has cancelled out his own comically melancholy face: he is the casualty. The humor bandages the painful wound of narcissistic injury, but hardly stops the flow of emotional blood from it. Indeed, Arneson compulsively repeats and repeats his hurt, and the proud humor that veils it, in self-portrait after self-portrait. It is this same hurt that spills, transfigured and depersonalized, into Arneson's horror-movie sculpture dealing with the threat of nuclear catastrophe—among the most powerful political art statements to have been made in recent years.

The Leonardo figure reappears on the base of *Self-Portrait with Bio Base,* 1982, a little more raunchy and tired looking—more realistically Arneson. (Good realism has an "ugly" look to it, as though the strong assertion of the reality principle in art necessarily meant the serious weakening of the pleasure principle that is usually thought of as its basis.) Arneson seems to be feeling his age in this self-portrait drawing—which contrasts sharply with the vigorous self-portrait bust that tops the base.

It is worth comparing the Leonardoized Arneson with Robert Morris's self-portrait in his *I-Box*, 1962. Morris's naked self, also comically self-aware—self-satirizing—is as completely cocooned by an anonymous abstract symbol as Arneson's figure is by Leonardo's ideal man. But Morris is more the poseur than Arneson, as Morris's sadomasochistic photo self-portrait, 1974, indicates. Arneson is playing with a firm sense of self rather than playacting a self, as Morris is. Arneson has a personal sense of self, Morris a conceptual one, distanced from its experiential reality. While both artists, in the 1980s, have become increasingly vaudevillian—self-defensively?—in their search for a public style with carrying power, and have created works that are a kind of prolegomena to a possible nuclear holocaust. Arneson's personal engagement is greater than Morris's, or at least more obvious. He does not see the nuclear holocaust from some transcendent, cosmic point of view, as Morris pretends to. Arneson could never imagine that he and his art's destiny could be separated from the world's.

Arneson, then, identifies with Leonardo—the first of many such identifications with artists officially more successful than himself. He envies these artists and cuts them down to size—recreates them in clay, i.e., in a vulnerable material that suggests their vulnerability. And their mortality—they are, as it were, buried ("alive") in earth. (Simply to render them in clay—rather than in bronze or stone—is comic and devaluing, an ironical commentary on their immortality as artists.) Yet they remain, however "funkified," ego ideals and emblems of success. Thus he shows us van Gogh, addressed familiarly as *Vince*, 1977 (a drawing for a clay work); Picasso, as *Pablo Ruiz with Itch*, 1980; Duchamp, at his most tacky and coy, as *Rrose Selavy*, 1978; and Francis Bacon, as *Raw Bacon*, 1980.

Jackson Pollock, obsessively depicted in a series of drawings and what are in effect ceramic death masks, 1983, is the only figure not presented satirically, perhaps because he's the only American in this internationally renowned group—the only unequivocally great modern American artist. Also, because America diminishes its geniuses, caricaturing them by popularizing them. Arneson may have felt the need to elevate Pollock by treating him with high seriousness. (Arneson may seem to be a spunky all-American artist, but he utilizes the American tendency to level whatever it embraces for his own sensitive high-art purpose of self-exploration, including the discovery of other strange selves.) In general, caricature in America masks incomprehension, whereas in Arneson it is an instrument of depth-psychological analysis. Popularization, the American form of homage, hollows out and trivializes—overobjectifies—the heroes it celebrates. It is only when the self is turned into contentless celebrity that it can become popular in America. It is widely distributed

only as a shadow of itself, and with no suggestion as to the difficult process in which it was produced. Arneson restores the tragic, tortured aspect of Pollock—resubjectifies him, as it were—which is the core of his heroic art, and the secret core of Arneson's apparently anti-heroic art. Arneson's identification with Pollock may also have to do with the artist's early death, until recently a source of anxiety for Arneson.

In general, the license Arneson takes in his representation of other artists, reducing their art to an extended personal quirk—Picasso's itchiness and physical restlessness, Duchamp's voyeuristic slyness—debunks them, but also allegorically suggests their power of sublimation and their self-awareness. They are familiarized into colleagues with compulsions, convertible into original outlooks.

Arneson has been called a California clown. There is certainly a strong streak of democratizing vulgarity in his work. He offers us a far from appetizing image of himself; we are as likely to choke on it as to find it funny. He undermines the inherent dignity and "nobility" of the bust format he customarily uses. He becomes all too familiar with his subjects. *George and Mona in the Baths of Coloma* (1976) downgrades George Washington and Mona Lisa, exemplarily dignified figures, to a sexually engaged couple. It is a more direct (more American?) revelation of their "underside"—presumably they're naked in the water—than that Duchamp (with supposedly more superior or sophisticated French indirection) made by way of the moustache and linguistic "code" he gave to Leonardo's *Mona Lisa*. Arneson doesn't operate in terms of elitist art jokes, but rather in wide-open populist terms.

What Arneson does is show himself, and the others he portrays, squirming in Procrustean place: he uses the bust format in as flexible a way as possible, but it nonetheless remains as fixed as if in a vise. For all the profound restlessness he gives his subjects, they can never escape from this highly symbolic formal mold. The traditional bust, with its constraining convention of a clear relationship between a highly held head and the "low" body of the base, can be stylized into an emblem of the fixed social model of self. It objectifies the conventional way of thinking of ourselves as partitioned into noble mind and ignoble body, simplified in the bust as the nondescript base. Arneson turns the bust upside down, "undoes" it: he treats the head very physically, turning it into a kind of grotesque organ, and the physical base as if it were the seat of the mind, a sort of "brainstorm" of information. By exploiting the inherent tension of the bust format, and making bust and base self-contradictory—physicalizing the head by generally treating it in an "ignoble" way and mentalizing the base by treating it as a kind of kiosk eccentrically covered with messages—Arneson makes his portrait-busts profoundly expressive.

His figures can be experienced as autonomous subjects. His Expressionistic handling, which sometimes seems "ornamental," is another means of articulating the figure's restless desire and effort to escape its fixed place and approved shape in the world—to transcend the conventional determination of the self, to break down its familiar boundaries by means of a wild subjectivity.

Arneson is transfixed by the contradiction between the self's awareness of itself and society's sense of it. He tries to emancipate the self from social conformity by overstating its inherent nonconformity. His figures almost always seem to be struggling to free themselves from some inner claustrophobia, the effect of bondage to external, artificial, bourgeois norms of self-presentation. Arneson depicts a self manically—heroically—struggling to liberate itself from the social control symbolized by the highly structured system of the bust format. He wants to break down its rigidity in order to convey the self's autonomy. In general, Arneson shows himself, and other artists, squirming like Laocoön to escape the coils of the snake of the stylistic/social "system." Such escapist resistance may be the essence of Funk, and the reason why California, which used to be the place to escape to—the escapist paradise—is its "natural" home.

The artist's—Arneson's—self is one that continues to resist being administered by society, long after the rest of us have capitulated. This is the essence of its subjectivity. So Arneson reshapes it, or pulls it out of shape and undermines our sense of its being set immutably in place. He shows its resistance to fixed shape and place to symbolize its resistance to assigned shape and place. By constantly playing with the relationship between bust and base, and by showing the portrait bust often in wild disarray—the parts of the face as deliberately disequilibrated as the relationship between bust and base—Arneson creates a disruptive, squirming effect, a subtly morbid discomfort that seems a prelude to a metamorphosis of self. Indeed, in *Mr. Hyde*, 1981, the metamorphosis has occurred: Arneson puts in a Dionysian appearance as the self-intoxicated Silenus. This head seems to me covertly preparatory for the various "death's-heads" of nuclear imagery, which tilt away from the erotic to the thanatopical, although retaining, in their "inflammatory" surfaces, a distinctly erotic element. These range from the victim heads of *Ass to Ash*, 1982 (a self-portrait), *Holy War Head* and *Head Mined*, both 1982–83, and *Ground Zero*, 1983, among others, to the victimizers' heads of *Federal Emergency Management Agency*, *Colonel Nuke Pricked*, and *Joint*, all 1984, and *General Nuke*, 1985. These heads are primitive—in different ways—in appearance and force, revealing the psychodynamic or psychodramatic underside of the human face. Its sociable everyday cover has been ripped off. In a 1978 drawing, *Double Mask: Wearing a Happy Face*, the game is

given away: Arneson's experience of the doubleness of self—the double-ness he tries to suggest in all his portraits—is both burdensome and liberating. For only when the self knows itself as double—squirming out of one psychic state and metamorphosing into another, its opposite—does it experience a sense of freedom. Ambivalence is freedom as well as suffering.

Arneson articulates ambivalence through violation of the norms of the bust's and face's appearance, violation which becomes an instrument of revelation—a revolutionary reminder of underlying, hidden reality. For me, perhaps Arneson's most startling reconstitution or reconsideration of the bust is his sexualization of the base into a body by giving it genitals, as in *Classical Exposure* and *Fragment of Western Civilization*, both 1972. In the latter, the genitals appear about midway up the pile of bricks—crucially placed atop the pyramid and supporting the rows of brick. It is these genitals, the normally invisible "fragment of Western civilization"—sometimes their public invisibility is a society's major claim to being civilized—that are the ironical subject matter of the work. Arneson's split head is separated from his tragically collapsed, fragmented body, which is also castrated. It is Arneson, as well as Western civilization, that is in ruins—that has lost its head and balls and so become a wreck. This con-version of the base into a herm shows his ability to put art history to depth-psychological use. His regression to past art history—which is fairly, if subliminally, constant in his work, and part of his effort to raise ceramics to the status of high art—is in the service of his own rebellious ego. It also reveals an intention to treat past art as a discreetly "primitive" avenue to a repressed psychosocial content.

In general, Arneson puts the portrait bust to symbolic psychological use: it becomes the "picture" frame of consciousness, the straitjacket he tries to break out of by deliberately acting unconsciously. He tries to squirm out of the fixed setting by presenting himself in a self-consciously unrepressed, anti-social way. In the public context of the bust, he ap-pears as though in private, deliberately doing perversely intimate things, such as picking his nose, as in *Two Finger Job*, 1980—reminding us of what the Viennese writer Georg Groddeck said about the nose-picking, i.e., masturbation, that even famous people do. Arneson, as noted, also vigorously experiments with the base as well as bust, often inscribing graf-fiti on it—making it as much a historical "speaking likeness" as the bust (the 1981 George Moscone portrait is a prime example)—or, as in *General Nuke*, making it as much a place for figuration as the bust. He seems to feel free to go as far as seems possible towards having them exchange roles—a topsy-turviness that is the ultimate put-down of and revolution against artistic convention. (In a sense, while Arneson is a reluctant

ceramist, even coming to the medium accidentally if not overtly against his will, one couldn't imagine him making his portraits in stone or bronze simply because these would be the conventional materials. However, Arneson has turned to these materials in experimentation and for their "immortality," as in *Self*, 1985.) This reversal of expectations is another example of his aggressive antisociality, emblem of his free spirit.

Arneson, then, takes a commemorative public form and uses it to express private rage. The hyperexpressivity of his portraits sabotages the dignified communicative vehicle he appropriates from art history. But Arneson is not simply a rebel and saboteur: he is in some sense insane, almost announces his insanity and his intention to get away with it. And art seems to be the one place where one can get away with insanity. Perhaps it is better to say that Arneson is searching for the moment of temporary insanity that Friedrich Schiller says is central to art. But Arneson realizes this moment of insanity so regularly—it almost seems a permanent fixture of his art—and flaunts it so forcefully, that one cannot help but believe that he may really be insane. He may have the extraordinary power to keep a hold on sanity while plumbing the depths of insanity. Perhaps his deafness puts him in the introspective state conducive to recognizing the insanity—infantilism—in himself, i.e., gives him greater inner access to and power to act out the child the Romantics thought the artist was. His rebellion may consist in his desire to maintain this contact with the child within—a double insanity, that of wanting to maintain contact, and wanting to give the spontaneous child free play in the adult world. Arneson does seem to believe the biblical notion that the truth can only come out of the mouth of the innocent child. Such innocence is truly insane.[5] His art shares the romanticization of insanity typical of—perhaps basic to—the best Modern art.

In general, Arneson's self-portraits show a self that may be regarded either as way-out Californian or possibly insane. *Captain Ace*, 1978, with his pilot's helmet and the symbolic squawking bird on his head, seems both. It also seems a simultaneously Californian and insane act to balance bricks on one's head, as Arneson does in *Balancing Act*, 1974. Certainly his anti-social facial behavior, as in *Klown* and *Balderdash-Dash*, both 1978, where he sticks out his tongue almost like a mental patient with no control of it because of drugs, verges on "nutsiness." In general, the mouth is highly mobile and "outspoken"—becoming, like the tongue, looser and looser, more and more of a "scream," as his art ripens. Important examples of this are *Assassination of a Famous Nut Artist*, 1972, *Current Event* and *Blown*, both 1973, *Last Gasp*, 1980, and *Raw Bacon*, 1981. One can also include works in which Arneson has a cigar or some other obscene object in his mouth, as in *Exaggeration*, 1972. The mobility he gives eyes,

as in *Roy of Port Costa* and *George and Mona in the Baths of Coloma*, both 1976, *Mr. Unatural* and *Rrose Selavy*, 1978, *Squint* and *Pablo Ruiz with Itch*, both 1980, certainly adds to the "craziness" of his figures. The artists *Roy* [de Forest] *of Port Costa*, *Mr. Unatural* (William Wiley), *David* [Gilhooly], 1977, and *Peter Voulkos*, 1979, look definitely demented, especially *David*, with the glasses hiding his eyes. They seem to blind him rather than enable him to see better, perhaps symbolizing the inner vision of the artist-seer. *Colonel Nuke* and *General Nuke* and all the military figures are clearly demented in their bloodthirstiness. *Eye of the Beholder*, 1982, in which we see Arneson blinding himself like Oedipus by poking out his witnessing, "knowing" eyes, and disintegrating into a mass of wildly expressionistic gestures, in a sense shows him totally "possessed" by his disturbing, prophetic inner vision of self as well as of nuclear holocaust.

Arneson acknowledges as a major source of inspiration the screaming and grimacing self-portrait busts by Franz Xavier Messerschmidt, an eighteenth-century German psychotic artist.[6] Historically and psychologically, the artist has been understood as mad, or more or less in control of the madness we all have—the madness that has been associated with our freedom.[7] Artists, like the mad, are also supposed to be prophets. Arneson seems more than ever determined to grow out of his funky sense of self into the role of prophet of nuclear madness and doom: more precisely, to put his madness to socio-political use. Indeed, the nuclear madness—society's madness—mirrors his personal madness. I think his madness, which was once very much rooted in what Alfred Adler has called "masculine protest,"[8] is now rooted more in an awareness of social stupidity and impending death, symbolized perhaps most succinctly and poignantly by *Homage to Philip Guston (1913–1980)*, 1980. The shoes of this work—the shoes that Guston depicted in his important late works—can hold their own with the hat worn by Adlai Stevenson cast in bronze by Claes Oldenburg and erected on the spot in London where Stevenson died of a heart attack (*Small Monument for a London Street: Fallen Hat [For Adlai Stevenson]*, 1967).

The sensibility of death is both personal and social for Arneson—or rather, his own death, which came into view with his cancer, and which looms larger and more vivid on the horizon as he ages, converges with the threat of the world's death through nuclear disaster, of which the world, like Arneson, has already had a foretaste. Freud has said that one cannot imagine one's own death; perhaps if one tries to do so one goes mad, or one can only imagine it through madness, including the madness of art, which reinforces and preserves the vision. Arneson imagines his death through the intensely Expressionistic articulation of nuclear death.

He brings out the latent insanity in Expressionistic style to make the fury with which death will come as self-evident as possible.

Indeed, death—in quieter, less dramatic form—has been his subject matter from the beginning. *No Deposit, No Return,* 1961, presents a discarded bottle—a negated form—fit only for art. And *Funk John,* 1963, and *John with Art,* 1964, are really about excrement, which is a form of death. Arneson's effort to sexualize objects, as in *Call Girl* and *Typewriter,* both 1966, creates life in dead objects. And the hand emerging from the *Toaster,* 1965, is like the hand of Lazarus as it reaches out of the tomb. *Smorgi-Bob, the Cook,* 1971, is a memorial to the abundance of life that is possible in the dead space of art—about the contradiction in terms, the living death (death of living, living of death) which art is. With *Fragment of Western Civilization* and *Assassination of a Famous Nut Artist,* death became an explicit theme in Arneson's art—both the world's death and the self's death. He was now openly on the way to the great tragic artist he has become.

It can be said that Arneson's art is about the "tragic flaw" endemic to the human condition, and particularly experienced by Arneson through his relentless pursuit of artistic power in order to feel manly and superior. In his work of the 1980s, Arneson confronts nuclear power like David facing Goliath. His only weapon is the seductiveness of his art—its subjectivity. Arneson's art is in fact powerfully, magically seductive in its fusion of Symbolist, Expressionist, and Surrealist styles.

Notes

1. Neal Benezra, *Robert Arneson: A Retrospective* (Des Moines, Iowa: Des Moines Art Center, 1985), p. 56, the exhibition catalogue for "Robert Arneson: A Retrospective," which opened at the Des Moines Art Center (February 8–April 6), traveled to the Hirshhorn Museum and Sculpture Garden, Washington, D.C. (April 30–July 6) and the Portland Art Museum, Oregon (August 1–September 28).

2. Ibid.

3. Ibid., p. 93. As Benezra points out, "The term 'Funk' art was coined by Peter Selz, in the title of an exhibition held at the University Art Museum, Berkeley, in 1967." Funk involves "playful impudence and often crude manipulation of materials," correlated with "an ironic attitude toward art and life" (p. 25). "Consciously rebelling against all standards of good taste in art," Arneson used "wit, satire, and irony" as "weapons" (p. 25).

4. Arneson's misgivings about—disaffection with—being a ceramist are numerous and great. Benezra describes how he backed into the field from art education (ibid., p. 11). Arneson has been critical of the ceramics establishment for its inability to accept radical innovation in the medium and of the larger art world for its inability to accept the artistic character of ceramics. Describing his graduate education, Arneson remarked: "I was a ceramist so therefore I wasn't a fine artist. The ceramists had to sit in the last three rows of the bus and we never got involved in philosophical issues" (p. 17). *Funk*

John, 1963 (destroyed), described by Arneson as his first mature work, is an ironical treatment of "the ultimate ceramic," as Arneson called the toilet—an anti-ceramic ceramic (p. 26). He was determined "to get away from the mystique, the preciousness" of ceramics (p. 29). He has spoken of himself ironically "as a ceramist, a man of baked goods" (p. 30).

5. Arneson has always described himself as "naive," the word he used to express his surprise at the rejection of the commissioned portrait-bust of George Moscone, the assassinated mayor of San Francisco. In 1978 he said: "Innocence is bliss. God, I love innocence. One is free. The more one knows, the more one cannot do. . . . I guess I was innocent all along. Of course in ceramics you're not an artist so you're really innocent" (ibid., p. 9). Benezra also states here that it was "precisely this innocence and a corresponding degree of freedom that allowed him to develop beyond anyone's expectations." Of course, Arneson's proclaimed innocence is quite canny. Asked whether *No Deposit, No Return,* 1961, was based on Jasper Johns's *Painted Bronze (Ale Cans),* 1960, Arneson confessed that he saw the Johns reproduced in *Artnews.* Arneson wanted "to maintain innocence on this"—"I would love to have been innocent and just have discovered it on my own terms. But looking back, one can't be innocent because of the nature of reproductions" (pp. 18, 20).

6. Arneson's use of Messerschmidt as a model shows his artistic sophistication and psychological self-awareness (Ibid., p. 30). Messerschmidt has been analyzed by Ernst Kris in "A Psychotic Sculptor of the Eighteenth Century," *Psychoanalytic Explorations in Art* (New York: Schocken, 1964). According to Kris, Messerschmidt pushed expression "in the direction of a grimace" (p. 136). "In everyday life grimacing occurs under two conditions: as a miscarried expressive movement, that is, when a repressed tendency interferes with the sequence of the intended expression—the smiling upon expressing condolence—and as an intended communication ('making a grimace,' 'striking a pose'). Both instances involve the expression of aggressive drives which in the first instance triumph over the ego, and in the second are intentionally used by the ego." Arneson, who probably knows Kris's essay, exploits the "autoplastic function" "characteristic of all expressive movements" (p. 137) for aggressive purposes. In his best self-portraits he in effect turns himself into a demon. (Messerschmidt reported being visited by demons at night; Arneson's art is a night vision in day colors.) Kris points out that grimaces are "the autoplastic ancestors of masks" (p. 138). Faces of demons appear as masks. Arneson offers a paranoid mask of selfhood. Kris notes that "in paranoid delusions" the persecutor "simultaneously punishes and seduces," a "double role" which suggests "an attempt at warding off the seduction by playing a female role" (p. 139). Margaret S. Mahler's concept of "pseudoimbecility," developed in the first of *The Selected Papers of Margaret S. Mahler,* vol. I, *Infantile Psychosis and Early Contributions* (New York: Jason Aronson, 1979) also seems applicable to Arneson. By pretending to be an imbecile, one gets away with being infantile.

7. For an intriguing discussion of the madness of art see Leon Edel, "Tristimania: The Madness of Art," *Stuff of Sleep and Dreams: Experiments in Literary Psychology* (London: Chatto & Windus, 1982). Jacques Lacan, in *The Language of the Self* (New York: Dell, 1975; Delta Books), has asserted that "madness is far from being an 'insult' to liberty: it is her most faithful companion, it follows her movement like a shadow. And the being of man not only cannot be understood without madness, but it would not be the being of man if it did not carry madness within it as the limit of its liberty" (p. 136). Lacan also quotes Pascal: "Men are so necessarily mad that it would be being mad

by another kind of madness *not* to be mad" (p. 135). Art is that other kind of madness. Arneson offers us an art that deliberately wants to articulate the original madness of being human, which makes his art doubly mad.

8. Adler argued that "masculine protest," conceived "as the striving to be strong and powerful in compensation for feeling unmanly, for a feeling of inferiority," was "the main dynamic principle." Heinz L. Ansbacher and Rowena R. Ansbacher (eds.), *The Individual Psychology of Alfred Adler* (New York: Harper & Row, 1964; Harper Torchbooks), p. 45.

The *Ars Moriendi* according to Robert Morris

*No one wept for the dead, because every one expected
death himself.*
 Agnolo di Tura, *Chronicle of Siena*, 1348

*All autumn, the chafe and jar
of nuclear war;
we have talked our extinction to death. . . .*
 Robert Lowell, Fall 1961

Robert Morris is the J. Robert Oppenheimer of Modern art. Witnessing
the first atomic explosion on July 16, 1945, Oppenheimer remembered
a fragment from the *Bhagavad Gita:* "I am become Death, the destroyer
of worlds." Morris returned in spirit to the moment of that explosion,
through his monumental *Jornada del Muerto* (1981)—Journey of Death—
titled after the place the first atomic weapon was tested. A wasteland,
the primitive *Jornada del Muerto* seemed like the end of the world—an ap-
propriate place for a nuclear explosion. Oppenheimer named the test site
"Trinity," not after the Christian one, but after the Hindu Trinity of
Brahma the Creator, Shiva the Destroyer, and Vishnu the Preserver. Trini-
ty site in the Jornada del Muerto was a place to reflect on first and last
things—where the creative and destructive, the human and cosmic, con-
verged. The first atomic explosion, with its strange intellectual as well
as physical beauty, was an apocalyptic event, inevitably evoking eschato-
logical ideas.

Morris's death-predicated, nuclear-disaster eighties works are his
Trinity, his art's climactic "endgame," where he most physically and com-
plexly articulates what his art was conceptually and subliminally about
from its start—the indwelling of the nothingness of death in being. But

This article originally appeared in *Robert Morris* (Exhibition Catalogue; Chicago: Museum
of Contemporary Art, 1986).

his art has always been intensely physical, and these are not the first of his works to manifest death in their being—to serve as *memento mori* on a journey of death. Death's concreteness was his art's implicit subject matter from the start. Morris's Minimalist objects are the simple material forms of death, preparing for the process works using waste and smoke.

Oppenheimer seemed unaware of the existential implications of atomic power until the trauma of the actual atomic explosion. He believed he was on a disinterested voyage of intellectual discovery. Similarly, prior to his art's "refraction" of atomic power, Morris seemed to believe it was purely about art, testing its boundaries. Awareness of possible atomic catastrophe seemed to catalyze Morris to declare his death-orientation openly, making clear that his has always been an art of truth. As Georges Bataille wrote, "The servants of science have excluded human destiny from the world of truth, and the servants of art have renounced making a true world out of what an anxious destiny has caused them to bring forth."[1] The atomic explosion showed Oppenheimer that human destiny catches up with and is inseparable from science, and generated in Morris an anxiety about his destiny that led him to connect his art more explicitly than ever to the true world, if also, paradoxically, to make it more aesthetic—"artful"—than it had ever been.

Morris's art is essentially applied theory. Both as intellectual and as administrator of his ideas, he has carefully controlled the adventure of his journey of death. The supposed randomness of his development is more apparent than real. Each "stylistic" change is another stopping place on his journey of death. Like cunning Odysseus's adventures, the seemingly bizarre artistic adventures that constitute the narrative of Morris's art can be understood as a series of willed accidents foreshadowing the climactic event he knows he will experience when he at last arrives home—when he at last will really die.

Oppenheimer gave death new means of dominance, demonstrating its omnipotence as never before. He let loose a new Black Death, releasing death's energy from the living atom. He knew that the atomic explosion was a cosmic demonstration—a potential destruction of the universe that recreated the moment of its physical creation—showing that the beginning and the end, the creative and the entropic, were one and the same.

Morris's art shares not only Oppenheimer's death-identification but also his cosmic perspective and obsession with power. The perspective turns the obsession into the paradoxical awareness that just when power is most explicit and triumphant it is most deadly, extinguishing itself and everything else. Morris's theatrical perspective existed long before the Hofmannsthal-like "World Theater" aspect of the eighties works—which,

like the World Theater, allegorically deal with the crisis and disintegration of civilization as well as art, and which, like it, use a version of the traditional language of art to make a modern point about decadence. The Conceptual/Minimalist works are inherently "stagy" as are the various environmental (including his 1978 drawings on the prison theme) and mirror works, which in their different ways throw one into a seemingly illimitable space—literally outer and figuratively inner space. They converge in the 1974 *Labyrinth* (as well as some of the grand, labyrinthine mirror constructions), a theatrical rendition of quasi-infinite outer space; confined in and moving through it, one experiences quasi-infinite inner space. In general, the sense of the infinite and the theatrical are inseparable. Such works as the 1971 *Observatory* and the 1980 *View from a Corner of Orion (Night)* are explicitly cosmic in perspective. In his essay "Aligned with Nazca" he describes his experience of an "art" meant to be viewed from outer space—from the cosmos at large.[2]

The sense that art has played itself out and must become theatrical to preserve itself—its objects must become performancelike to have effect and meaning, carrying power and staying power[3]—has long been prevalent in Morris's oeuvre. He has always had a sense of the inherent entropy of art—even of art as a theatrical way of cultivating, as well as demonstrating, entropy. This is evident from his attempt to show the contradiction inherent in art by "introducing" into it "a kind of order . . . that is not an art order" and that "maybe" makes [his] art "seem less like art than art was before."[4] This order implies the "nonhierarchic" character of Modern art in contrast to traditional art's hierarchic character. Morris's awareness of entropy appears also in his half-serious, half-tongue-in-cheek announcement of Modernism's death, in effect the ideological springboard for his "Postmodernist" eighties works. His 1974 photographic self-portrait in "bondage" is an especially striking instance of Morris theatrically straddling the boundary between art and nonart. To speak of art as inherently theatrical means to understand it as the privileged realm in which the inextricability of such fundamental opposites is made manifest.

> An emotional weariness with what underlies them [Modernist forms] has occurred. I would suggest that the shift has occurred with the growing awareness of the more global threats to the existence of life itself. Whether this takes the form of instant nuclear detonation or a more leisurely extinction from a combination of exhaustion of resources and the pervasive, industrially based trashing of the planet, that sense of doom has gathered on the horizon of our perceptions and grows larger everyday. Concomitantly, credible political ideologies for the ideal future no longer exist and the general values underlying rationalist doctrines for an improved future through science and technology are crumbling fast. . . . In any case the future no longer exists and a numbness in the

face of a gigantic failure of imagination has set in. The Decorative is the apt mode for such a sensibility, being a response on the edge of numbness.[5]

This statement can be taken as both the aesthetic and moral program for the *Burning Planet* works: their decorativeness articulates our numbness in the face of the threat of our extinction. Reconstituting the decorative by synthesizing representational and abstract styles—a "confusing" synthesis, since both function allegorically as well as literally—the new works are presumably a gigantic success of imagination. Yet they too are haunted by the dichotomy between art and nonart which pervades Morris's oeuvre. They are art works that show how they are made as much as the *Box with the Sound of Its Own Making* (1961). That is, they have the same manufactured look. (As Morris says, much of his work, in its nonart aspect, refers to "an order of things pretty basic to how things have been made for a very very long time," that is, he "doesn't refer to past art but to manufactured objects."[6]) They establish a disintegrative kind of order that is not entirely an integrative art order. It is a nonhierarchic order in which no aesthetic priorities can be determined. The *Burning Planet* and related works are structurally insecure. They have a peculiarly incomplete look, as though their parts had to be conceptually collaged to discover their unity. It is as though the work as a whole was anamorphic; its unity could be grasped only from a cosmic perspective. It is an unstable unity—a blind drift to unity rather than a realized togetherness of parts. Frame is as important as picture framed, and even when frame is incomplete (allegorically "broken," like Barnett Newman's *Broken Obelisk*) or more than one kind of frame is used—or the central picture itself is fragmented, as occurs in several works—each part is as important as every other. No part of the work is privileged over any other, not even the black felt which plays a cameo role in one work, a self-quotation reminding us of an earlier stage in Morris's development as well as the "gravity" of his theme. All parts loosely relate, sometimes through an ambiguous congruity, usually through an informal metonymic/metaphoric connection. While each element that Morris uses—socialized sign or primal mark—can be understood as irreducible or generic, their unity is not preconceived—predetermined. Relation is not guaranteed or predictable. This is typical of a construction or assemblage. Assemblage's uncertain unity perfectly suits the sense of coimplication of frame and picture, matter and energy, death and power.

Morris's eighties works are subtly dissonant assemblages of fragments that generally hang together, but their particularity—and imaginative success—lies in their vigorous assertion of their "fault lines." Part of the works' power is in these fractures. They subvert the works' general

tendency to be decorative, or rather, give it a different slant: disrupting the glamorous numbness of the decorative, the fractures make self-evident the extinction or nothingness the decorative mediates—the living death (numbness) the decorative asserts yet obscures. T. W. Adorno's conception of what makes for success in a modern work of art springs to mind: "the criterion of success is twofold: first, works of art must be able to integrate materials and details into their immanent law of form; and, second, they must not try to erase the fractures left by the process of integration, preserving instead in the aesthetic whole the traces of those elements that resist integration."[7] In Morris's nuclear extinction works there is no one immanent law of form, making their disintegrative potential more radical, their fractures more substantive. As much as anything else in the work, they "gesturally" pantomime the destructive power of the nuclear explosion. In these works it is generally the central image of the explosive, smoky firestorm that resists integration with the frame, with its signs of doom, or death and power—skull and bones and dead fetuses, and phalluses and phallic fists (opposites that do not smoothly integrate). Even when there is a show of integration—usually by establishing an erratic continuity between tongues of smoky flame (picture) and grotesquely long fingers of death or long-stemmed flowers of life (life and death forces are typically con-fused in Morris's frame)—there is a fresh demonstration of fragmentation. For example, when the death's-head leaves the frame and invades the picture, or when figures, more or less in disintegrative process of metamorphosis, appear in the central picture.

Conflict, the major mode in which disintegration displays itself, is everywhere in these works, giving them their creative/destructive drive and sensual, pleasurable texture—their obscene beauty. Morris has lifted the taboo on sensuality that seemed to exist in his early works, although it can be argued that their epistemological preoccupation with the concrete was a sublimated sensuality. The new sensuality is not unrelated to the fact that the works reify conflict, conceiving it as a kind of perverse harmony. In the extinction works Morris shows himself to be an exemplary hyper-Modernist. Adorno has written:

> The taboo on sensuality in the end spreads even to the opposite of pleasure, i.e., dissonance, because, through its specific negation of the pleasant, dissonance preserves the moment of pleasure, if only as a distant echo. The hyper-modern response is to be wary of dissonance because of its proximity to consonance. Hyper-Modernism . . . prefers to join forces with reified consciousness rather than stay on the side of an ideology of illusory humanness. Dissonance thus congeals into an indifferent material, a new kind of immediacy without memory trace of its past, without feeling, without an essence.[8]

Adorno has articulated the paradox of Morris's development. Through the sixties and seventies he explores the dissonance between art and nonart—including the spectator as nonart eager to identify with art. (In the distorting mirror works, the spectator is identified by art, that is, distorted so as to become "art"—remade into its order.) Sensuality is generated by the ambiguous, difficult relationship between these opposites. With the eighties work, sensuality seems to return with a vengeance, but it is a sham sensuality. For it is the sensuality of extinction—a sensual presentation of Nothingness in which there is not the slightest illusion of humanness. Death brings with it a false consciousness of eroticism, much as eroticism brings with it a false consciousness of death. The extinction works articulate "a new kind of immediacy without memory trace of the past." The debris that clutters the frames is more ideological than memorable; the death's-head under whose auspices all occurs is eternal. The extinction works are really "without feeling, without an essence"—without authentic sensuality, which signals the human.

This is why it is a serious mistake to regard Morris's colors as Turneresque or his fluidity in general—especially on the frames—as Art Nouveau, or the works in general as Baroque. For these signal a residually sentimental, "humanistic" relationship to nature, in Friedrich Schiller's sense of sentimentality as restoring a lost relationship with an idealized nature. The atomic truth makes that impossible, for it gives us nature not in the sentimentalized/humanized form of the picturesque (as Turner, Art Nouveau, and the Baroque do), but as a transhuman—inhuman—reality. Morris shows us this reality determining the human microcosm, which appears vividly if also pedantically—semantically—on the frames. (They have "human appeal" by reason of their illustrative character, accessibility as "message.") It also determines the indifferent, inhuman macrocosm, that is, the central image's firestorm, which is readable as an omen but incomprehensible in itself. The extinction works articulate nature as Pascal understood it, "an infinite sphere, whose center is everywhere and whose circumference is nowhere." The works' forceful center centrifugally erupts through the rectilinear frame, belying the perception that it is a boundary that contains anything. Morris's works, by reason of their articulation of the infinite let loose by nuclear extinction, are clearly sublime, offering "the counter-image of mere life."

Morris is not so much "hyperallusive" as sublime—which is to be beyond style. His art does not so much "gamely" or opportunistically manipulate styles as pose the general problem of the conflict between the process of aesthetic reconciliation which style is and the process of insistent concretization which reality is. Morris reconciles every known

style with every other by showing that all exist on the same aesthetic continuum, freeing himself to attend to the riddle of the ambiguous reconciliation of art with reality, restated in particularly dramatic form in the extinction works. They expose this conflict, central to art—showing it to be inherently a dialectic of the sublime—as perhaps never before in Morris's art. Adorno has written that "the ascendance of the sublime is identical with the need for art to avoid 'playing down' its fundamental contradictions but to bring them out instead. No longer is reconciliation the result of conflict; the only aesthetic purpose is to articulate this conflict."[9] As Annette Michelson has argued, Morris, like Richard Wagner and John Cage, "attacks, through a process of distension, the notion of wholly separable formal modes," "extending the transgressive tactics of the *Gesamtkunstwerk*" to "a reflective limit at which the very notion of Composition is reversed."[10] Michelson has connected this sublime decomposition—"deconstruction"—to Morris's aspiration to "a concreteness, an immediacy of presence greater than any purely linguistic concept would seem to afford."[11] But it is clear that Morris's obsession with the "very concrete" or "very much there"[12]—entropically concentrated matter—is contingent upon his equally deep obsession with concrete nothingness, the very much not there. It is through a process of extinction that Morris arrives at the concrete. Only when it is experienced as irreconcilable with the process of negation that brought it into being can the concrete be said to be affirmed.

Morris, then, conceives of art-making as a kind of *ars moriendi*. The demonstration of the nonart within art, or their inextricability, shows that in a sense art is living death. To make art today is to experience its death. But Morris's art-making—exemplarily in his eighties extinction works— is an art of dying in a deeper sense. The *Ars Moriendi* was a popular booklet (1564–70), almost half illustrations. Morris's eighties extinction works, from the *Firestorm* series (1982), form an *ars moriendi* and show his art seeking a new publicness and substantiveness. Like it, they combine text and image and are generally apocalyptically oriented. They are not unrelated to Albrecht Dürer's high art treatment of the Apocalypse, which draws on the populist *Ars Moriendi*. And like it, they deal with the dying person's mental state. If, at the moment of death, one was in a state of sin—filled with anger, impatience, or avarice—one's soul was jeopardized for all eternity. The state of sin was one of resistance to inevitable death.

The *Gita* also deals with one's spiritual state at impending death, advocating that it be a state of Yoga-like "indifference," "casting off attachment" (2:48). The Gita is a dialogue between Lord Krishna and Prince

Arjuna, who is about to begin a battle and face destruction. Lord Krishna is Arjuna's charioteer, in effect showing him ''the way,'' instructing him in the attitude with which he must face and endure death. One must be ''moodless.'' The purpose of the extinction works is to lead us to ''the Rule of Meditation'' on the changeless. Such meditation alone is the path to indifference or godlike detachment.

Morris, no longer the mortifier of the flesh of art he was in his Minimalist phase, uses his knowledge and power of making to create works, which, by confronting us with extinction in emblematic form, put us in a position to follow the Rule of Meditation. In the extinction works Morris plays the role of Arjuna learning the Rule—attaining a ''contemplative'' attitude to face the nuclear war that will result in the extinction of humanity. In other works, such as the *Jornada del Muerto* and the *Firestorm* series, Morris deals with actual events of World War II—the firestorms which arose from the saturation bombing of Dresden and the atomic bombing of Hiroshima—which presage the final nuclear firestorm, fabulous in scale and import. Indifference meets—masks?—futility in Morris's eschatological eighties works. Indifference, a state in which salvation is possible, is barely differentiated from futility, a state of sin. As with Oppenheimer in the *Jornada del Muerto,* Morris is in effect fighting for his soul's eternal future.

To paraphrase Schiller, ''the more imperious the subject matter the greater the artist's need to subsume it within an order of his own making.''[13] Morris's extinction works demonstrate that death truly considered—the death triumphant in the total war inseparable from the use of nuclear weapons—is so imperious a subject matter that it cannot help but make any order created by the artist to subsume it seem inadequate. Morris's nuclear extinction works are *necessarily* fragmented—their differentiation into two- and three-dimensional parts is a sign of their domination by death. Such fragmentation suggests their transience; it is not simply an indication of intellectual deconstruction but of potential literal destruction.

Continuing Schiller's line of thought, Morris's ''constructive sense of freedom,'' which should show itself in ''his articulation of the subject's latent structure, and [which] would include his fluency and the way he prevented the interest of any one part disrupting that of the whole,'' puts him in a paradoxical position. For to depict death is to depict disintegration—that is its ''latent structure.'' Morris's extinction works are extraordinary in their fluency; this comes from their articulation of disruptive disintegration as smooth integration. Such fluency is the result of a marvelous engineering tact. (Morris studied engineering in college; his ''self-deconstructing'' constructions can be regarded as showing his

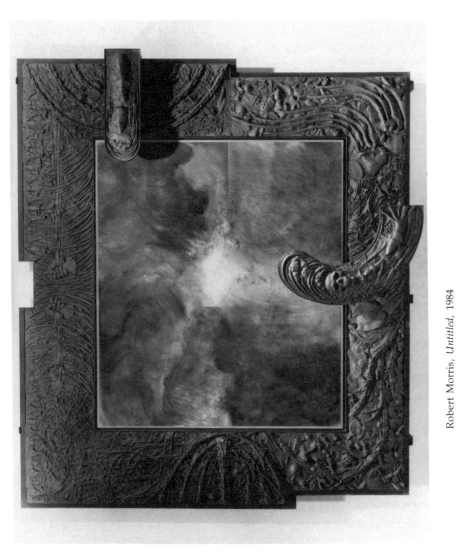

Robert Morris, *Untitled*, 1984
Painted cast hydrocal, pastel on paper, 90½″ × 95″ × 11″.
(Photo by Jon Abbott; courtesy Sonnabend Gallery, New York)

ingenious engineering abilities, as well as climactic realizations of the Constructivist ideal of the work of art as an engineering project.) Despite the works' obviously fragmentary character, there is a quasi-holistic aspect to them, especially in the firestorm's depiction. Morris's brilliant articulation of the unity of disintegration and integration—destruction and creation—makes his works powerful communicative actions, for it indicates that he understands the "simultaneity" of system and life-world.

There is ample evidence that Morris was death-obsessed from the beginning of his career. It sometimes seems as though he intended to joke death out of coming for him—preempting it, as it were. In 1965 Barbara Rose described Morris's project for his own mausoleum: "It is to consist of a sealed aluminum tube three miles long, inside which he wishes to be put, housed in an iron coffin suspended from pulleys. Every three months, the position of the coffin is to be changed by an attendant who will move along the outside of the tube holding a magnet. On a gravel walk leading to the entrance are swooning maidens, carved in marble in the style of Canova."[14] The same opposition exists in the extinction works but in subtler form. "Carved" sentimental frame is juxtaposed with fiery picture, coldly rendered.

The ironical, tragicomic mausoleum project shows Morris's typical narcissistic grandiosity. It can also be understood to show how profoundly he experienced the thought of death. It always had cosmic majesty for him. The cosmic or oceanic experience—which Morris's *Burning Planet* works articulate with an anguished flair—has been understood by Freud as a symbolic return to the womb, the place of one's creation. Can the oceanic experience be understood as a "preexperience"—rehearsal—of death, rather than a restoration of birth? Both involve a return to an undifferentiated state, in death's case through entropic dedifferentiation. Death is as "melting" or orgasmic an experience as love, which may in part explain the phallic imagery in many of the extinction works.

It is worth noting that the 1974 self-portrait poster presents an image of fettered power and has a sadomasochistic dimension to it, as does the equally notorious *I-Box* (1962), in which Morris also appears "nakedly." Many of Morris's works—the labyrinths and distorting mirrors, and even the Minimalist and process works—establish a sadomasochistic relationship with the participant observer, or put him in a sadomasochistic situation. Anthony Storr regards sadomasochism as "pseudo-sex," for it is "an expression of the status struggle," that is, the power struggle—the struggle to be master rather than slave, to dominate rather than submit.[15] (This struggle is inherent in theater, which is why it is the art which most explicitly shows what art is about. In theater the artist attempts to

dominate the spectator by sadomasochistically "submitting" to—simultaneously dominating and enslaving —him.) "Phallic envy" in both sexes indicates desire for power in "the dominance hierarchy," a drive whose "price . . . is to be excluded from the pleasures of love."[16] The climax of Morris's pursuit of the pleasure of power is his extinction works, whose cold sensuality has nothing to do with love.

In any case, Morris's mausoleum project shows his acute awareness of the body. He has spoken of the body as "in some way a measure of the work . . . the fact of the work reflecting back to the body, its scale, and that in turn reflecting the scale of the work back to the person." Perhaps the most scandalous work in which Morris represented his body is the *I-Box*. It can also be understood as having to do with death. Morris, as naked as on the day he was born—as naked as one will appear before God—is fitted in what might be called a conceptual coffin, in the shape of the letter "I." Like certain monks, Morris shows himself living in his coffin. His identity is entombed in his image, and his image is entombed in the "indifferent" linguistic self that belongs to everyone, but that can also be understood as changeless, unlike the mortal body it contains.

Morris's cenotaph works (1979–80) continue, in concept and assemblage structure, the narcissistic death-preoccupation as well as the projected grand scale of the mausoleum proposal. They also have the same jaunty, joking manner as the *I-Box* and self-portrait poster, and much of Morris's writing[17] and work. It is certainly apparent in the distorting mirrors and labyrinths, which comically trap one. I would argue that this ironical manner is an immature form of the Indifference the *Gita* teaches— a kind of manufactured demonstration of the Rule of Meditation. It almost seems to be daring death to strike him down—as, I think, the arrogant poses of the *I-Box* and the self-portrait poster do. Indeed, one can understand the latter—note the military helmet—as a perverse image of Arjuna in battle dress.

It has been pointed out that in pornography there is "the final absence of all emotions except the aggressive ones."[18] This seems true of the *Burning Planet* works, which are a kind of ironical pornography about the ultimate obscenity, death. It is to Barbara Rose's credit that she recognized the "memento mori" aspect of Minimalist works in general. Insofar as Morris's art remains a kind of recollection of death in the relative tranquillity of the work of art, it remains Minimalist in concept. Rose's recognition of the deliberate "unsaleability and functionlessness" of Minimalist works as a species of irony and black humor is an implicit acknowledgment of their "deathlikeness"—their zombie character. Whatever they

may theoretically be, they are for all practical purposes dead without "redeeming" commercial and social value. While such black humor sustains and reasserts in a contemporary way the resistance to social appropriation and materialism that was part of the original motivation of non-objectivity, it also points to the entropic character of Minimalist works. Smithson perceived them as such,[19] and Rose described Minimalism as "a negative art of denial and renunciation" with "mystical" implications.[20]

Morris's art is a demonstration of entropy in the service of a kind of sainthood—the martyrdom of nonattachment, at once the familiar modernist "non serviam" and timeless indifference. Entropy is a statement of eternity in the midst of temporality. Morris's pursuit of the non-hierarchic is a pursuit of entropy. Entropy makes itself dramatically felt in the *Untitled* environmental piece (1979) south of Seattle. Morris converted an abandoned quarry into a quasi-amphitheater/labyrinth. The terrain is topped by dead remnants of trees, charred and cut but still rooted. Death declares itself openly; the trees are the insignia of the entropy in the work.

The three *Blind Time* series (1973 and 1985, which Morris drew blindfolded; 1976, drawn by a blind person directed by Morris) also seem particularly telling demonstrations of the critical role entropy plays in art and art-making. The artist does not necessarily know what he is doing—what "insight" he has—when he is making art. Working blindly undermines the traditional idealization of the artist as someone who can "see through" everything as well as see everything clearly. It is deliberately entropic; the artist puts himself in the precarious position of being the critical spectator of his own art. He puts himself inside and outside it simultaneously, in an ambiguous creative/destructive relationship to it. Paul de Man observes that it is because the critic is "in the grip" of a "peculiar blindness" that he is perceptive, insightful. His "language could grope toward a certain degree of insight only because [his] method remained oblivious to the perception of this insight. The insight exists for a reader [spectator] in the privileged position of being able to observe the blindness as a phenomenon in its own right—the question of his own blindness being one which he is by definition incompetent to ask—and so being able to distinguish between statement and meaning."[21]

In the *Blind Time* drawings, vertigo is ceaseless, as in the nuclear extinction works. Are the *Blind Time* and *Firestorm* drawings statements or meanings? Are they—this question can be asked not only of the *Burning Planet* works, but of Morris's entire oeuvre—language or truth?

I contend that Morris's entropic art, and his general conception of art as inherently entropic, exists to catalyze, as well as function as the aesthetic correlate of, the "freedom" of Indifference advocated in the *Gita*.

Michael Podro has pointed out that Kant's aesthetics presented a new conception of the freedom that art affords, created by combining the two traditional meanings of artistic freedom. "The constructive procedure of the artist, the first sense of freedom, was conceived as bringing about the second, an inner composure. And in this way the role of art was seen as overcoming our ordinary relations to the world."[22] Morris uses the "constructive," engineered entropy of art—reflecting the destructive entropic processes ("blindness," war) of the world—to achieve "destructive" entropy, that is, the constructive attitude of Indifference to the destructive world. In this way, art overcomes our ordinary attitude to the world, while still participating in it. Art comes to be a way of accepting human destiny.

Rudolf Arnheim writes that "the increase of entropy is due to two quite different kinds of effect; on the one hand, a striving toward simplicity . . . and, on the other hand, disorderly destruction. Both lead to tension reduction."[23] Both operate in Morris. The "anonymous" (Indifferent) Minimalist works are perfect examples of the increase of entropy through simplicity. For Arnheim, the tension reduction achieved by "a minimal structure at a low level of order" can, "in the extreme . . . reach the emptiness of homogeneity."

Morris's Minimalist sculptures never reached the emptiness of homogeneity, for they incorporated the heterogeneity generated by the spectator's, or their own, movement. Thus, the simple L-shape structures Morris exhibited in 1965-67 can be moved. This displacement, however minimal, was sufficiently "anabolic"—Arnheim's word—to establish what he calls "a [minimal] structural theme." Such a "theme represents what the work 'is about,' " and functions as a "countertendency" to entropy, for it "introduces and maintains tension." Morris's Minimalist sculpture, including the felt pieces, is tendentiously antithematic (this can be argued for the *Burning Planet* works as well, simply by their idolization of extinction), yet the physical tension in it implies a need for an increase in entropy to bring it under complete "control." While the *Burning Planet* works assert entropic Indifference in the face of a countertendency to "content," tensing content presents itself as the anxiety-arousing historical possibility of nuclear disaster the works articulate. Entropy is paradoxical. At the same time that it makes the works anti-utopian, it makes them anti-historical. But it also presents emotional extinction (indifference, nonattachment) as a kind of utopia, and vigorously asserts the violence and tensions of history. This ambiguity is still another demonstration of the art/nonart dialectic that makes the extinction works, and Morris's art in general, "expressive," if hardly empathic.

The eighties works also increase entropy by creating an effect of "disorderly destruction." The Promethean cosmic fire stolen from the gods is catastrophically burning out of control in human history. Morris's art is explosively charged with the discontents of both divine art and human civilization.

As Michelson has noted, Morris is an essentially philosophical artist. He is a more profound philosopher than even she recognized—a "true philosopher," for he "is ever pursuing death and dying" (Plato, *Phaedo*, 64A). For Plato, the body is "a hinderer of acquirement of knowledge." Is Morris more of a Platonist than is realized? His obsession with the body is countered by his attempt to increase the entropy in his works to the limit. Simplicity gives the illusion of preservation, but it is destructive. The material of Morris's works seems to promise the immaterial. The *Burning Planet* series "promote" dematerialization, disembodiment—the catastrophe of human substance turning to insubstantial shadow, as occurred on the Miyuki Bridge in Hiroshima, drawn as part of *Jornada del Muerto*. If Morris's art is about death and its entropic effect, one has to reexamine the status of the body, and of bodiliness in general, in his art.

A. E. Taylor has pointed out that "it is . . . a mistake to attribute to Plato, as is so often done, the definition of philosophy as 'meditation on death.' " The Greek word Plato uses "does not mean meditation but *rehearsal* . . . the repeated practice by which we prepare ourselves for a performance. . . . The thought is thus that 'death' is like a play for which the philosopher's life has been a daily rehearsal. His business is to be perfect in his part when the curtain goes up. . . . It is implied throughout the argument that 'philosophy' has the special sense . . . of devotion to science as a way *to the salvation of the soul*."[24] Again, theater rears its head. Morris's reliefs are a performance of death. The Indifference they catalyze is necessary if the philosopher is to be perfect in his part when he faces death. Morris, who understands the "science" of his art very well, and whose work in general is inseparable from a kind of scientific understanding of the properties of materials and landscape, and who is an eternal actor, may or may not save his soul in the coming nuclear extinction. But he has positioned it in the drama of death he has unfolded so that it seems changeless.

Notes

1. Georges Bataille, "The Sorcerer's Apprentice," *Visions of Excess, Selected Writings, 1927–1939* (Minneapolis: University of Minnesota Press, 1985), p. 225.

2. Robert Morris, "Aligned with Nazca," *Artforum* 14 (October 1975): 26f. Many of Morris's works imply the same "cosmic" or aerial perspective—a grandiosity of spatial layout. This includes the various "splay pieces" of 1967–69, as I call them, including the different untitled metal and wood beam pieces, as well as the felt pieces, *Earthwork* (1968), *Steam Cloud* (1969), and various associated untitled pieces. In a sense, the mirror pieces also imply a cosmic perspective, in that they seem to expand space limitlessly and illusorily—the basic condition for the existence of the sublime.

3. I am suggesting that Morris, wittingly or unwittingly, reconciles the false bifurcation of "Art and Objecthood" (theater) posited by Michael Fried (*Minimal Art: A Critical Anthology,* ed. Gregory Battcock [New York: E. P. Dutton, 1968], pp. 116–47).

4. Robert Morris, "A Duologue" (with David Sylvester), *Robert Morris* (London: Tate Gallery, 1971; exhibition catalogue), p. 16. Morris's sense of the self-contradictoriness of the art work by reason of the "paradox" of its being at once art and nonart shows that he is an "unhappy consciousness" in Hegel's sense. For Morris, the "merely contradictory being" of art, its "inwardly disrupted," "dual-natured" character, is its true nature. G. W. F. Hegel, *Phenomenology of Spirit* (Oxford: Oxford University Press, 1977), p. 126. This accords well with the generally skeptical nature of his art, for the unhappy consciousness is a "stoical" hypostatization of skepticism.

5. Robert Morris, "American Quartet," *Art in America* 67 (December 1981): 105.

6. Morris, "A Duologue," p. 16.

7. T. W. Adorno, *Aesthetic Theory* (London: Routledge & Kegan Paul, 1984), pp. 9–10.

8. Ibid., p. 22.

9. Ibid., pp. 281–82.

10. Annette Michelson, *Robert Morris* (Washington: D.C., Corcoran Gallery of Art, 1969; exhibition catalogue), p. 23. Michelson notes that for Morris the characteristic *Gesamtkunstwerk* "passage from the scenic space of Theatre to the landscape space of the Theater of Operations, lies through a Theatre of Consciousness whose dimensions are articulated by structures perceived in time" (p. 27). The nuclear extinction works are the most ambitious demonstrations of such a passage. It involves at once "the radically engaging physicality" of the work, its power "to question the aesthetic . . . distinction . . . between a 'real' or operational space—that of the beholder—and a 'virtual' space, self-enclosed, optical, assumed to be that of sculpture" (p. 35).

11. Ibid., p. 9.

12. Robert Morris, "Dance," *The Village Voice* (February 3, 1966): 24.

13. Michael Podro, *The Critical Historians of Art* (New Haven: Yale University Press, 1982), p. 6.

14. Barbara Rose, "ABC Art," *Minimal Art: A Critical Anthology* (New York: E. P. Dutton, 1968), p. 295.

15. Anthony Storr, *Human Destructiveness* (New York: Basic Books, 1972), p. 62.

16. Ibid., p. 69.

17. For example, in "The Art of Existence: Three Extra-Visual Artists: Works in Progress,"

Artforum (January 1971), Morris invents fictional figures who are disguised versions of himself. "American Quartet" concludes with a disclaimer that subverts the argument, if headlining its dialectical character. The whole Duchampian aspect of Morris (Michelson, *Robert Morris*, pp. 50–53), can be understood not only as a tour de force of Modernist irony subverting meaning—or fetishizing meaninglessness—but as an example of American high jinks humor, not always as black as has been thought.

18. Storr, *Human Destructiveness*, p. 62.

19. Robert Smithson, "Entropy and the New Monuments," *The Writings of Robert Smithson* (New York: New York University Press, 1979), pp. 9–18.

20. Rose, "ABC Art," p. 296.

21. Paul de Man, "The Rhetoric of Blindness," *Blindness and Insight* (Minneapolis: University of Minnesota Press, 1983), p. 106.

22. Podro, *The Critical Historians of Art*, p. 6.

23. Rudolf Arnheim, *Entropy and Art* (Berkeley: University of California Press, 1971), p. 52.

24. Quoted in Jacques Choron, *Death and Western Thought* (New York: Collier Books, 1973), p. 50.

Inside Cindy Sherman

Ever since she began to make big color photographs, Cindy Sherman has been pushing the photograph's appearance to its mechanical limits, where it achieves what might be called a neo-"creative" effect: it appears perversely handmade. This is part of its ascension to high art. It is a crucial aspect of Sherman's effort to create the effect of visual intransigence—irreducibility and irreplaceability and intransitiveness (the ingredients of so-called uniqueness)—which is the "high" of high art. This effect is usually thought of as most likely to occur in, if it is not exclusive to, painting: a privileged "expressive" epiphenomenon of the intricate thickening and thinning of the flow of paint, of the complex current of touch that moves through it, sometimes imperceptibly. But Sherman shows herself to be a major photographer not only because of her successful displacement of painting, but because she uses photographic illusion—while calling full attention to its artificiality, staginess, fictionality—to generate fantasy images which are so convincing that we never doubt their emotional truth, as we do all too often with the typical Hollywood fantasy, which quickly loses all significance—except as a cultural curiosity—once we awaken from the spell of soft pathos it casts. We cannot awaken from Sherman's nightmare fantasies; not because they are nightmares—they are in fact more tragi-comic, or full of black humor, than bluntly bad dreams—but because they are so insidiously poisonous in their physical immediacy that they evoke raw emotions, which are hard to escape. It is the way their sensibility functions as part of the macabre whole that makes them emotionally effective, not the hammering death-obsession of the images.

Sherman's color is the major vehicle of this insidious immediacy, forcing us face down into a queasy scene impossible to stomach, a scene that looks like our own vomit—our own vomited fantasies. Is it an accident that two of Sherman's most interesting scenes deal with food, and that

This article originally appeared in *Artscribe* (September/October 1987).

in one the stew on the beach blanket has the anarchistically spilled look of vomit? Indeed, the works verge towards anarchy in their ingenious compositions, but it is as dishes of well-cooked colors that they first engross us. It is the delicious colors we consume before we know what we are doing—and then we find we have more in our mouths than we bargained for. The libidinous sumptuousness of the colors is the sugar-coating on the obscene—behind-the-scene—pictured. Each of Sherman's pictures is a pathology mocked by its healthy glowing colors. The contradiction suggests that each picture is a mock-pathology, but it may also be that it is lost somewhere on the vast continuum between the pathological and the healthy—some unholy mix arguing for their inseparability—or that the picture is so sick that the aesthetic health with which it glows confirms its incurability. Each picture is a psychosomatic manifestation of a sickness which is as indispensable as it is incurable: each picture is an eternal return of the necessary sickness of life. Indeed, the vital signs—dead fish on the shore, rodentlike creatures on the wrecked bed of love, cankerous bulging flesh of equivocal buttocks/breasts—are all amiss, diseased, but they are still vital. And we are given an odd kind of life by it: we are too close to the scene, forced into an involuntary intimacy with it, to detach ourselves from it, to view it purely aesthetically—is aesthetic neutrality another form of clinical detachment?—or even to find the reason for its chaos, its smell of violence. We must suffer the sickness with the artist.

One loses one's comfortableness with the color; its succulence begins to seem unsavory. Indeed, one begins to realize, like a country doctor—which is all a critic is—that Sherman's color is that of the worms in the wound of the patient in Kafka's story *Ein Landarzt*: "Worms, as thick and as long as 'the doctor's' little finger, themselves rose-red and blood-spotted . . . wriggling from their fastness in the interior of the wound towards the light." This "fine wound" is all the patient "brought into the world," his "sole endowment." Sherman pictures her wound in a variety of ways; its dazzling, lush color is the sign that it is her basic endowment. The color that flows from her wound does not clot; as we drink its voluptuousness in we experience our own unhealable luxurious wound. The grim beauty of the color is not the clot that inhibits the wound, but its mad exhibitionism, that of the doomed, indifferent to its effect on others—telling them that they, too, are wounded and doomed. Sherman uses the aesthetic, whose implicit purpose is to make the immediate integral and inescapable, to create an ethical illusion—a Kierkegaardian despair or sickness unto female death which takes the form of an unhealable wound. Sherman's pictures show us the living death of being female, but they also show us the living death of the self as such—the self split into fragments that can never come together into

a coherent whole, the self that in fact appears as one among the many fragments of a shattered world. The recurrent image of the self in Sherman's pictures is the fragment of a fragment—a fragment of intimacy in a destroyed, unreconstructable private world. Sherman's world. Sherman's pictures are, as it were, morbidly archaeological in character. They delve in death quixotically fabricated as culture.

Sherman creates a scatter effect of objects, almost to the point of chaos. One can perversely say she is "deconstructing" the world of the (female) subject, but the effect of the deconstruction is a sense of total abandonment. Her pictures are scenes of primitive abandonment, all the more terrifying because of the promise of happiness latent in the scenes—the glamor of happiness, promised by the glamor of the color. She shows us not fear of abandonment but its actuality—its fundamentality, whether in a generalized sense of vulnerability or in the broken promise of happiness that life made. Sometimes it is the abandonment implicit in the forced intimacy of rape, which speaks for the sense of the nothingness of oneself all human relationships sooner or later give, especially love relationships. The scenes often show a promise of pleasure become painful. The blood-red in many of the pictures suggests the generally destructive character of intimacy, whose debris is pictured. Sexuality is clearly the implied theme of a number of these works, as the picture of the destroyed bed with the figure watching the creatures on it suggests. (The bed suggests the lost paradise of love, from which the figure is exiled, a paradise whose lostness is confirmed by the fact that the creatures have turned to stone—become garden statuary.) In general, these works convey the sense of coming upon the dregs of some decadent, violent Bacchanalia. The pictures are more or less conspicuously scenes of a crime, as in the image where a woman's hand, bloody underwear, and fallen head, seen from the back, are visible on a forest floor.

The pictures are stills from Hollywood horror film scenes, their constructed look and mechanisms of representation are self-evident—in the picture just mentioned what is seen from the back is a woman's wig, and the leaves and pine cones look glossily fake—but they are nonetheless, as mentioned, emotionally effective. In fact, their very artificiality serves their emotional effectiveness, because it becomes a safe area from which we can explore its horror and the emotions aroused by it with a certain contemplative aloofness. And, as with the color, the general artificiality— the readability of the picture as artificial, a construction, with the attendent Eureka sense of "I get it (intellectually, aesthetically)!"—lures us into the destructive fantasy, and stimulates our own unconscious fantasy. By attending to the pictures intellectually and aesthetically, which they blatantly invite us to do, we anchor ourselves more firmly in their fantasy. It is the trick of the major artist: we are given the sense of being

Cindy Sherman, *Untitled*, 1987
Color photo, 71" × 47¾".
(Courtesy Metro Pictures, New York)

wide awake in the nightmare, carefully noticing the stuff out of which it is constructed, which makes it all the more convincingly an emotionally gripping nightmare. In a sense, our very alertness to the way the picture is made is a sign of our possession by its horror.

Sherman's pictures are an astonishing mix of paranoid and depressive fantasies. That is, they reveal the anxiety aroused by fear of destruction of the self by the other, and the anxiety aroused by the self's desire to destroy the other. Her pictures are an unholy mix of cruelties, in which there is no reparation for the self that feels vulnerable, or for the other broken on the rack of the self's fantasies of destruction. Sherman's work has been interpreted as a feminist demonstration of the variety of female roles—the lack of fixity of female, or for that matter any, identity, although instability seems to have been forced more on women than men. Sherman in a sense is destroying an already destroyed—bankrupt—social identity. Behind the masquerade of identities, none of them binding, and none of them invented by and belonging to woman, but forced upon her by man, there is supposedly a void, a faceless cipher—a nonentity and nonidentity. But this interpretation is a very partial truth. Sherman shows the disintegrative condition of the self as such, the self before it is firmly identified as male or female. This is suggested by the indeterminate gender of many of the faces and figures that appear in these pictures, and the presence of male or would-be male figures in some of them. Female attributes—for example, the woman's clothes in one untitled work (all are of 1987)—are just that, dispensable attributes, clothes that can be worn by anyone. The question is what the condition of the self is that will put them on—reach into the mess of the room and decide that they're for it because they'll reflect, even substantialize, it. These clothes exist within a repudiated world. Sherman is in fact thrusting the repudiated and abhorrent in our faces—especially in one startling picture of bulging flesh as full of sores as the flesh of the dead Christ in Grünewald's Isenheim Altarpiece.

It is not just the repudiated as such that Sherman represents—whether the repudiated as symbol of the victimized, annihilated female (repudiated and abhorrent because her very presence is a glorified nothingness)—but inwardly repudiated death, the abhorrent death she manifests in her pictures, the outlawed death lurking in herself. The sense of violent decay—of the inherent violence of decay—that permeates these pictures suggests Sherman's destructive aggression: that is the repressed repudiated and abhorrent that returns with a vengeance in these works. There is a certain violence in Sherman's constant shifting of roles, endless playing of endless roles—an aggression which mocks and finally destroys each role in the act of filling it, discards it in the very act of demonstrating

it. Nobody else can play it after Sherman has, which means there is nothing left to play—only the play of the color, the play of the artistic construction.

Sherman is an ultra-elegant nihilist. One can understand her nihilism through Heinz Kohut's conception of aggression as the product of the self's fragmentation and disintegration: Sherman is in effect announcing her own lack of integral selfhood through her nihilistic, aggressive playing and transformation of roles, each the fragment of a self that does not add up to a whole, that is less than the sum of its parts. Or it can be understood in Melanie Klein's terms as a manifestation of primal destructiveness, where the impulse to play a new role implies a desire to appropriate its power (every act of appropriation being an act of destruction and over-powering). In either case, there is no denying the underlying sense of destructive rage in Sherman's works.

This disintegrative rage is in no way denied by the theatrical, "egoistic" manner in which it is made manifest. What the theatrical "egoism"—the strong aesthetic flair—of the execution suggests is a certain ego strength; it is a survivor's strategy in the midst of the maelstrom of destructive rage. Sherman makes us not only complicitous detectives at the scene of a crime—the crime of the aggression a woman is not sup-posed to have, yet is regularly the victim of—but asks us to believe that we can be strengthened by the charnel house experience. We sift the ruins of Sherman's pictures in search of her identity, and we find it in the ten-sion between the erotic, glamorized pleasure of the color that is part of the ingeniousness of the artistic construction, and the thanatopsistic scene. The split personality of these pictures, which so readily and fully reveal the elegance of their methods yet harbor a mysterious, blank-faced violence—which with extraordinary power bring repulsive, ugly scenes under aesthetic control, make them aesthetically appetizing—surely signals Sherman's profound ambivalence about her experience of her womanhood, something she abhors yet enjoys, and brings under con-trol by putting it to artistic use. It is this artistic use—her wish to excel with a certain aesthetic purity as well as to represent inventively—that reveals her wish to heal a more fundamental wound of selfhood than that which is inflicted on her by being a woman.

Andy's Feelings

Sadism and masochism, or the impulse to look and be looked at. . . .
Sigmund Freud, *An Autobiographical Study,* 1925

Andy, Edie Sedgwick is alleged to have said, was "a sadistic faggot."
I don't think the homosexual part is much to the point of understanding
the extraordinary impact of Warhol on the art world and the capitalist
world, but the sadistic part is. Warhol became a cult figure in both
worlds—a famous artist and rich capitalist (they had equal priority)—
because he revealed their core tendency toward seductive exhibitionism:
the pseudo-revelatory serving up of oneself to the ideal spectator, that
is, the one who wants only to look, not understand. Certainly "recogni-
tion" means being looked at, at first by the initiates and then by as many
people as possible. The more people who see one, the greater the
recognition—a deeply satisfying narcissistic experience.

Warhol's point is that whether one is seen for one's art or one's
money, one is—must be—seen. His career makes it clear—perhaps for
the first time in the history of capitalist art—that it didn't much matter
whether one was seen for one's art or one's money. Preferably one was
seen for both. The two converged, vectoring in the common goal of being
seen. They were conditions for being seen, not ends in themselves. Each
became freshly topical through the other, and one was topical—looked
at *now*—if one was seen to have both. In fact, Warhol's career suggests
that it is almost impossible in a capitalist society to have money and not
sooner or later own art, and that it is almost impossible to make art that
is "interesting" and not sooner or later make money. Making money was
the ultimate art in capitalist society, and high art was simply money's
most exalted reification: art was money monumentalized. Not only did
art launder money, and money legitimize art as no amount of thought
about it could ever do, but both validated looking and being looked at

This article originally appeared in *Artscribe* (June/July 1987).

as the ultimate modes of being. They kept one alive. Warhol's whole career demonstrated that without each other both art and money were suspect: neither would really be seen—be alive.

Warhol, then, made it transparently clear that to be seen was all that mattered in life, and all that made life matter. Art and money were simply the means of being seen: they made one conspicuous enough to be visually consumed by the public at large. To be seen was, for Warhol, the most conspicuous form of consumption there was. To be seen means to become the object of envy, the envy that shows itself in the eyes of strangers, the envy that shows that they want to consume one. To be seen means to offer oneself as a feast for the eyes of strangers: to offer oneself as the sacramental meal in a cannibalistic ritual of "aesthetic" seeing. As Melanie Klein says, envy always works through the eyes, aggressively scooping out—emptying of all its goods—the object of desire. In the worlds of art and money the ideal or most consummate experience is to be envied by all, as though such envy made one ideal. In the worlds of art and money one becomes successful because one masochistically serves the envy of others.

What does one get in return? Public permission to have the profoundly sadistic pleasure of possessing others more completely than they possess themselves. Warhol became the most ecstatically consumed art object of capitalist desire; in return, he was given carte blanche to consume the capital—"real being"—of others, that is, to convert it completely into art. Others were assimilated to his art condition—becoming imagistic food for masturbatory thought—more rapidly than he was consumed by their looking. Like no other portraits, Warhol's give others the intoxicating illusion—the master illusion of art—of being seen as they want to be seen, when in fact they are presented as less than they are. That is the disillusioning truth that lies behind the illusion of truth that art creates. Warhol was a specialist in this art joke/art paradox. At one and the same time his portraits inflated and deflated his subject. In the end, his narcissism triumphed over theirs. Like a fickle God saving and damning in the same breath, Warhol bestowed the dubious immortality of being photographically reproduced on his subjects. The enduring visibility this gave them ensured that they could always be resurrected as a trivial passing fancy in some remote future.

Seeing, as Sigmund Freud tells us, is the second most primitive sexual activity. It is "an activity that is ultimately derived from touching. Visual impressions remain the most frequent pathway along which libidinal excitation is aroused." The sexual function, Freud wrote, is constituted by "component instincts" which "make their appearance in pairs of opposite impulses," the most primitive being the "impulses to look

and be looked at,'' from which sadism and masochism are derived. ''They operate independently of one another in their search for pleasure, and they find their object for the most part in the subject's own body. Thus to begin with they are noncentralized and predominantly *autoerotic*. Later they begin to be coordinated.'' They are never more than tentatively coordinated in Warhol. The object towards which they are directed by Warhol—all those self-styled celebrities eager to be consumed by his glance—are never more than surrogate selves for Warhol himself. They are never more than empty bodies he temporarily makes his own. The important thing about Warhol's portraits is not that they reproduce the other on the basis of a photographic appearance, but that the photograph confirms the emptiness of the other. That is, the other is dematerialized—disembodied (on the model of disembowelled)—by the photograph, which is the major means of seeing and being seen in our society.

While Warhol's portraits are photographically based, each has a partially—pseudo—impulsive look to it, which can be regarded as its residue of bodiliness. The texturing is virtually never completely uniform in a Warhol picture. There is a kind of glitch or imperfection in the reproduction—an illusory sign of hand, a routine trace of impulse. This is as crucial to the portrait as its photographic character. The photograph disembodies; what is left of the body survives in the form of the ''touch'' that signals ''Warhol.'' That touch is the sign of Warhol's own body. It is an indication of his essentially autoerotic relationship to the portraits he creates. It suggests the generally autoerotic character of photographic—mechanical—reproduction.

Warhol's subjects seem to demand to be photographed. In obliging, Warhol satisfies their, and his, narcissism. His photograph is the souvenir of this merger; the trace of impulse can be understood as the mingled emissions—libidinal excitations—of the subject's narcissism and Warhol's narcissism. A result of a seemingly technical defect in the mechanical process of reproduction, it is emotionally a sign of the autoerotic/narcissistic pleasure the portrait gives everyone concerned. It is even a sign of just how ''hygienic'' their primitively erotic relationship is. Neither ever lays a hand on the other, or loses ''self-possession,'' however much the self of both Warhol and his subject is no more than a form of looking, presumably *the* form of desire. Thus, mechanical reproduction is an impulsive self-production for both Warhol and his subject. Each is the Erostratus of the other, to refer to Sartre's story of that title.

Jean Baudrillard writes that Warhol demonstrates that ''the duplication of the sign . . .destroys its meaning. . . . The multiple replicas of Marilyn's face are there to show at the same time the death of the original and the end of representation.'' This is only half the story, and it is half

a lie. The meaning of the sign is not destroyed by its duplication, but emotionally absolutized. Warhol's works may be simulations—"hyper-realizations" of his subjects—but simulation is not simply a destruction of meaning. It is destruction, but a sadomasochistic destruction which deepens the meaning of what it destroys—plants it so deeply in the unconscious that it can never be uprooted or denied. Warhol's sadomasochistic destruction of the sign of the other both stabilizes—secures—its meaning, and suggests the instability of the destroyer—Warhol. It shows the other, seemingly destroyed (emptied of meaning) through reproduction, to be in fact indestructible—ineradicable, irreplaceable, unconditionally haunting—in the emotions of the destroyer; and it shows the destruction to be an enraged, resentful display of vulnerability—the expression of a profound feeling of nothingness, invisibility—by the destroyer. Warhol reproduces objects that have become entrenched in his unconscious, giving him a sense of being he does not usually have. Their "impulsive" reproduction—and it is crucial that it seems to be impulsive, that is, a kind of arbitrary reaching out to the other—is an acknowledgment of this entrenchment, of the inescapable inner necessity of the other.

Baudrillard believes that "the hyper-real . . . captures and obstructs the functioning of the real, the symbolic and the imaginary," shortcircuiting "the messages of the unconscious." But the truth is just the opposite: hyper-realism confirms unconscious significance. Baudrillard correctly speaks of "liquidation by simulation." But this is deceptive. Simulation looks like—and is—a public execution, but at the same time a private memorialization, even deification, of the ostensibly destroyed other. Simulation is a paradoxical process of internalization and mastery of an other experienced as overwhelming—a way of putting down and bringing under control an other who seems larger than life to, and generally bigger than, the one (Warhol) who creates the simulation, the substitution. The other displaced by the simulation becomes a kind of sacred icon to be meditated on in a fantasy of consolation for one's own inadequacy. Masochistically, Warhol felt inadequate compared to his subjects, whose self-love—the certainty that they were entitled to see and be seen—made them seem adequate in and for themselves. Even as photographically empty appearances they would always have more reality than he felt he would ever have. This feeling confirmed his sadistic treatment of them—his transformation of them into simulations, that is, his "de-realization" of them. But in a vicious circle this also announced his need for and envy of them. Warhol's portrait-simulations are the opium he uses to anaesthetize himself against the fate of forever feeling inadequate, empty, meaningless, unlovable, even nonexistent.

Simulations, then, don't just happen. They are deliberately destructive acts of vengeance. Indeed, Baudrillard's conceptualization of simulation is spiteful, vindictive. He wants to demonstrate that capitalist society is self-destructive—ultimately in a Bataille-type potlatch "exchange"—and he thinks he has found it committing suicide through reproduction. Warhol presumably typifies this tendency to death by simulation—living death—as well as announces, epistemologically, the primacy of hyper-reality. Liquidating whatever demands to be seen by simulating it, Warhol may indeed be exemplary of capitalism at its most decadently inhumane and emotionally regressive. But there is an inherently subjective meaning to his art. Capitalist society may be full of people like him, but to assume that capitalism alone is responsible for them (as Baudrillard implicitly does) is to reduce selfhood to a gross social product. It is also to assume that society is totalized by reproduction—that its members cannot critically resist it, that like Warhol they must succumb to it, be used by it rather than use it. Such an assumption is a delusion of the rhetorical grandeur of anti-capitalist discourse, rather than the result of a considered, unhateful look at the society's inhabitants.

According to Freud, sadomasochism involves taking "pleasure in any form of humiliation or subjection." In sadism, "the aggressive component of the sexual instinct . . . has become independent and exaggerated and . . . usurped the leading position." "Masochism is nothing more than an extension of sadism turned round upon the subject's own self, which thus . . . takes the place of the sexual object." For Warhol, as I have suggested, looking and being looked at are the quintessential, most intense forms of sexual activity and human relationship he knows. They are automatically aggressive—the products of a desire to overpower what is looked at. Simone de Beauvoir thought that the Marquis de Sade's sadism was "compensation for his inability to become emotionally intoxicated." The flat effect of Warhol's work—the arbitrary trace of impulse does nothing to relieve it—reveals a similar inability to feel others, and so in the end oneself; that is, to experience them and oneself as active subjects. Warhol's portraits are full of vicious passivity.

Sadomasochism, as Anthony Storr writes, is a complex power relationship masquerading as "pseudo-sex." It is a way of domination through submission, submission through domination. It is compensatory for infantile feelings of powerlessness and helplessness, leading to the adult feelings of inadequacy, emptiness, meaninglessness, even the nonexistence or invisibility already mentioned. Warhol's sadistic photographic overpowering of others, reducing them to simulacra, is in effect a masochistic acknowledgment of such infantile feelings. It infantilizes others into the same helplessness Warhol feels—the paralyzing feeling

of vulnerability he masks through his pseudo-expressivity. Warhol was a huge success because he appealed to our most regressive desire—our sadomasochistic desire to be celebrities, to see and be seen. Through it we publicly proclaim our delusion of the grandeur of our existence while privately whispering our feeling of inconsequence. No doubt this is a certain kind of modern self-realization.

Beuys or Warhol?

I see contemporary art caught in a tug-of-war between what can be called the media and therapeutic conceptions of art. It is a cold war that has been going on since the 1960s, and that has recently become hot. Warhol is on one side, Beuys on the other; each is a paradigmatic figure, as important for what he represents as for his actual art. Much is at stake in this war; one cannot remain neutral in it: I am for Beuys, and against Warhol. The clearest way to understand their difference is in terms of narcissism. As Erich Fromm wrote, in it "only the person himself . . . [is] experienced as fully real, while everybody and everything [else] . . . is not fully real, is perceived only by intellectual recognition, while *affectively* without weight and color." Warhol is the perfect narcissist, summarizing in his art the modern narcissistic idea of art for art's sake, and in his person the narcissism which supposedly guarantees—but is in fact the dregs—of the artist's "genius." In contrast, Beuys represents postwar art's major effort to transcend aesthetic and personal narcissism, and seriously relate to the socio-historical objects of the lifeworld. Beuys spreads and spends, as it were, the substance of his self in life-world material, such as the fat and felt on which his being once depended. Beuys responds to what Habermas calls the lifeworld's pathologies, while Warhol is pathology incarnate.

This distinction between an art that actively engages the lifeworld and one that is passive toward it correlates with Fromm's distinction between "the (biologically normal) love of life (biophilia) and the love of (and affinity to) death (necrophilia) . . . its pathological perversion." The choice between them is "the most fundamental problem" of our age. So long as art has a subliminal reparative function, it remains in the service of life. Beuys shows art's biophiliac tendency at its strongest. Warhol is the consummate necrophiliac; to completely submit to media reproduction—Warhol uses it to negate affect and as naive intellectual recognition—

This article originally appeared in *C Magazine* (Fall 1987).

is to embrace living death. In Warhol's use, reproduction is the instrument of death, a way of killing what has already been fast-frozen by society into an insidious banality, betraying life's spirit and process.

The current version of the media attitude has been articulated perhaps most clearly by Jack Goldstein. In 1981, he said that "you're passive to [the media language], you accept the fact that it manipulates and controls you and you in turn manipulate and control the audience that is tuned into your work by using the same processes that the culture utilizes. It's to do with liking the culture and not wanting to extricate yourself from it in any way." Is Goldstein speaking cynically, with tongue in cheek? Only a fool could, without qualification, like the culture, could restrain himself from criticizing its manipulative and controlling tendencies. But Goldstein is incapable of criticizing media language because he endorses the passivity implicit in it. His art elegantly embroiders media-derived imagery, making its "captivating" quality more evident. He is comfortably—aesthetically—imprisoned in it. Goldstein's remark seems to have a militant, calculated naiveté, but it is the sign of a fatal flaw. The capitulating passivity he speaks of signifies infantile, pathological dependence on the media.

In general, there is a dumb rush to media dependence, as if it was art's inevitable fate to be media-ted and it responded by becoming media-like in the first place. In much art, the media mode seems more dominant than anything; whatever criticality the art may or may not have is subsumed by its "media mimesis" This betrays art's power of imaginative articulation, on which its therapeutic effect depends. Media-oriented art is a way, as Baudelaire said, of discrediting and disdaining imagination, which "decomposes all creation, and with the raw materials accumulated and disposed in accordance with rules whose origins one cannot find save in the furthest depths of the soul . . . creates a new world"—that of the work of art. The media attitude implies an indifference to the psyche's health—an indifference which is a symptom of its disintegration and necrophilia. For the analytic decomposition of "all creation" into "raw materials," which are imaginatively synthesized into the work of art, is a metaphoric analysis and recomposition—reintegration—of the psyche, that is, an analysis and cure of "the soul."

Baudelaire's attack on photography (Salon of 1859) is in effect the first major critique of the media. It is worth emphasizing that for Baudelaire photography's major negative psychic effect was its encouragement of narcissism, the most regressive and involuted of psychic tendencies. With photography's invention, "our squalid society rushed, Narcissus to a man, to gaze at its trivial image." It may be that Baudelaire's remark—half in passing jest, half in ironic seriousness—is one of the earliest recognitions of the prevalence of the problem of narcissism in modern society.

(Photography—on which Warhol is totally dependent—may be both its symptom and a way of gaining narcissistic satisfaction that exacerbates the sickness it pretends to cure.) In any case, media-language art is profoundly narcissistic in that it unquestioningly accepts the banal sense of self manifest in the media. It implies that there is no deep, critical work of imagination—analysis and synthesis—that needs to be done on the self. The primary appeal of works of art is that they symbolically do the imaginative work of analysis and reintegration of the self for us, or catalyze it in us through our identification with them. They give our decomposition and recomposition of the psyche socio-aesthetic form, and acknowledge its inner necessity. Thus works of art acquire general human significance because of their therapeutic "suggestiveness," "contagion."

More than Baudelaire ever thought possible, Warhol uses photography and the media to invite us to gaze at our trivial image on its screens—indeed, trivializes the image so that it becomes unmistakably us. It offers us a fixed and superficially complete idea of our self, as though to be fixed in place and totalized by an image was to be healthy. Media articulation does not encourage us to alter our sense of reality, or in general lead to an alternate grasp of it, as imagination does. Nor does the media satisfy unconscious wishes deeply, which is why it relies on relentless reproduction to make its shallow point. In contrast, imagination subtly changes our sense of reality by subtly changing us. Such "change of heart" is part of art's subliminal therapeutic effect.

When Beuys spoke of his work with material as "a sort of psychological process" of self-healing, or of his performances as "a psychoanalytical action in which people could participate," he was explicitly acknowledging art's therapeutic task and his biophilia. Beuys had a "ritualistic respect for the healing potential of material," and tried to make his art of materials a mode of healing: "*Similia similibus curantur*: heal like with like, that is the homeopathic healing process." For Beuys, "the principle of form" is only one pole of art; the other is "a process of life." Their integration in "social sculpture" was a move "towards the possibility of creating a new planet." But, as he said, a social revolution can never occur "unless the transformation of soul, mind and will-power has taken place"—for him, through healing art.

In the last analysis, Warhol's media-oriented art is a cold art, while therapeutically oriented art is a warm art. It is worth noting that Beuys was concerned with keeping warm. He was always recapitulating the situation when, shot down in the Crimea in 1943, he was found unconscious in the snow by nomad Tartars: "Had it not been for the Tartars I would not be alive today. . . . They covered my body in fat to help it regenerate warmth, and wrapped it in felt as an insulator to keep warmth in." In contrast to this, Warhol was determined to remain cold;

his passivity was a successful form of coldness—a great necrophiliac achievement, for it rendered him deathlike. Perhaps both Beuys and Warhol suffered from narcissism, but in Warhol it became ingrained.

The psychoanalyst Heinz Kohut wrote that the infant learns "to maintain a feeling of warmth" by internalizing the mother's "physical and emotional warmth and other kinds of narcissistic maintenance." "Narcissistically disturbed individuals tend to be unable to feel warm or to keep warm. They rely on others to provide them not only with emotional but also with physical warmth." Warhol did not really resist his coldness; he apparently lived surrounded by others—in "society," full of coldness and fake warmth. In sharp contrast, Beuys fought his inner coldness as well as the world's coldness, and regarded art as a means of generating warmth. The moral choice between them is clear. To vote for Warhol is to give the victory to death. To give Beuys a vote of confidence is to give the victory to life. It is the major critical choice facing art, and the critic.

Regressive Reproduction and
Throwaway Conscience

In an untitled work of 1984, which includes the text "Put your money where your mouth is," Barbara Kruger shows a partially peeled banana between a pair of false teeth. It is no doubt an allegory. Man's "money" is his penis, and it is between his false teeth (on Mao's model of "paper tiger"). "Go suck yourself," Kruger seems to be saying to man, "you haven't got real teeth anyway. You can't bite." One of the truisms in Jenny Holzer's *Survival Series*, 1983, is: "It is in your self-interest to find a way to be very tender." Holzer presents an unresolvable antinomy, that is, she makes, in the words of Jonathan Culler, a " 'deconstructive movement' in which each pole of an opposition [is] used to show that the other is in error but in which the undecidable dialectic [between self-interest and tenderness] is inherent in the . . . possibilities of our conceptual framework."[1] In *Upstairs at Mobil: Creating Consent*, 1981, Hans Haacke exhibits an oil drum labelled "Mobil" and inscribed with two quotations, one above and one below the oil company's name. The one above states "We spent $102 million last year in advertising"; the one below states "We just want to be heard." It is signed "Rawleigh Warner Jr. Chairman." The drum has a TV antenna on it, as though the message was being broadcast to the world. "That's a lot of money just to be heard," Haacke seems to be saying. "Your ulterior motive has to be profit, discreetly made. You generate good will with your support of TV cultural programs, lulling people into forgetting that you control the market for one of the major products people use. Your support of culture isn't exactly an act of charity. Your advertising is a form of ideology."

All this art and much more—all the "art for social change," as it has been called—makes moral claims for itself. Is it entitled to make these claims? Just how moral is it? Or, perhaps better put, what is the nature

This article originally appeared in *Artscribe* (January/February 1987).

of the morality of the art of "social strategy," as it has also been called? Is it so straightforwardly, so unequivocally, moral?

It has been said that this new kind of Social Realism, this neo-revolutionary or would-be revolutionary art, does not presume to be our conscience. Yet it certainly sounds like the voice of conscience, bluntly speaking paradoxical truths that are hard to bring to consciousness and troubling to hear. Kruger makes a socio-political point. Much of her work is addressed to men; it reminds them that their power is in jeopardy, it threatens them with their own assumptions. Holzer displays in all its bleak obviousness a determining code of feeling, forcing us to recognize its influence over our own particular emotional life. Haacke depicts, in a kind of abstract effigy, a real social power, a corporation that concretely controls our lives and consciousness to assure its own profit. All of these artists offer what might be called "confrontational representation." Their art physically—with a quasi-theatrical physicality—confronts us with its relative directness of statement. But it also reverberates with implications that take deep hold psychically, thus confronting us emotionally as well. It vehemently possesses interpersonal space in order to have personal effect.

In their different ways, each of these artists speaks prophetically, up-braiding us, protesting the world, bringing us to full awareness of our historical situation. There is a messianic streak in their art. According to the Talmud, the Messiah will come only after a catastrophe, only after suffering and evil have become universal. These artists are not certain that the Messiah—the fully human being—is at hand, but they seem to smell catastrophe in the social air, in individual lives. Kruger seems to be telling men to repent their evil domination of women before it is too late; the image described conveys a veiled threat of castration. Holzer, many of whose texts are apocalyptic (in and of itself her textual stream of consciousness is violent in its relentlessness, brutal in its insistent hammering) offers a voice that seems as full of plight as it is aggressive. It is a voice catastrophically adrift in its own ambivalence. Haacke fearlessly dares to name the satanically manipulative monster—the idol—that uses the means of mass communication for its own ends. All of these artists—they are representative of many more—unmistakably declare their moral or psychomoral mission.

In a sense, they want to change the world by interpreting it artistically. That is, they want to reconcile the opposites in Marx's famous final and eleventh thesis on Feuerbach: "The philosophers have only *interpreted* the world, in various ways; the point, however, is to *change* it." They use art philosophically—analytically—to reveal the underlying mechanisms of social reality in order to change it. Interpreting the world shows

us just how much it controls us. Freed of its influence by acute and careful recognition of it, we are prepared to transform it. Interpretation puts us in a position to take control of our own destiny. These artists mean to be the intellectuals leading us to enlightenment about our enslaved condition, thus compelling us to rebel against it. The consciousness they engender by their art is revolutionary in import, for it is a premise catalytic of action—an argument for social change—rather than an end in itself.

But let us scrutinize the character of their moral attitude—their conscience—a little more closely. Erich Fromm has distinguished between two kinds of conscience, the authoritarian and the autonomous. Freud, Fromm argues, identified "authoritarian conscience," which is

> the voice of an internalized external authority (parents, state, public opinion, etc.) that, because it is internalized, is a considerably more effective regulator of conduct, for although man can hide from an external authority, he cannot escape his conscience, which is part of himself. The characteristic aspect of authoritarian conscience (the superego) is that its "prescriptions . . . are not determined by one's own value judgments but exclusively by the fact that its commands are taboos pronounced by authority." In other words, the prescriptions of conscience have validity not because they are good but because they are laid down by authorities.[2]

I submit that what we see in most of the art of the social moralists, as they are properly called, is a rebellion against authoritarian conscience. Holzer's verbiage is a purge, a vomiting out of the internalized prescriptions with which authoritarian society saturates consciousness, burdens the unconscious. Their contradictory form is less to the point than their authoritative structure—their declarative nature. Holzer projects the authoritarian inner voice in public signs. They are the instruments for projecting internalized prescriptions that have become a bad part of herself. The blatant publicness—demonstrativeness—of the signs makes the externalization process transparent and irreversible. In Kruger, the authoritarian male is externalized in allegorical or emblematic form. As with Holzer, the form of the projection matters less than the fact that it is vigorous and unrelenting. It must be in an obviously public medium—in Kruger's case, the photographic—in order to make the externalization emphatic. Kruger externalizes her own authoritarian—in her case, male—conscience, that is, the male authority that she is conscious of dominating her, but that has also been unconsciously internalized. Like Holzer, she puts her own authoritarian conscience on public show in a kind of show trial. In a sense, their art is a ritual of self-humiliation as much as an attack on authoritarian conscience. They oust the inner enemy, putting it on public display, so that they personally can never again be taken in by it, come under its spell. They are too aware of it for that, and spread

their awareness publicly. They attempt to free others of the tyranny of the inner authoritarian voice by making it external.

In Haacke, the monumental character of the Mobil oil drum sculpture mockingly articulates an aspect of the system of social authority in the terms of its own making. (Much of Haacke's art involves ironic monumentalization, the artistic publicizing of already public information. This process was once subdued and figurative but has become increasingly literal and blatant in his art.) The monolithic oil drum symbolizes Mobil's dictatorial authority. In other Mobil pieces Haacke shows the corporation condemning itself by its own words, displayed for all to see—another show trial technique. Haacke's Reagan pieces articulate a figure that not only has obvious social power as President of the United States, but special personal authority by reason of the major role he plays in the collective American unconscious—the powerful hold he has on the American imagination. Whether this is because he is an actor or not doesn't matter. His success may be "theatrical," but it is just that that makes it all the more important. Haacke's depiction of him as a monstrous matinee idol, in a kind of portrait of Dorian Gray manner, exploits this emotionally "pragmatic" success.

I would argue that Haacke struggles not so much to externalize Reagan, as *not to internalize him*—to resist the Reagan that most Americans find irresistible whether or not they agree with his policies, to resist the undertow of Reagan's popularity, which makes him as divine in life as a Roman emperor after death. Haacke struggles to keep the authoritarian conscience—in the form of Reagan—out of his psyche. Yet Reagan clearly has some hold on Haacke's imagination, or he would not depict him so vehemently. In a sense, Reagan has as much influence on Haacke's artistic production as he does on American society: Reagan demands a strong response, whether pro or con. One seems to perceive him as either all-good or all-bad, benign or malevolent—a splitting which suggests how primitive (pre-Oedipal) his power is. His "father of the country" style evokes the elemental power of the parent, a power which one either embraces for the illusory feeling of security it affords or repudiates in the name of one's own autonomy and realism. In general the obvious way in which such real social powers as Reagan and Mobil appear in Haacke's art has not only to do with his utilization of conventional, populist, at-hand methods of representational communication, but with his concern that such authoritarian types or forms do not become internalized as paternalistic, do not become "fantastic" and larger than life, do not get an unconscious or imaginative hold on one, do not blind us emotionally. Haacke does not want Reagan to capture the imagination and feelings of Americans the way Hitler once seemed to have captured those of the Germans.

Does the rebellion against authoritarian conscience imply a move toward autonomous conscience, or, as Fromm also calls it, "humanistic conscience"? Does the new moralistic art of disobedience—the "cardinal sin," as Fromm tells us, from the perspective of authoritarian conscience— imply a new commitment to humanistic conscience? Not self-evidently. "Humanistic conscience," writes Fromm, "is the voice of our self which summons us back to ourselves, to become what we potentially are."[3] Humanism, or a straw version of it, has been under attack for offering a fraudulent concept of a transcendent, implicitly phallocentric, self. Fromm's concept of self has nothing to do with this, but rather with the "un-annulable existential dichotomies" within which human needs must be realized, especially "the existential dichotomy between the unfolding of all a person's potential and the shortness of human life, which even under the most favorable conditions hardly permits a full unfolding."[4] In any case, "humanistic conscience sees everything that promotes growth, unfolding, and life as good, and everything that runs counter to this as evil. The criterion for good and evil is man's nature itself, in which the general principle of value, growth, and unfolding proves its validity."[5]

Do the social moralists have a humanistic conscience? I don't think so. They certainly know evil—the evil of authoritarian conscience—but it is not clear that they have any sense of good. They are incomplete prophets; they rail against the evil internalized in us, but they don't know what is good for us. There's certainly nothing wrong with that; better half a conscience than none at all. But it gives them what I would call a throwaway conscience, and makes their representational methods seem unexpectedly—and untherapeutically—regressive. That is, their throwaway conscience—their incomplete conscience, anti-authoritarian but also nonhumanistic—is in part responsible for the fact that their art is reproductive rather than productive. It is embedded in the indifference of reproductive representation. While it uses reproductive representation for its own critical—anti-authoritarian—purpose, it also subtly, and no doubt unwittingly, succumbs to its spirit of indifference.

Indeed, the mechanically reproductive character, inseparable from the photo-journalistic, or journalistic character, of their art has been much commented upon. Mechanical reproduction does seem to be the preferred (majority) method of art-making these days—the supposedly "advanced" method. But to inhabit the reproductive representational mode completely is to inhabit a socially controlled machine of creativity, or to accept social manipulation of creativity. I am using "creativity" in the sense in which D. W. Winnicott writes that "many individuals have experienced just enough of creative living to recognize that for most of the time they are living uncreatively, as if caught up in the creativity of someone else, or

of a machine.''[6] The social moralist artists accept the fact that their art is inescapably ''caught up in the creativity of someone else, or of a machine''—the social machine. Reproductive representation is the creative mode of the social machine, the socially approved mode of creativity. For it is creativity with little mystery to it—an upfront, relatively controllable creativity. The social moralist artists want to use commonplace methods of reproductive representation critically, and they do to some extent. But reproductive representation is omnipresent and omnipotent, and the monopoly of social power, which it represents. The social moralist artists become more manipulated than manipulative: they are used ''creatively'' by the social machine. They become a tic within the social machine, a minor malfunctioning, easily corrected yet allowed to exist at the whim of the powers that be. It uses them to show the full extent of its power.

The art of the social moralists has a completely and profoundly parasitic dependence on the methods of reproductive representation the social machine uses to propagate its authority. The social moralist artists want the power of the much copied, widely distributed image. As Kruger's montage technique and Holzer's digital signs indicate, the social moralists are completely hooked on reproductive representation. As Haacke's work shows, they are dependent on the creativity of social authority for their own creativity—the creativity of a Reagan, who can capture the collective imagination, the creativity of Mobil in its ingenious use of advertising to convince us that it has a heart, to create the big lie that a capitalist corporation is a social welfare organization. Their art depends on the halo effect of reproduction techniques and the halo effect of authority images. This dependence amounts to an unconscious merger, whatever the consciously critical relationship to the reproduction techniques and authority images.

The subversive impact of social moralist art is in a sense neutralized from the start by this dependence. Because of its dependence on reproduction techniques and authority images—its reproductive mediation of such images—it loses its impact rapidly. William Olander asks us to ''imagine the shock of the passer-by who, expecting the latest Coca-Cola ad on the Spectacolor board in Times Square, gets 'Torture is barbaric,' or the businessman who looks to the electronic moving-message for the current Dow Jones and is confronted, instead, with 'Trading a life for a life is fair enough.' ''[7] It's not hard to imagine the shock, but it's also not hard to imagine the shock as momentary. It is no more than the shock of any other ''creative novelty'' in the social machine. The message does not sink in, the effect does not last long, because the passer-by and businessman almost immediately recognize it as a product of the social

machine, just because it is in the reproductive mode. They rapidly adjust to it. It wouldn't be allowed in Times Square or on the electronic moving-message if in some way or other it didn't belong to the System, didn't have a function in it. And of course it's art, the product that helps us relax, regenerate. In Marx's ideal world, after we tend the sheep in the morning and write poetry in the afternoon, we criticize what we have written in the evening. Critical art is part of society's evening entertainment. Concern about the morality of what we've done during the day is evening entertainment. Let me hasten to say I don't endorse this neutralization; it's a fact of social life. It happens to social moralist art just because it's art, and because, by existing exclusively in the mode of reproductive representation, it involuntarily becomes the victim of the mode. It becomes just another minor "technological wonder."

The social moralists need more imagination. They have enough to utilize reproductive representation, and enough to attack some obvious authoritarian targets that control the levers of the social machine and have been more or less internalized. But they don't have imagination enough to generate an alternative to the System, or rather enough power and art to remind it of its lack of humanistic conscience, of generative creativity. Fromm, describing what he calls "the productive orientation," writes:

> The world outside oneself can be experienced in two ways: reproductively by perceiving actuality in the same fashion as a film makes a literal record of things (although even mere reproductive perception requires the active participation of the mind); and generatively by conceiving it, by enlivening and recreating this new material through the spontaneous activity of one's own mental and emotional powers. When the generative experience of the world is atrophied, the result is a relatedness to the world that is proudly called "realism," but that is actually nothing but a superficial kind of perception. The individual is then incapable of enlivening and newly creating the perception from the inside, with all the fibres of his capacity for experience. When reproductive perception is totally lacking, man has only his imagination. Such an individual is psychotic and cannot function in society.[8]

Social moralist art is not generative, which is what humanistic conscience is concerned to be. It is a certain kind of Realism—not entirely unimaginative, but all too reproductive. One might say it is reproduction with a vengeance—but still reproduction. It does not, to use Fromm's language, suggest a world "enlivened and enriched by [the artist's] own powers." Its criticality does not reach deeply enough inside the individual, catalyze a transformative process within the individual.

Paradoxically, the profundity of social moralist art lies exactly in that failure, for it reveals a general lack of humanistic conscience. Psychoanalysts hold that "superego formation—i.e., the addition of a set of moral values to the hierarchy of personal aims—is a decisive advance in behavior

regulation in the direction of personal autonomy.''[9] The achievement of personal autonomy is inseparable from the achievement of the reality principle—from illusionless recognition of reality. I want to suggest that social moralist art has an incomplete sense of reality because of its lack of imaginative or creative autonomy—its parasitic (regressive, unimaginative) dependence on reproductive representation, with its inherent indifference to humanistic concerns. The art of social morality does little to implant a humanistic conscience in the social machine.

What is reproductively represented tends to lose its humanistic import, while becoming strangely ''authoritarian.'' The recent ''Van Gogh by Toshiba'' advertisement, showing a TV image of a portrait by van Gogh, strips van Gogh's image of its humanistic import, or trivializes that import in the name of fidelity of color reproduction. At the least, the ad suggests that the humanistic import of his art is of no consequence. Technology demonstrates its power by appropriating the product of van Gogh's imaginative power. It is given a kind of lip-service. Here, high technology does not exist in the service of the image, but in its own. At the same time, by being reproductively represented, van Gogh's art becomes the authoritarian conscience of art—a new tyranny of style art must obey. Especially because, as the Toshiba ad tells us, van Gogh's *Portrait of a Peasant* has been made to ''look like a million dollars.''

Reproductive representation encourages the illusion that there is nothing humanistic at stake in life and art; it implicitly denies the generative power of imagination. What generative power reproductive representation has depends on preexisting imaginative creativity or humanistic attitudes—on generative images transferred into the social machine. Neo-moralist art falls short of its goal without knowing it, because of its distrust of the humanism of imagination—its preference for the illusions of reproductive representation. Social moralist art, while admirably anti-authoritarian, has forfeited imaginative power, which is in and of itself a form of humanistic conscience.

Notes

1. Jonathan Culler, *The Pursuit of Signs: Semiotics, Literature, Deconstruction* (Ithaca, N.Y.: Cornell University Press, 1981), p. 39.

2. Rainer Funk, *Erich Fromm: The Courage to Be Human* (New York: Continuum, 1982), pp. 49–50.

3. Quoted in ibid., p. 150.

4. Ibid., p. 59.

5. Ibid., pp. 150–51.

6. D. W. Winnicott, "Creativity and Its Origins," *Playing and Reality* (New York: Tavistock and Methuen, 1982), p. 65.

7. William Olander, "Re-coding the Codes: Jenny Holzer/Barbara Kruger/Richard Prince" (Exhibition Catalogue; Charlotte, N.C.: Knight Gallery, 1984), n.p.

8. Funk, *Erich Fromm,* p. 36.

9. John E. Gedo, *Beyond Interpretation* (New York: International Universities Press, 1979), p. 179.

Crowding the Picture:
Notes on American Activist Art Today

Revolt today has no more content than buying a bus ticket. Any genuine attack on society today must occur on the level of abstraction. . . . The only true wrestle is with abstraction: the credo, the slogan, the symbol.

Harold Rosenberg, "Themes"

Politics in the United States consists of the struggle between those whose change has been arrested by success or failure, on one side, and those who are still engaged in changing themselves, on the other.

Harold Rosenberg, "Themes"

Along this rocky road to the actual it is only possible to go Indian file, one at a time, so that "art" means "breaking up the crowd"— not "reflecting" its experience.

Harold Rosenberg, "The Herd of Independent Minds"

This seems a good time to analyze activist art—art that claims to be a kind of action rather than a kind of reflection. In the last decades, many American artists have joined the ranks of what was once an underdog troop. In this palace revolution that seeks to overthrow the ruling elite of formalism, even "revisions" of artistic language—experimental manipulations of the concepts and terms of high art—are considered valuable only if they serve the "higher" purpose of social change. And so where formalism offers art a certain hermetic integrity, activism promises it worldly influence and power.

But what if the proverbial choice between an art of the *vita contemplativa* and an art of the *vita activa* is no longer a valid one? What if

This article originally appeared in *Artforum* (May 1988).

the integrity proposed by the esthetic position is insufficient, and the kind of change demanded by the activist approach is disingenuously inhumane? The old bifurcation of life into sectors of being and doing now seems obsolete. The traditional notion of a singular heroic identity no longer does justice to the complexity of our social relationships, nor to the subtleties of our moral situation. Today, one needs the Solomon's wisdom and stamina to create an art that synthetizes the esthetic and activist impulses—one that addresses our humanness with depth and fullness, one that rearticulates a humanness that we feel has been obscured, even obliterated by society. A number of European artists (particularly in Germany and Italy) have risen to this challenge. In America, however, too many of our artists are settling for less, perhaps because they have not adequately recognized the rigorous demands of this enterprise.

America is above all a pluralistic society, a highly differentiated yet consummately interdependent organism. In our society, which has come to be termed the administered society, the psychopolitical tensions of class struggle, while far from irrelevant, are not all-relevant. The situation "of the 'lonely crowd,' or of isolation in the mass,"[1] as Jacques Ellul points out, is the basic social situation today.[2] The "lonely man" is the essential man, "and the larger the crowd in which he lives, the more isolated he is."[3] This is pluralism in action, ingeniously nondisruptive for all its discontinuities. For whenever a member of this lonely crowd tries to understand, articulate, or assert his or her *individual* loneliness, he or she comes up against the overwhelming evidence of togetherness with all others in the crowd, and personal loneliness seems a fantasy. (Or a neurosis.) And whenever, conversely, the individual tries to give himself or herself over completely to the crowd's trends and passions, he or she finds this untenable too, for the individual only reexperiences isolation within the crowd. Loneliness, then, even as it may be regarded as a sign of individuality, of separate and special selfhood, and/or resistance to the crowd, is in fact only the experience that confirms the inextricable interdependence that characterizes the crowd. Loneliness is the umbilical bond to the crowd. One cannot think of mass man without thinking of the loneliness that is innate to him. To be of the lonely crowd is to feel both an irreducible isolation and an irresistible belonging.

This is why the American lonely crowd assumes an eternally melioristic society, with a perhaps nominally utopian outlook: why should the crowd work for revolution when the world, however lonely, seems to be getting better and better—or at least getting to be a better place in which to negotiate loneliness, to hide from oneself? The lonely crowd fetishizes its slack "live and let live" philosophy (be lonely and let others

be lonely), believing it to be—and this is no doubt correct—preferable to the authoritarian ''live and think and be like me or be destroyed by me'' philosophy. But of course neither philosophy helps one realize life fully or tells why one should continue to live; and each is as full of grievances against life as the other, if more obviously so in the latter.

This is the lonely world that contemporary activist art enters into, speaks to. And such art is designed to confront rather than to console. Is the lonely crowd capable of accepting such artistic and activist urgency? Can it find the art contagious, be roused to action in the name of its cause? Can it throw off the chains of loneliness to create a community rather than a crowd?

It seems unlikely. For to inspire such response, this art must ''penetrate through the common experience to the actual situation,'' must grasp social reality creatively, that is, ''from the inside . . . as a situation with a human being in it,''[4] must wed insights to ''the potency of form'' that goes ''beyond mere talk.''[5] However, much of today's activist art plays to the common—crowd—experience, and thereby reinforces the very structures it seeks to undermine. We can look back at the social realism of the '30s as a forerunner of this. In the history-splashed panoramic murals of Thomas Hart Benton and Diego Rivera or the delineations of social suffering in the works of Philip Evergood and Ben Shahn, for example, the misery or nobility of the individual is posited as the reflection of a collective condition. Or, to put it in the terms of the lonely crowd, the individual simply echoes the voice of the crowd. A number of artists today believe they, too, are demythologizing reality, pulling back the curtain for us for a clear look at the social conditions that enslave us, define us. But just as the social realists of the '30s implicitly appropriated the big-screen techniques of the most formidable crowd-pleaser of their time—the movies—many of today's American artists mimic or employ techniques from advertising and TV. They believe this is the best way to reach the crowd—and perhaps they're right. But is it, in Rosenberg's words, the best way to ''break up the crowd''? Is it the best way to move the individual to take the risk of autonomy,[6] to begin the struggle of transforming his or her own identity, a process essential to genuine social transformation?

In fact, much of today's activist art does send a message, but not the one its makers intend. Often, this art's call for social change and/or social unity relies on familiar codes, with just enough overlay of allusion to some topical situation or event to suggest political urgency. And so even viewers who may be only nominally interested in the revolutionary implications of the struggle in Nicaragua referred to in Leon Golub's paintings, for example, can feel secure in believing that in their viewing of these works

they have had a political experience. The paintings' larger-than-life size, their agitated surfaces, the theatrical grandeur of their figures, who make war not love (even those who are on the same side seem to make war, perhaps in order not to have to make love), all resuggest the idea of the Hero, in whatever grotesque form. Such an idea caters to the lonely crowd, which, if it looks for salvation, looks for it in the miracle of the Great Man, be he tender or tyrannical.

Similarly, Martha Rosler's documentaries, with their apparently gritty, reportorial directness, use predetermined scenarios of misery. Rosler's intensity of focus is admirable, and she does meet a certain social reality. Her art's "factographic character," as it has been called by Benjamin Buchloh, is liberating—to a point. There's a problem, however, with her synecdochic expression of that reality. By representing a person's life with "the facts," Rosler shaves away the interior life, and the individual is flattened, once again, into cliché: "the abused women," "the working woman," etc.

Truly creative critical art, on the other hand, can go beyond, to question not just one stereotype, or the predominant stereotype, but *all* stereotypes. In this way, the very notion of common or uniform experience—the underpinning for lonely crowd passivity—would begin to crumble. Such an art does not require a retreat from social reality, but a deeper engagement with it. Rosenberg, using war as an example, suggests the power and potential of such a deeper engagement:

> The moment an artist, ignoring the war as an external fact known to all, approaches it as a possibility that must be endured in the imagination by anyone who would genuinely experience it, he . . . arouse[s] not only hostility on the part of officials who have a stake in the perpetuation of some agreed-upon version of the war, but also a general distrust and uneasiness. For the work of art takes away from its audience its sense of knowing where it stands . . . suggests to the audience that its situation might be quite different than it has suspected, that the situation is jammed with elements not yet perceived and lies open to the unknown, even though the event has already taken place.[7]

A number of our artists today do not thoroughly scrutinize mass conceptions of political reality, but unwittingly submit to them. And more problematically, they implicitly conform to stock notions of the way social change and/or social solidarity can be achieved. The work of Hans Haacke, Barbara Kruger, and Alexis Smith is to the point here. All rely on more or less familiar, easily readable images and language in a more or less tense state of juxtaposition. But after an initial surge, their art is victimized by its own media, sinks back into its sources, and what is left is the message that we can trust common experience to point the way to social transformations.

As suggested, the problem shared by many of our activist artists to-day lies in the way they understand—one might say in the credit they give—their viewer. At issue is whether the works of these artists engage the isolated individual within the lonely crowd in order to encourage self-awareness, independence, thoughtful examination, and action, or whether these works serve as propaganda for a myth (even though an alternative one). It's a slippery question, as Ellul understands, for propaganda for an alternative myth often seems to do both:

> Just because men are in a group, and therefore weakened, receptive, and in a state of psychological regression, they pretend all the more to be "strong individuals." The mass man . . . is more suggestible, but insists he is more forceful, he is more unstable, but thinks he is firm in his convictions. If one openly treats the mass as a mass, the individuals who form it will feel themselves belittled and will refuse to participate. . . . On the contrary, each one must feel individualized, each must have the impression that *he* is being looked at, that *he* is being addressed personally. Only then will he respond and cease to be anonymous (although in reality remaining anonymous). Thus all modern propaganda profits from the structure of the mass, but exploits the individual's need for self-affirmation; and the two actions must be conducted jointly, simultaneously.[8]

What's more, Ellul makes a useful distinction between the propaganda of agitation and the propaganda of integration.[9] The propaganda of agitation

> has the stamp of opposition. It is led by a party seeking to destroy the government or the established order. [It] tries to stretch energies to the utmost, obtain substantial sacrifices, and induce the individual to bear heavy ordeals. It takes him out of his every-day life, his normal framework, and plunges him into enthusiasm and adventure; it opens to him hitherto unsuspected possibilities, and suggests extraordinary goals that nevertheless seem to hin. completely within reach. Propaganda of agitation thus unleashes an explosive movement; it operates inside a crisis or actually provokes the crisis itself.[10]

I would argue that much of today's direct-action art lends itself to or is a species of the propaganda of agitation. It enjoys seeing all of social reality—the status quo on all fronts—as forever and completely "in crisis." As Ellul points out, the propaganda of agitation generally "can obtain only effects of relatively short duration."[11] But the "agitated" look and intention remain. What counts most, what one remembers most, about Jenny Holzer's flashing sentences on electronic message boards, for example, is their seemingly irrational relationship to one another, the digitalized fragmentation of the words themselves, their rapid movement past the eye. Disruption, structurally as well as conceptually, is the aim of Holzer's art (as it is with a number of others'). Disruption becomes an end in itself—it *is* the revolution. (And an old one at that.)

It is possible to interpret such agitational art as at once an anxious response to and rejection of what seems fated. More specifically, it may be a manic defense against oppressive fears of "death, chaos, and mystery."[12] This is not unrelated to José Ortega y Gasset's notion that the "universal pirouetting" of the modern artist can be seen as "an attempt to instill youthfulness into an ancient world."[13] But unfortunately, this universal pirouetting may be only spinning us back to the artist, not to the world.

There is another strain of activist art today that falls into the category of what Ellul calls the propaganda for integration. This art "aims at stabilizing the social body, at unifying and reinforcing it."[14] It accomplishes this by offering

> a complete system for explaining the world, and [providing] immediate incentives to action. We are here in the presence of an organized myth that tries to take hold of the entire person. Through the myth it creates, propaganda imposes a complete range of intuitive knowledge, susceptible of only one interpretation, unique and one-sided, and precluding any divergence. This myth becomes so powerful that it invades every area of consciousness, leaving no faculty or motivation intact.[15]

In short, this type of art calls for a new status quo—a new myth or conformity. This is what I take the work of Judy Chicago, and some of the works of May Stevens, for example, to offer. The decadent, oppressive capitalism, these works suggest, should be replaced by the wholesome new other-ism. But this is really the same old lonely crowd in new ideological clothing. The social harmony that such integration propaganda aims at can be as ruthlessly exclusive and as oppressive as the marginalizing structures it seeks to overthrow. It corresponds to the modern need, "to create and hear fables. . . . It also responds to man's intellectual sloth and desire for security."[16] It also becomes a solution to the problem of passivity.

> The individual becomes less and less capable of acting by himself; he needs the collective signals which integrate his actions into the complete mechanism. Modern life induces us to wait until we are told to act. Here again propaganda comes to the rescue.[17]

But it is the individual struggling for autonomy[18] within the crowd that art must try to reach, cultivate, encourage, support, draw out. Goya remains an exemplar for such nonpropagandistic activist art. I am speaking, particularly, of the Goya of *Los Desastres de la guerra*, the "*pinturas negras*" of the Quinta del Sordo, and the *Disparates*, all conceived between 1810 and 1820. With every touch, every gesture, every choice, Goya reminds us of Romanticism's discovery that life "is not a reality which encounters a greater or lesser number of problems, but that it consists

exclusively in the problem of itself.''[19] Goya's sensitivity to nuance, his transfigurations of light and dark, his leap away from the symbolic distortions of his earlier works, all make it possible for the viewer to experience horrific human catastrophes *from the inside.* In Goya, we are beyond figures of good and evil in any conventional sense: both the soldiers and their victims are miserable. The sociopolitical reality of war becomes, in these works, the vehicle for an unfolding of what human beings are capable of, what *individuals* are capable of. Without forsaking reportorial witnessing of the actual event, and yet without advocating *any* myth of man, society, or state, these works allow for freedom of insight as well as freedom of sight.

It was in a 1919 Berlin exhibition that the slogan "DADA stands on the side of the revolutionary Proletariat" was first posted.[20] And it was George Grosz and Wieland Herzfelde, John Heartfield's younger brother, who wrote:

> The pending revolution brought gradual understanding of this [social] system. There were no more laughing matters, there were more important problems than those of art; if art was still to have a meaning, it had to submit to those problems.[21]

But the anticipated revolution did *not* happen in Germany. That is no doubt why, 40 years later, Hannah Höch would describe the German Dadaists' relationship with the communists as "innocent and truly unpolitical.''[22] Asked whether "Dada had been, in a way, a kind of parody of a typically German *Reformbewegung,''*[23] Höch acknowledged that it had. Nonetheless, she did point out, Dada shocked people into realizing "that things could also be done differently, and that many of our unconventional ways of thinking, dressing, or reckoning are no less arbitrary than others which are generally accepted.''[24]

Germany's *Neue Sachlichkeit* (New Objectivity), Bernard S. Myers points out, was "another form of protest against the times . . . a bitter but dry and hard realism that is strongly emotional in character and social in content.''[25] *Neue Sachlichkeit* was informed by a subliminal romantic yearning for social intimacy—"brotherhood" or "sisterhood"—as an alternative to the compulsory alienation of contractual, capitalist society. This yearning took the form of identification with one's fellow sufferer, the implicit assumption being that through such communion a new society might be forged.

In fact, both these endeavors were premised on *ressentiment,*[26] intensified by the promises of imminent revolution. This *ressentiment* has deep Romantic roots, going back at least to Shelley's assertion that "poets are the unacknowledged legislators of the world,''[27] and is a manifestation of what Abraham Maslow has called "the arrogance of creativeness.''[28]

Now, with a revolution permanently pending and never arriving, a revolution permanently on hold, the seeds of German Romanticism and revolt, transplanted, have brought forth, paradoxically, a naive American "media-ated" realism. And so here, the desire to shock is what remains of German Dadaism. The major message is that everything can be done differently, which is a parody of the idea of revolution—a loss of any sense of purpose or direction. The problem is that this polymorphously perverse carnival of a world upside down, the sense of the chance character of all our engagements, becomes an enchantment in itself.

Artists like Ronnie Cutrone, Richard Hambleton, Keith Haring, Mike Kelley, Kenny Scharf, and Julie Wachtel, just to name a few, revel in their abilities to shock the viewer with supposedly "unexpected" comparisons and contrasts. But who is really shocked? As I suggested earlier, though it's true that such works provide an initial ironical spark, that spark is no greater than that provided by these artists' sources—in this case, the funny papers, Saturday-morning cartoons, '50s situation comedies and detective series. In fact, the modern viewer has grown accustomed to being momentarily "jarred." So these artists, rather than effectively commenting on or critiquing this state of affairs, satisfy what has become an addiction for the lonely crowd.

Similarly, what was for *Neue Sachlichkeit* a visionary possibility now runs the risk of becoming an insidious invitation to the "one society" of the neo-*Neue Sachlichkeit*. This art, rather than suggesting how individuals might identify their real inner needs and condition, enforces common experience, crowd mentality. Much of it shows little of the emotional sensitivity to the other—little of the fellow feeling—that informed *Neue Sachlichkeit*.

Among American activist artists today, Leon Golub seems the one with the most complex yearning for community, and with the most acute awareness of its aborted character in modern society. But, as Theodor Adorno suggested, one always has to wonder whether "the artistic attitude of howling and crudeness"[29] truly denounces, or instead identifies with, the forces of social oppression. The problem with Golub's work is that it implies that there is no socially feasible alternative to the all-powerful, totalitarian figure. In his earlier paintings from the "Mercenaries" and "Gigantomachies" series, Golub seems to be struggling imaginatively with his human figures as they act out their deadly games of dominance and submission: their bodies become raw tendons of paint. But the blacks of his more recent South Africa paintings—torturers and tortured—are flattened out. Through their clothes and limbs, the surface of the canvas appears, reiterating their status as social signifiers. Rather than urgent physical presences, they become emblems of the inevitable and inescapable evil of the crowd.

Similarly, Jenny Holzer's installation for the "*Skulptur Projekte in Münster 1987*" exhibition mocks that city's memorial to the fallen German dead of World War I by amplifying the notion of the soldier as an inhuman violator. But this stereotype does not cancel out the martyr stereotype, it only tightens the stranglehold that stereotypes have on us. Holzer militantly refuses to see man *from the inside,* and thus forecloses on that possibility for the viewer as well. Let Holzer manipulate a war memorial in her own world, the one at Fifth Avenue and Sixty-Seventh Street in New York, for example, and perhaps she would be obliged to examine issues of war—and man—with more complexity, to imagine and present the "human" aspects of inhumanity.

May Stevens's work is an important example of the propaganda of feminist integration. In *Mysteries and Politics,* 1978, or her "Ordinary/Extraordinary" series, beginning in 1980, the artist has achieved something valuable. In these works, Stevens brings female characters from radically different worlds into dialogue with one another. Stevens and her viewers are surely entitled to this feminist fantasy as an ideal to strive for. But when she in effect presents femaleness as exhaustive of humanness, Stevens seems to be suggesting that only one sex should be permitted admission to this Garden of Eden. (It is incidentally worth noting that the conception of woman as the eternally enigmatic and mysterious has contributed to male inability to see woman as fully human. There is little evidence that Stevens has adequately explored the implications of this problem.)

Hans Haacke's protests of the corporate world's appropriations of culture rely on an elegant editorial selection and presentation of images to score their points, to tell us that high culture is as politically naive as business is politically clever. Haacke stands foremost among the very few artists who have had the courage to remind us of the socially oppressive realities that art enters into; his interventionary works represent an important contribution. But in his dependence on the same "distorting" techniques as those employed by corporate public relations, by choosing some "facts" and omitting others, he manipulates the viewer into accepting his version of reality. Unfortunately, however, that version of reality strips art of its multifaceted complex nature and manifestations, so that Haacke's work can be seen as social realism raised to a higher level of abstraction—with culture taking the place of the undifferentiated individual.

Many more examples of today's activist art could be presented. My point remains that a significant amount of it, so full of *ressentiment,* runs the risk of symbolizing society's arrested metamorphosis, and, simultaneously, society's lonely-crowd way of looking at things, experiencing things, (mis)understanding things. As a result, it can end up

serving the purposes of what I would call "gallery leftism"—the establishment of a political identity in the art world that has an ambiguous significance in the larger world. Just as the gallery estheticism of formalist art may have served as an attempt to "prove" that art is more likely to afford a genuine, memorable—purer—experience than nature or life, so the gallery leftism of agitation or integration serves to prove that radicalism and social criticism are purer in the art world than in the lifeworld. But is this the vision, the goal, for which so many of our activist artists are reaching? I think not. In fact, the pretentiousness and self-privileging of either position—esthetic or activist—is self-defeating, a betrayal of the real needs of the individual members of the lonely crowd, and a betrayal of the potential of art to meet those needs.

But we can look to the best works of the artists I have discussed in this essay, as well as to the works of a number of other artists today, to see that activist art has not reached a dead end in America. Sue Coe's renderings of social atrocities, whether grand or intimate, violent or grieving, speak from the inside of life in order to give voice to the many oppressed and miserable. With his gorgeously frightening drawings from the "Firestorm" series, 1982, Robert Morris approaches a "known" catastrophe with enormous imagination. Nancy Spero's *Torture of Women*, 1976, in its outspoken rage, in its range of gestures from delicate to savage, presents images of women in pain, but simultaneously in action. Twisted and pulled, but also buoyantly leaping and determinedly striding, they affirm multiple possibilities while acknowledging the devastating effects of oppression. Vito Acconci and Bill Viola have both used mass-media tools to promote a more complex understanding and experience of the individual human being in the social world. In Acconci's *Sub-Urb* at Artpark, 1983, the viewer/participant's intense isolation in underground "rooms," coupled with the experience of collective address as evoked by the printed, posterlike words on the walls, serves to acknowledge both the tension and the relationship between the realms of public and private. Viola produces a kind of internal Sensurround in his *Reasons for Knocking at an Empty House*, 1982, dedicated to a worker injured by a blow to the head. While the viewer faces, up close, a videotape of Viola, and while Viola swallows, breathes, while his heart beats, the earphones the viewer is wearing amplify those sounds, and one seems to be entering the body of the man who suffered that pain. And the exuberant yet elegant work of Tim Rollins and K.O.S. asks its audience to go beyond questions of formalist eloquence to arrive at a larger definition of what constitutes effective activist art-making.

Finally, we can also look again to the past, to David's *The Death of Marat*, 1793, as a beacon for the rich possibilities of creative activist art.

David has risked a very special kind of displacement here: he has taken the fiery orator out of his familiar "crowd" context. The viewer finds Marat in the most intimate setting possible, his bath. And Marat is rendered in all his vulnerable humanness: his head, relaxed in death, bears the traces of both pain and peace; his limp hand, dropped to the floor, still clings to, but can no longer clutch, the pen. Body is not abstract here, but defined, palpable. David has stripped the scene of all the conventional codes and symbols of political struggle, the viewer and Marat "meet" one another one-to-one, yet we know we are in the presence of a powerful political picture. Intimate identification, rather than aggressive assertion, *The Death of Marat* suggests, is the mode by which one can achieve significant change, both personal and social. It is true that the activist that the artist shows us is dead. But Marat's existence, his political efforts, are all the more present as a subject for contemplation. Our hushed dialogue with David's Marat—a single, naked, dead human being—is the most radical and resonant example I know of for suggesting the human and political potential of activist art.

Notes

1. Jacques Ellul, *Propaganda: The Formation of Men's Attitudes* (first published in France, as *Propagandes*, 1962) (New York: Alfred A. Knopf, 1972), pp. 8–9.

2. See also David Riesman, *The Lonely Crowd: A Study of the Changing American Character* (New Haven: Yale University Press, 1973). The notion of the "lonely crowd" derives from Gustave le Bon's idea of the crowd, which was utilized by Freud and carried forward by Riesman and Ellul. It also involves Nietzsche's concept of "the [human] herd."

3. Ellul, p. 147.

4. Harold Rosenberg, *Discovering the Present: Three Decades in Art, Culture, and Politics* (Chicago: University of Chicago Press, 1973), p. 19.

5. Ibid., p. 53.

6. I am using "autonomy" in a modified Freudian sense, as the ability to withstand trauma from exterior as well as interior sources. David Shapiro, in his *Autonomy and Rigid Character* (New York: Basic Books, 1981), p. 16, describes autonomy as "a new kind of self-regulation . . . in the form of increasingly articulated conscious aims, and . . . a new kind of behavior, intentional, planful action—self-directed action in the proper sense." On pp. 17–18 he says that "the human sense of autonomy" derives from "active mastery of the environment." It involves an "advance, in the Marxist phrase, 'from the realm of necessity to the realm of freedom.' "

7. Rosenberg, p. 19.

8. Ellul, p. 8. Lucy R. Lippard's "Some Propaganda for Propaganda," in *Get the Message? A Decade of Art for Social Change* (New York: E. P. Dutton, 1984), pp. 114–23, totally ignores these issues. Her notion of "good propaganda" (p. 116) is a contradiction in terms.

9. Ellul acknowledges that this distinction echoes Lenin's well-known distinction between agitation and propaganda proper, and the equally well-known distinction between the "propaganda of subversion" and the "propaganda of collaboration" (p. 71).

10. Ibid., pp. 71–72.

11. Ibid.

12. D. W. Winnicott, "The Manic Defence," *Collected Papers* (London: Tavistock Publications, 1958), p. 132.

13. José Ortega y Gasset, "The Dehumanization of Art," *The Dehumanization of Art and Other Writings on Art and Culture* (Garden City, N.Y.: Doubleday & Company, 1956), pp. 46–47.

14. Ellul, p. 75.

15. Ibid., p. 11.

16. Ibid., p. 148.

17. Ibid. Ellul is describing what has come to be called the "diffusion of responsibility" that occurs in the lonely crowd. There is an inability to decide to take personal responsibility for anything that occurs. See C. Mynatt and S. J. Sherman, "Responsibility Attribution in Groups and Individuals: A Direct Test of the Diffusion of Responsibility Hypothesis," *Journal of Personality and Social Psychology* 32 (1975): 1111–18. See also B. Latane and J. M. Darley, *The Unresponsive Bystander* (New York: Appleton-Century-Crofts, 1970).

18. This returns us to Shapiro, who connects the "fixed purposiveness of the rigid person" (p. 75) with his or her continued "emulation and identification with images of superior authority derived from the child's image of the superior authority of the adult" (p. 74). Shapiro thinks this a "miscarriage" of the development of "volitional direction and control," not its "overdevelopment." "Flexibility—not rigidity—of behavior stands at the opposite pole from the immediacy and passivity of reaction of early childhood. Flexibility—not rigidity—reflects an active self-direction. Furthermore, flexibility—not rigidity—reflects a genuinely objective attitude toward the world" (pp. 74–75). Truly creative critical art participates in the individual's autonomy. Propaganda (and the media) encourages the emulation and identification with superior authority. Ellul's discussion (p. 149) of the way the individual in the lonely crowd "feels himself *diminished*" is also worth noting in this context. "He gets the feeling that he is under constant supervision and can never exercise his independent initiative. . . . He thinks he is always being pushed down to a lower level. He is a minor in that he can never act with full authority." This strongly resembles Shapiro's discussion of the difference between the rigid character and autonomy, and suggests a social rationale for it.

19. Ortega y Gasset, "In Search of Goethe from Within," *The Dehumanization of Art*, pp. 136–37.

20. Hannah Höch, quoted in Lucy R. Lippard, ed., *Dadas on Art* (Englewood Cliffs, N.J.: Prentice-Hall, 1971), p. 72.

21. Quoted in ibid., p. 81.

22. Quoted in ibid., p. 71.

23. Quoted in ibid., p. 77. Lippard, in "Dada in Berlin: Unfortunately Still Timely," *Get the Message?*, pp. 67–73, sidesteps this critical recognition. She notes that the German art of the time can be distinguished from other European art "by the depth of its bitterness," then goes on to add that, ironically, "Berlin Dada art, for all its disorientation, appears more hopeful and positive" (p. 72). Thus Lippard avoids considering how the varying degrees of frustration that underlay the art of the time may nevertheless have implied an unconscious awareness of the impossibility of social revolution in the Germany of the day, as well as an unconscious recognition of the necessity of profound personal revolution as a precondition for social revolution.

24. Quoted in ibid.

25. Bernard S. Myers, *The German Expressionists: A Generation in Revolt* (New York: Frederick A. Praeger, 1966), p. 227.

26. Max Scheler, in his *Ressentiment* (New York: The Free Press of Glencoe, 1961), pp. 45–46, describes *ressentiment* as "a self-poisoning of the mind . . . a lasting mental attitude, caused by the systematic repression of certain emotions and affects which, as such, are normal components of human nature. Their repression leads to the constant tendency to indulge in certain kinds of value delusions and corresponding value judgments. The emotions and affects primarily concerned are revenge, hatred, malice, envy, the impulse to detract, and spite." None of these feelings, writes Scheler, necessarily leads to *ressentiment*. It develops "only if there occurs neither a moral self-conquest . . . nor an act or some other adequate expression of emotion . . . and if this restraint is caused by a pronounced awareness of impotence. . . . Through its very origin, *ressentiment* is therefore chiefly confined to those who *serve* and are *dominated* at the moment, who fruitlessly resent the sting of authority. . . . The spiritual venom of *ressentiment* is extremely contagious" (p. 48).

27. This is the last line of Shelley's *A Defence of Poetry*, 1821. For an account of Shelley's revolutionary interests see Kenneth Neill Cameron, *The Young Shelley: Genesis of a Radical* (New York: Crowell-Collier, Collier Books, 1962).

28. Abraham H. Maslow, "Neurosis as a Failure of Personal Growth," *The Farther Reaches of Human Nature* (New York: Penguin Books, 1976), p. 39.

29. Theodor Adorno, *Aesthetic Theory* (London: Routledge & Kegan Paul, 1984), p. 327.

Chris Burden: The Feel of Power

*The fundamental concept in social science is Power, in the same sense
in which Energy is a fundamental concept in physics.*
　　　　Bertrand Russell, *Power, A New Social Analysis*, 1938

For years, Chris Burden was thought of as the masochist supreme, with
more than a touch of sadism thrown in. His career officially began with
his "performance" of April 26, 1971, "when he crawled into a small metal
locker at the University of California, Irvine. For five consecutive days
and nights he remained inside the locker. (There was a five-gallon bottle
of water in the locker directly above, and an empty five-gallon bottle in
the locker directly below.) On the fifth day, with a little help from his
friends, he rose from the locker." The "rose" is full of special import;
Donald Carroll completes the sentence with the words: "and ascended
into the firmament of art celebrities."[1] However ironically and mockingly,
Carroll suggests that Burden is desperately reliving a major myth of
selfhood—of which, in fact, the "art celebrity" is a vacuous echo, an un-
wholesome residue. Indeed, Burden has said that "the very instant [his
work] is made . . . it starts to become a myth."[2]

Perhaps the most "mythical" thing he has done was to have himself
crucified "spread-eagled across the back" of a blue Volkswagen on April
22, 1974. (Blue, no doubt, to symbolize the sky.) "I've thought about being
crucified lots of times," said Burden. The car "had to be a Volkswagen,"
the people's car—rather than, for example, "a Falcon," a car symbolic
of predatory individuality[3]—as if Burden, like Christ, could redeem all
the people, not just himself, with his crucifixion. I cannot help thinking
of the psychoanalyst Theodore Reik's conception of Christ as the ultimate
masochist, who expects to win the world through his sacrifice of himself.
The masochist always expects victory in the end, at least the victory of

Reprinted courtesy of the Newport Harbor Art Museum from the exhibition catalogue *Chris
Burden: A Twenty-Year Survey* (1988).

widespread recognition that comes with being internalized by others as a symbol of their deepest wishes. Carroll's cynicism about Burden's intentions is a characteristic art world response to him, saying more about the art world than about Burden. Such cynicism suggests the art world's inability to tolerate extreme seriousness outside its own conventions and familiar mediums. It also suggests the art world's continuing suspicion of performance art as no more than entertainment, a suspicion which is a projection of the art world's unconscious anxiety that it as a whole may be no more than entertainment (that is, a specialized spectacle for a particular class). The fact of the matter is that Burden's early self-torturing performances were more than unusually foolhardy—more extreme than the typical avant-garde risk-taking. Such risks were usually undertaken in the safety of symbolic form, not in a literally public space on a literally particular person. Rarely has the artist put himself forward so directly as Burden has. Burden's destructiveness is more complicated than the usual daredevil "flirtation" with death. If it is exhibitionism, it is an exhibitionism that threatens to destroy the object exhibited. It is impossible to reduce Burden to a sensationalist "Evel Knievel of art," as he has been called.

What was he doing, then, when he positioned himself to be electrocuted? In Santa Ana, California "for three nights in early September [1971] . . . dressed only in shorts, he had himself strapped to the floor with copper bands bolted into the concrete. Placed on each side of him was a bucket of water into which had been dropped a live 110-volt electric wire. Thus, either a clumsy or a malicious spectator could have put a quick end to his career then and there."[4] What was he doing when "he had himself shot"? "On November 19, 1971, Burden staged what remains his most famous piece. . . . While Burden stood against a wall, a friend with a .22 long rifle shot him in the left arm from about 12 feet away."[5] Or when, in a piece called *Icarus*, performed on April 13, 1973, he had his assistants pour "gasoline down [six-foot] sheets of glass" that sloped "onto the floor at right angles from [his] body" and then "ignite the gasoline," burning Burden?[6] Or when, later that same year, in a piece he called *Through the Night Softly*, "clad only in a swimming suit and lying on his stomach with his hands held behind his back, he wriggled and squirmed painfully through 50 feet of broken glass which had been strewn across a parking lot in downtown Los Angeles"?[7]

Is this potentially self-destructive behavior really just another careerist strategy, the latest ploy for becoming famous, or, as he himself has ironically suggested, a means of making his name "a commodity"?[8] Is this self-commodification—the final ironical form of self-mythification—his preemptive recognition of the way the art world will inevitably regard

his dangerous performances? Such regard is as good as repression. Is his own cynical self-regard a form of self-repression, his own reluctance to face up to what he is fully about, to deal adequately with his art's unconscious and social significance? Burden, who is regarded as a conceptual artist, describes his art as "the acting out of the idea, the materialization of the idea."[9] But until recently, in my opinion, it was not completely clear what idea: one had only his shocking actions, with the absurd relics of their aftermath. While not on a par with the objects of such conventional arts as painting, these are nonetheless "just the residue" of his art, which is the idea behind his performances, just as the real art of painting is the idea—of self—that happens "when the artist was making the painting."[10] One senses in Burden's performances a vestige of Harold Rosenberg's conception of action painting, where the canvas becomes an existential arena of self-creative, death-defying acts. Burden gives us the action without the painting—existential behavior liberated from a traditional context. It seems facile to reduce Burden's Neo-Existentialism simply to making "violation"—not following a rule—the rule, where others unthinkingly follow rules. Such an interpretation blindly plays into the hands of those who regard Burden simply as a publicity-seeking sensationalist. It is also erroneous to think that all Burden wants, like a compulsive Sisyphus, is to routinely "test or damage himself forevermore."[11] There is clearly a certain amount of self-testing in Burden's early work, but it is far from arbitrary and automatic. The ingenious way Burden keeps changing its method—the obsessive way he keeps reinventing his self-test—forces us to ask to what desperate purpose he is proving himself. Who is the self that keeps wrestling with the angel of death? What is the blessing that Burden wants from that angel, who only knows curses? Why does Burden want to become a hero, when to become heroic in our world means to be banalized into a celebrity, as Burden himself knows.

I think the answer to these questions has only become clear with Burden's recent works. Burden has been steeling himself to carry out his eighties "studies" of social power. They show him with full, mature self-consciousness. It is as though he himself knows what he is truly about for the first time. In 1986 he stated: "My current artistic research activity concerns investigating and testing the origin of power both physical and bureaucratic and how this power ultimately shapes the world in which we exist."[12] In this same statement he listed a number of works, all dealing with power, that he has recently completed (*Samson, Exposing the Foundation of the Museum*, and *All the Submarines of the United States of America*), that are in progress (*Sex Tower*, in model stage, and *Medusa's Head*, to be completed for this exhibition), or that are proposed (*Fist of Light, Spinning Dervish*, and *Moon Piece*). In a sense, from Burden's point of view,

it did not entirely matter whether these pieces were materially realized. The very fact that they have been conceived is their justification. But are they really about "the origin of power"? I think not: they are about its effect, that is, how it shapes the world, which is more demonstrable than its origin. Burden, I think, has all along been concerned with what it is to be on the receiving end of power—what it is to feel some institution's or material's or person's power in one's own very particular person and body. From the beginning, I want to contend, Burden has been concerned to experience and articulate what it is to suffer the power of the "other," in whatever form it takes. With his new projects, he wants to drag others—his viewers—into the experience, where in the previously mentioned seventies projects he alone was the victim. There is an intimation of this in *Prelude to 220, or 110*, for example, but there the onlookers were potential victimizers—executioners—not victims. Now he wants to torture others as well as himself, although to tempt viewers to become killers is in a sense to torture them.

The emphasis is still on the instrument through which the power operates, but where previously the instruments of power were relatively simple and straightforward—fasting, nails, a bullet, fire, broken glass— they are now rather elaborate, spectacular engineering feats, such as, in *Moon Piece*, launching "a very large (as large as possible) satellite whose *only* function and purpose would be to reflect sun light back to earth," or, in *Sex Tower*, building a "125-foot tower . . . with bundles of 6" × 6" timbers joined by 900 bolts, with the upper 25 feet tip gold leafed piercing a gold-leafed 12' tubular ring." These imposing constructions do not directly assault the self, but paranoically impinge on and threaten to overwhelm it, or at least topple it from its supervisory perch. Dwarfed— belittled—by these structures, the self controls nothing. What is noteworthy about all these construction performances, as they might be called, is that they do not involve the body. One might say, in view of its strong presence in the early performances, that the body is noteworthy by its absence. Burden's constructions can be conceived of as empty palaces of selfhood. He has in effect deprived the self of a resting place, completing the process of "self-deprivation" or "self-denial" begun in his early body performances. These can be conceived of as attempts to drive the self from the body—exorcism rituals making it a wanderer in a world of action. The eighties machines can be regarded as technological Juggernauts, totally annihilating whatever human beings cross their paths.

It is perhaps worth observing that Burden's father was an engineering professor. His appropriation of his father's profession—an appropriation which positions him as society's superego—seems to be as ironical as it is grandiose. He seems to be mocking his father by practicing a kind

of mock engineering with destructive, perverse, and confessional implications. He keeps his father's spirit alive in his engineering projects, but his is not an obviously useful, socially constructive engineering. It is on the whole more necrophiliac than biophiliac. Is Burden declaring the whole idea of social engineering bankrupt? At the least, he forces us to ask just how constructive mechanical (or "materialistic") engineering has been. What is the psychosocial idea behind it? It has given us war machines as well as bridges and skyscrapers. It is shortsighted to think of all engineering as automatically good, as we tend to do in America. (We may recall that the artist was once, at the beginning of the twentieth century, supposed to model himself on the engineer—as Burden has done with a vengeance. This is an idea shared by such future-oriented movements as the Constructionists and Futurists. Burden, in a deliberate stance of deviance, seems to be doing "bad works" where his father did "good works." Where his father was presumably naively optimistic about engineering, Burden is brutally pessimistic. His performing machines bring out the brutality—the "vice"—latent in engineering's virtue.

The question of the psychology of Burden's production may seem irrelevant and digressive, but in fact the issue of his motivation has haunted every critical examination of him. Those who think they answer it correctly with the notoriety argument—led on by Burden's mock confirmation of their answer—are critically irresponsible. To give, as has been done, the simplistic, standard art world answer of career advancement and gratuitous novelty is to miss the driven quality of Burden's work, to be blind to its special intensity, restlessness, and relentlessness. He has chosen a rather strange, dangerous, death-predicated way to make his name, and while his aggression—originally self-directed, now directed at society—is no doubt a familiar stance in the art world, it can hardly be described as one more celebrity pose—another socially encouraged manifestation of what the psychoanalyst D. W. Winnicott calls the false self. His aggression is in fact immanent in his work, structures it, and as such is a sign of Burden's true self, a self that can, with extraordinary composure, face "death, chaos, mystery."[13]

To me, what is most astonishing about Burden's art is his composure—not at all remarked by critics—in the destructive situations in which he put himself in his early body performances. He seems to expect the world to have the same composure in the face of his recent "research" onslaughts against it. These projects can be seen as testing the world's self-possession—putting its self-control on trial—by confronting it with its own potential for technological destruction. His power pieces—the eighties machines—are battering rams assaulting its self-conception. Does Burden expect the world to coolly hold its peace in this confrontation—

not to crush him as he wants to crush it? Or is he crying out for some special punishment equal to his own transgression?

Burden's composure is a sign of great ego strength, and it is this composure which signals the motivation behind Burden's art: reality-testing, more specifically, testing his own power of endurance in the face of destructive reality. His true art—the persistent idea in virtually all his works—consists in mithridatically strengthening his ego in the face of destructive and self-destructive tendencies, initially his own, now those of the modern technological world. In terms of Freud's structural model of the mind, Burden's art was first concerned with destructive id tendencies and is now concerned with destructive superego tendencies. The latter are latent in engineering—think of the punishment machine, that imperfect instrument of social engineering, in Kafka's *In the Penal Colony*— and made manifest in Burden's internalization of his father.

Burden can trust his ego to withstand—survive—his own deep tendencies to destruction, but he does not seem to believe that society will overcome its tendency to engineer its own destruction. (He seems to have displaced his own tendency to engineer his destruction—his death wish— onto society, in which it seems to be an actuality rather than fantasy.) For Burden, society is not worth relating to because its technological omnipotence gives one a sense of vulnerability, reinforcing one's already primitive sense of helplessness. But Burden recognizes that his life is inseparable from that of society. With great ego-strength, despite his sense of vulnerability within and from without, he makes a critical stand against it to avoid being completely victimized or weakened psychologically by it. His work is a reaction to its reality, not arbitrary violence against it. In the end, society may destroy him and itself, but it may also be brought to sufficient self-consciousness to reconsider its technological ways. (This hardly implies a pastoral retreat or utopian vision for Burden. Rather modestly, he seems to be calling for a rethinking of the use of technological power, beginning with social recognition of the truth of his witness of it.) At least that is the great, remote hope. It is as though, through his early performances, Burden gathered the strength, by critically confronting himself, to critically confront the world. He must do this to respect himself as well as to try to save society from itself.

Burden carries out the confrontation through his "crazy constructions," whose bizarreness reflects, like a funhouse distorting mirror, the world's technological madness, a form of power hunger. There is missionary zeal as well as carnival morbidity behind his construction performances. He is still a kind of Christ seeking to redeem the world, to save it from itself before it is too late. Rather moralistically, he has used his "father's" engineering instruments to reveal technology's general power over us.

Burden's recent work is not only a matter of articulating destruction. His machines can symbolize and do good as well as evil. Both his body and machine performances are about the uncertainty of "the outcome of the struggle between the forces of good and evil, or in psychiatric terms, between the benign and persecutory elements within and without the personality."[14] Perhaps the ultimate point of Burden's performances is the uncertainty of their outcome. Doubt about the outcome stands in sharp contrast to the deliberateness of their methods. Where initially Burden was acting out the persecutory element within his own personality, he has now matured to the point of recognizing that while technology also has a persecutory dimension—destructive potential—it also represents mankind's attempt to realize its deepest hopes for creating a good world, that is, for repairing nature and for self-repair. Burden has matured into ambivalence, or perhaps, in Melanie Klein's terms, he has moved from the paranoid-schizoid to the depressive position. Thus, while in *Spinning Dervish* "centrifugal force will cause the steel plates to move outwards and upwards to a horizontal position, thereby taking total control of space," and while *Medusa's Head* is "a metaphor for a world engulfed in its own technology," "*Moon Piece* would appear to be a bright automobile headlamp moving rapidly across the sky, 1/5 to 1/10 the size of the moon. The most sophisticated and the most primitive of cultures would be acutely aware that something had changed in the heavens."[15] Through a technological "miracle," Burden would create a new star of Bethlehem in anticipation of the second technological coming of Christ— the redemption of the world through technology.

Burden seems to have a particular fight to pick with the museum. It is as though the art world is too small a stage for him to make an appearance on, so he must symbolically destroy it by destroying the museum. Thus *Samson* and *Exposing the Foundation of the Museum* are concerned literally and symbolically with destroying it, demolishing its structure, and undermining its significance. These projects are straightforwardly subversive actions. In *A Fist of Light,* in an even more ingenious way, Burden demolishes the museum as an exhibition space and, by extension, the whole notion of art as something to be exhibited rather than performed and participated in. For me, it is in these museum projects that Burden makes his most trenchant statements about the bankruptcy of conventional art as a force for social change and consciousness-raising, as an instrument of personal and collective self-consciousness.

Samson is

> a museum installation consisting of a 100-ton jack connected to a gear box and a turnstile. The 100-ton jack pushes two large timbers against the bearing walls of the museum. Each visitor to the exhibition must pass through the turnstile in order to see the exhibition. Each input on the turnstile ever so slightly expands the jack, and ultimately

if enough people visit the exhibition *Samson* could theoretically destroy the building. Like a glacier its powerful movement is imperceptible to the naked eye. This sculptural installation subverts the notion of the sanctity of the museum (the shed that houses the art).

It does more: it undermines the very notion of museum art. The work is not simply about destroying the notion of the sanctity of the museum, but about destroying its very concept and necessity. The museum has come to be thought of as inseparable from art, as the natural place for art; but for Burden it has nothing to do with art's essence—its ideas. The credibility of the museum as a place for reflection on art is tied to the assumption that art can exist only in objects. By denying conventional art objects the shelter or home of the museum, art is forced to give up its objecthood and to take its place—try its luck—in the world outside the museum. It is forced to give up its pretense of sacredness and acknowledge its profane origins and end. In the world beyond the museum, art is not so much reflected upon as acted upon. It occurs as an action in a field of actions and potentially as part of a chain of actions directed to a particular purpose. *Samson* is a justification for Burden's own commitment to the conception of art as "action and participation," rather than as object.[16]

Moreover, *Samson* is a tidy example of Burden's sadomasochistic mentality, a mentality which, I think, is inseparable from the nihilism that Renato Poggioli regards as quintessentially avant-garde. Burden is Samson, with the strength to destroy the temple of art and the philistines who have come to gape at him as the latest art sensation. At the same time, they are the victims of their own curiosity about the novelties of art. As they enter the museum through the turnstile, they literally "screw" themselves, much as Burden once tried to "screw" himself by his art actions. But what strikes me as particularly noteworthy about *Samson* is the coldness of Burden's attitude, conveyed through his use of the glacier metaphor, the ruthless calculation or calibration of the whole event, and most of all the blindness of both Burden and the museum visitors. Their blindness is unwitting and self-evident; they have been put in an impossible, paradoxical situation created by Burden, who in effect subliminally and sadistically surrounds them.

Burden himself is in an impossible, paradoxical situation, which he is also blind to. For if the museum is abolished, as he seems to want it to be, then there will be no place to exhibit the mementos mori of his performances and to make him famous beyond the little circle of friends for whom he performs. Burden seems to want to remain isolated—in 1984 he moved to what has been described as an "isolated part of Topanga Canyon, N.W.L.A."—but he clearly does not want to remain obscure.

The museum is the avenue to public visibility. Perhaps more importantly, it legitimates his performances as art, precluding our conception of them as insane, anti-social acts and our tendency toward a reductionist understanding of them as exclusively symptoms of psychopathology. Without the museum as his institutional "cover," Burden risks being taken as a madman and social nuisance, if not a menace as well. Without the museum as a cover, he is truly nihilistic and agonistic—resentfully avant-garde.

Exposing the Foundation of the Museum has a similar metaphoric import, but it seems to me more desperately obvious. Burden proposed

> removing the concrete slab and excavating a 50-foot trench 16 feet wide and 10 feet deep along the length of the North-East interior wall of the Temporary Contemporary Museum building [of the Museum of Contemporary Art in Los Angeles]. This trench will reveal the concrete piers and footings which support the steel columns of the Museum's structure. Wooden steps and walkways along the trench will enable viewers to descend and observe at eye level the foundations of the Museum.

This "exposure" of the museum's "nakedness" as a construction much like any other is a more blatant demolition job on the traditional meaning of the museum than the *Samson* project. The violence is more direct—less insidious—if equally perverse. Indeed, Burden's perverseness is of the essence of his enterprise. It is not simply a matter of contradicting expectations, but of demonstrating that the "normal" idea of art and its place in the world are perverse—not Burden's idea of them.

When, as in *A Fist of Light*, Burden proposes "lighting the interior space of the [New] Museum with the maximum amount of light possible" so as "to totally saturate the entire space with light, attempting to remove all color in a visual analog of fission," he is in effect launching an attack on painting—that "colorful" art—to remind us that it is not the seat (indeed, throne) of art. Rather, it is a temporary resting spot for the idea of art; the art of pure light signals that art is a "colorless" idea in the mind, not an idea that must necessarily be materialized in color. Burden implies—correctly, I think—that there is more perversity in restricting art to a certain medium, in a sense petrifying it in the medium, than in conceiving of it as an idea at work in the world.

If we do accept Burden's definition of his activity as art, then what kind of art is he practicing? It is certainly not a purely theoretical activity, despite his emphasis on its ideational and "research" character. He does, after all, materialize his ideas, initially in his body, more recently in various "constructions." "Conceptual art" is really an insufficient name for what Burden does. It seems better to characterize his oeuvre as theatrical. But what is theatricality? It was once foolishly regarded as the enemy of

authentic art, but I suggest, as I think Burden would, that theatricality is art's essence. Put another way, art has a special monopoly on theatricality. Its theatricality is a special gift of understanding and disclosing the reality of the world.

For theatricality is a special demonstration of power: through his research on power—a research on its nature and effect that I maintain has been continuous in his work—Burden has his hand on the very pulse of art. Theatricality conveys every mode of power in highly sublimated form: information power, referent power, legitimate power, expert power, the power of reward, and coercive power. Theatricality presents, in highly concentrated form, information controlled and directed toward influencing specific beliefs and attitudes. It creates a situation in which the onlooker can have instant identity by finding traits he or she spontaneously incorporates in himself or herself. It confirms legitimacy, that is, the sense that a certain order, however initially strange in appearance, governs consciousness correctly and justly. It presents the artist as an expert in articulation, so expert as to be able to articulate things that no one else can and that would otherwise be left in obscurity. And it presents, as a psychic reward for accepting its fictions as convincing or binding, for intensely absorbing ourselves in them to the point of becoming unconscious of their fictionality, the "incitement premium of formal beauty," as Freud called it. Such total giving ourselves to art's fictions in fear that we will miss something uniquely significant—symbolized by "beauty"—is art's peculiar form of coercive power. There is a kind of harsh beauty in Burden's work, existing through the austerity of his means.

Power, as Talcott Parsons has said, is *the* form of social contract. Traditional art's theatrical power resides in its ability to make the social contract seem palatable, even pleasurable, so that we do not notice the power it has over us, let alone question that power, find flaws in the contract or understand its full consequences and nature. Traditional art persuades the viewer of the goodness of the social contract, drawing him blindly into it and giving it complete power over him. Traditional art acts to make us unconscious of the powers that control us—to which we are contracted—in part by theatricalizing them as "divine," that is, inevitable. The power of Burden's critical art—it is the power of what used to be called with conviction avant-garde art—is that it deconstructs, to use the fashionable word, the social contract; it calls it into question, reminds us that it has many problematic features, and puts us in a position to be able to consider its hold on us, a position which already half frees us of that hold. Burden's art brings us to consciousness of our condition of belief and attitude. It is a kind of working-through of cherished illusions. In

a fall from a dubious grace, we can no longer blindly accept our condition of illusion. We arrive at a self-consciousness, which carries with it a certain burden of autonomy—aloneness.

Burden discovered his autonomy through his early self-destructive actings-out. The self destroyed was the false self blindly accepting the conventions of the social contract; the true self initially emerged as the self that, as James Joyce's Stephen Dedalus put it, refuses to serve. Burden's later work is applied autonomy, as it were; it discloses the fraudulence of the social contract—especially the conventions that "govern" art and artists—from the perspective of autonomy. The autonomous self, rather than the binding social contract, is now absolute, has authority. Art's theatricality at its best, as in Burden, puts the self in this position of self-consciousness by showing it the workings of power in sublime form, form instantly assimilable by the unconscious because it creates the illusion of being a dream. This position may be an illusion generated by theatricality, but it is nonetheless one which generates an elementary critical power, that is, the power to disobey the social contract. First showing the falseness of the sense of self created by the social contract—its falsifying of selfhood, perhaps its ultimate power—through his violation of various aspects of the social contract, Burden then turns on the social contract itself, showing its inherent falseness.

More particularly, his early work shows us the false sense of the body the social contract gives us by denying its vulnerability and mortality, which Burden restores to consciousness. This work is determined to make us excruciatingly conscious of our bodies through painful empathy with the situation to which Burden subjects his own body. His more recent work shows us the false sense or illusion of dominance that the social contract of technology gives us. As he says about *Medusa's Head*, we inhabit "a world engulfed by technology," a world in which technology, like the steel plates of *Spinning Dervish*, has taken "total control of space." Similarly, the social contract of art, operating through the "machine" of the museum, has taken total control of the space of art. Burden tries to counteract this control by introducing into the museum space of art uncontrollable social power in the form of war machines. To exhibit *All the Submarines of the United States of America* in an institutional art space, as Burden recently did, is to violate preconceptions of what constitutes art and its proper subject matter, as enforced by the conventional social contract of art.

One can say that, as long ago as nineteenth–century Romanticism, the social contract of art was extended to cover every subject matter, including Burden's behavior. (War and history works are hardly new.) And

with Duchamp it was extended to the point that it became impossible to differentiate between art and nonart except on an institutional basis. But the fact of the matter is that the expansion served to put us into a critical relationship with art, not the world—forced us to reconceptualize art, not the world. It became an amusing art game to consider any artifact as art by reason of the artist's fiat, as Breton said of Duchamp's readymades. Burden asks the next question: what good does it do the artifact to become art? What new understanding of it do we gain by theatricalizing it? The answer can only be that we understand our own relationship to it—that we become conscious of the social contract we have implicitly made with it. To know the social contract we have made with the machine is to get some kind of control over what would have total control over us. Burden is not interested in assimilating new subject matter for the sake of its novelty or in order to give moribund art a new breath of life, the way an electric shock may stir a dead heart to life. Rather, Burden is determined to use art's theatrical power to put us in a critical relationship to reality that is generally hard to come by these days, especially through art. Burden has given the increasingly empty idea of "critical art" fresh credibility by showing that the social contract—symbolized by the museum—which gives art its reality is not binding. In this he is much more destructive and theatrical than Duchamp—and more sophisticated in his use of art's power.

Notes

1. Donald Carroll, "Chris Burden, Art on the Firing Line," *Coast* (August 1974): 29.

2. Quoted in ibid.

3. Ibid.

4. Ibid., p. 30.

5. Ibid. The distance, according to Burden's documentation, was "about 15 feet."

6. Ibid., p. 31.

7. Ibid.

8. Quoted in ibid.

9. Quoted in ibid., p. 29.

10. Quoted in ibid.

11. Jim Collins, "Chris Burden," *Artforum* (May 1974): 72.

12. Burden, Unpublished "Statement on Current Research Activities."

13. D. W. Winnicott, "The Manic Defense," *Collected Papers* (London: Tavistock, 1958), p. 132.

14. D. W. Winnicott, ''Psycho-analysis and the Sense of Guilt,'' *The Maturational Processes and the Facilitating Environment* (New York: International Universities Press, 1965), p. 25.

15. Burden, Unpublished ''Statement.''

16. It is astonishing that Frank Popper, in his comprehensive book on *Art: Action and Participation* (New York: New York University Press, 1975), does not mention Burden's work.

Young Necrophiliacs, Old Narcissists:
Art about the Death of Art

If we are to take it as a truth that knows no exception that everything living dies for internal *reasons—becomes inorganic once again— then we shall be compelled to say that "the aim of all life is death" and, looking backwards, that "inanimate things existed before living ones."*

Sigmund Freud

What is new is the notion that today art incorporates its eclipse.
T. W. Adorno

What strikes me about the work of Peter Halley, Peter Schuyff, Philip Taaffe—the leading young producers of the new abstract simulacrum[1]—is the shiny crispness of their paintings, intense to the point of pathology. Their work is so conscientiously clean looking, so full of the glamor of hygiene, so uncannily puritan, that one can't help but experience its hyper-resolve and super-finish as fanatical in import, a result of narcissistic inbreeding. Inbreeding, indeed, is what Postmodernism is about—as though art had no other way to sustain itself than to copulate with the stylistic corpses in its past. In Postmodernism art reproduces itself through its ancestors, an extension of the perverse, ancient Egyptian idea that for a royal, holy family to maintain its elite character all its marital unions must be incestuous, internal to it—a dubious way of recapitulating phylogeny to achieve ontogenic novelty and uniqueness. In art, as elsewhere, such incestuous unions are designed to ensure the future, but in fact they guarantee decadence. They are a demonstration of the peculiar, devious way the death instinct works itself out. The forced effort to maintain homogeneity—the hermetic refusal of heterogeneity—is

This article originally appeared in *Artscribe* (April/May 1986).

ultimately entropic. In art, the sterility of formalism—and the new abstraction is hyper-formalistic—is a direct result of such entropic inbreeding.

In the young masters of abstract semblance the corpse of abstract art, resurrected into a zombie state by the mechanism of semiotic parody—which alone keeps it from becoming a completely decorative robot in a fun house of art—is given a peculiarly vital appearance, as though it were a spontaneous fantasy, which makes it seem appetizing, although it is bitter to taste. It is so artfully made up to look like innocently enticing art, that its completely artifical, cosmetic character is forgotten. There is something unsavory and insidious in the hallucinogenic crispness of the new abstraction. Its eerie iridescence, like that of many deep sea creatures, seems to bespeak the full force of organic burgeoning, but it has an oddly inorganic—crystalline, mineral—aura to it. It is the phosphorescence of decay, creating the semblance of flourishing life.

The new abstraction is like a doll, so convincingly lifelike that we have trouble leaving it in the dolls' house. We are convinced that it must come alive, at least in the night mind. Like the character in the E. T. A. Hoffman story, or like Oskar Kokoschka with his woman doll, we refuse to accept the fact that the new abstract art is radically artificial—which is exactly why it seems not only lifelike, but better than life. It seems to concentrate more life in it than the art it mimics. But that is an illusion: dead things always seem more dense and less flimsy than alive things, which is why the new abstraction at first seems more gripping than the old abstraction. It is not just that, as Oscar Wilde said, life follows art, but that certain art seems so much more perfect than life and other art that we would rather live it than life, rather trust it than any other art. It is the illusion of the superiority of abstract art to both life and other kinds of art (more heterogeneous, continuous with life)—this snobbism—that Neo-Abstraction stresses and represents, and that is central to its appeal.

The aura of ambiguously organic/inorganic irradiation is most evident in Schuyff's *The Weld* (1985)—his work has been spoken of as appealing "to our magpie eye for shiny things"[2]—but it also informs the loosely Rothkoesque atmospherics of Taaffe's *Concordia* (1985), and the fervent geomorphic clarity and pseudosyntonic dayglo surfaces of Halley's paintings. Taaffe's vertical ornaments, with their touch of movement—prettified and stabilized Newman zips, some have said—suggest the ironic ornamentalism of all these artists. The ornament is the organic petrified; these artists have petrified organic art into inorganic ornamental status. All of them betray and subvert the attitude/ideology of the pioneering Abstractionists, offering visual enchantment without spiritual enigma—especially without the increasingly enigmatic (because increasingly remote to contemporary art thinking) moral intention of the seminal Abstrac-

tionists. Their sense of art in general, as a fundamentally ethical enterprise, has been lost in the supercilious aestheticism of the Neo-Abstractionists. Yet by reducing the old abstraction so completely to an aesthetic code, conscientiously used as a sign—talisman?—of art, they unwittingly show what semblance or simulation means: to thematize the notion of the death of art.

To codify the old abstraction is to make it smooth and polished. Jean-Paul Sartre has written that "the quality of 'smooth' or 'polished' symbolizes the fact that 'carnal possession' offers us the irritating but seductive figure of a body perpetually possessed and perpetually new, on which possession leaves no trace. What is smooth can be taken and felt but remains no less impenetrable, does not give way in the least beneath the appropriate caress."[3] The Neo-Abstractionists establish a frustrating erotic relationship with the old abstraction, which they think they possess carnally by codifying but in fact their codification leaves no trace on it. The old abstraction remains impenetrable behind the façade.

The smooth, polished character of Neo-Abstraction—of all appropriational, codifying art—also bespeaks its fetishistic character. Janine Chasseguet-Smirgel notes the "twofold property of the fetish: it is anal and shiny, often smelly and shiny."[4] Appropriation-and-codification (parody is facile codification) are an anal two-step. Neo-Abstractionist work is emotionally smelly and physically shiny, seeming to violate the taboo against touching shit, yet it treats past abstract art like shit—turns it into shit. The anally created world—"the dream of an anal creation of the [art] world"—as Chasseguet-Smirgel writes, seems to be "a world not ruled by our common laws . . . a marvellous and uncanny world."[5] This is because anality—and by extension the feceslike art-fetish created through it—is "connected with sham, counterfeit, forgery, fraudulence, deceit, cheating, trickery . . . in short with the world of semblance."[6]

Are the Neo-Abstractionists reflecting the anality—deception—of the "real" world? In a Walt Disney world where cartoon characters are invested with enormous emotion—the emotion we invest in pets and knickknacks—why shouldn't art be a cartoon of art, a playful pet, an intriguing knickknack? Don't we invest enormous emotion in semblances: isn't that the message of art? Hasn't the world learned that lesson well, becoming completely artificial—arty? Don't the Neo-Abstractionists offer us works of art that seem like purely technological inventions, just as we ourselves seem increasingly to be manufactured rather than grown?

It is not so simple. I see Neo-Abstraction, like all the neoisms that surround us in art today—the appropriation-and-codification, imitate-and-systematize-the-past productions—as a very anxious demonstration, something like a political rallying of the forces of art, of art's feeling of

vulnerability in the contemporary world, its feeling of being almost dead for all its apparent aliveness. The highly articulate, knowing character of Neo-Abstraction—even more so, I think, than Neo-Expressionism or Sigmar Polke-like Neo-Popism—masks this anxiety, but also is a way of thematizing the threat of art's death. It is a way of looking the threat in the eye and describing it precisely, by imitating the *rigor mortis* look of death before decay has visibly set in: putting the best artificial/cosmetic face on the death of art, as though to repress the consciousness that art may "naturally" die in the industrial world, which has only nominal use for it.

Sandor Ferenczi has pointed out that "imitation magic," as he calls it, is a way of imparting a traumatic impression of the world either in a search for sympathy and help or as a complaint against the feeling of vulnerability induced by the world, or both. Every such "imparting" involves the "imitating of something *alien*" a "primitive form of objectification," and a dilution or momentary mitigation of the original impression.[7] The new abstraction does several things at once. First, it imparts Abstract art's feeling of vulnerability within the art world (recently strongly oriented to the agitated figure) by magically imitating traditional Abstract art. Secondly it imparts the art world's feeling of vulnerability to the appropriative, culture-consuming bourgeois world, which seems ready to swallow any art whole, no matter how tasteless—suggesting the futility of art as such. Big fish swallows little fish: the new Abstract art swallows the big old Abstract art in the hope of showing that it too is big, and then says to the world: "Swallow me too." In its consumption of the old abstraction, Neo-Abstraction anxiously takes the bourgeois world's attitude to art. It may want to save the old abstraction, but its worldly treatment of it belittles and finally annuls it. (With friends like the new appropriators, old art needs no enemies.) Like the consuming world, neo-art in general overobjectifies the "original" art it appropriates—appropriation is inherently overobjectification—thus destroying it. Thirdly, like all neo-art, Neo-Abstraction imparts the sense (prevalent today) that no new art can be as good, "original," "authentic," and authoritative as the old art—or has to be in a world of technical reproduction rather than natural production—so that today's artist might as well copy the old art. Especially the old art's look of authority should be pantomimed, thereby giving the new art at least second-hand authority. It is nostalgia for the old authority that motivates neo-art—nostalgia for the days when revolutions could still be made simply by manifesto—when art seemed to have a manifest destiny. Worn with a certain contemporary flair, like used but still almost mint condition clothing, the old abstract art generates new excitement. The new abstract art is a version of what the psychoanalysts call "the exciting object," promising all but delivering

nothing, except a seductive set of signs. They're the satisfaction. While they're worn like the prophet's mantle, they are in fact glorified rags.

Philip Taaffe uses ethical jargon to justify his unethical appropriation of Op art, already a simulation of abstract art. He regards his work as "a very personal interpretation of a very public icon." He thinks of it "as having a tragic dimension," and is surprised at the surprise of an incredulous friend at this thought. Taaffe has nothing to say about how his choice of imagery allows "an element of tragedy to develop within [his] work."[8] He gives no indication of understanding the traditional meaning of tragedy as an articulation of conflict, nor awareness of the recent psychoanalytic interpretation of it as a reflection of the absence of empathy. Does he know what he is talking about when he uses such words as "personal" and "tragic," or are they simply ahistorical modish words in his clique? Do they express old desire or new intention, or are they old champagne bottles that can be filled with any cheap wine? All one sees is the lilt of his anal appropriation, his smooth-talking pictures. No tongue-tiedness, no stutter for golden youth as it mouths the language of its elders in vain. Similarly, Halley's bit of acknowledgment of Foucault's *Discipline and Punishment,* as though that gives a better smell to the droning of his appropriation machine—no clogging or constipation here—is simply piling intellectual appropriation upon aesthetic appropriation, anally mouthing what is fashionable to understand and fetishize, as if treating it as though it was created in a vacuum was a sign of its truthfulness.[9]

All of these artists are supposed to have a powerful "emotional pitch," as Taaffe puts it,[10] or "overheightened emotionalism," as one of their apologists said.[11] This is supposed to redeem their appropriation-and-codification act, and show it to be a redemption of a long-lost abstract art. Are they "emotional?" Another apologist has written: "The appropriation of other artists' imagery, at first seen as a way to question the idea of individual artistic originality, has become so common among younger artists that distinct individual approaches have begun to emerge. In thumbnail fashion: Sherrie Levine is the conceptualist appropriator, personally absent and deadpan in her copying; Mike Bidlo is the performance artist, burlesquing the legend of Picasso, Pollock or Warhol; Taaffe is the abstract painter, bringing to his Op art the kind of artificial, hedonistic focus on material and process that characterizes painters like Ryman or Marden."[12] The key words here are "deadpan," "burlesque," and "artificial"—all words once vigorously applied to Pop, and all implying the absence of subject and emotion, that is, the "personally absent." They bespeak the bypassing of the pursuit of sincerity and authenticity as culturally obsolete and "unrealistic"—insufficiently unobservant of and tough-minded in the face of today's world.

A remark by Adorno springs to mind as a comment on the latest version of Pop-smartassness, "Realism." "The disproportion between the all-powerful reality and the powerless subject creates a situation where reality becomes unreal because the experience of reality is beyond the grasp of the subject. This surplus of reality is reality's undoing. By slaying the subject, reality itself becomes lifeless. This transition is the aesthetic moment in anti-art."[13] The impersonality which is supposedly so crucial in the construction of reality—why is the impersonal more "realistic" than the personal?—and so central to the Pop mentality, resurfaces with a vengeance in Neo-Abstraction. In the New Impersonality of Neo-Abstraction the reality of art has become even more lifeless than it was in Pop art—I recall the confusion of many critics as to whether it was or wasn't art—because the subject has been slain, not just wounded, as in Pop. The New Impersonality of Neo-Abstraction is a kind of anti-art. In traditional anti-art, for example, Duchamp, art was subverted or "deadened"—destroyed—by being shown to exist relative to the stable institution of art and the unstable subjective response to objects. In the new anti-art, art is destroyed—or rather, its deadness is made explicit—by its being shown to have happened in the past, present art being based on a code of art formulated in the past. Roland Barthes has written that "the 'realistic' artist never places 'reality' at the origin of his discourse, but only and always, as far back as can be traced, an already written real, a prospective code."[14] In the new abstract anti-art, Abstract art—the symbol of art as such—is placed as far back as it can be traced, to a code of Abstract art formulated in the past, to an already written code of art. Indeed, the Neo-Abstractionists are writing art, not making it. They are profoundly conservative.

What has been drained out of Abstract art by them is its import for the subject—its attempt to respiritualize and morally reeducate the subject. The Neo-Abstractionists show that the eternal return of the repressed—repressed art—need not be a matter of Kierkegaardian repetition or Jungian synchronicity. It need not be a sacred event for—a sacred celebration of the power of—the unconscious. Instead, it can be an indication of a blind, profane repetition of stereotypes—perhaps the most direct of the "circuitous paths to death" that Freud spoke of as instinctively inevitable in life, including the life of art.

One last point about Neo-Abstraction: it is narcissism run rampant, become an absolute—narcissism as another of those unexpected paths to the death of art. Freud has described narcissism as a state in which an individual "retains his libido in his ego and pays none of it out in object-cathexes."[15] The New Impersonality of Neo-Abstraction suggests a radical withdrawal of libido from the objects of the world—suggests the

ego of art hermetically withdrawing into itself in a search for conviction in itself. Traditional Abstraction also withdrew from the objects of the world, but to reinvest libido in the experience of making objects of art, and in these objects. That is, traditional Abstraction remained outgoing, projective, "representational," like obviously representational art. Neo-Abstraction introjects the stylistic realizations of traditional abstraction as part of art's narcissistic search for a "pure" stylistic ego, that is, a style that will mirror only art itself. Stylistics—not the same as the development of a new style, but rather the masturbation of an old style—is the easiest path to self-belief, since it establishes art as a closed system. This signifies a near exhaustion of libido. It is this exhaustion of libido, inseparable from a desperate narcissism, that is responsible for the "healthy, overly hygienic trivialization" that Taaffe sees in much Neo-Surrealist art,[16] including no doubt the "retro-Surrealism" of Schuyff's 1982–83 work.[17] But it is also responsible for the same hygienic triviality of Taaffe's, and Halley's, retro-abstract work. It is total nonsense to say, as Carlo McCormick has, that

> In the art of Philip Taaffe and in most of the recent paintings of Peter Schuyff the quotation of 60s Op art is entirely warped. The formalism of artists such as Victor Vasarely and Bridget Riley is reduced to a background formula, and to information. Where most neo art movements strip the original style of its content (neo-expressionism is a fine example here), Taaffe and Schuyff are intentionally discarding the academic rigidity of their predecessor's work so as to invest the otherwise dry form of non-expression with an overheightened emotionalism. As Op tried to erase the presence of the artist's ego, and to replace it with transcendence, now the ego is supreme and the artist's hand is seen everywhere.[18]

It is no doubt customary for young artists to think of older artists as academic, but it should be remembered that Riley has asserted the emotional purpose of her art, and Vasarely's art has no less a purpose than to integrate scientific and artistic understanding of color/structure. In the effort to recover past art, its intentions are never relived, only its look appropriated. Neo-art, in unconscious fear that it has no serious intention, that it may be secretly dead on arrival, does not want to face the serious intentions of past art. It is no accident that Peter Halley, in a reverie "On Line," in part a celebration of driving on interstate highways— "behind the wheel . . . is to be at the altar of the linear"—does not recall Tony Smith's experience of the sublime on the New Jersey interstate. If Halley's art was an attempt to recollect in tranquillity that experience, it would have narcissistically known its own nothingness. The new Postmodernist sophistication masks the old obscenity of living death. Art dies when it cannot incorporate the heterogeneous object, only yeasay itself in the mirror of style.

Notes

1. Peter Halley, ''Frank Stella and the Simulacrum,'' *Flash Art* 126 (Feb./March 1986): 32–35. In this article Halley assimilates Stella to his own point of view, arguing that Stella's ''work conforms closely to a model of Postmodernism that is dominated by ideas of hyper-realization, simulation, closure, and fascination'' (p. 33)—like his own. In giving new life to the dead Modernism of Stella, Halley only confirms his deadness. Halley is not unlike Warhol; both celebrate the death instinct in art. But Halley turns Warhol on his head. Where Warhol idealizes the living photograph into dead art, Halley realizes dead art as a living photograph. Halley's works are like handpainted photographic reproductions of famous works of art, a little ''off'' to show Halley's own insincere hand.

2. Walter Robinson, ''Peter Schuyff at Pat Hearn,'' *Art in America* 74 (February 1986): 131.

3. Jean-Paul Sartre, *Being and Nothingness* (New York: Philosophical Library, 1957), p. 579.

4. Janine Chassegeut-Smirgel, *Creativity and Perversion* (London: Free Association Books, 1985), p. 88.

5. Ibid., p. 80.

6. Ibid., p. 81.

7. Sandor Ferenczi, ''Notes and Fragments,'' *Final Contributions to the Problems and Methods of Psychoanalysis* (New York: Bruner/Mazel, 1980), p. 266.

8. Philip Taaffe interviewed by Michael Kohn, *Flash Art* 124 (Oct./Nov. 1985): 72.

9. Jeanne Siegel, ''The Artist/Critic of the Eighties, Part One: Peter Halley and Stephen Westfall,'' *Arts Magazine* 60 (September 1985): 73.

10. Quoted by Walter Robinson, ''Philip Taaffe at Pat Hearn,'' *Art in America* 73 (January 1985): 137.

11. Carlo McCormick, ''Poptometry,'' *Artforum* 24 (November 1985): 90.

12. Robinson, ''Peter Schuyff,'' p. 137.

13. T. W. Adorno, *Aesthetic Theory* (London: Routledge & Kegan Paul, 1984), p. 45.

14. Roland Barthes, *S/Z* (New York: Hall and Wang, 1974; paperback), p. 167.

15. Sigmund Freud, *Beyond the Pleasure Principle* (New York: Liveright Publishing Co., 1961), p. 44.

16. Taaffe interview, p. 72.

17. Robinson, ''Peter Schuyff,'' p. 137.

18. McCormick, ''Poptometry,'' p. 90.

"Suffer the Little Children to Come unto Me": Twentieth-Century Folk Art

I have moreover retained a lasting affection and a reasoned admiration for that strange statuary art which, with its lustrous neatness, its blinding flashes of colour, its violence in gesture and decision of contour, represents so well childhood's ideas about beauty.
Charles Baudelaire, *A Philosophy of Toys*

At least since Gauguin wrote that "infantile things, far from being injurious to serious work, endow it with grace, gaiety and naiveté,"[1] the child's toy—described by Baudelaire as "barbaric," "primitive"[2]—has been the implicit model for Modern art, the alternative ideal of modern beauty in material form. Gauguin himself, in his search for an alternate source to the photographic, overobjectified image of a horse (traditional pedestal for the heroic human figure), turned inward. Going "back very far, even farther than the horses of the Parthenon, . . . as far back as the toys of my infancy, the good wooden hobby horse,"[3] he experienced the toy as the vital root of his intention. The toy, with its richness of association and simplicity of form—its evocation and existence as an emblem of a prehistoric aesthetic, yet by no means inarticulate or indefinite—was an altogether novel *disegno interne*. For Gauguin it was not only saturated in personal meaning and self-evidently pure or intelligible in form, but for these reasons universal in appeal, touching every viewer to the quick—the very origin—of his or her being. We were all once children, and still contain a hidden core of childish consciousness in our beings. The art object has the power to evoke our childhood attitudes, to play on and with them, to the extent it becomes toylike—an elemental object, as distinct from either an aesthetically banal or artistically extraordinary

This article originally appeared in *American Folk Art: The Herbert Waide Hemphill, Jr. Collection* (Exhibition Catalogue; Milwaukee: Milwaukee Art Museum, 1981).

object. To make it toylike the artist must become childlike—must become undeniably if not irretrievably infantile. He must become playful: the making of art must become spontaneous play with ordinary, if over-familiar, materials. The artist must lose his adult rationality and good judgment— the mature distinctions of his good taste—to the extent necessary to become a child, yet not to the extent of becoming altogether irrational, as truly "primitive" and "barbaric" as a child. He must, at most, become inadvertently irrational—irrational enough to take making toys seriously, but cunning enough to make toys that adults take seriously, to the extent of wanting to play with them again and again. To contemplate these toys itself becomes a species of play, a socially sanctioned occasion for the suspension of the other activities of life yet one serious enough for the emphatic reassertion of community—of the bond with what is fundamentally human. The regression to childhood's perspective is a desperate revolution in art and life, concerned to revitalize art's forms by recovering their origin in the inner rather than outer nature of life, and thus to achieve a new universality.

These attitudes had currency before Gauguin. The form which Baudelaire gave them—and his formulation is the touchstone for modern thinking about them—especially interests us, for it pinpoints exactly what is significant in modern (as distinct from traditional) folk art, which takes as its implicit ideal not the child's toy but "proper" art. For Baudelaire, "the child is possessed in the highest degree of the faculty of keenly interesting himself in things, be they apparently of the most trivial."[4] But more than that—and here Baudelaire is telling us exactly what is "modern" in Modern art, what is heroic about being new—"the child sees everything in a state of newness; he is always *drunk*."[5] For Baudelaire, "genius is nothing more nor less than *childhood recovered* at will—a childhood now equipped for self-expression with manhood's capacities and a power of analysis which enables it to order the mass of raw material which it has involuntarily accumulated. It is by this deep and joyful curiosity that we may explain the fixed and animally ecstatic gaze of a child confronted with something new."[6] There is this difference in the specifically folk genius: childhood may or may not be recovered at will—it is more likely to emerge spontaneously—and the toy which is the form of self-expression hardly seems to demonstrate "manhood's capacities and a power of analysis," as little as it seems an intricate or subtle ordering of "the mass of raw material" from which it is made. It is not that the folk genius lacks manhood's capacities and power of analysis and constructive ordering, but that the problem of making a toy consists, in Baudelaire's words, " in constructing an image as simple and as cheap as possible"[7]—an image which will suit a child's mind, not an adult's social and intellectual expectations. In the toy artifice and analysis are

kept to the necessary minimum, creating a sense of its involuntary construction, as if in direct reflection of the involuntary accumulation of the raw materials from which it is made. The folk toy is a construction that is a sign of impulsive, involuntary curiosity, childishly grabbing what it can from the worldly objects with which it has indiscriminately littered its life. The material seems hardly transformed by its use in the toy, which has the same raw look. But the construction, however naively accumulative or accretive in method, adds an air of urgency to this look, giving the toy a special sense of presence. The raw material, while still the detritus of a "drunken" way of life, seems organized toward an expressive end which makes it freshly engaging. But this is more than a matter of raw material acquiring expressive potential by being primitively organized into an elementary coherence. The toy, by reason of its "drunken," apparently "ecstatic" ordering of raw material, embodies childhood's powerful perspective, making all raw material miraculously "new," articulate in a way all but children find unexpected.

Old, trivial—no longer expressive—things, haphazardly accumulated rather than deliberately collected or chosen, add up or are shaped into something pertinent and personally new—a toy which fixes the sense of soul with which things are imbued by the child. Baudelaire remarks that "the length of life of a toy" depends on the child's "overriding desire . . . to get at and *see the soul* of their toys,"[8] a desire so insistent that it often leads to a short life for the toy. The child plays god with the toy, putting his own soul in it, which sees things as if they were divine, i.e., unique and original, or freshly made—on the earth for the first time. The child's perspective on "newness" is the only one which can overcome boredom, but the objects in which that perspective embeds itself are fragile, because of the restlessness within the perspective itself—its need to move on to constantly "new" objects. The toy whose parts are easily added to can easily have them subtracted, in a search for the soul that bound them together. This quickly thrown-together look—and it is evident as much in the whittlings of Edgar Tolson as in the paintings of "Peter Charlie" Bochero—is of the toy's essence, for this look is at once the sign of its childish soulfulness and the trivial things that are its objects and that it renews.

The folk object, then, is a species of toy, made by people in a kind of second childhood. Sometimes this is almost literal: one cannot help but note the number of folk artists, from Morris Hirschfield to Grandma Moses, who began to make art objects after retirement. Art in these cases is the reflection on life that follows vigorous participation in it, as well as the recovery of a childish attitude to it—childlike wonder at its continuing possibilities after so much of its actuality has been endured. But often it is simply the sign of a childlike attitude that has never been

outgrown—the sign of the presence of a child who has never grown up, and is still putting together a new world out of the old one. It is worth noting that folk objects often function as toys for children,[9] and children sometimes helped in their making.[10] Toys, of course, have been exhibited as folk art.[11] And it is worth noting that Herbert W. Hemphill, Jr., one of the most distinguished collectors of folk art, began collecting as a child, and never stopped, as if to ensure that the child in him remained intact in the adult.[12] It is not that reason is lost in the folk artist, but that the power of childhood sensibility is such, should it sustain itself by making its own toys, as to obliterate all signs of adult understanding, by subsuming them in another kind of comprehension. The numerous animal objects of folk art seem to me to indicate such an obviation, near total, of adult perspective, the folk artist taking the perspective of the child who identifies with the animal—that close-to-earth point of view which both children and animals have, giving them a certain affinity in their vision.[13] Prominent details become new because they stand out of an indefinite reality. The animal figure itself is prematurely totalized in this childlike way by the folk artist, who stresses his kinship with the animal—his experience of the animal's "stand" in the world. When the adult point of view is not denied, it is manipulated to the extent that it seems displaced—utterly disorienting, as in much political folk art.[14] Realistic meanings disappear into unrealistic signs, tokens of a naive allegiance to reality, minimal acceptance that it is in fact the case. But the political folk artist gives it in such an erratically personal way that it seems dispensible as fact, hardly seems the case—seems no more than an opportunity for the bravado of childish self-expression. "Reality" disappears at the same moment that it reappears in the sign-fragments of the folk object, which is what it means to treat reality playfully and give it a soul unimaginable to the adult mind.

This definition of folk art as toylike is a response to its spiritual or psychosocial function in the contemporary art world. Contemporary affection, even admiration for folk art, presupposes the necessity for a new childhood for art, in the situation of its presumed decadence. The sign of this decadence—the omen of the end of art—is art's self-destructive separation into "high art" and "popular culture," a distinction which seems increasingly easier to make in direct proportion to the degree one plagiarizes the other. Each develops to its extreme limit, from which it can be contemptuous of—and contemptuously use—the other. This bifurcation or polarization of art does not reflect some aborted Solomon's wisdom with respect to it—the establishment of a social hierarchy of art in the name of peace between the classes—but rather its devolution from a sense of clear and absolute standards into mutually exclusive and

totalitarian forms and standards. Each side claims the monopoly on art. "Popular culture" alone is truly art because it fulfills art's communal and communicative functions through its outreach to the greatest possible audience. "High art" is art because it is pure art—art about art. The only way out of this increasingly tense and alienating—from all art—double bind is a new beginning for art. This fresh start is always within reach, always practically not simply theoretically available, in folk art, which from the modern point of view takes us back directly to the origin of the work of art in the toy, and indirectly to the origin of the artist in the child. The folk art toy restores our sense—perhaps ironically, but nonetheless healthily—of art's social and emotional role without undermining our sense of art's formal identity.

Folk art represents an always available ground for the overcoming of the dissociation of sensibility—of thought from feeling—that T. S. Eliot described as the modern spiritual disease. The folk work of art seems responsive to the formal problems of art, even seems to represent basic thinking about the fundamentals of artistic form. At the same time it seems a mode of expression which taps into an almost infinite realm of preconscious and unconscious feeling. It combines self-consciousness about artistic making and a retreat into the fathomless feeling of the child—into a realm in which feeling and thought have not yet become separate and neither has attempted to usurp the role of the other, permanently replace the other with itself. The folk art toy represents a renewed unity of sensibility. In the world of Modern art, it symbolizes unified expression of being, self-expression which is not only a recovery of the integral self but the discovery of a world which seems paradise by reason of the self's sense of belonging in it. Direct expression of the integral self becomes direct creation of the world as home, ending the artist's concern to be at once popular in, yet detached from, the life-world. This simultaneity is why the folk art toy seems to have, in Gauguin's words, "grace, gaiety and naiveté," and why our sense of its nature is inseparable from our sense of knowing it from the perspective of the child. It is an object which by its very nature—by the character of its physicality and construction—puts us in the frame of mind by which we can know it as a subject, and as such beyond the dualities by which the world is unavoidably known by the analytic adult mind. The adult mind dialectically complicates its dualities to give the world the "newness" the child's mind spontaneously experiences it to possess. Folk art deprofessionalizes art, so that it is no longer a matter of specialization in either thought or feeling, but a renewal of their togetherness.

The definition of folk art as toylike is also an attempt to reconcile traditional romantic and modern sociological definitions of folk art. Arnold

Hauser notes that for the romantic, folk art—an art of the naive and the natural, organically rooted in the people and an unconscious expression of them—is "the prototype of the mysterious act of creation, from which all artistic values can be derived."[15] For the romantic, folk art is ahistorical, and thus transcends distinctions of class, being fundamentally collective to the extent that the individuals who make it are without significant identity. It is the inspired, original expression of a primordial people, a sign of their innate values. Indeed, from the romantic point of view folk art is innate art, originating independently of any cultural environment, and directly expressive of the people's will. In direct reaction to this point of view, the modern sociological point of view, unequivocally empirical, holds that folk art is more an "improvisation" than an inspiration, a manipulation of common forms and meanings rather than the expression of some primordial, instinctively given "material."[16] As Hauser says, the conception of folk art as a "cultural good that has sunken down," to a popular level (*herabgesunkenem Kulturgut*) has become commonplace.[17] For example, he observes that most folk songs are in literary language rather than dialect, i.e., more a matter of *langue* than *parole*: "Songs in dialect originate for the most part from professional poets, who believe they must climb down to the folk, while the folk, when it writes poetry, does not, as the romantics believe, do so 'naturally,' but rather presents it emotionally as well as linguistically in their Sunday best."[18] No one any longer doubts that "subjects or individual motifs, styles and forms, elements of feelings and ideas from the high culture penetrate downwards and become the possession of folk art."[19] Indeed, it has at last been suggested that twentieth-century American folk art be studied from this point of view.[20] The most casual examination of contemporary folk art proves the point: derivative content and form, whether from biblical, mythological, or political sources, self-evidently exists in "run down" form. Popular imagery, and popularized versions of culturally complex stories and ideas, are the obvious starting points for folk art constructions. Hauser quotes with approval Morf's assertion that the folk artist does "not compose, only arranges, or at most is able to vary, does not create, only chooses."[21] In general, for Hauser the folk artist is "the typical dilettante who needs models as soon as he begins" to work.[22] He is dependent almost entirely on memory and already publicized materials. At the same time, Hauser notes his indifference to criticism, his lack of competition with other artists and advertisement for his own art, and his indifference to aesthetic issues. While folk art may acquire aesthetic value for the elitist devotees of high art, the folk artist himself has no conception of art as a thing in itself, is unable to make and has no interest in making qualitative aesthetic distinctions, and in general has no intention of going beyond "the boundaries of his everyday life forms and needs."[23] His art is con-

tinuous with and inseparable from his life, rooted in it as belief is rooted in experience. Indeed, his art expresses his profound belief in his life-world, his sense of it as *the* world.

But the modern enlightened, matter-of-fact conception of folk art leads to a new romantic point of view on it. Its childishness is no longer understood as the sign of innate creativity, but the direct consequence of its profound embeddedness in the life-world. Folk art's childishness becomes the paradoxical sign of commitment to a world recognizing itself and the effect on the world to which it is "obedient"—into which it is locked by fate. Childishness is in fact the folk artist's form of self-consciousness. Childishness is the sign of the uncovering of rootedness, the sign of a being-in-the-world that not only knows its own ground inch by inch, but knows it to be the only possible ground of being-in-the-world. The folk artist has a childish dialectic with the world—and his "toys" give an elementary dialectical effect—in which he sees it as at once raw or involuntary, and fixed in its nature by him, by his relationship to it. He has no intention of denying its nature—which gives his art its involuntary aspect—but rather of pushing that nature until it is experienced as undeniable. He pushes it as far as it will go in his consciousness, and then in recognition of its undeniable reality "believes" in it. This dramatizes it—folk art is a dramatization of tested, undeniably encountered reality, a dramatization which reveals an attitude of active commitment rather than passive acceptance of it, a kind of joining up with what has been experienced as inescapable.

Conceiving the folk artist as a primitive dialectician, the inadequacy of the modern empirical conception of folk art's total dependence on the larger cultural environment becomes self-evident. Such dependence is only half the story. Folk art cannot be completely reduced to that dependence because of its romance with what has drifted down to it. That romance leads the folk artist to "discover" cultural leavings—from biblical stories (especially of the Fall of Man) to political imagery (Washington and Lincoln), in effect all kinds of verbal as well as visual clichés—as fated, as particularly applicable to his existence, not as a cultural sludge to be taken for granted, blindly and dumbly accepted. The sociological conception of folk art assumes a kind of passive innocence, a benighted state politely called naiveté but in fact regarded as dumbness if not stupidity. But this ignores the active use the folk artist makes of his raw material, his giving it new dramatic point and poignancy, fresh emotional power, so that it truly takes hold. The folk artist does not simply quote what he uses, but actively appropriates it, and reworks it—one might almost say reinvents it—so that it no longer seems commonplace. Perhaps it was commonplace and trivial by the time it reached him, but he not only shows there is still life in it, but that his life is in it, and has given it life.

There are many scenes of daily life in folk art,[24] revealing it as something not to be taken for granted but to be seriously—"romantically"—believed in, as the realm of our living presence. The banality of these scenes is transcended in the very act of their "realization." The formal elaboration of the daily scene objectifies an intuitive sense of its inevitability. Thus, the many images of home, from John Scholl's *Castle*, circa 1910, to Cleo Crawford's *Christmas*, 1938, presupposes the commonplace idea of home, and at the same time "speculatively" embroiders the simple image of home with formal niceties. The idea of home is transmuted into the sublime image of home, showing home not simply to be a fact of life but a fated fact of life. Certain things in life are given, which makes them all the more desirable, the folk artist seems to be saying. Certain things in life should never be taken for granted, especially those which are necessary for its survival. Folk art celebrates not only the given, but the necessarily given, for human existence—and finally things that, from any point of view, the world would never be the same and would be unimaginable without, such as animals. The folk artist is an ontologist out to prove that this is the best of all possible worlds, at least when it is understood that it is the only world we can inhabit, the only world made for us—and, seemingly, from our point of view. It is as though, in the case of the home or the animal, the artist became so intoxicated with the idea (not simply reality) of them, that only a toy home or a toy animal could do them justice, for only that toy made their Platonic intelligibility and necessity visible while not denying the comfort they give to human existence, a comfort without which it would not be possible. This is a matter of ideological and emotional comfort, as well as of practical comfort. Thus, the toy fixes, once and for all, the necessary facts of life in the firmament, showing them to be as fated and as radiant as the stars, and, like all inescapable things, as worthy of belief.

Similarly, the numerous religious scenes, from Carlos Cortes Coyle's *The Transformation*, 1934, to Sister Gertrude Morgan's *Jesus Is My Airplane*, circa 1970, presuppose familiarity with religious narrative to the point of boredom. But the narrative is revitalized by making clear that it applies to all times and places. This is accomplished not simply by adding elements of contemporary reality to it—such as Adam's three-piece suit in Coyle and the airplane in Morgan—but by treating it as a script for life as such. It becomes a dramatization of a fated reality rather than a matter-of-factly related fiction. In the very act of making it performative the folk artist makes in constative, i.e., in the very act of relating it the folk artist believes he has demonstrated its adequacy to life. The folk artist's ability to reveal the relevance of what seems irrelevant—because it is commonplace—depends on his ability to read facts as fated or to take

what is culturally presented as fated to be factual, thus making what is commonplace the sign of an uncommon, because unique, fate. For him the commonplace is the inescapable, which is what makes it so profound and important. For the folk artist, art is a way of making one's peace with what is given, and of recognizing that givenness as something neither wantonly there nor wantonly dispensable. It is uniquely and inevitably what it is, precisely particular yet necessarily the case. Each of its details testifies simultaneously to its particularity and necessity.

The folk toy's acceptance of necessity in its very nature is shown by its stylistic simplicity, evident in even the most garish, ornamental folk pieces. I see this simplicity as a way of assimilating and acknowledging the inevitable—the fated character of what is given, of what is to be rendered. (And it is only such fated things that folk art bothers to render.) Form is, in this sense, the sign of fate. For me, this is nowhere more evident than in the folk art treatment of wind and the automobile, a natural fact of life and a social fact of life, both of which the folk artist regards as fated. The one clearly is, the other seemed so on its appearance, i.e., became rather than was from the start an inescapable or elemental fact of life. The casual simplicity of weathervanes and of the automobile image in folk art sets both against the horizon of consciousness in such a way that their fatedness seems profoundly clear. It is as though they were always there, undeniable presences in the life-world, without which it could not be said to be constituted.

The Neo-Romantic definition of folk art once and for all dismisses the hierarchical approach to folk art which both the traditional romantic and the modern sociological conceptions shared. Folk art is not the higher expression of a lower—because prehistoric—folk, nor the lowest expression of high culture. Rather, it is an original dialectical treatment of commonly held cultural goods, which is exactly what makes it art rather than some raw expressivity approximating to art, or some mock version of what is properly art. It, too, has its norms, and these include the accent of belief transforming every element that seems plagiarized from a superior culture into a sign of fate.

The dialectic of this transformation involves the doubling of "conforms," the con-form being my term for a standard unit of culture—and I emphasize "standard." Folk art deals only in standard units—in an already standardized culture. High art may deal in nonstandard elements which are not regarded as elements of universal culture, or it may destandardize a given con-form by reworking it until it is unrecognizable as such, and has a qualitatively original effect. But in folk art there is rarely more than the juxtaposing of con-forms, making for an elementary dialectical effect, and generating a sense of irrationality. In Henry Darger's work

the combination of soft, innocent children and blunt, hard animal horns makes the children less than innocent, and creates an absurdity which is read as fierceness. In Harold Garrison's *Watergate Pistol* (1974) the artist's sense of creating a "machine (*hand made*)" summarizes the irony and absurdity of the whole work, and bespeaks the irrationality of a political machine in the hands of one man (Nixon). Similarly, Felipe Archuleta's *Baboon* (1978) depends for its effect on the contrast between such details as the teeth and eyebrows of the creature and the less detailed treatment of its body as a whole. Zeroing in on detail is a technical con-form which, taken together with a generalizing treatment, creates the kind of "static" which is essential to the folk piece. The clashing and melding of con-forms is typical of folk pieces, and is responsible for their tension, for the sense of their absurdity and aborted reality. It is what gives folk pieces their blunt look of deviance; the more recognizable the norms, i.e., con-forms, the more blunt the look. It is responsible for the sense of the folk piece walking the thin line between anarchy and autonomy that Baudelaire remarked, and that may be the source of modern individuality.[25] The folk toy risks anarchy in its pursuit of autonomy—in its effort to rise above con-forms. It has that "childlike barbarousness" which is as close as autonomy can go to anarchy—and as close as anarchy can go to autonomy.[26] Such barbarism, it might be noted, also shows in the didacticism that pervades folk art, a didacticism which comes from a reliance on con-forms, which is part of the burden of their use. This didacticism is as evident in Morris Hirshfield's nudes as in the anonymous *Orient Delights* (circa 1920) sign, as well as in the many moralizing religious and political pieces. The barbarism of using unadulterated con-forms is the barbarism of standardization, where what is standard seems to preach at one and, thereby caricatures itself.

The intention of the folk artist, then, is to be autonomous and make an autonomous work of art, while still being barbarically con-formist. The non-con-formist moment arises from the conflict of con-forms, including that between the style with which a subject matter is treated and the standard or expected style of treatment. Any old style understood as standard is often brought to bear "inappropriately" on a subject matter, making for an incongruity which makes for a momentous, non-con-formist work. But it is in the use to which the folk piece may be put that shows its real non-con-formity, the folk artist's assumed mantle of autonomy. S. P. Dinsmoor epitomizes this attitude of independence that verges on insanity (anarchy). "Of the glass-covered coffin in which he lies, he wrote: 'This lid will fly open and I will sail out like a locust. I have a cement angel outside to take me up.' However, Dinsmoor believed in hedging his bets, for he had himself buried with an ax by his side just in case the coffin

lid failed to fly open as planned.''[27] The quality of belief here is extraordinary, and shows exactly why orientation in the life-world must be considered in evaluating the quality of any work of art. The artist conforms to religious belief in the resurrection. His nonconformity lies in his doubts about God's ability to open the coffin lid—a little hitch. The conformist literature of the Bible tells us that God can resurrect bodies, but it doesn't say anything about His being able to lift coffin lids so as to get to the bodies. Conforming all the way, and in so doing becoming autonomous, Dinsmoor knows an ax can break through a coffin lid. Once resurrected he'll break through by his own efforts. Conforming, he knows he'll still need the angel to fly to heaven, and he has made sure the angel will stay put because it is of heavy cement. One system of con-forms hooks into another to make up an irrational whole which demonstrates the unexpected autonomy of the artist. He leaves all the belief systems intact, but puts them in paradoxical relationship to one another, so that they add up to what can only be taken as rational anarchy or irrational autonomy—inadvertent anarchy and inadvertent autonomy.

The Platonic realism of this is apparent: one can readily speak of Folk Platonism as determining not only the structure but the details of the folk piece. The con-form is treated as a Platonic idea. Ideational and visual con-forms are not only forced to correlate, but are treated as interchangeable. That is, the visual signifier is regarded as a direct and exact translation of the ideationally signified, so that the particular signifier seems irreplaceable and as such to have general validity. It seems to be as Platonically fated and real as the ideational system itself. Powerful belief has Platonized both sign and idea. At the same time, there is a kind of theatricality in this ontologizing or ''purifying'' of signs and ideas. The idea is easily fixed or stabilized by belief, but the sign seems less ready to submit to its proposed absoluteness. The more it is regarded as an exact translation of the idea—the more the visual con-form seems an exact duplicate, a clone of the ideational con-form—the more slippery the sign seems to become. The more the sign and the idea are regarded as having Platonic parity—if only by reason of their both being con-forms—the more spontaneous the sign seems and the more evasive the idea becomes. That is, at the very instant they seem most securely Platonic they are most manifestly non-conformist.

Such duplicity belongs to the toy. It unequivocally reads as a Platonic idea, but at the very moment it does so it becomes visible as a means of mediation, and thus reduces to raw material. It is a Platonic idea in scarecrow form, remaining Platonic so long as it is passionately believed to be uniquely itself, and as such autonomous. But it becomes anarchic the moment its formal origins in standard con-forms is recognized, and

then it dissolves into its commonplace nature, becomes an arbitrary object. All that it concentrates in its being is lost to the recognition of the ordinariness of its material and spiritual origins. But what is lost is spontaneously recovered by the innocent Platonic love that gave birth to the toy.

Notes

1. Quoted in Herschel B. Chipp, ed., *Theories of Modern Art* (Berkeley, Calif., 1968), p. 83.

2. Charles Baudelaire, "A Philosophy of Toys," *The Painter of Modern Life and Other Essays,* Jonathan Mayne, ed. (London, 1964), p. 199.

3. Chipp, *Theories*, p. 84. It is worth noting that Jackson Pollock's *The Wood Horse* (1948), in which the image of a hobby horse is used as a collage element, continues the tradition of interest in the toy as a source of art to the present day.

4. Charles Baudelaire, "The Painter of Modern Life," *The Painter of Modern Life and Other Essays*, Jonathan Mayne, ed. (London, 1964), p. 7.

5. Baudelaire, "The Painter of Modern Life," p. 8.

6. Ibid.

7. Baudelaire, "A Philosophy of Toys," p. 199.

8. Ibid., p. 202.

9. For example, Clark Coe's *Girl on a Pig* (ca. 1910) "was originally part of an almost life-size water-powered whirligig that Coe constructed to amuse a crippled nephew." Herbert W. Hemphill, Jr., and Julia Weissman, *Twentieth-Century American Folk Art and Artists* (New York, 1974), p. 36. The photograph of John Roeder's *Bay with Islands* (ca. 1948), with Roeder riding one "toy" and his child another, also makes the point (p. 110, fig. 150).

10. An instance is recorded by Hemphill, Jr. and Weissman, in ibid., p. 40.

11. An anonymous *Indian Doll* (ca. 1920) and an anonymous *Doll* (ca. 1930) probably of Pennsylvania Dutch origin are mentioned in ibid., p. 52, fig. 65 and p. 87, fig. 116.

12. This fact is noted in the introductions to the catalogues of two exhibitions of Hemphill's collection of American folk art, *Folk Art USA since 1900* (The Abby Aldrich Rockefeller Folk Art Center, Williamsburg, Virginia, 1980) and *Of the People, By the People, For the People* (Brainerd Art Gallery, State University College at Potsdam, New York, 1980.)

13. Hemphill, Jr. and Weissman show at least 34 images of single animals, approximately ten percent of the total number of folk artifacts illustrated.

14. There are 22 images of what can be regarded as political folk art in Hemphill Jr. and Weissman, of which at least half involve the jumbling of not always commensurate signs.

15. Arnold Hauser, *Soziologie der Kunst* (Munich, 1974), p. 603.

16. Ibid., p. 610.

17. Ibid., p. 606.

18. Ibid.

19. Ibid.

20. See Daniel Robbins, "Folk Sculpture without Folk," *Folk Sculpture USA*, Herbert W. Hemphill, Jr., ed. (Brooklyn, 1976), pp. 16–30. Catalogue of an exhibition at the Brooklyn Museum and the Los Angeles County Museum of Art.

21. Hauser, *Soziologie*, p. 606.

22. Ibid.

23. Ibid., p. 607.

24. Approximately one-third of the works illustrated in Hemphill, Jr. and Weissman, *Twentieth-Century American Folk Art*—some 127 pieces—can be regarded as scenes of daily life, or else as dealing with objects which are clearly part of everyday life.

25. Jonathan Mayne, "Editor's Introduction," Charles Baudelaire, *The Painter of Modern Life and Other Essays* (London, 1964), p. xvi.

26. Baudelaire, "The Painter of Modern Life," p. 15.

27. Quoted by Hemphill, Jr. and Weissman, in *Twentieth-Century American Folk Art*, p. 80.

Robert Kushner's Happy Consciousness

And yet this elimination of all ornament involves nothingness, in-volves death, and a monstrous dissolution is concealed behind it in which our age is crumbling away.

Hermann Broch, *The Sleepwalkers*

An art of happiness? Preposterous! Necessarily insignificant today. How can one dare be happy, or produce art that dares to make us happy, in such a wretched world? How can one tolerate an art that contradicts the futility of life in a heartless world? Happiness is for the inexperienced, the pretentiously innocent, who deny the evidence of suffering. Yet, the only really difficult, challenging art to practice today, and the hardest to make credible, is the art of happiness. To be open-eyed about the world and still be happy is the ony risk worth taking, in art as well as life.

In trying to rationalize my enjoyment of Robert Kushner's art—in feeling compelled to apologize intellectually for the deep pleasure I take in it, a pleasure that is more of a challenge to my being than transient sensual pleasure—I have been forced to rethink my sense of what is at stake in Modern art; in effect, to reevaluate it.

Ingrained habits of misery lead me to expect only the negative from Modern art. Theoretically, the best Modern art is a form of "negative dialectic," in T. W. Adorno's sense of the term. It articulates pathological self-doubt and the pathological character of the world, and epitomizes crisis and catastrophe. The expectations that surround Modern art, whatever their legitimacy—for the self and the world do seem to be in unusually morbid, critical condition today—have become a kind of folly; they ignore and impede the therapeutic possibilities of art. They suppress its creativity, locking it into a Procrustean bed of pathology. They absolutize negativity into what might be called "pathognosticism"—the

This article originally appeared in *Robert Kushner* (Exhibition Catalogue; Philadelphia: Institute of Contemporary Art, 1987).

belief, no doubt masochistic in import, that only by passing through the mystery of the negative can we know the truth of existence, only by yielding completely to the negative can we truly comprehend the mystery of being. Negativity, in world-historical form, is suffering, and only an art that articulates suffering can claim significance. Presumably, only the tragic sense of life, reflected in a tragically self-conscious art, is steadily meaningful.

Seeing Kushner's art against this conceptual background has made me realize that negativity has become reified—a cliché, a pillar of salt. The negative no longer represents the process and spirit of life, it is an obstacle to its movement. It has become *the* formula for intellectual and artistic sterility.

Because Kushner's art is a questioning and, through that questioning, a transcendence of the truth of the negative—without denying its reality—it represents a true, major alternative, both as an artistic lesson in life and as pure art. Kushner offers us a positive art that articulates happiness as a vital personal actuality rather than a collective utopian possibility. It is happiness as serenity in the face of the horrific facts of the world rather than happiness as defiant, bludgeoning ideology. It is happiness that is quietly, rather than exhibitionistically, revolutionary. In fact, the muscular serenity that Kushner articulates represents a triumph of will over legitimate disgust with the world.

Kushner's art indicates the only "positive negation," as the dialectician Adorno calls it,[1] the only authentic "negation of negation," possible today: positive emotional negation, in which art still reveals its dependence on the negative world, but does not submit to it inwardly. This does not mean reconciliation with the world but the development of interiority at its expense; that is, through a lack of emotional commitment to the world, art creates and articulates an interiority not fully informed by it. Serenity—a genuine, vital happiness—is a complex emotional response to the world, and a devastating critique of and alternative to it.

Such a successfully positive art shakes the traditional avant-garde assumption that only art that is profoundly negative is critical—that the positive can never be truly critical, can never be Modern. It challenges the whole theoretical structure that Adorno's assertion implies: "If art is to remain faithful to its concept, it must pass over into anti-art, or it must develop a sense of self-doubt which is born of the moral gap between its continued existence and mankind's catastrophes, past and future."[2] Is it immoral not to have self-doubt, or to have worked through it to self-regard? Is it obsolete for an art to have the confidence of happiness? Is it possible that the strategies of anti-art, which, in Adorno's words, involve the recognition that the "autonomy of art is exposed as

depending on its opposite other," namely "reality"[3]—that is, the assimilation of the socio-material world—can become a means of making a self-aware and self-assertive rather than a "feebleminded affirmation"?[4] Is it possible to have an art that uses "the discordant moment" inseparable from Modern art to new creative purpose as the catalyst of an affirmative aesthetic integration?

The attitude implicit in Kushner's new art of happiness (art of new happiness?) is a thread leading us through and out of the labyrinth of agony. His art neither takes pleasure in the dissonance that is the echo of the agony of history nor offers a consonance that can only seem a feebleminded pacifier in the historical circumstances. It suggests a horizon beyond that of human suffering, implying that even suffering may have its limits. By making happiness visible, he is counteracting the short-sightedness that sees agony as ultimate.

According to the modern vision of tragic negativity, one is either in agony or, as a survivor of history, responsible for it, by way of one's guilt. One has inescapable guilt, by which one involuntarily acknowledges one's spiritual, if not literal, responsibility for human agony. Kushner does not so much repudiate that guilt as offer us an art that, in effect, asks us to invent the light in which it can be properly seen. Kushner's art demands that light of delight we all saw by in childhood, in certain privileged moments of intimacy, which is why it seems mythical. The paradox of Kushner's art is that it uses the anti-art methods of modern negativity to positive purpose—from clashing vibrancies to readymade materials, from unresolved chords of color and shape to incommensurate fragments of reality. His reconstitution of the decorative suggests that "purposive purposelessness," which Kant considered the essence of aesthetic transcendence, is the sublimated effect of primitive happiness. It is the stripping of this primitive transcendence of happiness from the decorative that is responsible for its degradation.

In Kushner's hands, the decorative is not the irresponsible rejection of history it is usually thought to be but a symbolic restoration of the earliest history, the history of intimacy. Kushner's art addresses this intimacy that underlies and has been suppressed by social history—a history of adult conflict—supposedly because it is unrealistic. To understand the reality and workings of primitive intimacy requires a special sensitivity. Kushner recovers the sense of the decorative as the symbolic form of intimacy. For Kushner, the decorative is not an allegorization of ahistorical pleasure but the trace of the intimate in the supposedly world-historical.

Adorno has written that "even in a legendary, qualitatively better society of the future, art cannot afford to disavow the remembrance of accumulated agony. To do so would mean abrogating art's form."[5] Adorno seems to conceive of art as elegant agony. Kushner does not so

much disavow agony through aesthetic forgetfulness as imply that the discords through which agony is articulated are not the dead ashes of history but the violently vital flames in which the phoenix of serene happiness is reborn. Agony is ambivalent, and it is this ambivalence that Kushner articulates. It exists in the volatility or instability of his images, their peculiar ferment and moodiness. His works are not unequivocally hedonistic but rhythmically tense, with seemingly quixotic alternation between feelings of pleasure and frustration. For all their luxury, his figures become ambivalently charged in the way they simultaneously merge with and separate from the matrix of brightly colored fabrics. This is most evident in their contours; although edgy and dark with the frustration of separation from the untotalizable fluidity, they move with it.

In a sense, the figure is the phoenix of happiness rising from the flames of history, symbolized by the fragmentary, abandoned character of the fabrics that are Kushner's basic material. The eroticism of his work is deceptive; it is built up of fragments that represent the poignancy of remembrance, that most intimate of agonies. Each of Kushner's works reconstructs this lost, yet always latent eroticism, with its feeling of happiness—without which life is meaningless. The agony of history is the attempt to wipe it out as immature. History wants to teach us the reality principle—to be adult—but in so doing, in making reality coercive, it destroys the emotional bedrock of our being. Kushner's art is reparative, not simply declarative, of eroticism.

It is a serious mistake to regard pleasure as mindless. One cannot deny that pleasure is at the core of Kushner's art, but it is significant pleasure—the pleasure of unity of being—important not only for itself but for what it represents: the authentic happiness of being undivided after having been divided. It is the pleasure that comes from the difficult achievement of integration, and the surprising recognition that such unity of consciousness is a greater source of vitality than inner conflict. If, as Hegel says, "*Unhappy Consciousness* is the consciousness of self as a dual-natured, merely contradictory being,"[6] then Kushner proposes happy consciousness: the consciousness that the self is able to work through and overcome its contradictoriness. Contradiction is the germ of integration rather than an end in itself. Unhappy consciousness is a struggle for an elementary—one might say, pagan—recognition of the self, which is the primal source of the feeling of happiness. Kushner's paganism—self-evident in his figures, and especially in his celebratory identification with the flourishing of the life force in nature (a major source of his creativity)—is at the center of his integrity. As Hegel has said of unhappy consciousness, "consciousness of life, of its existence and activity, is only an agonizing over this existence and activity, for therein it is conscious

that its essence is only its opposite, is conscious only of its own nothingness." But the self overcomes the sense of nothingness by, as Hegel said, giving thanks to "the Unchangeable," thus experiencing "heart."[7] Kushner's art is pervaded by a heartfelt sense of thanksgiving to divinity.

Kushner makes division ingeniously and elegantly rhythmic; while it remains visible as tension, the work is no longer an "antagonistic totality," as Adorno calls it, speaking from the point of view that conceives art as a purely negative dialectic.[8] The objective division of the work—in Kushner, most evident through the cut-and-sewn character of his pieces—becomes symbolic of fresh self-differentiation. The mystical dimension of Kushner's work—it can be regarded as in-depth decorative—results from his presentation of each fabric fragment as a freshly differentiated perception of a naturally occurring reality. So-called mysticism, after all, is no more than a finer seeing of being. Kushner implies that such creative differentiation freshly integrates the self—overcoming, while utilizing, agony. Happiness is the liberation of creativity within an undeniable situation of agony; that is this artist's message.

Kushner also accomplishes something of more direct significance to art: He shows us the continued possibility of painting—painting in a higher, more fabulous fashion. His fabric medium is not only crucial to the complex, happy effect of his work—the colorful brightness of his materials affords a sense of plenitude—but because they are readymade. His works are assisted readymades; he paints and then sews fabric fragments together, which suggests that, today, authentic painting can only be a fiction of painting. His works are a kind of artificial (arch?) painting, as well as painted prefabrications—artifices appropriated for art by being integrated with paint. This is not a matter simply of low art being appropriated for high art—for many, if not all, of his fabrics are high-art forms in themselves—but of the creation of a fiction of painting, wherein its validity and significance are no longer clear. It is only through this particular fiction that the general promise of happiness implicit in art, and, traditionally, most articulated by painting (most in its care, as it were), can be preserved. Kushner's fictional painting acknowledges the distance between this promise and the unhappiness of reality. The point is made clear by Adorno's remark that "[Walter] Benjamin, by the way, refused, at least in conversation, to reject contemporary painting completely, despite his desperate advocacy of mechanical reproduction, arguing that the tradition of painting must be maintained and preserved for times less somber than ours."[9] Kushner's paradoxical painting is a major means of maintaining and preserving painting in our somber times. In a sense, his fiction of painting is the most sublime form it can take

today—the form in which its promise of happiness is most intact and vigorously asserted. In charging his material with the full weight and power of that promise through his appropriation of it as painting, he creates an art that transcends the conflict between mechanical reproduction and conventional painting.

All of Kushner's works have a double use, implicitly or explicitly: They are wall hangings, but also performance costumes, if not literally so. *Moonlight* (1974), for example, was based on the chador worn by Iranian women, while utilizing a traditional Chinese design. In such works, the aesthetic and the useful are not separated, in a way that suggests that Kushner is restoring the traditional meaning of decoration. As Ananda Coomaraswamy has pointed out:

> Ornamentation or decoration . . . which imply for us the notion of something adventitious and luxurious, added to utilities but not essential to their efficacy, originally implied a completion or fulfillment of the artifact or object in question; that to "decorate" an object or person originally meant to endow the object or person with its or his "necessary accidents," with a view to proper operation; and that the aesthetic senses of the words are secondary to their practical connotation; whatever was originally necessary to the completion of anything, and thus proper to it, naturally giving pleasure to the user; until later what had once been essential to the nature of the object came to be regarded as an "ornament" that could be added to it or omitted at will; until, in other words, the art by which the thing itself had been made whole began to mean only a sort of millinery or upholstery that covered over a body that had not been made by "art" but rather by "labor"—a point of view bound up with our peculiar distinction of a fine or useless from an applied or useful art, and of the artist from the workman, and with our substitution of ceremonies for rites.[10]

Coomaraswamy deplores this "degeneration of meaning" of the decorative. Kushner wants to regenerate its original meaning as essential to being: ornament completes it, assuring its functionality. He seems to think of ornamentation as magically transforming the thing ornamented, a residue of the traditional sense of the efficacy of decoration. It is this sense of the magic power of ornament that Kushner's works carry to an extreme, restoring, in the process, the concept of the decorative to dignity.

Each of his works, worn as a costume, is, in effect, an ornament of the body, much as images of relaxed, naked bodies ornament some of his surfaces. One's body must be naked when one wears the costume; it is the proper environment for the erotic activity of naked bodies. Each of Kushner's wall hangings is the magic carpet or blanket that serves as the emotional space on which an erotic fête champêtre may occur in the unmagical world. Kushner has spoken with admiration of Japanese geishas, calling them "professional charmers." Wearing the kimono— many of Kushner's works are derived from kimonos, and can be

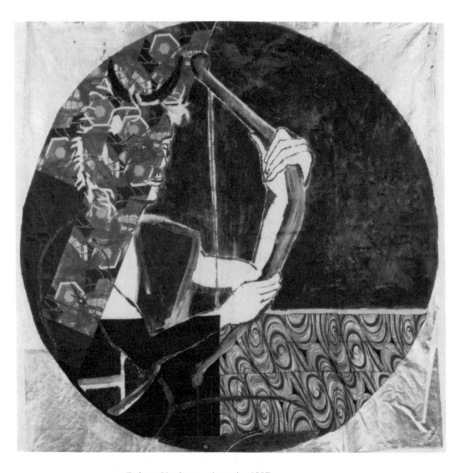

Robert Kushner, *Artemis*, 1987
Acrylic, metal leaf, mixed fabrics, 95″ × 96″.
(Courtesy Holly Solomon Gallery, New York)

understood as extended kimonos—over the naked body, restores its erotic and emotional efficacy, its power of feeling. It turns physical sensation into emotional response. Kushner's performances in his wall hangings are magical rituals of regeneration, or rejuvenation, of the body. Their import can be generalized: They suggest that all works of art are, at the most fundamental level, efforts to revitalize feeling where only meaningless sensation exists—meaningless because the sensation has been bifurcated into a necessary physical material and an adjectival unnecessary feeling response, much as we have separated necessary "labor" from unnecessary "art," as Coomaraswamy has said. Kushner's work, not unlike that of William Morris's decorative art, overcomes the pernicious division between labor and art, workman and artist, useful and fine art. It does so in the name of a unity of feeling and being. Kushner's works are meant to charm us into potency, to enchant our bodies so that they are strong and fluid with the vitality associated with the erotic.

Kushner's work refuses the "divorce of function and meaning" and asserts a "radical and natural connection between form and significance";[11] in this sense, it is profoundly anti-Modern. The Orientalism of his art—which exists even when the image, as in *Same Outfit* (1979), is derived from a Bloomingdale's shopping bag design ("vulgar, but well done," says Kushner; "tacky, but not kitsch")—is not simply a familiar Modernist stylistic strategy given new life but, rather, the articulation of an affinity with a certain attitude to art that assumes it is integrated with life from the start. In terms of Kushner's specific objects, this attitude can be articulated by reversing the Vedic statement "Ye weave your songs as men weave garments"; Kushner weaves his garments the way songs are woven.[12] The sense of Kushner's works as poems must also be understood in a Vedic context, wherein the poet is understood as an "enchanter" rather than as "one who merely pleases us by his sweet words"—i.e., Kushner's fabrics. An enchanter's poem has the "creative power . . . of wisdom"[13]—of wisdom's reparative power over life.

Much as, in the Veda, a jewel or talisman is worn "in order to have power,"[14] so one wears, and, by extension, looks at, Kushner's works—for serious looking is an empathic wearing—in order to have power, especially the power of the body's vitality, at stake in and represented by eroticism. Kushner regularly uses Oriental patterns—*Dancing at the Ritz* (1979) is derived from a Chinese interpretation of an Art Deco pattern—because they still possess the talismanic power of jewels, even to a jaded, empty aesthetic outlook. The exotic, always a representation of the opposite and, therefore, strange (which is why, in the West, it is symbolized by the East), exemplifies the most intimate power of our being. Kushner's generation of an intricate, illusionistic mosaic space out of flatness, and

his development of psychologically complicated scenes of intimate relationships, serve the sacred purposes of rejuvenation—the core purpose of creativity.

His work is cosmetic in the deepest sense, which, for Plato, meant "care of the body, a kind of catharsis, or purification."[15] One might even describe it as cosmetic Cubism: Kushner uses planes of colorful fabric in an additive way that generates a cathartic effect of wholeness larger than any of its parts. It is as though the disintegration of the body of the work of art into arbitrary parts was inadvertently a purification—perceived both unexpectedly and paradoxically as its fresh integrity.

Kushner's works suggest that the flatness and allover effect technically associated with the decorative have a complicated psychosomatic meaning and purpose. Flatness purifies the body by uniting it with a space radically different than—opposite to—its own; dynamic overallness proposes, to the emotions, a Dionysian merger with nature as a whole—with the life force. The decorative art of Robert Kushner has far-reaching implications. It compels a reexamination of what it means to be avant-garde and radical today, as well as a reappraisal of the conventional concepts for understanding art's aesthetic effect. In Kushner's hands, the decorative has acquired missionary zeal and force.

Notes

1. T. W. Adorno, *Aesthetic Theory* (London: Routledge and Kegan Paul, 1984), p. 445.

2. Ibid., p. 464.

3. Ibid., pp. 445–46.

4. Ibid., p. 59.

5. Ibid., p. 446.

6. G. W. F. Hegel, *Phenomenology of Spirit* (New York: Oxford University Press, 1977), p. 126.

7. Ibid., pp. 127, 132, 134.

8. Adorno, *Aesthetic Theory*, p. 446.

9. Ibid., p. 442.

10. Ananda Coomaraswamy, *Selected Papers, Traditional Art and Symbolism*, vol. 1, ed. Roger Lipsey (Princeton: Princeton University Press, 1977), p. 242.

11. Ibid., p. 243.

12. Ibid.

13. Ibid.

14. Ibid., p. 245.

15. Ibid., p. 249.

Part Three
Toward a Subjectivist Criticism

Art, Criticism, and Ideology

Much of what passes for criticism these days is in fact promotion that passes for information, impression management that passes for reporting. It is part of what Karl Mannheim called the democratization of culture, and it has all the problems of such democratization. In Mannheim's words, it involves the neutralization of whatever is democratized as well as its expansion by opening it to nonschematic discussion—the subjecting of culture to the conflict and stress of argument, which destroys all norms.[1] But that is on an intellectual, theoretical level. More practically and immediately, it subjects culture to the values of capitalism, reduces it to a possession and to bland gratification.

Now promotional criticism is a way of making culture gratifying, of telling us that what is aloof and "high" can in fact be intimate without losing its distance and disinterestedness. Promotional criticism accomplishes this by being at once shallow and intricate, making the culture accessible through wit but never articulating its inwardness, the depth of thought that in fact makes it high rather than low culture. It thus establishes culture as an object of belief rather than analyzes it as an object of thought. Promotional criticism never bothers to question its own presuppositions—never bothers to ask why we want to have art to believe in, what the promise or "salvation" inherent in that belief is.

All criticism is not promotional, as *Rezeptionsgeschichte*—the history of critical reception—makes clear. Such reception "may be spontaneous or reactionary, adaptive or critical, naive or scientific."[2] But whatever the form of the critic's response—whether it be an individual manner or the extension of a well-known communicative code to little-known art—it is fundamentally determined by a "receiving ideology," the outlook which in the first place permits the critic to experience the art as significant and so worthy of his careful attention.[3] For H. R. Jauss, the receiving ideology is not only representative of a larger cultural orientation, but actively

This article originally appeared in *Art in America* (Summer 1981).

makes history, as much as or at times seemingly more than the art to which it attends. It not only keeps the art in the historical game, as it were, but usually determines the rules of that game—rules which are made as much after the fact of the art as before its appearance.[4]

The receiving ideology is a "horizon of expectation," as Jauss says. This in turn is described as a kind of pre-knowing (*Vorwissen*), i.e., an informal structure of assumptions about art which become formal to the extent that the particular art critically attended to seems to conform to them. These assumptions are in effect questions which the art seems to answer, generalizations which the art seems to ground in experience. When an art concretizes our beliefs about art in general it is "successful," even if this concretization means no more than making us conscious of what we unconsciously or passively assumed, or even if it means making us question and discard what always seemed unquestionable and inevitable.

Walter Benjamin subsumes this epistemological effect of the horizon of expectation in an account of the social function of the receiving ideology: it is a programmatic belief about art reflecting art's role in the system of production and distribution of social goods. Until the work of art is "drawn into a dialectical, dynamic relationship" with a social observer self-consciously located in a particular history and world, it is "a piece of dead matter," or, what is the same thing, statically aesthetic—merely aesthetic. Beyond its aesthetic destiny is the larger authenticity of the work of art, which emerges only through its social reception, showing not only how the work of art "survives its creator and surpasses his intentions," but how its history is "an integral part of the impact" it continues to have. In sum, that impact "results not only from the encounter with the work of art but also through the encounter with that history which allowed it to endure to the present."[5] Only when the horizon of expectation is understood as specifically historical in character does expectation become truly critical, suggesting that criticism in part is a preliminary attempt to socialize the work of art, showing it to be viable to the extent it serves the community of human interests, however these interests may be interpreted.

It is worth noting that one, perhaps not unimportant, consequence of this conception of the crucial importance of the critic's receiving ideology is the dismissal of the traditional view that a detached approach to art is possible, corresponding to art's own presumed disinterestedness. Taste, conventionally the instrument of that "pure" or aesthetic approach, is the mask of an ideology, or else simply self-deception. Exclusive attention to style implies a particular attitude to art's social production and distribution—puts certain limits on art's material-technical production as

well as makes certain claims for its status and usefulness, like any other ideology. Indeed, one of the major tasks of any history of the reception of Modern art is the demonstration of the ideological import of supposedly socially neutral formal analysis of art.

In general, one of the curiosities of the receiving ideology is that it tends to appear as simply a matter of neutral sensibility, indeterminate in its relationship to art. Yet from an ideological point of view—which finds the source of individual mentality in the collective one through an analysis of the latter's habitual assumptions—just the opposite is the case. Original or highly individual art appears to be arbitrary until it is collectively grasped, i.e., falls in with a "universal" ideology, a typical pattern of social belief. Until that process is accomplished the art seems to have no *raison d'être*—for the prevailing ideology has a monopoly on reasons for existence. Simply put, only when an art is shown to exemplify an ideology does its existence seem justified—does it acquire presence and significance. Only as a sign of something more than itself does it become itself fully. From the point of view of ideology, no art can ever be of value in itself—can ever exist for itself, alone, in its own right. Its value comes from its horizon of expectation—from the history of desire in which, whether knowing so or not, it seeks to find its place.

Much as the formalist approach to art denies its ideological nature while at the same time being itself secretly ideological, so the promotional approach, by reason of its implicit assumption that whatever is exhibited is expected, dismisses the importance of ideological analysis of art. But the denial of the ideological origin and end of art is itself ideological. This denial's calculated naiveté, leaving the life of art if not unexamined then examined in only the most superficial terms—the terms of its immediate appearance (both formalist and promotional criticism do this, in their different ways)—is a strategy designed to stabilize or at least reaffirm the status quo of both art and criticism. In general, the informational approach, whatever the nature of the information mediated, automatically justifies the art it "informs" on, by reason of its lack of ideological self-consciousness. Such a lack goes hand in hand with, and is invariably masked by, attention to the formally immediate facts of art or the general manner of its presentation (which would include its stylistic or art-historical orientation). Isolated information, signaling an elementary response to an object without any sense of its end—skimming it without any examination of the depth of its reason for being—is the modern fetishism, the grand mystifier of modern consciousness of the world. While comprehensible in the terms Marx used to analyze fetishism in general, these terms do not explain the specific situation of art criticism.

They do not help us grasp the depth of self-hatred the art critic must suffer from—which plays into the hands of the artist's self-love—for him or her to surrender so completely to the informational-promotional approach. This lack of resistance to such an approach—indeed, the active encouragement of it, leading to its dominance—indicates the art critic's own great need for ideological analysis of what he does, a kind of psychoanalysis of his own intention toward art.

What are the final terms of the contrast between promotional and/or informational criticism and ideological criticism? Ideological criticism attempts to understand art in world-historical terms—insists on assuming art's responsibility to a larger history than merely its own. At its best, informational criticism regards art as more or less topical—the more topical the better. Ideological criticism's achievement of a world-historical perspective from which to view art contrasts sharply with promotional criticism's pursuit of topical art. The topical perspective produces a sense of art as temporarily impinging—barely "historical."

The notion of the topical is valuable as an antidote to the notion of the traditional—the way the one underplays historical determination counterbalances the way the other overplays it. The topical is short term, one might even say shortsighted, history, violently undermining the long-term history—the long look—tradition implies. The sense of what is topical is acutely relative, a passing sheen on the surface of events. To be sensitive to the topical is to respond to the ripples of this surface rather than the current beneath it. A critic who is sensitive to the topical has more equipment than is usual for a promotional critic, who habitually has no more than an erratic, makeshift sensibility and a limited sense of tradition. Nonetheless, the topical is a shaky focus in the generally unfocused field of the newsworthy—it is restricted in its probing, revelatory power.

The artist himself or herself, as well as the promotional critic, tends to be ignorant of or indifferent to art's ideological import. Oscar Wilde makes this point commenting on Walter Pater's interpretation of the *Mona Lisa.*

> And so the picture becomes more wonderful to us than it really is, and reveals to us a secret of which, in truth, it knows nothing, and the music of the mystical prose [of Pater] is as sweet in our ears as was that flute-player's music that lent to the lips of *La Gioconda* those subtle and poisonous curves. Do you ask me what Leonardo would have said had anyone told him of this picture that "all the thoughts and experience of the world had etched and moulded therein that which they had the power to refine and make expressive the outward form, the animalism of Greece, the lust of Rome, the reverie of the Middle Age with its spiritual ambition and imaginative loves, the return of the Pagan World, the sins of the Borgias?" He would probably have answered that he had contemplated none of these things, but had concerned himself with certain arrangements of lines and masses, and with new and curious colour-harmonies of blue and green.[6]

Wilde then speaks of "criticism of the highest kind," in effect ideological criticism:

> It does not confine itself . . . to discovering the real intention of the artist and accepting that as final. And in this it is right, for the meaning of any beautiful created thing is, at least, as much in the soul of him who looks at it, as it was in his soul who wrought it. Nay, it is rather the beholder who lends to the beautiful thing its myriad meanings, and makes it marvellous for us, and sets it in some new relation to the age, so that it becomes a vital portion of our lives, and a symbol of what we pray for, or perhaps of what, having prayed for, we fear that we may receive.[7]

That is the whole point of ideological criticism: to set art "in some new relation to the age, so that it becomes a vital portion of our lives." The promotional critic confirms the art as given, but has no sense, except the loosest, that it is given in terms of an "age"—constitutes and demonstrates something called an age. The promotional critic sees only a succession of events rather than the structure they make—the structure of a whole historical world. For all the relativity of its wholeness or unity, this life-world alone gives the events that constitute it the power to signify, making them something more than facts that inertly exist. The promotional critic does not really make art "a vital portion of our lives," only an ephemeral sensation—one among many sensations, an efficient source of liveliness and interest in a world of momentary effects. Only ideological analysis of the work of art gives it a chance to prove itself more enduringly—to sustain itself beyond its own initial effect, to be interesting beyond its usual attention-getting ways.

Case histories make the point decisively: artists who win recognition do so because of the ideological content of their art, and the ideological expectations it generates. If their art did not make ideological overtures to an audience, it would be invisible—its ideological aspect is the core of its appeal. The critical reception of Altdorfer and van Gogh, two established artists, and Cubism and Abstract Expressionism, two major movements, demonstrates this point precisely. Neither artist nor movement would have become established and "major" if they had not fallen within a certain ideological context.

Criticism of Altdorfer's art is inseparable from nationalism and Christianity, ideologies which have dominated general thinking about art and society for centuries. Altdorfer's art was regarded as of dubious importance until the idea of a united Germany became viable. While his art was always identified as German, it was not until the nineteenth century, when to be German meant to be a member of a strong nation, that his art was regarded as of major importance. Altdorfer came into his own as part of the process of political clarification of Germany. His art served German ideology by seeming to embody it, or at least anticipate it. Since

this ideology involved a Romantic Christian component—a conception of art as a mediator of "infinity or universality, moral or ethical consciousness," and as such having a "redemptive mission"[8]—Altdorfer's art came to be of value to German romantic thinking. Nature was interpreted as the image of redemptive infinity in his art, making it, from the romantic point of view, the exemplary Christian German art.

Friedrich Schlegel's analysis of Altdorfer's *Battle of Alexander* was the critical turning point in Altdorfer's reputation. It is noteworthy that Schlegel's positive evaluation of Altdorfer dialectically returns to and elaborates the original, naive appreciation of his art as *lustig*. When, in 1644, more than a century after Altdorfer's death, the chronicler Raselius described Altdorfer's work as *lustig*, the term did not mean "amusing" or "funny" as it does today, but rather, following Luther's usage, "a positive frame of mind." More concretely, it connoted "particularly lush, green, pleasant landscape or countryside." Aventius used the term to differentiate "fertile, hospitable soils from rough, infertile terrains . . . to describe the paradisical beauty of a garden 'as if God Himself had planted it'."[9] The language is of course appropriate to the leading master of the Danube School.

Schlegel's refinement and expansion of this early conception of Altdorfer's art offer a paradigm of critical reception in general. A "successful" art is at first spontaneously appreciated by random individuals, "amateurs" who are thought of as knowing nothing about and having nothing to do with art. Such spontaneous popular acclaim is then eclipsed by those in the know, connoisseurs such as Georg Sulzer. In 1792 he rejected Altdorfer and the whole "so-called German 'school' "—too "diverse" to be significant for Sulzer—for the more unified and humanistic Italian school. Finally, the art is re-viewed and revived through an explicitly ideological approach, which for all its sophistication incorporates the original naive—nonideological—appreciation.

This logic of criticism works itself out time and again, as if it were an essential paradigm of consciousness. For example, van Gogh's art was at first naively appreciated as the sign of a "saint" or "seeker," with little explanation of how this was so. Eventually it came to be respected as a demonstration of what one critic called "imaginative passion," a complex conception of temperament or emotion as the ground of creative individuality, artistic authenticity. Strong emotion in effect became ideological, being regarded as the subjective side of committed artistic labor, and van Gogh's "seeking" became an important early demonstration of such "Expressionistic" emotion. But there was a negative interlude in the criticism of van Gogh—a rejection of his art which meant a rejection of the ideology that carried it—epitomized by a view of him as a "sick

genius,'' whose art did not do justice to his genius just by reason of his ''excess'' of emotion.[10] While generally regarded as no longer appropriate to an understanding of van Gogh's art, this point of view is still very much alive in certain critics, e.g., Clement Greenberg.

On the whole, for an art to endure it must first be popularly received, then critically rejected, and finally ideologically acclaimed. This is particularly the case in the Modern period. The crossing of class and professional barriers is crucial in this process. The new art must first show that it has democratic appeal—appeal to those generally unschooled in art or not professionally interested in it. Then it must suffer a period of aristocratic rejection—rejection by those schooled in an accepted and thereby ''traditional'' art, those with a vested interest in a known art, and concerned to protect it at all costs. Finally, it is reconsidered by what might be called an intellectual aristocracy, knowledgeable about respectable past art but with no vested interest in it—a lack of total commitment reflecting the classlessness of the intellectual, at least in the sense of having no abiding interest or great belief in the class he or she belongs to. Because of this classlessness, the intellectual is open or speculative, and conceptually gambles on the new art by subsuming it in ideological interests greater than itself.

The new art becomes the illustration of a new mentality, losing uniqueness but gaining scope or influence. It becomes the sign of an idea rather than a thing in itself. Crucial to this entire process is the force of the art's rejection. It is likely to be acclaimed all the more vigorously if it has first been rejected as seriously inadequate. The intermediate step—it must compare very unfavorably to respectable art to the extent that it seems to set up a whole new standard of art (not simply seem mediocre, i.e., not up to the standards of respectable art)—is absolutely necessary. It is a reminder that the art, while it shows signs of greatness, falls short of it—until it is incorporated in some ideology.

This sense of falling short, as if by reason of some innate flaw—which later comes to be interpreted as the sign of an emerging ideology—was particularly evident in the response to Cubism. This style was initially regarded with barely disguised contempt by other artists, e.g., Matisse, and even such supporters as Apollinaire regarded it as a ''bizarre manifestation.'' At the same time, its shocking ''expressiveness'' was admired—or at least widely remarked—just because it was incomprehensibly new. This view became the stepping stone to a conception of Cubism as radical—perhaps more radical than it in fact was. It became apotheosized as an ''absolute'' Realism, demonstrating as no other art did the modern sense of reality as time-bound as well as space-bound, with the

sense of space determined by the sense of time. Conceived ideologically—and it almost had to be viewed as flawed artistically to be conceived ideologically—Cubism not only became artistically significant, but acquired a generalized world-historical import. It acquired "absolute" historical value as a symbol of the emerging modern outlook.[11]

In general, both Cubism and Abstract Expressionism met with less hostility from the popular press than might have been expected. If nothing else, they were regarded as significant news, phenomenal sensations. In the art world itself, Abstract Expressionism, initially understood as "A Problem for Critics"—the title of a 1945 exhibition organized by Howard Putzel inviting critics to name the new movement—was naively regarded as more important for its revelation of "creative intention than its material result," i.e., as seriously flawed in execution if not in conception. If this view had not existed, Abstract Expressionism might never have come to be seriously regarded in terms of depth psychology, or as a summary of the tradition of the new (an art history ideology).[12]

Inseparable from the recognition of the sensational novelty of Cubism and Abstract Expressionism was the "recognition" of their flawed character, by traditional artistic standards. This was epitomized by a sense of them as "bizarre"—the "adulatory" term of the first phase of appreciation. New, "avant-garde" art is necessarily experienced not simply as novel, but as flawed in its novelty. This is the first phase of the pride it is allowed to take in itself. Only then, as if in reaction to this "gut" response, can it be ideologically affirmed as world-historical. Upsetting so many people, it seems to create a new world of perception, initiating a new history of thought. Put another way, a new art must be experienced as uncategorizable and as such anti-social—the two go hand in hand—for it finally to make fresh ideological sense, i.e., seem to possess a new point of view. The difficulty in placing the art is a necessary part of its mystique; slow to come into public view, it seems all the more important when it does. Such difficulty and slowness are partial proof of its advanced character. To appear ideologically advanced the art had to seem arbitrary—this arbitrariness is part of its dynamic character.

New art seems flawed because no clear reason for its difference from other art can be seen: it is not understood as a logical development from earlier art and so it seems radically novel if not radically meaningful. That comes later. "Arbitrariness" has, of course, been the curse hurled at every important new art since Manet, whose arbitrariness involved, among other things, introducing jarringly contemporary figures into a classic order (*Déjeuner sur l'herbe*). By being contradictory it became at once sensational or shocking, and flawed. The label of arbitrariness is still in use, although it hardly seems to have any adhesive power. For example,

Greenberg has used it to dismiss Pop art and a host of other kinds of art, rudely regarded as "Novelty Art," i.e., as arbitrary art. It seems a pity that almost no new art that emerges these days is seriously regarded as arbitrary, for it is denied the period of heroic suffering and scandalous exile necessary to make it successful in the long run. In fact, the run seems shorter and shorter—the meaning of success has changed, and with it the logic of critical reception. Promotional criticism in fact signals and objectifies the change.

Promotional criticism must be understood against the background of earlier criticism. A three-way comparison can be set up, between the horizons of expectation of important art critics, of important writers whom we do not usually think of as art critics but who had highly developed expectations from art, and of the first promotional critics. I include in the first group, in addition to Wilde, Charles Baudelaire, Felix Fénéon, Walter Pater, John Ruskin, and Roger Fry. The second group comprises Champfleury and Paul Claudel. The final group contains the New York art critics Royal Cortissoz, James Gibbons Huneker, and Elizabeth Luther Cary. Promotional critics, even those unconsciously and incipiently promotional, do poor battle with new art, by reason of their old-fashioned weapons. While the only justification for promotional critics is as frontline infantry absorbing the shock of encounter with new art, they are generally equipped with no more than a swashbuckling sense of style (a rusty old sword in an age of throwers of ideological bombs) or else are experts in hand-to-hand connoisseur combat (in an age when radioactive material can be brilliantly manipulated by ingenious concepts).
 Baudelaire, Fénéon, Pater, Ruskin, and Fry are important examples of what Joan Halperin calls the "poet-translator." Acknowledging that "there is a lingering aura of inferiority, of drudge-work attached to" art criticism, and that it lacks "reputation as an established literary genre," she points out that nonetheless "some of the greatest writers of modern times, from Goethe to Proust, . . . have tried their hand at it," viewing it as a kind of "poetic" activity. Halperin uses poetic "in the broadest sense: the re-creation of an experience which the eye perceives and which touches the soul." Such a re-creation is in effect a "translation" of experience. As Halperin says, her "use of the word 'translate' is a careful one, based on Baudelaire's usage," and has nothing to do with "linguistic translation" or the translation "of a picture into words." These are false metaphors for poetic translation. "What the critic does is to translate his *experience* of the picture into words, just as the painter has translated his experience of a scene, a feeling, or an abstract vision, into a painting." "Translator" and "poet" were one and the same for Baudelaire. One

could be a "painter-poet," as he called Delacroix, or a "translator," as he described Constantin Guys, or a "critic-poet," as he described himself. He regarded all three as "creative artists."[13]

What is crucial in poetic translation—what is the critical element in it—is the discovery, isolation and analysis of the ideological import of the experience poetically translated. Poetic translation is a search for the universal ideology that informs the novel experience; unless the ideology emerges from the individual experience the poetic translation is unsuccessful, uncritical. The best art—and criticism—seems a synthesis of experience and ideology: successful art expresses ideology, however indirectly; indeed, ideology permeates art, giving it subtle coherence. The failure of much criticism shows that it is not easy to articulate the ideology that motivates an art, the mentality that makes it substantive. Similarly, the failure of much art indicates that it is difficult to be ideologically motivated, if easy to make stylish art.

Baudelaire's sense of modern life, Fénéon's anarchistic dandyism (and dandyish anarchism), Pater's cult of autonomous sensation, Ruskin's outlook on nature, and Fry's conception of art as an autonomous enterprise only incidentally in relation to history, are examples of receiving ideologies that establish a relatively clear and coherent horizon of expectation from art.[14] This horizon is unfolded in the course of the critic's poetic translation of the art he engages. In a sense, the revelation of the critic's horizon of expectation is the poetic element in the translation, as the art is revealed through *its* revelation of the critic's expectations.

In Champfleury and Claudel, ideology is overstated—overdetermines artistic significance, and in general finds only one kind of significance in the art experience. The receiving ideology is not understood in the course of analyzing the experience, but rather is given a priori; experience is deduced, as it were, from absolute ideology. Champfleury with his realism and Claudel with his Christianity offer two kinds of Procrustean bed, the one unrelentingly profane, the other ruthlessly sacred. Every "poetic" translation of experience must fit into one or the other bed to make sense. I put "poetic" in quotation marks here because there is obviously little poetry in the fit—the expectation of conformity to an ordained ideology. Instead, Champfleury and Claudel offer in effect predetermined prose translations of experience—the prosaic reduction of it to the matter-of-fact exemplification of the one truly universal ideology. For Champfleury, the "profane" realist must subordinate his imagination to his power of observation, issuing in *"le style plat"* (the flat style). From Claudel's point of view, "in forsaking God, painting like the other arts evolves towards nothingness (*le néant*)."

Both are sufficiently inconsistent, however, to admire art alien to their overdefined ideologies, particularly Claudel, with his respect for Oriental art. (It is interesting to note the way tough ideologues "soften" when it comes to art, perhaps only because it does not count for much in the larger struggle between competing ideologies. The stakes in art are not so high as total domination of a population's outlook. And yet this weakness for art that may be ideologically déclassé tells us something about the power of art in general—the way it can outdistance even the most absolute belief system. The freedom from ideology this implies is itself perhaps the most profound ideology art offers, if the implicit belief that no belief system is absolute or final can itself be understood as "ideological.") Nonetheless, neither Champfleury nor Claudel relinquishes his ideology's tight hold on his basic experience of art. Claudel basing his admiration for Oriental art on its religious expressivity, shows that the exception proves the rule—rationalizes all exceptions in ideological terms.

On the whole, such ideologues use criticism to circle back to a predetermined essence of art, which then is rooted out, so to speak, and elevated as independent of the art, with the art ultimately becoming beside the point of the universal ideology. The contribution of the art is that of a protective shell to a kernel. For Champfleury and Claudel it is the effort of consciousness to become enlightened—to overcome resistance to the "truth"—that is more important than any effort to understand art. Indeed, the fact that the truth may be presented artistically signifies only the subtlest resistance to it; for these writers, the protective shell of art is in fact an obstacle to unvarnished perception of truth. If the truth is discovered in art, then it, not the art, matters. For Champfleury and Claudel, the artless presentation of the truth alone matters in the long run.

In the cases of Baudelaire, Fénéon, Pater, Ruskin, and Fry, on the other hand, *art* is the truth. Less doctrinaire and certain of themselves than Champfleury and Claudel, they find it hard to separate the truth from its vehicle, and view the truth as less than absolute—as more a matter of relative orientation than dogmatically given. For Champfleury and Claudel, ideology descends from the horizon of expectation like a *deus ex machina*, resolving or ordering all experience. For the other critics noted, the receiving ideology is less firmly established, more playfully present— dangerously beckoning from the art like a siren song promising the pleasure of full understanding of life as well as art, yet still the expression and instrument of an uncertain desire. For Champfleury and Claudel, desire—the desire implicit in their ideology—is not only certain, but makes art in contrast seem an uncertain, infirm revelation of ideological commitment. They carry ideological analysis to an extreme which, while it

stops short of reducing art to absurdity, finally trivializes it as something not worth reckoning with.[15]

Finally, there are the first promotional critics, promotional despite their lofty conception of criticism—which is not, however, sufficiently lofty to let them view it as poetic translation. Nor is art for them anything more than "culture," so full of abstract significance that it is finally an empty experience. Royal Cortissoz believed that art criticism was "the domain of the cultured man," where culture meant "the best that had been thought and said in the world."[16] This did not include Modern art. Vacuous prejudice is operational in this concept of culture, for there is no sense of its use and purpose. Culture is what is valued by an elite as the mirror of its own elitism. It is the best that can be possessed, as though to possess something—to make it one's private property—was the most significant relationship one could have with it. Cortissoz, the long-time art critic of the New York *Daily Tribune* (from 1891 to 1948), had no ideological expectations from art, apart from the vague and pretentious expectation that it be "the best." This is not a true horizon of expectation—a *receiving* ideology—since it is not so much an analytic approach to art as an imperious overvaluation of it, in line with a hierarchical conception of culture.

Similarly, James Gibbons Huneker, art critic for the New York *Sun* from 1906 to 1912 and freelance art critic until his death in 1921, while more receptive to Modern art than Cortissoz, still had no clear ideological conception of it. It was simply an adventure, "one of the few thrills that life holds."[17] The "sincerity" of such modern artists as Picasso was good enough for Huneker; the ideology of their art hardly interested him. Faith in culture and in good intentions was enough to generate faith in art for Cortissoz and Huneker, but they really had no idea what the art they had faith in was about.

The same can be said about Elizabeth Luther Cary, first "Art Editor" of the *New York Times,* a position she held from 1908 to 1936. She, too, had a "random," keep-the-faith relationship to art, leading her to make a number of "random studies" of it, as she called a collection of her essays. Like Cortissoz, she regarded Matthew Arnold as her "spiritual ancestor," and endorsed a generalized version of his conception of culture, strongly emphasizing its moral purpose. With Arnold, she believed that "the exemplary critic . . . displayed 'dis-interestedness.' "[18] This obviously shut her out from ideological awareness of art, which for her was instead simply the object of the "free play of the mind." Her criticism tended to be blandly descriptive and mildly permissive, especially when it came to "the frame of mind called Modernism," which she found

incomprehensible. Like Cortissoz and Huneker, she saw herself as a defender of "civilization"—for her this was what criticism was finally about. In practice this meant a defense of familiar values rather than an exploration of new ones. "I detest and cannot understand the logic of primitive symbols used by the sophisticated person of today, not because the symbols are primitive but because we are not."[19] Such critics offer not so much poetic translations of art as prosaic versions of their own unexamined presuppositions, which tend to run to class prejudices.

Criticism, then, has a logic which, while not absolute, gives it a structure. To ignore or be blind to any part of that logic is to become a promotional critic. Such a critic can be of the old-fashioned kind just discussed, with a naive and foolish faith in culture as a defense against barbarism— culture as a class prejudice and the corset of the civilized. Or, in these "post-culture," media-saturated days, in which the media is the culture, the promotional critic is likely to be an "objective" reporter, managing facts to leave a certain impression. Whatever the case, the promotional critic involuntarily submits to the media's purpose of supplying and managing sensations. The media tends to be a place of fast fixes, with only a limited place for the laborious—often incompletely realized and always poetically inconclusive—translation of the ideology of art or culture.

The poetic translation of art—particularly a translation which finds the ideology of art less in art history and the art world than in the lifeworld or world-historical sphere—is minimally tolerated in the fast-paced world of media art politics, which stars certain sensations rather than others, and in general tends to offer an overblown sense of art, with little sense of what is nourishing in it. This will perhaps change when the ideology of promotion—the media—is itself poetically translated. This is a task truly worthy of the art critic, for the media are the subtlest art form in existence today. Any art that can inflate or deflate so readily and brilliantly as the media—that can make the big little and the little big, exploiting and absolutizing the relativity of the age so that we seem the victim of our own image and lose the very idea of a perspective on where we are—is a truly major art form deserving a truly great ideological analysis.

Cortissoz, Huneker, and Cary were the first unwitting victims of the media they worked for, which began to relativize the culture they were interested in protecting—a culture which itself was becoming increasingly relative. Today the media are self-consciously relative, cultivating relativism as a supposedly democratic strategy guaranteeing pluralism, but in fact acknowledging the difficulty of achieving any clear location in a relative situation. Such tender-minded critics as Cortissoz, Huneker,

and Cary have been replaced by more tough-minded informational or matter-of-fact critics, yet they too are deceived, since their obsession with the facts of art does nothing to change the relativity of the situation and value of the art they are informed about.

Being informed about art does not alleviate the relativity of its condition and meaning—does not really concretely ground it. All factual information about a particular art tends to have the effect of promoting it as more than relative, as stable in its condition and meaning—without any guarantee that such promotion will in fact make it more particular, or give it general credibility. In a sense, to promote an art is a way of *assuming* that its value is more than relative, as if to give it extra visibility were to become absolutely clear about it. And yet, as we realize from the increased reflection of art in the media today, to promote an art is only to make its condition *more* relative. It is to test its meaningfulness on a scale of values, in terms of kinds of significance, that the art may not be equal to. The art may not be able to carry the burden of meaning promotional exposure makes it subject to. Unwilling or unable to sustain greater and greater loads of imputed significance, it does not seem enduring.

In a sense, promotional criticism, establishing an ever more sophisticated relativism, does nothing more than make completely explicit and epitomize the appeal to relativism, masquerading as intellectual buffoonery, that is typical of much Modern art. For example, Duchamp can be regarded as the first promotional artist, as in his "promotion" of ready-mades as art. Duchamp himself made explicit the relativism that has implicitly motivated Modern art from Impressionism on, even from Courbet's Realism on. Such relativism was already evident in the journalistic immediacy Courbet gave to the figures in the *Funeral at Ornans*, and that Manet gave to the Figures in *Déjeuner sur l'herbe*. The inflated visibility of these figures destroyed the symbolic potential of the scene, or rather, undermined an already operational, traditional symbolic meaning. The disruption of symbolic potential by emphatic factuality gives the image relative meaning—dislocates its meaning so completely that it seems thoroughly indecisive. This may, initially, endear the image to the modern sensibility, preoccupied with the power of ambiguity in a world with no absolutes, but the indecisiveness finally works against the image. It drains it of all binding meaning, into a relative condition of potential significance which is never actualized. Ambiguity becomes a sign of the decay of the image's power rather than a sign of its continued vitality. Stuck in its ambiguity, taking a stand nowhere, the image fades into relative insignificance—playfully tempts us with significance, but, never clearly delivering any, becomes banal, and, indeed, truly matter of fact.

The intrusive unassimilated contemporaneity of Manet's figures tells us everything we need to know about the ideology of promotion. They exist as much to destroy the process of sedimentation by which experience is converted into symbolic value (acquires ''depth'')—the process by which symbolic meanings spontaneously precipitate out of experience—as to affirm and absolutize the readymade visibility of the contemporary world so that it seems inescapable and immortal. Insistence on complete contemporaneity—if necessary involving the contemporizing of the future (as in science fiction) as well as the past—is crucial to the promotional attitude, and is exactly what generates, in its wake, the haunting phantom of relativity, that at first is enlivening but is finally debilitating, and strips the promoted image of all meaning. Promotion, and the media which are its instruments, is desublimating—what Marcuse calls repressive desublimation—because it insists that everything be immediate in its impact, completely up front in its effect. (One might note the use of media source material such as newspapers—e.g., in Cubist collages—to give art an up-front, contemporary look. This whimsical, specious contemporaneity in the end undermines the art's impact by making it dependent on an ever-receding, increasingly relative present.) In general, the unsublime, utterly secular contemporaneity and visibility of the media is the true source of its allure.

While ultimately banal because unsymbolic, the artful immediacy of the promotional media promises us the infinite freedom of dealing with relative fact. It is easy to equate relativity with freedom, especially with freedom from ideology—and finally from a responsible critical awareness. But media relativity is a siren song leading one to crack up on the rocks of reality, after first making one mad with desire for reality. That the media have such compelling power shows them to be great art, altogether beyond the issue of high and low, avant-garde or kitsch art. Like Melville's confidence man, the promotional critic shows himself to be a great artist, for we cannot distinguish him from his disguises—we cannot distinguish his voice from that of the artists he promotes.

Notes

1. Karl Mannheim, ''The Democratization of Culture,'' *From Karl Mannheim*, ed. Kurt H. Wolff (New York, 1971), pp. 271–346.

2. Ulrich Klein, ''Rezeption,'' *Handlexikon der Literaturwissenschaft* (1976): 409.

3. Martin Warnke, Introduction to *Das Kunstwerk zwischen Wissenschaft und Weltanschauung*, 1970. Proceedings of a conference on *Rezeptionsgeschichte* at the twelfth Congress of German art historians (Cologne).

4. See Klein, "Rezeption," p. 412.

5. This summary of Benjamin's position is from Reinhild Janzen, *Albrecht Altdorfer: Four Centuries of Criticism* (Ann Arbor: UMI Research Press, 1980), p. 6. Like the other publications of the UMI Research Press cited here, this book is one of several *Studies in Fine Arts: Criticism* edited by me.

6. Oscar Wilde, "The Artist as Critic," *Intentions* (New York, 1912), pp. 141–42.

7. Ibid., pp. 142–43.

8. Janzen, *Albrecht Altdorfer*, p. 45.

9. Ibid., pp. 36–37.

10. Carol Zemel, *The Formation of a Legend: Van Gogh Criticism* (Ann Arbor: UMI Research Press, 1980).

11. See Lynn Gamwell, *Cubist Criticism* (Ann Arbor: UMI Research Press, 1980).

12. See Stephen Foster, *The Critics of Abstract Expressionism* (Ann Arbor: UMI Research Press, 1980).

13. Joan Halperin, *Félix Fénéon and the Language of Art Criticism* (Ann Arbor: UMI Research Press, 1980).

14. See Lee Johnson, *The Metaphor of Painting: Essays on Baudelaire, Ruskin, Proust, and Pater* (Ann Arbor: UMI Research Press, 1980) and Jacqueline Falkenheim, *Roger Fry and the Beginnings of Formalist Art Criticism* (Ann Arbor: UMI Research Press,1980).

15. See David Flanary, *Champfleury: The Realist Writer as Art Critic* (Ann Arbor: UMI Research Press, 1980) and Lynne Gelber, *In/Stability: The Shape and Space of Claudel's Art Criticism* (Ann Arbor: UMI Research Press, 1980).

16. Arlene Olson, *Art Critics and the Avant-Garde: New York, 1900–1913* (Ann Arbor: UMI Research Press, 1980), p. 54.

17. Ibid., p. 92.

18. Ibid., p. 150.

19. Ibid., p. 175.

Avant-Garde and Audience

[It is] a risky business [to send a picture] out into the world. How often it must be impaired by the eyes of the unfeeling and the cruelty of the impotent who would extend their affliction universally!
Mark Rothko

The history of advanced art is full of remarks similar to the above. In fact, they seem necessary to its self-consciousness—crucial to its sense of being "advanced." In the same vein of alienation, but even more aggressively, we have Adolph Gottlieb's generalization that artists are "at war with society," which is why they suffer from "social neglect" and "the inability to make a living." This goes hand in hand with Gottlieb's assertion that "abstraction enrages [the average man] because it makes him feel inferior. And he *is* inferior." Even more angrily, Gottlieb remarks: "I'd like more status than I have now, but not at the cost of closing the gap between artist and public. I'd like to widen it!" Are these simply local, parochial remarks, based on the situation of Abstract Expressionism at an early, bad moment in its history, when it was struggling for acceptance? But why would it want to be accepted by "average people," supposedly inherently inferior in intellectual terms? The issue, clearly, is a double bind, in which the avant-garde artist at once wants recognition but does not want it from those who are not the ideal audience. Which raises the question as to whether there is any such creature—whether the public can ever be other than the great, raging, ignorant beast that Plato regarded it to be in the *Republic*—and whether the artist, by seeming to posit an impossibly perfect audience, really wants any audience.

At a time when avant-garde art seems to have become advanced entertainment and claims for criticality are packaged as "strategy"—in media terms—does it still make sense to assume the old antagonism between the avant-garde and the idea of audience, their mutual ambivalence?

This article originally appeared in *Artforum* (December 1982).

Doesn't the media dependence on an increasing amount of new art suggest that the audience's expectations have actually become part of the art? At a time when claims of being advanced and critical are accompanied by media-wise presentations, is there any authenticity left to the concept of an avant-garde criticality that is not bound to the expectations of its audience yet still has the power to move the audience to self-doubt? Does it still make sense that an avant-garde artist, by virtue of the uncertainty of his or her right to exist, may be able to question the audience's certainty about its "natural" right to exist? I think so. The minimum meaning of criticality is the Joycean refusal to serve; "there is some s. I won't eat," as the hero of an e. e. cummings poem says. It still makes sense to refuse to serve the media, although it may be hard to find ways to do so as the media become increasingly sophisticated, fully realizing their insatiable appetite. The key meaning of avant-garde criticality from the first moment of its self-consciousness was resistance to the values of the public—whether in perception or attitude, ideology or behavior—in the name of shaping its self-consciousness. Avant-garde criticality is a form of civil disobedience in the face of an assumed consensus of values, an assumed oneness in world view. Its aim is to force the public into a position of conscience, to make it self-reflexive—to make it discover its own discontent. Freud said all psychoanalysis began in self-analysis; avant-garde criticality carries this truism to a dangerous extreme, in which the self analyzed seems to disintegrate under the pressure of the self-analysis, and can be reconstituted only in the terms of its own alienation—which are the source of its secret life. (Thus the label "experimental" is applied to the products of advanced criticality, for they offer no resolution for their analysis. They leave the fragments of a metaphoric self in a disintegrative state that, decoded, become the terms of self-consciousness—initiating self-renewal—of the spectator.) Avant-garde criticality thus constitutes a utopian challenge to the public, a challenge rooted in a Modern Realism—a Realism which recognizes the repressed, the neglected, the unreconciled, which for all its existence in a seeming limbo determines the functioning of the self.

The negative dialectic between avant-garde artist and audience discussed here, in its last, heroic efflorescence in the 1950s, seems to belong to an ancient, almost forgotten period, whose attitudes are alien to us. Then the lines between radical avant-garde and philistine bourgeois were clearly drawn; there was no democratic blurring of distinctions in the name of acceptance—under the illusion of "reaching the audience," shaping (and being shaped by) their consciousness. There was no mystique of cordial communality between radical artist and receptive public— no pretension that they were both conforming to the same thing

("enlightenment," which in practice turns out to be that old utilitarian-capitalist standby, enlightened self-interest).

We can gain some perspective on the question by comparing Rothko's sense of the audience's impotence with van Gogh's sense of the artist's impotence. "Society makes our existence wretchedly difficult at times, hence our impotence and the imperfection of our work. I believe that even Gauguin himself suffers greatly under it too, and cannot develop his powers, although it is in him to do it." Does Rothko presuppose the impotence of the audience in order to mask his own fear of artistic impotence? Is it risky to send a picture out into the world not because of the impotence of the world but because of the impotence of the picture? Van Gogh seems to suggest that art cannot have "that final force," as Paul Klee put it, unless "the people" are behind it—unless it has social support, in the deepest sense, in which it can be said to emerge from and bespeak a social matrix. Rothko, and the avant-garde artist in general, is afraid that his or her art might not do this—might not be able to articulate such a profound social understanding, and so it makes sense that society is attacked for the kind of banal meanings it expects. (In a sense, the shift from Abstract Expressionism to Pop art was a shift from an art of unclear social meaning to one whose social nature was all too clear, but which nonetheless did not clarify in the expected way the characteristic consciousness by which society codifies and structures reality. Fusing the viewpoints of Rothko and van Gogh, Pop art accepts—but with a good humor the earlier artists did not have—its own impotence or social ineffectuality, and that of the public, i.e., it acknowledges the public's own helplessness before and victimization by the media images that mean to bespeak its mentality.)

The question of the avant-garde artist's sense of a public can be focused even more precisely through a quotation from Umberto Eco's *Theory of Semiotics*: "Man is continuously making and re-making codes, but only insofar as other codes already exist. In the semiotic universe there are neither single protagonists nor charismatic prophets. Even prophets have to be socially *accepted* in order to be right; if not, they are wrong." In the semiotic universe that we all inhabit the artist is neither single protagonist nor charismatic prophet, but either right or wrong. And this does not depend entirely on the artist, but on the audience—representative of society as such—which accepts or rejects the work. For the traditional artist, this problem has no ultimate import; that artist's concern is with clarifying familiar codes, esthetically revitalizing them so that their integrity and significance become all the more evident and binding. The task of the traditional audience is to achieve, through the art, that contemplative recognition of codes accepted as truthful. But for the avant-garde artist who

means to transform familiar codes into unfamiliar art, which in turn bespeak a new mentality, to give the power of determining the art's significance to an audience is to forfeit the artist's very reason for being.

Avant-garde art tempts consciousness to transcend the smallness of its own systems—of the very idea of a final code—toward the grand appearance of reality freshly conceived. The history of avant-garde art demonstrates a restless, urgent, and forceful—but inconclusive—movement from code to code, each incompletely conceived, each seemingly preposterous at its inception, and yet each enlightening us about the power of consciousness itself, about the momentum it can generate both through itself and reactively. To put such a revolutionary art in the hands of a traditional audience is to misconceive profoundly the meaning of social acceptance. This audience wants stability, and it protects itself from discovering the relativity—and so potential loss—of its codes by dismissing avant-garde art as alternatively simply shocking obscure, or even boring. Avant-garde art is ultimately treated as not art—as a social curiosity; this gives it a certain social place, if not the most momentous one. And most avant-garde art protects itself from the audience by declaring it to be alien and ignorant, and even absurd in its attitudes—in its insistence on convention, its clinging to the familiar, and especially to its own expectations. Even when, as often occurs today, the avant-garde, institutionalized as an acceptable shock, a fashionable sensation, and even a necessary stimulus—but no more—to keep the blood circulating in the social system (enough disruption to prevent stagnation, but not enough to foster chaos), and even when the avant-garde opportunistically exploits this socially accepted nihilism, seemingly co-opting all other kinds of social revolution (avant-gardism becomes the one acceptable social revolution), a dysfunction in the social mentality has been revealed.

The separation of avant-garde art and audience remains, not only signaling a semiotic problem, but raising a more broadly social one. The relationship between art and the traditional audience is a paradigm for modern alienated social functioning, in which novel conceptions emerge, are either rejected or at best accepted in limited contexts, and are thereby neutralized. As a balance is struck between old and new codes—old and new art—the mechanism of social charisma is revealed as at once crucial for social functioning and as that which limits the social functioning of any new code or art. Avant-garde art is often trapped by its own charisma, which, whether negative or positive—whether based on the audience's rejection or acceptance of it—gives it its place, reducing its impact, making its message academic.

What kind of audience would mirror rather than oppose the advancing art—accept rather than reject the whole notion of an advance of art?

In contrast to the alien audience is the empathetic audience, which can, in Morris Graves's words, "reach pure consciousness" through the art. Much as, in Graves's words, "Pollock could dribble . . . his way into pure consciousness," so the empathetic audience can be "induce[d] . . . to a greater consciousness"—to a recognition of the "outrageous" power of consciousness to make and remake codes to reality, and the "outrageous" power art has of bespeaking the power of pure consciousness. This is the audience that believes in the myth of pure creativity—if not exactly ex nihile, then at least ex cathedra—that lies at the root of avant-gardism. For every maligned and alienated audience there is a mystified one over-confident in avant-garde art; both kinds of audience are necessary to the functioning of the avant-garde. The avant-garde needs to hypothesize an audience that can tap the limitless potential it posits for itself, as if to confirm its presence, much as the avant-garde needs to hypothesize an audience that cannot comprehend it, as if to make it all the more pressing—as if to inspire it all the more in its effort, in Mark Tobey's words, to "bring the intangible into the tangible." The avant-garde artist aims not to create a complete art—a completely codified style—but one that, in Tobey's words, does not seal "itself in one invention or one symbol like the walls of a tomb." The empathetic audience—what Duchamp described as the audience that would participate in the seance started by the artist-medium around a certain object and would complete its meaning, fully objectifying it—completes the art by discovering in it the audience's own sense of potentiality. Tobey and Duchamp remind one of Ludwig von Bertalanffy's observation that "all boundaries are ultimately dynamic"—exactly what the avant-garde means to demonstrate, and what it embodies in its conception of pure creativity or pure consciousness. Even spatial boundaries, von Bertalanffy writes, "exist only in naive observation."

In a sense traditional creativity means to confirm existing boundaries, to reinforce them with a vengeance in the name of social stability. The avant-garde point is that creativity—art—is an attempt to conceive new intentions, embodied in new symbols or codes, toward reality. This enterprise is possible only with the recognition—gratuitous and absurd from the viewpoint of the old world contained by the old boundaries—of the precariousness of old symbols and codes. But the key point from the standpoint of the empathetic audience is that the incompleteness of avant-garde art—the fact that the art does not completely codify a new world, seal it behind fortified boundaries, mask it with hermetic, impenetrable symbols—arouses the audience to a recognition of its own incompleteness, and so its own potentialities, which crystalize, come to consciousness—though in disguised, symbolic form—in response to the avant-garde art.

Rico Lebrun succinctly epitomizes avant-garde creativity when he calls it thinking with "a grandiose arbitrariness," which involves being "fugitives from the obvious and tangible." (For Lebrun, this means "writing the obscure diary of a twisted nerve center.") Franz Kline conveys the same sense of discovering the dynamic character of boundaries, to the point of precariousness, when he speaks of not having "a definite sense of procedure" in painting. And David Smith echoes Lebrun when he speaks of "an arrogant independence to create" as his "only motivation." The heroically creative artist—transcending, violating boundaries— needs the empathetic audience to bespeak his or her own sense of potential, as well as to counteract the sense of the alien audience, lurking in the wings of society, demanding that the artist acknowledge and conform to known boundaries. The avant-garde artist simultaneously imagines an accepting and a rejecting audience, both the reflections of the artist's own narcissistic fear of the loss of creativity, and uncertain sense of potency.

The real audience, of course, is the truly critical audience—the audience which neither unequivocally accepts nor unequivocally rejects an art, and questions all myths it invents in its defense as well as interpretations that predispose it to a fixed meaning. This is in contrast to the nominally critical audience that accepts or rejects an art on the basis of taste, including a taste for an accepted mode of interpretation; and that above all leaves an art's claims about itself unexamined. The anti-criticism stance of much avant-garde art is part of a reluctance to subject itself to a critical witness who refuses either to believe or disbelieve in it, but wants to understand its social role as well as its aesthetic contribution. This real critic is read away as irrelevant by the artist because the avant-garde critic makes clear to the artist his or her own uncertainty, and the general difficulty of remaking codes. The avant-garde critic does not provide the avant-garde artist with the line of descent which may be secretly desired— legitimacy—which is why artists, even avant-garde artists, prefer historians to critics. Instead the critic makes the artist all the more aware of the contingency of the art. The avant-garde critic makes the avant-garde artist aware that art, along with everything else, inhabits (in Eco's phrase) a semiotic universe, and in which the artist is neither a single protagonist nor a charismatic prophet. By demystifying the art the avant-garde critic denies it either an alien or an empathetic audience, and in so doing forces it away from its narcissistic self-definition toward a sense of its social limits. Ultimately, this should reinforce the sense of creative purpose; initially, though, it is taken as an arbitrary, profane intervention in that creative purpose. For the myth of pure creativity does not understand creativity as a form of intervention—so determined is it by its own underlying desire

to be accepted in its unacceptibility—and so it does not understand criticality.

The avant-garde critic's role, then, is essentially obscene, in the etymological sense of the term: to go behind the scene of the art. (The traditional critic helps create the scene.) This, too, means that the critic is not a satisfactory audience, which is not supposed to go backstage. The best audience remains up front, where it thinks all the action is. It is not guaranteed that in the end the avant-garde critic will see eye to eye with the artist. This is as it should be, for one of the meanings of avant-gardist—one of the things it means to demonstrate—is that the idea of a fixed audience is absurd in a situation in which there is a pursuit of potentialities, a desperate effort to demonstrate the openness of the world through an openness to the world—to show that there is not only no closure created by the codes used to comprehend but also no possibility of any foreclosure on any world by any boundary, since every boundary is seen as imposed.

For the earlier artists discussed here, the line between the audience and themselves was clear, if complex. Their agony about the mediation and reception—the recognition, in the deepest sense—of their art is part of their refusal to serve the audience's self-idealizing aims, that self-deception it thinks "culture" offers. For contemporary artists who have spent the last two decades obsessed with the question of media—some of them have become media entertainers of sorts—the issue of art and its publics has become overwhelming in its uncertainty because they want to be credible as avant-garde or critical and at the same time to serve and be loved by an audience. They are trapped by a world for which the media serve as an instrument for "romantically" expanding the self, revitalizing it by shocks to its sensibility, kicks to its constitution, experimental tricks played on its expectations.

At stake in the possible reconciliation between avant-garde artist and audience is the meaning and use of art: whether it obscures reality and discourages painful self-consciousness by entertaining its audience with idealism, or instead reveals reality to a resistant audience. The avant-garde audience that does not resist this revelation is at best a self-invented, shifting one, always as it were improvising itself, rather than one that assumes some opportunistic reciprocity between itself and the art. Speaking of what may paradoxically look to us like a lost paradise of alienation between avant-garde artists and audience, Rico Lebrun remarked, "if we artists are to survive this period at all—we will survive as spokesmen, never again as entertainers."

Collage: The Organizing Principle of Art in the Age of the Relativity of Art

The first part of the task is to define relativity for the purposes of this discussion; the second part is to bring it to bear on collage, conventionally described (if I may fall back on the dictionary) as "an agglomeration of fragments such as matchboxes, bus tickets, playing cards, pasted together and transposed, often with relating lines or color dabs, into an artistic composition of incongruous effect." The dictionary definition concludes with the statement: "It is a type of abstraction."[1] Note the emphasis on the following: agglomeration, fragments, transposition to an abstract plane, and incongruous effect. Collage composition does not cohere, and there is nothing inherent to it. It is the beginning—one might say, the model—for what has come to be called "junk art," being in a sense no more than an accumulation of the detritus of daily life in a composition that can only loosely be called a "synthesis." It implies an easy shift from the material of life to the material of art—the self-evidence of the relationship between the two. Decisions are involved in its creation—from the choice of material to the "composing" of the incongruous effect—but these seem secondary to the expectation of easy crossover between life and art, the easy "translatability" of the one into the other, with only minor artistic adjustments, represented in the dictionary definition by "relating lines or color dabs." However, these relational factors are crucial, for they complete the crossover. On them, as the formal confirmation of transposition, depends the success of the collage—its viability as a "structure" of relationships between fragments of material, and as a demonstration of the reversible relationship (the continuum) between life and art. The gathering together which collage is about becomes abstract and assumes the mantle of art only when token signs of art are

This article originally appeared in *Relativism in the Arts*, ed. by Betty J. Craige (Athens, Ga.: University of Georgia Press, 1983).

added to the mix; i.e., only when it is aestheticized by being "treated" (shall we say "purified"?) with the residue from a convention of art, traces that once signaled a full-fledged act of artistic creation. The artistic fragments refine the life fragments, giving them appeal to a more contemplative level of consciousness than is customary in everyday life, making them safely formal and aesthetically significant. "Laundered," the life fragments have—to use the critical term supposedly indicative of heightened aesthetic awareness—a "crispness" they did not have in life. This crispness is the sign of their autonomy, their new presence, ineffable as well as spontaneously eternal. The life fragments have been raised from a transient to an eternal present as painlessly as possible. The whole process is so patently a mockery of conventional conceptions of art-making—so summary a practice of the theory of art as imitation of nature—that it becomes hard to take collage seriously as art. It brings the whole idea of art into question, or else makes it seem a risky yet superficial venture.

At first glance, then, the collage approach to art—however much it is assumed to give familiar aesthetic results (whether it does or does not quickly becomes a matter of debate)—does not imply the most rigorous sense of art. This is where the idea of relativity becomes relevant; it accounts for that apparent lack of rigor and becomes a means of tracing its implications and finally of justifying it. The collage is only relatively, rather than absolutely, art. The word "only" signals the seeming sense of inadequacy of the collage in comparison to "real" art—the fall from aesthetic grace and decline in general status of art when it becomes all too obviously relative to life, and above all relative in itself, structurally indecisive or uncertain. It is thus no longer clearly autonomous or self-reliant, and when its relative condition is recognized as incurable, it is no longer self-evidently art. The collage seems adrift in a limbo that is neither life nor art, at least by the strictest standards. It seems to have lost its center of gravity, the clarity of its intention as art. It seems to be an agglomeration of literal fragments of life and art—the letter of both, without the spirit of either.

To speak of the relativity of art seems to reduce it to absurdity, to correlate with the methodological absurdity of transposing the important idea of relativity from the realm in which it originated to a realm in which it does not belong and in which it loses importance. To generalize the principle of relativity from physics to art—to exploit it beyond the boundaries of its customary usage—is inevitably to reduce art to pure physicality, for in its scientific usage relativity is descriptive of the workings of physical reality. To use it nonscientifically is to use it prescriptively, and so to misuse and falsify it. Relativity can only falsify what Baudelaire

called "artificial existence," the art which is one of the things in what Hannah Arendt calls the " 'artificial' world of things" created by work. If, as Arendt says, "the human condition of work is worldliness,"[2] and the world of the work of art is not the same as the material reality that physics investigates, then to reduce art to its physicality—literalness, as it is called by Modernism—is to deny its worldliness, and thereby to deny its identity as art. It is also to become estranged from the work that went into the making of art, as well as to disparage that work by characterizing it, presumptuously and prematurely, as merely physical.

But the idea of the relativity of art is not a reductionist strategy. On the contrary, it signals an expanded sense of the possibilities and effectiveness of art—an expanded sense of the meaning of creativity and of art's worldly role. This becomes clear when we recognize that relativity (and collage) presents itself as a solution to an epistemological rather than a physical problem: the problem of *conceiving* art, not simply the problem of receiving or perceiving what is already regarded as art. The latter unavoidably reflects the former, but is logically secondary to it. The philosophical generalization of relativity by Alfred North Whitehead makes its epistemological character self-evident, as does the self-conscious employment of the idea of relativity in psychological and sociological thinking, perhaps most obviously in the works of Jerome Kagan and Karl Mannheim. Here I will use their expanded conception of relativity— increasingly pertinent and analytically precise as it passes from metaphysical to psycho-social and historical meaning—as a scalpel to dissect collage, conceived as the case in point of the relativization of art, i.e., as *the* exemplification of the use and dominance of relativity in Modern art. The modern tendency to relativize both the structure and meaning of art self-consciously accelerates with collage. Relativity becomes the determinant of art's immanent structure and worldly consequence—the inescapably central factor in (to use Whitehead's language) the primordial and consequential nature of the work of art. From Cubist collage on, art can never be understood as anything but relative in its nature, and experience of it can never be anything but relative. In Kant's language, from the modern period on, it is a "transcendental illusion" to assume that art can be "complete" or absolute—that it can exist entirely in itself, on its own terms, rather than relative to those which can never be mistaken for art, which resist becoming those of art, and which are ostensibly indifferent to art, i.e., the terms in which life is given.

Whitehead defines the "principle of relativity" as follows: "That the potentiality for being an element in a real concrescence of many entities into one actuality, is the one general metaphysical character attaching to all entities, actual and nonactual; and that every item in its universe is

involved in each concrescence. In other words, it belongs to the nature of a 'being' that it is a potential for every 'becoming.' "[3] In the course of spelling out the implications of "the principle of universal relativity," Whitehead remarks that it "directly traverses Aristotle's dictum, '[A substance] is not present in a subject.' On the contrary, according to this principle an actual entity *is* present in other actual entities. In fact, if we allow for degrees of relevance, and for negligible relevance, we must say that every actual entity is present in every other actual entity."[4]

The ontological emphasis is Whitehead's; it amounts to an insistence on the actuality or presence of each entity in every other entity. That actuality is hardly demonstrable, at least on the level of everyday perception. Rather, it influences our expectations. We look for the variety of other entities in any one entity, rather than regarding that one entity as self-same—self-identified. It is identifiable in terms of its synthesis of other entities, each of which remains a possible part of itself. Collage is a demonstration of this process of the many becoming the one, with the one never fully resolved because of the many that continue to impinge upon it. Every entity is potentially relevant to every other entity's existence, is potentially a fragment in every other entity's existence. This is the relativistic message of collage: the keeping in play of the possibility of the entry of the many into the one, the fusion of the many into the one. Concrescence is, in effect, never finished, however much there may be the illusion of completeness. This is the poetry of becoming—the poetry of relativity—and it is what collage is about: the tentativeness of every unity of being because of the persistence of becoming, even when absolute entity-ness seems achieved.

The incongruous effect of the collage is based directly on its incompleteness, on the sense of perpetual becoming that animates it. It is always coming into being; it has never "been," as one can say of the more familiar, "absolute" type of art. It is always insistent yet porous, never resistant and substantive. Its parts always seem to be competing for a place in some unfinished scene, as if to finally give it the necessary accent that makes it complete. Yet nothing in the collage is necessary; each part is forever contending with every other, pushing every other part out of place, until the very idea of a place in an order becomes meaningless. Even the idea of displacement does not focus what is occurring in the collage. What counts is that it remains incompletely constituted, for all the fragments that constitute it. There is always something more that can be added to or taken away from its constitution, as if by some restless will. The collage seems unwilled, and yet it is willful. The collage is a metaphor of universal becoming, becoming that is arbitrary if self-conscious, as much a matter of blind momentum as directed process.

For Whitehead, becoming is finally directed by the "desire" of each entity to be itself by becoming more than itself, in a "decisive" way. Indeed, decision is the final step of concrescence for Whitehead. Decision is described in a subjective way as involving positive and negative prehensions, i.e., ap-prehensions of entities that seem relevant and irrelevant to one's becoming. The subject forming itself is not aimlessly adrift on a turbulent sea of becoming, but steers itself through this sea by *deciding* what might or might not be relevant to its being at any given moment of its becoming. Entities prehended positively become parts of the subject's actuality, "ingress"—to use another Whiteheadean term—into its existence, become constitutive of its concreteness.

Collage sums up, as it were, this process of assimilation: the tentativeness of being in the face of its own becoming, the uncertainty or ambiguity of the workings of becoming. Collage, for the first time in art, makes uncertainty a method of creation, apparent indeterminacy a procedure. Entities rejected for inclusion remain associated with the subject that chooses another kind of actuality, as the defining contour or fringe of that actuality. Collage—and we are talking about Cubist collage, as the first truly relativistic and self-conscious use of collage—is very much about these dark fringes, these absences, as well as about the positive presence of positively ap-prehended fragments. The informal fringe and the formal assertion of substance exist side by side in the collage, subtly mingling to generate its energy. This is a material togetherness, not simply a togetherness of signs, as formalist analysis—lately revived in semiotic terms—would have it.[5] That is, it has to do only secondarily with issues of representation and abstraction; primarily, it is about the establishment of a particular kind of artistic, subjective concreteness. The integration of substance and fringe may not give the kind of unity of being that is customarily regarded as grounding the work of art's necessity. It does, however, constitute a concretely becoming artistic subject which has its unity as much in the potentiality of its becoming as in the actuality of its presence.

This point is made clear when one recalls that, in his original definition of relativity, Whitehead remarked that "non-actual" as well as actual entities could be elements in a real concrescence. The "relating lines or color dabs" of the collage—the vestigial use of primary artistic constituents—are such nonactual (abstract) entities, signs of what Whitehead calls "eternal objects." Color is particularly remarked as such an object, as well as geometric form—always implicit in the use, even the most amorphous automatist use, of line. In collage we find abstract elements as material fragments—elements of a code of abstraction that no longer perform the abstractive function but exist as entities in their

own right. These fragments of art have equal status with fragments of life in the collage; they are as concrete, for the purposes of becoming, as life. They have no privileged position in the process of artistic becoming, just as the fragments of life (the traditional model of art) do not constitute a privileged source or root of art. There is no clear-cut, single ground of art in the collage: art is no longer either representational (an imitation of nature issuing in an illusion of life) or abstract (a formal construction issuing in a style). It is a creative, subjective choice of elements emblematic of becoming in general. The being of nature and the being of form lose their primacy in the subjective decisions of art, which can move freely between them to achieve its becoming. They unite in a dialectic of ap-prehension which is under subjective control. They are both subsumed in the actuality of the concrete work of art—"worked over" until they become art. The becoming of art is located not in life or style, but in the relativity of relations between them in a particular situation of concrescence. The collage replaces privilege with equivalence, definitions of artistic being with deconstructions of artistic becoming, unity with energy. The field of the work of art reveals itself more as determined by subjective work than as determined by a preconception of art as a certain kind of object, whether life-referencing or self-reflexive.

Let us get more particular, as a way of bringing the subjective character of the relativistic work of art to the fore—as a way of showing how the decisions that constitute the concrescence of a particular work of art are relative. Jerome Kagan, writing about "the need for more relativistic definitions of selected theoretical constructs" in psychology, asserts:

> "Relativistic" refers to a definition in which context and the state of the individual are part of the defining statement. Relativism does not preclude the development of operational definitions, but makes that task more difficult. Nineteenth-century physics viewed mass as an absolute value; twentieth-century physics made the definition of mass relative to the speed of light. Similarly, some of psychology's popular constructs have to be defined in relation to the state and belief structure of the organism, rather than in terms of an invariant set of external events. Closely related to this need is the suggestion that some of the energy devoted to a search for absolute stimulus characteristics of reinforcement be redirected to a search for the determinants of attention in the individual.[6]

What are the determinants of the artist's attention? Clearly, this question is more to the point of discovering the fundamentally relative situation of the work of art in its modern condition than are questions of subject matter and style—and than are inquiries as to what a truly modern subject matter and a truly modern style would be. There is no absolute definition of modern; "modern" in fact means this absence of or active

indifference to absoluteness. No subject matter or style is, once and for all, modern. Only the artist's living attention is modern; only in exercising his powers of ap-prehension is he up to date. By its seeming indifference to the fragments that constitute it—conveyed by the seemingly random way in which those fragments are gathered together—the collage forces us to turn from the fragments to the attention that selected them, the individuality they acquire by being brought together by a particular kind of attention. They themselves, simply by being fragments, exist in attenuated form as stimuli—but never with any absoluteness, only relative to an individual's attention. Why they might be stimulating depends on that attention and individuality. As Kagan says, "If a stimulus is to be regarded as an event to which a subject responds or is likely to respond then it is impossible to describe a stimulus without describing simultaneously the expectancy, and preparation of the organism for that stimulus. Effective stimuli must be distinct from the person's original adaptation level. Contrast and distinctiveness, which are relative, are part and parcel of the definition of a stimulus."[7]

For Kagan, this correlates with Whitehead's subjective process of positive and negative prehension, on the basis of a previously actualized ap-prehension (categorization) of actuality: "Man reacts less to the objective quality of external stimuli than he does to categorizations of those stimuli." The categorization or belief structure which is the already existing core of the entity in process of becoming controls, to a great extent, future actualization or concrescence of the entity. Its subjectivity is already bound by its beliefs, its categorization of its own actuality and that of the entities that constitute its world. Such categorical belief gives it formal closure and seeming unity—a sense of stable identity, however limited. In collage, implicit belief or preexisting categories of orientation—unconscious conditions of choice not necessarily known even to the artist—determines entry into the field of operations, the field of artistic becoming. The fragments that find their way into the field are only superficially found by chance. Chance is a disguise for the uncertain yet highly personal significance they are felt to have. They are fascinating because they are the objects of a belief that only half knows itself, and so experiences the world in a chance way. The fragments are experienced as profoundly meaningful, but the meaning cannot be spelled out completely and never seems to truly surface—which is what leaves the artist free to arrange the fragments as he wishes, in a whimsical or a willful way. This gives the collage an aura of creative freedom which is crucial to its sense of liveliness and to the artist's sense of self-determination. Freedom and chance, the determinate fragments and the indeterminate sense of their relation, become con-fused, making the fragments even more stimulating than expected.

All of this seems obvious, but there is a tension, the possibility of self-contradiction in the situation that is less obvious but at its center. The significance the artist finds in the fragments involves as much the deconstruction as the objectification of a belief—dissolving as well as acting upon an existing, if implicit, categorization of the world. This destructive dialectic is typical of the difficulty surrounding any attempt to "recover" a subjective sense of significance from an objective world, particularly when the objects of that world are regarded as absolute and the subject is understood to exist relative to them. Under such conditions, the subject always imagines that its consciousness of itself is a false consciousness. Its consciousness of objects is a true consciousness, and however much it may work against that consciousness by dealing with "deteriorated" objects—worn fragments of objects, suggestive of the relative way objects exist as objects—those objects remain intractable enough to obscure or mute the sense of self that arises from resistance to them. The objects, however fragmentary, dominate the subject's sense of itself; and yet the subject's power of belief in the objects has been shaken. Its categorization of the world seems close to collapse, if only because of its unwillingness to trust itself in the face of the objects of the world. They can be defied, if not dismissed, by being spontaneously rather than categorically regarded—by being regarded relativistically, rather than absolutely. This, at the least, frees the self from its own self-centeredness, the sense of a center that it acquires by reason of its belief structure. The belief structure is up for grabs in the relativistic situation of the collage— and the self is inwardly freed from objects, if not externally free of them. Objectivity is no longer a categorical imperative, but can be creatively conceived. A sense of spontaneity emerges which freshens the sense of individuality. This sense of spontaneity arises, in part, from the resistance of the self to its own unconscious categorization of the world, which becomes conscious in the course of being acted upon. And that very act sets the self against itself, which is one of the sources of its revived sense of individuality.

The collage is the scene of this struggle between an objective and subjective sense of worldliness. The subjective tries to defeat its own sense of what is typically objective by seeing all objectivity in relative terms, which at the same time restores its sense of its own primordial becoming. A sense of subjective, "artistic" becoming emerges in the collage, forever obscure or uncertain in its attribution of meaning—its categorization of or beliefs about the world—because it sees any definitive meaning as detrimental to its sense of becoming, as inhibiting of its sense of its own creative, powerful individuality. Yet that individuality refuses to

presuppose itself, and it only reluctantly presupposes objects. It conceives of itself entirely in terms of complete openness—what Smithson called an "open limit"—to becoming. It assumes that it is possible to exist on a completely open horizon of ap-prehension, in which no prehension is preordained as positive or negative. It desires to achieve a state in which choice is unnecessary, in which momentum comes not even from one's resistance to one's own choices, but from entirely selfless becoming, from loss in the creative flux of cosmic becoming. This is the impossible ideal: the loss of both subjectivity and objectivity in the ceaseless flow of entities, the loss of even the most elementary sense of the world in a primordial sense of becoming, in which all choices of being are so relative as to be irrelevant, in which all commitments seem superficial in terms of the total flow of things and feelings. In collage, one is ideally totalized by this indeterminate yet insistent flow.

In practice, the collage displays a situation of irreducible tension between a subjectivity eager to identify itself yet incapable of completely doing so, and an objectivity in the process of breaking down—objects in the process of losing their hold on subjects. If, as Kagan says, "contrast" is "an important key to understanding the incentives for human behavior,"[8] then a major incentive for modern artistic behavior is recognition of the contrast between dynamic becoming, overcoming all beliefs about being, and the undertow of a residual sense of being in this becoming. It is about the dynamics of belief—what Nietzsche called the desire for self-overcoming, so as to become freshly concrete. It is about the primal contrast that emerges when relativity invades the scene of being.

The collage, then, epitomizes the state of contrast between categorization of actuality and expectation of becoming—between categorization which determines expectation, and expectation which rebels against categorization by finding fresh stimulation in the world. The collage demonstrates rebellion against determining beliefs in the very act of articulating them through the choice of fragments. More obviously, the collage is a sum of contrasts which never totalize into a single kind of stimulation. Such lack of totalization, of complete objectification of stimuli in a single object, is crucial to the success of the collage. The sense of a restlessly shifting range of stimuli is the essence of the collage—a restlessness reflecting the individuality of the artist's becoming, as embodied in the willfulness of his attention. The unsettled state of the collage is itself emblematic of the will to individual becoming which emerges from the display of fragments. The collage is a relative state of artistic affairs, where relativity indicates the restlessness of individuality in the process of becoming. As such, the collage becomes emblematic of the task of art at

least since Baudelaire: the redemption of individuality in mass society, with its standardizations or categorizations—its banalization or deindividualizing of belief. Collage makes poetry with the prosaic fragments of dailiness. The poetry is a matter not just of recognizing the legitimacy of choosing one's own context of life from the universal dailiness and thereby in some sense escaping it, but of not getting locked into or trapped by this context. It is to be regarded as no more than a means of operating in the dismal dailiness, to be changed or discarded as soon as it, too, becomes a possessive, standard routine. Art teaches one to stay ahead of or to transcend dailiness by manipulating it, juggling its variables in endlessly interesting combinations. This implies a certain purposelessness, but also the playful purposefulness of continuing to become individual, even if the becoming is only pretending in a world that is "un-becoming" because it is banal—a world that has ceased to be anything but itself. The essential playfulness of the collage is a direct acknowledgment of the relativity of individuality in the world, as well as a way of expanding that world to include it, and of expanding individuality to include the world. One can view this ironically, but to do so implies a serious dedication to irony as the only way of individualizing in a world of standard categories.

Ironical contrast seems almost a mannerism in Cubist collage from the start, but it is so relentlessly pursued that it becomes visionary. Relativity shows itself succinctly in irony, which, however limited and transient—however quickly it becomes a cliché—becomes emblematic of the dialectic between individual and world, the emergence of each in the other. The limited becoming of the individual in the world—perhaps limited to his being relatively artistic, ironically artistic—in the last analysis turns out to be essential to the becoming of the world, whose own concrescence is inseparable from its individuation. Collage, relativistic art, implies such inseparability as an ultimate. It exists against all the forces that would absolutize one kind of being at the expense of the becoming of all other beings, thereby destroying the individuality of all kinds of being. This simple defiance, which is at the heart of relativism in Modern art and in the collage, becomes possible only when one explodes the object of art into theoretically innumerable fragments that never make more than an ironical whole. Those fragments establish an ironical individuality and locate that individuality in an ironical attention to detail that never adds up to a whole. With collage, art becomes a marginal, ironical way of coming into being without fully realizing one's being, i.e., one which is unassimilable by any other being, one which is free of subjective becoming.

Karl Mannheim offers a further qualification of relativism with his

idea of "existential relativity." This idea "is far from implying a relativism under which everybody and nobody is right; what it implies is rather a *relationism* which says that certain (qualitative) truths cannot even be grasped, or formulated, except in the framework of an existential correlation between subject and object."[9] In the course of characterizing "the existential relativity of knowledge," Mannheim remarks that "the situation facing our thinking today appears as follows: various groups are engaged in existential experiments with particular order patterns, none of which has sufficient general validity to encompass *in toto* the whole of present-day reality."[10] From art's point of view this is not the worst state of affairs; it makes for an easier "existential correlation between subject and object," a dialectic which does not have to trouble with validity because it is an experiment in ordering reality, rather than a way of decisively determining it. Such an existential experiment is a way of acknowledging its relativity.

The collage is an "existential experiment with particular order patterns" grounded by the self-conscious belief in the impossibility of ever finding one with general validity. In fact, the desire is *not* to find one, for that would be to interfere with or even to stop the experiment by making it serious. It would be to end the individuality of the experiment—to destroy it as an experiment in individuality. It would be to end its usefulness as the resistance of an individual against the implicitly assumed (if incompletely articulated) general validity of the social order.

Relativistic art denies the as-if absoluteness or assumed validity of the daily world of modern society—the daily order of a society that pretends to be traditionless. Relativistic art thus keeps it true to itself, asks it to trust the restless sense of becoming that comes with being self-consciously modern rather than the aspiration to universality by which it seeks to become generally valid. At the same time, relativistic art— collage—is the labor by which the modern world gives birth to a tradition of sorts, i.e., a determinate focusing of itself in a "transcendent" order. The structure that passes for tradition is tenuously evident through collage sedimentation of dailiness; it is as though collage was a delta at the end of a river of becoming, in whose very fertile soil one might grow new ideas of order. In another metaphor, collage is the fleeting archaeological residue of a society still in process of hectic becoming, a random—flirtatious—display of signs which that world self-consciously examines to read its destiny, as if they were sibylline. (Destiny is always rooted in tradition, even in the case of the "tradition of the new" that collage displays.) But there is an essential ambiguity in the collage, for its refractive revelation of the inner life of modern dailiness, leading to a sense, however makeshift, of a structured dailiness implying a tenable

if insecure tradition, is countered by its own dogged experimentalism or speculative stance, whose uncertainty directly correlates with the turbulence of modern becoming. This ambiguity—an inescapable structural fault, as it were—shows that collage is in perpetual deconstructive motion. In collage we watch the dailiness which is the veneer on—reification of—a supposedly generally valid social order deconstruct into a self-contradictory, experimentally realized—and so impossible to understand as generally valid or "traditional"—order. It is feverishly relational, existential; in no way can it be regarded as based on a preexisting paradigmatic order. It is constitutionally unstable, with further experimentation its only fallback position. This deconstructive experimentalism is quintessentially modern; it implies modern social belief in the relativity of all worlds, with their relativity to one another existentially prior to the separate tradition of each, for each is only fully known through its relation to the other. (This belief is masked and simplified by the concept of pluralism, which presupposes "spiritually" equivalent worlds, none superior nor more ordered and sustainable—"traditional"—than another.)

This circular relativism completes itself in Mannheim's conception of "perspectivistic" knowledge as the only way of avoiding historicist or nihilistic relativism, in which every point of view is regarded as equally valid. It is not that—in the collage, as everywhere in the modern world—every point of view is equally valid because none is generally valid. Rather, it is that a point of view or perspective must be self-consciously established, to the extent that it not only knows its own nature but can also deconstruct itself. Perspectives are not simply given; they are not stumbled upon and accepted as long-lost relatives. Instead, they must be worked up or, if already given, worked into, made one's own—experienced as emerging from one's own becoming.

There is already an implicit perspective in the seemingly random fragments of the collage. It is not simply the subjective attitude that results from a certain kind of individualizing attention, but an objective perspective implicit in the kind of things that are likely to end up as fragments and to be brought into the collage. The perspective is implicit in the fragments themselves, and individual attention seeks it out, tries to conform to it as well as to manipulate it for ironical (incongruous) effect.

This perspective in the things themselves implies that collage exists not only subjectively but also as a return to what Mannheim calls "the pre-theoretical vis-à-vis." (Mannheim uses the word *Gegenüber*—here translated as "vis-à-vis"—to avoid the word *Gegenstand* or object.)[11] This seems to contradict what was implicit earlier, and what seemed at the very core of the relativistic character of the collage: namely, the idea of

the impossibility of an unmediated relationship with reality. This relationship would be one of direct intuition rather than of dialectical or existential correlation, and it would seem to deny the very premise of "relationism." Yet, as noted at the beginning, the material fragments that constitute the collage exist in a certain raw state, and they keep sinking back into a pretheoretical state by reason of the dubious success of their synthesis into a conventionally unified art object. By not fully objectifying as art—by not absolutely *being* art—they present themselves as objects that seem to resist not only art but also any mediation, and thus they present themselves pretheoretically. This means that the worldly perspective inherent in them can be discovered—that, in not reaching the level of absolute art, they have fallen back into the general world. In failing to achieve an artificial existence, they appear opposite it as clues to the nature of being-in-the-world. They lose their status as physical stimuli and become sedimented meanings of worldliness, artifacts found in a particular excavation at a particular site of the world. The collage becomes simply a way of panning for the golden meanings of the world, an archaeological investigation into a present (if hidden) truth.

More precisely, the collage undermines our ideas about things by refusing to establish them in a systematic relationship, reducing them to the elements of artistic experience. As Mannheim says, systematization is "the first ordering of the 'elements of experience.' "[12] By not subsuming them in this primary order, collage sets them over against us so that they appear unmediated or pretheoretical, with an inherent perspective of their own. The collage becomes a medium in which real things can be discovered in their objective meaningfulness, as well as one in which artistic things can be invented for the purpose of achieving meaningfulness, i.e., ironical individuality. The duplicity or doubleness of the collage is a direct demonstration of its relativistic character. Self-contradictory, it seems more self-determining or self-created than if it were completely worldly or completely artistic in the conventional, absolutistic sense.

The collage is, then, self-relativizing. When we think of Mannheim's conception of "the self-relativization of thought and knowledge," we realize that he is describing their collage—artistic—character in modern times.[13] The instrument of self-relativization, for Mannheim, is the epoche, "a type of suspension of the validity of a judgment"—in the case of art, the judgment of taste.[14] Taste cannot be brought to bear on the collage, where the consensus of taste no longer determines artistic value. Taste, an eighteenth-century idea that reached a climax of use with this century's conception of Modernism, was a short-lived means of establishing an aristocratic mainstream of art within a situation of its increasing

democratization, i.e., its increasing openness to life. This openness is partly Romantic in origin—recall Goethe's idea that Romanticism means that no subject matter is alien to art. But, perhaps more crucially, it has to do with the sense of the expanded means of art, with art's eagerness to share in the explosion of technique characteristic of the Industrial Revolution. Taste involves keeping a restraint on technique, insisting that only the traditional media are sure sources of art. Collage destroys the very idea of a medium, of any one "pure" mode of art. With collage, art is nowhere and everywhere; it becomes a freewheeling way of dealing with random material, emblematic of fragmented experience. Modern experience seems fragmented because one never knows what will impinge upon it, what will turn up in it. It is radically open—radically democratic—because it distrusts categorizations of experience as much as it uses them. It discards its belief structure in the very moment of acting on it, initiating a new concrescence—discovering fresh possibilities of experience—in the very moment of acting on the ground of the old one. Subjective being is constantly being overturned by objective becoming, with its unexpected entities presenting themselves for ingression in one's existence. The entities represented by the fragments of the collage, however much they may be familiar and everyday, come to be part of oneself in a new way because one's attitude toward them "artistically" changes.

Mannheim describes self-relativization as "a new form of relativization introduced by the 'unmasking' turn of mind," which is inseparable from "the emergence of a new system of reference."[15] Collage is an unmasking of art and life as they grope toward new systems of self-reference. The fragmentary character of both is revealed, and from the fragments a new revelation emerges—not mechanically, but by way of what Whitehead calls the "creative flux" of the fragments. The establishment of this condition of creative flux—for Whitehead the category of categories, the ultimate category, the final generalization of the principle of relativity—is what collage is about, so that, in the "atomistic competition" between fragments (to use Mannheim's description of competition in democracy), a new sense of systematic possibilities for both life and art might emerge. The unmasking of old systems is necessary to establish the sense of creative flux and the possibility of new systems, new actualizations of meaningful form. This unmasking, as Mannheim says, "does not aim at simply rejecting certain ideas so much as at disintegrating them. . . . To unmask an idea, thus, is not to refute it theoretically, but to destroy its effectiveness."[16]

Collage destroys the effectiveness of the idea that the imitation of nature is the basis of art—the idea that art's highest achievement is not

simply to create an illusion of life, but to function as a kind of representation of it. Life can be directly referenced—directly incorporated into art—but not symbolically referenced. Or at least such symbolic referencing or representation of life is no longer the primary task of art, but simply one element in it. Collage also destroys the idea that life is a stable whole, indivisible—or rather, that the division of life will destroy it. Life still exists in fragments which afford new opportunities for experiencing it, new opportunities for finding meanings in it. Art and life become unexpected in the collage, which gives us the opportunity for a creative relationship with both of them. Neither is destroyed by having traditional ideas about it undermined. The disintegration of such traditional ideas which collage represents—for both life and art—does not disintegrate either. On the contrary, in collage what is most essential in both is revealed: their reality as creative fluxes. They have the same root: the relativistic, creative flux of democratic becoming.

What creative flux means in the practice of collage is described by Mannheim: "We understand, looking at things from our perspective, the possibility and necessity of the other perspectives; and no matter what our perspective is, we all experience the controlling 'stubbornness' of the data (*Gegebenheiten*)."[17] The data of life and art—the fragments—indisputably exist, but there is no necessary logic by which they can be ordered. Their "inner necessity" is found in the intention of our own perspective, our own subjective pursuit of meaningfulness—our own willingness to suspend our customary judgments, our categorical understanding of reality, the reality of life and art. The implication of collage, which appears arbitrary and so disturbing, is that it is extraordinarily difficult to suspend the given meanings, the expected forms, the obligatory order, the traditions (whether personal or social) by which we live, and to establish a creatively open horizon. It is a simple enough message, even socially proclaimed—the message of individual openness. But it is rarely acted upon, and it is generally regarded as a foolish, romantic rebellion against inescapable limits. But the stubbornness, the givenness of the data of life and art are not the same as the supposedly logical limits set upon them and used to control them. All such control aims to dominate them in the name of a specific perspective, which becomes a cause—to enlist them in the service of a self-styled heroic, universal cause. Returning to the roots of art and life—to creative flux—in the collage, we realize that no perspective is universal or absolute. From the matrix of fragments of both life and art, subjective perspective must be allowed to freely arise, as a dialectical response—a dialectical emergence.

This makes the collage the climactic realization of the romantic principle in art. Mannheim summarizes this principle by quoting Novalis:

> The world must be romanticized. That is the way to its original meaning. Romanticizing means nothing but raising to a higher level of quality. Through that operation the lower self is identified with a higher self, since our soul consists of a series of qualitatively different levels. This operation is still completely unknown. In giving a noble meaning to the vulgar, a mysterious appearance to the commonplace, the dignity of the unknown to the known, the semblance of infinity to the finite, I romanticize it.[18]

With collage, relativity becomes *the* way of romanticizing the world, counteracting what Breton calls "miserabilism," "the depreciation of reality in place of its exaltation."[19] By fragmenting the stubborn datum of reality until it becomes a raw stimulus—a fragmentation which encourages relationism and perspectivism to reconstitute reality into an exalted or mysterious semblance of a whole—the collage raises "our soul," as well as the world, "to a higher level of quality." Both come to seem infinitely extensive while bound to an irreducible stubborn fragment of reality.

For Mannheim, there is something fake as well as necessary about this forced march to the depths, this depreciation of the surface to evoke enigma where there may be none. As he says, "the romantic preoccupation with these 'depths' was not a true one. The predominance of the subjective approach introduced an arbitrary element into its interpretations and prevented the thinker from really getting inside his subject."[20] The elusiveness of the collage, its deliberate cultivation of relativity of appearance to undermine the absoluteness of reality—to get behind that façade of absoluteness in order to recover the reality of its becoming, its dialectical metamorphosis in its concretizing of its world—is at once an attempt "to sound the 'depths' of the soul" and "an ideological dressing-up of things as they are."[21] Collage accomplishes both. It evokes the sense of an independent depth of consciousness, of consciousness directed toward itself, clarifying its own perspective; and it evokes the sense of consciousness dressing up "things as they are" with the "profundity" of its own perspective, with the subjectivity of its own interpretation of reality. The seemingly unqualified subjectivity of the perspective counts for more than its regulatory power over reality. In response to Braque's dictum, "I love the rule that rectifies the emotion," Juan Gris said, "I love the emotion that rectifies the rule."[22] And as one art historian observes, "nowhere did he [Gris] so completely give himself over to his feelings as in his collages, on which he conferred a highly personal magic, interlocking reality and unreality like meshed gears."[23]

The untraditional collage is preferable to the traditional painting because of its greater romantic possibilities, the greater freedom of expression possible in it, and the greater ease with which traditional ideas of what a work of art should be—the realization of a "definitive" style and

an imitation of nature—can be dismissed. Relativism is the ideal instrument for romanticization of reality—the flotsam and jetsam of everyday life set adrift in the collage—because it denies certitude of style and nature, of ideals and models for art that might lead to its perfection. Instead of trying to perfect art and to indicate that art is a perfection of life, the collage, in an attempt to "keep alive a certain germ of experience . . . always splits up and relativizes what we believe to be 'rational' and 'objective,' " revealing a hidden "world of 'pure experience.' "[24] The myth of pure experience—immersion in creative flux—sustains collage, not only dismissing traditional ideas of the purpose of art, but also dismissing Modernist ideas that the "art" in art has to do with its making. The collage seems casually, even flimsily made, deliberately flawed as a constructed object. It has a ramshackle, helter-skelter look, as though the artist were unsuccessfully trying to clean up an accident. But it is precisely by being poorly made, as it were, that it "breaks into the 'here and now,' " "the first form of utopian consciousness."[25] By being inadequate as an object it acquires "an ecstatic center"[26] beyond its constituents. No longer strictly "congruent with existence"—and so no longer contained by even the thinnest illusion of a circumference, except by reason of its technical termination—the collage seems to center experience in the intensity of its immediacy, heightening our sense of the stubbornness with which it is given and the stubbornness with which we at once assimilate and resist it by means of our relative perspectives on it.

In sum, the collage is an awkward amalgam of three unresolved elements: (1) purely worldly elements, especially such fragments of dailiness as newspapers; (2) purely artistic elements such as line, color, and shape—the typical constituents of form; and (3) mixed or impure elements, or residual images of an imitated nature, ranging from the famous imitation wood grain and chair caning to traces of such domestic objects as clay pipes and such studio props as guitars. Gris's use of the mirror seems to summarize such elements, for it unequivocally demonstrates the illusory character of imitation by making the "imitation" of reality unmistakable. The elements are already "relative" by reason of their displacement from the life-world into the "art world," and by reason of their fragmentary state. Taken together, seen relative to one another, their relativity seems irresistible and fundamental. For all the stubbornness with which they are given, they can never again be regarded as *absolutely* given. They are an experiment in time and space—which shows that the old idea of Modern art as an experiment concerned with articulating the fourth dimension has, for all its charming naiveté, a certain truth to it. It is an imprecise but still perceptive way of acknowledging the relativity of concrescence, and of acknowledging Modern art as the major exemplification of such relativity.

Notes

1. *Webster's New Collegiate Dictionary*, 2nd ed.

2. Hannah Arendt, *The Human Condition* (Garden City, N.Y.: Doubleday Anchor Books, 1959), p. 9.

3. Alfred North Whitehead, *Process and Reality* (New York: Humanities Press, 1955), p. 33.

4. Ibid., p. 79.

5. See Rosalind Krauss, "Re-presenting Picasso," *Art in America* 68 (December 1980): 90–96.

6. Jerome Kagan, "On the Need for Relativism," in *The Ecology of Human Intelligence*, ed. Liam Hudson (Baltimore: Penguin Books, 1970), pp. 134–35.

7. Ibid., p. 135.

8. Ibid., p. 136.

9. Kurt H. Wolff, ed., *From Karl Mannheim* (New York: Oxford University Press, 1971), p. 226.

10. Ibid., p. 247.

11. Ibid., p. xxii.

12. Ibid., p. xxiii.

13. Ibid., p. xxxi.

14. Ibid., p. xxv.

15. Ibid., p. xxxiii.

16. Ibid.

17. Ibid., p. xxxv.

18. Ibid., p. xliv.

19. André Breton, "Away with Miserabilism!" in *Surrealism and Painting* (New York: Harper and Row, 1972), p. 348.

20. Wolff, ed., *From Mannheim*, p. xlv.

21. Ibid.

22. Herta Wescher, *Collage* (New York: Harry N. Abrams, 1979), p. 29.

23. Ibid.

24. Wolff, ed., *From Mannheim*, p. xlvii.

25. Ibid., p. lxiv.

26. Ibid., p. lxiii.

The Emptiness of Pluralism,
the End of the New

Pluralism has become an acceptable, even conventional—certainly highly convenient—mode of art understanding, the unconsciously expected state of affairs in art making and thus the properly dominant perspective on it. It signals what seems the most salient fact of modern artistic life: the enormous diversity of production, which no amount of sorting out can dissipate—a diversity taken as a sign of vitality, as proof of the unpredictability and multi-dimensionality of creativity. Pluralism becomes a way of celebrating creative fecundity, of announcing creativity for creativity's sake—of announcing a presumably absolute value. Pluralism is thus art's final line of self-defense. But less grandiosely, pluralism has another, more pragmatic point: to remind any critic that it is impossible to select a canon, to determine a mainstream of works to which all others must conform or become trivial. It reminds the determined viewer that no amount of awareness can discover absolute, or at least securely rationalized criteria of value. Indeed, artists themselves tend to evoke pluralism not only to give themselves a little place in some sort of sunlight, but to deny the superlative significance of any art. Their little place of course depends upon the lack of any larger place, but the point remains decisive: any approach that insists upon a single criterion of value would inevitably be reductive, losing sight of much on the plains to enjoy the view from some imaginary height.

Pluralism came to seem important in the seventies, almost because no one art seemed especially important. It signaled the loss of a dominant style, and the introduction, with feminist art, and political art, its larger category, of explicit ideological considerations in art making. Indeed, no style seemed more valid than any other because interest, spurred on by social events, shifted from style to content, conceived not only as

This article originally appeared in *Vanguard* (March 1984).

subject matter but as the effect of art in the larger world—what has been called by Hans Robert Jauss, the character of its "eventfulness" in the larger world of events. But pluralism quickly became generalized: it signaled the multiple uses of art as well as the multiple possibilities of style, none more valid than any other. It came to mean that art was more than an aesthetic matter, that art was too important to be left to aesthetics alone. For some artists and critics, aesthetics became a laughing matter, or at best radically relative. Pluralism thus became a major virtue, a kind of generosity toward art that renewed great expectations from it.

In fact, it is the appropriate mode for understanding art in democratic society. The critic was simply a better informed voter, selecting candidates from a wide field for important artistic offices, loosely hierarchical but interlocked in a balance of powers. And every few years, not because of fashion but because of democratic necessity, a new set of candidates was voted into office, achieving their prominence—their 15 minutes of fame, as Warhol cynically put it. The political analogy is not arbitrary. Pluralism is an art political conception, designed to make peace among the great variety of competing artists, to give each some kind of due, however facile a recognition it might be. The attitude of pluralism seems inevitable—properly responsive and responsible—in a situation of a burgeoning population of artists. An open rather than closed system seems to be forced upon the art world. Closed systems of artistic value become surrounded by so much oppositon that they have little influence, and become more pragmatic than theoretical in significance—market-oriented cliques rather than ideological groups. Pluralism is liberalism in the democracy of art. It allows for the free play of equal artistic possibilities and values; one can speak of the pluralistic enthusiasm for irreducible variety, a belief in equal opportunity which suggests a preference for the many over the one. "Let there be abundance!" seems to be the motto of pluralism, as though that will answer all questions of value and solve the problem of the future, as though equal opportunity makes for equal achievement.

Clearly, pluralism, is an anti-authoritarian attitude, and in a profounder way than one might imagine: it speaks not only against the emergence of any one art as authoritative in the present, but against the authority of tradition, based on a supposed consensus of values which, while not predictive, stabilizes and unconsciously sets the limits for the scene of current production. Whether defied or followed, in whatever form, the weight of tradition is indisputably there. But pluralism disputes our sense of tradition, is constantly discovering neglected values in the past. Overturning the essentialism which establishes orthodoxy—a canonical body of work—with a new pragmatism, pluralism allows no art to

become superordinate to the total field of artistic production. It denies heroic models, constant forms of production, ideal methods of inquiry into art and determination of artistic value. It is in effect a Jacobin revolution against any pretensions to aristocracy, perhaps anarchistic in ultimate import but certainly immediately salutary in a situation where unqualified claims of absolute significance are regularly made, even if only part of what has become routine hype. Indeed, it may be that pluralistic openness itself encourages such claims, since the field of artistic operations tends to become a free-for-all under its ministrations. But this does not deny the liberating effect of pluralism, for it forces the critic to realize the precariousness of any determination of value, and the necessity for examining counter-claims from alien art. It is presumably a healthy situation of competing values in which every art has some value.

The case for pluralism as "natural" to an artistic democracy is easily made. Through it one can certainly find one's way to compatibility with quite different arts. But I want to offer a critique of pluralism—thereby implicitly denying the acceptability of much contemporary production— not to return to a traditional canonical approach, but to uncover the self-doubt pluralism masks. It is not so wholesome as it seems, but is rather the sign of an identity crisis in Modern art, an inner uncertainty of direction inseparable from the rise of Postmodernism, which, whatever else it might be about, implies abandonment of novelty as an important source of artistic value. The long history of novelty is over, but pluralism rushes to sustain it in the guise of openness to variety, as though with enough variety we just might get some novelty. With surprise no longer mattering so much, no longer a sure sign of significance, there is a major vacuum of meaning in the production of art, a major loss of impetus. Pluralism is the illusion of fullness obscuring this vacuum and its consequences. Pluralism is not what it seems: it is not the sign of art's new presence, but of its loss of significant motivating force. It is the sign not of an emerging new order, but of the collapse of an old order, an old basis for the production of art. This critique is really a theoretical description of the ruined state of the old horizon of expectation in terms of which Modern art existed, a horizon perhaps most succinctly articulated by Baudelaire's concept of surprising novelty and the achievement of a childlike state of awareness. The ideal of being new has collapsed; a new sense of tradition waits in the wings, waits to create a new stage for art.

This critique is not about the reconstituted tradition that will emerge— making it once again an "event" rather than simply ballast—after Modern art's attempt at producing traditionless art, i.e., art which, because it attempts to be free of any sense of the past, means to create the illusion of unqualified and complete presentness. However, such art, which tries

hard to be a completely fresh experience, leaving no sediment in memory because it has no memories sustaining it—an art of absolute immediacy, totally absorbed in creating the artificial effect of a singular moment—is in fact a prelude to a deepened sense of and respect for tradition. Tradition is no longer simply the mood-heightening shadow of history, but means taking-stock after the intense, convulsive, all-absorbing experience of immediacy, which is really a kind of dream state. Tradition is a way of awakening from the nightmare of the present into the larger history of humanity. This history does not offer simply the consolation of secure past achievement but opens up the possibility of future achievement, without, of course, guaranteeing it. Tradition is not simply perspective, but possibility, in a way that actual presence, however heightened by immediacy, can never be. And because spirituality resides in possibility, tradition means the renewal of spirituality in a spiritless age of immediacy—an age which has no need of the spirit because it has eternally young, and so eternally novel, immediacy, the excitement of sheer givenness.

As I see it, the entire structure of Modernism—all the strategies by which an art declares itself to be Modern—is sustained by the pursuit of newness. There are various methods for generating novelty, and a whole set of expectations which structure the expectation of novelty. I would like to list some of these methods and expectations, briefly describing them afterwards. Each successful Modernist movement can be described in terms of the new kind of novelty it introduces. There are four main categories of novelty in Modern art: (1) perceptual novelty, represented by Impressionism; (2) spiritual novelty, represented by Post-Impressionism; (3) psychological novelty, a kind of secularized spiritual novelty, represented by Expressionism, and later Surrealism; and (4) conceptual novelty, by which I mean the novelty achieved by the self-questioning, as it were, or more conventionally self-referencing of the work of art, represented by Cubism.

The first three involve an emphasis on content, leading to formal innovation, as if to make a difficult, subtle content as self-evident as possible. The fourth involves an emphasis on form, in which each formal element of a theoretically defined work of art becomes the sign of an absent, or rather numinous work of art. From this ontological and epistemological rediscovery, as it were, of the work of art, a new sense of the content it might communicate is generated. It becomes a way of articulating the structures of everyday meaning as well as of what we mean by a work of art in a particular medium.

Perceptual novelty "progressively" becomes the pursuit of visual finesses, the recognition of an infinitely extensive continuum of nuances in perceived reality. Spiritual novelty becomes the obsessive search for

symbols to embody ineffable enigmas—for a language to articulate the experienced discontinuity between the everyday and the enigmatic. Psychological novelty becomes the experimental demonstration of complex feeling states, a presentation of them as if they were hypothetically ideal states of being rather than only vividly experienced, which makes them all the more awkward and authentic. Conceptual novelty becomes the attempt to generate formal ambiguities whose understanding is unavoidably ironical.

All of the modes of novelty eventually become ironical, as though mocking their own original intention. Irony signifies a loss of freshness of intention which can only superficially be regarded as a sign of maturity. More often, it implies a desperate attempt to sustain fading surprise at the originally novel. It implies an "intellectualization" of novelty, an elaboration of what was originally novel, that turns out to be suicidal for it. What was an originally spontaneous novelty becomes faked instantaneous novelty. That is, what was originally a novelty that was the product of internal necessity—primordial novelty—becomes a consciously created novelty that depends for its effect on its timing, i.e., its power over the "moment," finally its ability to create a sense of the "significant moment." In other words, all novelty eventually becomes a decadent manipulation of effects, losing that aura of primordial origination—the Surrealist "marvellous"—which was in fact the reason for our surprise at it. No longer surprising, it becomes a staged event, an all too artificial effect—an all too formalized affectation—that mocks our sense that it was originally a sign of fresh possibility, a new aesthetic formulation of existence.

There are three elements in the set of expectations which structure the general modern expectation of novelty: that art (and artists) be young, that it be nominal—art only in name—and that it be theoretically interpretable, as if that will keep it eternally young and nameless. This is clearly a circular set of expectations; all three conditions must be satisfied before an art can be regarded as truly novel, whatever new content it claims to offer. These are the formal conditions of newness; what was described above are possibly new, i.e., Modern, contents. I think the best ways to show what each of these conditioning expectations means is to give an example of its effect.

Here is what Claude Mauriac has written about the aging André Breton: "Having been in the avant-garde, and having been unanimously recognized for its leader, he never stopped being afraid that he might be left behind. Whence his inconceivable indulgence in the face of the most frivolous attempts of an untalented youth, to whom he always tends to give credit, just because it is youth and because it claims to be revolutionary."[1]

Here we see the consequence of the blind belief in youth, the deluded attempt to keep art young by idolizing the young who make it—those who have nothing but their youth to give it, as though their greater closeness to childhood gives them greater creativity. And here is the same Breton perpetrating the myth of the eternal youthfulness—absolute newness or enduring modernity—of the work of art by celebrating Duchamp's readymades, i.e., works of art only in name. Breton describes the readymades as "manufactured objects promoted to the dignity of works of art through the choice of the artist," whose "signature sweeps briefly over the narrowly defined object . . . and then focuses upon a whole mental process."[2] The artist's signature represents the naming of the practical physical object as a work of art, which naming brackets both its practicality and physicality, and makes it the starting point for a mental construct. But this construct can collapse at any moment, for the naming is not binding; the work of art can easily again, by another "mental act," become an ordinary object, losing its dignity—even when it is put in a museum and labeled as art. This uncertain situation in fact keeps it young, and opens the work of art to interpretation—the interpretation which continues to keep it young, a revolutionary "new event." The work of art must seem to insist upon its availability for interpretation, its desperate need for interpretation—the bottom line of its youthfulness. This finally leads to the assertion that interpretation *is* artistic identity, the fountain of youth in which art renews its identity as art. Thus, carrying the Duchampian concept of the readymade to *reductio ad absurdum*, Arthur Danto writes:

> The moment something is considered an artwork, it becomes subject to an *interpretation*. It owes its existence as an artwork to this, and when its claim to art is defeated, it loses its interpretation, and becomes a mere thing. The interpretation is in some measure a function of the artistic context of the work: it means something different depending on its art-historical location, its antecedents, and the like. . . . Art exists in an atmosphere of interpretation and an artwork is thus a vehicle of interpretation.[3]

Interpretation here simultaneously democratizes and renews the very nature of the work of art. The two are inseparable, for assured accessibility becomes the only way of ensuring youth or newness.

These strategies of newness—"arguments" for its fundamentality—as well as the assumption that content can be made new not only by finding new content but unexpectedly new aspects in old content—implying that they are necessarily there—become gospel in pluralism. For it implies an active diversity not simply a static abundance. Authentic pluralism must be stormy with the new, a kind of boiling cauldron of soupy creativity in which ever new art is generated, like a strange creature crawling

out of the primordial ooze. Pluralism implicitly suggests that it returns to the primordial condition of undifferentiated art making, in which all kinds of new things are "tried" until something "works." The trial-and-error implication locates newness in randomness, establishing a peculiar connection with Duchampian ideas. Randomness can eventually be tamed, and becomes a form of manipulation—becomes ironical and pseudo-spontaneous. Duchamp gave us the instant work of art—and in art criticism the instant intellectual—which from a traditional, or at least non-modern (nonnewness) point of view, is not a work of art, because it depends all too completely upon the flux of randomness within the pluralistic situation. But this is just the "Modern" point: the energetic pluralistic flux, even manipulated—channeled—is the only source of radical newness. And that is authoritative in itself.

But what dynamic pluralism does not comprehend, in its insistence on radical novelty as the true guide to artistic significance, is that newness becomes self-defeating just to the extent it increasingly becomes a matter of chance, manipulated or not. Novelty becomes less and less a basis for value because chance is fundamentally indifferent to value, and even when it is "steered" in a certain direction its results are only momentarily "valid." Duchamp has left us with a number of self-trivializing works, momentarily charged with the energy of the mental process that exemplified itself through them. Once they are no longer "electrified" by this process—once it has passed completely through them, which happens quickly—they are more inert and abandoned, meaningless and "objective," than they were before art decided to dignify them. The point is this: from a pluralistic point of view, in which newness is sought through random diversity, a work of art (1) cannot durably represent a standpoint or be understood as "taking a stand"; (2) can never be adequate to experience, educating one to it, as it were; and (3) can never become symbolic of the self so educated. From a pluralistic point of view, art is not a sedimentation of experience transformative of the self, but the momentary display of a mental process that is fundamentally indifferent to the objects in which it embodies itself. Art must be renewed because art objects are dispensable. This Dadaistic attitude is, I think, essential to pluralism, the dirty secret that keeps it going.

The traditional point of view is fundamentally opposed to the pluralistic point of view. It believes that works of art are authentic to the extent they take a stand, are adequate to experience, and symbolize a difficultly learned selfhood, even the aspiration to it. All other works of art are, indeed, mere decorative objects, and ultimately dispensable, i.e., one can do without them. They can never become part of one's existence, at least insofar as one respects it, does more than simply consent to it.

The "traditional" assumptions about art mentioned above amount to a vision of it as a reflective experience, a critical taking-stock of experience. But this requires something else: unreduced, and so seemingly primordial, experience. Novelty at its best symbolizes such rare, unpredictable experience. (Although novel immediacy is inherently the most reduced experience of art.) But the pursuit of novelty per se rarely shows art at its best. The grimace of newness on much so-called Modern art is a contrived experience; newness staged is hardly unreduced experience lived. The mistake of pluralism is to think that one can, as it were, invent primordial experience of the world simply by a kind of perpetual "creative" motion. Traditionalism knows that such experience cannot be produced on demand, and that one can do nothing artistically significant without it. One cannot force unreduced experience—that is already to reduce it—as pluralism believes.

This is not the place to elaborate on the reciprocity between authentic Modernism and authentic traditionalism—that sense of novelty that emerges from unreduced experience and the kind of reflection that is appropriate to it—but it is necessary to state unequivocally that pluralism has nothing to do with either. Pluralism is a democratic strategy to generate the sense of being-modern—as though being-democratic had something essential to do with being-modern—and to undermine the necessity of being-traditional. Its "communal" attitude betrays both the nature—the actual workings—of experience, and of reflective understanding. Pluralism presupposes that being-traditional is basically about determining authority; pluralism assumes a standing challenge to any would-be absolute authority by subversively positing alternative authority, destroying the idea of stable authority. It proposes multiple authorities, with political logic determining the entire system of authority. But the issue of authority is not simply who has it but what its source is, an issue that returns us to the relationship between the modern and the traditional. The primordiality of art depends upon the possibility of its mediation of unreduced experience of the world. The consequentiality of art depends upon the actuality it acquires by being reflectively received; it is from this that it acquires its necessity. Its primordiality is always contingent upon the "enigmatic" occurrence of unreduced experience. The pluralistic point of view is more concerned to give the greatest number authority than it is to understanding the complex dialectical conditions necessary for authenticity, which alone has durable authority.

If there is any one reason why the United States will become less likely to produce significant art, it is because of increasing pressure to blindly affirm a pluralistic attitude, a barely questioning acceptance of any and every art. Newness becomes the only criterion of acceptance; what else

is the new world about but perpetual newness, with its quasi-utopian promise. But novelty has worn thin, and become a somewhat shabby Emperor's new clothing. The new American art of quotation is a dubious, unconsciously mocking attempt to be traditional by reproducing, photographically or "expressively," and not without some disguising of sources, once important works of the modern tradition. Here "tradition" is understood as a static canon of authoritative works; the nostalgia for their authority hardly begins to understand or capture it, or the authenticity on which it is based. (Julian Schnabel's "heroism" is the most flagrant example.) This appropriation of past examples of authentic art—this kind of parasitic engulfment of them—hardly begins to achieve the "maximum" effect it is supposed to. These traditional works retain their authenticity, for all the violence done to them by the "mental process" of the artists who aggrandize them—who really treat them like fetishized commodities, implicitly accepting commercial taste. They are not the raw material for a new vision of art—the primordial experience they embody is hardly comprehended, and the criticality which gave them the consequentiality of becoming traditional altogether ignored, and would also not be comprehended. The most one can do is establish squatter's rights in them, as the best German and Italian Neo-Expressionists have done. To inhabit them like this is not to appropriate them, but rather to learn from them—to let oneself be shaped by them, as the historically closest art with which one has an affinity, which can possibly shape one. For American Modernism, to quote such art is simply to find another—an ironical—way of being new. It is to reduce this art to an empty image and dumb mark of newness, to make it one more card in the deck of a losing hand, one more coin of an already inflated, almost bankrupt currency. It is to extend pluralism absurdly, mindlessly. The new quotationism, with its puerile intellectualism, is the last gasp—the death rattle— of American pluralism.

Pluralism really means to deny the possibility of authenticity while going through the motions of creating "ideal" conditions for it. It is a soft-headed—certainly not critically hardheaded—approach to the field of art, which assumes that by celebrating its characteristic trends one has comprehended their significance. Pluralism is worse than a way of suspending critical judgment; it is not knowing how to make any—a kind of infantile attitude to art, that "miraculous," "exclusive" sign of human creativity. It is the ultimate critical know-nothingism, the refusal to speak evil of any art as part of the process of knowing the good art. No critic— or gallery or museum—worth his salt can accept the assumptions of pluralism, which does not mean that a critic achieves significance by becoming authoritarian in the name of any one art. Pluralism is inherently

uncritical; it has nothing to do with the difficult, visionary process of taking-stock that is criticism's reason for being. Criticism is necessarily tradition-oriented, not because it accepts any one body of authentic works, but because it means taking a stand to an art on the basis of an unreduced experience of it. It means seeing what one can learn from the art, how it nourishes one's sense of selfhood. It means respect for primordial experience in whatever form it is embodied, and attempting to preserve it in the terms of its own integrity. No critic worth that name can celebrate the new just because it is new—powered by immediacy—for pure novelty has a way of quickly aging, becoming more banal and "typical" than anything conventionally "traditional."

Notes

1. Claude Mauriac, *André Breton* (Paris: Editions de Flore, 1949), p. 345.

2. André Breton, "Marcel Duchamp," *Surrealism and Painting* (New York: Harper & Row, 1972; Icon Editions), p. 88.

3. Arthur Danto, "Artworks and Real Things," *Theoria* 34 (1973): 15.

Archaeologism: Postmodernism as Excavation

A good deal of eighties, so-called Postmodernist art has been described as "historicist." In fact, some critics think historicism is the essence of Postmodernism. I would like to suggest that historicism is a mode of archaeologism, which is the term I want to substitute for it. Archaeologism has been prevalent in modern thinking, from Sigmund Freud's use of the archaeological metaphor to explain the psychoanalytic enterprise to Michel Foucault's development of "archaeological analysis" as the "systematic description of a discourse-object," more particularly, of the "types of rules for discursive practices." Roland Barthes's emphasis on the "already written" is similarly archaeological in import. In art, as in other kinds of discourse, the Freudian and Foucaultian meanings of archaeologism converge: the rules that establish art's discursiveness exist at an "unconscious" depth beneath the artistic appearances they determine. They have the pull and gravity of the repressed, and can only be uncovered by a kind of archaeological excavation.

"Archaeologism" makes more sense as a descriptive term, for Postmodernism implies a break with Modernism whereas what we are witnessing in the eighties is its completion. That is, Modernism is in large part an attempt to become conscious of the rules that give art its existence, and to use them self-consciously to make art. This archaeological investigation is essentially completed. It seems that all the rules for making art—all the possible types of artistic discourse—have become self-evident to the point of seeming trite and routine. But it is just this familiarity and ordinariness—even weariness with them—that afford Postmodernists the confidence of playing with them "freely." More precisely, these rules can be used to generate an art which seems to exist out of contemporary time. Such an art does not bespeak the modern—which has become habitual—even though it is created by modern methods. Rather, it breaks our habit of modernity, our addiction to the modern look which gives

This article originally appeared in *Dialogue* (January/February 1988).

us a social high, makes us feel integrated with the contemporary life-world. It undermines our usual way of thinking about modernity. By articulating the psychohistorical content invested in modernity, but repressed by the modern look, such Postmodernist art subverts modernity, generating great anxiety: we can never again feel secure with our modernity once we have fully experienced the regressive forces informing it.

A superior example of archaeologism in eighties art is the work of Anselm Kiefer, which utilizes the Abstract Expressionist rule for the articulation of surface as well as other rules for certain types of representation in order to establish a monumentally specific surface that functions as a kind of representation. Kiefer in effect acknowledges this when he declares painting to be burning, a kind of scorched-earth technique. Kiefer's so-called Neo-Germanic and Neo-Expressionistic oeuvre, in its apparent archaism of method, ideology, and mood—and archaism is the appearance that is inseparable from the reality of archaeologism—seems to have nothing to do with the contemporary lifeworld. Nor does it advance our understanding of the rules for making art. Rather, it utilizes a well-known range of methods to establish an indirect, unexpected discourse about the contemporary German world. Kiefer's discourse about the German past is latent in—inherent to—that world, which has repressed it. Kiefer's oeuvre demonstrates that with the exhaustive uncovering of the rules for making art the issue of content comes forcefully to the fore: to make sense and have value, art must become a means for the uncovering of a repressed content.

Hard on the heels of Modernism's archaeological success in uncovering the rules of artmaking, comes the attempt to systematically excavate a content repressed by the contemporary world—usually by superficializing it—yet largely determining its appearances. One might say, if we are to maintain the differentiation between Modernism and Postmodernism, that Postmodernism completes the Modernist project of making the latent rules of art manifest, and pursues the Modernist project of making the latent content of the contemporary lifeworld manifest with a new intensity. What was once a secondary project now becomes freshly empowered as a primary project. The project of content replaces the project of form in importance. This project of content gives art inner necessity and special purpose in the lifeworld, and permits art to transcend its thematization of itself. Such self-thematization is the inevitable result of art's exhaustive self-discovery, the self-narrowing consequence of its fixation on its own rules and modes of existence. While the archaeologism of form is no longer sufficient reason for artistic being, the archaeologism of content is at least a necessary reason for art's existence.

The archaeologism of content poses a certain quandary. As Philip Rieff has pointed out, the analogy by which Freud linked archaeology and psychoanalysis is true to neither. Archaeology uncovers the buried physical past with no intention of transforming the physical present. It simply wants to analyze the way in which the past was given. Psychoanalysis uncovers the buried psychic past with every intention of transforming the psychic present, and preparing for a better psychic future. By consciously acknowledging the unconscious hold of the past, we can presumably change the present and future. They will not so inevitably follow from the past. I want to contend that the best Postmodern archaeologistic art is more psychoanalytical than archaeological in its orientation and purpose. It subsumes the archaeological in the psychoanalytic. The Postmodernist archaeologistic art that takes a Foucaultian approach to artistic discourse—for example, that analyzes rules for and types of representation—is less fraught with vital consequence than the Postmodernist archaeologistic art that implicitly takes a Freudian approach. Such art examines the unconscious import of conscious artistic articulation to free us from the power of the unexamined unconscious—indeed, from the power of art, which in part comes from the symbolization of the unconscious.

A Freudian "argument" on behalf of Kiefer would maintain that he is not neutrally analyzing the rules of the German discourse, but doing so to free Germany from the unconscious hold of that discourse on its contemporary existence. Unconscious acceptance of this discourse has brought Germany to the broken, precarious, "borderline" condition in which it exists today. Kiefer uses institutionalized modes of representation, from both "traditional" tradition and the tradition of the new—modes which today are hollow or dead-on-arrival, or at least quaint—to articulate an obsolete, yet still unconsciously binding, German authority and authenticity. His return to past styles—archaism—acknowledges a disturbance in present reality which must be "cured," hopefully once and for all. He takes "parental" representations—German father and mother figures and "primal scenes"—which are empty yet still highly charged forms, and cancels them through his complexly ironical handling of them. To give Martin Heidegger a tumor is to mock the *echt Deutsch* "profundity" of his thought. In general, Kiefer turns Germanness into mock spectacle, deflating it. He makes its mechanisms "spectacularly" visible. He liberates modern Germany from "primordial" Germanness by subtly working through it artistically—by setting what has become reified or essentialized into artistic process. That is, by establishing an artistic dialogue with Germanness rather than accepting it as ingratiatingly

self-evident—as speaking for itself—Kiefer brings it down to earth from its Platonic heaven, restores it to living memory, where it is no longer so awesome and untouchable, that is, taboo. Indeed, Kiefer hammers and hammers at certain Germanic themes, working and reworking them, as though emotionally working through them with great difficulty—the difficulty of overcoming his own German transference to them. He finally comes to handle them with a certain brilliant casualness—a witty, false innocence that suggests his liberation from their unconscious hold on him. The variety of images in each of his series, the variety of the series, and the physically overwhelming and even absurdist character of many of his works, arouses the spectator's seriousness and emphatic working through of Germanness, following Kiefer's lead.

The explicit archaeologism of the Postmodernist situation is perhaps most self-evident in architecture, where a wide variety of habitual styles are synthesized in a single work. Compared to the architects, an artist like Sherrie Levine is conservative in her utilization of the available stylistic possibilities. She suggests their interchangeability rather than synthesis. Each is equally valid, and in a sense morally if not aesthetically equivalent. That is, while clearly not the same stylistically, each has withstood the test of time, and has similar authority and authenticity. It is this that Levine wants to appropriate, not the style as such. This is not so much subversive as adulatory, however obliquely. The availability of an abundance of styles to work from, and the desire for authority and authenticity that are not one's own, typify the archaeologistic Postmodernist situation.

Both the abundance of styles and the authority and authenticity exist archaeologistically. That is, they are relics. They have become influential because in the present situation it seems impossible—and even beside the point—to achieve, after a lifetime of struggle, one's own special style, giving one authority and authenticity, because today it seems impossible to know what personal style, authority, and authenticity mean. And who wants to face the struggle, when one can appropriate a "learned," archaeologized style? The style one "owns" turns out to have been owned by others, as do one's authority and authenticity. They seem to have lost whatever irreducible meaningful core they had, in part because both have been dialectically analyzed to death—reduced to their objective and subjective components—and in part because the results of such analysis show them to be reducible to "ulterior motives." The fact that a serious compulsion to analyze them in order to be free of them develops, suggests that they may have been suspect to begin with; and the very recognition of their analyzability seems forever to destroy their mystique, dissolve

their aura. No authority and authenticity can be regarded as unconditionally valid; for them to present themselves as such is for them to function in an authoritarian way. And yet they remain, intriguing shells of authority and authenticity, there to be picked over, or used "decoratively," as insignia of "soul."

The present archaeologistic situation is "decadent," but also rich with opportunity. One may not be able to create one's own authoritative, authentic style, but one can appropriate existing authoritative, authentic styles to new purpose. The one extreme of such archaeologistic appropriation is represented by Levine, who seems simply parasitic on past, authoritative, authentic styles. She has an almost unilateral, one-dimensional—if hesitantly theatrical—relation to the styles she manipulates and scoops out. The other extreme is represented by Kiefer, who does not simply appropriate past authoritative, authentic styles but complexly synthesizes them to achieve what Jürgen Habermas has called an emancipatory effect.

Levine hungrily yearns for her own authority and authenticity; why not borrow them from the past? It's the Postmodern way. She supposedly absents or cancels past authority and authenticity in appropriating them, but more to the point is that she gives herself "presence." By reducing past styles to designer labels, she has made their authority and authenticity universally available, especially to herself. The appropriated art's supposedly masculine character rubs off on her, simply because she "womanhandles" it, that is, copies it. Levine's "radicalism" is really quite conservative, her "criticality" quite naive. Her work is an example of "negative archaeologism," that is, in her art the archaeological impulse is used to achieve nominal identity—identity in and through name only. This is the identity of the copy, however much a sophisticated "misreading" of the original it is.

This contrasts sharply with Kiefer's "positive archaeologism," where the past styles are not used to give one an identity—to identify one as having authority and authenticity just like those in the past—but in the service of contemporary psychosocial, extra-artistic purpose, growing out of profound political and historical need. For Levine, history exists in name only, as thoroughly finished and past. The present has no history other than the history of the past it "cosmetically" appropriates. Her need for this past is really quite banal. In contrast Kiefer has a great need for the past, which he sees as continuous with the present, even as still possible in the present or at least symbolizing forces still operational in the present. For him, history in general is fraught with consequence; it is not simply a superficially contemplated distant monument that can be livened

up by makeshift little theater techniques to render it "contemporary," as in Levine. For Kiefer, the archaeologistic Postmodernist project is hard work, as much as the avant-garde Modernist project was, but its critical point is different. Where the Modernist past achieved its authority and authenticity through its implicit utopian commitment to both art and society, the Postmodernist present involves a critical working through this obsolete commitment in order to liberate us from it. Kiefer does not theatrically appropriate authoritative, authentic past styles, but exhaustively works them through so that he can understand the nature of the commitment involved in their invention, in order not to make it himself. For it is, at the least, inappropriate in the contemporary world. In Levine, there is no understanding of the commitment embedded in the styles she appropriates, and no effect of emancipation from the commitment implicit in those styles. For her, they are artifacts that make minimal formal sense, and no other.

Part of Postmodernist archaeologism is disbelief in the historicist notion that, in Morris Cohen's words, "history is the main road to wisdom in human affairs." Understanding of the decline and fall of Rome does not seem to prevent our own decline and fall. At the same time, there is, Cohen says, a strong anti-historicist tradition. "In the Old and as well as the New Testament there is much of the anti-historical philosophy so keenly expressed in the book of Ecclesiastes to the effect that the earthly scene is all vanity and that there is nothing new under the sun. The canonical sayings of Jesus commanded men not only to take no thought of the morrow but to let the dead bury the dead." Cohen maintains that this same anti-historicism existed in nineteenth century America and continues to exist today. He notes that the practical minds of America paid only lip-service to the importance of history. Henry Ford's famous statement, "history is bunk," makes the point succinctly. This view, writes Cohen, is not limited to the "Philistines," but has been expressed in nobler and more piquant terms in the writings of Nietzsche and Emerson and Walt Whitman. But part of our Postmodernist dilemma is that we are as little comfortable with the notion of the vanity of history as we are with the notion of history as a source of wisdom. In our situation, history necessarily seems ornamental because we neither believe nor disbelieve in it.

We doubt that history can teach us anything but we do not think we can go beyond it. We are in the paradoxical condition of being stuck with but skeptical of it. Postmodernist archaeologism embodies both these extremes, which in a sense are cynical reformulations of historicism and anti-historicism. This ambivalent attitude is embodied in the Postmodernist ornamentalization of history, which in a sense reifies our "sublime"

indifference to yet resigned acceptance of it. But the Postmodernist ornamentalization of history, which seems of the essence of Postmodernism—being an issue for both Kiefer, who transcends it, and Levine, who unwittingly capitulates to it—still admits of a use of history. A self-consciously ornamentalist use of historical styles becomes a way of overcoming the seeming noncommittal relativism of the historical present. Existing ornamentally, historically authoritative, authentic styles function neither as monuments nor documents of the past, but as reminders—souvenirs?—of the necessity of commitment to "make history," moreover, of commitment that is seemingly not "relative," even if only "as if" absolute. Ornamentalization embodies this trenchant, difficult "as if." Through the contradiction between the apparently "relative" relationship to one another that historical styles have and their apparently inherent authority and authenticity—both extremes seem equally valid—the possibility of a postrelativist commitment rises, at once a spectre of the past and a siren song for the future. It is only through the ornamentalization of historical styles that this possibility seriously emerges, for such ornamentalization puts each historical style in stark comparative relation to every other in the very act of articulating its heroic status in itself.

Perhaps the hope at the bottom of the Pandora's Box of Postmodernist appropriation—the hope latent in manifest archaeologism—is the task this possibility imposes on artmaking. The possibility of an art of wise commitment and unconditional value haunts Postmodernist relativism and ornamentalism of the past. This possibility exists both as a fine crack in and control on Postmodernist archaeologism. If nothing else, it makes Postmodernism's facile commerce with historical styles more cautious and searching. The possibility of an art of nonironical commitment that emerges from the actuality of Postmodernism's appropriation of past artistic discourses, all of which seem of "relative" value (masked by the fact that the appropriation is carried out with an attitude that tends to vacillate between indifference and irony) is perhaps the ultimate archaeologistic effect. It may seem neo-utopian, but it exists to remind us that relativism is as corrosive as vitalizing—and that there may be no way out of it. The point of Postmodernism may be to remind us that there is no escape from the recognition of our own archaeological condition. Archaeologism, at the least, is clearly a stock-taking. But it also raises the Postmodernist question: does stock-taking imply that it is "too late" for American culture to recover its past commitments, or "better late than never" to become committed? Postmodernist archaeologism may embody the morbid, unconscious recognition and experience of our own historicity.

The Narcissistic Justification of Art Criticism

What is called an art object is an object in the world. This statement is simplistic and truistic, but it makes clear that the way we relate to art objects is not any different in kind from the way we relate to objects in general. We invest a good deal of interest in them—in the last analysis, perhaps an even profounder interest than in ordinary objects, for socially we are led to have great unconscious expectations from art objects, which is one of the ways we privilege them. When we do engage them, it is with the same seriousness with which we relate to the significant others in our lives. We relate to art objects perhaps even more seriously, for the instinct we invest in them seems peculiarly concentrated—purified beyond contingency, as though the art objects we commit ourselves to were destined for us. We are drawn to them in a fatal attraction, relate to them in an elective affinity beyond all anxiety. If this is true, as I think it is, then the psychoanalytic understanding of object relations seems useful in understanding the critical character of our relationship to them. Art critical discourse, at its best, is the disclosure of the depth of our relationship to art objects—the reasons for the intensity of our relationship.

The discourse of art criticism privileges the art object with a systematic kind of attention to it, which unfolds an intimate relationship with it. This critical discourse can come not only to represent it, but to function as its surrogate. When this happens, as it invariably does with the best art criticism, art criticism can be regarded as a kind of conceptual art. (The best art criticism is the narrative of a complex, intense conscious and unconscious involvement with the art object. It is a criticism whose concepts are transmuted passions, or stations on the way to the cross of an alchemical involvement with the art object.) The more public or assimilated the art object becomes—the more it seems like an irreplaceable, readily comprehensible part of the social landscape—the more art critical discourse about it seems inseparable from it.

This article originally appeared in *Art Criticism* (Fall 1985).

Art critical discourse comes to be not simply an avenue of approach to it, but the very place in which it is established, the public square in which it is the central monument. We may be unconscious of the critical space we are standing in when we consciously view the monument, but without that space there is in a sense no monument to see. That "conceptual" space concentrates in itself all our consciousness of the art monument. The conceptual space is the necessary condition which permits it to take a "stand"—permits it to make even the most elementary physical stand. Without that space the art monument has only the most minimum existence; it crawls on the ground like an infant rather than stands upright in the world like an adult. As much as a public monument is established by the mental as well as physical space it inhabits—it cannot really be said to establish itself—so the art object is established by (and in) the psychodynamic as well as historical aesthetic space created for it by art critical discourse about it. If there was no plaza of art critical consciousness marked out within the larger public realm or city of consciousness, the art object could not even be thought of as a "monument." It could not be known as either central or peripheral. It would simply be an art object barely differentiated from other art objects, and worse yet, from ordinary objects. That is, consciousness of and relationship with it would be "ordinary."

According to Baudelaire in the section on "What Is the Good of Criticism?" in "The Salon of 1846," there are two modes of art criticism: the temperamental and the "mathematical." I regard this distinction—which I will explore later—as crucial and far from simple, if superficially obvious. Baudelaire regarded them as antithetical, and praised the former as much as he deplored the latter, indicating that he regarded them as discontinuous. I will argue, with the help of psychoanalytic object relations theory, that the relationship between them is more complicated. They are distinct, but not unrelated stages—the mathematical in a sense grows out of and socializes the temperamental, with all the pruning and control that implies—in the development of a serious, intimate relationship with the art object. This development, just when it seems most mathematically complete—when it arrives at what seems like a full, "formal" clarification and exposition of the art object—unexpectedly points to a further, truly final stage of relationship to it. It is as though the temperamental relationship to it liberated it from enslavement in the Egypt of the everyday world, while the mathematical relationship to it was a kind of 40 years of intellectual wandering in the desert with it—40 years of keeping it alive in the desert of its own aesthetic purity and hypothetical self-sufficiency. It is only after this ascetic period of mathematical

understanding of the art object that one realizes there is the promised land of another kind of relationship with it, another way of inhabiting it. The mathematical understanding at best permits one a glimpse of this promised land, but does not guarantee entry into it. The two modes Baudelaire describes are unwittingly propaedeutic to the final stage of revelatory relationship to the art object. They are experimentally a leap of faith in a relationship to it that is difficult to realize, even unpredictable. They are a secondary discourse within this original relationship. Authentic art criticism involves a persistent drive, alternately impatient—temperamental—as well as patient—mathematical—to disclose this original relationship to the art object. The disclosure is itself the step in the development catalyzing the original relationship—seemingly bringing it into being. Yet the epiphanic, climatic disclosure of the originality of the relationship could not take place without the entire development of the relationship.

For Baudelaire, then, there is "cold, mathematical criticism which, on the pretext of explaining everything, has neither love nor hate, and voluntarily strips itself of every shred of temperament." And then there is the "amusing and poetic" art criticism Baudelaire prefers, the temperamental art criticism which, in the famous sentence, "should be partial, passionate and political, that is to say, written from an exclusive point of view, but a point of view that opens up the widest horizons."[1] The cold, mathematical relationship to the art object is essentially objective. It exists in terms of the ideal impersonality inseparable from austerely formal, rigorously rational analysis. The warm, temperamental relationship to the art object is essentially subjective. It is "precise" only in the sense that it offers one very particular existential perspective on the art object. It denies the possibility of explaining everything about the art object. Neither the personal nor the world-historical meanings of the art object can be exhaustively analyzed. Temperamental criticism thus implies the incompleteness—and ongoingness—of one's relationship to the art object, even its own incompleteness and lack of "integrity." It is just this strange "selflessness" which makes it temperamentally interesting. That is, to relate to an art object temperamentally is to recognize its "need" to be invested with one's own sense of selfhood, as well as the inadequacy of conscious, mathematical understanding it. Its existence as an open horizon makes it available as a talisman of one's "self"-development.

A useful way of understanding the temperamental and mathematical modes of relating to the art object is in terms of the psychoanalyst Harry Stack Sullivan's distinction between the *parataxic* and *syntactic* modes of

experience. Temperamental criticism is parataxic, while mathematical criticism is syntactic. The former is essentially imagistic criticism, the latter is interpretative criticism. But the understanding of criticism does not stop with the distinction between these two modes of critical relationship to the art object. Neither of them truly arrives at the goal of art criticism: *prototaxic* experience of the art object, to use a Sullivanian term again. This involves an epiphany of it as "momentary" or immediate—a rare disclosure of it as unequivocally and integrally present—as eternally pure presence. The development of art critical discourse from the parataxic to the syntactic modes positions consciousness for a transient prototaxic prehension of the art object. It is extremely difficult to articulate, even acknowledge, the prototaxic prehension, in part because it reveals the original "reason" one related to the art object, found it critically significant—invested one's feelings (temperament) and ideas ("mathematical" understanding) in it. Moreover, this climactic stage of critical relationship to and of the revelation of the art object is paradoxical, not only because it discloses the art object to be in complete dialectical, narcissistic reciprocity with oneself—giving one a momentary sense of completely being oneself, of wanting for nothing but the art object to be oneself, which correlates with experience of it as adequate and complete in itself (proudly "immediate")—but, more crucially, because the prototaxic experience of the art object is possible only after an intense mathematical/syntactic relationship to it.

That is, prototaxic experience of the special presentness of the art object becomes possible not, as one might expect, as a consequence of a temperamental/parataxic grasp of it, but by exhausting the possibilities of mathematical/syntactic interpretation of it. The systematic/scientific character of the mathematical/syntactic transcends the unsystematic/poetic character of the temperamental/parataxic. Prototaxic experience of epiphanic immediacy transcends—if in a less stable and predictable way than the mathematical transcends the temperamental—the mediational character of both. In each case, the transcendence is dialectical, forfeiting none of the "concepts" of the previous stage while reordering and resocializing them. But prototaxic experience unifies in a kind of transcendental intuition the irrationality of the art object that parataxic experience discloses and the rationality of the art object that syntactic experience discloses. The key point is that the parataxic and syntactic modes of relating to the art object regard it as never more than indirectly manifest—as necessarily mediated subjectively (temperamentally) or objectively (mathematically)—while the prototaxic mode assumes that it can be made immediately manifest, or directly experienceable.

Because prototaxic experience of the art object offers it with such absolute immediacy, prototaxic experience appears to be postlinguistic—from another point of view regressively prelinguistic or essentially somatic. This, together with the fact that it is beyond both the temperamental and mathematical grasp of the art object, makes the prototaxic experience of its immediate givenness seem mythical or fictional, however undeniable. The art object seems to exist in a paradoxical state of doubt-free givenness, a state which, apart from what it offers, comes to be doubted as truly the case. Prototaxic experience comes to be regarded as a wonderful illusion—divinely spurious. The aura of unreality that surrounds prototaxic experience signals its reality as a way of revealing the art object itself as a primordial fantasy of primitive givenness. In any case, it is perverse to have to experience the art object prototaxically only by way of as complete a syntactic articulation of it as possible. One can finally accept the fact that the terms of cold, mathematical, syntactic criticism are rooted, as it were, in warm, temperamental, parataxic criticism, but it is harder to accept the fact that prototaxic experience of the art object is possible only by exhausting all the syntactic means of articulating it. For this means going from the most sophisticated to the most primitive modes of articulation—from logical rigor to the seeming slackness of the inarticulate. As Sullivan writes, "the prototaxic or primitive mode" of experience is "ordinarily incapable of any formulation."[2] The unformulatable is experienced only after overformulation, as it were. Moreover, one can only formulate what cannot be formulated as the annihilation of expected formulations, not as something in itself. This also seems to be the only way it can be experienced—as the negation of every other experience. The nihilism of prototaxic experience of immediate presence seems clear—as clear as the experience seems an illusion. And yet the critical process aims at prototaxic experience of the art object. If it did not, it would not be "critical."

It is as though, in developing brilliant syntactic interpretations of the art object, one had created a magnificent critical divining rod—also adorned with beautiful temperamental images of the art object—to search for a treasure that did not necessarily exist, and was not necessarily a treasure. Criticism with such an ambition seems stupidly risky and absurd, yet if it did not have as its ambition an impossibly primitive, "fantastic" experience of the art object it would sell both itself and the art object short. It would neither realize its own temperamental and mathematical potential, nor disclose the vitality of the art object. Moreover, the possibility of prototaxic experience of the art object in a sense does no more than acknowledge the failure of all systems of thinking

about art. For to achieve their consensual accuracy they depend upon excluding the peculiar quality of the sheer givenness of the art object in contrast to other objects.

The prototaxic mode of experience is infantile. It is paradoxical that to establish an infantile mode of experience of the art object—immediate experience of it—requires such a heroic effort. But this is because only an infantile experience of the art object can disclose its extra-ordinary significance for us. Only the experience of it as "mothering" us with its "sensational" immediate givenness discloses the infantile character of our attachment to it. In a sense, the entire critical experience—all of critical discourse—exists to disclose the particular mothering experience that drew one into relationship with the art object—an experience of unconscious merger or profound intimacy with it that seemed to deny one's autonomy, yet was its root. The irony of art critical discourse is that all its analyses, whether poetic or mathematical, exist to discover the extra-analytic reason for the absurd intensity of one's relationship with and response to the art object.

Let us distinguish Sullivan's three modes of experience more precisely. The prototaxic mode is the primary, most infantile one. It involves the experience of "momentary states" with no "before and after," that is, with no awareness of "serial connection between them." In the prototaxic mode, the infant has "no awareness of himself as an entity separate from the rest of the world . . . his felt experience is all of a piece, undifferentiated, without definite limits . . . 'cosmic.' " With maturation, "the original undifferentiated wholeness of experience"—the difficult aim of critical experience of the art object—"is broken. However, the 'parts,' the diverse aspects . . . are not related or connected in a logical fashion. They 'just happen' together, or they ·do not, depending on circumstances. They . . . are felt as concomitant, not recognized as connected in an orderly way." That is, they exist in "poetic correspondence." This is the parataxic or temperamental mode of art criticism; it takes the form of poetic discourse declaring the correspondence between different subjective partial apprehensions of the art object. Indeed, speaking from the temperamental point of view, Baudelaire remarks, in the same section of "The Salon of 1846" that I have already quoted from, that "a sonnet or an elegy" may indeed be the best critical account of an art object. Finally, the syntactic mode of experience is established. It involves the " 'consensually validated' meaning of language—in the widest sense of language. These meanings have been acquired from group activities, interpersonal activities, social experience. Consensually validated symbol activity involves an appeal to principles which are accepted as true by the hearer."[3]

In a sense, parataxic, temperamental, poetic criticism is critic's criticism, in that it is a kind of shorthand "account" of critical experience of the art object. It is written critical poet/person to critical poet/person. It is a subjective appeal from one heart to another, an affair between lovers of art. It is an appeal to unknown others to love art as one would love oneself—even more than oneself, for in so doing one becomes more than one's ordinary, everyday self. But the poet-critic does not really care if he has company in his love for art; he is happy to be alone with it, to have the beloved for his own embrace alone. Indeed, the poet-critic is infatuated with the art object, and wants to possess it in an exclusive relationship. In contrast, for the mathematical critic, the other is an indispensable presence, the legitimator of his experience—the legitimator of a relationship to the art object that is beyond the poetry of love or hate for it. This cool mathematical critic practices a public, prosaic criticism, a criticism which performs a public service—which integrates the art object into civil society by civilizing it. However, civilized analytic interest in the art object is rarely durable, except—paradoxically—among a few temperamental aficionados. Few art objects enter the so-called canon, in comparison to the many produced. The syntactic understanding of art is always slipping—regressing to the poetic level which sustains it, and which it organizes. Or else, as we have noted, the syntactic understanding of art is transcended for a different kind of "subjective" reason: it seems to mirror the self of the mathematical critic of art, who thought he left love of it behind for a cold understanding. How unexpected for him to see himself in the art object when he thought he was looking at it scientifically! And how difficult it is to accept the fact that the poet-critic is never in a position to have the same narcissistic experience of the art object, for he loved the art object for itself—not, however unexpectedly, because it reflected himself. In a sense, the mathematical critic intellectually polishes the dark mirror of the art object to a shine. No longer dark, it speaks to him of his fundamental self. The poet-critic accepted that darkness as the art object's gift to his own dark—irrational—soul. He had no comprehension that his, and its, irrationality, were not fundamental. The mathematical critic alone is in a position to experience—through the unexpectedly completely present art object—what Heinz Kohut calls archaic narcissistic grandeur. The irreducible presence of the art object confirms the irreducible presence of the self.

Art critical discourse has an ultimately narcissistic purpose, in the deepest sense. In object relational terms, art is the new mother who gives one the feeling of omnipotence and integration the old one never really gave one. It is only after it is known as a set of obsolete rules that it can be experienced "cosmically" as an undifferentiated whole with which

one can merge. Prototaxic experience reveals what is most unpresentable or sublime about the art object: its capacity to love one for oneself. This is reversed, translated as lovableness of the art object in itself. But there is nothing lovable about the art object as such. It is lovable only because its immediacy, experienced with great difficulty, seems the mother of our own immediacy. It is in prototaxic experience of the art object that one has a truly "creative" relationship with it—experiences it esemplastically, to use Coleridge's term. That is, one creates the illusion of its immediacy to create the illusion that one was created for one's own sweet self. One experiences it as though it was created especially for oneself, as though its creativity is one's own self-creation. More pointedly, the entire aim of art critical discourse is narcissistic justification of the art object.

Notes

1. Charles Baudelaire, "The Salon of 1846," *The Mirror of Art*, ed. by Jonathan Mayne (Garden City, N.Y.: Doubleday & Co., 1956; Doubleday Anchor Books), p. 41.

2. Harry Stack Sullivan, *The Interpersonal Theory of Psychiatry* (New York: W. W. Norton & Co., 1953), p. 29.

3. Ibid., pp. 28–29.

The Subjective Aspect of Critical Evaluation

One can regard the critical evaluation of art as having an objective and subjective aspect, in dialectical relationship. In this talk I am going to emphasize the subjective aspect of critical evaluation, in part because it is often overlooked or neglected, which amount to the same repression of it. The demand that the critical evaluation of art be objective in basis and as scientific as possible, and the assumption that it can only make sense and be reliable if it is, is a partialization of the critical act which functions to support the illusion that there is nothing psychologically special about one's relationship with art, and that there is a normal, well-adjusted relationship to art to which everyone must aspire. No doubt in rebellious overcompensation, I want to carry my emphasis on the subjective aspect of critical evaluation to an extreme, even an abnormal reductionist extreme. By doing so I want to make a point as strongly as possible: that the most serious reason one turns to art is to satisfy a profound need—the need for a coherent, unified sense of self—that has not been satisfied in life, a need that becomes all the more pressing the more the world forces one to recognize one's limitations, undermines one's fantasy of omnipotence, treats one with the insulting casualness and subliminal indifference which it uses to assimilate everyone into its daily flow. It never mirrors one enough, and it eventually stops mirroring one altogether, or it mirrors one in such a grotesque way that one is unrecognizable to oneself, and would rather be unseen. It does this to everyone big or little, but it is those with pretensions to lasting significance that it most hurts with its callous appropriation, which is as good as disregard.

Art, for all its insidious worldness and reflection of dailiness—however sublime or ironical that reflection may be, however autonomous its insinuating language is or is not thought to be—has pretensions to lasting significance beyond those of any human endeavor. The scientist expects his truth to be superseded—it rarely becomes more than a working

This article originally appeared in *Art Criticism* (Winter 1985/86).

hypothesis—and the technician expects his technology to be improved, but the work of art claims to have enduring significance. To change it makes no sense. We do not look at a significant work of ancient art with the same amused curiosity with which we read about an ancient conception of the universe, but with the sense of being in touch with something immortal. It remains vital after we have analyzed it to death, which is why we regard it as having enduring significance. It is thus in a sense natural that we turn with serious critical attention to art when we feel our own immortality to be in question—when we begin to doubt our own lasting significance and, generalizing resentfully, feel the very notion of lasting significance to be preposterous. And yet it haunts us, for while the desire for immortality or lasting significance seems an emotional dead-end and intellectual monstrosity, it also metaphorically articulates in the very act of masking the primitive psychic need for unity or integrity of self. Successful integration promises lasting significance; put the other way, the self that appears to have lasting significance seems substantially whole.

Jung has argued that the main crisis in the course of individuation occurs in middle life, when the conflict between "archaic images of omnipotent selfhood" and "the demands made by social norms"[1] reaches a climax. It is then that one becomes seriously—not just spitefully—critical about life in general, and may be drawn into a seriously critical relationship with art, as a realm in which the conflict can be metaphorically articulated and worked through. The successful resolution of this conflict determines the character of one's maturity, and indeed, it is a conflict about the nature and meaning of maturity. Thus, the critical evaluation of art becomes especially serious—subjectively serious—at a particularly important developmental stage in life, and the dominant conflict of that stage cannot help but inform the critical evaluation of the art the critic seriously relates to. Indeed, it *must* inform his criticism if that criticism is to rise above business-as-usual professionalism and convey the art's significance in the very act of testing it—suggest what it optimally might be theoretically while recognizing what it is in fact.

Santayana has said that criticism is a serious moral activity, for it involves the attempt to distinguish the immortal from the mortal part of an art in the name of civilization.[2] Broadly understood, criticism is civilization's defense of itself. More particularly, it examines the changing sense of "immortal" and "mortal" that constitute the dialectic of civilization—the changing weight of meaning and value put on each term. Such serious moral activity requires a mature awareness of the possibilities as well as the actuality of life. That is, if criticism is to be serious it must be motivated by a mature sense of the conflicts that motivate life, and especially of the conflict which shows us life at its maturest. When the conflict between

the infantile sense of infinite possibility that fuels the expansion—creative ambition—of selfhood and the socialization process that seeks to normalize selfhood by compelling it to internalize conformist expectations is most overt, criticism can begin in deadly earnest, for it is faced with the most maturing conflict of all. It is the conflict most difficult to emerge from unscathed and yet potentially the most fruitful in creative self-integration. Immersed in this conflict, the critic can test the art for its maturing effect— for its effectiveness in helping the self toward mature recognition of the conflict. The tentative control—if not transcendence—afforded by recognition of the conflict begins the complex integration of its terms, that is, its always tentative and tenuous resolution.

In a sense, the critical act is a way of maturing through conflict with an art. The critic either denies that it is immortal, of lasting significance—omnipotent or symbolic of omnipotence—by confronting it with its mortal part, that is, the sociostylistic norms that motivate—"move"—it; or he confronts a mortal art with the criteria of supposedly lasting significance, reminds it of the factors that would make it all-powerful, turn all eyes to it, and that it is missing. In both cases he shows how the art is an unholy mix of immortal and mortal components, thus using the art to articulate and bring to consciousness the basic unconscious conflict motivating maturity. His criticism becomes a representation of the art in terms that convey the primary conflict of maturity, namely, the wish for immortality (in the guise of an infantile feeling of omnipotence) and the recognition of the reality of mortality (in the guise of recognition of social limitation). The critical act does not so much distinguish the immortal from the mortal part of the art, as Santayana said, as show how they interact—how they are integrated in the art. Criticism reminds every art, no matter what its claims to grandeur, that it is composed of mortal as well as immortal elements, and that it is not always clear which is which—reminding it that just that element which everyone thought guaranteed its immortality at the time of its making may turn out to be just the element that will make it look vulnerable and mortal to a future generation. By presenting the possibilities of opinion about it—simultaneously overestimating and underestimating it, showing the flux of the immortal and mortal variables at play in it, and their nominal character— the critic keeps alive consciousness of the conflict or dialectic between the unconscious archaic wish for omnipotence and the conscious recognition of social limitation that shapes the art's, as well as his own, maturity. In a sense, he uses the art to dramatize the conflict, even uses it as a stage on which to reenact his personal conflict, with the terms of his feeling subtly transposed into the terms of art. The art becomes a pantomime of the conflict. But since the conflict is universal or inescapable, the pantomime becomes an accurate articulation of what is most critical in the art.

However, there is a crucial difference between the art and the criticism. Where the art may or may not reconcile its wish for immortality with the reality of its mortality—offer us elements which can be regarded as making it of lasting significance as well as those which seem all too bound to a passing world, or rather put the elements of a particular world together "artistically" so that they seem memorable rather than matter-of-fact—criticism seeks to resolve the conflict, that is, offer us a sense of the art as a harmonious whole despite the contradiction which animates and threatens to disintegrate it. Criticism gets its credibility not only by articulating the contradictions that mature the art, but by showing that the art does in fact have a secret integrity. While it is overtly tense with contradiction, it is covertly a harmonious or cohesive whole, that is, has a secret, deep-lying unity of self. This unity is "proposed" by the criticism, and becomes a kind of ideal fiction against which the art is measured. In a sense, it is as fictional as the art itself, that is, as much a "pragmatic" or theatrical offer of ultimate significance to the art by the spectator as the art is a pragmatic or theatrical offer of partial significance to the spectator. In their different ways, criticism and art try to ingratiate themselves with each other. The critic solves, as it were, the riddle of the selfhood of the art—masked as the problem of its immortality—much as the art articulates the problematic character of the spectator's selfhood by metaphorically articulating the master dialectic of his being, the dialectic that matures self. The art that seems most significant is that which is like a Sphinx, asking the question "Who am I really, underneath this monstrous, crazy disguise which shows me to be self-contradictory, half-beast, half-human, half-mortal, half-immortal, it not being clear which half is which?" The critic shows that the art which is significant is the art that offers a covert "correction" of the contradiction, achieves a secret unity of the opposites, which is unconsciously appropriated by the spectator as a basic model of unified selfhood. Unconsciously appropriated, it seems timeless, that is, appropriate for all times if particular to none, which is one way of describing what seems effectively immortal. Thus, the critic shows that the problem of selfhood is solved in some art, if in no life. The critic not only stages the art as the drama of a self at odds with itself, but the drama of a self coming to terms with itself through being at odds with itself—dialectically "finding" itself in the very act of recognizing its contradictory and self-contradictory character.

But the critic does not discover the immortal part of the art he deals with, he imaginatively creates it. The immortal is the ultimate imaginary device by which the self is given ultimate integrity, or that ultimate good called integrity of self. The critic convinces us, through his vision of an

art, that the various works of art made by a particular artist have a secret, intricate unity of purpose which bespeaks an integral self. Such "integrity" guarantees the artist permanent significance for civilization. The critic creates the particular artist-self by showing how he secretly, with great ingenuity and effort, reconciles grandiose—godlike—creativity and social limitation, how he is simultaneously archaically absolute and intimately aware of and subtly articulate about the particularities of a given life-world and artworld. Criticism creates the cohesive artist-self as a kind of magical center of artistic production, or rather plots the artistic drama whose product is a seemingly exemplary unity of self. It is really a byproduct of the critic's use of the art to work through the primary conflict of his own existence at its midpoint towards his own mature self—his use of the impersonal art to articulate the conflict as a personal crossroads. He as it were repersonalizes the art in dialectical defiance of the kind of analysis that depersonalizes it. While he comes to recognize the conflict as universal through his "discovery" of it in the "chosen" art, his "recovery" of the buried treasure of integral selfhood from it comes through his own imaginative efforts: it is his own invention. There is more than a little of the hidden critic in every artist-self that civilization proclaims as significant. One of the reasons that every generation reevaluates the significance accorded the artists of the past—sometimes reconceiving them from the ground up—is that every generation has people—critics—who must "find" themselves through art, or rather conceive of a self that seems exemplary or critically significant in the civilization of that generation. The critic is responsible, as it were, for the artist's temporary immortality in a particular generation. The critic gives the art its exemplary value at a particular moment of civilization by showing how the art exemplifies the sublimest idea of self possible at the time.

Let us backtrack and start all over. The so-called critical evaluation of art is a largely unconscious matter. We approach art with a host of irrational expectations from it. Our cognitive analysis of art is only the tip of the iceberg of our relationship to it. These are truisms, but they have been violently repressed. To shift the metaphor, our cognitive relationship to art is a small island of consciousness in a sea of unconscious involvement with it. Cognitive analysis shores up the work of art against the waves of desire that batter it, but is also the intellectual reconstruction of an original romanticization of it. Reasoning about the historical place or ideological importance of an art tends to rationalize or justify a preexisting, largely unconscious, irrational psychodynamic relationship to it.

We never get seriously—even tragically—involved with a work of art just because it is there to be analyzed professionally, but because it

represents certain deep-seated feelings and attitudes we have. The work of art has charismatic power because it seems to satisfy our needs, to give voice to feelings that seem ineffable, even to put in socially presentable form attitudes that seem transgressively anti-social if not outright criminal. We expect the work to mirror us, and when it doesn't, our relationship to it becomes tragic. We feel abandoned by our last hope for an "understanding" relationship. (It is an "ineffable" relationship—one in which there is no need for speech, for we are as close to the unconscious of the work as an infant is to its mother's unconscious.) This psychodynamic symbolic function of art, whose complexity I have barely intimated, tends to be obscured by the militantly cognitive response to art. Discussion about whether an art is stylistically or ideologically innovative or conservative tends to mask an emotional, even characterological, "prejudice" in favor of the innovative or conservative. Much debate about the critical value of an art is a kind of allegorical warfare to defend certain preexisting, characteristic "points of view" or "outlooks." The art is a pawn in this fight. It is of value only insofar as it exemplifies the prejudiced point of view, rather than for itself, as it were. "Truth" is in the point of view—the typical prejudice—not in the art. One does not go to art expecting to have one's mind changed by it, but to have it confirm one's preexisting point of view. If it doesn't, it is dismissed as trivial or reactionary or banal or boring or whatever. One uses the work of art to demonstrate one's commitment to the outlook, even as a kind of proof of it. Attention to art becomes a kind of irrational rationalization of the outlook, as though because one is supposedly rationally attending to the work of art one's outlook is rational and has been arrived at rationally. But the attempt to objectively "justify" the outlook by using art as an example of it is like making the proverbial symbolic slip of the emotional tongue, revelatory of the basic irrationality or subjectivity of the outlook.

The question of the way one evaluates an art is inseparable from the question of the kind of satisfaction that art gives. In *Civilization and Its Discontents* Freud classed art in general as an "auxiliary construction," one of three "palliative remedies" for the difficulty, even unbearability of life, full of "too much pain, too many disappointments, impossible tasks." The "remedies"—consolations—for the wretchedness of life are "powerful diversions of interest, which lead us to care little for our misery; substitutive gratifications, which lessen it; and intoxicating substances, which make us insensitive to it. Something of this kind is indispensable."[3] Art is a substitutive gratification. It is, as Freud said, a "phantasy-pleasure," a "sublimation of the instincts" "frustrated by the outer world," the "transferring of instinctual aims" into a direction in which

they cannot be frustrated. Art is a civilized kind of satisfaction of instinctual aims, ''but compared with that of gratifying gross primitive instincts its intensity is tempered and diffused; it does not overwhelm us physically.'' It seems to be possible to say that from Freud's perspective art can also be regarded as a powerful diversion of interest and an intoxicating substance. Indeed, the aesthete—the absolute lover of art—can be understood to regard art as a kind of superior brandy. As Wilhelm Busch—quoted by Freud in his discussion of art—wrote, ''The man who cares has brandy too,'' and perhaps finally cares more for the brandy than anything else. After all, it is the brandy that restores him to ''equilibrium.'' As Baudelaire said in the preface to ''The Salon of 1846,'' ''Art is an infinitely precious good, a draught both refreshing and cheering which restores the stomach and the mind to the natural equilibrium of the ideal.''[4]

But Freud's view of human needs—the instincts to be satisfied—has come to seem too limited to many psychoanalytic thinkers. For many of them so-called gross primitive instincts are not so primitive, however gross they may be. Their satisfaction subserves the satisfaction of other instincts, which they in fact ''express.'' Erich Fromm's conception of what he calls ''psychic needs'' or ''existential needs'' is one important formulation of these ''alternate,'' more psychologically primitive, needs. To understand them in relationship to art is to gain an understanding of the kind of satisfaction art can afford and the kind of credibility a critical evaluation of art can have. Among the interpersonalists or proto-interpersonalists, Fromm's understanding of the psychic needs which arise from and articulate the ''conflict'' which is ''man's essence,'' and which ''enables and obliges him to find an answer to his dichotomies,'' seems the most clearly and comprehensively formulated.[5] The basic contradiction underlying the tragic ''contradictions which man cannot annul but to which he can react in various ways, relative to his character and culture,''[6] is the ''essential dichotomy between the unfolding of all a person's potential and the shortness of life, which even under favorable conditions hardly permits a full unfolding.''[7] This is complicated by another contradiction: ''man is subject to nature, yet 'transcends all other life because he is, for the first time, *life aware of itself.*' ''[8] Full human unfolding implies a full awareness of life, which is tragically impossible. It is because of this complicated tragic conflict that ''man 'is forced to overcome the horror of separateness, of powerlessness and of lostness, and find new forms of relating himself to the world to enable him to feel at home.' ''[9] The existential/psychic needs arise from this effort. Fromm identifies six of them: ''the need for relatedness, for transcendence, for rootedness, for a sense

of identity, and for a frame of orientation and an object of devotion,"
and "for effectiveness."[10] Taken together, they dialectically articulate the
unannulable tragic conflict at the core of life, without overcoming it.

It has been pointed out that Fromm's important distinction between
these true human needs and "the 'inhuman needs' . . . suggested to
man . . . to draw his attention away from his true human needs" is de-
rived from "Marx's concept of needs that are created to force man to make
new sacrifices and to place him in new dependencies."[11] However, Marx
had no adequate conception of psychic needs. He seems to have
understood, at least partially, "alienated man," but as Fromm said, to
take alienated man as the point of departure for psychological under-
standing is to fail to grasp "nonalienated existence, which is determined
only by existential dichotomies."[12] It is by putting ourselves "in the
psychological position of the person who has lost unity with nature as
a result of his specific human qualities, and seeks to recover that unity,"
that we can understand not only "authentic human needs" but the critical
role a relationship to art can play in satisfying them, or rather, in giving
us the illusion that they can be convincingly satisfied. Art, I am going
to argue, presents itself as the permanent satisfaction of psychic needs.
The illusion of permanent satisfaction is the grandest of the grand
illusions—the most fundamental illusion necessary to magical survival.
It is the expectation on which all the other satisfactions art affords are
built. It is the most unconscious expectation we have from art.

An art becomes critically significant when it seems to promise us one
or more of the following satisfactions for the different yet inseparable
psychic needs: a seemingly instinctive relationship to it as though it was
a new nature, transcendence of what Fromm calls "the hell of self-
centeredness and hence self-imprisonment,"[13] new roots for existence,
a sense of being self-identical, a devotional object through which we can
orient ourselves to existence, and a sense of primitive mastery. An art
is critically significant when it seems to transport us to a realm where
there is no tragic experience of recurrent psychic need. In general, suc-
cessful art, perhaps the most acceptable public form of wishful thinking,
creates the illusion of being existentially needless.

These satisfactions form a hierarchical order, with a sense of primitive
mastery being the most superficial sense of satisfaction a work of art can
afford and the sense of being self-identical—being integral, having
integrity—being the profoundest satisfaction it can afford. Generating an
instinctive, charismatic relationship to it as though it was a new or sec-
ond nature seems to me the second most superficial satisfaction it can
afford, while a sense of it as a new root for existence prepares the way
for the sense of it as a source of self-identity. Instinctive relationship to

seemingly charismatic art prepares the way for transcendence of the old everyday self that superficially seems central. In general, I submit that the hierarchy of satisfactions is as follows, moving from the simplest or straightforward to the most complex psychic need art can seem to satisfy: (1) the need for effectiveness; (2) the need for relatedness; (3) the need for rootedness; (4) the need for transcendence; (5) the need for a frame of orientation and an object of devotion; and (6) the need for an experience of identity or unity. It is the last on which I concentrated in the first part of the paper, and the most difficult to assess. If art seems to satisfy the preoedipal need for an experience of identity or unity, then our relationship to art has to be described as ultimately narcissistic, that is, it satisfies the narcissistic need for an archaic sense of selfhood—a need not satisfied in the mundane world. We turn to art for its satisfaction. Indeed, one can even argue that the other kinds of satisfaction, from the gross physical sexual kind Freud thought was fundamental, to the psychic satisfactions Fromm thought were necessary, are readily convertible into narcissistic satisfaction, that is, used for narcissistic purposes. In any case, if our relationship to art is ultimately narcissistic, it must be described in terms of Kohut's conception of narcissistic transference, which for convenience I will summarize in Donald Kalsched's words as "a two-faceted transference constellation alternating between the 'mirror transference' and the 'idealizing' or 'twinship' transference."[14] Kalsched remarks that narcissism or the narcissistic transference is "so ubiquitous . . . that we are tempted to conclude that it [articulates] something fundamental about the *process of psychic internalization,* i.e., the processes by which psyche itself is transmuted from the 'illusory' interpersonal space and takes up residence as internal structure."[15] I submit that the Jungian account of the middle life crisis of individuation involving a conflict between infantile feelings of omnipotence and the recognition of social norms is a crisis of interpersonal space—a crisis which issues in the mature recognition of its illusory or pragmatic/theatrical character—and that the mature result, in which the psyche "takes up residence as internal structure," that is, as integral, independent self, is the experience of identity or unity so profoundly necessary throughout life but not readily forthcoming from it, and which art affords at its maturest. The critical relationship to art, which I submit is the model relationship to it, begins interpersonally in the theatrical mirror transference—the work of art seems to promise a glimpse of one's deepest self, seems to reflect as through a glass darkly its basic unity of being. The critical relationship to art then becomes explicitly idealizing: the artist is unconsciously regarded by the critic as his twin, his double. The art is encountered and analyzed in the aura of this two-faceted narcissistic transference, out of which emerges a fantasy or

transference representation of the artist-self, which is internalized by the critic. But it is in fact the critic's self "making sense" of the art, that is, giving it a self of which the particular works are regarded as emanations. Through the process of unconsciously narcissistically oriented analysis of the art the critic simultaneously imagines and internalizes the artist-self, but in fact it is his own to begin with. It may have constituted itself by imaginative identification with the artist's work, but its form preexisted the work, not Platonically, but in the theatrical interpersonal space of his relationship to it, which arose and became consequential in the first place because of his expectation that art could satisfy his need for integral selfhood, indeed, was the royal road to it, the privileged path to an experience of identity or unity of self. I think this expectation is socio-historically generated, but the key point here is that the critic becomes pregnant, as it were, with a sense of integrity, through his relationship with art. It is not clear to me whether the art that makes him pregnant irradiated him the way the Holy Ghost irradiated the Virgin Mother, or whether he had full-fledged intercourse with it—knows it in a really carnal way—to conceive his self and know its self. I suspect some art makes the critic feel virginal again, while other art makes him feel like a tired whore turning tricks for the same old customer in a new disguise. Whether spiritual or vulgar, the ultimate value of an art seems to depend on the kind of integrity it makes one feel one has. The question for criticism is whether art, having mediated in however perverse way a sense of integrity, can remain, to use Paul Tillich's term, an object of "ultimate concern," or whether, having done so, it fades away through overfamiliarity. I think every particular art must lose significance, must come to seem more mortal than immortal, because the satisfaction art offers is not enduring however much it creates the illusion of permanent satisfaction. Once we have experienced the sense of integrity mature art can afford, we are quickly disillusioned by the art if not by the experience of integrity. But the critic returns to relate to other, seemingly fresh, art, in however Sisyphean a way, because there seems few other relationships in our society—apart from the rare significantly intimate ones—which afford the experience of integrity. But in his eternal return to art he has to answer another question the art of our society seems to confront him with: how much fresh art is mature art, that is, seems to articulate the developmental crisis through which the mature self might be created? How much art speaks to one's mature self? How much art is really worth intimately working through, critically evaluating seriously, that is, for the sake of the illusion of the salvation or integrity of the self?

Notes

1. Elizabeth Wright, *Psychoanalytic Criticism: Theory in Practice* (New York: Methuen, 1984), p. 70.

2. George Santayana, *The Life of Reason* (New York: Charles Scribner's Sons, 1954), p. 356.

3. Sigmund Freud, *Civilization and Its Discontents* (London: Hogarth Press, 1930), p. 25.

4. Charles Baudelaire, "The Salon of 1846," *The Mirror of Art* (Garden City, N.Y.: Doubleday Anchor Books, 1956), p. 38.

5. Rainer Funk, *Erich Fromm: The Courage to Be Human* (New York: Continuum, 1982), p. 59.

6. Quoted in ibid., p. 58.

7. Ibid., p. 59.

8. Ibid.

9. Ibid., p. 60.

10. Ibid., pp. 61–62.

11. Ibid., p. 61.

12. Ibid.

13. Quoted in ibid., p. 63.

14. Donald Kalsched, "Narcissism and the Search for Interiority," *Money, Food, Drink, and Fashion and Analytic Training: Depth Dimensions of Physical Existence* (Fellbach-Oeffingen, Adolf Bonz, 1983; Proceedings of the Eighth International Congress for Analytical Psychology), p. 302.

15. Ibid., p. 304.

Artist Envy

There is no denying psychoanalysis' fascination with the artist as a "special case." As the psychoanalyst John Gedo has shown, by now the "artist type" has been put through every conceptual and theoretical apparatus invented by psychoanalysis.[1] Typically, these studies reflect more about the character of psychoanalysis, and about its attitude to the artist and by implication to art, than they tell us about the nature of making art, or about the psychological reasons for making art rather than doing something else. And when they do engage works of art they have almost always regarded them as self-reflexive, symbolic acts of the artist's psyche rather than as possessing, despite their case-historical dimension, a creative integrity of their own.

For someone in whose life the arts play a serious part—without necessarily being fetishized or overidealized—the whole psychoanalytic understanding of art seems far removed from the experience of it. For example, although that experience is not exclusively aesthetic, and certainly has a strong psychological dimension, over and beyond that dimension is a sense of creative reconstruction and reconsideration of reality that is often missed from the psychoanalytic viewpoint. Because of this felt discrepancy between the psychoanalytic approach to art and art's self-understanding, many artists have been reluctant to accept the psychoanalytic gambit toward art as even minimally heuristic. This is more than the common resistance to analytic understanding, more than the patient's repression of his or her inner life. It is a defense of art against what seems to be a misunderstanding of it committed by people with no real conviction in it. To the artist, the psychoanalyst adds a twist to the conventional, vulgar attitude to art, the view of art as at best a fortuitous pleasure and more often as the symptom of a maladaptation to reality. Thus it makes sense for the artist to resist psychoanalysis as a threat to his or her very existence: if art is a symptom, surely the cure would mean the elimina-

This article originally appeared in *Artforum* (November 1987).

tion of art. This is the artist's understandable anxiety, but clearly there are many misunderstandings between the two fields, and many points to the paradoxical story.

Successful psychoanalysis really wants to liberate psychic energy, which is essentially creative, from its bondage in symptoms. It has no intention of hindering the artist from making his or her art, but rather recognizes that art is a major indicator of creativity, and thus of health. It respects art as a civilized and civilizing source. It sees that if the artist does not live up to his or her own artistic potential, that may be because of commonplace or specific psychic dysfunctions, and it seeks to free the artist—and the art—from those dysfunctions. As Susan Deri remarks, though psychoanalysis "can elicit patients' authentic form-creative potentials and liberate them from functioning under the auspices of a 'false self' and from repetitive fixation on the traumatizing aspects of the past," it "cannot produce artists."[2] The good psychoanalyst recognizes this, and deals with the artist's person, and, no doubt, with the meaning to that person of being an artist. Sometimes, during the analytic process, people whose calling is not art may indeed opt not to be artists. In fact, psychoanalysis may strengthen the commitment of convinced artists to their art in the face of "realistic" odds, and it may help them understand more clearly the goals of their art.

In general, however, both psychoanalysts and artists, each in their different ways, have repeated W. B. Yeats's idea that perfection of the life or of the work is possible, but not both. As Ellen Handler Spitz has pointed out, psychoanalysis generally follows Plato in believing that the artist's psychopathology, or "madness," is intense and intractable, "inspiring" him or her to art yet making for a damaged life.[3] But psychoanalysis is not alone here; many people follow Plato in this view. This preconception has led to the psychoanalytic correlation of art and madness, a correlation with profound implications yet also a great potential for shallow misuse. Psychoanalysis often seems to suggest that art does not so much overcome madness as intricately reflect it, and that the artist has a more intimate, aware experience of madness than any other human type, apart from the outright mad.

The considerations stretched out so far here on the relations of art and psychoanalysis could take off in a seemingly infinite number of possible examinations of this intricate theme. One could, for example, examine why psychoanalysts seem more attracted to grand literary figures such as Sophocles, Shakespeare, and Goethe than to visual artists, despite the fact that the most influential psychoanalytic theorizing on art is to be found in Freud's essays on Leonardo and Michelangelo. For Freud, despite his extensive citation of literary artists, visual artists seemed

ultimately more interesting, because the visual medium resembles the dream more than the literary narrative does. One could also write about why certain artists hold a special interest for psychoanalysts—why in visual art, for example, expressive, angst-driven work tends to attract more analysis than the Duchampian "art about art" tradition. Or one could proceed through the vast jungle of psychoanalytic literature on art, acknowledging its brilliantly ingenious interpretations here, its peculiar insensitivity to art and artists there. A number of extraordinary examinations of particular artists have been written, such as that of Goethe by Kurt Eissler, of Michelangelo by Robert Liebert, and Freud's own on Leonardo. A number of writers have in fact worked their way critically through this literature; among the most interesting recent discussions are those by Gedo, Spitz, and Elizabeth Wright.[4] These are all important topics. They are not, however, the raison d'etre of this essay.

Since its birth, psychoanalysis as a branch of knowledge has been fascinated with the figure of the artist. And basically for just as long, paradoxes have pervaded its discourse on artists. On the one hand the artist has been the model, as it were, for the healthy human being, the person whose mysterious ability to create is made concrete and actual. But the artist has also been seen as more fixated on infantile or primitive processes, in effect more traumatized, than other people. The paradox echoes the psychoanalyst's ambivalence toward the artist, and ambivalence is the tip of the iceberg.

Freud's term for his inquiry of 1910 into the unconscious of Leonardo was "pathography," and as Spitz points out, "pathography implies writing about suffering, illness, or feeling, with important overtones of empathic response on the part of the author for his subject."[5] While Freud never claimed psychoanalysis could "give an account of the way in which artistic activity derives from the primal instincts of the mind," and asserted that "pathography does not in the least aim at making the great man's achievements intelligible,"[6] the fact is that pathography was the jumping-off point for the development of a theory of artistic creation. Moreover, by reason of its empathic character, pathography implies the special energy—the energy of identification—with which psychoanalysts have pursued artists.

This relationship has many levels. It began in the early days of psychoanalysis, and its roots are partly historical. Psychoanalysis then was deeply suspect intellectually, and unacceptable socially, while art, even if often controversial, was an ingrained, time-honored part of culture. Psychoanalysts saw artists as more socially acceptable than they themselves, yet they also recognized artists as outsiders like themselves. Psychoanalysts also defined themselves as a kind of artist, masters of the

"art of interpretation," as Freud called it.[7] The identification persists to-day, though the social condition of psychoanalysis has changed. Like most identifications, this one involves admiration, empathy, and envy, both the desire to incorporate in oneself a quality one is drawn to in someone else and an uneasy, often unconscious feeling of one's own lack of that quality. At the same time, such "artist envy" is balanced by the most ordinary psychoanalyst's unconscious feeling of superiority to the greatest artist, for psychoanalysts see themselves as using the art of interpreta-tion to apply a scientific understanding of the psyche—see themselves as scientists as well as artists. To scientists, after all, art is a way not so much of gaining new knowledge as of expressing in socially novel ways the already known; it is science that they believe to be the field of true discovery. Thus to the psychoanalyst's artist envy is added the scientist's implicit contempt for the arts, going back at least to Plato's banishment of poets from the Republic and his degradation of art as inferior knowledge—an illusion of knowledge hardly worthy of the name.

Freud praised Michelangelo as an "artist in whose works there is so much thought striving for expression," an artist who "has often enough gone to the utmost limit of what is expressible in art." Yet Freud's talk of "the obscurity which surrounds his work" cannot help but imply that Michelangelo has not expressed enough.[8] And this extends to the idea that he has not understood enough: how could he have, when obscurity is endemic to his art, and to art in general. The implication is that Michelangelo's art does not express as much as artful yet scientific psychoanalytic interpretation, which is devoted to eliminating the ob-scurity surrounding the workings of the human psyche.

Freud admired the playwright and novelist Arthur Schnitzler, who seemed to Freud to intuit truths about the psyche that he himself only discovered through laborious scientific work with patients. Similarly, in his essay "Fear of Breakdown" D. W. Winnicott writes, "Naturally, if what I say has truth in it, this will already have been dealt with by the world's poets [artists], but the flashes of insight that come in poetry [art] cannot absolve us from our painful task of getting step by step away from ignorance toward our goal."[9] Psychoanalysis, then, has to struggle for its revelations, while art, whatever the inadequacy of its expression, achieves its understanding spontaneously, at least in this view. (It is, however, referred to as just a "flash," and in practical opposition to the idea of actually getting away from ignorance.) This supposed disparity is one source of the psychoanalyst's envy of the artist, but an even more crucial issue than that of intuition is relevant here. In a letter to Oskar Pfister, a pastor and psychoanalyst, Freud took his correspondent to task "for being 'overdecent' and insufficiently ruthless to his patient," and

advised him "to behave like the artist who steals his wife's household money to buy paint and burns the furniture to warm the room for his model."[10] It is revealing here that Freud justifies the necessary "coldness in feeling in the analyst"[11] that he recommends elsewhere by allusion to the artist, and the artist's hypothetical criminality. An apocryphal story—told by an anonymous psychoanalyst—illustrates this supposed criminal coldness: the sculptor Benvenuto Cellini, casting a statue, is said to have needed some calcium for the bronze alloy, and, finding none in the studio, to have thrown a little boy into the pot for the calcium in his bones. "What was the life of a little boy to the claim of art?"[12]

On more or less the same subject, in a telling passage on the artist in his article "Psycho-Analysis and the Sense of Guilt" (1958), Winnicott writes,

> It is interesting to note that the creative artist is able to reach to a kind of socialization which obviates the need for guilt-feeling and the associated reparative and restitutive activity that forms the basis for ordinary constructive work. The creative artist or thinker may, in fact, fail to understand, or even may despise, the feelings of concern that motivate a less creative person; and of artists it may be said that some have no capacity for guilt and yet achieve a socialization through their exceptional talent. Ordinary guilt-ridden people find this bewildering; yet they have a sneaking regard for ruthlessness that does in fact, in such circumstances, achieve more than guilt-driven labor.[13]

The tough-minded, amoral attitude that Winnicott finds in the artist is found professionally essential and admirable in psychoanalysis. It is the attitude that the psychoanalyst must maintain in his or her practice, an attitude that Freud, in a famous metaphor, compared to that of a surgeon.[14] Guiltless ruthlessness is often presented in the service of a higher cause (perhaps its quintessential sign), whether for art or for psychoanalysis. But psychoanalysts usually imagine that through their silence and science they outdo the artist in coldness, raising themselves over the artist, just as the artist, in this view, is assumed to be higher than the ordinary, less creative person. The psychoanalyst, I would argue, is envious of the artist—for reasons inherent to the nature of psycho-analysis and art—and this envy informs the psychoanalytic understanding of the artist.

In her brilliant analysis of envy, Melanie Klein describes it as "the angry feeling that another person possesses and enjoys something desirable—the envious impulse being to take it away or to spoil it."[15] Fur-thermore, as Klein points out, envy tends to feed on itself, to increase by its own momentum; and so, as the artist becomes more envied, he or she becomes at once more begrudged. The psychoanalyst envies the artist's guiltless ruthlessness, and at the same time wants to spoil it by

analyzing it as a defect in humanity. (In doing so, of course, the analyst, who sees in the artist's supposed ruthlessness his or her own, raises the question of his or her own defectiveness—another troubling unconscious recognition.) Part of that spoiling is to conceive the artist as amoral. Excessive envy is especially pernicious, for it tends to devalue what it envies. As Klein says,

> The fact that envy spoils the capacity for enjoyment explains to some extent why envy is so persistent. For it is *enjoyment* and the *gratitude* to which it gives rise that mitigate destructive impulses, envy, and greed. To look at it from another angle: greed, envy, and persecutory anxiety, which are bound up with each other, inevitably increase each other. The feeling of the harm done by envy, the great anxiety that stems from this, and the resulting uncertainty about the goodness of the object, have the effect of increasing greed and destructive impulses.[16]

The envy of psychoanalysts for artists has often led them toward skepticism of art, an eternal nagging doubt that it can ever really be wholly authentic as an endeavor. Their skepticism is mitigated by their appreciation of art's power to describe human beings and human ideas and emotions, and to convince society of the validity of its descriptions, but their ambivalence toward art makes their appreciation of it more disturbing rather than less. Their position resembles, in Klein's words, the criticism of "the envious patient [who] grudges the analyst the success of his work," and who even comes to doubt the validity of the analytic enterprise as such.[17] Psychoanalysis can devalue the artist's work the way this kind of patient's criticism can devalue the psychoanalyst's work. As Klein says, "There are very pertinent psychological reasons why envy ranks among the seven 'deadly sins.' "[18]

The psychoanalyst claims a power of resurrection greater than that of the artist, far greater, in fact, since from the psychoanalytic perspective the resurrection offered by art, however ecstatic, is a deceptive, transient high, the fraudulent illusion of healing rather than its reality. Envy of the artist's guiltless ruthlessness is only a part of the psychoanalyst's anxious, envious "understanding" of the artist. The analyst cannot help but envy the artist, who supposedly lets his or her sense of omnipotence run loose, and may even use it as the emotional basis of creativity. The psychoanalyst has to confront his or her own sense of omnipotence—or, as Winnicott calls it, the "area of omnipotent control"[19]—since it may threaten the patient, whose feeling of vulnerability is a sine qua non of psychoanalyst's work. As Freud wrote in *Totem and Taboo* (1912), in a chapter entitled "Animism, Magic and the Omnipotence of Thoughts,"

> In only a single field of our civilization has the omnipotence of thoughts been retained, and that is in the field of art. Only in art does it still happen that a man who is con-

sumed by desires performs something resembling the accomplishment of those desires and that what he does in play produces emotional effects—thanks to artistic illusion—just as though it were something real. People speak with justice of the '''magic of art'' and compare artists to magicians. But the comparison is perhaps more significant than it claims to be. There can be no doubt that art did not begin as art for art's sake. It worked originally in the service of impulses which are for the most part extinct today. And among them we may suspect the presence of many magical purposes.[20]

What astonishes Freud is the way the artist can be socially operational and successful yet retain intact the anti-social narcissistic principle of omnipotence of thought. But the artist, of course, is not entirely narcissistic. Works of art, Freud writes, "differed from the asocial, narcissistic products of dreaming in that they were calculated to arouse interest in other people and were able to evoke and to gratify the same unconscious wishes in them [as in the artist] too." While "the artist, like the neurotic, had withdrawn from an unsatisfying reality into [the] world of imagination . . . unlike the neurotic, he knew how to find a way back from it and once more to get a firm foothold in reality."[21] In the end, however, Freud must repudiate art in the name of science, and he does so in the last chapter of the *New Introductory Lectures of Psycho-Analysis* (1933). Here, declaring "religion alone" as science's "really serious enemy," he dismisses art as "almost always harmless and beneficent, [for] it does not seek to be anything else but an illusion. Save in the case of a few people who are, one might say, obsessed by Art, it never dares to make any attacks on the realm of reality."[22] (Freud's description of such an art-obsessed person is worth quoting in this context: "A clever young philosopher, with leanings towards aesthetic exquisiteness, hastens to twitch the crease in his trousers into place before lying down [on the couch] for the first sitting; he reveals himself as an erstwhile coprophiliac of the highest refinement, as was to be expected of the developed aesthete.")[23]

Behind psychoanalysis' envy of art lies the fact that the psychoanalyst is afraid of becoming the same kind of dealer in illusion—"confidence man"—that he or she believes the artist to exemplify. Psychoanalysis is haunted by the thought that it may be inauthentic science (as, in fact, has been cogently argued).[24] As long as this suspicion remains, psychoanalysts cannot help but unconsciously fear that they are illusionists like artists. To psychoanalysts, art's magical illusions have their value, but they are a form of subjective expression, no doubt with piecemeal insights but lacking genuine, scientific validity. (Since Freud, psychoanalysis has of course been reconceived by philosophers as a hermeneutics and phenomenology of the dialectics of feeling, its "scientism" supposedly being self-misunderstanding. This view aims to overcome the idea that the only legitimate kind of science is modeled on one

kind of supposedly solid knowledge. At the same time, it tilts psycho-analysis toward art, which, like psychoanalysis, can be regarded as an interpreter of the illusions inherent in life, if by way of the creation of "counter-illusions.") However, psychoanalysis, while wanting to free itself and us of illusions, knows that the life-world is pervaded by them; understands that because we are always in a condition of projecting our unconscious expectations on the world we are always in a condition of illusion; knows that they must be perpetually worked through. Authentic psychoanalysis, like authentic avant-garde art, is premised on enormous dissatisfaction with, even disbelief in, existing psychosocial illusions; but it is aware that the truth with which it replaces them is another kind of illusion that is also all too artistic. Thus, for all its disdain of illusion, and its fear of being regarded as merely art, psychoanalysis in effect finds itself in a kind of dependent relationship with art. It knows it needs knowledge of illusions in all their various cultural manifestations.

This awareness is implicit in Freud's avant-garde proposal that in "a college of psychoanalysis, . . . analytic instruction would include branches of knowledge which are remote from medicine and which the doctor does not come across in his practice: the history of civilization, mythology, the psychology of religion and the science of literature. Unless he is well at home in these subjects, an analyst can make nothing of a large amount of his material."[25] Freud implies an essential relationship between psychoanalysis and art, one that gives psychoanalysis access to art's insights—licenses psychoanalysis to bring up from the artistic netherworld such ideas as those embodied in the very name of its perhaps most salient discovery, the Oedipus complex.

A major formulation of this "dependent" relationship between art and psychoanalysis is Heinz Kohut's "hypothesis of artistic anticipation," which gives the "great artist" credit for being "ahead of his time in focusing on the nuclear psychological problems of his era,"[26] but argues that "the investigative efforts of the scientific psychologist"[27] comprehensively and coherently realize the goal of understanding that the artist recognizes only intuitively. Winnicott says something similar when he remarks that "the intuitive flashes of the great, . . . and even the elaborate constructs of poets and philosophers, are lacking in clinical applicability," and that psychoanalysis makes scientifically and usefully available—clinically operational—"much that was previously locked up" in such intuitive flashes.[28] In the very act of praising artists for their intuitions, Kohut and Winnicott dismiss them by regarding them as "anticipatory" but inoperational in the actual circumstances of life or therapy. They credit the artist, the object of envy, who is acknowledged as offering the seminal intuitive flashes that start thought moving, but they also claim that these insights are impractical in the end, remaining merely "artistic."

One last word about the psychoanalyst's envy of the artist, particularly the visual artist. For Freud, visual art is necessarily more erotic than literary art, since after touch the visual is the major medium of communication of sexual excitement and ideas.[29] For the psychoanalyst, the visual in general is more primitive than the verbal, particularly because it implies "the earliest closeness with the mother in the preverbal state," the "understanding [that] needs no words to express it."[30] Thus more sexual pleasure lies in the visual artist's work than in that of the psychoanalyst, who works in words, and is a kind of literary artist. To the analyst, the visual artist seems closer to the source of primal enjoyment than the literary artist. This is another reason for the psychoanalyst's confused attraction to the artist: the analyst suspects that it is in the very nature of art's effort that it can establish an enviable state of preverbal closeness with the viewer. The analyst desires this state, for preverbal closeness is the optimum condition toward which the relationship between patient and analyst drifts, a regressive condition reparative of the damage each does to the other by reason of each's unconscious envy of the other. As in Kafka's *A Country Doctor*, the psychoanalyst in effect must empathetically lie on the couch with the patient. Without that empathy, the analyst will not be cured of his or her delusion of omnipotence. (Empathy takes one out of that delusion.) Nor will the patient be cured, since he or she needs the analyst as a part of him or herself. Perhaps the final reason for the psychoanalyst's envy of the artist is that the artist seems spontaneously to have this empathy or unconscious closeness with his or her public, or at least creates the illusion of having it. Just as psychoanalysis has worked woman's "penis envy" into the ground, up pops its own artist envy.

Notes

1. John E. Gedo, *Portraits of the Artist* (New York Guilford Press, 1983): section 1, pp. 1–40.

2. Susan K. Deri, *Symbolization and Creativity* (New York: International Universities Press, 1984), p. 346.

3. Ellen Handler Spitz, *Art and Psyche* (New Haven: Yale University Press, 1985), p. 28.

4. Gedo and Spitz are cited above; Wright is Elizabeth Wright, *Psychoanalytic Criticism: Theory in Practice* (London and New York: Methuen, 1984).

5. Spitz, *Art and Psyche*, p. 28.

6. Quoted in ibid.

7. Among other places, Freud alludes to the "art of interpretation" in "Further Recommendations in the Technique of Psychoanalysis" (1914), collected in Philip Rieff, ed., *Freud: Therapy and Technique* (New York: Macmillan Publishing Co., Inc., Collier Books, 1963), p. 158.

8. Sigmund Freud, "The Moses of Michelangelo" (1914), collected in Rieff, ed., *Freud: Character and Culture* (New York: Collier Books, 1963), p. 106.

9. Quoted in Murray Cox, *Structuring the Therapeutic Process: Compromise with Chaos* (Oxford, England: Pergamon Press, 1978), pp. 280–81.

10. Quoted in Janet Malcolm, *Psychoanalysis: The Impossible Profession* (New York: Alfred A. Knopf, Borzoi Books, 1982), p. 80.

11. Freud, "Recommendations for Physicians on the Psychoanalytic Method of Treatment" (1912), in Rieff, *Freud: Therapy and Technique*, p. 80.

12. Malcolm, *Psychoanalysis*, p. 80.

13. D. W. Winnicott, "Psycho-Analysis and the Sense of Guilt" (1958), *The Maturational Processes and the Facilitating Environment* (New York: International Universities Press, 1965), p. 26.

14. Freud, "Recommendations for Physicians on the Psychoanalytic Method of Treatment," p. 121. Freud wrote: "I cannot recommend my colleagues emphatically enough to take as a model in psychoanalytic treatment the surgeon who puts aside all his own feelings, including that of human sympathy, and concentrates his mind on one single purpose, that of performing the operation as skillfully as possible." Such "coldness in feeling," he said, "is the condition which brings the greatest advantage to both persons involved, ensuring a needful protection for the physician's emotional life and the greatest measure of aid for the patient that is possible at the present time." That is, "coldness" represses the psychoanalyst's own psychopathology so that he or she can fully attend to the patient's.

15. Melanie Klein, "Envy and Gratitude" (1957), *Envy and Gratitude and Other Works 1946–1963* (New York: Macmillan Publishing Co., Inc., Free Press, 1984), p. 181.

16. Ibid., pp. 186–87.

17. Ibid., p. 184.

18. Ibid., p. 189.

19. Quoted in Arnold H. Modell, "Object Relations Theory," in Arnold Rothstein, ed., *Models of the Mind: Their Relationships to Clinical Work* (New York: International Universities Press, 1985), p. 97.

20. Freud, *Totem and Taboo* (New York: W. W. Norton & Company, Norton Library, 1950), p. 90.

21. Freud, *An Autobiographical Study* (New York: W. W. Norton & Company, Norton Library, 1963), pp. 122–23.

22. Freud, *New Introductory Lectures on Psycho-Analysis* (New York: W. W. Norton & Company, 1933), p. 219.

23. Freud, "Further Recommendations in the Technique of Psychoanalysis," p. 151.

24. See Adolf Grünbaum, *The Foundations of Psychoanalysis, A Philosophical Critique* (Berkeley: University of California Press, paperback edition, 1985).

25. Quoted in Peter Loewenberg, "Why Psychoanalysis Needs the Social Scientist and the Historian," in Geoffrey Cocks and Travis L. Crosby, eds., *Psycho/History: Readings*

in the Method of Psychology, Psychoanalysis, and History (New Haven: Yale University Press, 1987), p. 30. More recently, Richard Chessick has made a somewhat similar recommendation; see his "Education of the Psychotherapist," *Why Psychotherapists Fail* (New York: Science House, 1971), pp. 35–49.

26. Heinz Kohut, *The Restoration of the Self* (New York: International Universities Press, 1977), p. 285.

27. Ibid., p. 296.

28. Winnicott, "Psycho-Analysis," p. 15.

29. Freud, "Three Essays on the Theory of Sexuality" (1905) *Standard Edition*, vol. 7, p. 156.

30. Klein, "Envy and Gratitude," p. 188.

Index